Olmec Art of Ancient Mexico

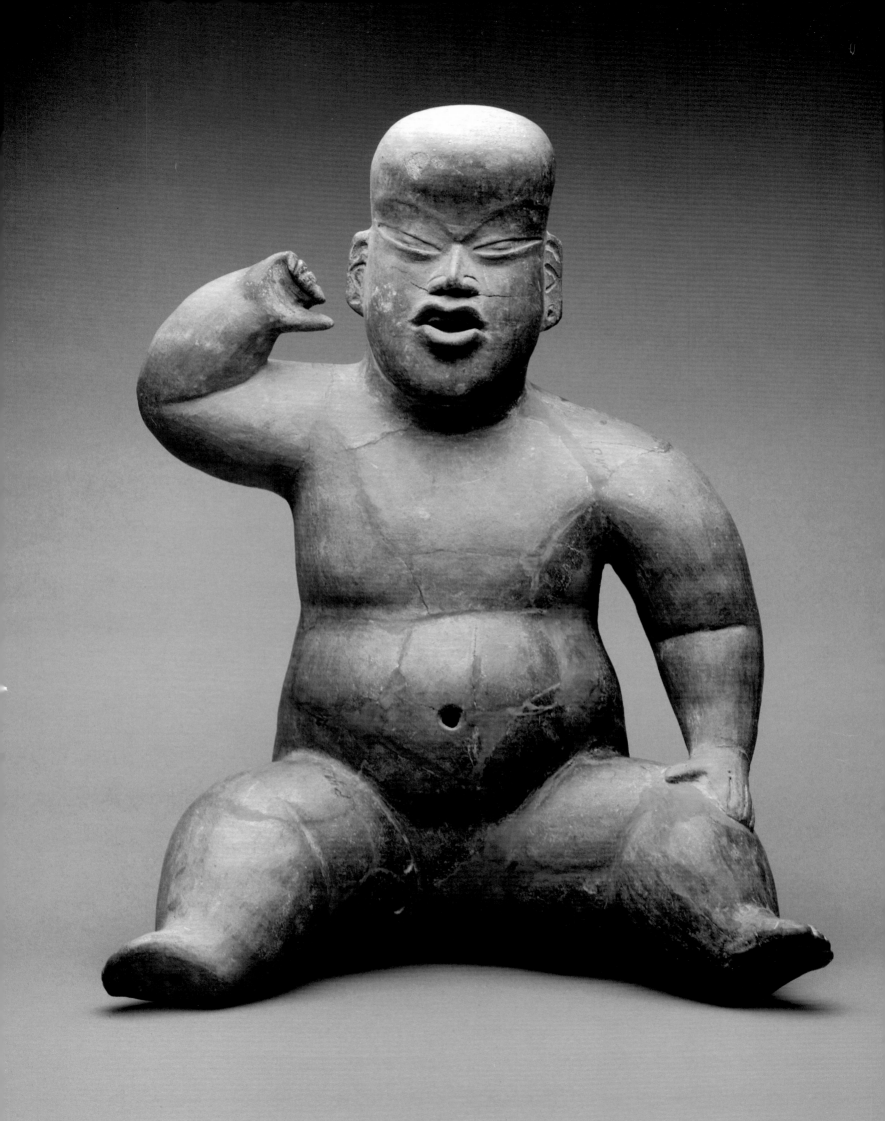

Olmec Art of Ancient Mexico

Edited by Elizabeth P. Benson and Beatriz de la Fuente

WITH CONTRIBUTIONS BY

Marcia Castro-Leal

Ann Cyphers

Richard A. Diehl

Rebecca González Lauck

David C. Grove

Peter David Joralemon

Eduardo Matos Moctezuma

Christine Niederberger

Patricia Ochoa

Anatole Pohorilenko

Mari Carmen Serra Puche

Felipe Solís Olguín

NATIONAL GALLERY OF ART, WASHINGTON

Distributed by Harry N. Abrams, Inc., New York

The exhibition is organized by the National Gallery of Art, Washington, in collaboration with the Consejo Nacional para la Cultura y las Artes, through its Instituto Nacional de Antropología e Historia.

The exhibition is made possible by The Fund for the International Exchange of Art.

The exhibition is supported by an indemnity from the Federal Council on the Arts and the Humanities.

National Gallery of Art, Washington
30 June–20 October 1996

The book was produced by the Editors Office, National Gallery of Art
Editor-in-Chief, Frances P. Smyth
Senior Editor, Mary Yakush
Editor, Susan Higman
Production Manager, Chris Vogel
Designer, Bruce Campbell, Mystic, Connecticut

Typesetter, Paul Baker Typography, Inc., Chicago, Illinois
Digital layout, Studio 405, Washington, D.C.
Printed on Vintage Velvet by Hull Printing, Meriden, Connecticut
Maps (pp. 14, 15), Bruce Daniel, American Custom Maps, Albuquerque, New Mexico
Bound by Acme Bookbinding, Inc., Charlestown, Massachusetts

Translations from the Spanish are by Mary Pye, research assistant, Center for Advanced Study in the Visual Arts

frontispieces: p. 2, cat. 21; p. 16, cat. 51; p. 28, detail of cat. 3; p. 34, cat. 115; p. 40, cat. 7; p. 50, detail of cat. 9; p. 60, detail of cat. 2; p. 72, detail of cat. 17; p. 82, cat. 25; p. 94, cat. 4; p. 104, cat. 42; p. 118, cat. 111; p. 132, cat. 9; p. 138, cat. 90; p. 144, cat. 10

LIBRARY OF CONGRESS CATALOGING-IN-PUBLICATION DATA
Olmec art of ancient Mexico / edited by Elizabeth P. Benson &
Beatriz de la Fuente ; with contributions by Richard Diehl ...
[et al.].
p.cm.
To accompany an exhibition at the National Gallery of Art, Washington, June 30 to Oct. 20, 1996.
Includes bibliographical references.
ISBN 0-89468-250-4 (paper); 0-8109-6328-0 (cloth)
1. Olmec art—Exhibitions. I. Benson, Elizabeth P. II.
Fuente, Beatriz de la. III. Diehl, Richard A. IV. National
Gallery of Art (U.S.)
F1219.8.O56O46 1996
709'.72—dc20 96-10906
CIP

Contents

Forewords

The art style known as Olmec is the earliest, one of the finest, and the least known of the great Pre-Columbian styles of Mexico and upper Central America. The Olmec civilization, which flourished nearly three thousand years ago, left no written records. The attainment of a high cultural and social level is apparent, however, in the astounding objects represented in this exhibition.

The National Gallery of Art was one of the first American art museums to show Pre-Columbian artifacts, starting with the Robert Woods Bliss Collection, on loan to the National Gallery from 1947 until 1962. Bliss began his collection with an Olmec piece, exhibited here. The Gallery has also organized exhibitions of Aztec art of Central Mexico and of early art from Costa Rica. A section of the *Circa 1492* exhibition included Aztec and Inca art, and Central American and Colombian gold. This exhibition, with objects lent from Mexican museums as well as from museums and collections around the world, is the first comprehensive presentation of the extraordinary art of the Olmec.

We wish to express our sincere appreciation to all those who have contributed to the success of this endeavor, in particular the lenders, without whom the exhibition would not be possible. Special thanks are extended to those public institutions that made multiple loans, specifically the Museo Nacional de Antropología, Mexico City; the Museo de Antropología de Xalapa, Universidad Veracruzana; Dumbarton Oaks Research Library and Collections, Washington, D.C.; American Museum of Natural History; The Metropolitan Museum of Art; The Art Museum, Princeton University; and Dallas Museum of Art.

An exhibition of this scale and importance requires the close cooperation of many people, and never have so many colleagues in the United States and Mexico collaborated so closely at every stage of development. This exhibition has been organized jointly by the National Gallery of Art and the Consejo Nacional para la Cultura y las Artes, through its Instituto Nacional de Antropología e Historia. We are indebted to Rafael Tovar, president of the Consejo Nacional para la Cultura y las Artes, and María Teresa Franco, director general of the Instituto Nacional de Antropología e Historia, for the leadership and cooperation over several years that has resulted in this landmark exhibition. This venture could not have been achieved without the work of the distinguished Organizing and Academic Committees. Their enormous collaborative efforts have guided both the exhibition and the catalogue.

We are grateful to the Honorable James R. Jones, U.S. ambassador to Mexico, Donald R. Hamilton, minister counsellor for cultural and information affairs, and Angier Peavy, cultural attaché at the U.S. Embassy in Mexico City. A special debt of gratitude is due Bertha Cea Echenique, senior cultural affairs specialist at the U.S. Embassy, for her unfailing helpfulness and competence in assisting with virtually every aspect of the exhibition's organization in Mexico. At the Embassy of Mexico in Washington we thank the Honorable H. E. Jesus Silva-Herzog, ambassador of Mexico, as well as Manuel Cosío, former minister for cultural affairs at the Mexican Cultural Institute, for his generous cooperation, and Alvaro Rodríguez Tirado, current cultural minister, for his continued efforts on our behalf.

In Mexico we have been assisted greatly by many people and institutions, including Patricio Chirinos Calero, Gobernador Constitucional del Estado de Veracruz; Emilio Gidi Villareal, rector of the Universidad Veracruzana; Roberto Madrazo Pintado, Gobernador Constitucional del Estado de Tabasco; Raul Villarino Ruiz, at the Centro INAH (Tabasco); Andrés González Pagés and Carlos Sebastián Hernández Villegas of the Instituto de Cultura de Tabasco; Jaime García Amaral and Miriam Kaiser at the Consejo Nacional para la Cultura y las Artes; and Miguel-Angel Fernández and Ana Coudurier at the Instituto Nacional de Antropología e Historia.

In this Olmec exhibition, presenting the remarkable beginnings of Pre-Columbian art, the National Gallery of Art provides an opportunity to view some of the most glorious early art of this hemisphere.

Earl A. Powell III
Director, National Gallery of Art

Originally used to describe an art style, the term "Olmec" has come to designate the culture that created the style. The Olmec culture achieved notable advances in science, technology, and social development, but it is best known for its art.

It is with great pride that we present in the National Gallery of Art, one of the world's most prestigious museums, *Olmec Art of Ancient Mexico*. The stunning works in this exhibition—monumental and life-size sculptures, small-scale objects, religious items, decorative articles, jewelry, and items for everyday use—provide a window into the Olmec world. The geographical areas where the style developed, from capitals such as La Venta to other places of Olmec influence, beyond the Gulf Coast of Mexico, are well represented here. The objects manifest the central themes of Olmec art and culture: depictions of the cosmos, the human figure, and the elite.

Many of these works are known the world over, including two of the seventeen colossal heads found to date. Undoubtedly, these are the most spectacular and representative creations of Olmec art, along with such masterpieces as the Wrestler, the Las Lima Figure, and Offering 4 from La Venta, also on display.

A team of specialists from Mexico and the United States has shared in the tasks of selection, study, organization, and presentation of works, and a number of institutions have made the exhibition possible. Recognition is due to the National Gallery of Art; the Embassy of the United States of America in Mexico; the Secretary of Foreign Affairs of Mexico, through the Mexican Embassy in the United States and the Mexican Cultural Institute in Washington; the Consejo Nacional para la Cultura y las Artes, through the Instituto Nacional de Antropología e Historia; the Secretary of Education of Mexico; and the Secretary of Tourism of Mexico.

It is our sincere hope that visitors to this exhibition enjoy this magnificent opportunity to admire and appreciate the art of the Olmec, the oldest civilization of Mesoamerica.

Rafael Tovar
President, Consejo Nacional para la Cultura y las Artes

THE ORGANIZING COMMITTEE

Mari Carmen Serra Puche, director, Museo Nacional de Antropología

Beatriz de la Fuente, former director, Instituto de Investigaciones Estéticas, Universidad Nacional Autónoma de México

Richard A. Diehl, professor of anthropology, The University of Alabama, Tuscaloosa

Elizabeth P. Benson, Institute of Andean Studies, Berkeley, California

THE ACADEMIC COMMITTEE

Marcia Castro-Leal, curator, Sala del Golfo, Museo Nacional de Antropología

Christine Niederberger, archaeologist, Instituto Nacional de Antropología e Historia

Rebecca B. González Lauck, archaeologist, Instituto Nacional de Antropología e Historia

David C. Grove, professor of anthropology and Jubilee Professor of Liberal Arts and Sciences, University of Illinois, Urbana-Champaign

Peter David Joralemon, Pre-Columbian Art Research Associates, New York

Lenders to the Exhibition

American Museum of Natural History, New York

The Art Museum, Princeton University

Jeanette Bello

The British Museum

The Brooklyn Museum

The Cleveland Museum of Art

Collection Leof Vinot

Dallas Museum of Art

Denver Art Museum

Dumbarton Oaks Research Library and Collections,
Washington, D.C.

Los Angeles County Museum of Art

Dana B. Martin

Robin B. Martin

The Metropolitan Museum of Art

Middle American Research Institute, Tulane University,
New Orleans

The Montreal Museum of Fine Arts

Munson-Williams-Proctor Institute, Utica, New York

Museo Amparo, Puebla, Mexico

Museo de Antropología de Xalapa, Universidad
Veracruzana

Museo del Estado de Puebla, Mexico

Museo del Jade Fidel Tristan, Instituto Nacional de
Seguros, San José, Costa Rica

Museo del Templo Mayor, Mexico City

Museo Nacional de Antropología, Mexico City

Museo Nacional de Arqueología y Etnología,
Guatemala City

Museo Regional de Antropología Carlos Pellicer Cámara,
Villahermosa

Museo Regional de Antropología, Mérida, Yucatan

Museo Regional de Chiapas, Mexico

Museum für Völkerkunde, Vienna

Museum Ludwig, Cologne

Museum of Fine Arts, Boston

National Museum of the American Indian, Smithsonian
Institution

Parque Museo de La Venta, Villahermosa

Peabody Museum of Archaeology and Ethnology,
Harvard University

Private collections

Rautenstrauch-Joest-Museum der Stadt Köln

Sainsbury Centre for Visual Arts, University of East
Anglia, Norwich

The Saint Louis Art Museum

The Snite Museum of Art

Tucson Museum of Art

Wadsworth Atheneum, Hartford

Acknowledgments

We gratefully acknowledge the assistance of the directors and staff of all the lending institutions and are particularly thankful for the expertise of colleagues Charles Spencer and Belinda Kaye, American Museum of Natural History, New York; Allen Rosenbaum, Gillett G. Griffin, and Maureen McCormick, The Art Museum, Princeton University; B. John Mack, the British Museum; Diana Fane, The Brooklyn Museum; Margaret Young-Sánchez, The Cleveland Museum of Art; Elizabeth Boone, Jeffrey Quilter, Carol Callaway, and Joseph Mills, Dumbarton Oaks Research Library and Collections, Washington, D.C.; Julie Jones, The Metropolitan Museum of Art; Robert Little and Mayo Graham, The Montreal Museum of Fine Arts; Sara Ladrón de Guevara, Museo de Antropología de Xalapa, Universidad Veracruzana; Zulay Soto Mendez, Museo del Jade Fidel Tristan, Instituto Nacional de Seguros, Costa Rica; Eduardo Matos Moctezuma, Museo del Templo Mayor; Felipe Solís Olguín and Patricia Ochoa, Museo Nacional de Antropología, Mexico City; Melania Ortiz Volio, Museo Nacional de Costa Rica; Gerald W. van Bussel, Museum für Völkerkunde, Vienna; Kenn Yazzie, National Museum of the American Indian, Smithsonian Institution; Jane Walsh and Dennis Stanford, National Museum of Natural History, Smithsonian Institution; Genevieve Fisher, Peabody Museum of Archaeology and Ethnology, Harvard University; Gabriele Sill-Schmitt, Rautenstrauch-Joest-Museum der Stadt Köln; Douglas Bradley, The Snite Museum of Art, University of Notre Dame; and Susan Dolan, Tucson Museum of Art.

We owe special thanks to the following individuals for their contributions: John E. Clark, New World Archaeological Foundation; Ann Cyphers, Universidad Nacional Autónoma de México; Michael Kan, Detroit Institute of Arts; Justin and Barbara Kerr; Joyce Marcus, University of Michigan; Edward and Vivian Merrin; Mario Navarrete, formerly of the Museo de Antropología de Xalapa, Universidad Veracruzana; Mirtha Virginia Perea, Embassy of Costa Rica, Washington, D.C.; Anatole Pohorilenko, Philadelphia; and F. Kent Reilly III, Southwest Texas State University.

At the National Gallery of Art, in the exhibitions office, D. Dodge Thompson administered the exhibition with great skill, and Linda Thomas gave unsparingly of her generous spirit and energy in handling the many intricacies involved in coordinating this complicated project. Cameran G. Castiel was indispensable to the success of this endeavor, contributing her experience and valuable advice, and Jennifer Fletcher provided invaluable organizational coordination at every stage. Jay Levenson was involved in the early stages of the project. Susan Arensberg wrote the brochure and produced the video with Elyse Kunz, aided by Isabelle Dervaux, Rolly Strauss, and Divya Muralidhara. Frances P. Smyth and the staff of the editors office edited and produced the catalogue. Mariah R. Seagle deftly organized the photographic material for publication. The elegant catalogue design is the accomplishment of Bruce Campbell. Joseph Krakora and Sandra Masur of the external affairs office were instrumental in securing funding for the exhibition. In the general counsel's office Elizabeth A. Croog and Nancy Breuer handled legal matters. Sara Sanders-Buell of the department of imaging and visual services coordinated visual resources. Ysabel Lightner and Noriko Bové of the museum bookstores produced products to accompany the exhibition. Deborah Ziska handled all of the promotional details for the information office.

The transportation and installation of these works of art have been unusually complicated, and many people have contributed enormously. In the registrar's office, Sally Freitag, Michelle Fondas, and Andrew Krieger are to be commended for their tireless efforts. Mervin Richard of the conservation department oversaw condition reporting and special packing requirements. In the design and installation department, Gaillard Ravenel, Mark Leithauser, Gordon Anson, William Bowser, Linda Heinrich, and Jane Rodgers have presented the exhibition in a manner that portrays the objects with all the drama and sensitivity of the Olmec style itself.

Elizabeth P. Benson and Beatriz de la Fuente

Introduction

The Olmec formed the foundation of Mesoamerican civilization, one of the world's most impressive cultural traditions. The Aztec, the last in a long line of Mesoamerican civilizations, marked the end of that tradition when they were overwhelmed by Hernán Cortés and his companions in 1521. The Aztec, Toltec, Maya, Teotihuacano, Zapotec, and other Pre-Columbian civilizations shared a cultural pattern unlike any other in the world, the result of thousands of generations living completely isolated from the peoples of Europe, Asia, and Africa. Archaeologists have traced these civilizations of Mexico and Central America back to the Olmec, who lived in southeastern Mexico in the first and second millennia before the birth of Christ.

The Mesoamerican cultural pattern was found in a continuous stretch of terrain extending from north-central Mexico southeast to northern Central America. Farming was practiced by families residing in small villages and towns. Maize, beans, squashes, and chili peppers were the plants that fueled this civilization. Relatively simple technology based on stone tools, pottery, basketry, and wooden instruments combined with sophisticated farming techniques to produce enough food to support populations of more than ten million at the time of the Spanish Conquest.

Mesoamerican societies were not egalitarian, however. Each local group was part of a much larger political and social unit ruled by an elite class residing in large towns and cities. The remains of these spectacular centers dot the Mesoamerican landscape today, evoking a past shrouded in the mists of prehistory. Teotihuacan, Copan, Palenque, Chichén Itzá, Tikal, Monte Albán: their temples, palaces, ballcourts, and sculpture engage millions of modern visitors who hope to understand the past by looking at it through the eyes of the present. These centers were home to the rulers, priests, merchants, warriors, and craft specialists who were supported by taxes levied on the farmers; in return, they ran the affairs of the society. In these centers the true range of wealth and social status that characterized Mesoamerican civilizations was most evident. Here, too, was the focus of rituals and celebrations dedicated to appease the inhabitants of the underworld, those who controlled the destinies of all humans, king and commoner alike.

Civilizations are societies with large populations; complex social, economic, religious, and political institutions; and notable achievements in the arts. *Pristine civilizations* are those that arose independent of contacts with other cultures on a similar level of development; thus, by definition, they are the first cultures in a given part of the world. The Mesoamerican civilization was one of only five or six such civilizations in human history, sharing that distinction with early civilizations in Egypt, Mesopotamia, the Indus valley, north China, and the Andes. As Olmec culture is the earliest identifiable complex culture in Mesoamerica, many questions arise about its role in the beginnings of that civilization and its influence on later ones. Over the years, two basic schools of thought have emerged on these issues. One holds that the Olmec created the basic Mesoamerican culture patterns, especially those related to a culture of the elite, such as manifestations of political power, long-distance trade, religion, ritual, and, above all, art. Exponents of this position sometimes call the Olmec Mesoamerica's "Mother Culture" and argue that many features of Olmec civilization were diffused to contemporaries in other parts of Mesoamerica and became the matrix for all later cultures in the region.

Opponents of this hypothesis maintain that many cultural features, beliefs, and art motifs commonly called Olmec were, in fact, not unique to the Olmec, and that neighboring groups in Oaxaca, the Basin of Mexico, and the Pacific Coast were as highly developed as the Olmec of the south Gulf Coast. They also emphasize the role of local cultural processes in the formation of the later Zapotec, Maya, and Central Mexican civilizations and downplay the Olmec contribution to later cultures. These various positions are fully represented in the essays in this catalogue, and although I am a stout defender of the Olmec-centric perspective, I believe I speak for all of my colleagues, regardless of their views, when I say that the debate is not only useful and necessary but one of the things that make Olmec studies so exciting in the 1990s.

The essays that follow deal with much more than these debates about the role of the Olmec in Mesoamerican history: they represent modern attempts to understand what Olmec art meant to its creators. Perhaps equally important

is the question of what it means to us. No one who views Olmec art can fail to relate to it in some fashion. Scholar or lay person, aficionado or neophyte, everyone responds differently to the subtleties of form, the realistic portraits, and the grotesques that abound in Olmec art, but none of us comes away untouched. Perhaps the true magic of the Olmec lies in their ability to strike deep chords in people so distant from them in time, place, and culture.

Richard A. Diehl

Olmec Art of
Ancient Mexico

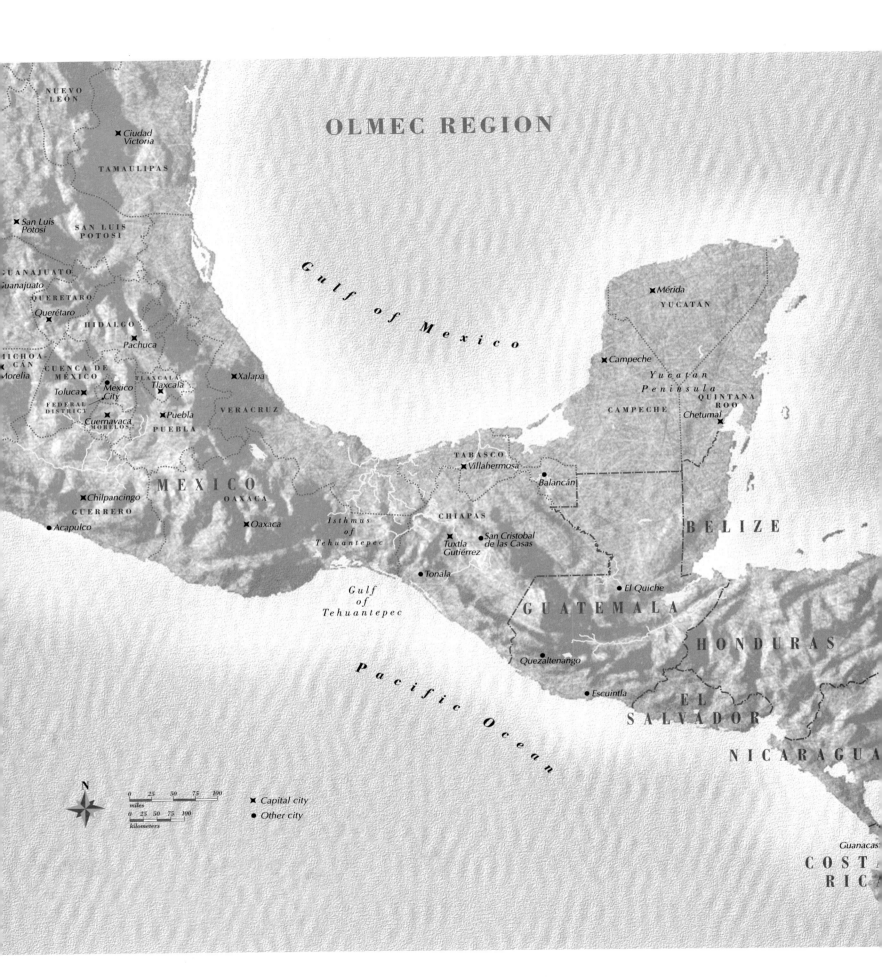

OLMEC REGION

NUEVO
LEÓN

✖ Ciudad
Victoria

TAMAULIPAS

Gulf of Mexico

✖ Mérida
YUCATAN

✖ San Luis
Potosi

SAN LUIS
POTOSI

GUANAJUATO

Guanajuato

QUERETARO

✖ Querétaro

HIDALGO

✖ Pachuca

✖ Campeche

Yucatan
Peninsula

QUINTANA
ROO

MICHOA-
CÁN

Morelia

CUENCA DE
MÉXICO

TLAXCALA

✖ Xalapa

CAMPECHE

✖ Chetumal

✖ Toluca

✖ Mexico
City

✖ Tlaxcala

FEDERAL
DISTRICT

✖ Cuernavaca
MORELOS

✖ Puebla

VERACRUZ

PUEBLA

TABASCO

✖ Villahermosa

MEXICO

OAXACA

● Balancán

BELIZE

✖ Chilpancingo

GUERRERO

CHIAPAS

● Acapulco

✖ Oaxaca

Isthmus
of
Tehuantepec

Tuxtla
Gutiérrez

● San Cristobal
de las Casas

● El Quiche

● Tonala

Gulf
of
Tehuantepec

GUATEMALA

HONDURAS

Pacific Ocean

● Quezaltenango

● Escuintla

EL
SALVADOR

NICARAGUA

N

0 25 50 75 100
miles

0 25 50 75 100
kilometers

✖ Capital city
● Other city

Guanacas

COSTA
RICA

14

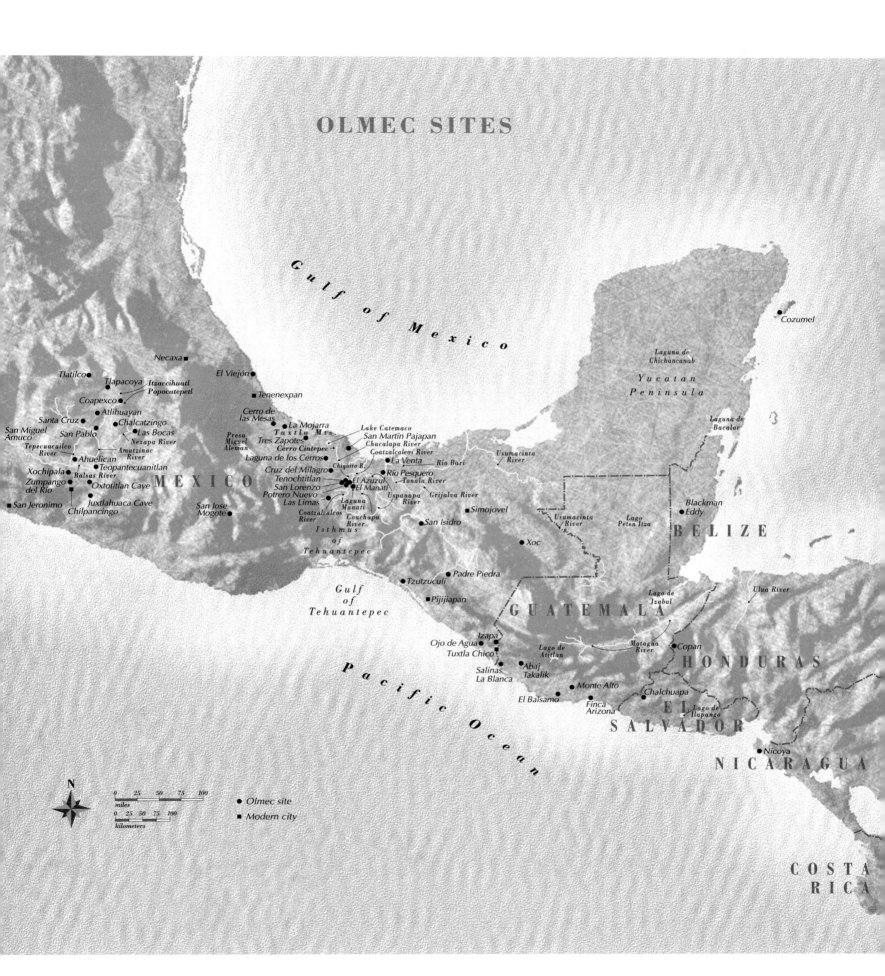

OLMEC SITES

Gulf of Mexico

Cozumel

Laguna de
Chichancanab

Yucatan
Peninsula

Laguna de
Bacalar

Necaxa

Tlatilco
Tlapacoya El Viejón
Itzaccihuatl
Coapexco Popocatepetl
Tenenexpan
Atlihuayan
Santa Cruz Chalcatzingo
 Cerro de
San Miguel las Mesas
Amuco San Pablo La Mojarra
 Las Bocas Tuxtla Mts. Lake Catemaco
Tepecuacuileo Nexapa River Tres Zapotes San Martín Pajapan
River Amatzinac Presa Cerro Cintepec Chacalapa River
Ahuelican River Miguel Laguna de los Cerros Coatzalcaleos River
Xochipala Teopantecuanitlan Aleman Cruz del Milagro La Venta Río Bari
Zumpango Balsas River Tenochtitlan Chiquito R. Usumacinta
del Río Oxtotitlan Cave San Lorenzo El Azuzul Río Pesquero River
 MEXICO Potrero Nuevo El Manati Tonala River
San Jeronimo Juxtlahuaca Cave Las Limas Laguna Uspanapa
 Chilpancingo Coatzalcalcos Manati River Grijalva River
 San Jose River Coachapa Blackman
 Mogote Isthmus River Eddy
 of Simojovel Lago
 Tehuantepec Peten Itza BELIZE
 San Isidro
 Usumacinta
 River
Gulf Ulua River
of Padre Piedra
Tehuantepec Tzutzuculi
 Pijijiapan GUATEMALA Lago de
 Izabal Motagua
 River Copan
 Izapa
 Ojo de Agua Lago de HONDURAS
 Tuxtla Chico Atitlan
 Salinas Abaj
 La Blanca Takalik Chalchuapa
 Monte Alto EL Lago de
 El Balsamo Finca SALVADOR Ilapango
 Arizona

Pacific Ocean

Nicoya

NICARAGUA

COSTA
RICA

N

0 25 50 75 100
miles
0 25 50 75 100
kilometers

● Olmec site
■ Modern city

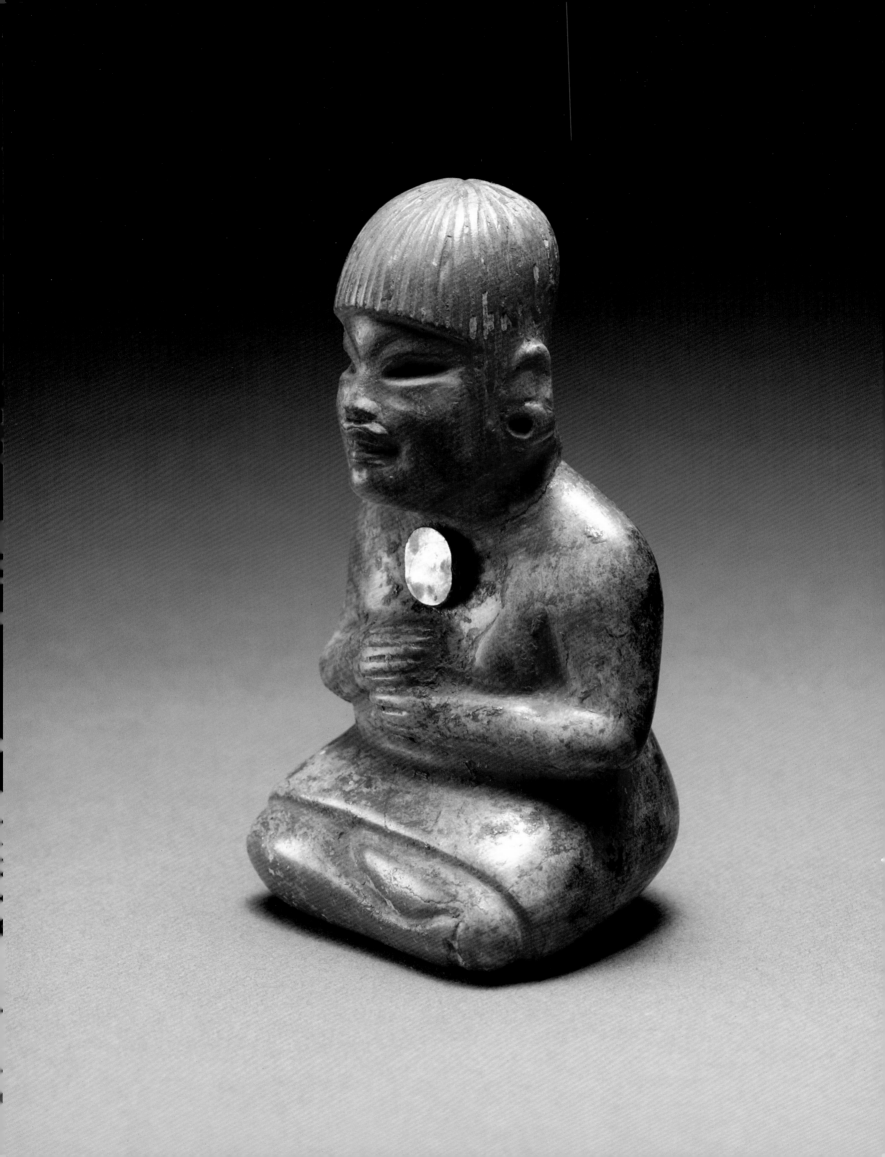

History of Olmec Investigations

ELIZABETH P. BENSON

THE BEGINNINGS

Interest in the Olmec began, one might argue, in Pre-Columbian times with the persistence of Olmec traits into later art styles and the cherishing—and sometimes reworking—of Olmec heirlooms or "found pieces" by later Pre-Columbian peoples (cats. 46, 61, 87, 93–95, 97, 102–103). From the point of view of non-Indian interest, knowledge of the Olmec can be said to have started at the beginning of the nineteenth century, when the great traveler and scholar Alexander von Humboldt brought back to Berlin from Mexico an incised celt, which still bears his name (Humboldt 1810: pl. 28). (The Humboldt Celt has been missing from the Berlin Museum für Völkerkunde since World War II.) Olmec studies are quite recent, and yet Olmec objects have been known—although not by that name—since the early nineteenth century. During the second half of that century and the beginning of the twentieth, objects of similar style, often from the Gulf Coast area, were found, published, and described. Olmec studies started with descriptions of the strange art style.

Investigations began in 1862, when José María Melgar y Serrano, residing temporarily in San Andrés Tuxtla, Veracruz, heard of a colossal head, which had been found a few years earlier near Tres Zapotes, and rode out to see it (Melgar y Serrano: 1869, 1871; see Piña Chan 1989: 25; Stirling 1968: 2). This was the first of the now-famous colossal heads to be encountered. Eduard Seler, one of the great early Pre-Columbian scholars, saw the head "on the way from Los Lirios to Tres Zapotes," during a journey in 1906–1907 (Seler-Sachs 1922: 543–544).

In 1888, Alfredo Chavero published a large votive axe (fig. 1) and compared it to the Tres Zapotes (Hueyapan) colossal head, which he republished. In the same year, Gustav Eisen, a Swedish-American scientist, published some sculptures from the Pacific slopes of Guatemala. George Kunz, in 1889 and 1890, described an axe that he owned (cat. 110), comparing it with the one described by Chavero and one in the British Museum, from Oaxaca. The Kunz Axe was first published by Marshall Saville in 1900; in 1929, Saville published "Votive Axes from Ancient Mexico," expanded from his 1900 article. Saville was

aware that there was now a small corpus of objects in a distinctive art style that had been previously unknown.

In 1892, Francisco del Paso y Troncoso used the phrase "Olmec type" to describe ceramic figurines found in Morelos and Guerrero (Piña Chan 1989: 25). "Olmec" derives from a word for rubber, which is indigenous to the Gulf Coast region where the earliest Olmec discoveries were made. A group of people there at the time of the Spanish Conquest were called Olmec, "People of the Rubber Country." Paso y Troncoso, however, used this term for objects that had not been found in the Gulf Coast region, although they were of the style that was being encountered there.

THE EARLY WORK

Serious investigation began in 1925, when Frans Blom and Oliver La Farge, from Tulane University, went to the site of La Venta, Tabasco, in the course of a survey of southeastern Mexico (Blom and La Farge 1926). La Venta lies on a ridge east of the Tonala River, near the Gulf of Mexico. In 1519, Bernal Díaz del Castillo, during his explorations with

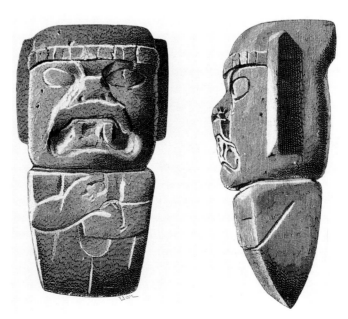

Fig. 1. Stone axe (after Chavero 1888: 64).

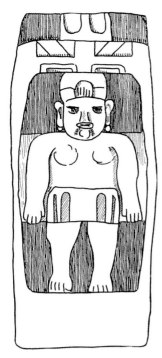

Fig. 2. Drawing of La Venta Stela 1 (after Blom and La Farge 1926: fig. 67).

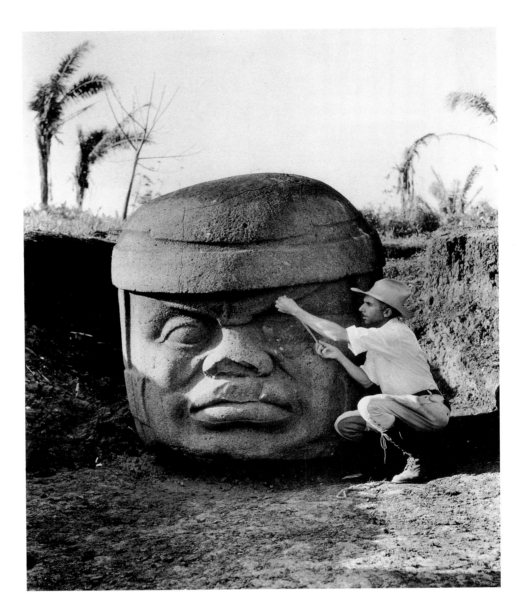

Fig. 3. Matthew Stirling with Tres Zapotes Colossal Head 1.

Juan de Grijalva, had gone up the Tonala River and may have seen the ruins of La Venta; he described a visit to the town of Tonala (Díaz del Castillo 1956: 27–28; see also Stirling 1943b: 49). In *Tribes and Temples*, Blom and La Farge published a number of La Venta monuments, including a colossal head, the second one found (Blom and La Farge 1926: 81–90). They made a rough plan of the site, including the impressively large pyramid, at that time enveloped in tropical vegetation, and they described the two stelae (fig. 2) and four altars that they discovered, as well as "a long row of stones like small pillars," forming something like a fence. Blom and La Farge also recorded a monument (cat. 5), which they found atop the San Martín Pajapan volcano in the Tuxtla Mountains, with a cache beneath it (Blom and La Farge 1926: 45–47, figs. 41–43; see also Easby and Scott 1970: fig. 5; Medellín Zenil and Torres Guzmán 1968; Saunders 1989: 34–37). The monument had been discovered in 1897 by a surveyor, who, in attempting to move it, broke the arms and also found a modest cache of jades under it.

The following year, Hermann Beyer, reviewing *Tribes and Temples*, referred to the San Martín Pajapan monument as "Olmec." This was the first English use of the word. Saville, in his 1929 article on votive axes, also used the term Olmec.

In Central Mexico, early in this century, scholars were becoming aware of the archaeological depth in the Valley of Mexico, and of the fact that the "archaic" period was not simple (Vaillant 1935a: 291–294). Zelia Nuttall, in 1902, noted that the figurines under the *pedegral* (lava) were different from the Aztec ones on top, and Manuel Gamio, in 1909, made excavations at Azcapotzalco, where he recognized a succession of various types of pottery. In 1911, Franz Boas and Seler began to collect material from Zacatenco and Ticoman.

Between 1928 and 1933, George Vaillant excavated for the American Museum of Natural History in the Valley of Mexico at Zacatenco, Ticoman, and El Arbolillo, and at Gualupita, on the northern outskirts of Cuernavaca, Morelos (Vaillant 1930, 1931, 1935b; Vaillant and Vaillant 1934). He found, among other early styles, ceramics and jade related to those reported from the Gulf Coast. Gualupita produced gadrooned bottles, incised neckless jars, whiteware dishes, and large, hollow clay figures,

which Vaillant and his wife, Susannah, recognized as akin to ceramics from the Gulf Coast. Jade jaguar-fang pendants, "in what we now know to be typical Olmec style," were encountered at Zacatenco and at El Arbolillo. Vaillant found two jade beads with the burial of a child at El Arbolillo, and two earplugs with another baby; he found jade beads also at Gualupita. The objects suggested to Vaillant that there had been trade for jade with peoples to the south, specifically in Oaxaca and Guerrero (Vaillant 1935a; see also Stirling 1961: 44; Coe 1965a: 7).

Other discoveries were made at about this time. In 1933, in Veracruz, a *campesino* at Antonio Plaza came across a sculpture known now as The Wrestler (cat. 11; de la Fuente 1973: 121), one of the more remarkable figures yet found. In 1934, Eulalia Guzman reported Olmec-style reliefs carved on cliffsides at Chalcatzingo, Morelos; these had been uncovered by a storm two years earlier.

Matthew Stirling's interest in the Olmec had begun c. 1918 at the University of California, where he saw a picture of a "crying-baby" jade maskette, published in 1898 by Thomas Wilson of the Smithsonian Institution (Stirling 1968: 1). Later, in Berlin, Stirling went to see the maskette. When he joined the Smithsonian Institution staff in 1921, he was beginning to realize that there must be important sites where this art could be found, and so he planned projects in Tabasco and Veracruz.

Stirling worked at a number of sites in what is known, to some, as the Olmec "heartland." He began in 1938 with a survey of the western margin of the Olmec area and excavation at Tres Zapotes (see Castro-Leal, this volume; Stirling 1943b, 1965; see also Drucker 1943: 1952). Backed by the National Geographic Society, he examined and photographed the colossal head, which he found in a court surrounded by four mounds (fig. 3). Nearby, a mound group extended for some two miles along the Arroyo Hueyapan. Tres Zapotes had a long history of occupation. Stirling worked there again the following season, and then went on to Cerro de las Mesas and established that it was mostly a later (Early Classic) site with a Late Olmec occupation and a number of impressive Olmec heirlooms placed in a cache (cats. 61, 103). Stirling also went to La Venta and excavated there for four seasons, finding four more colossal heads, three more stelae, a fifth altar, and a basalt-columned sunken courtyard, with a sarcophagus carved with dragon features and a burial with a bundle of precious objects (cats. 45, 51, etc.). Various other treasures included jade canine fangs and ear ornaments. In 1945, Stirling found San Lorenzo, Veracruz, where he uncovered five more colossal heads and fifteen other sculptures (cats. 2, 8; Stirling 1955).

Miguel Covarrubias, a remarkably talented artist, illustrator, writer, anthropologist, and collector, was a lively advocate of Pre-Columbian studies, especially drawn to the Olmec. Returning to Mexico to live in 1942, after some years spent largely in the United States, he fell in with an-

thropologists and archaeologists, and was involved with the National Museum of Anthropology (Mexico 1987: 259; Rubín de la Borbolla 1987).

Covarrubias became interested in a brickyard on the northwest outskirts of Mexico City, where, beginning in 1936, workers digging for clay discovered quantities of ancient remains (Covarrubias 1957: 17–18; Abascal y Macias 1987: 178–183; see also Tolstoy 1989a: 101). The site, which had rich burials, bore the appropriate name of Tlatilco, "Where Things are Hidden." Covarrubias and others acquired objects there. Because of the richness of the finds, the National Institute of Anthropology and History began excavations there in 1942 under Covarrubias and Hugo Moedano Koer. A more extensive project was undertaken at Tlatilco in 1947, under Daniel Rubín de la Borbolla and Covarrubias (see cat. 26; Grove; Niederberger, "Basin of Mexico"; Porter 1953).

Covarrubias noted that objects of the style called Olmec were found mainly in Veracruz, Tabasco, Chiapas, Guerrero, Morelos, Oaxaca, and southern Puebla; that they also appeared occasionally in the valleys of Mexico, Toluca, and Tlaxcala, and in Guatemala; their northernmost frontier was the state of Michoacan, at El Opeño and Tzintzuntzan; the southernmost limit was Guanacaste, Costa Rica (Covarrubias 1946: 83, n. 9). This is roughly the geographic definition of Mesoamerica, defined by Paul Kirchhoff in 1943 as a region of high development and common traits throughout its Pre-Columbian history.

THE *MESA REDONDA*

In 1942, a group of Mexican and North American archaeologists met at Tuxtla Gutiérrez, Chiapas, to discuss the Olmec and other archaeological matters (Tuxtla Gutiérrez 1942). The Commission of this Second Round Table on Anthropological Problems of Mexico and Central America consisted of Alfonso Caso, Covarrubias, Wigberto Jiménez Moreno (who published in the same year "The Enigma of the Olmecs"), Kirchhoff, Enrique Juan Palacios, J. Eric S. Thompson, and Jorge A. Vivo. Among others speaking were Eduardo Noguera, Salvador Toscano, Jorge Lines, Vaillant, and Stirling. The discussion largely concerned the Olmec. Some of it dealt with the historical Olmec, and a great deal with linguistics, in an effort to identify the makers of the artifacts. (The identity and the language continue to be a puzzle [see Diehl 1989: 20–21; Stuart 1993: 105–110]). Lines' presentation of an Olmec "baby-face" from Costa Rica emphasized the far reach of the style.

Covarrubias spoke on Olmec style and interpretation. In those days, when one could be both an archaeologist and a collector, he was lauded by the prominent archaeologist Caso for having formed a collection that enabled the proper study of the style: "...the patient and intelligent search made by Senor Miguel Covarrubias has permitted

him to form an indispensable collection for the study of the Olmecs" (cat 36; Tuxtla Gutiérrez 1942: 43). Noguera spoke on "The Olmec Problem and Archaic Culture." One facet of the problem was the fact that objects of Olmec style were coming from a wide range of places. Part of the problem was the name, given that it also referred to a historical people and that there is no known relationship between the historical Olmec people and the people we now know to be much earlier. The dating was another problem.

At the *Mesa Redonda*, there was an attempt to change the name Olmec to "Culture of La Venta," but, even fifty years ago, it was too late. Covarrubias, a few years later, wrote: "The term Olmec…has proved so confusing, even to archaeologists, that an explanation of its implications becomes imperative…. The…name…is clumsy and impractical; [but] habit has branded it Olmec, and Olmec it will probably remain…" (Covarrubias 1946b: 82).

Toscano discussed two opinions on the relative date of the Olmec style: one, that of Vaillant and others, that it was very early; the other, that of Eric Thompson, that it dated to A.D. 900–1200, in the Postclassic period. Earlier, Blom and La Farge, because they saw a strong Maya influence in La Venta sculpture, were "inclined to ascribe these ruins to the Maya culture" (Blom and La Farge 1926: 83–90). They wrote of Stela 2: "There is no doubt that this figure is strongly influenced by Maya art, if it is not really Maya." Today, we see Maya influenced by Olmec, but one must give Blom and La Farge credit for their pioneering work and not fault them for misinterpreting what was so totally new and without context. The Maya had long been thought to be the originators of all high culture in Mesoamerica. One reason that Stirling undertook his excavations was because he doubted this.

Most of the archaeologists present at the *Mesa Redonda*, some seventeen years after Blom and La Farge's expedi-

tion, concluded that the Olmec style was pre-Maya and of an "archaic" period, a well-developed culture that influenced later cultures. Despite the convictions of most *Mesa Redonda* participants, however, the belief that Olmec was contemporary with Maya and/or was Maya-influenced hung on among some scholars. It was not until the application of C-14 dating and the archaeological investigations of the 1950s and 1960s that the earliness of Olmec civilization at San Lorenzo and at La Venta was established.

THE 1950s

The 1950s brought increasing attention to the Olmec. Philip Drucker, who had worked with Stirling, published a book on the ceramics and art of La Venta, and Drucker and Eduardo Contreras surveyed eastern Tabasco, near La Venta, in 1952 (Drucker 1952; Drucker and Contreras 1953). In 1955, Drucker worked with Robert Heizer and Robert Squier on a large project at La Venta, under the aegis of the National Geographic Society, Smithsonian Institution, and the University of California (Drucker and Heizer 1956; Drucker, Heizer, and Squier 1959). The work included excavation and support-area studies, as well as analyses of style and ceramics. The excavations uncovered thirty dedicatory offerings or caches, including three massive ones. A scene with standing figures and celts placed like stelae (cat. 42) had been buried with elaborate care.

Tlatilco was excavated again in the 1950s by Román Piña Chan and by Muriel Noe Porter; the physical anthropologist Arturo Romano examined skeletal material (Porter 1953; Piña Chan 1958; Romano 1972a, 1972b; see also Coe 1965b: 10). Hundreds of burials were found, with Olmec and non-Olmec grave goods. In one burial, a jade canine tooth was discovered in the mouth of a human

Fig. 4. Excavation of San Lorenzo Monument 34 by Michael Coe.

body (Stirling 1961: 44). Piña Chan also published on the Preclassic cultures of the Valley of Mexico generally and on Chalcatzingo (Piña Chan 1955a, 1955b).

The New World Archeological Foundation began its work in Chiapas in the late 1950s, under Gareth Lowe (Lowe 1959; Navarrete 1959, 1960; see also Lee 1989: 214). The Foundation has produced many publications on its fieldwork in Chiapas; these have often dealt with Olmec remains. The 1950s also saw the publication of more remote evidence of Olmec-style distribution: Stanley Boggs' article on Olmec carvings on living rock in El Salvador; Edwin Shook's publication on an Olmec sculpture from the Pacific slopes of Guatemala; and Carlos Balser's paper on Olmec "baby-faces" found in Costa Rica are examples (Boggs 1950; Shook 1956; Balser 1959).

The search for the beginnings of the Olmec sculpture style continued. Piña Chan suggested Morelos as a place of origin, while Covarrubias argued that Olmec-style artifacts are so frequent and so important in Guerrero that they cannot be considered trade objects, and that the Olmec occupation on the Pacific side of the mountains was probably earlier than that on the Gulf Coast (Piña Chan 1955a: 106; Covarrubias 1957: 76, 110; see also Diehl 1989: 20).

THE 1960s

Olmec paintings were first discovered in the 1960s on the walls of caves at Juxtlahuaca, Guerrero, in 1966, and at nearby Oxtotitlan, in 1968 (see Niederberger, "Guerrero"; Gay 1967; Grove 1969, 1970a). A painting of a ruler on an altar or throne at Oxtotitlan recalled Gulf Coast sculpture, but new themes also appeared.

On the Gulf Coast, there were explorations at Laguna de los Cerros by Alfonso Medellín Zenil (Medellín Zenil 1960, 1971). San Lorenzo underwent a major excavation project from 1966 to 1968, under Michael Coe and Richard Diehl, supported by Yale University (see Cyphers; Coe and Diehl 1980). New sculpture was discovered there, sometimes by use of a magnetometer to locate iron-rich basalt (fig. 4; cat. 12). Seventeen C-14 samples yielded dates of 1200–900 B.C. for the florescence of the site. Questions of subsistence were addressed, not only by examining midden remains but by exploring life on the river today as a window on the past.

Drucker and Heizer returned to La Venta in 1967 and 1968. In 1955, wood fragments had been found at La Venta, which could be used in the newly developed C-14 dating. New C-14 samples from the late 1960s confirmed a 1000–600 B.C. dating for La Venta as a major center; the area was first inhabited c. 1750 B.C. (Berger, Graham, and Heizer 1967; Heizer 1968; Heizer, Drucker, and Graham 1968; Heizer, Graham, and Napton 1968; Diehl 1990). In addition to further excavation and new C-14 dates, there was exploration of the recently cleared pyramid; Drucker and Heizer suggested that it may have been constructed to imitate a volcano, like those in the nearby Tuxtla Mountains. A magnetometer survey suggested that there is basalt inside (Morrison and Benavente 1970; Morrison, Clewlow, and Heizer 1970).

The site of Río (or Arroyo) Pesquero, Veracruz, an accidental discovery, yielded about twenty-five life-sized masks of beautiful jade, probably all portraits (cats. 76–81), and hundreds of jade or serpentine celts, many of which were incised (cat. 117), as well as other jade objects (see Diehl).

An important single-sculpture discovery in the Gulf Coast region was the Las Limas Figure (cat. 9), which was found by children and set up in a shrine in their village (Beltrán 1965; Medellín Zenil 1965). This sculpture, with its important incised designs, has become a key to Olmec iconography (Joralemon 1971, 1976; Coe 1989).

Paul Tolstoy and Louise Paradis excavated at Tlatilco, Tlapacoya (Ayotla), and other Valley of Mexico sites in the 1960s, finding that the earliest ceramic occupation in the valley appeared to be Olmec, a level dating to c. 1000 B.C. or earlier at Tlatilco (Tolstoy and Paradis 1970, 1971). About ten percent of the excavated Tlatilco burials with grave goods were Olmec. Christine Niederberger had also excavated at Tlapacoya-Zohapilco, to the southeast of Mexico City (see Niederberger, "Basin of Mexico"; Niederberger 1969, 1975, 1976). The site of Las Bocas, in the state of Puebla, yielded many handsome nonarchaeologically excavated objects, but attempts to study the site in the 1960s were fruitless (see Grove).

In Oaxaca, in the mid-1960s, Kent Flannery, of the University of Michigan, began working at San Jose Mogote (see Grove; Flannery 1968, 1976; see also Flannery, Marcus, and Kowaleski 1981; Flannery and Marcus 1983, 1994; Marcus 1989). This was the largest Formative period community in the region, probably both a ritual center and a trade-route station. Flannery found that magnetite mirrors of the type excavated in late deposits at San Lorenzo were being made in San Jose Mogote, and that quantities of imported goods had been traded into San Jose Mogote.

In Chiapas, the Preclassic was explored at Altamira and Izapa, and an Olmecoid sculpture was found at Padre Piedra (Ekholm-Miller 1969; Green and Lowe 1967; Lowe 1975). At Finca Arizona, near the south coast of Guatemala, Edwin Shook found a jade jaguar tooth, ear flares, and tubular beads (Stirling 1961: 44).

The Dumbarton Oaks Conference on the Olmec was held in 1967, twenty-five years after the Tuxtla Gutiérrez Round Table; the proceedings were published the following year (Benson 1968). Coe organized an exhibition at the Museum of Primitive Art, "The Jaguar's Children: Preclassic Art from Central Mexico," with a catalogue, and he also published articles on the distribution of the Olmec style and an archaeological synthesis of the Gulf Coast region, as well as a study of a reworked winged pendant (cat. 86; Coe 1965a, 1965b, 1965c, 1966). Piña Chan and Luis Covarrubias published *El Pueblo del Jaguar*, a com-

pendium of Olmec art, in 1964, and Ignacio Bernal's *The Olmec World* came out in Mexico in 1968, in the United States in 1969.

Covarrubias had suggested the use of folklore to interpret Olmec art, but it was Peter Furst, exploring the Latin American ethnographic literature on jaguars and on shamanic transformation, who approached this method on a deeper, broader scale (see cats. 66, 68–71; Covarrubias 1946: 98–99; Furst 1968; see also Furst 1981).

Given the wide spread of Olmec artifacts, there was inevitably consideration of whether or not there was an Olmec empire. Caso and Bernal separately proposed that there was (Caso 1965; Bernal 1969), but this question has yet to be resolved.

THE 1970S

In 1970, a symposium on "Observations on the Emergence of Civilization in Mesoamerica" was held at the Wenner-Gren Foundation for Anthropological Research, Burg Wartenstein, Austria (Heizer, Graham, and Clewlow 1971). At the University of California at Los Angeles, a conference on "Origins of Religious Art and Iconography in Preclassic Mesoamerica" took place in 1973 (Nicholson 1976).

In Veracruz, the Rancho Cobata (Cerro el Vigía) colossal head, the "largest and most peculiar of the known Olmec heads" (Lowe 1989b: 51)—its proportions and style are different from those of the other heads—was found in 1970 and published by Beatriz de la Fuente (de la Fuente 1973:

124–126, pl. 88). De la Fuente's 1973 catalogue of Olmec monumental sculpture was an important contribution, and she has since published other valuable books on Olmec sculpture style and history (de la Fuente 1975, 1984, 1987, 1992a, 1992b). Most fieldwork ceased on the Gulf Coast in the 1970s, although Frederick Bove produced a study on Laguna de los Cerros in 1977.

Excavations had begun in the Valley of Mexico in the late 1960s (Tolstoy and Paradis 1970, 1971; Tolstoy 1989a; Tolstoy et al. 1977). Coapexco, one of the earliest sites in the valley, coeval with Tlatilco and Tlapacoya, yielded Olmec-style objects. Tlapacoya also received attention (Tolstoy and Paradis 1970; Niederberger 1976; Tolstoy 1989a). Like Tlatilco, Tlapacoya has non-Olmec features. The two sites have somewhat similar material (Piña Chan 1958).

In Chiapas, the New World Archeological Foundation discovered and published a number of Olmec-style rock carvings in southern Chiapas: at Xoc (fig. 5), Pijijiapan (fig. 6), and Tzutzuculi (Ekholm-Miller 1973; Navarrete 1974; McDonald 1977, 1983). Chiapas has yielded more than thirty Olmec-related stone sculptures, as well as portable celts, scepters, pectorals, and figurines (Navarrete 1959, 1960, 1971, 1974; Ekholm-Miller 1973; Lee 1989). Most of the sculpture is not firmly datable. There are some platforms, but architectural remains are almost unknown for the Early Olmec horizon in Chiapas. The earliest monumental public building found in Chiapas is a Late Olmec structure at Izapa (Ekholm-Miller 1969; Lee 1989: 207). By Middle Formative times, plain stelae were

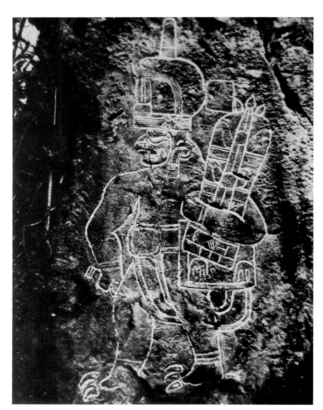

Fig. 5. Carving on a rock at Xoc, Chiapas. This monument was destroyed in an apparent looting attempt (after Ekholm-Miller 1973: fig. 10).

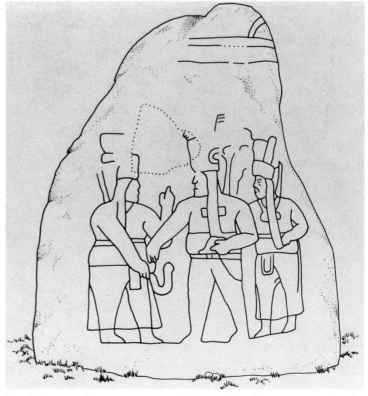

Fig. 6. Drawing of Stone 1, carving at Pijijiapan (after Navarrete 1974: fig. 3).

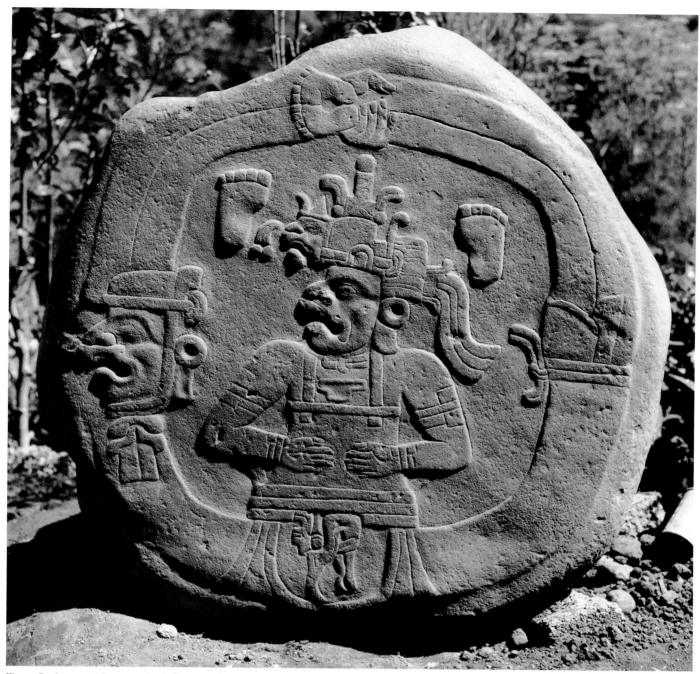

Fig. 7. Sculpture with an acrobatic figure and a spoon worn as a pendant, from unknown site, Pacific slopes of Guatemala.

erected in cities and villages in the highlands and the south coast of Guatemala and Chiapas (Shook 1971: 72). Their use may have been astronomical. Such sculpture is not an Early or Middle Olmec trait, but La Venta did produce stelae late in its sequence. The concept of stelae may have come from the Pacific slopes and traveled to the Gulf Coast.

New findings were made also on the Pacific slopes of Guatemala (fig. 7). In 1976, John Graham, of the University of California, Berkeley, who had worked with Heizer, began archaeological work, with the support of the National Geographic Society, at Abaj Takalik, in a fertile zone in the lower Pacific piedmont of southwestern Guatemala (Graham 1977, 1979, 1982, 1989; Graham, Heizer, and Shook 1978; see also Schieber de Lavarreda

1994: 77). Graham has described Abaj Takalik as "the most important Olmec site known at present" within Pacific Guatemala (Graham 1989: 231). The site extends for about nine square kilometers over nine artificially leveled terraces. It is well situated as a trade-route station between the Guatemala highlands and the coastal plain, and it apparently thrived as such. One hundred and seventy carved and plain stone monuments have been found there, mostly of local andesite boulders. The carved monuments are generally Olmec in style. One colossal head has been found, which seems to be closer to Gulf Coast heads than the cruder ones found earlier at Monte Alto (Escuintla, Guatemala) and elsewhere. The Abaj Takalik head has been partially recarved to depict a figure seated in a cave or niche (Graham 1982: figs. 1, 2). Monuments were appar-

ently recarved to make other kinds of sculptures also on the Gulf Coast (Cyphers 1995: 16, fig. 9; Porter 1989, 1990). Mutilation of monuments had been previously noted, and the reasons for it variously discussed; more recently, evidence of recarving has been observed (Coe and Diehl 1980; Grove 1981b; Angulo 1987: 155). Resetting of monuments also took place in ancient times at Abaj Takalik, as it did at San Lorenzo.

In Guerrero, Xochipala, a site with both local and Olmec components, was discovered (cats. 20, 84); an exhibition of material from Xochipala was held at The Art Museum, Princeton, in 1972 (Gay 1972b). An Olmec-style rock carving was found at San Miguel Amuco, Guerrero, with Olmec objects nearby (Grove and Paradis 1971; Paradis 1981: 196–202). This is a trade-route area, and the Olmec style is again combined with a local culture. Paradis worked in this region of the Middle Balsas in the 1970s (Paradis 1978, 1981). John Henderson excavated at Atopula, Guerrero, which yielded Early Classic material, much of which was Olmec-related (Henderson 1979). In 1972, the ten-year Chalcatzingo Project began a multidisciplinary, cooperative endeavor under David Grove, with Ann Cyphers Guillén, Jorge Angulo, and others (see Grove). Chalcatzingo has a long history of occupation as a central Mexican site; the period of Olmec influence dates from 1100 to 500 B.C. With its extraordinary rocks and a view out over the plains, it must have been a sacred site, a strategic place, and a trading station (Angulo 1987: 132). Greenstone—mostly jade and serpentine—passed through Chalcatzingo between central Mexico and the Gulf Coast (Grove, in Stuart 1993: 110). Chalcatzingo had its own resouces of iron ore, ferrous pigment, chert, and kaolin clay (Grove 1984: 161; 1987a: 376–386).

Olmec-style jades and ceramics have been found in the Maya area (see González Lauck and Solis Olguín, this volume). In 1942, Alfred Kidder published several pieces encountered in Yucatan, and, in 1976, L. R. V. Joesink-Mandeville and Sylvia Meluzin illustrated some of these and other examples of Olmec or Olmec-influenced art from Kabah and Mayapan (Yucatan) and from Dzibalchen (Campeche). In 1973, William Rathje, Jeremy Sabloff, and David Gregory published a Late Olmec jade bib-pendant from Cozumel (cat. 95). A large assortment of jades was taken from the Cenote of Sacrifice at Chichen Itza (Proskouriakoff 1974; see also Andrews 1986: 23, 28); cat. 97 is said to have come from near Mérida, Yucatan (Coe 1966). Under a plaza at the Classic Maya site of Seibal, six jade celts, a jade bloodletter, and five ceramic jars—placed in a cruciform, La Venta-style arrangement—were dated to c. 900 B.C. (Willey 1978: 88–89, figs. 90, 91; Andrews 1986: 27). Clamshell pendants have been found at Komchen and Barton Ramie, and other jades and ceramics have appeared in other Maya sites (Andrews 1986: 29–30; Stuart 1993: 110).

Interpretations of style and iconography began seriously in the 1970s. The decade saw the publication of David Joralemon's 1971 study of Olmec gods, and his further article in 1976. He and other writers have addressed the meaning of motifs and possible rites (Coe 1972, 1973; Gay 1973; Grove 1973; Joralemon 1981; Angulo 1987; Grove 1987b; Fields 1991; Joyce et al. 1991; Cyphers Guillén 1992c; Bernal-García 1994). Various authors have addressed Olmec cosmology—for example, speculations about Olmec astronomy (Hatch 1971). William Clewlow (1974) and Susan Milbrath (1979) leaned heavily on stylistic considerations in their works on the chronological sequence of monumental sculpture.

The 1980s

At La Venta, a new project began in 1984, under Rebecca González Lauck of the National Institute of Anthropology and History (INAH) (González Lauck 1988, 1989; Rust 1992; Stuart 1993: 101–107). In 1988, the INAH and the Tabascan Institute of Culture formed the La Venta Archaeological Project to protect, investigate, and restore the zone, for the petroleum industry had produced an airstrip and a population of some 230 people within the site.

In 1987, a laborer, cutting grass with a machete, discovered three sculptures at El Azuzul, a small satellite community of San Lorenzo (see Cyphers; Cyphers Guillén 1992b, 1994b; Cyphers Guillén and Botas 1994: 273–283; Stuart 1993: 101, 105). Two human figures, wearing loincloths and elaborate headdresses like bridal veils, were posed with arms straight down to the ground before two seated jaguars.

Also in 1987, the pilgrimage site of El Manatí was discovered by a villager digging a fish pond (Ortiz Ceballos and Rodríguez 1989; Stuart 1993: 92–94, 101). Probably a sacred spring in a small hill, where offerings were made, it yielded some thirty-six extraordinary wooden figures, painted red and black; there were also skeletons of children, as well as rubber balls and stone axes. In discussions about the origin of Olmec stone monumental sculpture, it had been suggested that earlier sculpture might have been carved from wood, which is usually not preserved in the hot, moist climate of the Gulf Coast region. The wooden figures at El Manatí proved, if nothing else, that wooden sculpture was made on the Gulf Coast. The site has been excavated by Ponciano Ortiz Ceballos, of the University of Veracruz, and María del Carmen Rodríguez, of the INAH.

An important discovery of the 1980s was Teopantecuanitlan, "Place of the Temple of the Jaguars," in Guerrero, a site spanning the period 1400–500 B.C. Guadelupe Martínez Donjuán, of the INAH, is directing excavations there (see Niederberger, "Guerrero"; Martínez Donjuán 1982, 1985, 1986; Grove 1989a: 142; Porter Weaver 1993: 46–47; Stuart 1993: 109–114). Stone-faced architecture, monumental relief carvings, and stairways with *alfardas* (balustrades) are striking features. A large—but not colos-

sal—stone head dates to 800–600 B.C. Teopantecuanitlan also has aqueducts and drains, possibly at a level that predates San Lorenzo. Teopantecuantitlan was central between the coastal areas and was likely a ritual place as well as a thriving trading station. Chilpancingo is a nearby site with a high-status funerary chamber, discovered in 1988 (see Niederberger, "Guerrero"; Reyna Robles and Martínez Donjuán 1989).

In Central Mexico, further work was undertaken at Tlatilco under the direction of Roberto García Moll.

A new project was launched at Abaj Takali, in 1987, by Miguel Orrego Corzo, with the support of the Ministry of Culture and Sport (Orrego Corzo 1990; Schieber de Lavarreda 1994). A terrace there and a ballcourt associated with it date to the Middle Formative period. Other Middle Formative ballcourts are found at La Venta and San Lorenzo, and in Chiapas. A ritual ballgame was important throughout the history of Mesoamerica.

A number of "Early Olmec horizon" sites lie along waterways in southern Chiapas, in the Central Depression, in the Middle Grijalva region, and near the Pacific Coast (Lee 1989: 206). Mirador and Plumajillo, Chiapas, have been described as more similar to San Lorenzo and La Venta in terms of ceramics than to any other site in central Chiapas (Agrinier 1984; Lee 1989: 208–209). Pierre Agrinier, who excavated there, argued that intensive Olmec occupation of Mirador-Plumajillo was the result of an immigrant colony established to exploit the iron-ore sources and produce drilled cubes and perhaps some iron mirrors, which have been widely found at sites with Olmec-style objects.

More Olmec remains appeared in the Maya area. In 1984, a cache of some forty small carved jades of Middle Formative Olmec style was found in northern Yucatan, apparently brought into the northern Maya lowlands, probably in the Middle Formative, from a number of different

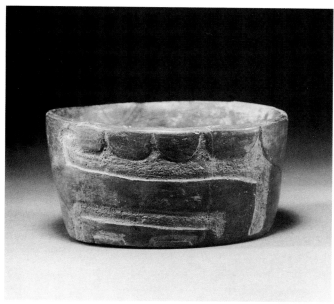

Fig. 8. Ceramic cylinder vessel from a cemetery at Copan, Instituto Hondureño de Antropología e Historia.

sources and placed there by the Maya, separately from any Maya remains (Andrews 1986, 1987).

At the Maya site of Copan, best known as a great Late Classic center, Late Formative ceramic vessels with Olmec motifs had been found in 1893, with burials in a cave (Gordon 1898). Parts of Copan had been inhabited since the latter part of the second millennium B.C., and Early and Middle Formative remains have been encountered again in recent excavations in the same area of Copan (Fash 1991: 63–70; Garber et al. 1993: 216; Andrews 1986: 27–28; Schele and Miller 1986: pls. 17, 28–30). Notable finds are cobblestone platforms with subfloor burials that have ceramics similar to those found by Gordon, dating to 900–400 B.C. (fig. 8). More than five hundred pieces of jade were found in four burials. One burial, the richest yet known in the Maya area from that period, contained four ceramic vessels, nine polished stone celts, and more than three hundred drilled jade objects, including effigy jaguar claws, earspools, a necklace, and armlets. These may be the earliest finely worked jades yet found in the Americas.

Fifteen individuals were buried in the south platform in this section of Copan and at least thirty-two in the north platform. The ceramics with incised designs associated with these burials are of interest (Fash 1991: 69–70). William Fash, who excavated them, queries whether the motifs might be patterns indicating lineage. At San Jose Mogote, Oaxaca, the "fire-serpent" motif (with bars, Us, flame-brow, and paw-wing) was found with human remains only in certain areas, and the "were-jaguar" (with cleft head and vertical bars) only in other areas (Pyne 1976: 273). At Copan, the "flame-brow" is found on the north platform, the "hand-wing" in the south platform. Such motifs must have often had different meanings and usage in different places.

In other parts of Honduras, jades and other Olmec objects have been encountered, dating from 1000–1 B.C. (cat. 65; Healy 1992: 100–102).

The beginning of the decade saw the publication of *The Olmec and Their Neighbors*, a volume honoring Stirling (Benson 1981a). The end of the decade produced *Regional Perspectives on the Olmec*, the proceedings of a conference held in 1983 at the School of American Research, Albuquerque; *El Preclásico o Formativo: Avances y Perspectivas: Seminario de Arqueología Dr. Román Piña Chan*, in 1989; and a symposium on "Recientes Investigaciones sobre la Civilización Olmeca," sponsored in October 1989 by the Mexican Society of Anthropology and organized by González Lauck (Sharer and Grove 1989; Carmona Machias 1989; Mexico 1990). Iconographic/cosmological studies include Kent Reilly's articles on ritual spaces and the watery underworld, and on the shamanic aspects of royal Olmec art (Reilly 1989, 1991, 1994b). It becomes more and more clear that Olmec art—at least, in some regions—was the art of kings, of royal portraits, of the elite

association with the supernatural world and the rituals that maintained that association.

THE 1990S

The San Lorenzo Tenochtitlan Archaeological Project, under the Institute of Anthropological Investigations, National Autonomous University of Mexico, begun in 1990, was directed by Cyphers (see Cyphers). San Lorenzo and the surrounding region have been examined for evidence of the use of the site and its support area. A number of new monuments, including colossal heads, have been found recently at San Lorenzo and nearby (see Cyphers; de la Fuente 1987; Cyphers Guillén 1992b, 1994a, 1994b; Cyphers 1995; Cyphers Guillén and Botas 1994; Stuart 1993: 100–101, 105).

In 1994, the INAH began work, under Rodríguez, at La Merced, a watery site near El Manatí. The site has public spaces, mounds, and a pyramid rather like that at La Venta. Sculpture has been found there, as well as a great quantity of stone axes.

The La Venta project continues under González Lauck. San Lorenzo and La Venta are still the only Gulf Coast sites that have been worked on to any extent. Most work has been done in the ceremonial centers; more excavation is needed in support areas as well as in the centers. The Gulf Coast is now well-to-do and developing rapidly, and serious salvage archaeology needs to be done before the sites disappear.

In 1991, Grove worked at La Isla, a small site near Laguna de los Cerros, and Susan Gillespie investigated an Olmec monument workshop at nearby Llano del Jícaro (Grove and Gillespie 1992b; Grove et al. 1993; Grove 1994; Gillespie 1994). There Gillespie found basalt boulders and nine worked stones, in an area probably inhabited by stonecarvers.

Blackman Eddy, a site in Belize, has recently been explored (Garber et al. 1995). It has a long history, beginning with Middle Formative remains. Work on early sites in Oaxaca continues, as does work on Abaj Takalik, and excavation in Chiapas by the New World Archeological Foundation (Flannery and Marcus 1994; Schieber de Lavarreda 1994). For the most part, reports are not yet in on this work. Indeed, although many publications are noted here, a great deal of Olmec archaeological research has not been published.

Iconographic studies continue, notably in the catalogue of the 1995 Princeton exhibit, "The Olmec World: Ritual and Rulership."

THE OLMEC PROBLEM

The dating part of the original "Olmec problem" has now been—or can be—solved. The antiquity is established, although there is still discussion about what is earlier where. The name Olmec is still part of the problem. Scholars who work outside the Gulf Coast area dislike "Olmec," because it refers to that region, and the "Olmec" phenomenon is pan-Mesoamerican. Many scholars reject the term "heartland" for the Gulf Coast, not only because the style is widespread, but because elements of it may have been earlier in some regions than on the Gulf Coast (Graham 1982, 1989; Grove 1989b: 10; Flannery and Marcus 1994: 373). Reilly has proposed Formative Period Ceremonial Complex for a geographically dispersed ceremonial complex with its most concentrated expression on the Gulf Coast (Reilly 1989: 6). This name is accurate, but unlikely to replace Olmec in most conversations. Grove has suggested "X Complex," but, although shorter, it is not catchier (Grove 1989b: 10). The term Olmec, improper from the beginning, will surely continue to be used; perhaps the only solution is to redefine it. After all, the use of "Olmec" for this style was apparently first applied to objects from central Mexico.

Related to the name problem are the major questions of who and what the Olmec people were and what was going on during the near-millennium that the Olmec style persisted throughout much of Mesoamerica. Why and how was the style so widespread? What did it mean? What was the mechanism that carried it?

Trade or exchange through interregional networks has been examined with care, because of its importance in understanding the Olmec phenomenon. Jane Pires-Ferreira and others have written of the movements of cacao (chocolate), mollusk shell, turtle shell, fish, stingray spines, shark teeth, rubber, salt, tar, pottery, clay, obsidian, iron ore and pigments, turquoise, mica, jade, and other stones (see Niederberger, "Guerrero"; Pires-Ferreira 1976a, 1976b). Obsidian, a volcanic glass used for weapons, tools, and ornaments, can usually be traced to one of a few sources. Although there were other sources, people from both coasts were trading for it from central Guatemala (Hester, Heizer, and Jack 1971; Hester, Jack, and Heizer 1971; Lee 1989: 214–215; Pires-Ferreira 1976a). "The presently known Early Olmec-horizon sites in central Chiapas with the closest ceramic affiliations to San Lorenzo are all located midway on trade routes to the obsidian mines of Guatemala and the cacao of the Soconusco" (Lee 1989: 222).

Joyce Marcus has observed that San Jose Mogote belonged to a vast network of long-distance trading partners between 1150 and 850 B.C. (Marcus 1989: 168–169, 190–192). Excavations there yielded *Spondylus*, pearl oyster, jade, and other imported luxury trade items. Mussels and turtle shells for drums went from the Gulf Coast to Oaxaca. Magnetite mirrors went from Oaxaca to Morelos to San Lorenzo. Vessels of Oaxaca gray clay have been found at San Lorenzo, Tlapacoya, and a Chiapas site. Other pottery types were traded from the Gulf Coast to Oaxaca.

James Garber et al. cite Coe's (1968) theory of a jade route "extending from unknown sources in Guerrero to the Gulf Coast" and argue that, with new evidence, it has

been partly reconstructed: Chalcatzingo, Teopantecuani-tlan, Oxtotitlan, and Juxtlahuaca were distribution centers in the Middle Formative (Garber et al. 1993: 211–215). Serpentine may have been part of the jade network; serpentine sources are known for Guerrero and elsewhere, but jade sources are still unknown.

Olmec stone-carving may well have begun in Guerrero or a region that includes Guerrero. Griffin proposes that the Formative Olmec explored the working of hard stones and "created the greatest lithic tradition of the ancient world" in Guerrero (see Griffin 1993: 203–206). Henderson points out that more Olmec jades have been found in Guerrero than in all the rest of Mexico, and that, almost without exceptions, they have no archaeological context (Henderson 1979). Although jade sources have not yet been found in Guerrero, the jade workshop that Niederberger found may indicate a likely source possibility. Other discussion has concerned the possible importation of jade from Costa Rica, but no centers of jade production have yet been identified in Costa Rica, nor have there been confirmed finds of jade (Soto 1993: 68–69). Anatole Pohorilenko has argued that the Olmec blue-green jade found in Costa Rica probably came from Guerrero, Chiapas, highland Guatemala, and El Salvador (Pohorilenko 1981: 326).

Little jade has been found at San Lorenzo (Coe and Diehl 1980: 35). Jade was found in excavations at La Venta, a later site. At San Jose Mogote, in the San Jose phase (1150–850 B.C.), nearly all burials had a jade bead in the mouth (Flannery and Marcus 1983; Garber et al. 1993: 211). Jade comes from Early Formative contexts at Tlatilco (Tolstoy 1989a; Garber et al. 1993: 211). Garber et al. observe that the earliest documented use of greenstone appears on the Pacific Coast of Chiapas c. 1500 B.C., before it appears on the Gulf Coast; they speculate that it was not "Gulf Coast contacts" that underlay the widespread adoption of greenstone but the social function of these objects as elite status markers. Greenstone carvings are probably always found in elite burials or caches at important sites.

The places that participated in trade and other exchange had to have had a certain level of development in order to participate in those exchanges. The Gulf Coast sites could not have developed as they did, had it not been for developed sites with which they could deal, all of these sites encouraging the growth of the others. Griffin and others have posited a system rather like that of "city states" (Griffin 1993: 207). Most of the influence and impetus seems to have come from the Gulf Coast in the early period; by Late Olmec times, probably much of the impetus was coming from the other direction. Monte Albán and Izapa were developing; Gulf Coast cities were becoming less important. At all times, traffic was going in various directions in a complex pattern.

The style usually has similar iconography and traits, but, although always recognizable, it appears quite differently in different settings. The large sculpture of the Gulf Coast varies considerably from that of Teopantecuanitlan or Abaj Takalik—which are different from each other. The Gulf Coast has the most intense manifestation of the style. Most of the style elements—but not necessarily all—probably came from there. The motifs may have had different uses and meanings in different places, and they would have changed through time as well as space. The style was probably an elite marker in most places; its motifs may have been group symbols in Oaxaca, where the style is less strongly present in monumental sculpture. The style may have marked colonization in other areas (Agrinier 1984), or sacred places on the routes.

Archaeologists who work in Chiapas describe their Olmec-style monuments as deriving from the art of the Gulf Coast. Thomas Lee writes that much of the cultural tradition in Chiapas at the begining of the Early Olmec horizon emanated from the Gulf Coast and that Olmec "heartland" sites received prized imports directly from and through Chiapas (Lee 1989: 221). Some of those who excavate in adjacent Guatemala claim that monuments there are earlier than those on the Gulf Coast. Graham argues that the Olmec style originated in the Pacific Piedmont (Graham 1982). On the other hand, Lee Parsons, who has worked at various sites in the piedmont, is not convinced that Early and Middle Formative monumental stone sculpture exists in the Southern Pacific Coast region; late Olmec sculptures are found at Abaj Takalik, but not early ones. He disagrees with Graham that certain boulder sculpture is proto-Olmec. Parsons believes that monumental sculpture originated on the Gulf Coast (Parsons 1986: 8).

Flannery and Marcus argue that certain "Olmec" motifs appear in Oaxaca earlier than on the Gulf Coast (Wicke 1971: 161–162; Marcus 1989: 155; Flannery and Marcus 1983). According to Grove, the Gulf Coast Olmec brought their ideology to great aesthetic heights, but their magnificent monuments were technological and social achievements rather than evidence of Gulf Coast origins for the ideology, and that there is no archaeological evidence that any or all of the motifs originated on the Gulf Coast and/or diffused from there (Grove 1989b: 12). On the other hand, he writes of Chalcatzingo: "I believe that this monumental art was first initiated by artists trained on the Gulf coast" (Grove 1989a: 130–131).

The Gulf Coast people did not spring out of nowhere, and they were not the only people with an advanced society. Carefully laid-out ceremonial sites started early in many places. People were farming, making pottery, and trading for some time before the Olmec phenomenon. Yet many of the accomplishments of "the Olmec Horizon" are unique. The Gulf Coast region undoubtedly led many of these advances, but the Olmec phenomenon could not have evolved only in one region, for it was fed by many ideas, energies, and materials.

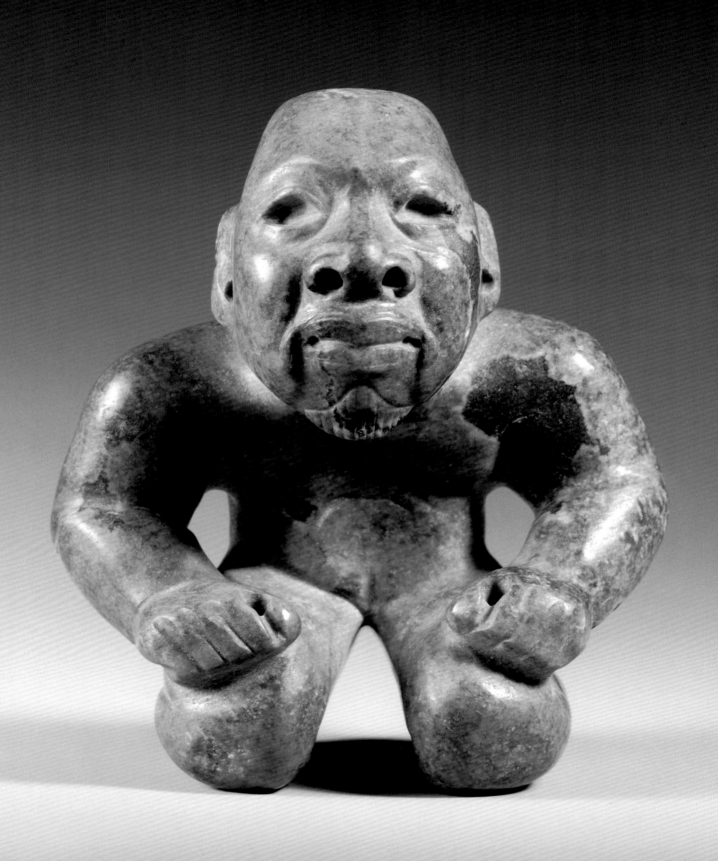

The Olmec World

RICHARD A. DIEHL

INTRODUCTION

In 1862 I was living in San Andrés Tuxtla, a town in Veracruz state, Mexico, and during some of my excursions I learned of a Colossal Head which had been uncovered a few years before,....During one of my trips in search of antiquities I visited the hacienda (of Hueyapan) and asked the owner to take me to see it: we went, and I was truly surprised: as a work of art it is without exaggeration a magnificent sculpture, as can be seen in the accompanying photograph, but what impressed me most was the Ethiopian physical type it represents; I reflected that undoubtedly Negroes had been in this country and this had been in the earliest times of the world: that head was not only important for Mexican archaeology, but also for the world in general. (Melgar y Serrano 1869)

These words, published in an obscure Mexican journal more than 125 years ago, gave the world its first view of the ancient Olmec culture of southern Mexico, the first civilization in the Americas. In addition to their great antiquity, the Olmec, now known to be Native Americans rather than Africans, as imagined by Melgar y Serrano, created some of the most beautiful and puzzling works of art. A selection of these objects is the subject of this exhibition and catalogue. The essays and object descriptions that follow present the many new and exciting ideas about the Olmec, the result of recent investigations by archaeologists, art historians, and other scholars. However, no society or art tradition can be understood, or even appreciated, without consideration of its unique social, cultural, and historical contexts. My purpose in this brief introduction is to set just such a stage.

Olmec civilization was Pre-Columbian America's first complex culture. Individuals and families were divided into two distinct social strata: a small elite which enjoyed wealth, social status, political privileges, and religious power; and the vast majority who did not. This societal division into "haves" and "have nots" is the quintessential characteristic of civilization, and it first appeared in Olmec culture a century or two after 1500 B.C. Shortly thereafter, similar cultures arose independently in Oaxaca to the west and along the tropical Pacific Coast of Chiapas and Guatemala. Through commercial and social contacts, the Olmec and their neighbors exchanged greenstones, feathers, and exotic goods prized by local elites, as well as ideas and cultural "influences" that expressed shared beliefs and symbols. The nature of these contacts, and especially the impact of the Olmec on the other groups, is the subject of spirited and at times even heated debate.

The Olmec homeland occupies southeastern Veracruz state and adjacent portions of Tabasco, Mexico, the region the Aztecs later called *Olman*, "The Rubber Country." Olman is river country, where fast-moving streams flow into large, meandering rivers such as the Papaloapan, Coatzacoalcos, Tonala, and Usumacinta. Until recently, tropical forests covered the riverine lowlands as well as the volcanic Tuxtla Mountains that form Olman's western boundary. River levees and swamp margins offered land that was easily cultivated, and forests and streams provided abundant fish, game, and wild plants. The Tuxtla Mountains contained white kaolin clay used for ritual pottery vessels and volcanic stone that could be carved into sculpture.

The Olmec were a truly prehistoric people who left no written records, if indeed they ever had a writing system. Thus, archaeologists and other scholars must reconstruct Olmec culture and history by studying fragments of pottery, stone tools, buildings, sculptures, and other surviving remains. Many different reconstructions of Olmec life and history have been proposed since Melgar y Serrano's day; some have faded in the light of new information, others still provoke spirited debate. These debates are evident in the essays that follow. Scholars frequently disagree with one another, and there is as much controversy as consensus in Olmec studies today. Fortunately, archaeologists are beginning a new round of field investigations in Olman just as art historians and iconographers are undertaking new studies of the objects. Such studies will resolve some of the disputed issues, but even so, many of the "truths" accepted today will seem as outlandish to future scholars as Melgar y Serrano's evocation of African ancestry seems to us now.

Olmec Culture and History

Traces of Olman's earliest inhabitants lie buried beneath the deep alluvial silts and volcanic ash that blanket the region. The oldest of these discovered so far, the Barí phase culture near the later Olmec center of La Venta, dates to the second half of the third millennium B.C. By 2250 B.C. Barí phase farmers occupied the well-drained, slightly raised river levees and mangrove swamp margins so abundant in the region. They planted maize and beans in small clearings in the high jungle, harvested wild palm nuts and other plant foods, and consumed fish, turtles, clams, and other aquatic life. Their simple pottery vessels are the earliest known in the region and among the oldest in Mesoamerica. Although they used the same basic tools and equipment as later Olmec farmers, they differed greatly from their descendants in social, economic, political, and perhaps religious customs. Evidence suggests that they lived in small, egalitarian societies with only minimal status differences. They did not construct mounds or large public buildings, carve sculpture, or import exotic objects from distant places. They may have held religious beliefs and practices similar to those of their Olmec descendants, but no evidence of it has survived. It was in these realms of social, economic, political, and religious development, rather than in basic subsistence or technology, that their Olmec descendants would create the forms and practices that became the standard for all later Pre-Columbian civilizations.

Gradual but profound changes occurred during the next thousand years. Agriculture came to dominate the economy and subsistence patterns of the region, especially as maize became more productive; populations grew in size and complexity, and towns emerged as a new type of human settlement. Technological and stylistic changes took place in the manufacture of pottery and stone tools, but were of only minor significance compared to the most important change: the gradual domination of the region's social, political, and economic life by a small emerging elite. At the same time, the basic Olmec religious complex and the unique art style that portrayed it came into existence. By 1200 B.C., these evolutionary processes crystallized into what we call Olmec culture or civilization.

Cultural evolution, however, is an ongoing process. In Olmec country, the process quickened after 1200 B.C. as one Olmec center rose to replace another until, near the end of the millennium, profound changes in both the Olmec heartland and other parts of Mesoamerica brought Olmec culture as a recognizable entity to an end. Archaeologists divide this Olmec cultural sequence into four periods: Initial Olmec (1200–900 B.C.), Intermediate Olmec (900–600 B.C.), Terminal Olmec (600–300 B.C.), and Epi-Olmec (300 B.C.–A.D. 300). The traditional reconstruction holds that, in general terms, three centers flourished and declined in sequence: San Lorenzo (Initial Olmec), La Venta (Intermediate Olmec), and Tres Zapotes (Terminal Olmec). Recent investigations, however, reveal a much more complex history. Today we realize, for example, that La Venta may have been a large and important center before 900 B.C.; that Laguna de los Cerros, Las Limas, and other Olmec archaeological sites must be fit into the picture; and that despite the presence of colossal heads, Tres Zapotes may postdate the demise of true Olmec culture by several centuries. Considerable research needs to be done before archaeologists will really understand the historical trajectory of Olmec culture.

San Lorenzo, a large and very complex archaeological site atop a plateau overlooking the Río Chiquito branch of the Coatzacoalcos River, is the best known Initial Olmec center. Although occupied and abandoned repeatedly over 2,500 years, San Lorenzo attained its cultural and political zenith between 1200–900 B.C., when more than eighty stone monuments, including ten colossal heads and several of ancient America's finest in-the-round sculptures, were created. Its territory or realm covered most of the Coatzacoalcos River basin and included Potrero Nuevo, El Azuzul, the cult shrine at El Manatí, and numerous villages, hamlets, and homesteads. Although the best-known Initial Olmec center, other sites—such as La Venta, Laguna de los Cerros, and Las Limas—may have rivaled it in size and importance. Outside the Olmec homeland, archaeologists have identified numerous Formative period settlements that appear to have maintained ties with San Lorenzo; these include Tlatilco and Las Bocas in the Central Mexican Highlands, San Jose Mogote in the Valley of Oaxaca, and several centers along the Pacific slopes of Chiapas and Guatemala.

In approximately 950 B.C. San Lorenzo was abandoned, for unknown reasons, and La Venta soon replaced it as the preeminent Olmec center. This fascinating Olmec center, located near the now extinct Barí River, held sway over much of eastern Olman, extending its control into what is today central Tabasco state. Radiocarbon determinations date Complex A, a small but extensively excavated ceremonial court at the north end of the site, to the Intermediate Olmec period, and archaeologists believe that the enigmatic Great Pyramid as well as its large earth mounds and stone monuments also date to this time. Surveys in La Venta's hinterland revealed a hierarchical settlement pattern of communities, including villages with earth mounds, smaller ones without such structures, and tiny hamlets. La Venta may also have established cult shrines at sacred places. One such shrine may have been Río Pesquero, where archaeologists and looters have removed many beautiful greenstone objects, including masks, figurines, and perhaps as many as one thousand greenstone celts, apparently deposited under water. Another shrine may have been established at the summit of San Martín Pajapan volcano in the Tuxtla Mountains, the find spot for the outstanding sculpture known today as the Lord of San

Martín. La Venta's contacts with groups in other parts of Mesoamerica were even more extensive than those of San Lorenzo.

Although they may have shared a common language, perhaps an ancestral form of Mixe, Zoque, and Popoluca still spoken in the region, the Olmec never formed a single ethnic group, nation, or empire. Instead, the landscape was a patchwork of loosely integrated chiefdoms, political units composed of a capital town where the elite and their relatives resided, and numerous smaller satellite villages and farms in the surrounding hinterland.

Olmec religion and the art style that expressed the cosmology on which it was based integrated the many different Olmec societies into one distinctive culture. This style set the Olmec apart from their neighbors and trading partners, many of whom borrowed Olmec ideas about religion and elite cultural expression along with the icons and motifs that represented them. The Olmec style was surely not the first in Mesoamerica; its integration of form, meaning, sophisticated conception, and mastery of hard-to-work materials suggest a gestation period of centuries. Unfortunately, whatever preceded it has disappeared completely, probably because the cloth, wood, leather, and basketry on which it was found have not survived the forces of time and decay.

The Olmec were Native Americans, direct descendants of earlier farmer-fisher folk of southern Mexico whose ancestry reaches back to the Paleo-Indians who entered North America from northeast Asia during the Great Ice Age or Pleistocene era. Although archaeologists have not yet recovered any Olmec skeletons complete enough for scientific study, Olmec art contains many realistic depictions of humans that inform us about their physical appearance. Mexican archaeologist Ignacio Bernal summarized the Olmec physical type:

> …persons of low stature (brachytype) but with well-formed bodies tending towards obesity, slanted eyes that are puffy and have the epicanthus fold, a short wide nose, mouth with thick lips and corner turned down, a prominent jaw and a short, heavy neck (Bernal 1969: 25–26).

Descendants of the Olmec continued to occupy the region long after the culture ceased to exist, and people who fit Bernal's description are still found in Olman today.

Subsistence

Farming, especially the cultivation of maize, was the basis of Olmec subsistence. This seed plant, the Mesoamerican staff of life, was first domesticated in the arid central and southern Mexican highlands at least two thousand years before Olmec culture emerged. Maize reached Olman before 2000 B.C. and soon adapted to the constant heat and humidity of the tropical lowlands. The size of the ears and number of kernels increased over the centuries, so that by 1000 B.C. highly productive strains of maize became the staple food in a rich and varied Olmec diet. Not surprisingly, maize symbolism occurs frequently in Olmec pictorial art, and some scholars identify a maize deity among these portrayals. Excavations at La Venta and elsewhere have shown that the Olmec also ate beans, chocolate (cacao), wild palm nuts, and fish, clams, turtles, domestic dogs, deer, and caiman. Olmec farmers probably also raised manioc, squash, and other crops, as well as medicinal and narcotic plants not yet identified in the archaeological deposits.

Technology

Olmec families had access to a simple yet sophisticated tool kit of material culture. A typical Olmec house would have contained scores of pottery vessels for food and water storage, cooking, eating and drinking, and ceremonial use. Some were undecorated, while others, presumably those used in ritual and ceremony, display painted and incised designs and symbols. Other items found in the typical house may have included basalt querns (*metates*) and two-handed milling stones (*manos*); gourds used as drinking vessels, canteens, and containers for miscellaneous objects; razor-sharp obsidian blades and scrapers; ground stone axes for clearing fields; and stone celts and wedges for working wood into dugout canoes, weapons, fish traps, benches, and other utilitarian objects, as well as ceremonial masks, costume elements, and ritual paraphernalia.

Stone-working was the Olmec's claim to fame, especially the carving of large basalt monuments and small objects of semiprecious jadeite and similar hard greenstones. The egalitarian societies that preceded the Olmec lacked elites who required elaborate jewelry and sculptural pronouncements of their worldly role and ties to the supernatural realm. Emerging social complexity required mechanisms by which the new rulers could proclaim and validate their special status in the strongest possible ways, a challenge that resulted in the creation of some of the boldest stone sculpture and most exquisite portable objects and jewelry of the ancient world.

The Olmec Community

Most Olmec lived in small hamlets and villages where everybody was related or at least acquainted. Although settlements of this type have yet to be excavated in the Olmec homeland, contemporary sites elsewhere in Mesoamerica suggest that they contained rectangular houses with mud-plastered pole walls, beaten-earth floors, and woven thatch roofs. Three or four such structures surrounding a central courtyard formed a compound occupied by kinsmen who shared work tasks and formed the basic social groups of Olmec society. Rituals were conducted in such compounds. Villages may have had special ritual or ceremonial buildings and areas, but only the largest villages had a formal temple placed on top of an earth mound.

San Lorenzo, La Venta, Laguna de los Cerros, Las

Limas, Tres Zapotes, and the other major Olmec towns had populations numbering in the thousands. Such communities were once thought to be empty ceremonial centers inhabited by only a few priests, but investigations at San Lorenzo and La Venta indicate that they contained many house compounds similar to those in the villages as well as elaborate temples, palaces, and elite residences on top of earth mounds formally arranged in plaza groups. Recent excavations at San Lorenzo revealed the elaborate nature of one such building, the "Red Palace." This structure, which may have been the residence of a high-ranking noble family, had plastered and painted walls, stone column roof supports, and other elaborate architectural elements. La Venta's many large earth mounds may have supported similar buildings. Complex A, the only amply excavated portion of La Venta, yielded a variety of objects buried beneath its mounds and plaza floors, from single pottery vessels to multiton offerings in giant pits, and enigmatic mosaic pavements of hundreds of serpentine blocks. Such construction required considerable public labor and provides striking evidence for Olmec piety as well as the ability of the elite to marshal the support of their followers.

Olmec Society

Archaeologists call Olmec societies *chiefdoms*, in which differences in wealth and power exist but are not as defined and permanent as in more complex societies structured along lines of class and caste. This basic division of Olmec societies into two distinct social strata, fluid and rudimentary as it was, constituted the fundamental difference between the Olmec and all of their predecessors and marked the emergence of an entirely new kind of social world.

Unfortunately, almost nothing is known about Olmec commoners and their lifestyles. They do not appear in the art, nor have archaeologists systematically examined their remains.

Olmec leaders, their relatives, and their ancestors, putative or real, were the basic subject matter of Olmec art. Colossal heads appear to be portraits of living or recently deceased rulers, and at least some were recarved from existing thrones (erroneously labeled "altars" by early archaeologists), huge rectangular stone monuments depicting the ruler and his divine ancestry. Other ruler portraits include seated figures carved in the round, the most dynamic sculptures known in ancient America, and standing depictions on the stelae of La Venta and the magnificent Laguna de los Cerros Monument 10.

Olmec rulers were distinguished from their compatriots by their dress, housing, behavior, and lifestyle. Of these, most is known about the costumes. The appearance of Olmec lords and their companions can be gleaned from their portrayals on sculpture, ceramic figurines, cave paintings, and other visual representations, as well as the rich jewelry associated with the badly disintegrated skele-

tons in burials at La Venta. Headdress, a ruler's most striking status symbol, came in almost endless variety. Those on colossal heads look like cloth or leather "helmets" similar to old-style American football headgear; others include feather constructions divided into four segments, towering racks with wooden or wicker frames almost as tall as the wearer, and hats reminiscent of vaudeville "boaters," to name a few. Many are decorated with long, iridescent green quetzal feathers, as well as those of harpy eagles and other birds, while yet others present full-sized wooden or stone masks depicting the face of a "were-jaguar." Large, multicomponent earspools made from jadeite or other precious materials were worn, and rulers frequently sport heavy jade-bead necklaces with a polished iron-ore mirror or greenstone plaque in the center. Loincloths, cutaway skirtlike garments, netted or feathered capes, and the pelts of jaguars or caimans covered the shoulders or midsections, while bracelets, ligatures on the arms and legs, and sandals completed the costume. It is not hard to imagine how uncomfortable such an outfit must have been in the blazing sun and humidity of Olman! In addition to their elaborate costumes, rulers are depicted holding or using a variety of sacred and powerful objects, such as scepters, ceremonial bars, greenstone celts and figurines, and stingray spine bloodletters.

Olmec Decline

The archaeological record becomes very murky after about 400 B.C. Both San Lorenzo and La Venta were abandoned by this time; the former was reoccupied more than a thousand years later, while La Venta remained overgrown with jungle until the early years of this century. Tres Zapotes arose as a major center on the western edge of the Tuxtla Mountains a century or so after 400 B.C., but its status as Olmec is open to question. Only two of the forty-plus sculptures known from Tres Zapotes are truly Olmec. Both are colossal heads; ironically, one is the head reported by Melgar y Serrano, which gave the world its first notice of Olmec culture. Most of the remaining sculptures show strong resemblances to the Izapa style, which most archaeologists believe evolved out of an Olmec matrix in its Pacific Coast homeland and then spread back across the Isthmus of Tehuantepec to fill the void left by the demise of its Olmec ancestor.

At the same time, Mesoamerica's oldest writing system came into existence somewhere in the trans-Isthmian region. Known variously as the Epi-Olmec, Isthmian, or Tuxtla script, it used hieroglyphs to express calendrical notations and much more. Just what else was recorded is the subject of considerable debate, because epigraphers are only now beginning to decipher the script. But the most accepted readings of La Mojarra Stela 1 and the Tuxtla Statuette, the only two complete texts known, indicate a concern with the history and the lives of rulers, shamans, and other important people. Much remains to be learned

about this script, not the least of which is why it did not appear earlier when Olmec culture was at its height, when it would have been so useful for recording information of the sort that is so central to the whole Olmec concept of art.

By 300 B.C., or perhaps even earlier, Olmec culture and art had ceased to exist. Centers and their rulers lost power, only to be replaced by competitors. There is no evidence to suggest the region was depopulated or that natural or man-made disasters overcame the Olmec. Instead, Olmec culture evolved into something new. Those new cultures differed from their Olmec ancestors in only two ways: they were no longer the cultural leaders of Mesoamerica, and they did not express their ideas and beliefs in the Olmec art style.

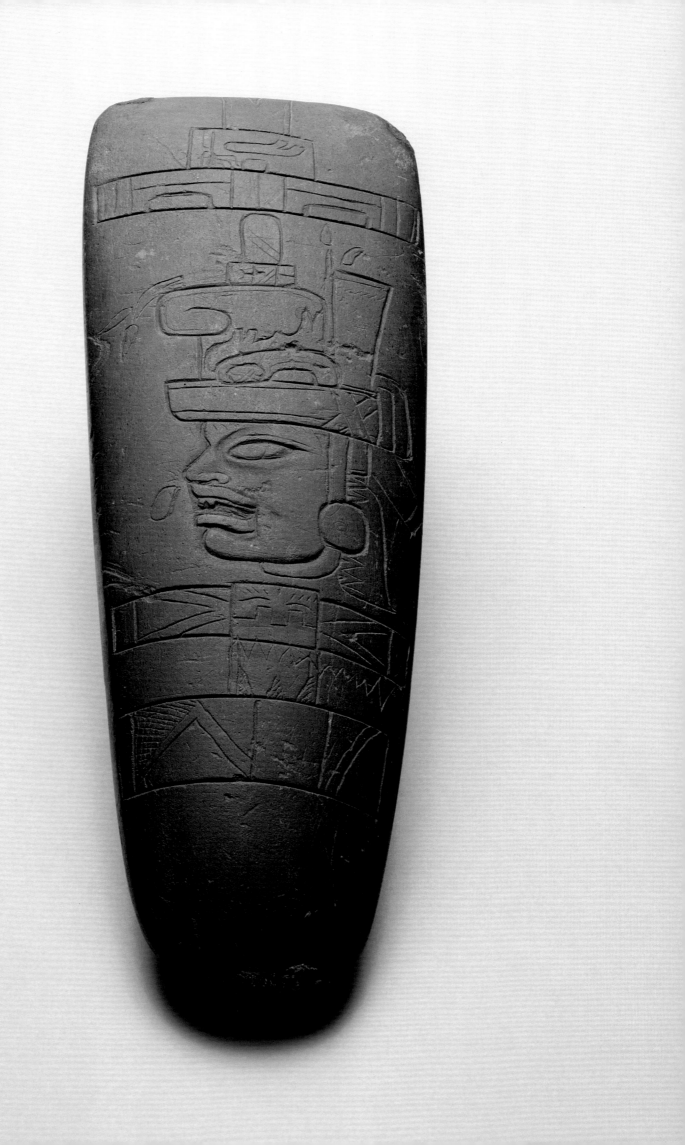

Daily Life in Olmec Times

MARI CARMEN SERRA PUCHE, WITH FERNÁN GONZÁLEZ
DE LA VARA AND KARINA R. DURAND V.

When we speak of daily life in the Formative period, what comes to mind is a rural village, a community of wattle-and-daub houses with thatched palm roofs, clustered around a patio where the inhabitants perform a variety of tasks. Corn grows next to the houses; in the distance are mountains and a body of water in which men in canoes fish and hunt aquatic birds.

This typical image is probably accurate, but deceptive. The reconstruction is based principally on ethnographic analogies and documents written after the Conquest, and to a lesser degree on archaeological excavations. This information is valid, but if applied perfunctorily to communities that existed almost three thousand years ago, it may present a distorted view of the reality.

This is not to negate the continuities extant in the indigenous lifestyle since 1000 B.C.; certainly house size has varied little. This was established in excavations of household units at sites like Tierras Largas in Oaxaca or Terremote Tlaltenco in the southern end of the Basin of Mexico. It is also certain that basic subsistence activities were already developed by the Formative period, and that most of the craft skills were already known by the Olmec period. It is equally certain that the basic household assemblage of the pre-Hispanic era has changed little since the arrival of the Europeans in the New World (Winter 1972; Serra 1988).

Nevertheless, while we speak from a large database on the existing continuities from the pre-Hispanic era, for a more precise image it is necessary not only to recognize the similarities in our reconstruction, but also to ask ourselves what the differences are between an extinct community of 2,000 years ago and a modern village. Some of these differences can help us to understand the context in which Olmec societies developed.

Settlement pattern research from a variety of regions in Mesoamerica shows that communities where Olmec materials have been found occupied a wide range of ecological niches, from jungles and coastal swamps to temperate forest zones more than 2,500 meters above sea level, as in the case of the sites of Coapexco in the Valley of Mexico and Loma del Conejo and Metepec in the Valley of Toluca (Tolstoy and Fish 1973; González de la Vara 1994).

This broad site distribution indicates the ability of sedentary villages to exploit distinct, adjacent zones of natural resources. Demographic studies for the Early and Middle Formative periods also show that population density in nuclear zones, like the Oaxaca valley and the Basin of Mexico, was minimal. Even if we suppose that population density was greater in the lowlands, and that there was a period of rapid demographic expansion, the population would still be much lower than in the Postclassic era.

This low population density reminds us that Early Formative period sites were pioneer communities, submerged within a vast, almost virgin environment; population would have been concentrated near neighboring communities or along communication routes. Beyond the rivers and lagoons were large, unpopulated expanses in dense forests and almost impenetrable jungles. In the Maya area, where there were few navigable rivers, colonization would have begun after other regions of Mesoamerica.

To understand Formative period geography, it is not enough to know our own deteriorated environment, nor that of the Postclassic period—overpopulated, if we accept the calculations of Borah and Cook. Perhaps a more precise image would be that of the Amazon region, where only occasional clearing and cultivation would have broken the immensity of the vegetation coverage (Borah and Cook 1963).

Another aspect that would seem to differentiate Formative period communities from their Postclassic counterparts is diet. While it was likely that agriculture was already the basic form of subsistence in Olmec times (without which the dense populations of San Lorenzo and La Venta would be unthinkable), the proportion of cultigens planted was much greater in the Postclassic era than in earlier times; this is due, in part, to the greater early availability of forest resources that were already scarce at the time of the Conquest, or, at least, were not part of the diet of all the members of a community. Settlement pattern studies at Formative sites like Mazatán, Zohapilco, and Terremote clearly show a diet more rich in animal protein, as indicated by the variety of consumption patterns, in contrast to later sites like Teotihuacan and Tenochtitlan.

On the other hand, the importance of nonagricultural resources to Formative period inhabitants likely required a greater amount of time to exploit; hence, hunting and collecting would have continued as important activities, whereas they would not have been as productive for more numerous and complex societies (Niederberger 1976; Serra 1988; Stark and Voorhies 1978).

Low population density, together with a simple technology, translates into a lower capacity for transforming the natural environment. Formative period man had to coexist with adverse natural conditions and animals that competed with him for his habitat. These animals—as clearly seen from Olmec iconography—were the primary material for his mythic constructions. Such concepts show us a close relationship between man and his environment. Later, with the development of urban life and demographic growth, this relationship would lose importance with respect to the coexistence within and between various human groups. It is in this sense that Olmec communities were probably very different from those of the imperial warriors of the Postclassic period, as is evident in Olmec art, which depicts a close union with nature.

Another key difference is the lack of social institutions like those of the Postclassic era. While Olmec art sometimes represents leaders, priests, and possibly soldiers, it is difficult to imagine that such institutions as the army, priest caste, or administrative-political groups were already fully developed by Olmec times. The Olmec probably had some institutional frameworks, but none with the characteristics of Postclassic societies, where the village was constantly affected by the directives of a dominating central government: exacting tribute, conducting warfare, participating in public rituals, and obligating people to work more intensively and with less benefit than in earlier eras.

The abundance of Olmec representations that relate to ritual clearly indicate that religion played a central role in the daily life of Formative period villages; there are also notable differences when compared to later eras. The written sources of the Conquest period present a ritual life with rigidly established astronomical calendars, divinations, dates dedicated to some type of deity, human sacrifices—a constant ritual life. According to archaeological evidence, the Middle Formative Olmec probably already had a calendar, such as the solar calendar and the 260-day ritual calendar, although it had not yet acquired the importance that it would have for later cultures; otherwise there would have been evidence of calendric writing from these earliest periods. To date, the oldest calendric inscription corresponds to the Late Formative period, when the Olmec culture was already vanishing (Flannery, Marcus, and Kowaleski 1981).

Religion, as a reflection of society and daily life, must have been quite different from that encountered by the sixteenth-century missionaries, because people were responding to different social and economic circumstances.

It does not seem appropriate to view Olmec religion as unique and immutable, given that the Formative period is by definition an era of change and social development, as well as one of constant economic and political transformation. For this reason, it would not be possible to apply only one scheme to Olmec religion and *cosmovisión*.

THE SCOPE OF DAILY LIFE

Formative society was immersed in nature: agriculture, hunting, and collecting were the central activities of the community; dangerous animals surrounded houses and fields; natural phenomena were a constant threat. Formative period social groups—without a writing system, judicial norms, or urbanization—probably lacked the civic strength to guarantee social order and the class structure to control power and the priesthood.

Daily life developed in three principal areas: the countryside, the village, and the ceremonial center. Special localities outside these categories include the agricultural fields, obsidian mines, trade networks, and sacred places in uninhabited areas.

The Countryside

Pre-Hispanic peoples saw the countryside as an alter ego of the human community; it was the place of animals, on which they conferred a consciousness similar to that of humans. According to Terrence Kaufman, one of the central religious concepts of pre-Hispanic religion—the *nahual*—developed from Olmec times, with the idea that each human had an animal counterpart that lived in the wild, or in the forests around the community (Campbell and Kaufman 1976).

These forest regions, while of ritual importance, were little used by man except for occasional hunting or travel. Most humans would have rarely ventured more than a few kilometers from their communities. Formative period cultivators likely coexisted with nomadic groups of hunter-gatherers, with whom they established an economic partnership; the presence of late remains of campsites in places like Guila Naquitz or Santa Marta Cave would support this hypothesis (McClung and Serra 1993). According to data analyzed by Kent Flannery in Oaxaca, cultivation was concentrated in this zone, where it was possible also to gather or hunt most of the necessities of daily life (Flannery 1976: 103).

Agriculture was likely the principal subsistence activity in Formative period Mesoamerica. The most common technique involved the slashing and burning of vegetation, replacing it with fields of corn, beans, squash, and other crops that would be rotated annually. Shortly before the rainy season, an area covered in woods was selected. The largest trees were cut down and dried before being burned, and the terrain was cleared of plants and animals that might destroy the crops. At the onset of the rainy season,

crops would be planted directly into the ash-covered ground, which would serve as fertilizer. The field would be used for a few years until the nutrients in the soil were exhausted, then the terrain was abandoned and another selected for cultivation.

This technique is efficient, does not exhaust natural resources, and allows the vegetation to recuperate; however, it is not viable in areas of dense population. Formative inhabitants could use other techniques, such as "wet farming" along the river levees, which Michael Coe believes fostered Olmec social development, or "dry farming," which Flannery proposes for the Valley of Oaxaca (Coe and Diehl 1980; Flannery 1976: 103). However, these methods could only be used in certain areas and their importance was not central, because "wet farming" runs the risk of flooding and other natural catastrophes, and "dry farming" can only be used in very limited stretches of terrain.

The slash-and-burn technique was probably the predominant agriculture practice of the Formative era. Although it requires the walking of great distances and the task of eliminating the vegetation, this method requires only a few members to accomplish successfully; the men of one extended family would be sufficient for all labor, including harvesting.

While agriculture has proved to be the primary subsistence base, it would have required care for six months and intensive work only during specific times (burning, planting, weeding, and harvesting); the rest of the family's time would have been occupied with other beneficial activities, such as gathering, fishing, and hunting.

The collecting of forest products and small animals yielded a wide variety of easily obtainable products: amaranth, fruit, nopal,[1] mesquite, small shellfish, etc. For collecting one only needs to know resource availability by season to take advantage of them without effort. Gathering did not require sophisticated techniques or intensive labor; old people, women, and children participated in these activities.

Hunting would have required more vigorous members of the community; the hunt for animals and their capture, the erecting of campsites for the butchering of animals, the rapid transport of the meat, etc., would have taken place far from the villages. Early hunting was most likely the activity of a male group that required the participation and organization of adults within the community. The principal prey seem to have been deer and rabbits, but monkeys, armadillos, and opossums, for example, were also hunted. In the zones farthest from the village were larger prey like tapirs, wild boar, and cats. In addition, migratory and aquatic birds such as doves and ducks were captured in the lakes of the Basin of Mexico and in coastal zones of Mesoamerica (cat. 27).

Fishing was another essential activity for Olmec subsistence. Work in the coastal zones of the Pacific and on the Gulf of Mexico reveals that shellfish and fish were integral to the diet; rich fish resources permitted the emergence of sedentary communities prior to the adoption of agriculture. These groups likely employed nets and other equipment for catching fish, shrimp, and shellfish, but the simplest tools, such as spears or lances, were also common (cat. 26).

The Village

Most of the Formative period population lived in a village. According to Joyce Marcus (1976), the typical village would have covered 5 to 7 hectares. There also would have been hamlets of 1 to 2 hectares, as well as villages of 20 hectares. The village was the place of residence for various family groups, understood as diverse, consanguineous arrangements of several generations. The family unit provided for its needs by collecting and food production, as well as by creating tools. This fundamental family unit would have shared a section of the village and would have associated with other families through kinship ties, economic relations, and participation in common activities.

These kinship relations satisfied the requirements of reproduction for the whole community. The village was probably divided into larger family segments that recognized a common ancestor, who may have been a real or mythic person, perhaps an animal or being that personified the forces of nature. The association of descendants from such an antecedent, known as a lineage, would have shared a common zone in the village and participated in distinctive activities.

Life expectancy was much shorter than today; the typical adult lived to an average of thirty to forty years. At sites like Tlatilco, the percentage of individuals who surpassed the age of fifty was less than five percent. In addition, infant mortality was considerable, and more than seventy percent of the population did not reach the age of thirty-five at this site. These factors did not impede demographic growth throughout the Formative period; the advances in agricultural production and the early age of marriage contributed to population increase. At the same time, a variable diet permitted the population to be more healthy and attain greater stature than in later periods; despite this, the average person was smaller than a modern adult, about 160 centimeters (McClung and Serra 1993).

The Formative people had robust and strong bodies, the men as well as the women, a sign that both sexes performed tasks that exacted considerable effort. Deformation of the crania and other parts of the body was common: tabular-erect cranial deformation and the mutilation of teeth were customs that persisted throughout Mesoamerican history (cat. 91).

Apart from deformation, the people of the Formative period used bodily adornments to indicate social position, sex, and age (cat. 47). Figurines, ceramic as well as green-

stone, show face and body painting, complex tattoos, scarification, and the use of pectorals, collars, earplugs, helmets, and bracelets (cat. 86).

Body adornment was important, and clothing was rarely used. Men covered themselves with a knotted cloth around the waist, and used belts and sashes; sometimes they wore sandals and headdresses. Women were naked, except for a short skirt of cotton or other vegetable fiber. Typically they were crowned with some type of headdress; some had turbans, others wore beads or flowers in their hair. Still others preferred complicated coiffures with bows and pieces of cloth similar to those used by indigenous groups today. Headdress may have served as identification for a specific individual, and through these markers group, family, or personal identities were established.

Daily village life included a variety of activities necessary for group survival, including food preparation, tool-making, caring for children, the elderly, and the sick, as well as building and maintaining shelters.

The houses of a typical village have varied little to the present day. They were constructed over an area of 4 by 6 meters, bounded by a row of stones or posts. Walls were of interwoven cane, covered by a layer of mud and straw; the roof was of palm leaves or straw. By the Middle Formative period, there was evidence of houses utilizing stone as well as adobe walls, but this was generally restricted to the most important population centers (Serra 1986).

The hearth, which served to warm the house and cook the food, was sometimes found inside or near the edges of a wall. Conical-shaped pits were excavated to store food, probably seeds. In many of these deposits, human remains as well as pieces of ceramic and organic rubbish were found, indicating a secondary use as a garbage midden or tomb (cats. 31, 32, 38).

A patio was located in the front of the house, where in the daylight hours many tasks would be performed: the making of arrows and blades for hunting; the treating and drying of skins for clothing; the utilization of vegetable fibers for baskets, hampers, and cradles; the weaving of textiles; and the production of ceramics. Craftsmanship at the village level was not a full-time specialization, and these craftsmen also participated in other camp labors. Perhaps there already existed individuals recognized for their mastery in certain crafts, but they shared their products with members of the same family group.

Daily life was not limited to production activities; a strong ritual component permeated each of these tasks. Village rituals encompassed familiar phenomena such as birth, marriage, death of village members, as well as the passage of puberty and curing sickness. A religious specialist or shaman guided these activities. Figurines and reliefs of these personages depict them covered in animal skins and various adornments that signified their magical powers. The shaman performed rituals of healing and the invocation of ancestor spirits; he would have presided over the birth of a new member and would have been at the side of a dying individual, endowing him with offerings to the beings of the great beyond. The rich vestiges at sites like Tlatilco (cat. 25) and Las Bocas leave no doubt as to the beliefs in an afterlife; for this reason the dead were offered food, and at times were accompanied by dogs and other animals that would have helped them in their new life.

Certainly the activities of the shaman or religious specialist were not limited to the above-mentioned rituals. They were in charge of knowledge and the control of natural forces: they helped bring the rains, prevented lightning from striking, and averted attacks by fierce or poisonous animals. The shaman was the most venerated and feared figure in the village; his prestige was such that people would come from other areas to consult with him. Although he was not a leader, his ritual authority was not disputed by other members of the village.

The Ceremonial Center

The life of the people who inhabited the villages was not spent entirely in their localities; at specific times of the year the village needed to apply to communities of greater size to obtain scarce resources and to participate in community ritual. These activities gave rise to a new type of settlement: ceremonial centers.

The first ceremonial centers emerged around 1200 b.c. throughout the area of what would later be called Mesoamerica. Sites like Teopantecuanitlan in Guerrero, Chalcatzingo in Morelos, San Lorenzo in Veracruz, Tlatilco and Temamatla in the Basin of Mexico, Las Bocas in Puebla, or San Jose Mogote in Oaxaca attest to the birth of a new social order. Hundreds and sometimes thousands of persons were concentrated around the public monumental structures; the areal extension of such centers surpassed that of the villages. There were sites that reached 150 or more hectares in the states of Guerrero, Tabasco, and Veracruz (see also Cyphers, this volume); there the sculptural and architectural art of the Early Formative period was concentrated.

The ceremonial center was contemporaneous with the appearance of Olmec art and the works that indicated craft specialization. The management and administration of thousands of people implies the development of new rules of coexistence and new forms of subsistence to guarantee the continuation of society; the first ceremonial centers were likely places of apprenticeship for the emerging social organization (cat. 42). Unfortunately, there is an insufficient number of studied cases for a complete view of these ceremonial centers. One of these small centers systematically excavated is San Jose Mogote. The explorations carried out in the 1960s and 1970s revealed a complex community where people specialized in the production of precious goods like pyrite mirrors, jade and

shell adornments, ceramics with Olmec motifs, and obsidian instruments (cat. 34; Flannery and Marcus 1994). The production areas at these sites have been called workshops, for convenience. They have been found at other sites, such as Teopantecuanitlan, where Niederberger has excavated areas of shell-working, and El Mirador in Chiapas, where ilmenite cubes were manufactured; recently sculpture and cube workshops have been found at San Lorenzo (Niederberger 1986; Agrinier 1989; Cyphers 1994b).

The existence of massive production workshops is tied to regional exchange networks, which indicate that the traffic of goods and ideas was concentrated here. At specific times throughout the year, groups would proceed to faraway regions and offer their merchandise in exchange for products that were not available locally. The most precious objects were hard minerals such as jade and pyrite, but also valued were luxury ceramics, skins of wild animals, quetzal plumes, marine shells, etc.; this exchange also included goods of common use like obsidian, silex,[2] utilitarian ceramics, various animal meats, perhaps honey and cacao, blankets, and many other products that do not survive in the archaeological record.

The ceremonial center was also the seat of political and religious power. There governing groups administered activities, advanced the development of crafts, regulated celebrations and ceremonies, and supported construction and monumental sculpture—all activities that enhanced the government and prestige of the community.

The elites wore rich vestments to distinguish themselves from the rest of the population. The sculpture and reliefs seen at sites like Chalcatzingo, La Venta, and San Lorenzo portray them with large capes, headdresses with god figures, collars and earplugs of fine stones, and other symbols of command like scepters, staffs, and ceremonial bars, jade pectorals, etc. The houses where the leaders lived were also distinguished from those of the common people. Some were located on elevated platforms over the rest of the site or very near the ceremonial area, as at Chalcatzingo and Temamatla (Grove 1987a; Serra, in press). At San Lorenzo the most complex settlement arrangements had foundations and stone drains perfectly sculpted; they included enormous stone columns in their porticos (Cyphers 1994b).

Funerary rituals were also more or less elaborate according to status. Rulers had tombs of worked stone, basalt columns, and sarcophagi. Their mortuary tombs were placed in the center of the site; commoners were buried directly below or near the house. At La Venta, the ruler was accompanied by rich offerings of jade and shell, the body covered in hematite, with numerous vessels holding objects for his trip to the great beyond (Drucker 1952).

To date, the buildings encountered in the ceremonial centers show orientations toward certain cardinal points. This relates to the calendric requirements indicating the beginning of seasons throughout the year, the arrival of the rains, the planting season, the harvest, etc. The information obtained by study of star movements was essential for the development of an abundant harvest and for predicting the best times for hunting or collecting. The sacralization of these dates was converted into a source of power for groups that administered the ceremonial center and outlying areas. The control of daily activities through ritual was the basis for social hierarchy and the development of complex societies in Mesoamerica.

OLMEC AND NON-OLMEC DURING THE OLMEC PERIOD

To understand the importance of the Olmec in the development of daily activities during the Early and Middle Formative period, it is necessary to ask, albeit superficially, what is Olmec? Until now there has not been a satisfactory definition of this concept; some have considered it an ethnicity, others a religion, others an art style. The last definition has the advantage of not needing a prior interpretation to be applied. Simply, all objects that have the style are considered Olmec; this presents new questions. What importance do Olmec objects have in the daily life of the Formative village? What is the scope of the production and use of the Olmec artistic style? These questions still have no definitive answer, but this article suggests some perspectives for investigation.

The greater part of the utilitarian lithics as well as ceramics in Olmec period villages are not Olmec in style; most daily activities did not require the use of objects with artistic features. The value and function of Olmec art objects are recognized in the Basin of Mexico as well as in Veracruz; in fact, there are more objects of "Olmec" style in the highlands of Mesoamerica than on the coasts of Tabasco or Veracruz. Olmec objects seem to have been produced primarily at ceremonial centers for later distribution to villages, and locally produced from the Valley of Toluca to the coast of El Salvador, although the function of these objects was mainly related to the ceremonial life at the centers of power. If they were in fact Olmec objects, with the exception of some ceramic forms, they did not have a practical function. Instead, they served to formalize a variety of social relations that occurred within Formative period communities of Mesoamerica, which was of enormous importance for the development of the great pre-Hispanic civilizations.

After completing an inventory of the objects presented here and taking into account the considerations reviewed here, it still can be asked: can one speak of a particular daily life of the Olmec?

NOTES

1. A type of cactus.
2. Silex is a crystalline compound occurring in quartz, sand, flint, etc.; it was potentially used as temper in pottery production.

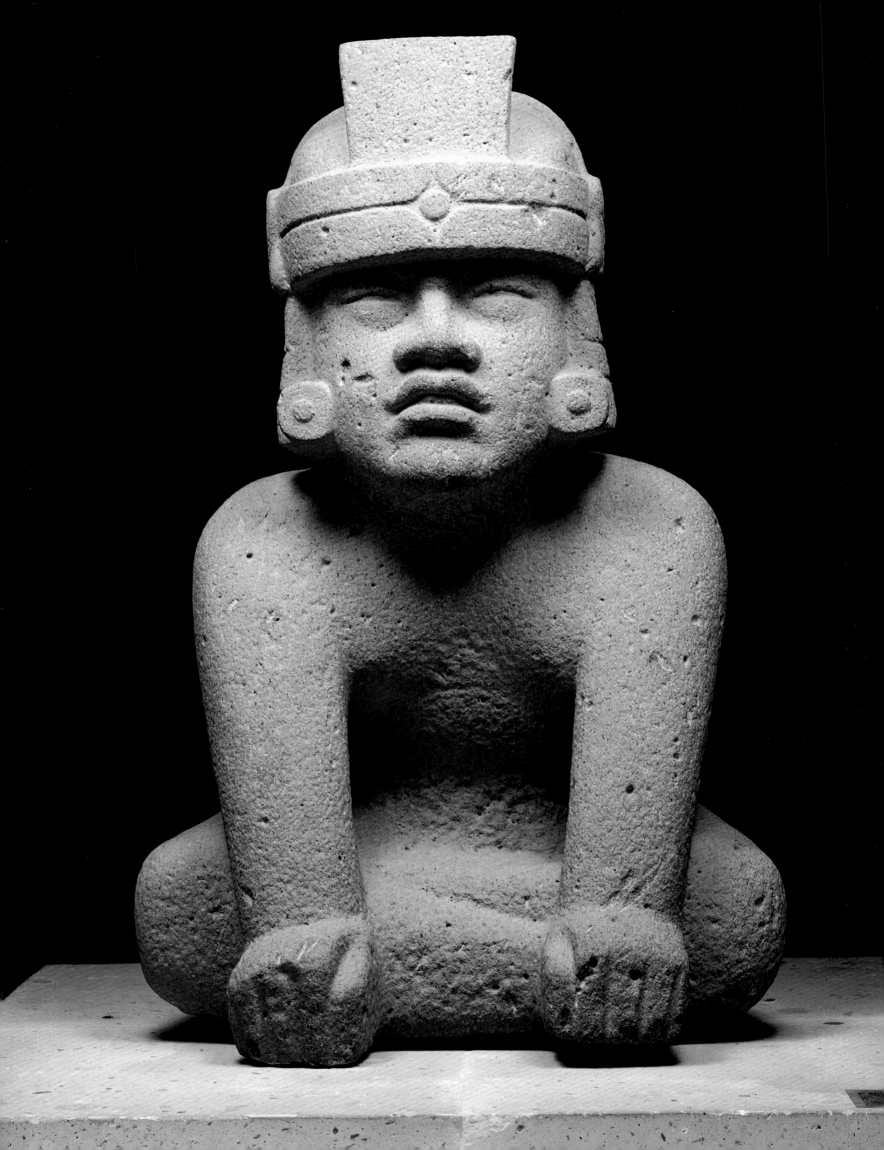

Homocentrism in Olmec Monumental Art

BEATRIZ DE LA FUENTE

Among the many iconographic subtleties through which the Olmec artist expressed himself, the monumental sculpture reveals that which man made, conceived, and speculated upon in the cosmos. Universal themes of reproduction, birth, and death have always figured in human creative potential. For the Olmec, such themes are manifest in the abbreviated language of architecture and urbanism, and in their splendid colossal stone monuments.

These sculptures, with their eminently homocentric message, can only be appreciated if one considers their placement in an environment scaled to human proportion. Thus, it is necessary to consider fundamental aspects of Olmec urbanism and architecture, as it was within this context that the monumental sculptures were located.

URBANISM AND ARCHITECTURE

The governing principles of Mesoamerican architecture were established in Olmec cities. The constrained space is ordered and defined by the harmonious arrangement of structures; since Olmec times, the monumentality that is basic to it has been achieved through demarcation of a plaza by the use of platforms or pyramidal structures. In the interaction of empty space and constructed volumes, the following intervene: the plaza, a place of congregation; the footpath, road, or avenue, a spatial resource of communication; and the truncated pyramid, a geometrical space composed of superimposed tiers and the cosmic seat for the deity who inhabits the vertex. These principles, which ordered the terrain and revealed the harmony of the cosmos, are observed already in Olmec cities, and were used to spectacular effect in the planning of many other later Mesoamerican cities and areas.

Olmec architecture is known principally by the archaeological explorations at La Venta, Tabasco, and at San Lorenzo, Veracruz, where the urban plan is determined by a virtual central axis, oriented from south to north with a deviation toward the east. In addition to establishing the basic elements of Mesoamerican architecture, these cities reveal other Olmec characteristics, such as the frequency of adobe as a construction material, the use of stone facing and colored clay, and the presence of great sections of stone, cut like boxes with a lid, which served as aqueducts.

This architecture was not necessarily built with long-lasting materials, but the accessible resources, both perishable or permanent, signal the sacred nature of the place to the community. These characteristics apply, in essence, to constructions that had symbolic or ritual attributes, for they were designed to indicate a sacred area. Other structures, some funerary, were arranged in floors beneath the earth's surface, where they were invisible and marked a sacred place. Few examples are yet known: the mortuary chamber closed off by monolithic columns; plazas bordered by columns of the same type of stone; enormous caches of serpentine flagstones buried as a ritual offering, such as the stone mosaic "floors" at La Venta, which represent schematic masks.

Olmec architecture established the formal patterns that were followed in Mesoamerica and also indicated another convention, that of relating the axes of the city, the orientations of the buildings, and the placement of monumental sculptures to astronomy.

Among the principal elements of pre-Hispanic monuments, two have existed since Olmec times. One is the explicit perceptual quality: the monument, be it architectural or sculptural, transmits a message based on its visible appearance. The other is the hidden message, perhaps more significant, that is not intended to be easily seen. An example of this second type is Offering 4 at La Venta; centuries later, the basis of Mexica[1] sculpture—such as that of the Coatlicue or the Chac-mools—harks back to these flagstones, serpentine mosaics, and designs. Although these images do not have the same specific reading, they share a universal meaning. Some are displayed and freely read—in agreement with established patterns—while other figures are beyond common visual perception. The esoteric reading is, at the same time, more intimate. For the Olmec, there are two ways to present reality: one perceptible, the other imagined.

The Olmec initiated the tradition that accepts a conceptual duality: that of the visible, which is apparent in the plastic forms of the physical world, and the invisible, which occurs at the conceptual level of interpretation and the imagination. There is no meaningful difference between what one looks at and what one sees. Both modes of perception are of equal relevance and weight in Mesoamerican life and beliefs.

The formal boundaries between Olmec architecture and monumental sculpture are not clearly discernible. Both share the quality of volume: their profound stability on the earth; their formal sculptural geometry; and the internal rhythms resolved within their masses do not irrupt into space.

MONUMENTAL SCULPTURE

Approximately three hundred or more monumental sculptures, complete and in fragments, are known from the principal sites of San Lorenzo, which includes Tenochtitlan, Potrero Nuevo, and El Azuzul; La Venta; Laguna de Los Cerros; and Tres Zapotes. Tres Zapotes incorporates Arroyo Sonso, Cuauhtotolapan Viejo, Las Limas, El Viejón, Estero Rabón, Cruz del Milagro, San Martín Pajapan, Santiago Tuxtla, and Loma del Zapote.

Hundreds of workers participated in the creation of colossal sculptures, from the moment in which the block came loose in the quarry until its final carving. The result: stone images, destined to outlive mortals, with their fundamental significance locked inside.

These sculptures have three principal functions: to mark a sacred place; to transmit the sensibility of the community that created them; and to express symbolically or narrate metaphorically facts, ideas, beliefs, myths, and rituals.

One example of the primary function, that of marking a sacred space, is the patio north of the great pyramid at La Venta, bounded by the natural finished columns of basalt. Another example is Offering 4, at the same site, which was "revisited" by the Olmec to assure its preservation.

It is also evident that Olmec sculptural forms transmitted aspects of the sensibility of their creators. Thus, the volume of the three-dimensional image is created within the sculptor's imagination and involved the formulation of a new reality; the monumentality expresses yearnings for grandeur, domain, and perpetuity; the mass is arranged solidly in the earth and indicates a desire for permanence; and the geometric structures of bodies manifest a clear and ordered conception of man and the world around him. Other fundamental qualities of form include the internal rhythm of the closed form, the surfaces that search for and find the roundness that covers the strict geometry, and the overall harmony of correct proportion.

The Olmec sculptor never liked planes, angles, edges, and absolute symmetry; aggressive geometry apparently did not fit his sensibility. Rather, his art reflects nature-based forms and presents an organized *cosmovisión* with a sense of permanence. In the history of Mesoamerican art, the Olmec, and centuries later, the Mexica, achieved monumentality in true sculpture in the round.

The forms are integrated into a total image that expresses a concept or specific theme. It is this function of sculpture, that of subject matter and content, that has attracted the most interest in Olmec scholars looking for answers to the enigma of Olmec ideology and religion. All, or almost all, studies have overlapped, generalizing that such matters are concentrated in the figure of a being or jaguar monster that incorporates into its feline aspect human and fantastic features.

The Olmec do not constitute an inferior stage of intellectual development, but rather their own mode of existence, different from that of Western man. The Olmec had to confront the primordial experiences of life and death, and the sentiments of smallness and finiteness before the forces of nature and the magnitude of the cosmos, and probably would have given specific responses to universal problems. To understand these responses, we would have to decipher the singular code that validated them. This goal has been attempted, but not necessarily achieved in past decades. For the present, this decipherment is supported, in essence, by the information derived from various anthropological methodologies and the methods of art history. In other words, the interpretations have been divided, on the one hand, by the archaeological evidence, and on the other hand, by the information found in the permanent work of art.

I will not try to identify the supposed "gods" and their attributes. Rather, within what is possible, I am interested in seeing how the monumental sculpture expresses—in its images and principal concepts—the problems inherent in human nature. Olmec sculpture incorporated symbols that were accepted and understood in their time; they are the best testimony we have to penetrate the conceptual world and religion of the Olmec. How did the Olmec respond to their relationships with the supernatural, and to the search for the meaning of existence? How did they realize the sensory life and nature that enveloped them within its powers? And, in what form did they conceive death, at which they all inevitably arrived? The responses that would have been given to such notions are what constitutes the essence of Olmec religion; they are partially resolved in Olmec colossal sculpture.

What evidence does this sculpture offer us? Nearly two-thirds of the sculptures represent purely human figures—complete or decapitated heads, torsos, and fragments; sometimes they incorporate animal and fantastic aspects (de la Fuente 1973). Others have jaguar aspects, called "humanized jaguars" or "monster jaguars"; the rest remain outside of these broad classifications. From the large number of examples evident in the sculptures, I can estab-

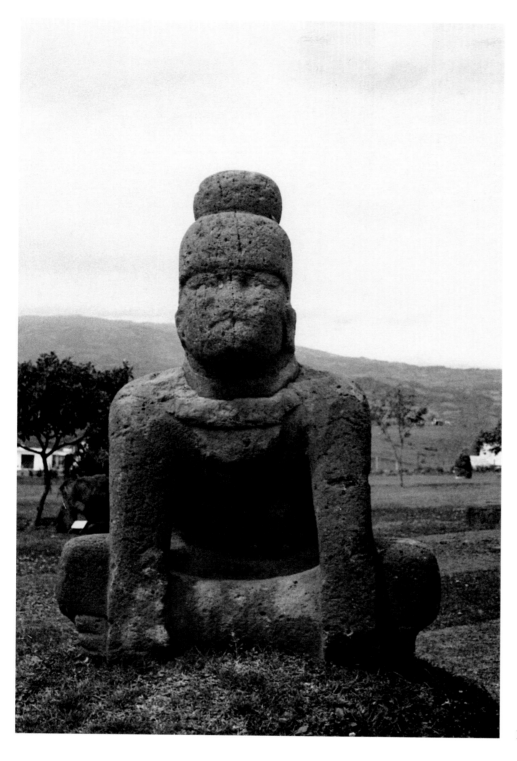

Fig. 1. Cuauhtotolapan Monument 1.

lish that the overwhelming majority represent human figures; indeed, I have referred previously to Olmec sculpture as "the men of stone" (de la Fuente 1977).

The Major Themes Represented

What is represented in Olmec sculpture? Which are the images they wanted to preserve indefinitely? There are three notable groups.

First is the group of human figures, which is the most abundant and is exemplified magnificently by the colossal heads and by the sculptures of whole bodies, like "The Prince" from the site of Cruz del Milagro (cat. 7); Monu-

ment 1 of Cuauhtotolapan (fig. 1); Monuments 3, 6, 11, and 19 of Laguna de los Cerros; the twins of El Azuzul; the kneeling figure from San Lorenzo; Monument 47, also from San Lorenzo; the torso from Potrero Nuevo; and Monument 77 from La Venta (cat. 10).

A second group consists of figures that have been called "composites," a mix of fantastic or imagined characters—a combination of human features with distinct animal species lacking parallels in nature. It is a special group, classifiable into different types. Examples include "Altar" or "Throne" 1 (fig. 2) and Monuments 6, 11, 59, and 64 of La Venta; Monument 5 of Estero Rabón; Monuments 1, 2, and 8 of Laguna de los Cerros; Monuments 10 and 52 of

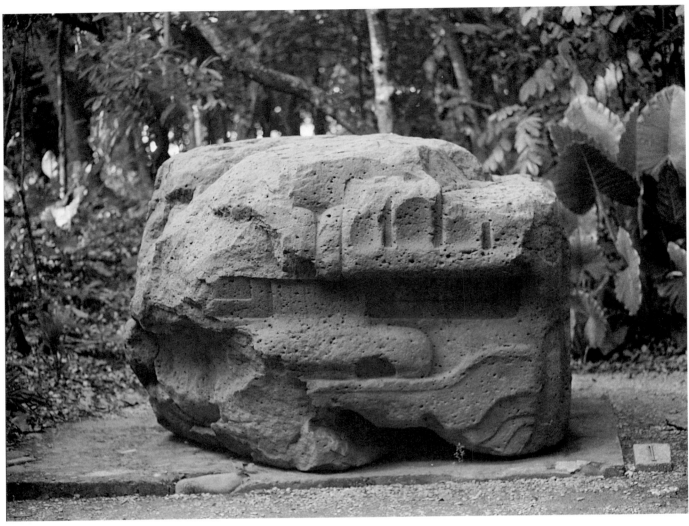

Fig. 2. La Venta Altar 1.

San Lorenzo (cats. 8, 12); and the small jaguar sculpture discovered recently at San Lorenzo by Ann Cyphers.[2]

The third group consists of the most rare animal representations that follow natural models. Here, I record principally San Lorenzo Monuments 21 and 43; the felines recently found at El Azuzul; and the naturalistic serpent winding around the priest in Monument 19 at La Venta (cat. 17). Although it constitutes a small percentage of the total, this is an important group of figures. They are composed of distinct features, some physically real and others imagined, corresponding to various categories.

These themes, revealing the common experience of the human condition, are joined for better comprehension. The rare occasions when there is no human appearance are mythic images and effigies. The groups are not entirely exclusive; frequently, characteristic aspects of the images in one group appear in others.

The Mythic Images

It is not easy to distinguish myths in the field of sacred figurative art; it also seems difficult to assign a structured mythology. If the Olmec monuments depicting mythic rep-

resentations could be interpreted with precision, they would reveal the sources of Mesoamerican thought.

As in science, the myths try to explain the universe and provide man with the means to reassure himself of his material and spiritual possessions. They exist as realities in the collective conscience; they narrate events that occurred at the time of their origins; and they tell how reality came into existence through these feats of supernatural beings. The myths explain creation. They relate how things came to be, through the development of the sacred into the terrestrial, and, in this case, the finding of perfection in the human.

In an attempt to define Olmec sculptural art and the common matters of universal mythology, I find that the imagery is not primarily narrative, but that it expresses fundamental concepts in a concise manner. The figure of a feline taking between its jaws a falling human figure—recently found at San Lorenzo—is certainly a scene that alludes to an essential concept: the sun, animated with its bright light, grasps another light, that of man, indicating the immediate destiny of man; in descending, he will disappear completely. It is an allegorical vision, unified and

dual, for day and night, birth and death, and the indissoluble union of man and nature. It is also the victory of the sun, which takes form in the powerful feline image, and the submission of man who accepts his destiny as part of the universe.

After years of investigating the unity of universal themes represented in Olmec sculpture, I have found three groups that form the whole of these mythic images. The first is constituted by three sculptures of unique importance: Monument 1 from Tenochtitlan,[3] Monument 3 at Potrero Nuevo, and Monument 20 from Laguna de los Cerros. Their relevance derives from their traditional acceptance as the representation of the sexual union between a jaguar and a woman; it has been said that they are the antecedents of the Olmec, since from this union resulted the "jaguar being," the "jaguar monster," or the "humanized jaguar," which is recognized as the prototypic image of Olmec art, and therefore, the most powerful figure of this credo and religion. With a base in such unfounded assertions in what this icon represents, a fabulous version of the origins of the Olmec has been reiterated. For this, if one notes carefully the representations of these sculptures, one will appreciate that the two figures are involved in the same action; however, they are of a different nature than that previously interpreted. In some cases, two human bodies are perceived: in those from Tenochtitlan and Laguna de los Cerros and the other at Potrero Nuevo, one sees a jaguar with the paws and tail of a simian. It is not a faithful visual reproduction; in all cases it would be the stone incarnation of the mythic creation, the supernatural union established as paradigm of all unions: the sacred origin of man. It is, in short, a creation realized in stone of the myth that establishes the supernatural and sacred character of the Olmec people. To mold the myth, one defines and recovers the reality.

A second group is composed of sculptures with figures that emerge from a niche reminiscent of a cave. They are enormous geometric monuments, in which a rectangular block supports an upper covering that projects over its lateral and frontal faces. In the principal face of the stone, a projecting relief is carved: a human figure appears to emerge from or be seated in this niche. Previously this type of sculpture was designated as an "altar" with a sacrificial function; today they are called "thrones," since they are supposed to represent the seat, real or symbolic, of the ruler. Visually a figure in the round projects from what simulates a cave entrance. The figure seems to emerge from the rocky shelters that lead into the underworld; it could be the birth of man emerging from the semidarkness of the underworld. On the sides of the powerful image are representations of men, engraved and embossed designs of figures complementary to the principal narration.

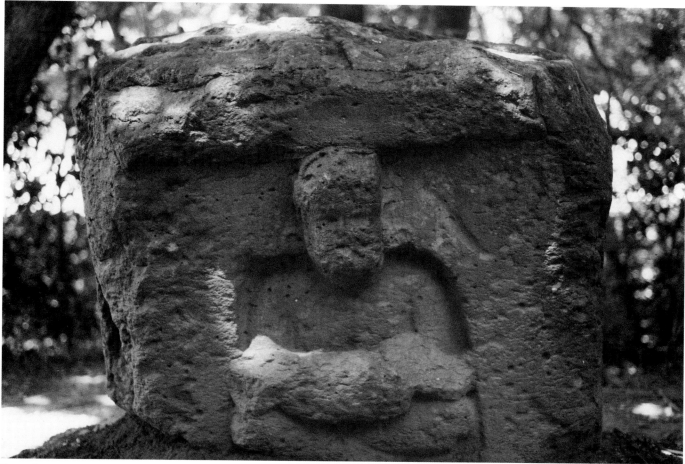

Fig. 3. La Venta Altar 2.

These surround the origin myth; it is the cave of the earth, the great ancestral mother, the recent birth of man that equals the unique potentiality of the fertile woman. The underworld supported from nature gives birth to the sacred principle of eternal life. The origin myth, which presupposes the continuity of the cosmogony, is thus established.

The Olmec, like all humans, questioned their origins; they justified their existence with myth, to which life gave concrete images. Today, the visual symbol of the origin of the Mexican people is the eagle resting on a nopal cactus with a serpent in its beak—it expresses an existential situation, hence, its constant repetition. The Olmec theme of man emerging from a cave is reiterated in Olmec sculpture, and later was repeated in both Maya and Mexica cultures.

I have also incorporated into this third group figures that carry in their arms children with fantastic heads, because iconographically they allude to the origin myth in aspects of renovation and fertility. Various modalities exist in their formal appearance; underneath they communicate the same message. Thus, one notes in the "altars" or "thrones" of Monument 20 of San Lorenzo[4] and Monuments 2 and 5 at La Venta (fig. 3), the man leaving the cave, the terrestrial mother, carrying in his arms the body of an infant with a huge head. Its lack of animation seems to indicate, in spite of its open eyes, that it is profoundly sleeping or newly dead. This scene may represent a precious offering, as in the blood of Christ; in Olmec iconography, it is the sacrificed supernatural child. One has to keep in mind that the fundamental significance of "to sacrifice" is "to make sacred." The man is making an offering and has the wisdom to comprehend the sacred and the supernatural.

"Altar" or "Throne" 5 from La Venta is a monumental sculpture, with the exception of its figurative scenes; it is known as the Quintuplet Altar because of four pairs of embossed images on its sides, and one, in high relief, on the front. The lateral representations of standing men holding children with human bodies and fantastic heads are characteristically Olmec. The frontal image is seated and masterfully carved; it simulates the cradling of an inanimate chimerical child. The contrast between the postures of these figures cannot be accidental: some embody life, the others seem to be dead.

A variant of this third group, depicting the man-infant myth, also carries in its arms a metaphorical infantile image. The splendid Las Limas Figure bears incised images on its shoulders, knees, and face (cat. 9).

The myths and the supernatural access are reached through the spiritual participation of man. The image, essentially human, is found in the creation myths of this exceptional people: the myth gave origin to and channeled the development of the great cultures of Mesoamerica. The artist and Mexican scholar Miguel Covarrubias considered it "the mother culture" of all others of ancient Mexico (Covarrubias 1961: 63). The Olmec developed and culminated the epics of the first civilization of Mesoamerica.

In Olmec times, the human figure was the vehicle of transmission for a conception of the world established for man.

The Supernatural Beings

Other images, always unique figures, incorporate in their essentially human aspect one or more animal features, as well as other purely imaginary ones. Consequently, they seem at once fantastic and almost human. To this group of composite images belong those that have been called traditionally "jaguars," "humanized jaguars," and "jaguar monsters." These are considered "deities" on the basis of their emblematic attributes, facial and body alterations, and indications of infancy or maturity.

This group generally belongs to an order that is rooted in the human body; even while exhibiting other features, its composition is basically human. Examples are present in San Lorenzo Monuments 10 and 52. However, they are less frequent in monumental sculpture than in small-format carvings.

In this group of supernatural beings I include the images of other animals that are unique, such as the felines of the recent finding at El Azuzul, and the birds of San Lorenzo.

The Human Figure

Images that have exclusively human features are the most numerous, and their depiction, within unmistakable Olmec conventions, is marked by its evident naturalistic character. In this very broad classification, one notices representations ranging from the most faithful, those that seek to imitate visual reality, to those that show, in a more conventional manner, the integrated traits that express the spirit of the community. With the exception of the colossal heads, masks, and other small pieces, one is not dealing with a universe of historic dimension. One cannot see a Western disposition in these "realistic" reproductions of physical, moral, and psychological dimension. It is, rather, a concept—a bridge—between the supernatural and the terrestrial worlds. It is, in synthesis, the human form in which divine power has a seat. Man, in his natural appearance, although synthetically represented, is the fundamental vehicle of the sculptural expression.

In the human figures group are three related themes: "lords under supernatural protection," "priests" or "mediators," and "human figures," which comprise portraits and masks. These themes are not chronologically sequential; they may occur simultaneously. However, it is likely that while the themes remain constant, the technique and style variables express a sequence. Hence, the three-dimensional sculptures, essentially unique and conceptual, dominate Olmec sculpture from the earliest times.

The relief forms and scenes replace them in the Late Olmec period.

The theme of "lords under supernatural protection" is established in sculptures like those from San Martín Pajapan (cat. 5) and the Monument 44 fragments conserved from La Venta. In both cases, a human face forms part of a wide, squared head, on which sits an elaborate, cube-shaped headdress depicting another face with fantastic features and large human dimensions.

In some of the reliefs carved directly in stone, such as Stelae 2 and 3 of La Venta, the principal personages at the center are defined and surrounded by a small group of supernatural images.

The same thematic idea is noted in "Altar" or "Throne" 4 of La Venta, where the supernatural being appears synthesized in symbolic linear designs. Other images exhibit similar subject matter, for example, the reliefs on Monument 19 of La Venta, in which the undulating body of a stylized serpent—symbol of the supernatural—at once encircles and protects a seated human figure who shows his priestly nature by the bag he carries in his right hand (cat. 17). Man, always the fundamental image, is represented with human features and characteristics—there is no distortion; the forms are, in their roundness and synthesis, anchored in a scheme of undeniable quality.

Other sculptures integrated within this group are unique human figures; they have been called "priests" or "mediators," because the features are exclusively human. Almost all are seated in a lotus or half-kneeling position. They lack individuality, which is indicated only by the vestment and headdress, as in Monument 77 of La Venta (cat. 10). Many examples that probably had a human head are now decapitated, for example, the "torsos" of Laguna de los Cerros and the sculpture now in the small museum at Potrero Nuevo. Some sculptures in this category, found outside of the principal sites, are masterpieces of Olmec art: Monument 1 of Cuauhtotolapan (fig. 1) and "The Prince" of Cruz del Milagro (cat. 7). Images of initiates or priests elected by those who adjudged them to have exceptional powers, these sculptures in their perfect calm and serenity express a transcendent and human mode of being. They indicate that the human condition can be altered by spiritual illumination.

The Twins

To date, there are three pairs of monumental sculptures of the Olmec twins: Monument 44 at La Venta and the sculpture from San Martín Pajapan (cat. 5); the "Atlases" of the "throne" or "altar" of Potrero Nuevo (cat. 3); and the majestic figures of El Azuzul. Each pair exhibits its own formal and iconographic identity. I would like to point out that the twins seem to stand guard, in particular, the pair that is sheltered in the small museum situated on a hill that rises over abundant running waters in southern Veracruz; it is known as El Azuzul. These two elegant, solemn,

and splendid carvings are exceptional among Olmec sculptures. Even though they are equal, there are certain details in the craftsmanship that make them different. At the risk of committing a perceptual error, I would say that the features of the twins are not precisely identical.

Three magnificent Olmec sculptures were found accidentally at El Azuzul, in the Tequistepec municipality, very near San Lorenzo Tenochtitlan. One of them is the great feline representation; the other two of interest here are similar monumental human figures. There is no doubt they are twins. These sculptures depict the same person or anthropomorphic concept and express the same governing principle of the beliefs of the peoples who inhabited Mesoamerica.

It seems that in Olmec sculpture, of both large and small dimensions, there are no other pieces equivalent to the twins of El Azuzul in their natural expression, perfect geometric structures, unequaled harmonious pattern, and precise carving. These sculptures present a deep artistic identity, grounded in the unique phenomenon of Mesoamerican art that is powerful, vigorous, and monumental; it is an undeniable manifestation.

The stone twins of El Azuzul are on their knees and leaning forward; they carry a carefully designed horizontal bar. They have the same attire and headdress, and show formal and iconographic similarities to other works, such as Monuments 52 of San Lorenzo and 30 of La Venta. Of undeniable Olmec creation, their style, defined as that of a local workshop, shows its synthetic forms, knowingly arranged in geometric structure, a quality that formally links them to the human representations of San Lorenzo, the torso of Laguna de los Cerros, and the statue of Cuauhtotolapan.

In spite of these typically Olmec features, they do not have the portrait quality one sees in the colossal heads, and are instead incorporated within the class of "mediators," that is, the "intermediators" between the powers of man and those that seek to dominate. Mediators escape a strictly rational explanation. No explicitly personal features are shown; they are, in fact, archetypical and symbolic faces that make concrete the beliefs of community life. For now, the El Azuzul twins are the most ancient monumental sculptures in Mesoamerica. They reveal that by the Middle Formative period the belief in a principal source in the conceptual reality and myth had been established: the supreme concept of duality.

The other "twin" figures to which I have alluded are the "Atlases" of the "altar" or "throne" of Potrero Nuevo (cat. 3), today found in the Museum of Anthropology at the University of Veracruz in Xalapa. They are small-proportioned figures, obese and large-headed—perhaps dwarfs—which show the body almost naked with a helmet encircling the head. If in appearance they are equal, their ornaments distinguish them. However, they show no intentional alteration, on a visual basis, of individual qualities or

particular expressions. They are, in summary, representations of a stylistic convention, in which they express, before all, the disposition of a world conception through human forms.

As for the other twin sculptures, one at San Martín Pajapan and the fragment of Monument 44 from La Venta, they are not basically human representations; they are anthropomorphic beings with magical and religious qualities, as seen from the superposition of the supernatural face and the headdress that encircles and protects it. Both sculptures express the same conceptual pattern of two opposed principles that are, at the same time, complementary. These principles order the cosmos and integrate into one. Life and death, feminine and masculine, day and night, good and evil are opposing natural phenomena for the same reason that they complement each other. Each of them, and many more, has an equivalent on the opposite side of the scales.

The twins of El Azuzul are, for Olmec times, the definitive expression of the dual and homocentric conception that permeated the beliefs of this people. But the twins, idea and myth, were born with the Olmec people and developed later in the complex belief systems of the Maya as well as the peoples of the Mexican highlands. The already famous twins of El Azuzul are a unique masterpiece making concrete this primordial concept in a representation of sensual human appearance.

Anthropomorphic twins are a cultural phenomenon of Mesoamerica, as demonstrated by two brief examples of the myths of the post-Olmec peoples. One concerns the Hero Twins of the Popol Vuh, the Maya version of human origins. This tale is primarily dedicated to the deeds of the twins: Hunapu, god of the hunt, and Ixbalanque, whose name means "small jaguar." The supernatural feats of the Hero Twins are always positive. They fight and conquer the imposter Vucub-Caquix and his sons, Zipacna and Cabraca, and in the ritual ballgame destroy the necrophilic beings of Xibalba, the terrible underworld. The Hero Twins were burned and through sacrifice returned to "eternal life," with the title of "those of the center"; one was converted into the Sun, and the other into the Moon.

A different version of the twins myth is known from the Nahua, another cultural nucleus of pre-Hispanic civilization in the highlands of Central Mexico. The Quetzalcoatl twins are known through tradition; the dual being is, at the same time, god-man, the legendary ruler of Tula, and the deified supernatural with the appearance of a plumed serpent. The myth deals with the sun, whose constancy makes it the twin of Venus (the planet which has visible daytime cycles), and the rest of the planets, which appear in the dying light of the sun. The dual quality of Quetzalcoatl is complex; his twin is Xolotl, he who inhabits the darkness of the underworld. Xolotl signifies at the same time twin and dog. However, the sun in its path through the underworld—when it is invisible—is represented by a jaguar, whose skin reproduces the starry sky.

There are many other similarities in universal mythology; all allude to common responses in similar cultural circumstances. The twins are feminine and masculine, day and night, sun and moon, light and darkness.

The Colossal Heads

The last thematic group is unique in the history of art: the colossal heads. Seventeen are known. Ten come from San Lorenzo, four from La Venta, and three others from Tres Zapotes and its surrounding area. It is almost certain that those found at San Lorenzo are the oldest; they are without doubt the most perfect. The remaining heads share equivalent themes, but there are notable stylistic variables. Looking at each separately, one notes the originality of the individual character, nobility, dignity, and skill in its execution.

The colossal heads represent the same racial type. Each one is distinct in the care and naturalness of the expression; the features are subtly different, and the designs and the symbols in the headdress and pendants they wear are varied. The differences in expression reveal the character and individuality of the model.

Various hypotheses have been proposed with respect to what they represent; the majority of the opinions identify them as portraits. Some suggest that they are individuals of a black race (Medellín Zenil 1960), warriors (Coe 1965b, Piña Chan and Covarrubias 1964), ballplayers who attest to decapitation sacrifices (Piña Chan and Covarrubias 1964), commemorative monuments to leaders who had died (Westheim 1963), or gods of vegetation (Coe 1972). They have also been considered idealized portraits (Kubler 1961) and, more recently, images of the rulers of jaguar dynasties (Coe 1972). I think they represent rulers, each with distinct traits and expressions. Given such a hierarchy, the rulers would have had attributes of religious and military character, in addition to commemorations.

In effect, I believe that the colossal heads are portraits in which the image represented is the image of a concept. The importance of the portrait is evident within the Mesoamerican world; the dynastic representation and the illustrious quality justified the aristocracy (Schele and Miller 1986; Schele and Freidel 1990, among others). It is fair to suppose that the Olmec people portrayed supreme leaders through their master artists. The portrait manifests a fundamental fact: man finds himself. He recognizes his essence and his modifications, and he expresses his awareness of the dimension that relates him to the world.

It is traditionally said that portraiture is, in the broadest sense, the representation of an individual, live or dead, real or imagined, through the interpretation of physical and moral features. Even when there are other concepts and definitions in a portrait, the image demands a substantial degree of resemblance to the model.

Such an idea perhaps does not arise with the desire to

preserve the appearance of a ruler, leader, or some principal member of the community, except as was sufficient to make explicit his importance with characteristic attributes and emblems. However, in time, I hope to particularize the image of the individual that would have been perpetuated in a material less destructible than the human. I believe that the images were those of powerful men recently deceased or those equally important who wanted, and with luck could have, presence of their physical appearance at moments of their greatest terrestrial and spiritual dominion. There was a fundamental interest in retaining the personal similarity and thus assuring the continuity of what the people thought was supernatural power.

It has been repeatedly stated that figurative Pre-Columbian art did not produce portraits. Such an assertion has been supported principally by the consideration that, in the art of ancient Mexico, as in all the original arts, the human image is a conventional depiction, which is realized only through capturing specific attributes or particular details. However, there are abundant examples to illustrate the intents and consequences of distinct dimensions depicting specific human figures. Hence, one recognizes within the schemes and conventions that men participated in a significant hierarchical situation in their community; their rank was indicated by the attributes they wore, not by their particular physical appearance. An example would be the "priest" or "mediator" figures in Olmec sculpture; there are also those in other artistic manifestations, principally Teotihuacan, Huastec, and

Mexica. Also, portrait figures frequently reproduce the natural model and express different states of feeling.

It is possible to record, among other Olmec works, the unequaled colossal heads, the sumptuous masks of Río Pesquero, as well as the figures of Xochipala, whose intention is to simulate the features and expression of a real physiognomy. Later, there were the many terra-cotta representations from the center of Veracruz, the stone reliefs and paintings of the Classic Maya world, and the Caxcatla murals. The figurative pre-Hispanic universe was opened up to the notion of the man-nature unity, thanks to the wisdom of the people who today, for lack of a better name, we call Olmec.

In summary, Mesoamerican figurative art (initiated as three-dimensional art by the Olmec), established two ways of presenting the human figure—I refer to the extremes since there are numerous intermediate dimensions—one was depersonalized and conventional; the other, individual and unique. The Olmec achieved an advanced civilization that maintained a close relationship with the world of nature, which one understood and explained through the specific knowledge of man.

NOTES
1. Mexica is another name used for the Aztec.
2. This flagstone relief sculpture depicts a small feline with huge circular plaques for eyes and a falling man between its jaws.
3. Now located in the small private museum at El Azuzul.
4. Today found outside of the Museum of Tenochtitlan, Veracruz.

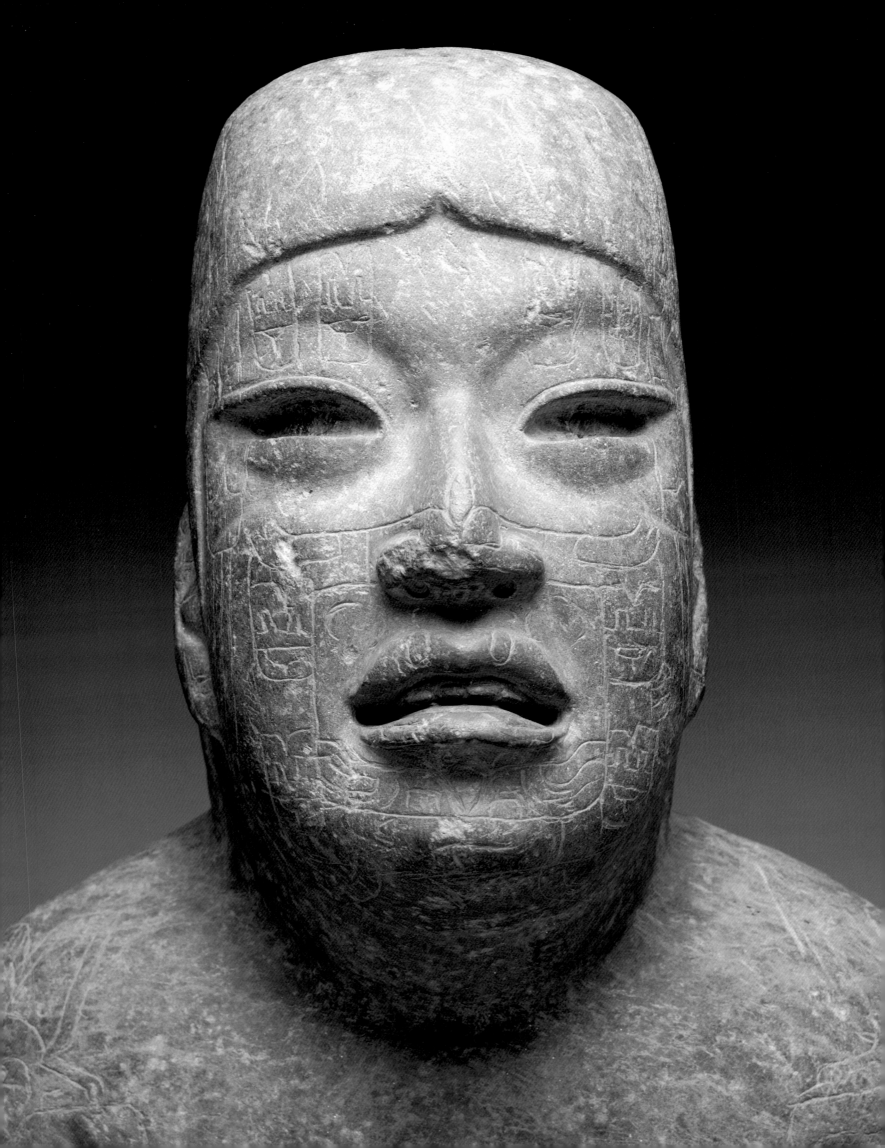

In Search of the Olmec Cosmos: Reconstructing the World View of Mexico's First Civilization

PETER DAVID JORALEMON

INTRODUCTION

José Melgar y Serrano's brief description of an Olmec colossal head, published in 1869, marks the beginning of the study of Mexico's most ancient sophisticated art tradition. More substantive research on Olmec art was published in 1929 by Marshall Saville, who in two articles on Mexican votive axes argued that they represent supernatural creatures who combine human and jaguar characteristics. He speculated that these beings relate to Tezcatlipoca, an Aztec jaguar god, the son of the creator couple and patron of sorcerers and magicians, who was closely linked to thunderstorms and to the stone axes that ancient Mexicans believed rained from the sky as physical manifestations of lightning. Later, Miguel Covarrubias, writing about Olmec style and iconography, became interested in a theory that Olmec human-jaguar beings, also called were-jaguars, represent the Olmec rain god. He believed that this divinity was central to Olmec religion and the direct ancestor of the rain gods who were so important in later Mesoamerican cultures.

In the 1960s, Ignacio Bernal, Román Piña Chan and Luis Covarrubias, and Michael Coe all published overviews of Olmec civilization. Of particular importance to the understanding of Olmec iconography was Coe's interpretation of the greenstone statue from Las Limas, Veracruz (cat. 9), in which he noted that each profile head incised on the shoulders and knees has distinctive iconographic attributes that represent a different Olmec god. His hypothesis argues that Olmec religion was polytheistic, that the Olmec world view was based on a philosophy of dualism, and that an ideological continuity linked Olmec gods with Aztec supernatural beings. This interpretation of the Las Limas Figure opened up new vistas in the study of Olmec symbolism.

Formal Qualities of Olmec Art and Iconography

Olmec art is defined by its formal qualities and its specific iconographic content. Representations tend to be self-contained and emblematic. Artists favored three-dimensional forms rendered in the round and finished on all sides. Formal, frontal poses predominate, although dynamic postures are sometimes used to great effect. Small-scale artwork is usually highly finished with ceramic objects burnished and jades and greenstones polished to a mirror shine. Iconographic information is often incised or carved on the surface of such objects, breaking up the polish and contrasting with the shiny finish. Sometimes the engraved lines are finely executed, but more often they are rather crudely rendered. Cinnabar and other red pigments were sometimes used to highlight the symbolic elements and make them more visible to the naked eye.

The human form is the focus of Olmec art. Figures are commonly depicted as well-fed infants, stocky adults, or wrinkled old people. Males and individuals of indeterminate gender predominate, although females are well represented in ceramic figurines. Olmec human representations typically have an infantile aspect with oversized, bald heads, soft fleshy features, and toothless gums. Emotions and psychological states are rarely depicted. Relatively few works of art show narrative scenes with interaction between figures or episodes arranged in sequence. Olmec sculptures often portray composite beings that are biologically impossible, mingling human traits with characteristics of various animals.

Olmec iconography is generally pictured in a symbolic shorthand made up of condensed or abbreviated forms and abstract motifs. Olmec artists frequently utilized the principle of *pars pro toto*, in which a part of an image rep-

resents the whole. For example, the jaguar dragon—paw-wing motif is composed of the head and feet of the Olmec dragon. Any element of this symbolic compound can signify the dragon. Some motifs occur individually in many iconographic contexts and may have quite general meanings (e.g., the cleft head, the St. Andrew's cross); others are frequently combined into glyphlike compounds with a more narrow distribution and a more specific meaning (e.g., four-dots-and-bar, crossed-bands, dotted bracket motif). Certain iconographic elements form clusters that identify particular supernatural creatures and human beings. The bird monster, for example, is designated by flame eyebrows, crescent eye, and recurved beak.

Symmetry is very important in Olmec art, especially in iconographic images incised or carved in low relief. Profile depictions are generated by vertically splitting a frontal image in half, or bisecting a frontal form along its horizontal axis. Bilateral symmetry is a key compositional technique used in many complex Olmec sculptures; attention is focused on the central figure by carving it in the round, in deep, almost three-dimensional relief, or by making it large and complex. Secondary elements are positioned in flanking pairs in low relief or simple abbreviated incisions. The central figure flanked by paired secondary elements occurs often, probably in relation to the four cardinal directions and the central axis.

Mesoamerican Religion

Mesoamerican societies shared many cultural traits, the most important of which was their common world view. Underlying all Mesoamerican thought was a sense of dualism coupled with the concept of the unity of opposites. Equally important was a deep-rooted belief in the cyclical nature of time and events, and the notion that the existence of humans, gods, and the universe itself is ultimately and irrevocably determined by fate.

The Mesoamerican world view included ideas about the creation of time and space, and the structure of the cosmos; the gods, spirits, and supernatural beings who rule the universe; and rulers, priests, and shamans who could communicate with the deities. It also emcompassed a rich body of ritual practices necessary to maintain the energy and harmony of the cosmos and propitiate the divinities. There were certainly regional and cultural variations of the Mesoamerican world view, as well as changes in concepts over time. Nevertheless, the system of thought and practice played a unifying role in the history of the region. Olmec artists were the first to formulate a comprehensive visual language to represent their beliefs about the cosmos.

Chronologically positioned between the era of egalitarian village cultures and the age of hierarchical urban societies, Olmec civilization had a world view that blended three distinct traditions of thought. Most ancient was the shamanistic ideology from the Early Hunters period (25,000–7000 B.C.). This ideology postulates that the cosmos is a multitiered world with the heavens above, the earth at the center, and the underworld below. Space was further defined by the cardinal directions and a fifth axis, up-down, at the center of the world. The directional template formed a structure for the universe and its inhabitants. Shamans were men and women called to a religious vocation centered on spiritual travel to different planes of the cosmos. Aided by animal familiars called nagual, into whose form a shaman could transform, these individuals visited other worlds to gain information about healing the sick, determining the cause of past events, and predicting the future. Spiritual travel was achieved in trance states induced by meditation, starvation, psychotropic drugs, or other ecstatic techniques.

A second set of beliefs important in Olmec ideology first developed during the Archaic and Early Formative periods (7000–1500 B.C.), when food crops like corn, beans, and squash became domesticated. Vastly enlarged food supplies, some of which could be stored for long periods of time, fostered population growth and enabled farmers to live in sedentary villages near their fields. New technologies, such as the grinding of stone tools and pottery making, further transformed the cultural landscape. Although shamanism continued to flourish, the primary concern of Archaic and Early Formative religion must have been the natural forces that made agriculture possible: sun, rain, and the fertility of soil and crops. Individual cultigens may well have had sacred qualities in the eyes of the farmers. In addition to agricultural rituals, the religious life of this period centered on sacred places such as springs, caves, and volcanoes. Temples with officiating priests must have appeared throughout Mesoamerica, and ritual human sacrifice is first documented in this period. Mortuary offerings and carefully prepared burials suggest an emerging cult of the dead and reverence for ancestors.

A third component of the Olmec world view crystallized in the middle of the second millennium before Christ, just before the dawn of Olmec civilization. These beliefs centered on the ruler and his role in society and the cosmos. As population swelled in the farming villages of the Early Formative period, new pressures undermined the established egalitarian social order. Differences in status and rank emerged and social stratification took hold in many regions. Within a few centuries, hierarchical societies led by powerful elite families ruled large farming populations in many parts of Mesoamerica. To separate themselves from commoners and to reinforce their legitimacy and right to rule, elite lineages claimed divine ancestry. At the top of this new social order was the ruler, who stood at the center of the world and possessed the power to communicate with the gods and ancestors and to mediate between the supernatural forces and the human community. He ruled with divine guidance and authority, protected by the ancestors and the gods. His right to rule entailed ritual obligations to propitiate the supernatural powers and

maintain the equilibrium of the cosmos.

At the center of the Olmec cosmos was the earth itself. Imagined as a mythological dragon, the earth floated on the primordial ocean. From the earth monster's fertile body sprouted a vast array of plants. The mountains that formed the creature's back were home to storm clouds with their lightning, thunder, and rain. The dragon's gaping mouth was the cavelike portal to the underworld. Above the earth was the celestial plane, realm of sun, moon, planets, and stars. The sky was ruled by the bird monster, probably the Olmec sun god, whose warmth and energy powered the cosmos and made plants grow. His daily transit of the heavens gave measure to time's most basic cycle. Beneath the earth dragon's floating body was the cosmic sea. Master of the underworld was the fish monster. The underworld was the land of the dead, dwelling place of the ancestors. It was also the place of emergence, where potent forces made their way into the realms of earth and sky. At the corners of the universe were atlantean figures who supported the architecture of the cosmos. Olmec belief probably included both earth-bearers and sky-bearers, as depicted on Potrero Nuevo Monument 2 (cat. 3).

In addition to the three vertical realms of the cosmos, horizontal space was divided into quadrants by the four cardinal directions. If later Mesoamerican thought is any guide, the directions were associated with different trees, birds, colors, gods, and units of time. A fifth up-down axis pierced the center of the earth. This direction was especially important, because all oppositions were resolved in the center. There the creative forces of the cosmos were focused and shamans, priests, and rulers could affect their spiritual travels.

On the earth itself were sacred places where gods were venerated and episodes in divine and human history were recalled. Olmec sacred geography included caves like Juxtlahuaca in Guerrero, springs like El Manatí in Veracruz, mountains like Cerro Delgado and Cerro Chalcatzingo at Chalcatzingo in Morelos, and volcanoes like San Martín Pajapan in Veracruz. Whether pilgrimage sites, places of sacrifice, or sanctuaries for initiation, they dotted the Olmec landscape with sanctified ground.

In Olmec thought it was essential to live and die in harmony with the cosmic powers. It was particularly critical that important sites be properly oriented in relation to the cardinal directions and constructed in accordance with the laws of symmetry. A north/south axis dominates the site plans of San Lorenzo, La Venta, and other Olmec centers. The orientation of a site not only determined the placement of architectural features like pyramids, platforms, and courtyards, it also affected the positioning of underground caches, offerings, and burials.

The cosmic order was maintained in a state of dynamic equilibrium by the balance of opposing forces. In Mesoamerican thought jaguars and serpents were the traditional symbols of opposition. That such a concept existed in Olmec times is suggested by the feline and serpent that confront each other in the Juxtlahuaca cave paintings. Mythical jaguars and snakes devouring human beings are depicted in Relief 4 and 5 at Chalcatzingo. Jaguar-serpent pairings are also shown in a Las Bocas effigy vessel now in the Australian National Gallery and Monument 1 from Los Soldados. The Aztecs believed that the history of the cosmos was the story of the eternal struggle between Tezcatlipoca, a jaguar god, and Quetzalcoatl, the feathered serpent. Perhaps a similar concept was central to Olmec religion.

The perpetual struggle between opposing forces is a fundamental tenet of the Olmec philosophy of dualism. However, Olmec belief also celebrated the unity of opposites. All unities consist of contrasting pairs. An extraordinary embodiment of this concept is a ceramic vessel from Santa Cruz, Morelos, in the shape of an old woman. Although aged and emaciated, she has an enormously pregnant belly and kneels in the traditional Mesoamerican birthing position. The artist skillfully contrasts the pregnant belly and skeletalized body, fertile womb and exhausted breasts, youthful fecundity and barrenness of old age, and in so doing illustrates the richness and depth of Olmec dualistic thought.

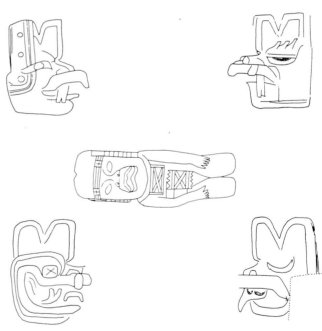

Fig. 1. Detail of incised designs on Las Limas Figure (cat. 9).

The Gods

The Las Limas Figure provides a key to the identification of five important Olmec supernatural beings (cat. 9). The statue depicts a seated young lord holding a mythological infant in his lap. The child has a cleft head with werejaguar features and a pudgy body. Incised motifs decorate the young lord's face, but the most important designs are engraved on the shoulders and legs. Each depicts a profile head with a V-shaped cleft in the top. The shoulder pro-

files depict the bird monster and banded-eye god; the legs are decorated with the dragon and fish monster.

Engraved on the left shoulder is a bird monster with flame eyebrows, derived from the crest of the harpy eagle, and a trough-shaped eye. The jutting beak curves down at the tip and an upper fang with cleft squared end hangs from the mouth. On the opposite shoulder is the banded-eye god, who has an almond-shaped eye with a rounded iris. Extending vertically from the top of the head is a spotted band that transects the eye and curves sharply around to the back of the head. The elongated upper jaw turns down at the tip. A cleft upper tooth extends across the lower lip. On the figure's right leg is the dragon's profile head. The lozenge-shaped eye has a crossed-bands motif. The creature's open mouth has a blunt end and a back that rises up in a gentle curve; within are a bracket-shaped tooth and bifid tongue. On the opposite leg is the fish monster's image. He has a crescent-shaped eye and a large upper jaw with squared-off tip. An enormous pointed tooth protrudes from the end of the upper jaw.

The cluster of iconographic attributes that distinguish each of the gods depicted on the Las Limas Figure appear on many other Olmec objects, sometimes fully elaborated, sometimes simplified and abstract. The repeated occurrence of these clustered motifs on works of art throughout Mesoamerica indicates that these mythological creatures were central to Olmec religion.

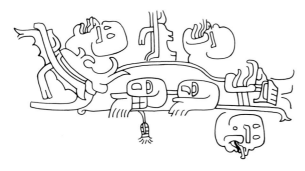

Fig. 2. Detail of incised design on Young Lord (cat. 50).

No other Olmec supernatural being is portrayed in such variable form or in so many materials and dimensions as the dragon. He appears throughout the Olmec world during the entire span of Olmec civilization. Previously discussed as the earth monster, lord of the middle realm of the cosmos, this hybrid combines attributes from several tropical forest predators: its primary aspect is based on the caiman; a secondary one is derived from a toad, probably the *Bufo marinus*. Traits of eagle, jaguar, and serpent are sometimes affixed to these core entities. The dragon's attributes include a massive head with flame eyebrows, L-shaped eyes, and bulbous nose. The elongated upper jaw is usually shaped like an ∟ in profile and a downturned ∪ in front view. Upper teeth are always prominent, depicted as fangs or ∪-shaped brackets. A bifid tongue occasionally protrudes from the mouth. The lower jaw is receding or

absent altogether. The earth monster's body generally has a crocodilian form, although toadlike shapes are not uncommon. Paw-wing motifs represent the creature's feet.

Similar to the dragon profile on the Las Limas Figure is the face incised on a jade mask from Río Pesquero (cat. 77) and the painted earth monster throne in Mural 1 at Oxtotitlan. Three-dimensional versions of the dragon are well documented: the La Venta Sarcophagus, Tlapacoya effigy vessel (cat. 29), and a jade sculpture from the Guennol Collection all depict the god in detail. The earth monster's head is a frequent subject in Olmec art, as in the San Lorenzo waterspout (cat. 14) and La Venta Altar 1. An incised and painted bowl from Tlapacoya (cat. 39) shows two views of the dragon's head. A blackware bowl from Tenenexpan has a frontal earth monster head flanked by paw-wing motifs, and a Tlatilco blackware bottle is decorated with a carved profile dragon head and a paw-wing symbol (cat. 36). Other works of art portray human figures wearing the earth monster's skin or mask. The Atlihuayan ceramic figure (cat. 23) wears the deity's pelt over the head and back. The jade votive axes from the National Museum of Anthropology (cat. 111) and the British Museum depict an anthropomorphic being wearing a dragon mask.

Because the earth monster is the earth itself, corn or other plants grow from his body. The La Venta sarcophagus, Chalcatzingo Relief 1 and the cave mouth (cat. 15), and the ceremonial bloodletter from Tabasco (cat. 104) are examples of the dragon's association with agricultural fertility and the abundance of the harvest.

The earth monster's open mouth was the portal to the underworld and the land of the ancestors. La Venta Throne 4, Chalcatzingo Relief 1, and a basalt monument from Ojo de Agua in Chiapas all show human or anthropomorphic figures either framed within or emerging from the dragon's open maw. The Chalcatzingo cave mouth originally functioned as a doorway, presumably leading into a space of utmost sanctity.

The importance of the dragon in the ideology of Olmec rulership is suggested by the god's function as a throne or support for the mighty and by his imagery on badges of office. Oxtotitlan Mural 1 depicts an Olmec dignitary seated on an earth monster throne. Monumental examples of dragon thrones have been found at San Lorenzo, La Venta, and Chalcatzingo. Earth monster images decorate the scepter that rulers display as a symbol of office. Such scepters are illustrated on La Venta Stela 2 and on the Young Lord from Guatemala (cat. 50). Only a few scepters have actually been excavated, and two of those are embellished with dragon heads.

A second supernatural creature engraved on the Las Limas Figure is the bird monster, sun god and lord of the celestial realm, who is strongly linked to the power and authority of the ruler. He has associations with corn and agricultural fertility, and connections to the mysterious dwarfs so frequently depicted in Olmec stone sculpture.

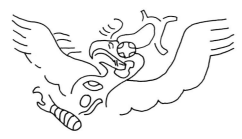

Fig. 3. Detail of incised design on obsidian core, La Venta Tomb C.

Primarily derived from the powerful harpy eagle, the bird monster sometimes has jaguar and reptilian characteristics, particularly fangs. It appears throughout the Olmec world during both Early and Middle Formative times, occasionally on monumental sculptures, rock carvings, and cave paintings, sometimes on ceramic vessels, and frequently on jade and serpentine masks, ornaments, and ritual implements.

A naturalistically rendered image of the creature is incised on an obsidian core found with other finely worked stone objects in the Cist Tomb at La Venta. Other full-figure representations of the avian being decorate a jade bloodletter from Veracruz (cat. 105) and a celt from Costa Rica (cat. 87). A blackware effigy bottle from Las Bocas has the shape of the deity's head, and a modeled cup from Xochipala shows a youthful Olmec human wearing a bird monster helmet. A painted *tecomate* from Las Bocas (cat. 33) has four descending profile bird heads around its neck. Central Highland blackware bottles and *tecomate*s are sometimes decorated with the avian god's footprint.

The bird monster's association with Olmec rulership is indicated by his frequent appearance on ruler's costumes and ornaments. The enthroned dignitary shown on Mural 1 at Oxtotitlan wears an avian costume that may represent the sky god. The creature's massive head has an erectile feather crest and recurved beak. His eye may once have contained an iron-ore mirror. La Venta Throne 4 portrays a muscular seated personage emerging from the dragon's open mouth and wearing a bird monster helmet embellished with mat motifs, representative of royal power. The powerful Olmec figure depicted on a rock carving from Xoc in Chiapas wears a bird monster mask across his face and talons on his feet. A related ruler incised on a jade celt in the Dallas Art Museum (cat. 118) wears an avian mask with Kan cross in the eye, a towering headdress, and an ankle-length cape. The Dumbarton Oaks jade dignitary from the Río Pesquero (cat. 52) has a richly detailed costume with at least nine bird monster profiles on the headdress and cape. Life-sized masks of the god carved in jade and serpentine have been found in Veracruz and Guatemala. Bird monster heads decorate elegant jade earplugs, pendants, mirrors, spoons, and bloodletters throughout Mesoamerica.

The bird monster is sometimes shown as an anthropomorph with avian head and human body in a slightly crouched position. The human form is usually short and stocky, suggesting the proportions of a dwarf. The celestial deity has close associations with maize and with the chinless dwarfs often represented in Olmec stone sculpture from the Gulf Coast. An extraordinary brownstone dwarf has a pair of crisply carved avian profile heads framing its eyes and a sack full of corncobs slung across its back; another wears a bird monster helmet. The sky god often has a prominent feather plume or crest running down the center of the head, deep trough-shaped eyes, and a beak with downcurved tip. Such statues have been found in Mexico, Guatemala, and El Salvador. They may depict shamanic transformation figures or masked mythological beings.

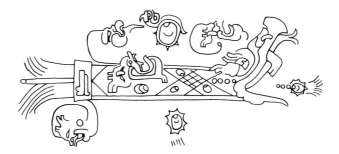

Fig. 4. Detail of incised design on Young Lord (cat. 50).

Incised on the left leg of the Las Limas Figure is the profile head of the fish monster. Based on the great white shark and sometimes bearing attributes of other creatures, this god is the ruler of the sea and the lord of the underworld and land of the dead. His traits include a large, crescent-shaped eye, an elongated upper jaw with blunt end and prominent pointed teeth, and a receding or absent lower jaw. The teeth are sometimes shown with serrated edges typical of shark teeth. In front they are usually slightly curved or triangular, and the back teeth have the curved form of a comma. Olmec artists portrayed the sea god in Early and Middle Formative times. Although uncommon, his images are found on Central Mexican ceramic vessels, a Gulf Coast monument, and small-scale jade and serpentine sculptures from Mexico and Guatemala. His position in the iconographic program of the Las Limas Figure and the Young Lord from Guatemala mark him as an important Olmec supernatural.

The most complete representation of the fish monster is carved on Monument 58 from San Lorenzo (cat. 16). Closely related to the Las Limas profile, the relief shows the marine beast with an impressive set of pointed upper teeth and an elongated body with dorsal fin and bifid tail. A crossed-bands motif appears in the middle of the body. The fish monsters carved on a blackware bottle from Las Bocas (cat. 37) and incised on the leg of the Young Lord from Guatemala are not as naturally rendered, but they display the same diagnostic traits as on the San Lorenzo monument.

Fig. 5. Rollout of design on ceramic bowl, Tlapacoya.

The banded-eye god is the fourth supernatural being incised on the Las Limas Figure and the most enigmatic. His diagnostic attributes include almond-shaped eyes with round iris, a band running across the face and transecting the eye, and an open mouth with elongated upper lip, toothless gums, and downturned corners. Strangely enough, the deity is known only in profile renderings. Although depicted in both Early and Middle Formative times, his images are rare and generally concentrated on Early Formative incised ceramic bowls from the Central Mexican Highlands, particularly Tlapacoya. No representations of the deity's body have yet been discovered, so little can be said about the banded-eye god's identity or place in the Olmec cosmos.

Two occurrences of the divinity's profile head on stone sculptures are especially intriguing. On the Young Lord from Guatemala, he is attached to the hindquarters of the fish monster. Other evidence also suggests a close association with the sea god. On the jade plaque from the National Museum of Anthropology (cat. 90), the finely carved human head has attributes of the banded-eye god, but the profile head of the deity is joined to the human figure's forehead. In this variation, the creature has three pendant dot motifs on top of the head, perhaps to symbolize rain.

Fig. 6. Carved fragment of a serpentine vessel, Veracruz.

The fifth Olmec divinity portrayed on the Las Limas Figure, and the only one shown in full three-dimensional form, is the supernatural infant held in the lap of the seated lord. He represents the Olmec god of rain and storms. He has close associations with domesticated plants, particularly corn, and agricultural fertility. His worship may have involved the sacrifice of human infants. The deity is based on the were-jaguar features and a pudgy, sexless body with stocky proportions. However, his

most distinctive characteristics are specific items of costume and ornaments. Particularly important is a striated headband decorated with a pair of well-spaced identical ornaments, often raised bosses. Attached to the headband are long rectangular pleated elements that either just cover or extend in front of the ears. The god often wears a rectangular pectoral and loincloth decorated with the crossed-bands symbol. The rain deity is represented in monumental sculpture and on small objects of jade, serpentine, and other greenstones. His image is strangely absent from Olmec ceramics. Found in every part of the Olmec world, throughout the long span of Olmec civilization, his image was especially common during the Middle Formative period.

The most interesting large-scale sculpture of the rain god is Monument 52 from San Lorenzo (cat. 12), where the creature sits upright with flexed legs held close to the body. The massive head has a cleft top, were-jaguar features, and the deity's diagnostic headband assemblage. Carved on the forehead are two downturned trident motifs, which may be water symbols. A rectangular pectoral with crossed-bands is worn around the neck. A trough-shaped channel extends down the back of the monument. The carving was once part of San Lorenzo's remarkable system of lagunas and stone conduits that carried water from the surface of the plateau to its base. Monument 52's function reinforces the god's association with water.

Several finely carved jades also depict the full figure of the storm god. In the Brooklyn Museum is a standing Olmec figure holding a pudgy, sexless image of the rain god vertically against his headband and ear coverings (cat. 48). A jade from Río Pesquero portrays a rain divinity with rigid body and wide-open eyes, wearing the usual headgear, lying on the back of a naturalistically rendered jaguar, and grasping the animal's tail firmly in both hands. A third jade statue of a stooped figure, dressed in the storm god's headband, pectoral, and loincloth, carries a woven pack containing a large corncob on his back (cat. 74).

Other monumental sculptures and small-scale stone figures and votive axes depict the rain god with were-jaguar face and typical regalia, but with an anthropomorphic body. Occasionally Olmec artists showed dignitaries with naturalistically modeled faces wearing the storm god's headgear, pectoral, and loincloth. Such figures have been found at La Venta (cat. 10) and El Azuzul.

The presentation of the rain god infant in the lap of the Las Limas Figure with other Olmec supernaturals looking on raises questions about whether other Olmec monuments, reliefs, and small-scale stone sculptures also show the offering of the were-jaguar infant. In some examples the baby is damaged beyond recognition, and in other cases the child is rendered as an abstract symbol. La Venta Throne 5 portrays a muscular Olmec figure emerging from a dragon mouth, holding a battered infant in the lap. The ruler wears a conical hat with a headband decorated with

a were-jaguar maskette topped with three raindrop motifs. Unfortunately, the infant figure is badly damaged. On the sides of the throne are pairs of Olmec men struggling with very lively were-jaguar babies. Relief 1 at Chalcatzingo shows a figure seated within the earth monster's mouth wearing an elaborate feathered costume with raindrops and presenting a ceremonial bar in the lap. Around the relief are thunder clouds, sheets of rain, raindrop symbols, and corn plants, all images that celebrate the fertilizing power of the rains. A small stone statue in the Metropolitan Museum of Art depicts a figure seated on a cloud throne and holding a rigid baby (cat. 53). These sculptures and others likely portray the same mythic event as on the Las Limas Figure. Could the seated ruler be presenting an infant storm god brought from the interior of the earth? Or could the baby be a human sacrifice sacred to the rain god? Whether dead or alive, deity or offering, the presentation of the supernatural infant is accompanied by symbols of the rains that ensure an abundant harvest.

Five major supernatural beings are depicted on the Las Limas Figure; other deities are represented elsewhere in Olmec art. In particular, the corn god, were-jaguar, and feathered serpent played significant roles in Olmec religious life.

Fig. 8. Incised designs on two jade celts from Río Pesquero, Verzcruz.

Fig. 7. Detail of jade figure from Río Pesquero, Verzcruz (cat. 52).

The Olmec corn god is closely related to the rain god held in the arms of the Las Limas Figure. Both have were-jaguar features, and sometimes the corn god wears the rain deity's pleated ear decorations. The maize god is easily identified by the vegetation symbols sprouting from the cleft in his head. They range from simple germinating seed motifs, to ears of maize flanked by drooping leaves, to entire plants with abstract corncobs. He also has diagnostic headgear: a headband with round or square elements at the center, often with sprouting designs, flanked by two pairs of identical celt-shaped motifs symbolizing ears of corn. In more elaborate representations the celt forms are replaced by cleft rectangles or torch symbols, both of which refer to corn and agricultural abundance.

The corn deity is closely linked to the iconography of rulership. Royal figures often wear the divinity's distinctive headgear, displaying his sprouting head at the top of elaborate headdresses. Such symbols of authority as torches, "knuckle-dusters," and bundles are often embellished with corn god attributes. The ruler is responsible for the fertility of the earth and the abundance of the harvest, so his connections with the maize deity are strong.

Most commonly depicted on Middle Formative small stone carvings, particularly jade and serpentine celts, the corn god rarely appears in monumental sculpture and is never represented in ceramic art. There is a clear correlation between maize deity imagery and stone axe blades. It is likely that jade celts were symbolic ears of corn in Olmec iconography. Their elongated shape, green color, and preciousness would have enhanced the metaphoric identification with corncobs. An elaborately incised axe blade from Las Bocas depicts three celts, each with vegetation emerging from the top.

A second key supernatural being, not pictured on the Las Limas Figure, is the enigmatic were-jaguar. Portrayed

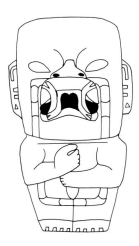

Fig. 9. Jade votive axe, southern Veracruz or Tabasco (cat. 110).

on monumental sculpture and small stone figures and masks, the deity combines characteristics of human infant and jaguar. His head usually has soft fleshy contours and a squarish outline with a cleft in the top. Slanted almond eyes with incised irises are set in swollen sockets. The mouth has a large flared upper lip and downturned corners. The gums are often toothless, although some examples have large fangs with bifurcated tips. Rectangular flanges mark the ears. The creature never wears a headband, headdress, or other defining attributes. He is easily recognizable from his features alone. The were-jaguar god's powerfully modeled head is the central element in the headdress worn by the crouching figure from San Martín Pajapan (cat. 5). He is beautifully rendered in jade on the Kunz Axe from the American Museum of Natural History (cat. 110) and the jade mask at Dumbarton Oaks (cat. 82). From Río Pesquero come two life-sized masks and figures representing the god.

Matthew Stirling suggested that the Olmec were-jaguar might be the offspring of a mythic marriage between a human being and a jaguar, depicted on several battered volcanic stone monuments from Potrero Nuevo and elsewhere in the Gulf Coast lowlands. Scholars still debate Stirling's reading of the damaged monumental sculptures. However, a cave painting from Oxtotitlan, Guerrero, clearly shows a sexual relationship between a jaguar and an Olmec male with erect phallus. Whether the sacred union of human and feline was an origin myth for a certain lineage, clan, or people or a legend about the birth of a deity, it provides a reasonable explanation for the most mysterious images in Olmec art.

Fig. 10. Relief 5, Chalcatzingo, Morelos.

Finally, the feathered serpent is a divinity of considerable significance in Olmec civilization. Depicted on monumental sculpture, rock carvings, cave paintings, ceramic vessels, and stone statues, the deity is the ancestor of the plumed serpent who appears throughout Mesoamerican history in different guises. In Olmec art the reptilian god is generally portrayed as a rattlesnake with thick powerful body shown coiled or undulating. He is sometimes covered with feather motifs. On top of the skull is a feather crest; a multilobed winglike element appears at the back of the head. The feathered serpent is often depicted in close association with human figures. La Venta Monument 19 shows a seated personage, probably a priest holding an incense bag, framed within the body of the snake god (cat.

17). Small sculptures from Guerrero and the highlands of Guatemala (cat. 72) depict the deity with coiled body and open jaws framing a face with human features. Relief 5 from Chalcatzingo shows a feathered serpent devouring a sprawling human form. Later, the feathered serpent became known as Quetzalcoatl, one of the most important Mesoamerican gods. A creator deity, he was lord of life and a generous benefactor of mankind. He made the human race from the bones of the ancestors vitalized with blood from his own body. He obtained corn to plant in the fields and taught men how to make works of art. He was closely associated with priests and their sacred writings. He taught the science of measuring time and using numbers. The feathered serpent was also the lord of the wind and the god of the planet Venus.

Certain Olmec gods seem to form iconographic pairs. The designs incised on the Young Lord, for example, show the bird monster emerging from the hindquarters of the dragon, while the banded-eye god is embedded in the back of the fish monster. Other evidence suggests that the rain god and the maize deity form a third pair. Although the supernatural creatures within each pairing are clearly recognizable, they sometimes share motifs with the other member of the dyad. For example, flame eyebrows appear on both dragon and bird monster images. Pleated ear decorations are worn by both the rain deity and the corn god. The deities clearly linked on the Young Lord are depicted as separate entities on the Las Limas Figure. The meaning of these god pairs is elusive. Mesoamerican thought is essentially dualistic, and twins and pairs of supernatural beings play an important role.

Olmec religion may have been centered on the supernatural beings described above, but other animal forms also played a role. Generally rendered in naturalistic fashion, these representations include hummingbirds, ducks, parrots, pelicans, monkeys, jaguars, rabbits, turtles, snakes, toads, frogs, scorpions, and fish. They often have an immediacy and appeal missing from the more mythological creatures. Nevertheless, Olmec artists did not depict all the animals in their environment, and it must be assumed that every being they did represent had a special quality or feature that made it magical or sacred.

Olmec artists also had a fascination with dwarfs and hunchbacks. Such human forms are often portrayed in art from west Mexico and the Maya area, but Olmec representations have a special intensity. Dwarfs and hunchbacks must have been credited with magical abilities and spiritual powers. They may have been more frequently born into families of artists than into the general population. Olmec ceramicists and lapidaries used cinnabar—mercuric sulfide—to enhance their work and sanctify it before burial in graves and offerings. Mercuric sulfide may cause birth defects and abnormalities in certain doses, and Olmec artists were exposed to this ore, often in easily ingested powdered form, throughout their lives. Olmec

dwarfs range from fetal beings to chinless characters, with swollen cheeks and large feet, to animated beings with oversized hands. Dwarfs who bear iconographic designs are associated with the bird monster and maize symbolism. Some wear helmets or carved motifs on head and body. Although they come in all dimensions from monumental figures carved in basalt to tiny jade amulets, they are almost never represented in ceramic. Miguel Covarrubias believed that they might be related to the mischievous *chaneques* known among indigenous peoples in Veracruz and Guerrero. Hunchbacks are more rarely depicted in Olmec art and more standardized in form. They are usually portrayed in a standing pose with tall shaved heads and sometimes a chin beard, chicken chests, and tightly flexed arms held close to the torso. A large rounded hump protrudes from the top of the back. Usually carved in serpentine or jade, only a few ceramic examples are known. Many Olmec hunchbacks come from Guerrero.

Central to Olmec religious life were the shamans and priests who understood the supernatural dimension of the universe and knew the rituals necessary to propitiate the gods. Shamans had close bonds to naguals or animal familiars. Through trance techniques and hallucinogenic drugs, shamans were able to transform themselves into their animal companions and in this altered state travel through the cosmos and interact with the spirit world. A small number of Olmec sculptures portray shamans at various stages of the transformation process. Generally small-scale sculptures carved in dark-colored jade and serpentine, some depict the shaman in a kneeling position, alert and awaiting the start of the process (cat. 68). Others show the shaman midway through the crossover with features of jaguar and human mingled in his body (cat. 69). A few portray the climax of the shaman's journey when his transformation into a jaguar is complete (cats. 70–71). Though small in scale, these sculptures are among the most powerful and dynamic images in Olmec art.

Unlike shamans, Olmec priests were not specialists in animal transformation or spiritual travel. Instead, they were men and women devoted to the worship of particular gods. Cult leaders, temple guardians, and ritual experts, priests conducted the prayers, sacrifices, and ritual performances necessary to commemorate events in the lives of the gods and propitiate them with offerings to obtain their blessings on human beings and their enterprises. Identifying priests in Olmec art is difficult. Many of the images depicting humans wearing deity masks or helmets may represent priests impersonating gods for ritual purposes. Ceremonial objects like bloodletters, spoons, and mirrors may have been just as important in priestly activities as royal ceremonies. The human sacrifice depicted on Chalcatzingo Relief 2 is enacted by three men in deity costumes who may be priests. A polychrome painting deep inside Juxtlahuaca cave probably depicts an initiation ceremony carried out by an officiating priest.

CONCLUSION

Although decoding Olmec iconography reveals much about the individual elements that make up the belief system of Mesoamerica's first civilization, it is difficult to reconstruct the narratives and legends that give broader meaning to the symbolic images. Tantalizing hints of lost mythic cycles are found in the Chalcatzingo reliefs, the El Azuzul tableau, the La Venta figurine cache (cat. 42), and other works. Nevertheless, Olmec art generally emphasizes images that are iconic and emblematic, rather than narrative. Scholars speculate about the stories that were central to the Olmec world view, but only the broad outlines of such legends can be recovered from the existing data.

Although earlier religious traditions were incorporated into the Olmec world view and other ideas borrowed from the contemporary societies, Olmec artists were the first Mesoamericans to develop a sophisticated symbolic language to communicate their vision of the cosmos and to create lasting images of the supernatural beings who ruled their world. The boldness of their rendering, the confidence in their use of materials, the daring to do that which had not been done before allowed the Olmec artists to create works with a power and dynamism that is unmatched in the ancient Americas.

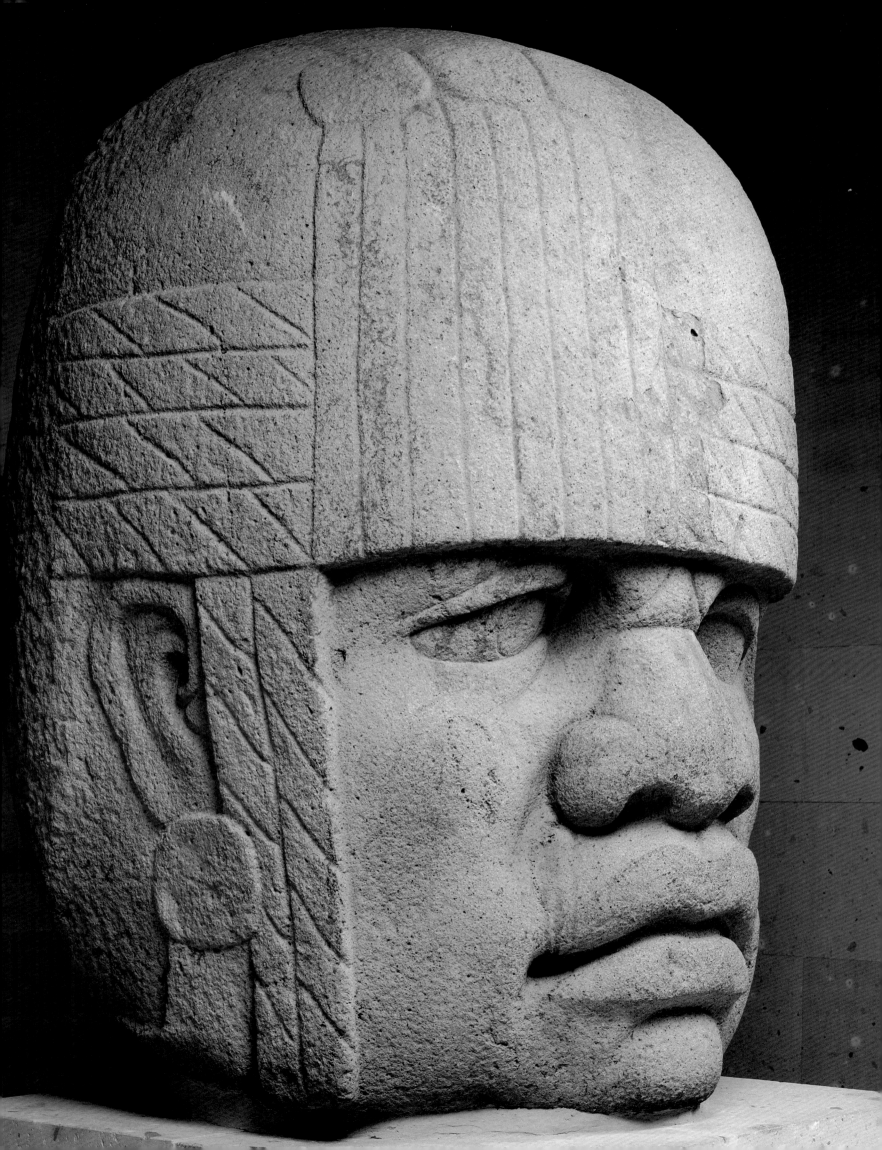

Reconstructing Olmec Life at San Lorenzo

ANN CYPHERS

INTRODUCTION

Over a period of thousands of years, the earliest inhabitants of Mesoamerica gradually developed plant domestication, agricultural practices, and sedentary life. During the second millennium B.C., these early egalitarian societies became larger and more stratified. By 1200 B.C., a distinct and increasingly complex civilization began to emerge along the Gulf Coast of what is now the Mexican state of Veracruz: the Olmec.

The Olmec lived in the tropical lowlands, along the coastal plain of Veracruz and Tabasco, sometimes called the Olmec heartland (fig. 1). The exuberance and fertility of the environment facilitated key aspects of life, and the culture achieved a strong regional integration and marked cultural pattern. Although other areas of Mesoamerica may show Olmec influence, none of these is characterized by the constellation of cultural traits that define the Olmec heartland.

Olmec culture was originally defined by its art, and even today sites with monumental or portable sculpture in that style are often identified as Olmec. The Olmec style is distinctive in its sculptural technique and concepts, the most notable being the colossal heads, monolithic thrones, and fantastic representations of animals and humans. Nevertheless, the Olmec cultural pattern possesses additional characteristics now under study: the shape, location, and layout of settlements; public and private architecture; the scale and application of particular technologies; and patterns of regional and long-distance trade.

The Olmec was not the first culture to develop in Mesoamerica. The Soconusco region, on the Pacific Coast, shows significant cultural developments before 1500 B.C. (Clark 1994), but it never achieved the complexity of the Olmec. Alfonso Caso (1965), Miguel Covarrubias (1957), Matthew Stirling (1968), and Michael Coe (1965c) once proposed the Olmec as the "mother culture"; although not the earliest culture, it is America's first civilization (Coe 1968). The Olmec established a number of traits of the Mesoamerican cultural tradition, which are found in virtually all ancient Mesoamerican societies. Some scholars have proposed that the Olmec were not as highly devel-oped as once thought and that other societies achieved a similar degree of development (Grove 1989b; Demarest 1989; Hammond 1988). Instead of mother culture, these scholars speak of contemporaneous sister cultures, a Complex X, or "a complex lattice of interaction...with multiple centers of cultural innovation," and assume the existence of cultures of a similar developmental level in Early Formative Mesoamerica. Recent research by the San Lorenzo Tenochtitlan Archaeological Project shows that the scale and degree of development at San Lorenzo during the Early Formative period far surpasses all other contemporaneous sites. Thus, scholars such as Caso, Covarrubias, Stirling, Bernal, and Coe, among others, were correct in their initial evaluation of the Olmec heartland as the focus of the earliest and most complex Formative culture. San Lorenzo, the first regional center to develop in the heartland, should be recognized as the premier Olmec center of the Early Formative period.

THE PHYSICAL SETTING

San Lorenzo is located in the municipality of Texistepec in Veracruz, a territory included within the lower Coatzacoalcos River drainage. The lower reaches of the Coatzacoalcos River flow through a broad, low plain that has many characteristics of a delta. The waters feeding the system originate in the Sierra Atravesada and its tributaries. This drainage, the only completely tropical river system in modern Mexico, defines the widest part of the gulf coastal plain at approximately 60 kilometers. As it emerges onto the plain, where it has frequently migrated, the river achieves the classic pattern of meanders characterized by a constantly changing hydrology. Today the lower Coatzacoalcos River drainage is a plain with a complex pattern of ancient and recent oxbow lakes and meanders.

Within the plain, ancient geologic terraces dating from the Miocene period emerge as high ground between 40 and 80 meters above sea level. Now, as in the past, people seek out the high ground for permanent habitation. San Lorenzo, for example, is located in the highest area in the

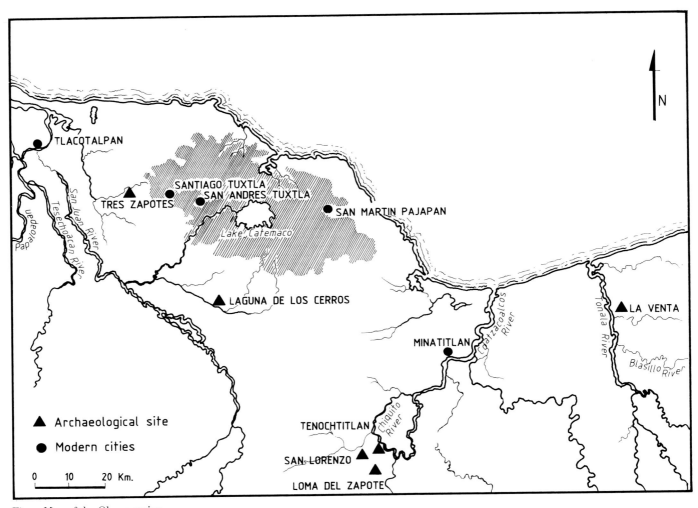

Fig. 1. Map of the Olmec region.

study region and is always safe from flooding. Some 60 kilometers to the northwest, the majestic volcanic mountains of Santa Marta and San Martín maintain a lofty vigil of the zone from the Tuxtlas, and Tres Picos looms to the south. Closer to San Lorenzo, the two highest points, once sacred to the Olmec, are the salt domes of Cerro El Mixe and the Cerro El Manatí.

In ancient times, high tropical jungle covered the region like a canopy. The Olmec preference for hard, well-polished axes reflects the challenge presented by their environment; to plant crops, the jungle had to be constantly cut down and pared back. Thirty-five years ago the jungle still existed, but now it has virtually disappeared, having been replaced with vast grasslands and agricultural fields. Deforestation and the effects of cattle-ranching, industry, and agriculture have totally altered the landscape.

The study of the regional geomorphology conducted by Mario Arturo Ortiz reveals new aspects of the environment around San Lorenzo (Ortiz and Cyphers, in press). Ortiz has defined a sequence of alluvial changes caused by the emergence of salt structures and by regional tectonics. Erosion, sedimentation, and subsidence have also contributed to the changes in the terrain.

These new data indicate that, during the Formative period, San Lorenzo was surrounded by two branches of the ancient Coatzacoalcos River, no longer active. One of these coincides with the Tatagapa River, to the west of San Lorenzo. The other channel, the Potrero Nuevo-Azuzul, passed close to the site on the east at the foot of the elevated lands; however, this channel does not coincide with the present course of the Chiquito River, which may be more recent. The bifurcation of the river created two confluences, the southern one at the Las Camelias pass, and another to the north of Tenochtitlan (fig. 2). In both confluences important Early Formative settlements (with monumental stone art), such as El Remolino and Loma del Zapote, are located. In addition, other confluences uniting with the Tatagapa on the west can be identified. These river courses have been dramatically altered due to the uplift of the volcanic mass of the Tuxtlas (Herrera 1978), known to have been active during the Early and Middle Formative (Drucker 1943; Santley 1992: 155; Byrne and Horn 1989). Major changes in drainage patterns since the Early Formative period have been recently detected by Ortiz and suggest that sites such as Tres Zapotes and Laguna de los Cerros may have been connected to the lower

Coatzacoalcos drainage by fluvial courses.

In a sense, the high ground of San Lorenzo was an island, similar to La Venta in Tabasco. It occupied a privileged place on high land in the lower Coatzacoalcos River drainage, where it dominated two or more river confluences, a strategic position for controlling communications, transportation, and trade. This geographic position afforded ideal opportunities for growth and development.

In the dry season when water levels were low, the main routes were the permanent rivers; in wetter months, the fluvial network expanded to include other channels swelled to form an elaborate web of communication and transportation routes, and uplands to the south were connected to the lower plain.

An understanding of the environment is key to understanding the Olmec way of life. From subsistence adaptations to settlement patterns, the Olmec were meticulous observers of the natural landscape, a talent that fostered their survival and progress.

ARCHAEOLOGICAL INVESTIGATIONS AT SAN LORENZO

The first scientific report of San Lorenzo was by Matthew Stirling, pioneer of Olmec archaeology, who was taken by friends to a new site with great stone monuments (1947; 1955). Stirling's visit culminated in the formulation of a research project in 1945 and 1946, sponsored by The National Geographic Society and the Smithsonian Institution. The principal goal of the project was to discover new stone monuments to obtain more information on the Olmec culture and place it chronologically in relation to that of the Maya. While Stirling was in the field at San Lorenzo, other scholars were hotly debating the contemporaneity of San Lorenzo, La Venta, and Tres Zapotes to the Classic period Maya.

Stirling, with his wife, Philip Drucker, and Richard Stewart, built an archaeological field camp at the site and dedicated much time to inspecting the area. They found the largest Olmec colossal head, El Rey, quite near their camp. Trenches were dug in mound structures in the central area of the site; Stirling had been highly successful at La Venta in finding a center-line axis with many offerings, so he expected to find something similar at San Lorenzo. In this respect he must have been disappointed, however, because San Lorenzo did not follow the architectural pattern of La Venta.

On the basis of his work at San Lorenzo, Stirling proposed a number of theories about the Olmec, many of which remain controversial. He defined the three sites of San Lorenzo, Tenochtitlan, and Potrero Nuevo as San Lorenzo Tenochtitlan, because the boundaries between them were difficult to define. San Lorenzo stood out to him as the principal occupation because of the large number of monuments found there. His perception of the environment and geography was exceptionally accurate, despite the fact that detailed maps were nonexistent. It is clear from his reports that he traveled most of the terrain and was thus able to understand the lay of the land and the seasonal changes affecting it. For example, he conjectured that in ancient times the river passed closer to San Lorenzo than it does today. He noted the peninsula where

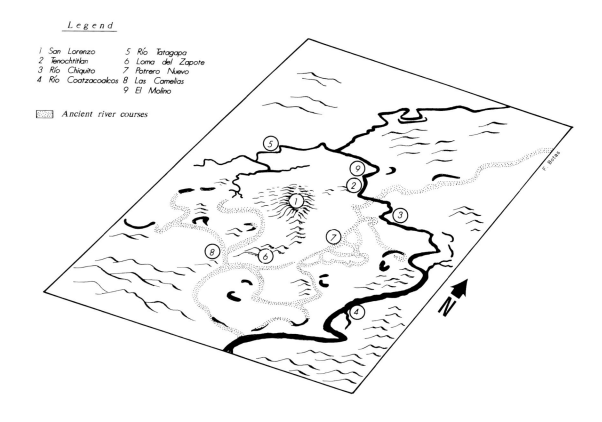

Legend

1 San Lorenzo
2 Tenochtitlan
3 Río Chiquito
4 Río Coatzacoalcos
5 Río Tatagapa
6 Loma del Zapote
7 Potrero Nuevo
8 Las Camelias
9 El Molino

▨ Ancient river courses

Fig. 2. Map reconstructing the ancient landscape around San Lorenzo.

Potrero Nuevo is located, with its numerous low mounds that rise above floodwater in times of heavy rainfall. His reports deal mostly with the discovery of stone monuments and reporting accurately their location and description. Later, Coe reconstructed his excavations on the basis of his field notes (Coe and Diehl 1980).

The twenty-two monuments, including colossal heads, altars, and sculptures in the round, provided new data for Stirling's theories. He was the first to propose that the colossal heads were portraits of prominent individuals, thus setting the stage for later interpretations of rulership. He also observed that the majority of representations in Olmec art were of humans and anthropomorphic beings, and noted the prevalence of the jaguar and jaguarlike beings along with snakes, eagles, and the stingray. His interpretation of Monument 1 from Tenochtitlan and Monument 3 from Potrero Nuevo as copulation scenes were widely accepted at one time (see Davis 1978). The copulation of a woman and a jaguar, according to Stirling, resulted in the birth of strange beings, often babies, that show a combination of jaguar and human features.

In his survey of San Lorenzo, Stirling noted that many monuments were found in ravines and supposed that these had been deliberately cast there by later peoples (1955: 9), a theme later developed by Coe and Richard Diehl (1980: I, 188) as a great destruction caused by Nacaste-phase peoples. Stirling's explorations formed the basis for all later investigations at San Lorenzo.

Almost twenty years after Stirling, Coe proposed the Río Chiquito Project, 1966–1968, which was designed to investigate more fully the site. Coe's contributions to the archaeology of San Lorenzo are numerous and varied. Not only did he conduct an extensive program of excavation that permitted him to develop the first well-founded chronological sequence for the site, but also, with the aid of Ray Krotser, he was able to map the heights of San Lorenzo. This resulted in the first detailed topographic map of a major Olmec center, and it continues to be the base map of the site used today. The Río Chiquito Project included the application of new technology to archaeological studies. Among these, the use of a cesium magnetometer to locate stone monuments stands out as a pioneering application of remote-sensing techniques to the Olmec heartland (Breiner and Coe 1972). Using this technique, seventeen stone monuments were added to the corpus of Olmec sculpture. An intensive program of aerial photography covering 77 square kilometers around San Lorenzo resulted in detailed topographic, soil, vegetation, and land-use maps. The final publication of the Río Chiquito Project provides a detailed catalogue of monuments, most of which are keyed into their original locations on the topographic map. Detailed cross-section maps of the excavations and meticulous descriptions of the stratigraphy and features encountered during excavation provide an excellent site report.

Coe and Diehl offer insights and interpretations in the final publication on the major issues pertaining to San Lorenzo. The earliest manifestation of occupation at San Lorenzo appeared during the Ojochi phase, 1500–1350 B.C., and the stratigraphic and chronological sequences indicate that Olmec culture developed in the Gulf Coast lowlands. San Lorenzo is interpreted as a highly developed society, at least a chiefdom-level organization, and may have even attained statehood. The leadership, represented in the colossal heads, was secular, not religious, and power resided in a hereditary lineage or dynasty (Coe 1972). The sociopolitical organization necessary to obtain and transport the large stones for the monuments required a highly efficient and strong centralized organization. Coe and Diehl propose that the Olmec lords gained control of the river levee lands, where highly productive grain crops insured a surplus production used to underwrite craft specialization and trade. The rulers' economic power was based on the control and distribution of scarce resources. Basalt, greenstone, hematite, magnetite, ilmenite, and obsidian were traded, and specialized craft activities were conducted at the site. The Olmec of San Lorenzo are portrayed as warlike due to the presence of cannibalized remains and other evidence in their art.

With regard to the stone sculptures, Coe and Diehl propose that monuments were deliberately mutilated, laid out in lines, and covered up by the Olmec themselves. Areas such as Group D were considered the preferred dumping grounds for monuments at the time of the great destruction of the site around 900 B.C. (Coe and Diehl 1980: II, 152).

The site map provides information about the extent and configuration of San Lorenzo. The large and deep ravines that dissect the site, as well as the long ridges, were considered to be deliberate constructions. In fact, Coe proposes that a bilateral symmetry in the overall layout existed, and that the plateau actually was a giant bird effigy never finished by the Olmec (cf. Diehl 1981). What is important in this observation is that Coe and Diehl recognized that the site is located on a natural elevated terrain, but the entire hill was somehow modified by the Olmec. Coe proposed also that the main area of the site contained the core ceremonial structures, which were dismantled for fill in later times (Coe and Diehl 1980: I, 29), a theory not supported by Diehl (1981) and Kent Flannery (1982).

Following the Río Chiquito Project, the exploration of several magnetic anomalies continued under the auspices of the Instituto Nacional de Antropología e Historia. In 1969, under Francisco Beverido, the search resulted in the excavation of Colossal Head 7 (Monument 53) as well as several other sculptures and tests in the Basalt Workshop. In 1970, Jürgen Brüggeman came to the site to check the large anomaly detected near Laguna 8, which resulted in the discovery of Colossal Head 8 (Monument 61). Further anomalies were tested and several other monu-

ments discovered (Brüggeman and Hers 1970; Breiner and Coe 1972).

Twenty years later, I initiated the San Lorenzo Tenochtitlan Archaeological Project, which was originally designed to investigate one of the most ignored aspects of Olmec archaeology, the habitation areas. In time, the project gradually expanded its goals to cover more fully multiple aspects of ancient settlement patterns at the residential, community, and regional levels. The principal objectives are the delimitation and excavation of diverse areas with specific functions, extensive regional settlement survey, and the analysis of the ancient environment in order to reconstruct the landscape and its utilization for subsistence.

To understand and explain the differential use of space over time, excavations were conducted in the domestic, productive, and ceremonial areas. Special attention was given to the excavation of areas where sculpture had been found in order to obtain evidence from the original context regarding the function of the monuments.

The extensive regional surveys conducted by Stacey Symonds (1995) and Roberto Lunagómez (1995) systematically and intensively covered 400 square kilometers of the San Lorenzo hinterland. A 20-meter spacing between surveyors permitted virtually all surface remains to be registered. With these data, the patterns of growth and location can be understood, allowing us to comprehend more fully the relationship between the hinterland areas and the regional center and the history of environmental exploitation.

The San Lorenzo Tenochtitlan Archaeological Project has successfully built upon the important work conducted by previous projects, and with the new data from six years of research at the site, a new view of San Lorenzo emerges for scholarly consideration.

ANCIENT LIFE AT SAN LORENZO

Before 1500 B.C., the first humans inhabited carefully selected sites throughout the lower Coatzacoalcos River drainage. The rivers and nearby Gulf of Mexico marked life's tempo. Canoes traveled up and down the rivers, to and from settlements. Access to resources was via canoes and rafts, and trading networks facilitated access to foods and materials. Since early times, these settlers created and maintained complex relations within the region and with distant areas of Mesoamerica. They instituted a distinct culture pattern that gave rise to dramatic cultural transformations over a few centuries.

In this water-rich landscape, small sites were situated close to the river in strategic spots, defined by slight elevations barely safe from flooding. Such riverine locations were convenient to exploitable aquatic resources and fertile bottomland for cultivation. Floods of extraordinary magnitude invaded yards and forced the people to flee to higher ground temporarily, or perhaps they took refuge in

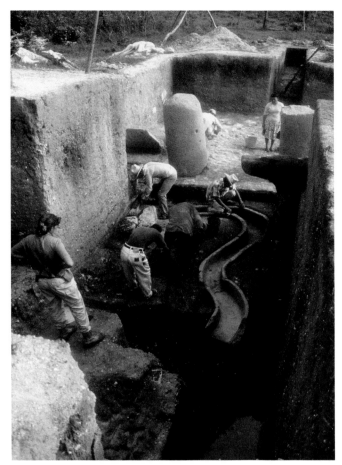
Fig. 3. The Red Palace at San Lorenzo.

lofts in their houses, as do the contemporary inhabitants of the region.

As the early inhabitants coordinated economically, socially, and politically, they began to form a regional, cultural identity in which cooperation, exchange, and production were administered on a more formal basis. In this early phase of development, a specific site, San Lorenzo, emerged as the most powerful place, and, by 1200 B.C., it was the capital of the lower Coatzacoalcos River drainage.

The transition to the florescent phase of San Lorenzo, traditionally considered between 1200 and 900 B.C. (Coe and Diehl 1980), was gradual, and not characterized by any abrupt changes. The Olmec development was *sui generis* on the Gulf Coast, eliminating transoceanic or highland diffusion as the source of Olmec culture.

At San Lorenzo, the rulers, their families, and attendants lived on the heights of the site. Palaces and elite residences are scattered across the central upper portion of the site, where most of the sculptures are found. An important palatial residence excavated by the project, the "Red Palace," shows the ostentatious use of stone elements such as columns, aqueducts, and step coverings (fig. 3). Only the extremely wealthy and powerful could afford to incorporate a scarce and imported resource such as basalt

into a dwelling. Craft activities directly under the control of the elite are also concentrated around the Red Palace; examples are the Basalt Workshop and the Monument Recycling Workshop. The economic and symbolic value of stone made it important that raw materials, products, and discarded sculptures be safeguarded under the protection of the elite, who controlled the raw material, technology, and symbolic content of sculpting. Another important residence was built on a low (less than 2 meters high) but large clay platform measuring 50 by 75 meters; a 12-meter-long apsidal-shaped superstructure occupied the top along with activity areas and refuse pits.

Below, on the terraced sides of the plateau, concentrations of habitation areas are found. These dwellings are less elaborate and may be built of wattle-and-daub or mud walls made with the *terre a pisé* technique. Floors were prepared with tamped dirt covered with a layer of irregularly shaped sedimentary stones, and the roofs were of palm thatch (Zurita, in press). Some dwellings tend to be large, covering more than 100 square meters. Buildings in the household cluster vary in form, size, and function. One residence has a low patio altar, indicating the establishment of a Mesoamerican pattern prevalent in later times. Cooking areas are found outside the main dwelling and consist of hearths with fire dogs or shaped clay hearths. The Olmec kept their structures clean, as is evidenced by the house floors already excavated. Garbage was deposited in pits, thrown into gullies as landfill, or thrown away from the dwellings usually downslope. Dwellings on the terraces show that craft activities were conducted at the domestic level. All dwellings are typified by the hoarding of stone pieces, whether these be sculpture fragments, discarded *manos*, *metates*, or other implements. The exorbitant cost of obtaining stone meant that the Olmec had to adopt an extremely pragmatic approach to its use, manufacture, and recycling.

The nature of Olmec subsistence is still elusive due to the poor preservation of botanical remains in the Tropics. However, with the powerful multidisciplinary application of palynology (Martínez, Ramírez-Arraiga, and Cyphers 1994), phytolith studies (Zurita, in press), and macroremains analysis (Lane n.d.), it is now possible to confirm the presence of the Mesoamerican triad of maize, beans, and squash at San Lorenzo. The utilization of root crops, such as *yuca*, *malanga*, *camote*, and *ñame*, is more difficult to ascertain, and to date, no evidence for their use has been recovered. Grinding stones, such as *manos*, *metates*, and mortars are additional evidence for the processing of grains. No ceramic griddles have been found at the site, so it is possible that maize was consumed as tamales instead of tortillas. The very large ceramic basins recovered in excavations could have been used for steaming tamales.

The Olmec relied on a variety of other food sources in addition to cultivated crops. Fish are abundant in the rivers, lagoons, and swamps and were a major protein source for the Olmec as for inhabitants of the region today. Contamination of the rivers and lagoons along with over-exploitation of these resources is rapidly diminishing their abundance. Fishing was generally an individual or family activity, except in the hunt of the bobo fish. Each fall the bobo fish migrates from upriver to spawn, and great organized fishing expeditions are organized along the lower Coatzacoalcos River to trap this enormous egg-laden fish, considered a delicacy. The presence of shark teeth in the excavations suggests that these were probably hunted either in the sea or in the rivers, since even in recent times the tide has brought them upriver. The Olmec also hunted white-tailed deer and white-lipped peccaries (Wing 1980); probably many other species were hunted but the remains of such prey were scattered by the dogs scavenging around the household garbage debris. The domesticated dog was also a source of food, as indicated by remains often found in domestic debris. In traditional societies, large festivities are characterized by the ostentatious consumption of protein, and dogs, fish, turtle, deer, and peccary would have been likely banquet food.

San Lorenzo is characterized by a large number of craft activities. The sculpture recycling and the ilmenite workshops are so extensive in area and quantity of materials that they seem to indicate an industrial scale of manufacture. With such production strategies achieved during the apogee phase, agriculture and the importation of foodstuffs must have been intensified to maintain an ever-increasing group of craftspeople and other nonfood producers.

The largest activity found to date is the recycling of monuments and the fabrication of preforms. Obsolete sculptures were hoarded for recarving west of the Red Palace. To the east of that structure was the Basalt Workshop; an 18-metric-ton monument was being mined as a source of basalt for *metate* and lid preforms. The elite maintained tight control on the raw material, technology, and finished product.

On the southwestern edge of the plateau another specialized workshop area has been excavated. Here basalt recycling was also being conducted at a smaller scale for the fabrication of round basalt plates. Near this area, large pits filled with more than six metric tons of ilmenite multidrilled blocks were recovered. These blocks are the used-up or discarded pieces of a rotation technology used in drilling (Di Castro, in press).

Obsidian-working seems to have been conducted at the household level. Very few wasted cores have been found, even though prismatic obsidian blades are common during the apogee phase. It is likely that the cores were shattered to produce flakes for cutting and scraping. The obsidian at San Lorenzo derives from three basic sources: Guadalupe Victoria in Puebla, Otumba in Central Mexico, and El Chayal in Guatemala (Cobean et al. 1971; Cobean et al. 1991).

In archaeology, a number of methods are used for estimating the population, including site area and density of surface artifacts. At San Lorenzo, the large amount of overburden makes the application of artifact density a difficult method for estimating population. When Krotser finished the topographic map of the site, a number of small, low habitation mounds were noted on the surface. Coe and Diehl (1980: I, 29) used the presence of these two hundred mounds as a basis for estimating a resident population of one thousand for the site. Testing of these mounds in recent years shows them not to be Formative nor to contain evidence for structures, so that now it is necessary to reconsider the proposed population estimate for the site. Habitation occurs in defined areas of the site, as shown by survey and excavation, so the previous idea that Olmec centers such as San Lorenzo were vacant ceremonial centers must be discarded.

During recent site work, an intensive systematic survey was conducted by Lunagómez (1995), who discovered that surface remains extend from the heights to the 30-meter contour interval to cover approximately 690 hectares or 7 square kilometers during the Early Formative period. The limits of the site are presently being tested for the extent and intensity of habitation at the periphery, and initial tests show that the edges were fairly densely occupied. The depth of Formative deposits makes it difficult to calculate the density of structures across the site. Known structures are very large and are surrounded by other structures. We are still a long way from being able to discuss the nature of domestic units and the probable number of residents per household cluster, and hence for the site in general. But all evidence indicates that occupation covered the site and along the elevated ridge to the south and north, down to the floodplains below. The nature of the settlement also shows a complexity in structure types, sizes, and activity areas.

In general, the elite areas are found on the top of the plateau with the less important residences clustered on the terraces and slopes below. There is no evidence for the existence of agricultural plots on the elevated lands; on the contrary, all of this land appears to have been intensively occupied. The lands that were farmed would have been the levees and the floodplains as well as the now dissected uplands to the south and west. The sustaining agricultural area for San Lorenzo would have been found away from the site, so farmers would have had to have traveled a considerable distance to their fields. This is a common pattern today in the region, where farmers may travel up to two hours on foot or horseback to their fields.

In addition to being farmers, fishermen, hunters, and artisans, the inhabitants of San Lorenzo were involved in regional and long-distance trade. Causeways in the region testify to the importance of the fluvial network in the life of ancient San Lorenzo, where they served as docks for receiving raw materials, produce, and other products.

The presence of a natural dendritic communication and transportation system considerably reduces time in transport and makes it possible for a key central place to receive, store, and redistribute large quantities of foodstuffs, raw materials, and manufactured products. The strong emphasis on production or crafts at San Lorenzo goes hand in hand with its role as the main redistribution node in the river system.

ART AND ARCHITECTURE

Olmec art is characterized by diversity, not uniformity. The sculpture is highly varied in form and theme, even though a number of traits are common. Stirling (1955) and Beatriz de la Fuente (1981) have pointed out that the principal representation in Olmec art is the human form. In the elaborate Olmec belief system, status, power, and animals were intimately related to render tribute to the rulers and supernatural deities. The central position of the feline in Olmec art has been repeatedly questioned; however, recent discoveries by the San Lorenzo Tenochtitlan Archaeological Project have augmented the number of feline representations for San Lorenzo. At present count, San Lorenzo possesses the largest number of clear feline representations of all Olmec sites, thus establishing the feline as one of the most ancient Olmec symbols. After the decline of San Lorenzo, feline representations may have declined in popularity or been transformed.

The intrinsic meaning of Olmec stone sculpture has provided an important basis for interpretation of that culture. Most monuments were found on the banks of ravines or other chance means outside a systematic archaeological context. Interpretation and reconstruction relied heavily on ethnohistoric and ethnographic analogies, because the monuments lack a context that could provide additional information. Olmec ideology and rituals need to be examined with accurate chronological and contextual controls to achieve accurate interpretations. An indispensable point of departure is rigorous archaeological context. "Context" implies associations with other objects, architecture, features, individuals, and groups, all of which provide archaeological and sociological information necessary for understanding meaning and function.

The emphasis of the San Lorenzo Tenochtitlan Archaeological Project is on the context of Olmec sculptures at San Lorenzo and hinterland sites. A case in point is the area of the site known as Group D, where Coe and Diehl (1980) reported monuments deliberately placed in lines and ceremonially covered. Recent excavations of the wider context of these monuments revealed the presence of additional and unaligned monuments deliberately stored for recarving (Cyphers, in press). The wider context of the sculpture revealed the presence of tools and debitage associated with the recarving process.

Contextual data recovered by the project indicates that

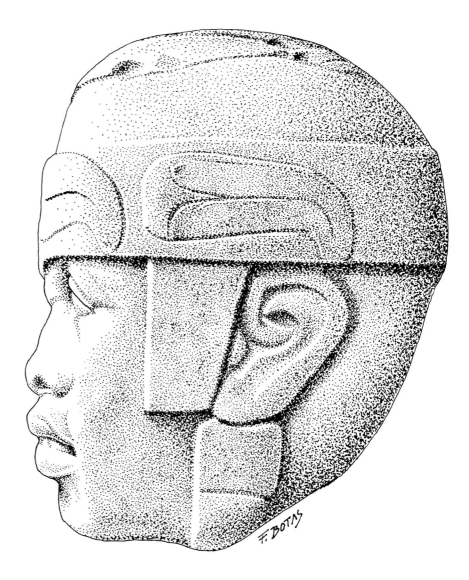

Fig. 4. Colossal Head 8 (Monument 61)
from San Lorenzo.

Olmec sculptures were not mere idols to be worshiped in sacred spaces. In fact, the sculptures were used in ensembles or groups to reenact mythological or historical events. The data to support this interpretation come from individual as well as specific groups of monuments. The use of monuments to form scenic displays indicates that each Olmec sculpture constitutes a distinctive piece of a conceptual framework about the earth and cosmos. When organized into scenic displays, the sculptures can evoke numerous concepts and their rearrangement can transmit a variety of messages.

The specific context of the large throne (Monument 14), Colossal Head 8 (Monument 61; cat. 1; fig. 4), the 171-meter-long basalt aqueduct, and other feline sculptures, illustrates the importance of the sculpture's setting. The location of the sculptures in and near a red-plastered earthen platform with associated offerings and sacrifices shows the theme of rulership associated with felines and water.

In the case of Loma del Zapote, three distinct settings of sculpture are indicated. The first is the decapitated and dismembered Xochiltepec torso, in which the position of the fractured legs indicated that it had to be seated atop an elevated surface. The use of human figures

in conjunction with thrones is suggested by the Oxtotitlan, Guerrero, Olmec cave painting (Grove 1973), and this piece suggests that not only rulers but also stone figures were seated on thrones.

The second case from Loma del Zapote is that of a decapitated, dismembered, caped figure set on the edge of a structure containing a subfloor burial (fig. 5). Even though disfigured and ritually placed, the sculpture continued to hold important meanings associated with sacrifice and burial.

The third and most spectacular contextual case of scenic display is to be found on the Azuzul acropolis, also part of the Loma del Zapote site (fig. 6). Two male twins face two stylistically similar felines, and all were ceremonially placed on the edge of a pavement separating lower and upper bodies of monumental architecture. The arrangement and characteristics of the human figures and felines provide parallels, perhaps coincidental, to later period myths about twins and jaguars, the most notable of which is the Popol Vuh's tale of the Hero Twins (Edmonson 1971). The context of these sculptures clearly indicates that this is the abandoned display of a ritual reenactment of a historical or mythical event with possible astronomical symbolism.

In summary, the creation of scenic displays by the Olmec was a means to re-create mythological and historical events, and, at the same time, create the kinds of commemorative and/or cyclical festivities to celebrate them. The relocation of monuments for rites implied accompanying labor obligations and fomented the integration and participation of many social sectors. All of this served to confirm Olmec social identity, rulership, and cosmological principles.

The spaces built by human beings reflect their ideas about the universe they live in. Architectural spaces express their way of living and thinking as well as the way in which they conduct their activities. Architecture reflects the way they conceive the relationship among humans, environment, and cosmos, a concept called *cosmovisión* in Spanish.

The pattern of monumental architecture in Mesoamerica varies from site to site, but it can be characterized by a general predefined pattern in which mounds or pyramids were built around plazas. The Early Formative architecture of San Lorenzo is not typical of this later Mesoamerican pattern of pyramids and plazas. In San Lorenzo the monumental modification of natural landforms was the way the

Fig. 5. Headless, caped torso from Loma del Zapote.

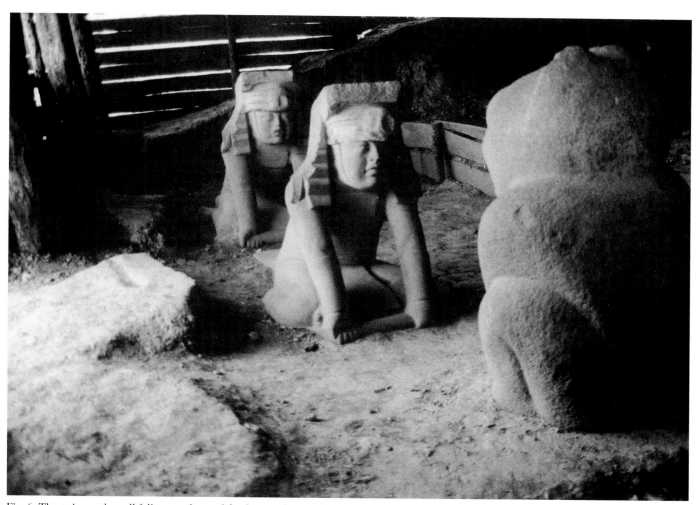

Fig. 6. The twins and small feline are three of the four sculptures forming an ancient Olmec scene on El Azuzul acropolis.

Olmec formed desired spaces. The San Lorenzo plateau may be considered one of the largest works of monumental architecture in Early Formative Mesoamerica because it was modified using enormous human labor for the construction of terraces, filling and cutting operations, and earth removal, thus transforming the natural landscape into a space for both sacred and everyday purposes. This impressive activity is visible in the construction of two and three levels of long and wide terraces below the heights of San Lorenzo, which provided areas for habitation and production. The leveling of the plateau, achieved with thousands of cubic meters of earth fill brought in from the low-lying areas, and in conjunction with large retaining walls, required a considerable work force. Today the form of the plateau is distorted by erosion and human activity following the Olmec occupation, all of which have erased the original silhouette of this enormous earthen monument, possibly the first "sacred mountain" in Mesoamerica.

Other important architectural elements of the Early Formative period are the low earthen platforms and the causeways. The low platforms, frequently plastered with red-pigmented sands, were used for public, ceremonial, and residential activities. The Olmec were master builders and utilized the materials available in their local environment to construct their dwellings and sacred ceremonial buildings.

SOCIOPOLITICAL ORGANIZATION

San Lorenzo constituted a well-integrated and structured hierarchical society. The success of its integration and development was the result of adaptive strategies used to exploit its environment efficiently and take advantage of its optimum geographical location.

Previous studies considered San Lorenzo a fairly small, 53-hectare site (Marcus 1976), but recent work by the San Lorenzo Tenochtitlan Archaeological Project has demonstrated that it covers more than 690 hectares (Lunagómez 1995). Coupled with the data on the internal differentiation demonstrated by the site, San Lorenzo can be considered the largest and most complex Early Formative site in Mesoamerica. This constellation of functions and characteristics tends to indicate a society that has attained incipient statehood.

The population of San Lorenzo's hinterland increased during the apogee phase, creating a hierarchical settlement pattern in which San Lorenzo functioned as the regional center around which a complicated administrative hierarchy of small and large sites was located, each specialized according to its geographical position (Lunagómez 1995; Symonds 1995). Because it was located in a strategic spot in the communication network, San Lorenzo was able to regulate the importation and exportation of local and regional products. The centralization of sites and

the population increase coincided with intensive production specialization and the appearance of an exchange network regulated by the elite.

During this time, large monuments created in volcanic stone brought from the Tuxtla Mountains (Coe and Fernández 1980) were dedicated. An efficient organization that could control a large work force was necessary to conduct this extraordinary activity, in which stones as large as 25 metric tons were transported. It is not known if the monuments were brought as uncarved blocks and sculpted on the site or if they arrived already carved. Without the use of the wheel and beasts of burden, the Olmec relied completely on a human labor force. Both land and water routes are feasible for the transport of stone, although it is obvious that land routes provided greater safety. The magnitude of the work force necessary to transport the stones places the Olmec on a plane of organization and technology truly exceptional for their times. Numerous workers, specialists in maneuvering ropes and knots, rollers and wood, as well as coordinators, were necessary. People in charge of feeding the work force added to the total number of individuals involved. The transportation of stones was an effort as monumental, or more so, than the construction of great architectural works.

The rulers of San Lorenzo, whose portraits are the ten colossal heads, achieved an extraordinary power that was legitimated and reinforced with complicated ceremonies and sumptuous monuments. The colossal heads and thrones were probably never transported to other communities because they are the most important symbols of Olmec leadership, centered at the capital of San Lorenzo.

DECADENCE

The florescence of San Lorenzo lasted until 900 B.C., when the site suffered a significant decline and population loss. The site was not totally abandoned because there is evidence for Middle and Late Formative occupation there. During the Classic period, however, there is no evidence for occupation. It is not until the Late Classic-Early Postclassic that a significant occupation at the site and a powerful renewal of settlement in the region again occurs (Symonds 1995).

After the florescence of San Lorenzo, La Venta rose in importance. We do not know if La Venta, or some other site, was responsible for the decline of San Lorenzo. Various causes of its decadence have been proposed, including internal revolt, invasions, and a gradual loss of importance. The decadence of San Lorenzo may have been gradual, the result of internal problems in the functioning of the regional polity.

The research conducted by the San Lorenzo Tenochtitlan Archaeological Project adds another possible factor for the decline of the site. Regional evidence exists for tectonic activity emanating from the Tuxtla Mountains, which

could have had repercussions in the San Lorenzo region in terms of ash fall and subsequent ecological alterations. Evidence indicates that tectonic movements (uplift) affected the river courses and land altitude, thus effectively changing the physical geography.

A dramatically changing environment applies stress to human occupations and their traditional way of life. Gradual and/or sudden environmental disequilibrium may cause internal problems of a social, political, and economic nature, such as disruptions in trade and communications and significant crop losses. The search for additional archaeological evidence of natural catastrophe and specific human response and adaptation must continue for these questions to be addressed fully.

The transition to the Middle Formative shows a reduc-tion in population and a change in the settlement pattern. Between 900 and 400 B.C. the importance of San Lorenzo waned, but its legacy continued in other Olmec sites that achieved greatness.

ACKNOWLEDGMENTS

The research reported here was made possible by the American Philosophical Society, the National Endowment for the Humanities, the National Geographic Society, the Consejo Nacional de Ciencia y Tecnología, the Instituto de Investigaciones Antropológicas, and the Dirección General de Asuntos del Personal Académico de la Universidad Nacional Autónoma de México.

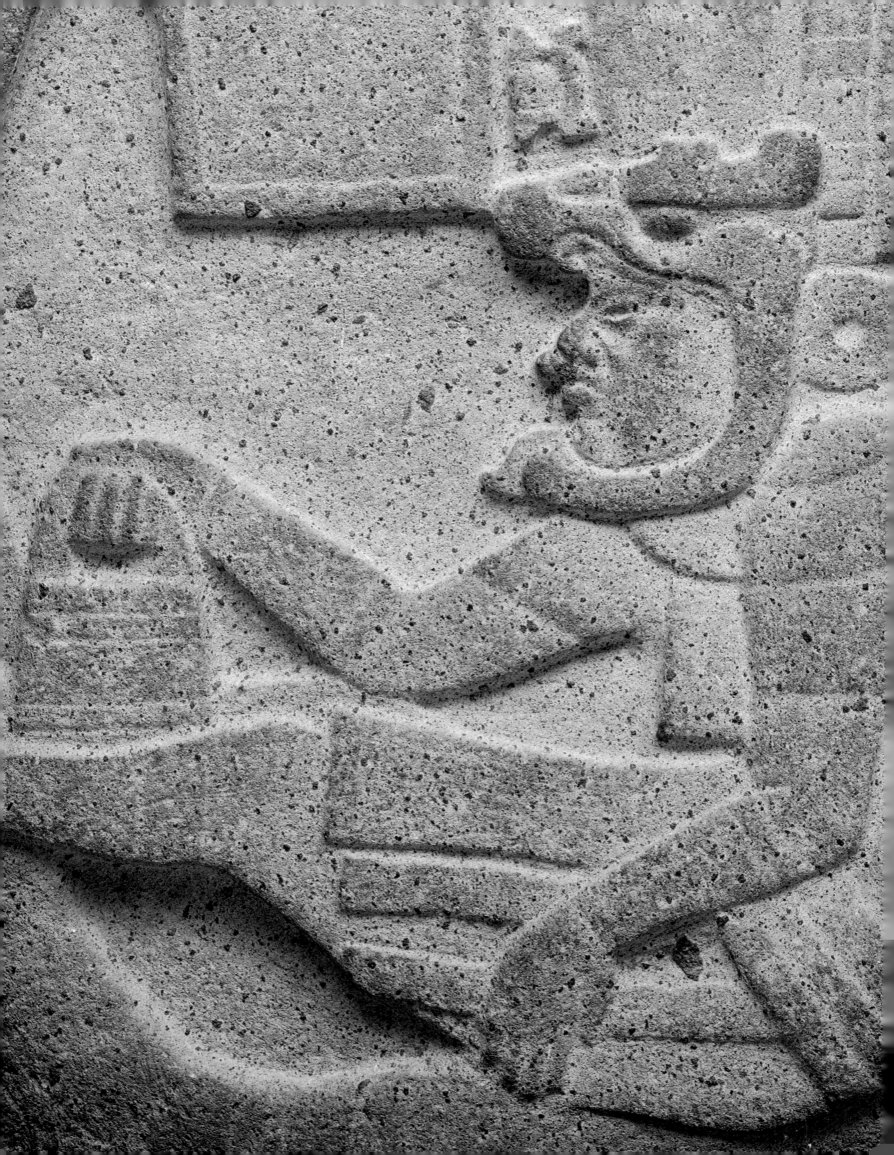

La Venta: An Olmec Capital

REBECCA GONZÁLEZ LAUCK

GEOGRAPHIC-ENVIRONMENTAL SETTING

La Venta, located in the extreme northwest of the Huimanguillo municipality in the state of Tabasco, is slightly more than 15 kilometers directly south of the coast of the Gulf of Mexico. This zone, which forms part of the largest alluvial plain in the country, extends 40 kilometers south of La Venta. Within this coastal plain of the gulf, less than 10 meters above sea level, are natural elevations corresponding to the Miocene and Pleistocene epochs. On one of these elevations, the Olmec constructed what we now know as the La Venta archaeological zone. The terrain surrounding the site consists of low-lying wetlands, which seem to have been so for at least two millennia, with varying levels of moisture (Jiménez Salas 1990a, 1990b; West, Psuty, and Thom 1969).

Hydrographic features predominate in the countryside around La Venta. At present, the Tonala River is 4 kilometers west of the site. Two tributaries, the Chicozapote and Blasillo rivers, flank La Venta to the north and south, respectively. The Chicozapote River is 13 kilometers from La Venta, and the Blasillo is 2 kilometers away. Permanent and seasonal bodies of water are found throughout the area, both fresh and saltwater. Recent geomorphological studies suggest that the La Venta environment was very dynamic, with constantly changing river courses (backwash channels, abandoned meanders, etc.). The now silted Palma River, for example, less than 1 kilometer north of La Venta, was active until the beginning of this century. Settlements with long occupations are found on its banks from the pre-Hispanic epoch until today (Covarrubias 1946: 123; González Lauck 1988: 137–139; Jiménez Salas 1990: 6; Rust and Sharer 1988; Stirling 1943b: 50).

The climate of La Venta, characterized as the humid Tropics, has an average annual temperature of 26 degrees Celsius and an average annual rainfall of 2,000 millimeters. These factors form one of the richest and most varied environments in existence. Within a day's walk from La Venta, four different ecosystems are found (marshes, mangrove swamp, tropical forest, ocean), with diverse flora and fauna: mojarra, snook, pompano, catfish, carp, striped mullet, alligator gar, crocodiles, turtles, freshwater clams, snails, migratory ducks, manatee, white-tailed deer, fe-lines, iguanas, frogs, crabs, oysters, mussels, and freshwater and marine shrimp, for example (González and Jiménez 1991). These exploitable resources were used as food and construction materials in the daily life of the ancient inhabitants, and were also incorporated into their art. Farming was concentrated in the rich alluvial soils along the slightly elevated river banks, where it is now possible to harvest up to three times a year. In a settlement neighboring La Venta, evidence has been found for corn (*Zea mais*) of teosinte size associated with ceramic material dated to 1750 B.C., indicating the most ancient occupation in the neighboring region to date (Rust and Leyden 1994).

CHRONOLOGY

La Venta is generally dated to between 1000 and 600 B.C., based on the archaeological investigations undertaken in 1955, 1964, and 1967 (Berger, Graham, and Hester 1967; Drucker, Heizer, and Squier 1959; Squier 1964). These approximations are the basis for the dating for the architectural sequence of Complex A, in which four construction phases of one hundred years each were proposed. In addition to questions raised by William Coe and Robert Stuckenwrath (1964) over this sequence, it should be noted that the carbon samples used for this dating came from construction fills, with the exception of one found in a sealed context. Thus, although the materials used for the earth constructions have been adequately dated, these dates do not necessarily apply to the construction and use of the buildings.

Recognizing the limitations of the evidence, including the "acceptable" results of the radiocarbon dating, pre-Hispanic settlement at La Venta can be dated between 1100 B.C. to A.D. 800, while dates recovered from the surrounding area fall between 1750 B.C. and A.D. 1460 (Raab, Boxt, and Bradford 1995; Rust and Leyden 1994). The Olmec occupation at La Venta is concentrated between 1200 and 400 B.C. (Heizer 1971: 52). Unfortunately, there are no reliable chronological sequences for the ceramic, architectural, and/or sculptural traditions that elucidate the cultural history of La Venta during its eight-hundred-year existence.

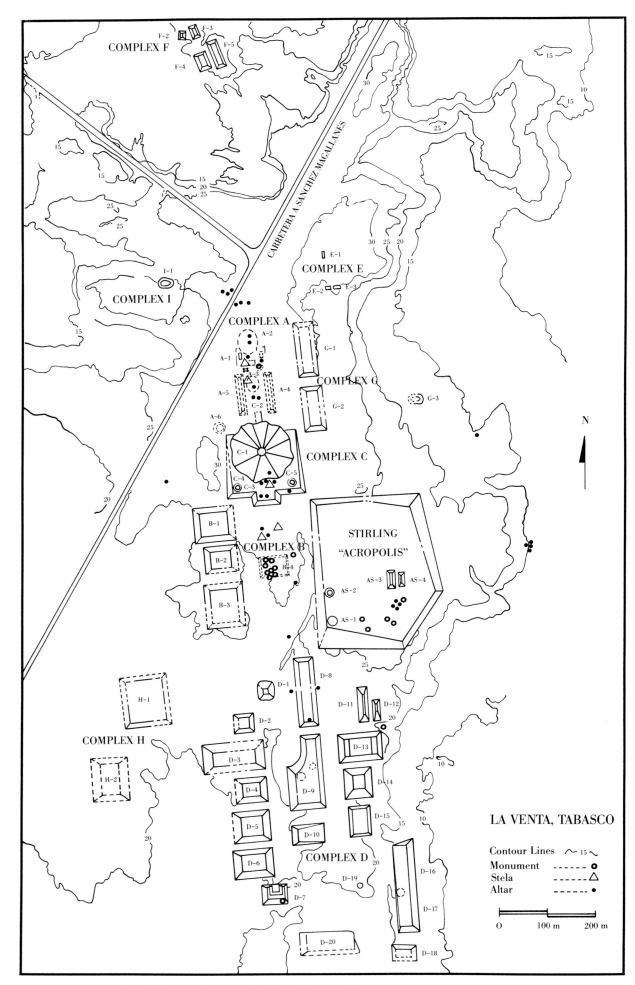

Fig. 1. Architectural plan of Olmec settlement at La Venta, Tabasco, Mexico.

Olmec Settlement at La Venta

There has been a reluctance to categorize La Venta as an urban settlement, despite decades in which the Olmec have been identified as a "civilization"—a word with a Latin root that means "a society with cities." Sufficient archaeological information to label La Venta as a city has existed for seventy years, since Frans Blom and Oliver La Farge (1926) first reported on La Venta in the archaeological literature. For one, there was a large resident population at the site, a number of specialists not dedicated to food production, and political, religious, economic, and/or military relations with other sites within its area of influence.

One of the most solid arguments for the definition of La Venta as a city is its architecture (fig. 1). It is estimated that the original site covered some 200 hectares, while today little more than half of the site has survived the incursions of urban and industrial blight from the modern town of La Venta; this is why the plan of the ancient city presented here is incomplete.[1] Among the registered edifices are civic-ceremonial structures (Complex C), civic-administrative structures (Complexes B, D, G, H, and the Stirling "Acropolis"), a small but impressive ceremonial precinct (Complex A), and evidence for residential areas within and outside of the city limits (Complexes E, I, and the sustaining area). The architectural layout of La Venta represents the final Olmec occupation of the site between 600 and 400 B.C.,[2] which is marked by a high degree of architectural organization and planning. It remains to be determined if the entire site followed a "master plan," and, if it did, its antiquity.

Local clays and sands were used as construction materials in the architecture at La Venta, as were various exotic stones from far away. The elevated platforms likely supported structures made of perishable materials, such as packed earth floors, palm roofs, wooden posts, and wattle-and-daub walls.

Complex C

Structure C-1, also known as "The Great Mound" or "The Great Pyramid," is the central architectural feature of La Venta. From the summit, one has an unrestricted view for 360 degrees. The structure is also visible from many kilometers away. More than 30 meters in height, the structure was built over a platform that was enclosed on three sides. On the southeast and southwest corners of the platform are two small oval-shaped mounds; in the center of the southern side is a central projection, on which Blom and La Farge (1926) discovered two of the first La Venta sculptures—"Altars" 2 and 3.

Structure C-1, a predominantly earthen construction, has eroded, causing speculation about its original configuration, function, and significance. Only recently have systematic investigations been initiated on the southern side

of this building, which has permitted the definition of the last phase of construction and offered a more realistic appreciation of what was possibly the most important pyramidal construction of the Olmec world.

Toward the upper parts of the construction is a slightly stepped slope, with white limestone intermittently embedded in the sandy clay mass that forms an abutment to retain the principal construction material. In the central projection, in a space more than 8 meters wide, there are no embedded stones, and the eroded remains preserve what would have been steps to the summit of this pyramidal structure. The architectural remains found in recent archaeological excavations on the south side of Structure C-1 indicate a pyramidal structure with a series of stepped volumes and inset corners that recede from the sides of the central access. The sophistication of the shape and construction methods indicate a preestablished and long architectural tradition.

A carbon sample was recovered from a burned area of the original structure surface, resulting in an approximate date of 394 ±30 B.C. (INAH-1874). This date produces a logical sequence—though still extremely limited—with the sample M-536, recovered in 1955 from the north side of Structure C-1, under the clay mass that produced the date

Fig. 2. Southeast side of Structure C-1 of La Venta, Tabasco, Mexico, during excavation.

of 655 ± 300 B.C. (Berger, Graham, and Heizer 1967: 14; Drucker, Heizer, and Squier 1959: 119).

Six monumental sculptures, evenly distributed east and west of the south access, have been found at the foot of the southern front of Structure C-1 of La Venta. Monuments 25/26 and 27 and Stela 5 were found to the southwest, and Monuments 87, 88, and 89 were found on the southeast (fig. 2; Drucker, Heizer, and Squier 1959: 120; González Lauck 1988: 142–149; Mercado Arregín 1994). Four of these sculptures—Monuments 25/26, 27, 88, and 89—are carved in low relief, representing essentially the same theme: a supernatural being with almond-shaped eyes; a wide, flat nose; and a buccal mask that hides the upper lip but reveals gums with a single central tooth and two fangs over the lower lip of a downturned mouth. Earspools and headdresses of the represented figure are identifiable in these features. Below the faces are three horizontal bands interwoven with vertical bands substituting for the bodies of the figures. Of the two remaining sculptures, Stela 5, also carved in low relief, depicts a historical event of the Olmec elite. Monument 87 has no relief, but the smooth face may have been painted with an image, although no traces of pigment were noted.

With the exception of Monument 27, all of the sculptures at the foot of the south side of Structure C-1 were found as the Olmec had left them, because their basal ends were embedded into the ground. The sculptural works, besides demonstrating the contemporaneity of the group, coincide temporally and stylistically with the results of the recent chronometric approximation; in other words, they are of late Olmec style. Additionally, they depict a mythological being in different aspects, although they could also be interpreted as diverse beings, which predominate thematically over this building, as well as historic events of the Olmec elite, in this case represented by Stela 5. Sculptures of this type (i.e., Monuments 25/26, 27, 88, and 89) may be monumental representations of votive celts (Porter 1989). Particularly notable is the variety of greenstone (gneiss, schist, and serpentine) of the south side sculptures, which create the impression of monumental votive celts in imitation of portable ones worked in greenstone.

While what is here described for Complex C is just the beginning of a long-term archaeological investigation, the function, nature, and dating of Structure C-1 or "The Great Pyramid" of the Olmec world is beginning to be seen more clearly. This structure demonstrates that in the first centuries before our era, various architectural-sculptural canons were firmly established—canons that were, in essence, used in civic-ceremonial constructions throughout the cultural history of ancient Middle America.

Complex A

Adjacent to and directly north of the pyramidal structure C-1 is the ceremonial precinct of the ancient city of La Venta, called Complex A.[3] This small architectural group, the most extensively excavated at the site, was investigated in the 1942, 1943, and 1955 seasons, when a series of impressive and extraordinary finds came to light (Drucker 1952; Drucker, Heizer and Squier 1959). Much of what was known initially about the Olmec was invariably colored by the spectacular discoveries in Complex A, which reinforced the erroneous conception of "vacant ceremonial centers"—a common and predominant idea in the early decades of the discipline. The ceremonial precinct, however, now fits within a much more coherent context, forming an integral part of a pre-Hispanic city.

The architecture of Complex A is distinguished by the bilateral symmetry of its constructions, which are organized as two contiguous courts. The north court has enjoyed the greatest fame at La Venta, given the exceptional quality of the findings there. The court was bounded by a discontinuous wall of basalt columns embedded vertically in a red-clay fill, creating an interior, slightly sunken space of approximately 40 meters (north-south) by 57 meters (east-west). The north side was interrupted by Structure A-2, while the south side was bounded by Mounds A-1-e and A-1-f, which were surrounded by the basalt columns. In the interior of the north court, a small platform was found in each of the northwest and northeast corners, with another in the center. The north court of Complex A had two entrances: one between its northeast corner and Structure A-2, indicated by limestone flagstones; to the south, between Mounds A-1-e and A-1-f, another entrance was found, indicated by stairs made of basalt columns piled horizontally.

Structure A-2 seems to have been a stepped earthen platform 4 meters high. Within this was an unusual funerary chamber with walls and roof constructed of basalt columns. Inside, over limestone flagstones, were found the bones of two or three young individuals, very badly preserved, covered with red pigment, and associated with a rich collection of objects, which the discoverers describe:

> With one of these [burials] were two handsome jade figurines. One was a seated figure, hands resting on knees, made from vivid green jade….With it was a standing male figure of translucent blue jade.
>
> Two feet beyond them we came upon a realistic reproduction of a fresh-water clamshell of heavy polished jade, about 10 inches long, and perforated for use as a pendant. Inside it was a small oval mirror of brilliant crystalline hematite.
>
> Lying under this "clamshell" was what is possibly the most exquisite example of jade carving known from ancient America—a seated female figure of highly polished dark-colored jade, with a circular mirror of crystalline hematite attached to the chest [cat. 51].
>
> The arms were held across the chest, the right hand above the left. Long hair, neatly dressed, hung down the back. The features were realistic, with the slightly parted

lips outlined by a delicate hairline. The face had a relaxed and pleasant expression.

About a foot and a half from this same deposit were a jade frog, a green jade leaf, a jade "flower," and two large rectangular ear ornaments of dark-green jade, each engraved with eagle-head designs.

Around them were a number of long jade beads of especially beautiful material, carved like sections of bamboo.

Near the southwest corner of the platform was an unusual necklace or headdress, apparently rolled into a bundle. This consisted of six stingray tails about 6 inches long, set with small squares of glittering crystalline hematite. A seventh, evidently the central piece of the necklace, a reproduction of one of these tails, was carved from translucent green jade. Each piece was perforated at the base [cat. 108].

Near by was a handsome, highly polished blue jade awl or perforator, with large bulbous handle, but with the point broken off. Beside it was a small pottery vessel, placed against a burned human skullcap....

In the southeast corner of the platform we found another fine standing human figurine of translucent blue jade, with wide mouth depressed at the corners, flat nose, and narrow head [cat. 45]. The figure rested on an unusually large shark tooth.

Scattered about were a number of beads, all of extra fine quality jade, and near the southeast corner of the tomb we found some of the milk teeth of a child.

Beside the engraved ear ornaments was a pair of clay ear-spools, painted a pale blue as if in imitation of jade, and with them two pieces of green polished jade, carved in the shape of a pair of human hands [cat. 85]. Two oval-

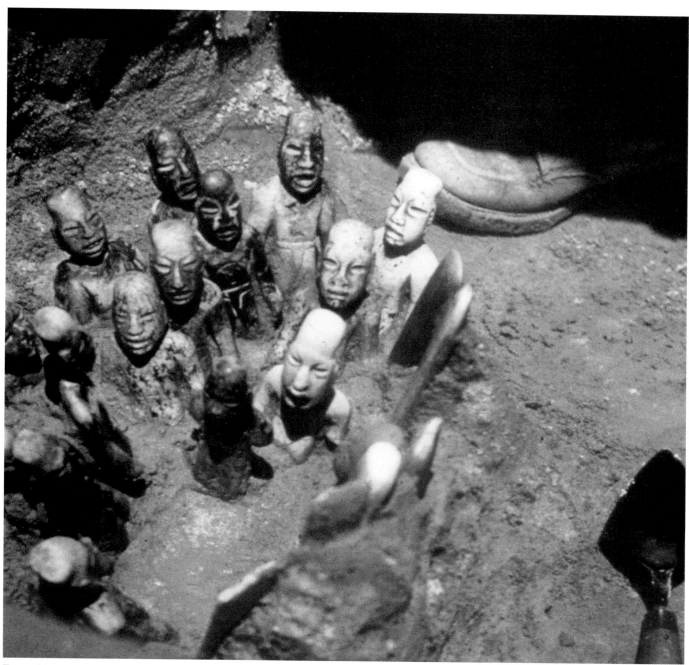

Fig. 3. Offering 4 of Complex A, La Venta.

shaped pieces of polished obsidian and two similar pairs of green jade were probably eyes set in carved wooden masks or figures. The wood had disappeared.

Throughout the layer were copious unrestorable traces of organic material. The red cinnabar lay in a fashion which gave the impression that it had been inside of wrapped bundles. Probably the bodies had been thus wrapped before interment. (Stirling and Stirling 1942: 640–642)

Directly to the south of this tomb a series of basalt columns was found in a horizontal position, under which were thirty-seven jade objects: principally celts, most of them smooth, but some with incised decorations. Also in an area heavy with cinnabar, two earspools and necklace beads were found, as well as fragments of hematite mirrors (Wedel 1952: 27).

As if that were not enough, directly south and still within Mound A-2, was Monument 6: a monolithic coffer with its lid worked in sandstone, representing in low relief on three sides a mythological being combining real and fantastic animal features. This "sarcophagus," 281 centimeters in length by 96 centimeters in width and 89 centimeters in depth, contained "two magnificent paper-thin, mottled green jade circular ear ornaments. To each had been attached, by means of drilled holes, the representations of a jaguar claw fashioned from a translucent emerald-green jade," a male figurine worked in serpentine, as well as a worked perforator of highly polished jade. Based on the disposition of these objects within the "sarcophagus," it is thought to have originally formed part of the burial (Stirling and Stirling 1942: 638–639).

More than 50 offerings were found dispersed among both courts of Complex A. The greater part of these consisted of portable objects, such as clay vessels and votive celts. One that has received great attention is Offering 4 (fig. 3), which is distinguished by its grouping of sixteen male figurines. Two of these figurines are worked in jade, thirteen in serpentine, and one in sandstone. This last one was positioned to face the rest of the group: four of the figurines file in front of the sandstone one, and the remaining eleven are arranged in a semicircle, as if to observe the others. Behind the sandstone figurine were six fragments of celts, erected as if to represent stelae. The significance of this scene is unknown, but its importance was such that the ancient inhabitants of La Venta considered it necessary to depict it in stone for posterity.

The small ceremonial precinct of La Venta has also produced a type of offering unique in the ancient history of Middle America: massive offerings. These are divided into two groups: those that present an abstract mosaic design formed by blocks of serpentine, and those without a design. Three examples have been found from the first group: two in the north court and one in the south court of Complex A. Those of the north court were deposited under two mounds (A-1-e and A-1-f) that close off the boundary

south of the north court of Complex A. On the surface these mounds are surrounded by basalt columns, embedded in a red clay, which covered the stepped platform constructed of sixteen rows of adobe blocks. These structures were built over a large artificial cavity, which was 8 meters underground. Within this hole were deposited carefully selected stones cemented in clay; with them was constructed a subterranean platform of less than 3 meters in height by almost 9 meters in width and more than 12 meters in length. Over this were placed 443 rectangular serpentine blocks forming a mosaic with an abstract design, measuring roughly 4.5 meters square (fig. 4). In the principal part of the mosaic, the negative spaces were filled with a yellow clay, while around the edges a red-purple earth was deposited that emphasized and contrasted with the green mosaic stones. The investigators who discovered these offerings imaginatively described them as "jaguar masks" (Wedel 1952: 56–59). They were probably not intended for exhibition, because they were covered with a thick layer of clay and sands, and buried underground.

The other type of offering was no less impressive. Massive Offering 3, located in the central part of the north patio of Complex A, was found in a cavity 23 meters square at a depth of almost 4 meters. Within this orifice, six horizontal layers of serpentine blocks were deposited, covering an area almost 20 meters square. These stones, however, were not arranged in a particular design but rather formed a subterranean surface paved with greenstone. Like the other massive offerings, this one was covered with sand and clay so as not to leave it exposed to profane view.

The La Venta Massive Offerings were not identical in their elaboration and presentation, but all of them respect the concept of carefully depositing enormous quantities of greenstone under the surface of the earth. Even the massive offerings (1 and 4) that were found symmetrically arranged at the southern boundary of the heart of the ceremonial precinct have differences between them, although they seem the most similar to each other. In spite of the impact of these remains, their precise significance still eludes us; perhaps they were offerings to Mother Earth (Marcus 1989: 173). The north patio of Complex A guarded four of the six massive offerings, underscoring the sacred nature of this small precinct.

Complexes B, D, G, H, and the Stirling "Acropolis"

Although the striking features of the ceremonial heart of La Venta are the best known, Complex A, in fact, is quite different from the other architectural units of this ancient city. One of clearest differences between Complex A and the others is the size of the structures, as is apparent in the architectural plan.

Another difference is in the use of space. The sacred precinct of La Venta, with its hidden, subterranean features, has extremely limited access. La Venta architects skillfully accentuated this effect with the location of this

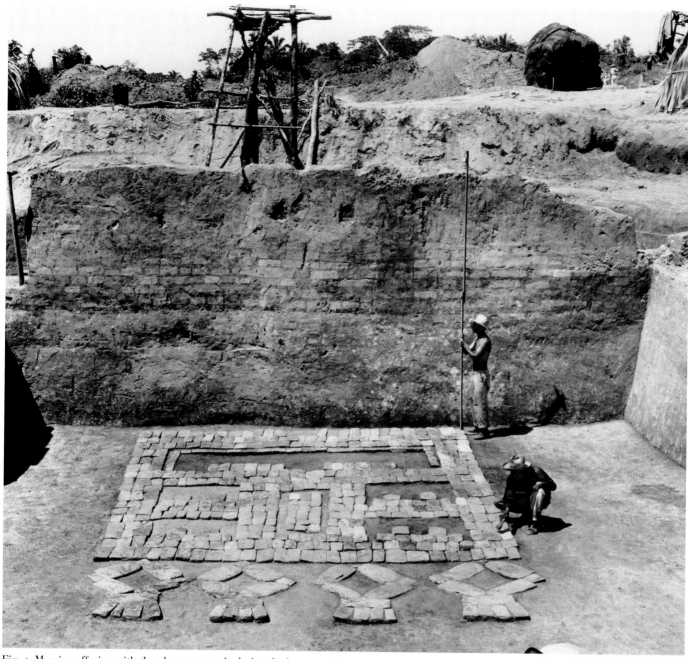

Fig. 4. Massive offering with the abstract mosaic design during excavation.

architectural group: directly adjacent to the north of the highest structure of the city (C-1) and those of greater scale directly to the west (Complex G), and possibly to the east (a continuation of the alignment of platforms of Complex B?). In contrast, open spaces that invite concentrations of people for special events and public ceremonies are present in the ancient city of La Venta. The largest of these covers an area of 42,000 square meters, interrupted only by a low platform (B-4). To the north of this enormous "plaza" the imposing pyramid is visible, and to the west front is seen one of the largest structures of La Venta, the so-called Stirling Acropolis. Other spaces exist, including a type of elongated "plaza," as seen especially between the structures of Complex D. These, in particular, seemed

to be reflected in the "avenues" and temple platforms in the central part of Teotihuacan, more than half a millennium later (Proskouriakoff 1971: 142).

Enormous gaps still exist in our knowledge of the primary aspects of much of the architecture and urban space in this ancient Olmec city. An example is the Stirling "Acropolis," which, like other structures at La Venta, was subject to archaeological excavations in the past that, while producing interesting data, were insufficient to determine the precise nature, dating, and function of its construction. Previous investigations have found U-shaped water distribution channels made of volcanic stone cemented with tar, some with covers, in addition to concentrations of sculptural fragments that indicate the presence

of possible workshops, while alignments of basalt columns, visible at surface level, still have not been investigated systematically (González Lauck 1990; Heizer, Drucker, and Graham 1968; Heizer, Graham, and Napton 1968).

Little is known of Complex B. On Platform B-4, a concentration of sculptural fragments was found in the archaeological investigations of the 1970s. Salvage archaeology, carried out in the 1980s to the north of Platform B-1, uncovered materials relating to the carving process, among them different types of lithic instruments, the reuse of utilitarian objects, and debitage (Rojas Chávez, J.M., personal communication, 1994).

Apart from the architectural design of Complex D, our information there is still extremely limited. Excavations in Structure D-7, however, in the extreme south of the area of monumental architecture in the archaeological zone, produced another bit of evidence regarding the function of the sculptural works. On Structure D-7, Blom and La Farge (1926) report three monumental sandstone sculptures in an advanced state of erosion. The three represent, in different sizes, a squatting human figure with arms outstretched as if to support an enormous helmet (Stirling 1968). The location and position of this sculptural group seems to reflect that of the three colossal heads that Stirling (1940) discovered in the northern part of the archaeological zone. In both cases, the sculptures mark the principal area of the city, perhaps signaling the main entrances. In the absence of a written language, these images probably transmitted a visual message that, in the Olmec cultural context, was implicitly understood by the viewers.

Complexes E, I, and the Sustaining Area of La Venta

One of the most important recent findings was the location of areas that indicate permanent residences for large numbers of inhabitants. These areas were first detected in 1984 in the so-called Complex E of La Venta, northeast of the ceremonial precinct, where surface reconnaissance located low-lying habitational platforms. This finding was confirmed by means of chemical evaluations of the soil, in which the unusual concentration of phosphates indicates the possible use of the area as a habitational zone (Barba Pingarrón 1988: 198). Other excavations report packed earthen household floors and cavities for food storage with a radiocarbon date of 680 ±90 B.C. (Rust and Sharer 1988).

As a direct consequence of having detected a habitational zone within the confines of the city, the contiguous area and surroundings, called the "sustaining area," began to be investigated. These works confirmed the presence of an ancient river drainage directly north of La Venta, reported by Stirling (1943: 50), on whose margins were detected a series of small settlements contemporary with the La Venta occupation in the first 1,500 years before our era (Jiménez Salas 1990a, 1990b; Rust 1987, 1988). This changes radically the traditional idea that the surroundings of La Venta were not conducive to human occupation. Indeed, far from being inhospitable swamps, these areas were extraordinarily rich.

In surface reconnaissance of the surroundings of La Venta during 1986 and 1987, in an area approximately 40 kilometers around the site, a little more than one hundred pre-Hispanic settlements were located (Rust 1987, 1988). Most of the sites are barely known and have been dated tentatively on the basis of surface material and test pits. To date, fifty-eight sites have been reported that correspond to the first millennium before our era. Many of these were located along the margins of the river drainages, some of which are now silted. This riverine pattern signals the close relationship that the ancient inhabitants of the region had with the river and other bodies of water: for comestible resources and communication routes, and the agricultural potential of the alluvial earth that became enriched with each inundation.

While still lacking adequate foundation, the recent archaeological evidence provides sufficient encouragement to see that the population that had existed in the surroundings of La Venta varied in terms of diet, construction, and other cultural materials. The surface remains in the La Venta sustaining area present two groups of settlement: those with only simple habitational platforms and those with more elaborate platforms, as well as simple ones. Within the category of habitational platforms, the most common are rectangular in shape with an area of 14 to 15 meters square. They present packed earthen floors, postholes, hearths, and remnants of wattle-and-daub walls and roofs, as well as ceramic, lithic, bone, and shell remains (Raab, Boxt, and Bradford 1995; Rust 1988: 24). The Olmec seem to have consumed different types of fish, turtle, deer, domestic dog, and aquatic animals, such as crocodiles. These last three animal remains appear with greater frequency at those sites with the most elaborate construction (Rust 1989). This evidence points to a clear and complex social differentiation between the resident population of La Venta as well as its neighboring areas in the first millennium of our era.

FINAL COMMENTS

The architectural remains of the ancient city of La Venta are truly impressive. There is no comparable city of the Olmec civilization within the Gulf Coast region or its confines. This highlights La Venta in its cultural and temporal context, designating it as a capital—where it had, undoubtedly, a concentration of power that was manifested through diverse cultural products. In this case, its architecture is one of the most tangible reflections, as was its large sculptural corpus and the valuable objects deposited in the ceremonial precinct of the ancient city.

Since the 1970s, enormous advances have been made in the definition of the Olmec civilization. This, in part, is

supported by the significant body of information revealed from fourteen seasons of fieldwork in the remains of La Venta, a city of the first magnitude in the Olmec world.

NOTES

1. For example, it is known that the alignment of the buildings today, which runs from Structure D-7 to B-1, was continuous until the 1970s, when two platforms were demolished between Structures D-2 and B-3. Also, on the basis of various lines of evidence, it is very probable that this alignment of structures extended toward where, in 1939, Matthew Stirling found three colossal heads.

2. Complex F is excluded in this discussion, because it corresponds to a post-Olmec occupation.

3. This architectural unit has been the most severely modified in recent times and, therefore, presently on the surface it is not possible to appreciate most of the features that were seen in the first half of this century.

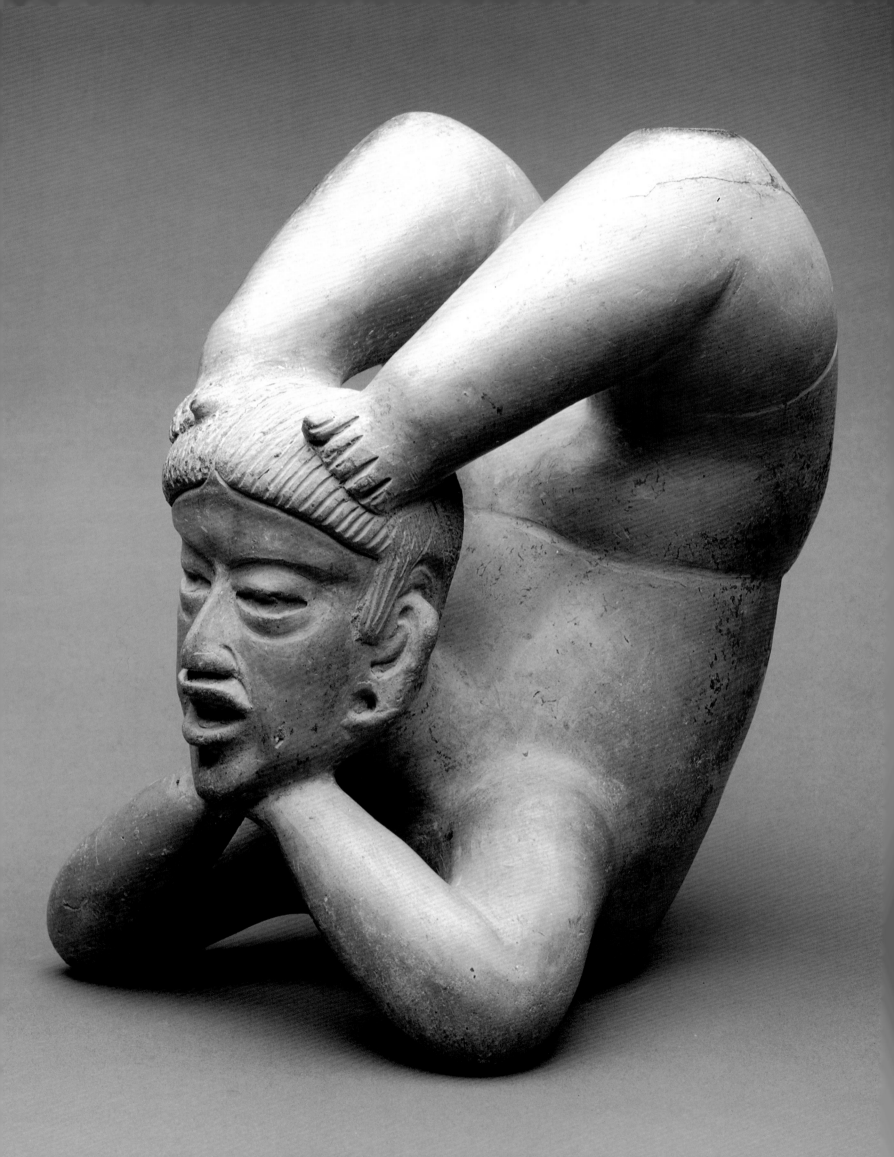

The Basin of Mexico: A Multimillennial Development Toward Cultural Complexity

CHRISTINE NIEDERBERGER

The political and economic power of the Basin of Mexico during the first millennium A.D. and on the eve of the Spanish Conquest has been the subject of massive and well-documented investigation. In contrast, the preceding epoch—from 1500 to 200 B.C.—remains inadequately studied. Ironically, it was during this fascinating period—somewhat ill-designated as "Formative," considering its complexity—that ranked societies and regional capitals began to develop in the southern and western fertile zones.

As nodes in a network of regional and interregional exchange, these first capitals, centers of political and economic organization, were also a focal point for information storage, including the production, reception, and redistribution of graphic symbols and sacred messages. They constituted an active component in the nascent Mesoamerican sphere of interaction, particularly during the pan-Mesoamerican cultural horizon, conventionally called "Olmec," from 1200 to 700/600 B.C.

Today, knowledge results from a long struggle against the conventional belief that the Basin of Mexico, until the Late Formative period, was characterized by simple egalitarian peasant societies that were culturally very static. A corollary opinion held that Olmec-style artifacts abruptly appeared in the region as evidence of foreign influence or domination by a single, distant ethnic group with greater sociocultural complexity. In those early stages of Olmec research, the multimillennial regional sequence of socioeconomic changes—initiated with early, sedentary villages in optimal habitats near the end of the sixth millennium B.C.—was not yet known. Furthermore, many scholars, given the desolate condition of the modern landscape, were convinced that in contrast to the lush and luxuriant Gulf Coast lowlands, the Basin of Mexico was unable to support complex human settlements before the development of irrigation practices. This hypothesis reveals a mis-understanding of the ancient geography of the basin. In fact, in pre-Hispanic times, large areas of this temperate lacustrine basin constituted one of the most favorable environments for human occupation.

SPLENDID LANDSCAPES AND ABUNDANT RESOURCES

On the eve of the twenty-first century, the Basin of Mexico, with one of the world's largest metropolitan centers, offers little evidence of the extraordinary ecological bounty of its past. The artificial drainage of its ancient lakes—a remarkable, highly productive aquatic world—completed around 1900, is but one of the many environmental deteriorations of modern times, which include anarchic urban growth, deforestation, erosion, and chemical and organic pollution of the air and water.

This vast basin covering 9,600 square kilometers has always presented a notable diversity. The floor is approximately 2,230 meters above sea level—an altitude that corresponds to a temperate climate in Middle America—and is surrounded by a mountain range whose highest peaks, the snowy volcanoes of Ixtaccihuatl and Popocatepetl, form the Sierra Nevada and rise above 5,000 meters (fig. 1). Thus, rainfall, soil characteristics, and plant covers vary according to altitude. In addition, three lacustrine sub-basins—the northern, central, and southern—have distinct environments.

More relevant perhaps for ancient human settlements is the contrast between the northeastern and southwestern regions. The north, adjoining the semiarid plains of the Northern Mexican Plateau, as well as the eastern regions of Texcoco in the lee of the Sierra Nevada, have less than 700 millimeters of annual rainfall. In contrast, the green and fertile western edges of the central subbasin, where the regional center of Tlatilco developed around 1250 B.C.,

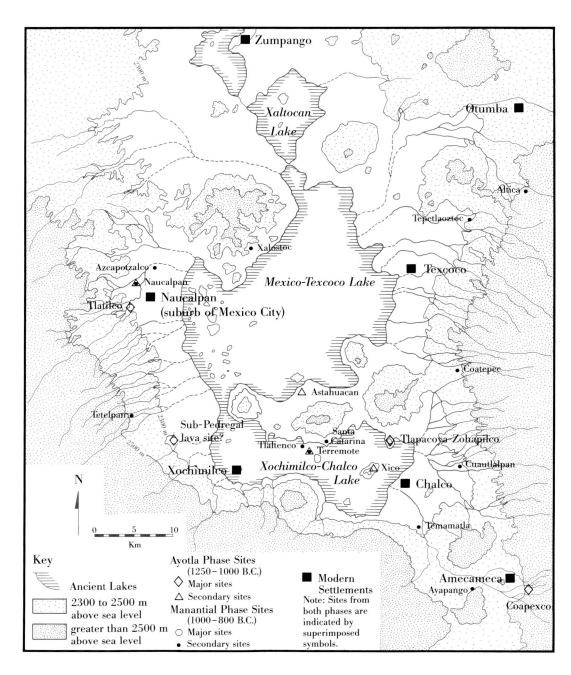

Key

Ancient Lakes

2300 to 2500 m
above sea level

greater than 2500 m
above sea level

Ayotla Phase Sites
(1250–1000 B.C.)
◇ Major sites
△ Secondary sites
Manantial Phase Sites
(1000–800 B.C.)
○ Major sites
• Secondary sites

■ Modern
Settlements
Note: Sites from
both phases are
indicated by
superimposed
symbols.

Map 1. Ancient sites in the
Basin of Mexico.

as well as the southern subbasin of Chalco-Xochimilco, where, at the same time, the regional capital of Tlapacoya-Zohapilco arose, receive more precipitation. Until recent times, these western and southern zones were marked by perennial rivers, which have now been piped and drained northward. Following a long pre-Hispanic tradition, studied by Pedro Armillas (1971), this area also saw the apogee, in Aztec times, of one of the most ingenious farming systems of Pre-Columbian America, namely, horticultural gardens on artificial islets, or "chinampa," built in the shallow zone of freshwater lakes.

Studies of ancient landscapes and faunal, pollen, and archaeological remains have shown that the shores of the freshwater Chalco-Xochimilco lake at Tlapacoya-Zohapilco was occupied year-round by pre- or protoagricultural communities as early as the sixth millennium B.C. (Niederberger 1987). Its inhabitants had access to nearby and diversified ecological zones. They exploited a lacus-

trine environment rich with fishes, turtles, and amphibians or resident aquatic birds, such as coots and Mexican ducks, as well as migratory geese, grebes, and ducks, including pintails, mallards, shovelers, teals, and red-heads. On riverine fertile alluvial soils, horticultural experiments were already under way; they also took advantage of the resources of the neighboring pine-oak-alder forests, habitat of small and large mammals such as the white-tailed deer.

During the third millennium B.C., agricultural practices with such plants as maize, amaranth, green tomato, squash, chayote, and chili pepper were fully implemented. Zohapilco's inhabitants then used larger and more standardized stone-grinding tools. New forms of plastic expression occur, as in the most ancient known example in Middle America of an anthropomorphic figurine of baked clay. Pottery vessels become part of daily life, slightly later, during the second millennium B.C.

Around 1200 B.C., regional centers develop at Tlapacoya-

Fig. 1. The snow-capped Popocatepetl volcano at the southern lacustrine basin.

Zohapilco and in other zones such as Coapexco or Tlatilco, the result of a long regional maturation. Their activities indicate that the Basin of Mexico, with its favorable environment, its system of lacustrine basins offering transportation facilities, and its highly prized regional obsidian mines, was already beginning to represent one of the key zones of early Mesoamerica during "Formative" time (1500–200 B.C.) and, within this period, the "Olmec" cultural horizon (1200–700 B.C.).

CHRONOLOGY IN THE FORMATIVE PERIOD

The active role of the Basin of Mexico in the emergence and development of early pan-Mesoamerican technoeconomic strategies and Olmec horizon cultural patterns has long been obscured by a series of misinterpretations. First, a monumental error in the relative and absolute chronology, maintained until the late 1960s, has led to the mistaken belief that the Late Formative sites of El Arbolillo and Zacatenco, studied by George Vaillant in the 1930s, were very ancient. These sites, with C-type prognathous clay figurines, incorrectly dated to 2000/1500 B.C., were said to represent "the very first and primitive villages" of the basin. Thus, when sophisticated, still undated, Olmec-style artifacts were discovered, first in the site of Tlatilco,

in the 1940s, they were interpreted as indications of a later development and as the mark of culturally more advanced intruders within Zacatenco static culture and primitive villages. Today it is acknowledged that El Arbolillo and Zacatenco sites are, in fact, late peripheral occupations of large regional centers, evolving from 600/500 B.C. onward. The Olmec-style horizon, with complex ranked societies, largely precedes them in time and constituted, between 1200 and 700 B.C., a coherent cultural entity. But, curiously enough, the firmly held belief in a Basin of Mexico marked, during Formative times, by a cultural lag or by the existence of two-tiered contemporaneous cultures is still directly or indirectly implied in many publications.

Fortunately, with a large set of carbon-14 dates from reliable stratigraphical excavations, the Basin of Mexico now has solid benchmarks to define the sociocultural and technoeconomic evolution from 6000 B.C. to Teotihuacan times, including the Olmec horizon period. Again, the deep archaeological deposits of Tlapacoya-Zohapilco were instrumental in those definitions. The Ayotla Olmec horizon phase I of this site (1200–1000 B.C.) was first adequately dated by Paul Tolstoy. We later amplified the definition of this phase with the study of a larger amount of diversified material and related paleoenvironmental evidence. At the same time, the data of our excavation permitted us to date

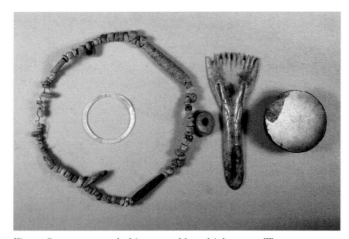

Fig. 2. Ornaments and objects used by a high-status Tlapacoya personage during the Ayotla-Manantial phase.

and define a long pre-Ayotla cultural sequence—with the Playa (5500–3500 B.C.), Zohapilco (2500–2000 B.C.), and Nevada (1400–1200 B.C.) phases—and a post-Ayotla period, with the densely represented cultural phases that we named Manantial (Olmec horizon phase II, 1000–800 B.C.) and Tetelpan (Olmec horizon phase III, 800–700 B.C.) (Niederberger 1979, 1987). Tetelpan horizon, where Olmec style and iconography faded away and disappeared, was the immediate predecessor of Zacatenco culture development. The initial definition of the Zacatenco phase (700–400 B.C.) and later Ticoman horizon (400–100 B.C.) is based on the pioneering work of Vaillant of the early 1930s. It is worth noting that Vaillant never attributed a great antiquity to the El Arbolillo and Zacatenco sites; in the absence of carbon-14 dating, he prudently ascribed them to an Intermediate period, between yet unknown occupations and the later Teotihuacan period.

This, in broad strokes, is the sequence now used as the framework of many recent highland investigations. But its impact goes far beyond chronology reappraisal to affect the basic conceptions of the sociopolitical nature and the rhythm of evolution of the ancient societies of the Basin of Mexico. The regional build-up toward increasing cultural complexity is now well attested. This phenomenon, together with the contextual data, led us to discard the term "Olmec" as synonymous with a specific Gulf Coast ethnic group that dominated or indirectly influenced less-advanced societies. For us, then, "Olmec" is limited to the sense of a specific style and civilization.

MASSIVE DESTRUCTION OF EARLY MESOAMERICAN SITES DURING PRE-HISPANIC AND MODERN TIMES

Another reason why the nature of Early Formative cultures in the basin has been constantly misunderstood is that the area suffered repeated and massive destructions of its most ancient sites by later occupations. As a result, few to none of the early structural surface remains have survived the

impact of three successive and powerful urban centers: Teotihuacan and satellite settlements; Aztec Tenochtitlan and related sites; and the twentieth-century megalopolis of Mexico City.

Tlapacoya

Among eradication and "recycling" processes of early Mesoamerican sites and features, one of the most unfortunate has been the destruction of the Olmec horizon site of Tlapacoya, in great part bulldozed out, in 1958, for the Mexico-Puebla Highway. An earthen platform projecting from the hill toward the ancient lake—of which some basal external limits still may be observed—was destroyed. At the time, people aware of Tlapacoya's importance bought sacks of earth from the site to sort out. Now, Olmec horizon phase I (Ayotla) and II (Manantial) ceramic vessels, figurines, jade and serpentine ornaments and celts, seashell bracelets and pendants, iron-ore mirrors, and other elaborate burial offerings from this structure are in the Roch Collection, now at the National University of Mexico (fig. 2), in nearby private haciendas, and in Mexican and U.S. museums, such as the National Museum of the American Indian, now in New York. At the edge of this large devastated area remain the Ayotla zone and the Zohapilco

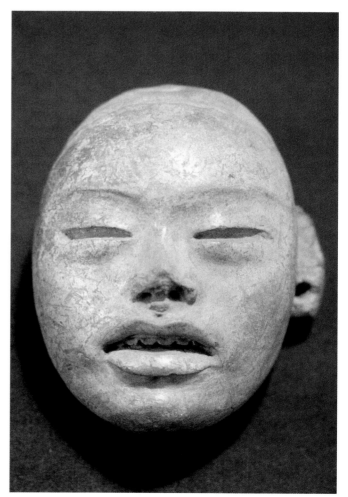

Fig. 3. White-slipped polished head from Tlatilco, probably from the Ayotla phase. Once in the Covarrubias Collection, it is now in the National Museum of Anthropology.

ancient shores, where the long six-millennia cultural sequence, reported above, has been rescued.

In ancient times, the island of Tlapacoya, a dome-shaped volcanic formation of pink andesite, seen from far away and reflecting in the surrounding lake, must have been an impressive sight, conceived of as a sacred place. For decades, however, Tlapacoya has also been systematically dynamited and exploited as an andesite source and quarry.

In 1992, cliff and cave paintings from different chronological periods were discovered in Tlapacoya above the Zohapilco ancient shores area. Several paintings, including a chubby chin and baby-face profile and an oval cartouche with cross-hatching, seem to date to the Ayotla-Manantial period. They are oriented toward the east—the most important direction in ancient Mesoamerica—and the snowy summits of Ixtaccihuatl and Popocatepetl. Receiving the early light of sunrise, they may have constituted a significant component of sacred space.

Tlatilco

Site destruction and misinterpretation can also result from systematic looting and limited archaeological excavations, as at Tlatilco, which served for decades as a clay source and brick-manufacturing yard. The site, together with hundreds of ancient burials, was largely destroyed before being built over with multistoried buildings and highways. Located within the fertile western alluvial plains of the Hondo River, Tlatilco, a large Formative site contemporaneous with Tlapacoya, was visited regularly since the mid-1930s by collectors, eager to see the new findings of brick-makers. The great artist and anthropologist Miguel Covarrubias was soon aware of the fact. After his acquisition of fine clay vessels decorated with abstract motifs, figurines of superb craftsmanship, and green metamorphic stone objects such as earplugs, celts, or Olmec-style figurines, he decided to undertake preliminary excavations in 1942 (fig. 3). In a second field season, from 1947 to 1949, aided by Muriel Porter, Román Piña Chan, and Arturo Romano, Covarrubias and field director Daniel Rubín de la Borbolla excavated and studied two hundred burials. The third field season, in 1955, directed by Piña Chan, exposed numerous bottle-shaped food-storage or rubbish pits and explored twenty-five burials outside the central area. The fourth and final field season, directed by Romano, from 1962 to 1969, brought to light another 214 burials (fig. 4). Only at the very end was attention directed to the systematic study of occupational levels.

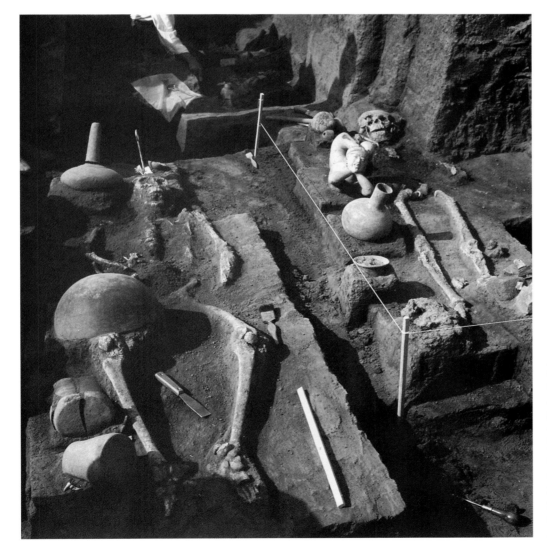

Fig. 4. Burials 154 and 155, excavated at Tlatilco in 1967. At right, burial 154 is of a high-status adult male, with intentional cranial deformation. His funerary offerings included quartz amulets, jadeite and bone earspools, an iron-ore mirror, flint and obsidian artifacts, metamorphic greenstones, and ceramic vessels. The white-slipped vessel is an acrobat effigy.

In other words, from 1942 to 1968, Tlatilco had been considered the most important necropolis of Formative times, when, in fact, it represents a large city with houses, subsistence remains—including maize, coots, white-tailed deer, peccaries, turkeys, and domestic dogs—refuse pits, and associated burials, as well as evidence of involvement in long-distance exchange networks. The site not only had simple houses, but probably also clay-surfaced earthen platforms, as suggested by the mounds, terraces, and steps observed in the profiles of fresh-cuts during excavation.

As to chronology, several phenomena may account for the failure to date the different components of the Tlatilco occupations correctly. Among them, the priority given to the excavations of burials and other nonstratified elements, and the inclination to date the evidence to the late Zacatenco sequence established by Vaillant.

Faced with the stylistic heterogeneity of apparently simultaneous deposits, Covarrubias, and many of his successors, postulated that Tlatilco was a Zacatenco-type simple rural community converted into a large Olmec colony, with local peasants in conflict with an intrusive Olmec elite or with an Olmec culture-bearer upper-class.

Today, cross-correlations with the master sequence established at Tlapacoya-Zohapilco indicate that Tlatilco covers at least eight hundred years, from 1200 to 400 B.C., and that the Tlatilco people of the pan-Mesoamerican Olmec horizon were not even contemporaneous with the late occupations of the site, related to Zacatenco cultures.

Nevertheless, even today some scholars still refer to the Olmec "presence" in highland sites or postulate that the people from the Gulf Coast were exporting elaborate objects to the inhabitants of the Basin of Mexico, who were likely considered barbarian. Other researchers, who have not evaluated the recent data, hold that the Basin of Mexico, and many highland sites in Mesoamerica, had not reached, during Early Formative times, the degree of sociocultural complexity of other areas. But, in fact, not only did these ancient societies achieve the same level of cultural evolution, they also generated, as far as ceramic iconography is concerned, one of the most complex and sophisticated records of Olmec horizon Mesoamerica.

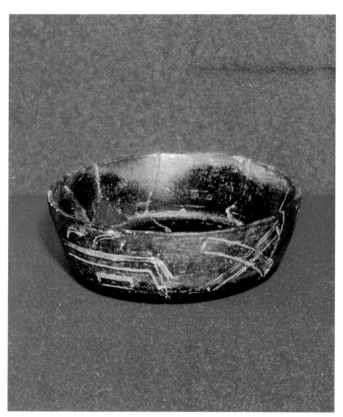

Fig. 5. Small, white-rimmed black vessel from Tlapacoya, with crossed bands and "fire-serpent" excised symbols.

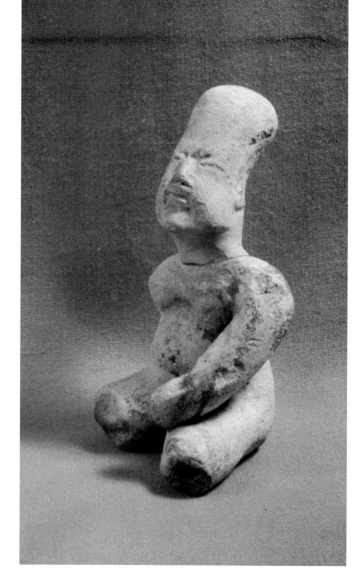

Fig. 6. White-slipped clay personage of the Pilli type, with particularly pronounced intentional cranial deformation, from Tlapacoya. Ayotla phase. 9.4 cm.

THE ICONOGRAPHY

Pottery, figurines, and other artifacts provide a basis for the internal chronology of Olmec horizon deposits — corresponding to the Ayotla, Manantial, and Tetelpan cultural phases — and also allows the analysis of a rich and coherent set of signs related to prevailing norms and belief systems.

A wealth of iconographic information derives from the passionate work and skillful drawings of Covarrubias (1957), and from the publications on Tlatilco (Porter 1953, n.d.; Piña Chan 1958, 1971; Coe 1965b; García Moll et al. 1991) and Tlapacoya (Porter 1967; Reyna Robles 1971; Niederberger 1976, 1987).

Fired-clay pottery, in particular the beautifully crafted globular bottles with straight necks, and flat-based vessels with vertical or slightly outflaring walls, carried powerful graphic messages (fig. 5). Locally made, as shown by mineralogical analysis, they attest to the existence of artisans, highly trained not only in their craft but also in complex hermeneutics. Among the purest examples of Olmec style and graphic symbolism on ceramic, they offer the range of stylistic variations and symbols in use in ancient Mesoamerica. These symbols include the St. Andrew's cross; the U, L, and reversed E motifs; circles, bars, double spirals, diamonds, and five-dot symbols; four-petaled flowers; representations of an eye, foot, hand, or claw; small hand shields; burning torches; and V-shaped or cleft-head motifs, often with sprouting plants.

Within the dense repertoire of composite and fantastic mythological creatures — often evoked by isolated features such as a reptilian fang, feline paw, human hand, bird's wing, or a serpent's body — figure powerful anthropomorphic representations with feline features, and, as noted by David Joralemon (1976), abbreviated animal forms, including raptorial birds, caimans, fish, felines, and serpents, combined to form hybrids. These representations convey a wide range of complex messages, as shown by the many efforts to decode them. Symbols may represent celestial bodies or underworld powers, natural forces, status objects, or sacred events.

The series of human/feline cleft-head profiles marked with wrathful expressions — a recurrent motif on Tlapacoya vessels — may be emblematic of sacred political power. But the same motif, in frontal position with a gaping mouth, a metaphor for a cavern and the entrance to the underworld, appears to relate to world views and religious concepts. Dragonlike figures, such as the clay sculpture of a crested-saurian creature, may depict a prototypical form of the Mesoamerican earth monster. An extraordinary motif, incised on the flat bottom of a Tlapacoyan vessel, also shows a hybrid fish or amphibian body, bulbous nose, fangs, and most interesting, a closed eye crossed by a vertical band, symbol of death in later Mesoamerican cultures. An impressive clay mask of Tlatilco, vertically split into two faces — one depicting death, and the other showing a

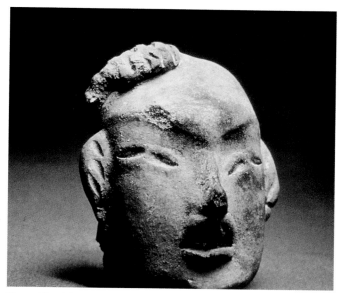

Fig. 7. Head fragment of a Tlapacoya hollow-clay personage from the Ayotla phase. 7.5 cm.

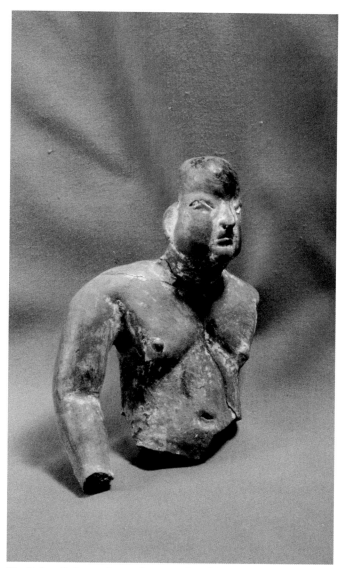

Fig. 8. Small clay sculpture fragment from Tlapacoya, representing the head and torso of an adult male with shaved head and intentional cranial deformation. Approximately 30 cm.

grimacing figure—reveals an interest in duality concepts and the Mesoamerican preoccupation with the ephemeral nature of life.

Certain glyphlike symbols may represent some pristine forms of writing. At the heart of this debate is a clay stamp from Tlatilco, of the Ayotla/Manantial phase, which has three graphic elements: a cleft cartouche with bar and dots; a four-petaled flower; and a hybrid man/feline head profile. For David Kelley (1966) they may already represent true ideograms, corresponding to a precise signification accompanied by a phonetic reading. This category of elements must indeed be placed at the origin of Mesoamerican writing systems. But we believe that they should be better defined as mythograms. These are graphic symbols with accurate meaning that may relate to codified signs of titles, sacred forces, or emblems of lineage or locality, but without systematic phonetic counterparts. In any case, such evidence shows the cultural complexity of Early Formative societies in the Basin of Mexico.

Within the group of modeled clay figurines of the Pilli and Isla types, a wide range of categories can be observed: real or conventional personages and dignitaries, including numerous male figures, often with cranial deformation and shaved heads, sometimes with small central or lateral hairlocks (figs. 6–9); large baby-faced hollow figurines (cat. 22); personages involved in public ceremonies or events, such as acrobats or masked figures; mythological beings or depictions of local or pan-Mesoamerican sacred powers.

Among elaborately costumed figurines, one category conveys a particularly strong iconographic message. Tlapacoya has yielded a large number of them. These have generally been interpreted as dignitaries or religious authorities related to the ballgame, which, in Mesoamerica, always has sacred connotations (figs. 10–11). Some of them may represent ballplayers in ceremonial attire: an impressive towering headdress, huge earplugs, wrist and ankle bands, protective belt or waist yoke, and hip padding. Often they also wear a buccal mask. The headdress may be crowned with a curving, plantlike motif. An important element of this attire is what seems to be an iron-ore concave mirror, worn as a pectoral or a belt ornament. John B. Carlson (1981) has studied Formative mirrors in the light of later Mesoamerican evidence. Concave iron-ore mirrors are generally high-status emblems, a mark of power, and related to sun symbols. They were also used for ritual smoke-producing or fire-making, and divinatory purposes. In another context, unadorned D-type figurines, common during the Manantial phase, may wear a small, plane-surface hematite pectoral mirror that may be associated with shamanism and healing (fig. 12).

D-type figurines, including the delicate and gracious D1 figures called by Vaillant "pretty ladies," have long been considered, together with a particularly imaginative set of pottery forms—such as stirrup-spouted vessels, spouted trays, globular gadrooned red-on-buff jars, animal

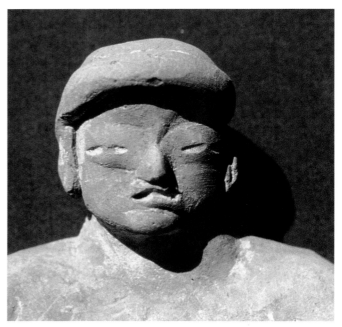

Fig. 9. Clay representation of an Ayotla phase male personage, of the Pilli type, wearing a turban. 22 cm.

effigy vessels—as part of an independent cultural assemblage of unknown origin. At one time this undated set was considered a sort of *tertium quid*, neither "Olmec" nor "Zacatenco" in style; it was then qualified as a "Tlatilco-style" manifestation, because of its frequent appearance at that site.

The Tlapacoya-Zohapilco sequence has now clarified the situation. This set of vessels and figurines, common in highland communities, is not characteristic of a site, but constitutes a hallmark of the Manantial cultural phase and chronology, as well as an excellent example of the notable creativity and skill of highland craftsmen between 1000 and 800 B.C. Simultaneously, as an intrinsic part of the same societies, and as an expression of a pan-Mesoamerican belief system, seals, vessels, and other artifacts with esoteric motifs continued to be made. A typical example is a remarkable Manantial phase cylindrical white-slipped vessel found at Tlapacoya. Within a "double-line-break" framework, characteristic of the Manantial graphic repertoire, it shows, in a very fine and fluid outline, an extraordinary composition of five intertwined faces of a cleft-head human/feline creature. These supernatural faces are of different sizes, with frontal and profile views, one with a three-pronged plant symbol sprouting from his jaws. Two are associated with the glyphlike five-dot motif, a significant graphic element of that epoch.

Archaeological evidence from the Basin of Mexico and from Puebla shows that they were also unsurpassed masters in the observation and rendering of animal life. Effigy vessels of ducks and other common animals are among the most moving evocations produced in small clay sculptures in Mesoamerica (cat. 27).

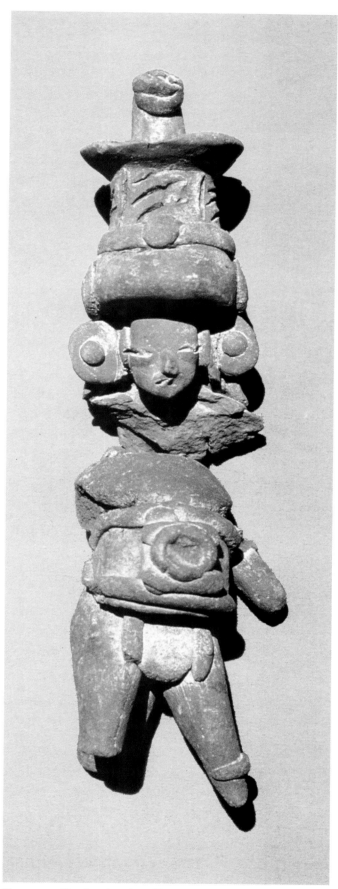

Figs. 10, 11. Clay figurines from Tlapacoya.

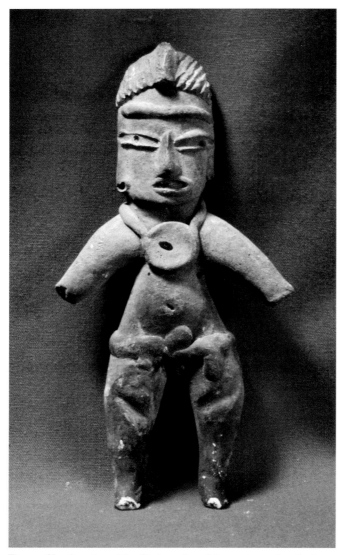

Fig. 12. Clay figurine of the D2 type, found in great number during the Manantial phase in Tlatilco and Tlapacoya, as well as other highland sites. 11 cm.

Nature and Function of the Regional Center Toward 1000 b.c.

During the Ayotla/Manantial phase, regional centers emerged in several areas of the Basin of Mexico: Tlatilco, in the western plains; Tlapacoya-Zohapilco, in the southern lacustrine zone; Coapexco, in the extreme southeastern mountain area; and, under the Pedregal lava flow, which destroyed the mounds of Cuicuilco, a fourth site may also exist. Coapexco, a shallow early Ayotla site, later covered with final Formative and Aztec settlements, occupied a strategic position above the Amecameca valley, connecting highland sites to tropical lowlands. The extent of Coapexco during the early Ayotla phase has been estimated to be 50 hectares (Tolstoy et al. 1977). Excavations and surface survey indicate that Tlapacoya, head of the southern regional polity, was surrounded by at least seven satellites during the Manantial phase. Constant demographic growth and an efficient agrarian system are attested; these led to the colonization and development of

northern sites, such as Xalostoc, where irrigation practices are already manifested (Nichols 1982).

Data from Tlapacoya and Tlatilco clearly indicate that both sites were the center of a formalized configuration of political and sacred authority, and public ceremonies, and that they constituted a focal point in the elaboration, reception, and redistribution of sacred and secular information.

As regional capitals they were characterized by a relatively large population, organized into groups by function and social status. An excellent key to the understanding of this internal social hierarchy was given by the data gathered at Tlatilco and communicated or published by Porter, Romano, and García Moll. Our comparative study of burial offerings reveals considerable variation between individuals. Clustered burials show groups with no or limited offerings, or with specialized craft tools; burials with rich and varied offerings but no prized exotic items; and high-status burials with regional and exotic prestige goods, such as jadeite, serpentine, seashells, and iron-ore mirrors.

One funerary offering, reported in the 1940s, contained 806 blue-green jade beads, some carved in the shape of squash; some 20 light green jade beads associated with a bowl full of ocher; pieces of iron-ore mirror; and 12 refined pottery vessels including fine, highly polished white-slipped ware. Armillas made a study of the drill-holes of the beads and concluded that it was the largest cache of jade ever found in the basin, and the largest jade necklace ever found in the Americas.

Tlatilco elite burials of the Ayotla/Manantial phase are also characterized by the presence of seashells, including large conchs, unworked or transformed into bracelets or musical instruments, and adornments made of the nacreous *Pinctada mazatlanica* or pearl oyster of the Pacific Coast, also well represented in contemporary highland sites (Pires-Ferreira 1976b).

The presence of these exotic goods, fruit of an active and regular interregional exchange, evinces a key function of the regional capital: the organization and control of the economic system.

The Dual Nature of Interregional Exchange Systems

With the rise of regional capitals, centers of stable polity and specialized craftsmanship, several concomitant phenomena can be observed. One is the almost explosive development of long-distance exchange activities. Obsidian from the Basin of Mexico, a material that provided the best cutting tools of the pre-Hispanic world, had been traded for centuries, but, toward the end of the second millennium b.c., through the canal of Tlapacoya and Tlatilco, and most probably Coapexco, a wide range of commodities was circulating. This included obsidian, chert, exotic clays from Oaxaca (Flannery and Marcus 1994: 165), iron ore probably from Oaxaca/Chiapas, serpentine and blue-green jade from Guerrero, asphalt from the Gulf Coast, travertine

onyx from Puebla, *Pseudemys* marine turtles, and Pacific Coast seashells.

The Pacific Highlands pearl oyster route, archaeologically documented and passing through Teopantecuanitlan, Guerrero, was active within this multidirectional network of commodities exchange.

Since the pioneering work of Marcel Mauss in the 1920s, the noneconomic dimension of such exchange systems has been stressed. All structured systems of goods exchange are doubled by an equally dense and regular exchange network of information. Through the bias of this dual conduct, some forms of cultural symbiosis are intrinsically associated with the economic exchange. In Middle America, toward the end of the second millennium B.C., all the societies involved in such a system shared a common set of visual and semantic symbols. It is our belief that all the active and regular components of this sphere pertain to the same level of sociocultural complexity. In varying degrees, they all contributed to the multimillennial and complex processes leading to the crystallization of "Olmec" style and belief systems, in other words, to the birth of Mesoamerican civilization.

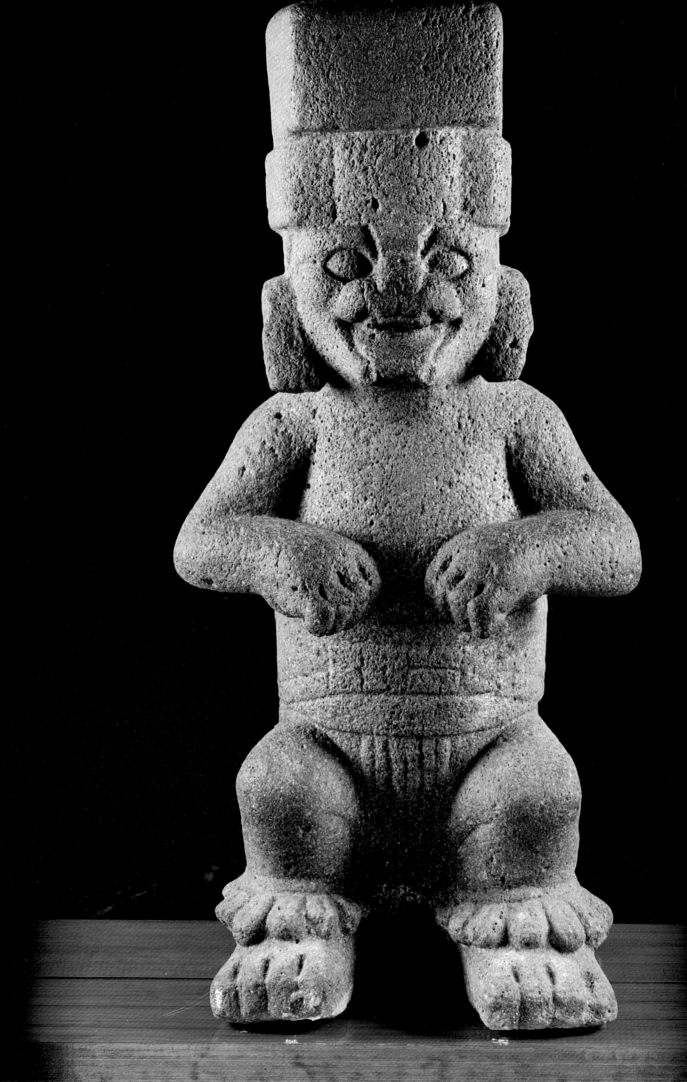

Olmec Horizon Guerrero

CHRISTINE NIEDERBERGER

Guerrero, in southwestern Mexico, is a land of contrast. Its high mountain ranges and rugged escarpments form imposing structural barriers that foster cultural isolation, while its complex hydrographic system, valleys, and Pacific Coast plains offer natural pathways for the circulation of men, products, and information.

Particularly relevant to development in ancient societies was the Balsas River, which flows from northeast to southwest, crossing distinct altitudinal levels and biogeographic zones. From its source in the high Mexican Plateau, east of the Sierra Nevada, until it empties into the Pacific Ocean, the Balsas, one of the few perennial rivers of western Mexico, covers approximately 800 kilometers. Numerous northern tributaries, from the Central Mexican Plateau, and southern tributaries, from the Sierra Madre del Sur, form a vast basin estimated at 108,000 square kilometers. This basin provides moisture and water supplies for domestic and agricultural use, alluvial plants, animal life, and transportation.

A gift of nature in the semiarid lowlands of western Mexico, especially during the dry season from November to April, the constant flow of the Balsas was systematically exploited for agricultural purposes in the pre-Hispanic era. Indeed, data from sixteenth-century sources, analyzed by anthropologist Pedro Armillas, indicate that the Balsas basin had been, before the Spanish Conquest, one of the most important regions of irrigated agriculture in Mesoamerica and a major zone of production of such valued cultivated plants as cotton and cacao. With this in mind, the existence of intensive agrosystems and megalithic irrigation structures in the Balsas area as early as the Olmec horizon takes on broader significance.

DISCOVERING THE ANCIENT PAST

The history of research on the Olmec horizon, which extended from approximately 1200 to 600 B.C., has been marked by the coexistence of two highly contradictory views of Guerrero's role in the development of Olmec sociocultural patterns and belief systems. One long-standing position posits Guerrero as a culturally passive and marginal frontier zone, whose major interest in early

Mesoamerica was as the source of highly valued items, such as jadeite, serpentine, or marine shells. At the other extreme, another view, first presented in the 1940s by Miguel Covarrubias, based on the impressive number of portable Olmec-style sculptures found in Guerrero, postulates that this region was the cradle of Olmec civilization.

Isolated finds have been reported from numerous areas, in particular from San Jeronimo, Zihuatanejo, Petatlán or Ometepec on the coastal zone; from Olinala and Tlapa in the Eastern Mountain region; from the Middle Balsas area; and from Huitzuco, Xalitla, Xochipala, Zumpango, and Chilpancingo in the central zone. The categories most often represented among those artifacts are highly polished jadeite or serpentine human masks, figurines and celts, spoonlike objects, perforator handles, earplugs, and pendants. Many are finely engraved with typical pan-Mesoamerican Olmec motifs, such as the hybrid with anthropomorphic, feline, and reptilian features. These elements, with strong semantic contents, include cleft-head motifs, sometimes with sprouting vegetation; almond-shaped eyes; flame eyebrows; snarling mouth; fangs; and the ubiquitous crossed-bands symbol on headbands or pectorals. The pearly surface of seashells was also considered a desirable support for the shared repertoire of signs and symbols. Wood must also have been used, as suggested by the well-preserved wooden mask with jade inlays found in the Canyon de la Mano, near Iguala. As to fired-clay craftsmanship, including fine vessels decorated with elaborated abstract motifs, Guerrero has yielded a remarkable number of white-slipped baby-type plump figurines, made in an effortless interplay of curves and counter-curves, with an innate sense of three-dimensional rendering characteristic of Olmec art.

In his 1957 *Indian Art of Mexico and Central America*, illustrated with his own remarkable drawings, Covarrubias noted that Guerrero was the most challenging and the least known of the Mexican states. In spite of the vast number of archaeological objects found there, the region was virtually unexplored, with the exception of looters and treasure hunters. Nearly forty years later, the same observation can be made, as most of the archaeological excavations carried out there have not been planned projects, but rather the result of urgent salvage actions to stop looting or to facili-

tate the construction of public works, such as the Infiernillo dam, near the Balsas mouth, or the new highway to Acapulco. Nevertheless, recent archaeological discoveries should provide significant breakthroughs in the understanding of ancient Guerrero's role in the development of early Mesoamerican civilization.

CAVE PAINTINGS

Guerrero is exceptionally rich in Olmec period cave and cliff paintings. The Juxtlahuaca cave, reported by Carlo Gay and Gillett Griffin in 1966 and situated in the eastern region of the Sierra Madre del Sur, near the village of Colotlipa, offers well-preserved evidence of rupestrian paintings related to social life and belief. In the deepest levels of the grotto, a polychrome scene shows a mythological ruler or actual dignitary: a lordly, standing personage in a brightly colored tunic with red, yellow, and black horizontal stripes, a high headdress with long green feathers in a red device, large earrings, and jaguar-skin gauntlets and leggings (fig. 1). In his right hand he holds a trifold element, and in his left a large, flexible rope leading to a much smaller, reddish figure with a black-painted face, who sits at his feet looking up at him. This scene strongly resembles the pictorial conventions of later palatine Mesoamerican art, where relative size and location of figures express a visual message of social rank or vassalage. The smaller figure, with necklace and squarish headdress, is not necessarily a captive; another plausible interpretation, always within the framework of ranked society, is that the scene presents a metaphoric image of dynastic succession or validation of lineage continuity. Other paintings in the cave include that of a reddish quadruped with spotted, jaguar-like skin and a large red serpent with a long, curvilinear tongue and a feathered headdress. The serpent's eye is marked, as if to enhance his mythological nature, with the crossed-bands motif.

To the north of Juxtlahuaca, in an Oxtotitlan rock shelter and cliffs, another group of Olmec horizon rupestrian paintings were reported by Jean Dubernard and thoroughly studied in 1970 by David Grove. They include a kneeling human figure, human-head profiles within a four-petaled flower cartouche or wearing a serpentlike buccal mask, a scene evoking a sexual relationship between a standing figure and a feline, and an elaborate reptilian creature with feathered crest, bifid tongue, and fangs. Of utmost interest is Painting 3, in the north grotto, depicting the head of a bird-serpent hybrid with three or more circles. This combination of a symbolic element with probable numerical signs could represent, as noted by Grove, one of the earliest date glyphs in Mesoamerica. On the cliff wall, a singularly instructive painting, nearly 4 meters wide and 2.5 meters high, illustrates a sumptuously dressed dignitary on a large, thronelike structure, an effigy of a stylized hybrid. The figure wears a horned owl head-

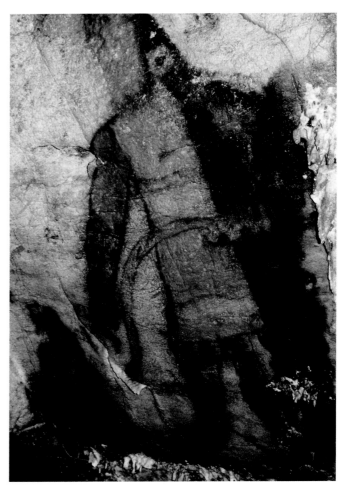

Fig. 1. Olmec horizon cave painting in Juxtlahuaca.

dress, a cape with blue-green, red, and ocher feathers, a rectangular pectoral with the crossed-bands motif, a blue-green loincloth, and a red fringed skirt with hand and scroll symbols. The coexistence of several water symbols in the Oxtotitlan paintings has led some scholars to suggest the site as a shrine to agricultural fertility and as a sacrificial space dominating spring-irrigated lower fields. But the iconographic and semantic richness of the site may also evoke cosmological cycles, myths of origin, and legitimization of rulership. Today, the list of Guerrero cave paintings goes beyond these remarkable sites. In 1989, Samuel Villela reported the discovery of a new set of Olmec horizon paintings at Cacahuaziziqui, southwest of Tlapa, and at Texayac and Tepila, east of Tierra Colorada.

GUERRERO'S ROLE IN THE OLMEC PERIOD CULTURAL SYSTEM

The corpus of rock paintings found in Guerrero has often led to extreme and unlikely diffusionistic interpretations. In this context, these paintings would have been made by intruders or conquerors, designated as "Olmecs," coming from a culturally more advanced and rather distant region: the Gulf Coast. This kind of traditional inference clearly

shows the semantic problems in the use of the term "Olmec" to define the cultural system observed in ancient Mesoamerica between 1200 and 600 B.C., as we have noted since the early 1970s. Once used to classify the first archaeological discoveries made at La Venta, Tres Zapotes, and San Lorenzo in the Gulf Coast—and following the name of a protohistoric group living in this region on the eve of the Spanish Conquest—the term soon began to acquire ambiguous and inevitable semantic properties. Every archaeological manifestation labeled "Olmec" in style, regardless of the distance from La Venta or San Lorenzo, would be seen as the consequence of direct or indirect influence from a unique, "Promethean" Gulf Coast ethnic group. Both from a general anthropological point of view and from factual archaeological data, this interpretative scheme seems difficult to sustain.

In a milder, but still diffusionistic, vein, it has been argued that local chiefs, outside the Gulf Coast area, heads of "provincial" communities of lesser social complexity, were acquiring Olmec-style prestige items, following norms created in the Gulf Coast area, to reinforce their sociopolitical status. The first discovery of a monolithic Olmec-style stela in a collection in Arcelia, near Amuco, in the Tierra Caliente of the Middle Balsas region, reported by Grove and Louise Paradis in 1971—as well as subsequent archaeological exploration by Paradis (1978)—to bring contextual evidence to this monolith, was placed within this conceptual framework.

Based on our archaeological work in the Basin of Mexico and in Guerrero and the thorough research of our colleagues in Oaxaca, Chiapas, or Morelos, we contend that Olmec-period early Mesoamerican groups and polities had an *identical* level of sociocultural complexity. In this context, explaining cultural similarities by simple direct or indirect mechanisms of contact, generated by the economic needs and political decisions of a single zone, does not seem to offer a totally convincing explanation. Thus, we will not use here the unavoidable word "Olmec" to refer to a particular people; instead, it will be applied strictly to a style and, more broadly, a civilization.

A REGIONAL CAPITAL WITH MONUMENTAL ARCHITECTURE

The strong argument for Guerrero as a marginal outpost or reflection of distant, more advanced cultures was the fact that no large, early Mesoamerican city—in the Latin sense of "caput," not "urbs"—had been yet reported from the region. This argument collapsed in 1983 with the discovery of a remarkable Olmec horizon city situated near the confluence of the Mezcala-Balsas River and the Amacuzac River, in eastern Guerrero. First known as Tlacozoltitlan and later renamed Teopantecuanitlan, this site, with its monumental public architecture, was rescued from systematic looting by the National Institute of Anthropology and History and its representative Guadalupe Martínez Donjuán (1986).

Within the period under consideration here, four phases of occupation, based on seven C-14 determinations, expressed in uncalibrated years B.C., can be proposed. The pre-1000 B.C. phase, with the dates of 1423±112 and 1390±126 (this last one obtained from a level below the yellow clay floor of the central precinct), still remains archaeologically undefined, although clay ceremonial architecture may have been undertaken at the end of this phase. Phase II, from 1000 to 800 B.C., with determinations of 844±58 and 822±117, corresponds to the monumental stone architecture levels, which expanded during phase III, from 800 to 700 B.C., in which the determination of 790±42 was obtained. Phase IV, from 700 to 500 B.C., with determinations of 623±69 and 610±12, is related to the weakening of ancient symbolic and stylistic Olmec norms, consistent with the development of pan-Mesoamerican deculturation processes. Following surface surveys and pottery-sherd analysis, the site may have covered, during its apogee, in phases II and III, approximately 160 hectares.

The Ceremonial-Civic Center

The religious and political focus of this vast settlement was a series of monumental structures on ascending levels, along a north-south axis offering a deviation of 13°30′ east of astronomic north. The southern platform, a remodeled natural eminence, itself leaning on a mountain ridge, dominated a series of lower platforms and esplanades. Within this lower zone, the entrance to the ceremonial area, a set of megalithic sculptures in the round were unearthed, including an uncarved stela, a large reptilian-shaped creature, a rectangular thronelike block with a protruding human head in a cartouche, as well as a 1-meter-high monolithic human head, badly defaced. This ascending series of platforms and esplanades was interrupted by an elaborate sunken patio, one of the most remarkable elements of the site.

This sunken rectangular enclosure, 18.6 by 14.2 meters, together with a corridor and surrounding stairways, was first made of yellowish clay and compacted earth. The two double staircases of the southern corridor have a median ramp, which ends in a pillar in the form of a highly stylized feline head with flame eyebrows (fig. 2).

During phase II, the inner walls of the sunken enclosure were covered with large, well-cut travertine stones. Inside, four monumental sculptures, weighing about three tons and shaped like an upside-down T, were found (fig. 3). Each monolith is decorated with deep incisions representing the powerful image of an anthropomorphic feline with almond-shaped eyes, a bulbous nose, an inverted U-shaped mouth (in some cases covered with red cinnabar), and a frontal band with the cleft motif and the crossed-

Fig. 2. Lateral view of a pillar with a feline ear volute.

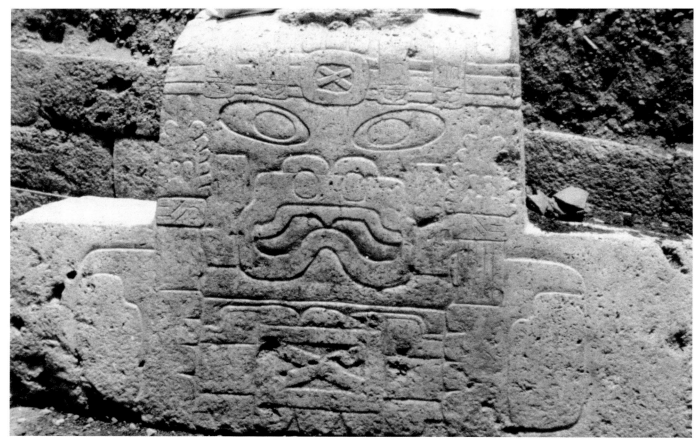

Fig. 3. One of four monumental stone sculptures of inverted T-shape found in the ceremonial sunken court of Teopantecuanitlan.

bands symbol. Each of these mythological beings holds a bundlelike object, interpreted as a plant or flame-topped torch. But, the most striking phenomenon, which has captured the attention of archaeologists and visiting researchers alike, is their evident association with cardinal directions and the movement of heavenly bodies. It has been suggested that the sunken court, a pivotal space linking human and supernatural worlds, functioned as a metaphoric portal to the otherworld, while the monoliths symbolized sacred, personified mountains and the four corners of the world (Reilly 1994a). The precinct has also been interpreted as a symbolic ballcourt, where solar movements could be reenacted under the vigilance of the four anthropomorphic felines, transformed into deified ballplayers (Angulo 1994). In any case, the two monoliths to the east wall and their two counterparts to the west wall—like the east and west world-bearers or Bakabob of the later Maya civilization—appear to track the course of the sun.

From a structural point of view, the first cities of complex agrarian societies—whether in China or in the Mediterranean basin—generally reflect, in their plans, a centripetal conception of the world. They are conceived as the stable navel and the microcosmic replica of the universe. They create order and, by the definition and interplay of symbolic correspondence, generate metaphoric devices to control the outer world as well as systems of life and cosmos. In our opinion, the ancient city of Teopantecuanitlan represents the clearest example of this phenomenon in early Mesoamerica.

Hydraulic Works

In ancient cities, profane and sacred activities are deeply intertwined. Thus, technoeconomic developments necessary to the orderly functioning and material survival of the group are well-integrated parts of the sociopolitical organization. Particularly significant in Teopantecuanitlan public life is the early development of two types of sophisticated water-control systems. The first one, common to several ancient Olmec cities, was conceived in Teopantecuanitlan to drain the sunken precinct and the ceremonial area. It comprises subterranean canals of small, U-shaped stones covered with flat lids. The second type of water-control system, unexpected at this ancient level, involved land and water management on a larger scale. Remarkable for its megalithic proportions and the human labor implied in its construction, this hydraulic work was designed to irrigate low-lying cultivated fields. The main feature, explored by Martínez Donjuán (1994), consisted of a 0.7- to 0.9-meter-wide megalithic conduit, made of two parallel rows of thick stone slabs, 1.2 to 1.9 meters high, covered with stone lids and connected to a higher storage dam. Over the canal is Structure 3; of a later date than the canal, it includes large stone slabs extracted from the aqueduct. The facade is decorated with stone slabs that

form triangular-shaped niches with a central protruding circular stone. This stylized motif, certainly not without semantic content, is also present in Chalcatzingo (Morelos), where it is ascribed to the period 700–500 B.C. (Grove 1987a).

This megalithic hydraulic construction represents, at present, the earliest known example of canal irrigation technology in Mesoamerica. The synchronic development in western Mexico of a large regional capital and of an elaborate hydraulic technology, is, in fact, consistent with natural and cultural data. In semiarid zones or regions with dry and rainy seasons, in Old World Middle East as in western Mexico, irrigation is the basic technology necessary to create agrarian settlements of sufficient cultural complexity. Río Balsas protohistoric data have shown how irrigation practices led to a radical transformation of alluvial lands and to the production of agricultural surpluses.

Life in a Residential Unit

Crucial to the global understanding of the social and economic structure of Teopantecuanitlan is the study of its basic component: the household unit. The archaeological work we conducted in a group of domestic units, near the Río Balsas, in site 5/6 of the "Lomeríos" zone, was fruitful in that sense. Teopantecuanitlan, as is the rule for the emergence of large regional capitals, was not only a sacred place but also a powerful economic center and nodal point in the interregional exchange networks of ancient Mesoamerica (Niederberger 1986; 1995).

During phase II, the Lomeríos residential unit, probably occupied by a large extended family, included several houses clustered around a courtyard. The structures, spared by recent severe erosion, include the remains of a rectangular house made of perishable material and built on a stone-wall foundation (S-5) and traces of a more elaborate, adobe dwelling with a low rock and rubble platform (S-6). The surrounding domestic space included working areas, hearths, bell-shaped storage and refuse pits, which were used in some cases for burials. The Lomeríos household unit has yielded dense evidence not only of subsistence-related activities but also of a regular involvement in specialized craft production and operations aimed at acquiring scarce and highly prized resources.

Particularly rich in data was the series of subterranean bell-shaped pits attached to S-5 house. Probably used originally for food storage, they served as refuse pits for household debris. The analysis of their contents shows that in addition to maize, identified in the pollen record, the diet of the inhabitants included the Balsas River catfish and freshwater mollusks, crabs, rabbits, red brockets, white-tailed deer, and, in a proportion reaching more than half of the total animal consumption, dogs.

Notched-stone artifacts may have been used as net-sinkers, and obsidian projectile points were used in hunting tools. Well-balanced perforated pottery disks may have

Fig. 4. Head of a hollow, white-slipped clay figurine from Site 5, Teopantecuanitlan. 5.2 cm.

Fig. 5. Head of a solid clay figurine from Site 5, Teopantecuanitlan. 6 cm.

served as spindle whorls. Seeds were ground on legless, oval grinding stones with loaf-shaped grinders or *manos*. Cooking was done in pottery containers, generally on fired-clay heavy braziers. Pottery vessels also present several forms of monochrome jars, bowls, and large flat griddles as well as sophisticated vessels with painted and incised decorations. These include typical Guerrero granular ware as well as pan-Mesoamerican white-slipped hemispherical bowls and flat-based dishes with outflaring sides decorated with the "double-line break," "cleft head," and other incised motifs. An interesting pottery example illustrates a singular synchretism of regional Guerrero traits and Olmec horizon attributes. It consists of a three-dimensionally modeled, cylindrical, light-brown effigy vessel showing a human face with almond-shaped eyes and cheeks, incised with the ubiquitous abstract Olmec motif of the human/reptilian/feline hybrid.

Among anthropomorphic fired-clay representations, the uncommonly large number of hollow baby-faced figurines, present in the Lomeríos unit, is noteworthy (fig. 4). Made in different sizes, covered with a highly burnished white slip, they are characterized by their babylike plump body, arms,

and legs, rendered masterfully in a true clay sculptural art. Eye pupils are indicated by neat, round punctuation. In several cases, crossed eyes, which in some later Mesoamerican cultures were artificially induced and considered a sign of beauty, are observed. Hands and feet show minutely worked nails. As to solid clay figurines, some of them wear traces of body paint and display various headdress: frontal band with central motif, plain or incised turbans, ring-shaped or hanging decorated elements for hair adornments (fig. 5). In some instances, as in the case of the baby-face figurines, the head is shaved, except for the lateral locks. Their form attests to the practice of intentional skull deformation. Parallel vertical scarifications on both cheeks are also observed. The dominant type of solid figurine presents well-modeled features with an appliqué technique for the nose and mouth and almond-shaped eyes without pupils that we classified as osp, the Spanish abbreviation for "eye without pupil." Nose-plugs in several osp figurines offer evidence of the practice of perforation of the nose septum.

Inhabitants of the Lomeríos unit wore personal ornaments of an exotic or high value, suggesting, with other ev-

idence, that they held a relatively prominent rank within Teopantecuanitlan society. This is probably due to their active participation in interregional exchange networks. In the platform area, pieces of exotic iron-ore mirrors were found. Together with an impressive amount of golden-shimmering mica platelets of unknown use, fragments of fine annular earspools, made of translucent whitish or amber-colored travertine onyx, were found within the area of the S-5 house. Superbly worked, thin-walled, highly polished earspools, made of regional dark or light green serpentine and other green metamorphic rocks, as well as lip-plugs and stylets, were also part of the personal belongings of the dwellers.

Nonsubsistence Economy, Craft Specialization, and Long-Distance Exchange Networks

Knowledge of the Olmec world has long been biased by the paucity of archaeological works in several key zones, such as Puebla and Guerrero. Studies carried out in the Lomeríos residential unit bring into focus the dynamic role of Teopantecuanitlan and of Guerrero Pacific western regions, in general, within ancient Mesoamerican economic systems, including the circulation of mica, iron ore, jadeite, serpentine, onyx, obsidian, and seashells.

No geological sources for obsidian, one of the most valued raw materials in pre-Hispanic times, have been reported in Guerrero. Thus, its presence in Teopan-

tecuanitlan is the result of regular participation in long-distance exchange networks. Lithic studies show that, apart from a few green specimens, the majority of the obsidian of the Lomeríos household unit presents a specific luster, flow structure, and particular black/gray-banded patterns. Pending analysis for trace-element composition, our hypothesis, based upon our experience of Basin of Mexico lithic sources and industry, is that a large part of the obsidian present in the Lomeríos unit comes from the Basin of Mexico Otumba zone. The interregional north-south trade route may have passed through Tlapacoya, the Amecameca mountain pass, and sites along the Amacuzac River. The south-north archaeological flow of goods, in the other direction, is well documented.

In the Lomeríos unit, two facts are striking. First, statistical analysis has shown that, paradoxically, exotic obsidian was more important than local or regional lithic material, such as good-quality chert of various colors, worked into both heavy-duty and specialized tools; limestone; chalcedony; schist; quartzite; green metamorphic stone made into axes and celts; and volcanic and conglomerate rocks, some of them water-rolled cobblestones from the Balsas River. The second remarkable phenomenon is that among the different categories of obsidian artifacts gathered, prismatic blades represent, in the platform area, seventy-five percent of all artifacts produced in this material. Although prismatic blades, prized for their cutting

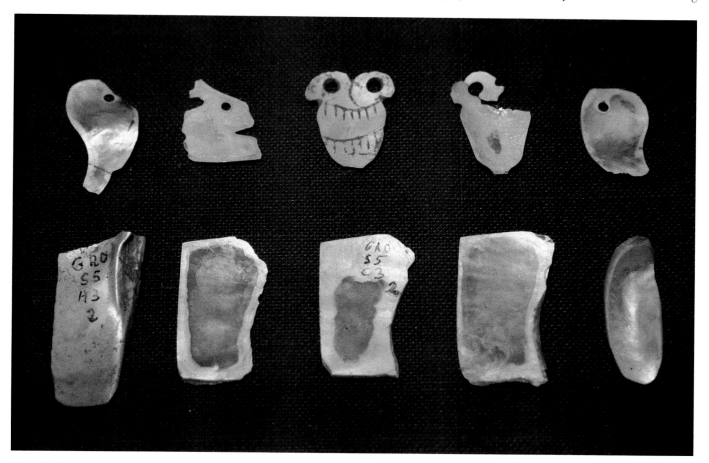

Fig. 6. Evidence gathered in Site 5, by the author. These small ornaments, prized for their nacreous surface, are made from the Pacific pearl oyster (the specimen at lower right, an unfinished piece, is 3 cm long). The pieces in the top row, with drilled holes, may have been used in necklaces or sewn onto garments.

edges, may have been imported, technical studies of debitage modalities seem to indicate that obsidian was mostly imported as preformed cores, ready to be reduced by pressure technique into blades by Teopantecuanitlan artisans. Blades of different widths and exhausted prismatic cores of obsidian are present in the Lomeríos lithic record. Furthermore, the occurrence of two concentrations of these prismatic blades—some complete and showing a superb skill in debitage tasks—strongly suggests the existence within the household unit of storing features for this category of artifacts.

Marine shells have been valued in all ancient cultures for their role in ceremonial exchange, their attributed symbolic meanings and magical powers, and for providing a precious material for refined ornaments, emblems of wealth and status. In ancient Mesoamerica, Teopantecuanitlan seems to have been a center for seashell exchange (fig. 6). Archaeological evidence indeed shows that the Lomeríos group had regular direct or indirect relationships with the Pacific Coast economic sphere. In the residential unit, we found not only numerous remains of marine shells—following studies made by Oscar Polaco of INAH—of at least eight genera, all from the Pacific Ocean, but also unmistakable evidence of specialized shell-working activities. Among these marine shells, the *Pinctada mazatlanica*, or the pearl oyster, was without any doubt the most valued and represents seventy-eight percent of the total number of seashell objects or fragments gathered. The pearl oyster, a 10- to 12-centimeter-long bivalve, possesses a thick, splendidly iridescent and nacreous inner surface, relatively flat and large, which can be cut, drilled, laminated, polished, or engraved. All these operations are clearly attested in the Lomeríos unit remains. In some loci, inside and outside the S-5 house structure, were found nacre powder, unworked broken fragments, waste debris—such as pearl oyster flakes and *Murex* columela and *Astrea* apex—as well as pieces in process and finished products. This leads us to postulate the existence in this residential unit of areas for specialized shell-working activities. Those who engaged in this craft—and who also worked, on a lesser scale, a local nacreous fresh-water bivalve of the *Unio popei* species—were probably part-time artisans. Among finished products were found vivid orange beads, perhaps from *Spondylus*, and hard and thick bracelet parts, made out of a large heavy conch, as well as pearl oyster long-peaked bird's heads, small heartlike engraved pendants, and numerous geometric pieces, often perforated. Beautiful finished shell zoomorphic and geometric ornaments made out of pearl oyster have been recovered in the Teopantecuanitlan ceremonial central zone. Geometric ornaments were found within the small altarlike area with infants and dog burials, excavated by Lorena Gamez Eternod, outside the northwest corner of the ceremonial precinct.

The Lomeríos group, together with other household units of the site, must have played a prominent role in seashell procurement systems and craft production as well as redistribution.

An excellent marker of interregional exchanges, the Pacific pearl oyster has been found in Olmec levels in San Pablo Nexpa (Morelos) and in Tlapacoya and Tlatilco in the high Basin of Mexico, among other sites. The integration of distribution patterns and new data permits us to document archaeologically the existence, around 1000 B.C., of a south-north economic route passing probably through the Tecaxac Papagayo-Omitlan hydrographic basin, crossing the southern Sierra Madre and the Juxtlahuaca and Oxtotitlan areas, toward Teopantecuanitlan and the geomorphological passage of the Amacuzac valley to highland sites. Parallel communication axes or ramifications of this Omitlan-Amacuzac route have certainly existed, connecting singularly important sites such as Xochipala and Chilpancingo.

Xochipala and Chilpancingo

For decades, early Olmec-style objects have proceeded from the vast site of Xochipala, situated in an ancient lacustrine basin. Among them figure gray-ware cylinders and globular dark brown pottery vessels with abstract excised motifs—such as the paw-wing and crossed-bands—iron-ore mirrors, and large pearl oyster ornaments such as a pendant, magnificently ornate with a man/feline profile incised symbol (Gay 1974). As these objects have been, unfortunately, removed from their original context, only scientific investigations, such as the excavations undertaken by Paul Schmidt (1990) and Rosa Reyna Robles, can open the way to a better understanding of the modalities of development of Xochipala as an important Olmec regional capital.

It was in the Xochipala region that, in 1906, Adela Breton discovered a masonry corbeled vault within a Classic period stone structure, an elaborate architectural feature considered to be a Protoclassic Maya invention and later brought to Guerrero by diffusion. Since then, other stone corbeled vaults have been reported from many Guerrero sites, including looted structures of Teopantecuanitlan, and an early dating of this construction technique is now emerging in new data from this region.

In fact, as a result of a public works project in 1988 (Reyna Robles and Martínez Donjuán 1989), an extraordinary and fortuitous discovery was made in Chilpancingo, which casts serious doubt on the theory that the corbeled vault was of Maya origin. This discovery consists of a group of burials, with cists, crypts, and a high-status stone mortuary chamber with a corbeled-vault roof and ceramic assemblages dating before 600 B.C. It also shows evidence of the early development in Guerrero of wealthy, hierarchical societies.

As to the question of whether the Gulf Coast zone, the Guerrero area, or other regions constitute the actual cradle

of "Olmec" civilization, it seems to be a false problem. In spite of geographical gaps and chronological imprecisions in our archaeological inventory, a growing number of agrarian regions or sites offer a coherent set of early Mesoamerican architectural vestiges and Olmec-style elements. The evidence strongly suggests the existence, in each relevant zone, of several interrelated phenomena: a certain demographic mass; an efficient agrarian economy; and ranked societies of marked cultural complexity, active partners in the elaboration of a common system of beliefs, through a long-standing interregional exchange of both an economic and a nonmaterial nature.

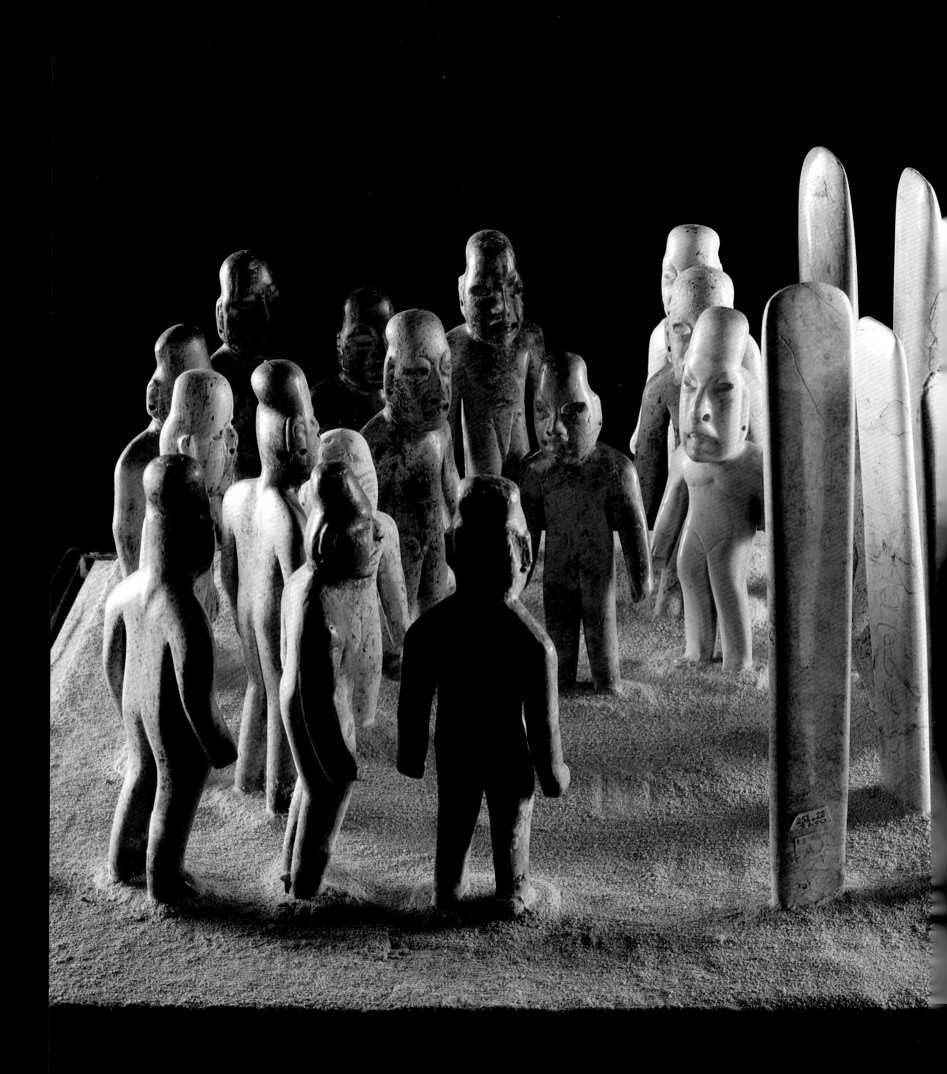

Archaeological Contexts of Olmec Art Outside of the Gulf Coast

DAVID C. GROVE

The Mesoamerican landscape is extremely diverse, ranging from the geologically complex mountainous interior of Central Mexico and highland Guatemala to the low tropical coastal plains of the Gulf and Pacific coasts. Those greatly different settings were home to an equally varied number of Formative period farming societies that adapted to their particular regional ecosystems in distinctive ways. Yet while those myriad societies were separated by topography, ethnicity, and language, their daily life and ritual systems nevertheless followed a basic "Mesoamerican template." By c. 1150 B.C., that template included a small group of iconographic motifs that were executed onto the local pottery vessels from region to region across most of Mesoamerica. Those motifs represent the first manifestation of what many scholars call "olmec art."[1] Although olmec art is frequently treated in books and museum exhibitions as if it were uniform and unchanging for nearly seven hundred years, the motifs and media that are classified as olmec art display important variations that are distinctive to each region. Those same motifs and media also evolved and changed over time (Grove 1993: 83–111).

When olmec motifs and artifacts are treated as "art" and are exhibited in a museum, they take on an impersonal character that removes them from the reality of the past, namely, the fact that many of them were produced by humble peoples who lived in small agrarian villages, and that these objects functioned in some manner in the everyday lives of those people, often in very mundane ways. In museums the objects are viewed primarily for their aesthetic qualities. In fact, because of aesthetics, only certain objects are deemed worthy of display, and the total range of materials produced in those ancient villages is never shown. There is little question that such selective bias influences the viewer's perception of the object and of the ancient society responsible for its creation, and it fre-quently prejudices scholarly perceptions as well. That is certainly true of olmec art.

Archaeological research (excavation) in Mesoamerica is carried out to gather data on the lifeways of that area's ancient societies. To gain such data on the Olmec and the numerous other Formative period societies, my colleagues and I excavate the ancient village sites to uncover the remains and artifacts in their undisturbed social context, which is absolutely vital to understanding the function of both artifacts and art. In the pages that follow I discuss the context of olmec art at several archaeological sites in the highland Central Mexican states of Morelos, Puebla, and Oaxaca, with a brief commentary on the olmec art in southern Mesoamerica.

Not all olmec objects that appear in museums and elsewhere have been legally excavated and removed from their countries of origin; my discussion also includes a few examples of the impact that illicit excavations have on the archaeological record, and ultimately, upon the way in which they restrict access to knowledge about past societies. Finally, because there are distinct differences in Early and Middle Formative art, artifacts, and archaeological remains, I discuss those time periods separately.

THE EARLY FORMATIVE PERIOD (C. 1800–900 B.C.)

The major marker for the beginning of the Early Formative period is the appearance of pottery in the archaeological record. Those ceramics were produced by peoples that lived in small villages and subsisted by farming, hunting, and gathering. Some of the early clay vessels were decorated with red slip, or with simple incised curvilinear or geometric designs, but the latter do not seem to have had iconic value. The Early Formative period was also a time of growing social complexity, and over time, some villages

became larger and more important than others. Similarly, certain villagers also became more eminent and began to denote their higher social rank with special objects of adornment, such as iron-ore mirrors and greenstone beads and pendants. Pottery vessels likewise became more varied and more elaborate. At approximately 1150 B.C., some vessels were given iconographic decoration, that is, olmec motifs. By 900 B.C. the societies across Mesoamerica had grown in number, complexity, and diversity, and it is within that framework that we can begin to examine the context of olmec art.

Central Mexico: Morelos

The Central Mexican state of Morelos lies directly to the south of the Basin of Mexico, but is separated from the basin by a range of mountains. Morelos is lower in altitude and seasonally warmer than the basin, and for centuries has been an important source of agricultural produce for the latter area. That same role may have occurred in pre-Hispanic times as well, particularly during the zenith of the great urban city of Teotihuacan (c. 300–600 A.D.). Nonetheless, from the Formative period onward, there were always important social and economic interactions between villages and cities of Morelos and those of the Basin of Mexico.

The majority of Early Formative (pre-900 B.C.) villages in Morelos occur along the humid river valleys in the water-rich western two-thirds of the state. There the settlements were usually situated on low river terraces that overlooked expanses of river bottomland of sufficient size for farming. Because that setting is also the preferred location for present-day villages, many of the early sites lie beneath their modern counterparts and cannot easily be investigated. Therefore, none has been extensively excavated, and those at which research has been undertaken have provided data primarily related to burial practices (Grove 1974). That situation is analogous to what is known about the famed Early Formative period site of Tlatilco, in the Basin of Mexico, where again only grave data are available. It is therefore of interest to note that the ceramic burial objects placed with the deceased in the early farming villages of Morelos are virtually identical to those found in the graves at Tlatilco. Those include red-on-brown bottles in various "exotic" forms, including some with stirrup-spouts, many plain pots, an occasional olmec vessel or figurine, and an abundance of "pretty lady" figurines. Although these objects were recovered from graves, many of them presumably had once served utilitarian or ritual functions in the daily life of the individuals with whom they were buried.

The strong similarity in the pottery at sites within the southwestern Basin of Mexico and across the entire state of Morelos enables archaeologists to define what can be called the "Tlatilco culture" and to demarcate its geographical extent (Grove 1974: 3–4). The sheer quantity of Tlatilco culture sites along the agriculturally rich river valleys of Morelos provides strong evidence that in spite of the modern fame given to Tlatilco, the culture itself was primarily a phenomenon of the Morelos area, where it probably had its origins. A three-tiered hierarchy of settlements occurs along those Morelos valleys: one large village, several smaller villages, and numerous hamlets. That pattern suggests that each valley was the location of a minor chiefdom that focused on the largest village, the chiefly "center" for exchange and redistribution activities. One important item received in Morelos through economic exchange transactions with Basin of Mexico sites, and probably redistributed by chiefly centers to their subsidiary villages, was obsidian (volcanic glass) from a source in the eastern Teotihuacan valley.

The pottery of Tlatilco culture includes bowls and jars decorated with olmec motifs, and baby-face figurines. Although very minor variations in Tlatilco culture pottery sometimes occur from valley to valley, most variations are probably attributable to the artistic licenses taken by the potters at each production village. Nevertheless, throughout the region of Tlatilco culture, vessels decorated with olmec motifs constitute less than five percent of the ceramic assemblages, and those vessels appear to be locally produced, not imports. The baby-face figurines are likewise infrequent and manufactured from local clays. Such olmec ceramics occur in tiny rural hamlets as well as in the larger villages of the Tlatilco culture area, signifying that they were objects that were utilized by peoples at all levels of those societies, and were not unusual or special status items associated only with persons of high social rank. The above observations on percentage, local vessel forms, and equality of distribution appear equally applicable to Early Formative period sites throughout Central Mexico.

Throughout the highlands during the Formative period the most common burial practice was to inter the deceased beneath the floor of the house. In addition, there is reason to believe that a person's social position in life is reflected archaeologically by the burial treatment and offerings they received at death (Tolstoy 1989a: 85–121). Some individuals have many ceramic vessels, and others have few or none. Often nonceramic objects, such as bone and stone tools, appear in the graves. The placement of burial goods also varies. Some individuals have goods around the head and shoulders, others at their midsection, or feet, and some throughout the entire grave pit (García Moll et al. 1991). All of those patterns can assist scholars in understanding more about these ancient societies.

An unusual exception to the practice of house subfloor burials occurs at the site of San Pablo, on the Río Cuautla in south-central Morelos. There, on a hillside several hundred meters above the actual village site, is a circular burial mound, approximately 30 meters in diameter and 1.6 meters in height, its lower exterior faced with rounded

Fig. 1. San Pablo, Morelos. The Early Formative burial mound is in the left center of the photograph.

river stones (fig. 1). It is the only such mound known in Central Mexico, and when discovered in 1966 it had already been extensively looted (Grove 1970b: 62–73). Rescue excavations and other data unequivocally indicate that it had been a Tlatilco culture cemetery area, and several pot sherds with olmec motifs were found among the debris left by the looters. Because San Pablo may have been the chiefly village in that area, its unique burial mound raises the question of whether the mound had been a special burial precinct for particular highly ranked members of the village. Regrettably, looters had indiscriminately dug pits throughout the mound in their hunt for whole pots and figurines (fig. 2), and ultimately obliterated all evi-

dence of grave pits and skeletons, thus destroying all the vital data that could have answered that question. Although a large quantity of the ceramic objects from the San Pablo burial mound were smuggled out of Mexico and made their way to a major art museum in the United States, they can provide no answers to the many questions concerning the life and social system of the village at San Pablo, or of Tlatilco culture in general, because the objects lack the most fundamental unit of information, their original burial context.

Evidence of Early Formative period platform-mound architecture is presently coming to light in regions to the south of the Tlatilco culture sphere (Lesure, in press;

Fig. 2. Looter's pits, San Pablo mound.

Flannery and Marcus 1976a: 205–221; Flannery and Marcus 1994: 365–371), and some of those mounds may classify as "public architecture," that is, architecture that was important to village-wide ritual activities. In the central highlands, pre-900 B.C. platform mounds are known at only one site, Chalcatzingo, the Tlatilco culture chiefly center of the Amatzinac valley in far eastern Morelos (Grove and Cyphers Guillén 1987: 29–31, 36; Prindiville and Grove 1987: 63). The largest of Chalcatzingo's two mounds is 2 meters tall and more than 15 meters long. It is earthen, but faced on its lower sides with stones. Today it is deeply buried beneath several Middle Formative period rebuilding episodes and is therefore difficult to explore completely. However, its central location and its centuries of use indicate that it had served as a locus for ritual activities at Chalcatzingo, and therefore can be classified as "public architecture." On the other hand, the site's second Early Formative period stone-faced platform is smaller and may have been the substructure of a special elite residence. A new research effort was begun at Chalcatzingo in 1995 to investigate both of those mounds and to gather data on the Tlatilco culture village. Because Chalcatzingo was one of two Central Mexican chiefly villages that created and displayed olmec monuments c. 700 B.C., it will be discussed again below in greater detail.

Central Mexico: Puebla

The state of Puebla occupies a large region east of the Basin of Mexico and Morelos. However, archaeological knowledge of the pre-900 B.C. villages and pottery that existed within that broad expanse of territory is quite limited, and the data on the context of olmec ceramics there are therefore minimal. That is particularly true of Las Bocas, the state's most famous Early Formative period site. Las Bocas is situated in the Izucar de Matamoros valley in western Puebla, and its distinctive Early Formative period olmec pottery and figurines have made it renowned among museums and collectors (Coe 1965b). Nonetheless, absolutely nothing is known about the people who created those ceramic objects, or about the role that those particular objects played in daily life and rituals, for all of the Las Bocas pieces were illicitly excavated in the 1960s. By the time Mexican archaeologists attempted to investigate the ancient village site in 1966, it was already too late—the archaeological deposits had already been completely destroyed by the intensive illicit digging.

Las Bocas and neighboring Early Formative period villages of the Izucar de Matamoros area, like their contemporaries across Mesoamerica, developed their own local ceramic tradition—including their own variations of olmec ceramics—the "Las Bocas style." Those objects are sought by looters and craved by art museums, yet, as elsewhere, they constitute less than five percent of the actual ceramic assemblage. Therefore, while they garner attention, the question of what became of the other ninety-five percent must be raised. Unfortunately, the answer is visible in the destruction wrought by looters at sites such as Las Bocas.

Las Bocas has been misrepresented in museum cata-

logues and popular literature because the fame of the site and its pottery does not reflect archaeological reality. Las Bocas was not the chiefly center for its area, but a relatively small village, so small, in fact, that it could have yielded only a tiny fraction of the quantity of artifacts that continue to be attributed to it today. The continuing demand for "Las Bocas" pottery has therefore led to the pillaging and virtual destruction of sites across that area of western Puebla. On the antiquities market the pottery and figurines plundered from those and other sites are nonetheless labeled as "Las Bocas," a fictitious "pedigree" that raises both their prestige and their price. That same general market demand has also created an industry of clever modern counterfeits, and fraudulent "pedigree" names such as "Las Bocas," "Tlatilco," "Xochipala," and "olmec" provide an air of authenticity to such pieces as well.

Central Mexico: Oaxaca

The best data relating to the social context of olmec pottery come from the major Early Formative period chiefly center in the Valley of Oaxaca, San Jose Mogote. That important site is adjacent to good agricultural bottomlands several miles north of the valley's famed Classic period hilltop center, Monte Albán. San Jose Mogote is one of the most thoroughly investigated Formative period archaeological sites in Central Mexico and therefore provides some particularly valuable insights on Early Formative period community organization not yet available at other Mesoamerican sites.

San Jose Mogote was the largest village in the valley and was clearly its major chiefly center. The central sector of the Early Formative period village encompassed an area greater than 20 hectares (about 50 acres) and may have contained more than one hundred houses. Among the locally produced pottery vessels utilized by the villagers were a small percentage with olmec motifs. Two motifs predominate, the "fire-serpent" (e.g., cat. 34) and "were-jaguar" (e.g., cat. 39); the former were executed on black vessels and the latter on white pots. The archaeological data suggest that pots with those motifs have discrete distributions within the village. Some houses at San Jose Mogote apparently utilized only black "fire-serpent" pottery, and others only white "were-jaguar" pottery. In addition, archaeologists have distinguished three separate residential wards (south, east, and west) within the main village area, and the motif dichotomy extends to the wards as well. Black "fire-serpent" vessels are more important in the eastern and western wards, while white ceramics with "were-jaguar" motifs are more common in the southern ward (Flannery and Marcus 1976b: 374–383; Marcus 1989: 148–197; Pyne 1976: 272–282).

That same dichotomy also extends to the regional level. Only "fire-serpent" vessels appear in the burials of some of the small villages in the valley, while only "were-jaguar"

vessels occur in others. The differential use and distribution of those motifs indicates that "fire-serpent" and "were-jaguar" symbols functioned in the Valley of Oaxaca as important social markers, perhaps differentiating social groups. Those groups seem to have been ward-specific within the large chiefly village of San Jose Mogote, and village-specific among the valley's smaller settlements (Flannery and Marcus 1976b: 381–382; Marcus 1989: 169–170). The San Jose Mogote data demonstrate that the pottery labeled olmec served the local and regional social networks, and is not necessarily related in any way to the Gulf Coast Olmec. It provides a valuable explanatory model for understanding the social role of olmec pottery in other areas of Mesoamerica as well, including Gulf Coast Olmec society.

The Middle Formative Period (900–500 b.c.)

By 900 b.c., normal population growth had led to an ever-increasing number of agricultural villages across Mesoamerica, and a corresponding increase in regional chiefly centers. Those chiefly villages increased the demand for natural resources and nonlocal commodities, and new regional and interregional chiefly alliances and more complex exchange networks developed. The changes that distinguish the transition from the Early to Middle Formative period, so often incorrectly characterized in the literature as a sudden "revolution," seem actually to have resulted from nothing more nor less than the slow process of continuing social evolution (Grove and Gillespie 1992a: 15–36; Grove 1993).

One feature of the Middle Formative period was the increasing importance of chiefly and elite ranks among the varied Mesoamerican societies, and that greater importance is manifested in the archaeological record by an increase in elite objects. Over roughly a century, the olmec pottery vessels and the clay baby figurines were gradually replaced by plainer bowls with far simpler decorations and by new and more varied figurine types. At the same time, chiefs and other individuals of high rank increasingly displayed their special social position by possessing and adorning themselves with greenstone jewelry. Therefore, it is during the Middle Formative period that greenstone (serpentine, jadeite, etc.) beads, pendants, necklaces, figures, and bloodletting lancets first appear in significant quantities in the archaeological record. Importantly, the basic iconography that had earlier characterized olmec ceramics was now executed and elaborated on greenstone objects. In social terms, the widespread symbol system of Formative period Mesoamerica, once available to everyone on ceramic vessels, was now essentially controlled by the elite and predominant only on greenstone objects (Grove and Gillespie 1992a; Grove 1993). The elite individuals of Mesoamerica's many regionally distinct societies

Fig. 3. Chalcatzingo, Morelos, with the Cerro Chalcatzingo (right) and Cerro Delgado (left). The site begins at the base of the *cerros*.

presumably used those items during their lifetimes, and were buried with them at their deaths. Therefore, the most common archaeological context of greenstone objects is as grave goods.

The major geological sources of greenstone occur primarily in Guerrero and the Motagua valley of Guatemala, far from the Gulf Coast Olmec centers. Thus most Mesoamerican societies, including the Olmec, acquired both greenstone raw materials and finished objects by trade and exchange. Actual archaeological data related to the production and interregional trade of greenstone objects are nevertheless virtually nonexistent. Enough data do exist to indicate that various regional centers were acquiring unworked greenstone and producing beads, pendants, and other smaller items of adornment on their own. Whether that local production extended to larger and more

exceptional objects, such as celts and figurines, remains to be determined. However, those latter objects exhibit "stylistic" variabilities that imply at least three independent regions of production: Pacific Coast Chiapas-Guatemala, Guerrero, and the Gulf Coast.

During the Early Formative period, stone monuments, the distinguishing hallmark of the Gulf Coast Olmec, occur only within the Olmec domain.[2] That exclusivity disappeared during the Middle Formative period, and Olmec-like monumental art was created and displayed at a small chain of chiefly centers in west-central Mexico, and a second chain of centers along the Pacific Coast of southern Mesoamerica. The following section discusses Middle Formative period monumental art in the context of one site, Chalcatzingo, the most extensively investigated Middle Formative period site in the central highlands.

Chalcatzingo

The ancient village at Chalcatzingo (Grove 1984; Grove 1987a) is situated at the base of the Cerro Delgado and the Cerro Chalcatzingo, two imposing stone peaks that thrust upward from the flat terrain of the Amatzinac valley (fig. 3). As discussed earlier, the village had been an important Early Formative (Tlatilco culture) chiefly center involved in intraregional and interregional trade, and the only known of those centers with platform-mound architecture. Chalcatzingo's prominence continued and increased in the subsequent centuries that constitute the Middle Formative period, but with two significant changes. The Tlatilco culture village had been established on the natural hillslopes at the base of the *cerros*, but by 900 B.C. the peoples at Chalcatzingo had remodeled their hillside village site into a series of low, broad terraces. Furthermore, sometime after 900 B.C. the villagers began creating and erecting monumental art at the settlement, presumably at the behest of their ruler. The reasons behind Chalcatzingo's adoption of monumental art remain obscure, but those stone carvings show clear links to the Olmec. The Chalcatzingo monuments follow the basic canons of Olmec monumental art, they were created using a stone-carving technology borrowed from the Olmec, and several of the carvings share particular motifs with some of La Venta's monuments. Results of archaeological research at Chal-

catzingo indicate that the site's carvings date to 700–500 B.C. (Grove 1989a: 132–139), making them contemporaneous with most of the monuments at the Olmec center of La Venta. Only one other Middle Formative period center in Central Mexico also exhibits both major public architecture and stone monumental art—Teopantecuanitlan, Guerrero, a site with close associations to Chalcatzingo.

The Middle Formative period village at Chalcatzingo extended across the hillside terraces. Dominating the village from its position on the uppermost central terrace is a massive earthen platform mound, approximately 70 meters long and 7 meters high (fig. 4). This is the site's major "public architecture" and is the largest Middle Formative period mound known in Mexico's central highlands. That great mound represents the final stage of more than a half-millennium of enlargements and rebuildings, and buried deep within it as its innermost core is the Early Formative period platform mound that had been the central focus of the Tlatilco culture village at Chalcatzingo (Prindiville and Grove 1987: 63). The organizational pattern established before 900 B.C. had been maintained for more than five hundred years.

A special elite residential structure also stood on the uppermost terrace, about 100 meters south of the large platform mound, near the talus slopes of the Cerro Chalcatzingo. During the Middle Formative period that dwell-

Fig. 4. Main platform mound, Middle Formative period, Chalcatzingo, Morelos. An Early Formative period mound is buried beneath this 70-meter-long earthen structure. The stone pyramid at the right end of the platform mound is a later Classic period construction.

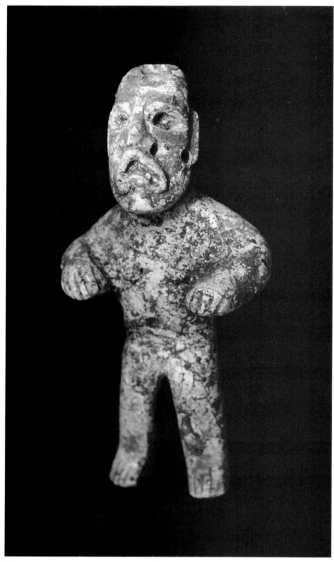

Fig. 5. Greenstone "were-jaguar" from crypt burial beneath Chalcatzingo's elite residence, c. 700-500 B.C.

Fig. 6. Statue head found with a crypt burial beneath Chalcatzingo's elite residence, c. 700-500 B.C.

ing had apparently served as the home for several generations of Chalcatzingo's chiefly lineage. The burials of those individuals were found interred beneath the floor of the structure. Several other elite graves were also found atop the central platform mound. Many of the site's elite graves were crypts formed from stone slabs. Greenstone beads, earspools, and pendants often accompanied the crypt burials (de Morales 1987: 95–113). Two of the seven crypts below the floor of the chiefly residence seem to be a purposeful pairing, one above the other, and both contained special objects. Placed at the midpoint of the skeleton in the lower crypt was a greenstone "were-jaguar" figure (fig. 5; similar to cat. 43 and the figures in cat. 42). An extraordinary object lay at the feet of the burial in the upper crypt, a stone statue head (fig. 6), damaged where it had been struck with the blow that decapitated it from its statue. That head was one of the first pieces of archaeological evidence suggesting that olmec monument mutilation had not resulted from a revolution or act of iconoclastic fervor, as many scholars then believed. Because the head occurred in a burial context, it raised the possibility that portrait monuments may have been destroyed at the death of the chiefly person they portray (Grove 1981b: 62–65).

Chalcatzingo's thirty Middle Formative period monuments are spatially separated into distinct southern and northern groups, and it is significant that the thematic content of those two groups is markedly different, with a mythic-religious theme in the south and a rulership theme in the north (Grove 1984: 49–68, 109–122). The southern monument group is primarily composed of carvings executed in bas-relief on boulders and exposed rock surfaces of the Cerro Chalcatzingo. The largest and best known of the mythic-religious carvings is Monument 1, a bas-relief executed on a cliff face high on the mountain (fig. 7). Often referred to as "El Rey" (the king), the carving depicts a personage seated within a large U-shaped niche, iconographically the mouth of an earth supernatural, and symbolically representing a mountain cave and entrance to the "otherworld." Clouds with falling raindrops hang above the cave, from the mouth of which emanate scrolls of wind or mist. The personage within the cave is perhaps a deceased ancestral chief, revered by the village as mediator to the supernatural forces that bring the rains necessary for agricultural fertility (Grove 1987a: 425–427). The symbolic association between caves and rain is quite ancient in Mesoamerica, a fact affirmed in this scene carved about 700 B.C. It is not coincidental, therefore, that this scene is executed on a rock face immediately adjacent to the ravine that carries rainwater runoff down the steep mountain slope.

The bas-relief carving of Chalcatzingo Monument 1 essentially presents a two-dimensional portrayal of the same fundamental symbolism communicated on the large three-dimensional Olmec altars, such as La Venta Altar 5, in which a personage sits within the altar's frontal (cave)

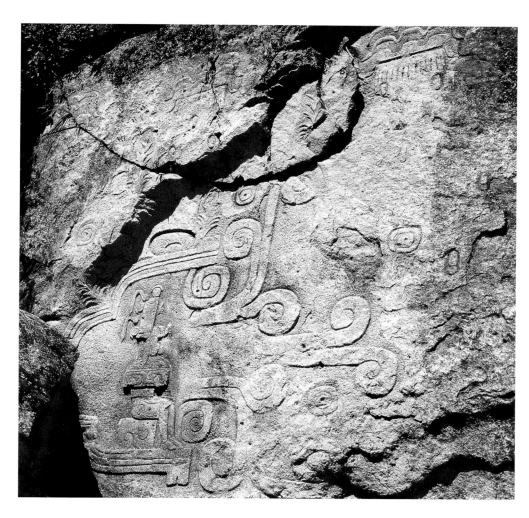

Fig. 7. Chalcatzingo Monument 1, "El Rey," a bas-relief on the Cerro Chalcatzingo depicting a personage seated within a cave. Middle Formative period.

niche. The personage in Altar 5 holds a supernatural baby, while Chalcatzingo's "El Rey" holds a rectangular scroll. The headdress of "El Rey" and the personage in La Venta's Altar 5 both contain a triple raindrop motif (!!!), which is quite rare in olmec art, suggesting that the two monuments are probably contemporaneous (Grove 1987a: 427; Grove 1989a: 133–134). The motif is also present on cat. 90, a greenstone plaque.

Five boulders on the talus slopes at the base of the Cerro Chalcatzingo are also carved with bas-relief images, and they are spaced in a linear arrangement that suggests a narrative sequence. Four of the carvings show felines and a serpent attacking or dominating human figures (fig. 8), perhaps representing mythical events in the primordial past of the peoples of Chalcatzingo. In contrast, the fifth and final relief (fig. 9) displays a scene with four humans. Three are standing and wear tall turbanlike headdresses. Their faces are hidden behind zoomorphic masks, and each holds a stafflike object. The fourth personage is seated before them, his mask is turned to the back of his head, exposing his face and small pointed beard. The scene portrays a ritual that was apparently related to the narrative sequence shown in the adjacent reliefs, and provides a brief glimpse into the richness of Middle Formative period ceremonial activities that would not otherwise be retrievable by usual archaeological means.

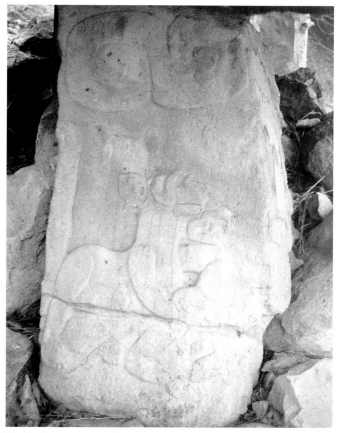

Fig. 8. Monument 31, Chalcatzingo, recently discovered, depicting a snarling feline above a prone human figure. Middle Formative period.

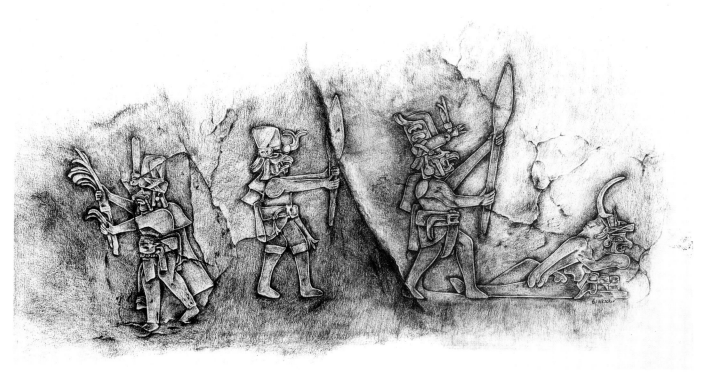

Fig. 9. Monument 2, Chalcatzingo, a ritual scene in bas-relief on a boulder on the talus slopes of the Cerro Chalcatzingo. Middle Formative period.

Before discussing the northern "rulership" monuments, two isolated carvings that were also erected in the southern area merit mention. One is executed in bas-relief on a boulder near the southwestern edge of the site (Monument 12; fig. 10). It depicts a "flying" personage wearing an animal headdress and carrying a torchlike object in one hand. Two long-tailed quetzal-like birds occur above the personage, and a parrot flies below him. Both birds are tropical and neither is native to Central Mexico. In fact, the monument exhibits close affinities to La Venta art. "Flying" personages are engraved on two greenstone objects from La Venta (including cat. 98, and a celt in cat. 42), and the monument shows particular stylistic similarities to La Venta Monument 19 (cat. 17) in its headdress treatment and in the paired quetzals (Grove 1987a: 428–429; Grove 1989a: 135–136).

The other solitary carving, Monument 9 (cat. 15), is one of the most important at Chalcatzingo, for it had been erected at the symbolic center of the site, atop the great 70-meter-long earthen platform mound. This architectural element physically and symbolically separates the southern and northern sectors and their distinct monument groups. Monument 9 displays a large supernatural face with a gaping cruciform mouth. It is the frontal view of the earth supernatural, the mountain-cave motif of Monument 1 ("El Rey") on the Cerro Chalcatzingo. As in Monument 1, the supernatural face's eyes carry a faint crossed-band (X) motif, and plants sprout from the outer corners of the great mouth. However, in this carving the

center of the mouth is hollow, passing entirely through the stone. Ritual activities atop the platform mound would have been readily visible to the peoples in the ancient village, and may have involved ceremonies during which people or objects were moved through the open mouth of the monument.

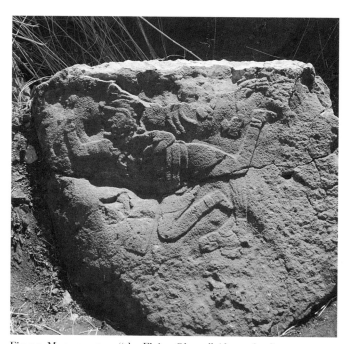

Fig. 10. Monument 12, "the Flying Olmec." Above the figure are two long-tailed birds; a parrot flies below his legs. Middle Formative period.

Monument 9 and Monument 1 both illustrate the mountain-cave motif. The Cerro Chalcatzingo seems the appropriate location for such a mountain-cave carving, particularly since the *cerro* was undoubtedly viewed as a sacred mountain by the peoples who inhabited the village at its base. However, why had a monument displaying such a motif been erected atop the central platform mound? I believe the answer is that Monument 9 and its mountain-cave face apparently served to designate symbolically the immense artificial mound as another "sacred mountain." Two stelae (Monuments 25/26, 27) with large supernatural faces were also erected at the base of the large earthen pyramid at the Olmec site of La Venta (Drucker, Heizer, and Squier 1959: fig. 59, 60; González Lauck 1988: 129), suggesting they served similarly to identify that mound as a sacred mountain.

Chalcatzingo's northern monument group includes four stelae that each displays bas-relief carvings depicting specific personages (Grove 1981b: 61–62). A statue of a seated personage was also found in the same area (Grove 1981b: 55; Grove and Angulo 1987: 125). Most of the carvings had suffered one form or another of decapitation, a form of ritual termination also common to Gulf Coast Olmec monuments. They were all apparently portrait carvings of particular rulers, and at least three of the stelae had

originally been erected beside low, rectangular stone-faced platforms that occur on three contiguous northern terraces. Remnant basal sections of several other stelae are still visible in the fields adjacent to those platforms and indicate that such monuments were common in the northern site area. While the rectangular stone platforms may have once served as the substructures of chiefly residences, their upper surfaces have been destroyed by erosion and modern agricultural activities, and therefore any evidence of possible residential superstructures has also been destroyed.

A second significant architectural feature occurs in the northern sector—a large, shallow stone-faced sunken patio that encompassed a surface area of more than 100 square meters. Such sunken patios have not yet been found at Gulf Coast Olmec sites, but an analogous patio occurs at Teopantecuanitlan, Guerrero, the chiefly center that apparently had significant interactions with Chalcatzingo (Grove 1987a: 429; Grove 1989a: 142–145). Such sunken patios may perhaps be an architectural feature indigenous to Formative period Guerrero and Morelos. At Chalcatzingo, however, a very Olmec-like stone tabletop altar sits at the midpoint of the sunken patio's south wall (fig. 11; Fash 1987: 82–94; Grove 1984: 65–68; Grove 1989a: 137–139). It is the *only* tabletop altar ever found outside of

Fig. 11. Sunken patio and tabletop altar, during excavation, Chalcatzingo.

the Gulf Coast, but differs from its Olmec counterparts in several significant respects. First, the front of the altar is adorned only with the eyes of an earth supernatural, and it lacks a frontal niche. Second, its Olmec correlates are monolithic, that is, each carved from a massive multiton block of basalt that had been transported a great distance and at great labor to an Olmec center. Ironically, although suitable multiton blocks of stone abound at Chalcatzingo only a few hundred meters away from the patio, the table-top altar is constructed of a large stone slab, and has a hollow center. Importantly, two elite burials occurred within the altar's interior.

The Chalcatzingo tabletop altar and patio serve to demonstrate that while some features of Chalcatzingo's monumental art have marked similarities to Gulf Coast Olmec monuments, others do not. The "El Rey" carving displays the triple raindrop motif that occurs also on La Venta's Altar 5, yet the cruciform mountain-cave mouth motif is *not* a Gulf Coast Olmec motif.

The peoples of the central highlands were not linguistically or ethnically Olmec. It is highly significant that for a few centuries the peoples living in both Chalcatzingo and Teopantecuanitlan created and displayed certain Gulf Coast Olmec symbols of ideological and political power, and even "terminated" the monuments in a Gulf Coast manner. Unquestionably, some highly meaningful social and economic interactions linked those two Central Mexican centers to one or more Gulf Coast Olmec chiefdoms, perhaps as alliances by which the Olmec insured their access to desired Central Mexican resources such as greenstone and obsidian. It must also be recognized, however, that such interactions seem to have only significantly involved two Central Mexican centers, Chalcatzingo and Teopantecuanitlan, and that those centers remained independent and also developed their own "highland" variations to the system of monumental art that they had incorporated. In that vein it is worth noting that the closest counterparts in olmec art to the four carved faces that adorn the sunken patio at Teopantecuanitlan lie not with monuments, but with engraved faces on highly portable olmec greenstone celts!

Comments on Southern Mesoamerica

Although the Olmec's greatest legacy to later Mesoamerican civilizations appears among the Classic period Maya, olmec ceramics are virtually unknown in the heartland of the Maya realm. In regions peripheral to the Maya region, such as the Pacific Coast of Chiapas and Guatemala, olmec ceramics occur at Early Formative period sites in the manner that they do in regions further north, that is, in small percentages and exhibiting regional variations. During the Middle Formative period a few centers in those same areas of coastal piedmont and plains began carving and displaying small quantities of olmec monumental art. Those include the Chiapas sites of Pijijiapan, Padre Piedra,

Tzutzuculi, and Xoc (see also cat. 4; Demarest 1989: 303–311; Ekholm-Miller 1973; Lee 1989: 198–226; Lowe 1994: 113–127; McDonald 1983; Navarrete 1974), La Blanca and Abaj Takalik, Guatemala, and Chalchuapa, El Salvador (Anderson 1978: 155–180; Boggs 1950; Demarest 1989: 311–344; Graham 1977: 196–197; Love 1991: 47–76). If economic alliances with the Gulf Coast Olmec perhaps underlie the use of monumental art by Chalcatzingo and Teopantecuanitlan, then a similar situation involving the exploitation of Motagua valley jade and Pacific Coast cacao may help explain the presence of centers with olmec monuments in that region of southern Mesoamerica.

Small greenstone objects are also found in southern Mesoamerica (for example, cats. 50, 65, 72, 87, 89, 91, 119), but their presence there reflects another phenomenon. Such highly portable exotic objects were greatly desired by elite personages throughout Mesoamerica, and were widely traded during the Middle Formative period and also as "heirloomed objects" in subsequent centuries. Two examples of the latter are the olmec pendant found with a Classic period Maya burial on the island of Cozumel (cat. 95; Gregory 1975: 104), and a greenstone olmec maskette recovered during the recent excavations of the Aztec main pyramid in Mexico City (cat. 94; Matos 1989: 481–484).

Olmec ceramics have not been reported from highland Guatemala nor from the Peten or Yucatan. However, because the Early Formative period is not well documented within those areas, it remains to be seen whether the absence of olmec ceramics reflects a past reality or is merely a product of our current knowledge. It is interesting to note in that regard, however, that some olmec ceramics have been recovered in Honduras, including several vessels associated with a 900 B.C. burial at the famous Maya site of Copan (Fash 1991: 67–70; Healy 1974: 335–337). Recently, several pot sherds with olmec motifs have been excavated in the Belize valley. The significance of those scattered finds is still unclear, for although they may indicate that early stratigraphic levels with olmec pottery simply have not yet been found, the Honduran and Belizian finds can also be viewed as "peripheral" to the Maya heartland and perhaps the heartland itself contains no such pottery. Archaeological explorations over the next few decades may slowly clarify such questions plaguing scholars investigating the Olmec and Formative period Mesoamerica.

NOTES

1. The relationship of olmec art to the Gulf Coast archaeological culture called Olmec is a hotly debated topic today (Sharer and Grove 1989), but the puzzle is as old as olmec/Olmec studies. Some scholars see the art as representative of Gulf Coast Olmec "influence" over the remainder of Mesoamerica. Others, of which I am one, view the motifs and small

portable objects as revealing a nearly pan-Mesoamerican belief system of multiple origins (Sharer and Grove 1989: 8–14; Demarest 1989: 304–322; Flannery and Marcus 1994: 387–390). An obvious problem is that both the archaeological culture and the art share the same name, and that leads to confusion. Although I normally do not use the term olmec for the widespread art, in this essay I shall do so but with one important modification. I use the term with an uppercase "O" when referring to the archaeological culture of the Gulf Coast, and a lowercase "o" when speaking of the art.

Fifty years ago, Mexican artist Miguel Covarrubias was one of the first scholars to label the widely shared iconographic motifs and babylike figures with the term "olmec" (Covarrubias 1942: 46–49). Covarrubias had an astute vision of Pre-Columbian art. He understood that the Gulf Coast Olmec used the olmec motifs on both their pottery and on their major distinguishing art form, stone monuments, but he also argued (Covarrubias 1957: 76, 110) that the art's "most archaic forms" may have originated on the "Pacific slopes of Oaxaca and Guerrero," rather than on the Gulf Coast. At that time, another of Mexico's premier archaeologists, Román Piña Chan (Piña Chan 1955b: 106–107), also held a similar point of view, suggesting that it originated at the "confluence of the states of Guerrero, Puebla, and Morelos."

The Olmec was one of many societies that used the motifs on their pottery. However, they also incorporated some motifs onto stone monuments, a medium not utilized by other Mesoamerican societies. Over the years many scholars have assumed and asserted that because the Olmec were the creators of those magnificent stone monuments, they were also responsible for the widespread distribution of olmec art in Mesoamerica. However, the early observations of Covarrubias and Piña Chan illustrate the possibility that the various motifs now lumped together under the term olmec may have actually originated in many different areas of Mesoamerica, rather than in just one specific region—the Gulf Coast. Even assuming the strict Olmec-centric position and the scenario that at c. 1150 B.C. societies from Central Mexico to Honduras may have somehow adopted those symbols from the Gulf Coast Olmec, it must be acknowledged that those symbols soon became an integral part of the more particular iconographic systems of all of those societies, and that subsequently the symbols were manipulated and used by those diverse societies in their own ways until that art no longer had any significant relationship to its point of origin. A century or half a millennium later, the art should no longer be seen as representative of ongoing "influences" emanating from the Gulf Coast. Nevertheless, it commonly is. Whichever position scholars hold in the debate on the nature of olmec art, one thing is certain—in the absence of sufficient radiocarbon dates to resolve the problem, the debate will continue for many more years.

2. If, as some scholars contend, the Olmec influenced other Mesoamerican societies during the time span of the Early Formative period, why then is the greatest Olmec artistic achievement—monumental art—unrepresented at those "influenced" sites outside of the Gulf Coast?

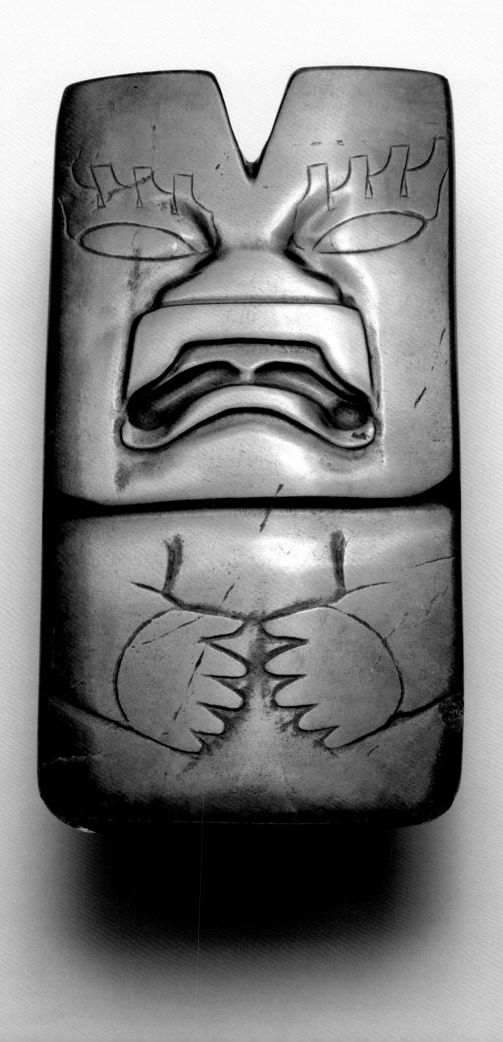

Portable Carvings in the Olmec Style

ANATOLE POHORILENKO

For Beatriz de la Fuente

INTRODUCTION

Ever since Marshall Saville published the extraordinary Kunz Axe in 1900, jade carvings in the Olmec style have provided scholars with information about the Olmec civilization and its people. Among the most extraordinary cultural achievements of the New World, these carvings are unrivaled in their sculptural configuration, tridimensional modeling, low relief, and polished concave surfaces. Artisans working in the Olmec style not only excelled in the sensitive modeling of the face, but imbued their figures, whether thumb-sized or monumental, with serene and yet powerful expressions that are both disturbing and appealing. Early on it was noted that these carvings had close thematic and stylistic affinities to monuments from the Gulf Coast of Mexico, where, according to seventeenth-century Spanish chronicles, a pre-Hispanic culture of extraordinary stone carvers once lived. Later discoveries not only confirmed this affinity, but also suggested that the many carved jades found throughout Mesoamerica were either the products of or influenced by this civilization (Stirling 1943a; Drucker, Heizer, and Squier 1959; Coe 1968).

Archaeologists began to study Olmec portable carvings for clues to the origins, geographical distribution, and physical type of the Olmec population, and whether its presence outside of the Olmec heartland (i.e., the southern Gulf Coast) was the result of religious proselytizing, conquest, or trade. It became commonplace to view the Olmec as a "mother" culture whose civilizing influence served as a developmental stimulus for less developed contemporary societies. Most importantly, these carvings were the only source for information on the nature of Olmec religion and other forms of ideological expression. Realistic images were thought to depict Olmec rulers, and composite images were supposed to represent Olmec deities (Covarrubias 1957; Coe 1965b, 1968; Joralemon 1976). Recently excavated data from different areas of Mesoamerica, however, together with new approaches to the study of Olmec art as a structured system of visual communication, have

led scholars to question some of these long-held perceptions (Grove 1989b; Flannery and Marcus 1994). It now appears that the civilizing role of the Gulf Coast Olmec was significantly less than originally thought. Pottery forms and decorative techniques once considered distinctly Olmec were apparently in existence before the appearance of the Olmec style (Pohorilenko 1990a). The same is true of activities such as the modeling of solid and hollow figurines, the carving of jade, the use of stone masonry, the coating of earthen platforms with lime plaster, the building of pyramids, and the orientation of a ceremonial center eight degrees west of true north (Flannery and Marcus 1994; Garber et al. 1993; Grove 1992). The significance of this evidence led David Grove (1989b: 14) to remark that "we cannot afford at this time to use the same term [Olmec] for artifacts and art motifs which we also use to name an archaeological culture."

Throughout this paper the term Olmec is used to designate a style of visual expression as opposed to an archaeological culture.

PROBLEMATIC ISSUES

Some of the finest examples of Olmec carving, including such singular pieces as the figure holding an infant from the Brooklyn Museum (cat. 48), the Kunz Axe (cat. 110), the Young Lord (cat. 50), the Necaxa jade (cat. 73), and the Río Pesquero statuette in the Dumbarton Oaks Collection (cat. 52), do not come from scientifically controlled excavations and, consequently, lack important contextual information essential to archaeological study. Although Early Formative pottery and figurines in the Olmec style may have also been produced by non-Olmec peoples, I believe that most of the early Middle Formative stone sculpture, both portable and monumental, was indeed carved by the Gulf Coast Olmec.

The comparatively small fraction of extant stone artifacts unearthed at La Venta (Drucker, Heizer, and Squier

1959) indicate that portable carvings in the Olmec style were placed as offerings in presumed elite burials under house floors, in stone coffers, and in tombs built of huge basalt columns. They were also included in dedicatory caches that celebrated the construction, and, possibly, the use termination of mounds, platforms, pyramids, and plazas, and were ritually placed in front of or under monumental sculptures. Small stone artifacts at La Venta were also found in pseudo-burials, in cruciform arrangements, and, as suggested by the contents of Offering 4, in what appears to be a scene of a ceremonial congregation of baby-face individuals (cat. 42).

Olmec-style jades were found also in offerings containing non-Olmec stone artifacts, as was the case with the enormous caches of Cerro de las Mesas (Drucker 1955) and Chacsinkin, from the Yucatan Peninsula (Andrews 1986, 1987). It is possible, as suggested by the Olmec-style carvings found in Costa Rica, that these beautiful objects of translucent blue-green jadeite were unearthed by peoples of other cultures, traded, often reworked, and finally redeposited, together with locally manufactured objects, in burial or dedicatory caches (Pohorilenko 1981). Such objects are usually referred to, incorrectly, as "heirlooms."

Chronology is another related problem: no Olmec-style portable carving has ever been conclusively dated, either by direct association or on the basis of style. This problem not only affects the enormous number of pieces lacking contextual information, but also artifacts unearthed on site. Although there are various means of dating burials and dedicatory caches, the assigned dates are not necessarily applicable to the objects found within. One way archaeologists have dealt with these problems of chronology is by dating the artifact to the cultural phase of the burial or offering in which it was found. As in the case of heirlooms, some carved jades must have been around for centuries before being placed in burials or dedicatory caches. On a stylistic level, this problem is compounded by the fact that many of these figurines and masks show secondary pictorial motifs that may have been added long after the original carving. Often the primary artifact differs substantially from the style and mode of application of its secondary motifs.

OLMEC JADE AND THE ARCHAEOLOGICAL RECORD

Jade was the most highly prized mineral in Pre-Columbian Mesoamerica. As a general term, "jade" designates lapidary work and, often, refers to the carving of other greenstones, including serpentine. When the term is applied to translucent, nearly pure bluish green stone, it incorrectly refers to jadeite, a mineral primarily composed of sodium, aluminum, silicon, and oxygen, formed under low temperature and very high pressure. Seldom occurring in a pure state, it contains varying amounts of albite, acmite, and diopside. The characteristic greenish blue hue is attributed to the presence of minute quantities of chromium, even in colorless jades. Jadeite is much harder than obsidian and slightly softer than quartz; because of its structure, it is the toughest and most durable of stones. The only secure deposits of Pre-Columbian jadeite occur near Manzanal, above Guatemala's Motagua valley, which is essentially a single deposit; Costa Rican jades may have come from this source (Lange, Bishop, and van Zelst 1981).

In addition to jadeite and serpentine, artisans working in the Olmec style used a variety of stones, including aventurine quartz, rock granite, alabaster, obsidian, chloromelanite, and such iron oxides as magnetite and ilmenite. When placing a carved object in a burial or dedicatory offering, it was customary to rub it with reddish dustings or cinnabar.

The ability to carve and polish extremely hard stones seems to have been known before the introduction of the Olmec style (Garber et al. 1993), but the Gulf Coast Olmec may have perfected the skill. As early as 1400 B.C., Mesoamerican societies already included stone beads, awls, celts, and *manos* and *metates* as part of their "tool kit." Excavated burials from this early period have yielded skeletons with globular beads and single pieces of jadeite in their mouths. Olmec-styled artifacts may have been drilled with solid or hollow quartz or other hardstone materials, but cutting or sawing was probably achieved with hard wood, bone, or other perishables, such as easily resharpened tools and hard abrasive materials. The actual job of cutting or sawing, grinding down, and smoothing was done, most likely, with cord or agave fibers coated with such abrasives as pulverized rock and/or sand, or by mixing both with fine bits of jade. Some of the drills used in making suspension holes were apparently the diameter of a sewing needle. The carving of a jade figurine began with the laying out and subsequent grinding of the facial planes, followed by the detailing of its features and, prior to polishing, the incising of secondary motifs. Some pieces show motifs engraved after the application of the final polish. The tools must have been small for easy handling, and the piece securely mounted for absolute control.

There are no real clues as to how the pieces attained their high sheen. Tatiana Proskouriakoff (1974: 9) believed that the jade artifacts must have been polished repeatedly, each time with a piece of leather and a different type of abrasive. This notion was based on Sahagun's description of the Aztec method of polishing greenstone: "polished, ground, worked with abrasive sand, glued with bat excrement, rubbed with fine care, made to shine." Regardless of how it was done, the carving was extremely labor intensive, requiring excellent knowledge of the stone and its response to certain tools and degrees of pressure. This laborious and time-consuming process made it almost necessary that more than one person, or task specialist, be involved in the manufacture of a given piece.

Curiously, except for La Venta, where large quantities of superbly carved jadeite were excavated, no other Olmec site known for its monumental carvings has produced any appreciable amount of Olmec-styled greenstone artifacts. San Lorenzo has yielded only a handful of carved artifacts that Michael Coe and Richard Diehl (1980: 223–246) called ornaments.

The Tres Zapotes greenstone finds are limited to one teardrop pendant, one bead, and a greenstone mask (Drucker 1943: 17, 25; 1952: pl. 66). Cerro de las Mesas, the Veracruz site famous for its cache offering of nearly seven hundred stone artifacts, had only three heirloom pieces carved in an unmistakable Olmec style (Drucker 1955: pls. 27, 28a, 38b).

At Chalcatzingo, Charlotte Thomson (1987: 295–304) reports 365 greenstone artifacts, of which 145 were carved out of jadeite, 35 out of serpentine, and 44 out of fuchsite. Most of the greenstone artifacts found there do not come from burial contexts but from dedicatory and termination offerings. Thomson points out, however, that the finest quality jade and artifacts of greatest aesthetic interest were placed, nearly always, in Cantera phase graves (700–500 B.C.).

In a marked contrast to the noted sites, La Venta yielded more than two hundred pictorially significant greenstone artifacts in the Olmec style. Although it has not been possible to date the portable carvings unearthed at La Venta, it is widely accepted that they were deposited sometime between 800 and 500 B.C.

Archaeologists are fairly confident, however, that Olmec-style jade artifacts occurred shortly after 1000 B.C. (Garber et al. 1993). They seemed to have reached their maximum productivity during 800 and 600 B.C. and, for unknown reasons, ceased to be made after 500 B.C. It should not be assumed that just because small stone carvings were no longer fashioned in the Olmec style that its forms and underlying concepts had disappeared entirely. Many of its thematic and structural aspects—some even suggest meaning—had been adopted, elaborated on, sometimes transformed, and incorporated into the representational language of such cultures as Izapan, Zapotec, and Maya (Quirate 1973, 1981; Marcus 1989, 1992; Proskouriakoff 1968; Joyce et al. 1991; Reilly 1991).

THE OLMEC REPRESENTATIONAL SYSTEM

The images of the Olmec representational system were expressed in two separate but complementary ways, one natural and the other composite. Animals and humans were rendered with a remarkable degree of naturalism. Composite representations, on the other hand, were structured according to explicit rules, in which *pars pro toto* elements —parts that stand for the whole—would combine to form hybrids that do not occur in nature. This tradition

of constructing composite images was introduced by the Olmec style around 1200 B.C.

The Olmec representational system was primarily based on three themes: the baby-face, the composite zoomorph, and the composite anthropomorph. The composite anthropomorph, sometimes known as the "were-jaguar," is a hybrid made up of elements related to the other two. Each theme was identified with a number of associated motifs, forming thematic complexes. Most of the motifs, though symbolically traceable to the composite zoomorph, became closely identified with one or another theme, as was the case of the St. Andrew's cross or the V-cleft motif.

The Baby-Face Thematic Complex

The body of the baby-face figure is the basic human form of the Olmec representational system. Except for a specific class of dwarfs and masks, it characterizes the shape and appearance of all realistic anthropomorphic representations and, more importantly, it determines the morphology of one of the system's most significant images, that of the composite anthropomorph.

The baby-face head is usually pear-shaped, due in great measure to cranial deformation, lack of hair, and heavy jowls; it is often large in relation to its body. Brows are never fully characterized except as a raised surface area, and the tissue around the eyes is nearly always depicted as swollen. The hollowed-out eyes may be elliptical, slit, or almond-shaped, and most are placed on a horizontal axis. When indicated, irises are often cross-eyed. The shape of the noses varies. Most are short and wide, but some are elongated, arched, or puglike. All baby-faces show prominent and well-rounded chins, and except for an occasional goatee, they are usually clean shaven.

The rest of the body is rendered in a more summary fashion and shows no evidence of the pictorial detail usually lavished on the head and its physiognomic elements. Necks are always short and wide, torsos are compact, and limbs consistently short and stocky. There are instances, however, when the torso is lean and the limbs elongated. Sometimes the upper body is sensitively carved to show soft musculature. Infant baby-faces, modeled as large, hollow clay figures, were usually depicted naked, with no genitalia (cats. 21, 22). Some babies wear skull-hugging helmets. Adolescent and adult baby-faces were modeled as small, solid clay figurines, carved out of jadeite or serpentine, or sculpted as huge stone monuments. As suggested by the standing helmeted figurine from Las Choapas (de la Fuente 1977: figs. 1, 3), colossal heads are monumental versions of adolescent or adult baby-face persons.

The baby-face image extended to dwarfs and acrobats. This particular type of visage first appeared in the Central Highlands and the Gulf Coast with the Olmec representational system at about 1200 B.C. and continued to represent the human form, particularly as portable stone images, for

the next seven hundred years. Somatic and motor studies of stone and clay baby-faces strongly support the position that they were actual depictions of individuals afflicted with Down's syndrome and related conditions (Pohorilenko 1975). In a representational system where human and animal beings symbolized natural phenomena, the baby-face figures were used to represent mankind.

Portable jade or serpentine carvings of the baby-face physical type occur as seated or standing figurines, dwarfs, acrobats, masks, and body parts. They generally measure from 5 to 18 centimeters in height, though some images may be larger than 50 centimeters high. These figurines usually have perforated earlobes and nasal septum. Many have drilled pits at the corners of the mouth, and occasionally at the center of the upper gum ridge.

Portable sculptures were usually carved without a supporting surface. The best known exceptions are three jade carvings in this exhibition (cats. 53, 54, 63).

Small seated baby-faces are usually shown with their legs crossed and their cupped hands or open palms resting on their thighs or knees, but there are many variations, all rather formal. Many wear helmets and loincloths; only seated ones are shown elaborately costumed. Costumed baby-face adolescents and adults are further identified with the composite anthropomorph by wearing his "mask" as an emblem or a headdress crowntop element. This identification is clearly visible on such carvings as the Río Pesquero figurine (cat. 52).

Portable stone depictions of standing baby-face adults outnumber seated versions four to one. Standing images may show helmets and loincloth, but never appear in full composite anthropomorph regalia (cats. 45, 46, 48, 49). The arms of standing baby-faces are usually rigid and symmetrical. Many hang alongside but away from the body, showing the elbows slightly bent and the hands cupped or closed in a fist. An equal number of figurines show the arms projecting forward from the shoulders or elbows, with the cupped hands facing down (cat. 43). The hands of some standing baby-faces are placed on the chest, or at waist level, separate, touching, or superimposed. Baby-face carvings are also shown holding "torches," "knuckle-dusters," and composite anthropomorphic infants. Identical objects are held by the Las Limas Figure (cat. 9). Contrasting with the formal stances of both seated and standing figurines, recumbent baby-faces are presented in a relaxed position with one hand touching the head while the other, bent, rests on the chest or on a raised knee (cat. 56). One curious detail not seen on seated or recumbent figurines, but clearly visible on images of standing baby-faces and dwarfs, is that the legs are always shown slightly bent at the knees (cat. 42). This peculiar stance is exclusively associated with baby-face representations and is not found outside the Olmec style. No tridimensional monumental carvings of standing baby-face individuals are known.

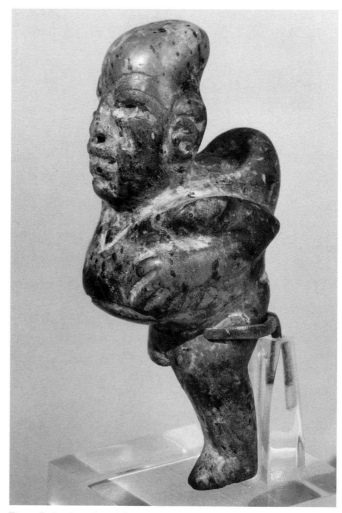

Fig. 1. Baby-face dwarf. Serpentine, 8.9 cm.

Both seated and standing baby-face portable images show secondary incisions depicting motifs related to the composite anthropomorph. The four dots and bar on the back of the composite anthropomorph mask carved atop the headdress of cat. 52 is reproduced also on the arms and thighs of a standing baby-face of serpentine (Coe 1967: 111, figs. 1 and 3). Similar motifs occur with composite anthropomorph images on votive axes and celts.

Not all dwarfs traditionally regarded as Olmec have the baby-face physiognomy, whether straight backed (cat. 60) or pigeon-chested (fig. 1). About thirty known specimens, complete figures and fragments, are characterized by an oval-shaped head, small nose, and receding lower jaw. Their arms and legs are very thin, and their severely crouched stance requires exaggeratedly large feet, which turn inward, the toes touching. The large feet and the posture serve to anchor the figure, whose principal mass is concentrated in its large head (fig. 2). These large *chaneques*, as Miguel Covarrubias (1942) called them, show a much wider variety of motion and range of age than the baby-face dwarfs. Some *chaneques* have incised secondary motifs in the Olmec style (Vaillant 1932: 516), while others appear with the everted upper lip of the composite anthro-

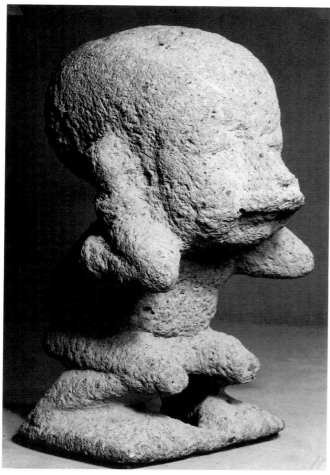

Fig. 2. *Chaneque* dwarf. Basalt, 20 cm.

ered. The Las Choapas type of mask appears to have been introduced into the Olmec representational system after 700 B.C.

The twenty-two masks characterized by baby-face features are usually smaller than the Las Choapas type. A small number of them, reported to be from Chiapas, tend to show a much rounder face, similar to the one reported from El Salvador (cat. 83). They also exhibit secondary depictions that relate them to the composite anthropomorph (cat. 91).

The purpose of these masks is not clear. Some masks, especially those showing the baby-face characteristics, were too small to have been worn. Perhaps they were placed over mortuary bundles.

The Olmec style included a tradition of carving body parts such as ears, legs, and hands as referential symbols for the human body. The carved splayed hands recovered at La Venta—also known as the hand–paw–wing motif—are of particular interest (cat. 85). An identical pair, even to the length of the forearms, is depicted below the head of a composite anthropomorph on a celt from Guatemala (Navarrete 1971: fig. 5). Similarly splayed hands appear on the extremities of the pelt worn by the Atlihuayan infant (cat. 23) and on abbreviated versions of this composite zoomorph (fig. 3). Although splayed hands are a baby-face *pars pro toto* element, as a symbolic motif it is usually shown as part of the composite zoomorph thematic complex, with strong associations to caves. Open human hands with spread fingers are also depicted in Olmec art. Sometimes they seem to have been mutilated, as in the hand shown on a celt, where the end portion of each finger was deliberately amputated (cat. 116). Incised on the back of this hand is a symbol for a cave entrance.

Small jadeite legs carved in the round, with a typical baby-face bent knee, have been reported from Guerrero

pomorph. Despite their frequent representation, the significance of dwarfs in early Mesoamerica is still a mystery.

Two types of realistic masks are often associated with the Olmec style: those with a baby-face and those without. The latter is herein referred to as the Las Choapas type. (This appellation does not necessarily imply that all such masks have come from the coastal site of Las Choapas, in Veracruz.)

When compared to the baby-face mask, the facial contour of a medium-to-large Las Choapas type tends to be more elongated, with a narrower and longer nose, and no puffy tissue around the eyes. It also has fairly thin lips and a mouth that seldom suggests a trapezoid, as in some baby-face images. But they share the baby-face's ears, bar-like projections with both the helix and lobes attached to the head; they show buccal pits and occasionally exhibit extraordinary secondary incisions in the purest Olmec style (cat. 77). These extraordinary masks are portraits in stone. When worn, the large ones cover the entire face. Some masks depict portions of helmets, headdresses, or hair, often extending well onto the crown. If worn with some sort of headdress, their construction and perforations suggest that the wearer's entire head could have been cov-

Fig. 3. Profile head versions of the reptilian zoomorph, with the splayed hand motif. Clay vessels from Tlatilco (from Covarrubias 1957: fig. 9).

(Griffin 1981: 221, fig. 22). Another pair of legs, apparently part of a necklace, were incised on a votive axe from Etzatlan, Jalisco (Ochoa 1976: fig. 2). These legs bear the same knotted-bands motif seen on the arms and legs of the Río Pesquero figurine.

The Composite Zoomorph

For the archaeologist, the appearance of Calzadas Carved and Limón Carved-Incised pottery in the Gulf Coast, at about 1150 B.C., marks the introduction of the Olmec representational system in Mesoamerica. The novelty of this pottery lies not in the shape, clay, or technique, but in the subject matter on its outer walls—the profile of the composite zoomorph and its associated motifs. In addition to the Gulf Coast, where pottery bearing this type of image has been recognized as Olmec (Coe and Diehl 1980: 159), the ware has been unearthed also in the Central Highlands of Mexico (Porter 1953; Niederberger 1987), the Etla Valley of Oaxaca (Flannery and Marcus 1994), and in the Middle Grijalva region of Chiapas (Lowe 1981). Donald Lathrap (1971) and Michael Muse and Terrence Stocker (1974) identified the principal image on this type of pottery as reptilian.

One of the three fundamental themes in Olmec art, this zoomorph is characterized by a lizardlike body with serrated brows, trough- or L-shaped eyes, and a bandlike mouth with drooping corners. There is no lower jaw, but some examples have raised mouth corners. In nearly all images, while the eyes and the nose may be omitted, the serrated brows and mouth are usually shown. When present, the nose rests directly upon the upper lip. Teeth are usually shown as downturned brackets, with some images also having rear-curving fangs. *Pars pro toto* versions may be limited to serrated brows, buccal bands with straight or drooping mouth corners, L-shaped eyes, downturned brackets, or any combination of these. The downturned E motif appears to represent its frontal head, while a cleft brow stands in for the profile. Moreover, the zoomorph appears with many motifs: the opposed volutes, the circle, the mat, the lozenge, the sunburst, the St. Andrew's cross, the splayed hand, and the cleft rectangle, among others (fig. 4).

Whereas the image of the composite zoomorph is primarily represented in head form or as *pars pro toto* elements, a few full-bodied versions were modeled as solid clay figurines and as clay effigy vessels (cat. 29). The pelt of a reptilian zoomorph is worn by the Atlihuayan baby (cat. 23). This theme is carved in relief on rock outcroppings, on small carvings, and, in head and *pars pro toto* form, on monumental altars. Except for a realistic crocodilian head fragment carved in basalt (cat. 14), there are no tridimensional monuments of this subject. Frontal head versions of the zoomorph may be also seen incised on the navel area of carved standing baby-faces (Joralemon 1976: fig. 10s) and composite anthropomorphs (cat. 89).

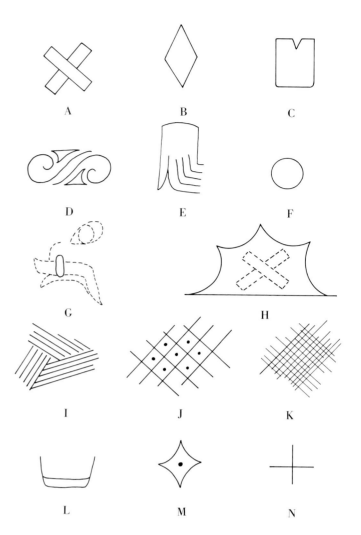

Fig. 4. (A) St. Andrew's cross, (B) lozenge, (C) cleft rectangle, (D) opposed volutes, (E) splayed hand, (F) circle, (G) figure-eight, (H) sunburst, (I) mat, (J) dotted squares, (K) cross-hatching, (L) bracket, (M) dotted star, (N) cross.

In addition to the remarkable zoomorph from the Brooklyn Museum (fig. 5), the image of the composite zoomorph, in a head version, appears on a staff-shaped artifact known as a "scepter." This double-headed staff shows the heads of the composite anthropomorph and that of the zoomorph in profile connected by a shaft (cat. 104). The structure of this artifact is compositionally identical to the incision on the Young Lord's thighs (cat. 50), except that in the carving the body is replaced by a three-ringed shaft.

Pars pro toto elements related to the composite zoomorph were also delicately carved as separate portable jade artifacts, including serrated and cleft brows (Joralemon 1971: fig. 30). Cleft brows are also shown as part of headdress assemblages in which they represent the zoomorph (cat. 118). On these headdresses, the zoomorph has a composite anthropomorph *pars pro toto* element placed above it. Such abbreviated pictorial compositions stand for the full image of a composite anthropomorph sitting atop the composite zoomorph.

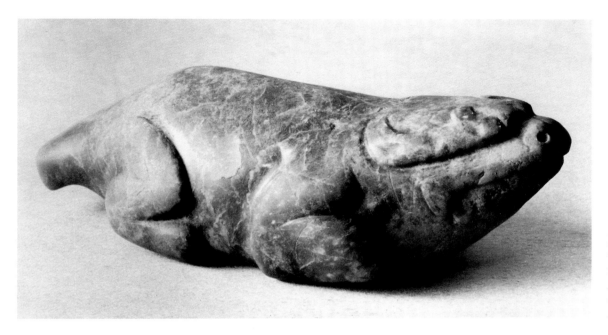

Fig. 5. Full-length version of the reptilian zoomorph. Jadeite, with traces of cinnabar. 12 x 4.8 x 3.8 cm.

Olmec art is based on the premise that all the components of a composite image represent living beings. As such, the body may be reptilian, human, catlike, serpent-like, fishlike, embryonic frogs (tadpoles), and so on (Pohorilenko 1990b). Certain animal traits articulated onto a baby-face body produced the image we call the composite anthropomorph (cat. 12). Thus, the composite tadpole, or "spoon," is a combination of a raptorial avian beak, saurian serrated brows, and a serpent's fang, all placed in the appropriate areas of the embryonic body of a frog or toad (cat. 100).

The saurian or reptilian zoomorph is the first to appear on Olmec-style pottery. Often confused with the "were-jaguar," this zoomorph has intrigued scholars for decades. Coe (1965b: figs. 29, 30, and 31) called it the "jaguar dragon," Nanette Pyne (1976: figs 9.7a, b, and c) refers to the same image as "fire-serpent" or "sky-dragon," and David Joralemon (1971, 1976) named it God I, a supernatural deity worshiped by the Gulf Coast Olmec, whose primary associations were earth, water, agricultural fertility, and dynastic succession. Grove (1970a, 1973) suggested that monumental altars depicting the reptilian zoomorph, which he calls "earth monster," represent royal thrones whose iconography is linked to the supernatural origins and divine rights of Olmec rulers.

Aside from its possible intrinsic meaning, the explicit importance of the composite zoomorph seems to rest upon its pictorial role *vis a vis* the composite anthropomorph. The cleft depression, serrated brows, and everted upper lip, all defining traits for the composite anthropomorph, are saurian or reptilian. Moreover, both themes share a number of motifs. Buccal and ear bands often depicted on baby-face figurines and on both baby-face and Las Choapas masks symbolize pictorially the zoomorph's most important natural affiliation, the cave. Whenever these two themes are depicted together, the anthropomorph is shown sitting upon the head or inside the mouth of the reptilian zoomorph. Based on the composite zoomorph theme they bear, it is likely that Olmec altars, before they became "royal thrones," as suggested by Grove, were originally monumental symbols of sacred mountains upon which the composite anthropomorph was placed during ritual events.

The Composite Anthropomorph

The defining characteristics of the composite anthropomorph are the product of an articulation of composite zoomorph elements onto a baby-face frame (figs. 6, 7). The resulting image always shows an everted upper lip, even though serrated brows, trough- or L-shaped eyes, or split fangs may be absent. This defining trait is sometimes accompanied by a figure-eight motif (cat. 73), also seen on reptilian zoomorphs (cat. 29). As the hallmark of the Olmec style, this combination of human and animal traits into a single image achieves a powerful and yet disturbing effect on the viewer.

A properly attired composite anthropomorph wears a headdress with a single or cross-shaped rear cleft, a headdress band, earbars, and an optional nape cloth. A pendant depicting the St. Andrew's cross motif is optional, as is the presence of this motif on the navel. A cape and wristlets and/or anklets may complete the attire. The headdress is by far the most important dress item. In two-dimensional depictions, the rear cleft depression becomes a single V indentation, usually placed directly on top of the head. Aside from its other symbolic connotations, this cleft may stand for the entire headdress.

Composite anthropomorphs were rendered as infants, adolescents, and adults. A portable image of an infant anthropomorph is seen in the arms of a statuette (cat. 48), while a monumental version may be seen in the Las Limas sculpture (cat. 9). Full-length versions of adolescent or

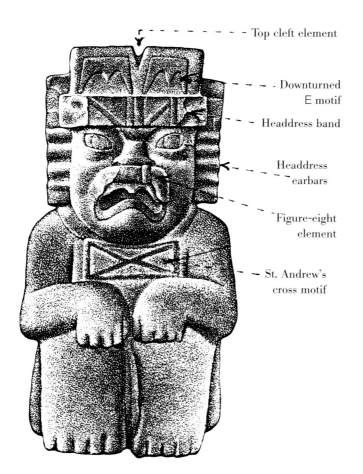

Fig. 6. Seated composite anthropomorph, San Lorenzo Monument 52. Basalt, 90 cm (from Coe and Diehl 1980: fig. 494).

Top cleft element

Downturned E motif

Headdress band

Headdress earbars

Figure-eight element

St. Andrew's cross motif

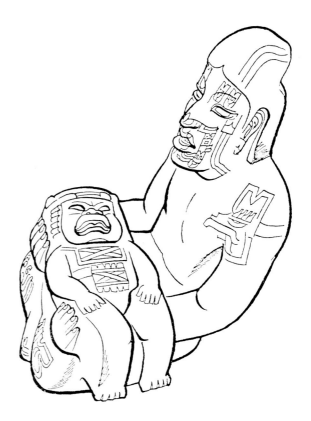

Fig. 7. The composite anthropomorph in the arms of the Las Limas Figure (from Medellín Zenil 1965: fig. 17).

adult anthropomorphs occur on votive axes, cleft plaques, and San Lorenzo Monument 52, among others. Like baby-faces, anthropomorphs were depicted seated (cat. 73) and standing (cat. 50). Composite anthropomorphs can be shown holding torches and "knuckle-dusters." Head versions of this theme appear on both portable and monumental carvings. Profile versions are commonly incised as part of ear and buccal bands, as well as on clay vessels (cat.

40). Pottery bearing abbreviated versions of this motif occurs at about 1000 B.C. in the Gulf Coast, Oaxaca, and the Central Highlands of Mexico (Coe and Diehl 1980; Flannery and Marcus 1994; Niederberger 1976).

Some of the most interesting versions of the composite anthropomorph are rendered as secondary images on objects that could be worn. These include masks, earspools, and various types of pendants. As with some realistic baby-

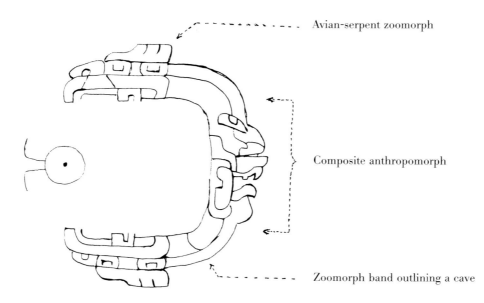

Avian-serpent zoomorph

Composite anthropomorph

Zoomorph band outlining a cave

Fig. 8. Profile head of a composite anthropomorph inside a cave. Structured as an ear or buccal band, this composition depicts the extensions of the composite anthropomorph's head as serpents with avian beaks and serrated brows. This design appears incised on a pair of earflares included in the burial offering of La Venta Tomb C (from Drucker 1952: fig. 466).

face and Las Choapas masks, life-size masks depicting the face of the composite anthropomorph may show a full complement of serrated brows, everted upper lip, and canines showing a nonfeline type of occlusion. These composite masks have an uncanny resemblance to the composite anthropomorph visages on cleft-plaque pendants (cat. 111) and votive axes (cat. 110). Life-size masks were probably worn during rituals that required the impersonation of the composite anthropomorph.

Approximately seventy-two earspools have been recovered archaeologically from Cerro de las Mesas, La Venta, San Isidro, and Chalcatzingo. One pair unearthed at La Venta has the profile of a raptorial bird incised in such a way that the flare's throat coincides with the bird's eye. Another pair from La Venta shows double avian heads with serrated brows attached to serpent's bodies. In a compositional structure reminiscent of earbands with the profile "mask" of the composite anthropomorph, these flares seem to show the head of the anthropomorph inside a cave (fig. 8).

Pendants, or pectorals, form yet another category of portable artifacts depicting the composite anthropomorph. Masks with panels are a horizontal type of pendant, gener-

ally rectangular in outline, consisting of a raised, squarish central "mask" flanked by two lateral panels. Three out of the eight known masks with panels show the baby-face head on its raised central portion, whereas the image of the composite anthropomorph appears on the rest. The largest extant specimen of this type of pendant measures 26.7 centimeters and is regarded by scholars as an heirloom because of the Maya hieroglyphs incised on its back (cat. 97).

Cleft plaques are rectangular jade or serpentine pendants. An average cleft plaque measures between 18 and 20 centimeters in height and 8 to 10 centimeters in width, with a varying thickness of about 1.6 to 2.8 centimeters. Its only subject matter is a full-length version of the composite anthropomorph carved in low relief (cat. 111). Because these artifacts have holes suitable for suspension and are similar to an oversized but identical artifact worn by the figure in the Ojo de Agua monument, it is possible to suggest that these beautifully carved artifacts were worn as pendants.

The third type of pectoral is the squarish pendant. Commonly referred to as disks, plaques, round plaques, or mirror backs, they have a squarish shape with rounded corners, one side flat and the other convex. Carved of jadeite or serpentine, these artifacts measure anywhere from 9 to 12 centimeters on the side. All five known pendants bear a cleft-head version of the composite anthropomorph at the bottom edge. In some pieces the entire cleft rectangle appears as a raised surface with the features shown in low relief, excision, and incision. One squarish pendant shows the head of the anthropomorph inside a cave, represented by an abbreviated image of the composite zoomorph placed above the anthropomorph's image. John Carlson (1981) linked these squarish pendants to Olmec mirrors.

A number of small greenstone carvings bearing the composite anthropomorph were probably worn as pendants, although they do not resemble those described above. Among these are two breastplate-type artifacts. One shows a baby-face individual combining a number of profile head versions of the composite anthropomorph. The cleft depression on its head corresponds to the mouth of this composite (cat. 90). The other is a plaque depicting a fanged and bearded anthropomorph sporting a headdress with earbars and the double-merlon motif, flanked by two cleft rectangles (cat. 96). Yet another depicts a full-length composite anthropomorph in a twisting, three-quarters view (fig. 9). A number of clamshells carved out of translucent grayish-blue jadeite are also known.

The image of the composite anthropomorph is ubiquitous also on a category of portable stone artifacts that represent greenstone copies of objects or tools used in everyday activities. A typical Olmec-style votive axe often carries a full-length version, with the head of the axe corresponding to the head of the image, and the blade to

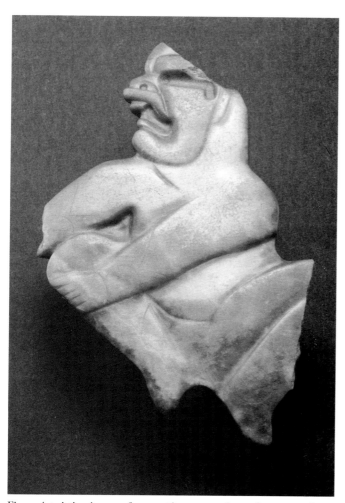

Fig. 9. A twisting image of a squatting composite anthropomorph with circle motifs on the wrists and ankles. Jade, 13.5 cm.

its body. The effect of such a 1:1 ratio seems to enhance the sense of monumentality projected by these portable carvings. Votive axes were fashioned out of jadeite, serpentine, quartzite, granite, and other types of greenstone. An average votive axe is about 30 centimeters long, 13.8 centimeters wide, and 10.2 centimeters thick.

There is great variability in the presentation of the composite anthropomorph as it is depicted on votive axes. Some are shown full length, while on others its image is limited to a frontal head version. When not showing the anthropomorph's body, blades may have incised secondary motifs associated with the anthropomorph or be left blank. Buccal bands are present on some of these images. It is very likely that the large and heavy, beautifully carved jade axes were never meant to be used in utilitarian activities, but their role was strictly symbolic, in rituals and ceremonies related to the planting cycle, which probably included felling, burning, and clearing the land.

Also used in propitiatory rituals were jade carvings of such utilitarian objects as canoes and awl-like perforators. These flat-bottomed, dugout canoes may show head images of the composite anthropomorph or be carved in the shape of a hand (cats. 102, 103). Awl-like perforators often show the anthropomorph theme carved or incised on the handle.

Another fascinating utilitarian object carved out of jade and serpentine is the celt. A true celt has an elliptical to rectangular cross-section, with a bit that is ordinarily convex and symmetrical, and a narrower but thicker poll. Celts were carved out of jadeite, serpentine, slate, and other types of greenstone. The maximum width of a celt occurs near the bit, gradually tapering toward the poll. Incised celts range in length from 12 to 38 centimeters. Although both sides of the celt usually mirror each other in outline, finish, and surface slant, two of the three incised celts from La Venta Offering 1942-c were faceted (Drucker, Heizer, and Squier 1959: fig. 65). Of the 569 greenstone celts recovered from La Venta excavations, only 12 bore incised or carved secondary depictions.

Almost exclusively, the subject matter depicted on celts is the composite anthropomorph and its associated motifs. The head of the subject is usually placed toward the bit end. Sometimes head versions of the anthropomorph are shown surrounded by four motifs, similar in structure to a four-dots-and-bar motif (cat. 117). On large celts the motifs may be placed above and/or below the central image (cats. 115, 116). An abstracted full-length version of the anthropomorph was incised on the faceted celt from La Venta. This image lacks a mouth which, instead, is indicated by a pair of figure-eight elements, the device used to hold the everted upper lip of the anthropomorph in place. The body is indicated by a pair of "knuckle-dusters" (cat. 114).

A small number of celts depict standing or seated baby-faces. In one such carving (cat. 118), an elaborately dressed

individual wears a complicated headdress depicting, twice, abbreviated versions of a composite anthropomorph sitting atop a composite zoomorph. A similar headdress composition occurs on another celt (cat. 119). Composite anthropomorphs depicted on celts are shown holding "folded cloth" (cat. 117) "knuckle-dusters," bars, and torches. In addition to their utilitarian morphology, inclusion in various types of offerings, and possible use in ceremonial contexts, celts are the only portable Olmec-style artifacts in which the placement of the thematic matter and affiliated motifs suggests that they may also have been used as some sort of mnemonic tablet.

Finally, there is a group of remarkable portable carvings whose explicit function is not known. These include *yuguitos*—little yokes—and the double-headed staff. It has been a long-held belief that *yuguitos* were related to the Mesoamerican ball game. However, the two known *yuguitos* bearing secondary images in the Olmec style show the face of the composite anthropomorph in the manner of headdress insignia, suggesting that these artifacts may, in fact, be stone helmets (cat. 109). Supporting this observation are the incised motifs on the forehead of a Las Choapas mask in the Peabody Museum, Harvard University (cat. 93).

Double-headed staffs pose a similar functional problem. Called "scepters" by some scholars, no portable or monumental carving has ever indicated how they were used. One interesting characteristic of these staffs is that the image of the anthropomorph depicted at one of its ends usually has a conelike element rising above the cleft on its headdress (cat. 104). Similar cone motifs appear on images of the anthropomorph depicted on celts, squarish pendants, and on a rock carving in Chiapas known as Xoc (Ekholm-Miller 1973).

The composite anthropomorph is closely linked to both the baby-face and the composite zoomorph. However, unlike baby-faces, only composite anthropomorphs were shown with reptilian attributes, seated on the composite zoomorph, and depicted inside caves. Therefore, I do not believe that the composite anthropomorph should be regarded as a supernatural deity or the image of a ruler wearing animal attributes. More likely, they were representations of living baby-face individuals who, on certain religious occasions, wore the attributes and symbols of the composite zoomorph for ceremonial purposes.

FAUNAL IMAGES IN THE OLMEC STYLE

Some of the most beautiful animal images in Olmec art were not carved out of jade, but modeled in clay. Effigy vessels depicting ducks, fishes, monkeys, and other animals were reported to have been found at Tlatilco, Tlapacoya, and Las Bocas, in the Central Highlands (cats. 26–28). These realistic faunal depictions carry on their bodies or have incised or excised on their bases Olmec

Fig. 10. Plain tadpole. Also known as a "spoon." Jadeite, 12.6 cm.

motifs, including the splayed hand and opposed volutes, which are part of the composite zoomorph iconic complex and appear on Calzadas Carved and Limón Carved-Incised pottery from San Lorenzo (Coe and Diehl 1980: 162–175). While faunal depictions in jade are rare, they are present in representations of a composite nature.

Conceived as a vertical cross-section of an embryonic frog or toad, Olmec tadpoles, also known as "spoons," constitute an aesthetic expression of unparalleled simplicity and elegance (fig. 10). The Olmec-style tadpole consists of a horizontal spine line running across the top, two concave arched depressions corresponding to the head and a larger belly, and an elongated, bladelike tail, also showing a depression. Two invisible suspension holes suggest that this artifact was intended to hang horizontally.

As with most living subjects depicted in the Olmec style, tadpoles were rendered as plain (i.e., realistic) and composite. Most plain tadpoles are devoid of any secondary depiction, but four such artifacts have both eye and mouth clearly indicated. Secondary incisions occur on the belly and tail portions of the plain tadpole (cat. 99), and usually show composite anthropomorph heads, realistic baby-face heads, cave motifs formed by arched arms with splayed hands, floral designs, and straight-snouted versions of a reptilian zoomorph.

The composite tadpole has a wide, curving raptorial beak, serrated brow, turned-back fang, and a raised buccal rictus (cat. 100). These "bird monsters," as Drucker (1952: pl. 54) called them, are related to the serpentine composite zoomorphs depicted on a pair of La Venta earspools. I believe that plain and composite tadpoles were introduced into the Olmec representational system after 700 B.C. and had their primary locus in the southeastern region of Mesoamerica, possibly in the Pacific Coast and highland areas of Guatemala and, perhaps, Chiapas.

The most beautiful and expressive renderings of ducks are found in clay effigy vessels (cat. 27). In portable carvings, this fowl is primarily depicted as a realistic head or, in bill form, part of composite heads which were worn as individual pendants or part of necklaces. While solid clay ducks have been recovered from late Early Formative deposits at San Lorenzo (1250–1150 B.C.), realistically carved small jade duck heads have been found at La Venta and Chalcatzingo. Composite versions always show a duck bill attached to a human head (fig. 11). According to a portable carving in the Museum für Völkerkunde, Berlin, the duck was directly associated with corn (fig. 12).

A splendid stone monkey with its arms and tail curling above its head was unearthed in Cantera phase deposits at Chalcatzingo (Thomson 1987: fig. 17.6). This monkey is carved out of fine blue-green chalcedony; one in the American Museum of Natural History, New York, is of blue-green jadeite (cat. 88). Both monkeys have the suspension hole in the tail. There are also jade carvings of monkey heads. The significance of monkeys in Olmec art is still a mystery.

Catlike *pars pro toto* attributes appear on composite depictions in the form of canines, tails, ears, or body (Metcalf and Flannery 1967). Images with split fangs, such as those on the composite anthropomorph on the Kunz Axe, do not, however, correspond to a feline type of occlusion. I believe these cleft fangs had the same symbolic meaning as the St. Andrew's cross motif placed inside mouths, that of the four cardinal directions. Also, the jaguar's snarl, often regarded as typical of such "were-jaguar" depictions as the Necaxa figurine (cat. 73), is not a feline characteristic but is shown on the saurian effigy vessel from Tlapacoya (cat. 29) as a reptilian trait.

Avian presence within the Olmec representational system has a wide distribution only in *pars pro toto* form. Raptorial beaks appear as buccal masks on some standing figurines, carved in the round, or on votive axes and squarish pendants. They also appear on composite tadpoles. Full-bodied avian costumes appear on the Tuxtla statuette and were worn by the seated individual painted on Mural I, at Oxtotitlan. Avian talons are incised on an obsidian core (Drucker 1952: fig. 48), and appear as part of dress on monuments. Feathers occur as head crests or tufts. A tail made of feathers occurs on the pelt worn by the Atlihuayan infant (cat. 23). Whereas the combination of

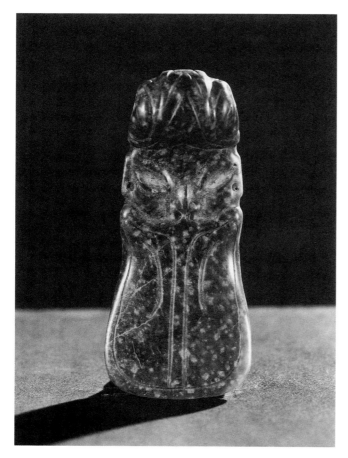

Fig. 11. A pendant depicting a man wearing a buccal mask in the shape of a duck's bill. Jadeite, 8.3 cm.

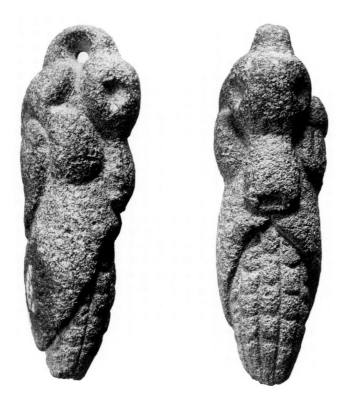

Fig. 12. A composite representation of an ear of corn, with the husk in the shape of a duck. 11 cm.

serrated brows and avian beaks occurs in San Lorenzo as early as 1150 B.C. (Coe and Diehl 1980: fig. 140g), avian and serpentine combinations in Olmec art become prevalent only after 700 B.C.

Faunal subjects in Olmec art were particularly important early on, when abbreviated versions of the reptilian zoomorph were frequently depicted on clay pottery, with a number of other animals that were modeled as realistic clay effigy vessels.

After the pictorial dominance of the composite anthropomorph during the first half of the Middle Formative period, the composite zoomorph thematic complex returned to favor after 700 B.C., perhaps as the consequence of the appearance in Olmec art of individuals with nonbaby-face characteristics and a concomitant emphasis on avian and serpentine themes. Where once composite anthropomorphs showed animal attributes exclusively related to the reptilian zoomorph, now nonbaby-face figures wore buccal and facial masks showing avian beaks, or entire avian or serpentlike costumes (cat. 72). Despite these changes and whatever other symbolic implications they may have had, the newly introduced avian-serpent zoomorphs continued to maintain the reptilian's association with mountains and caves.

CONCLUSION

The roots of the images so succinctly expressed by these Olmec-style portable carvings may go back to the middle of the second millennium B.C. At that time people in Mesoamerica lived in small agricultural hamlets and modeled clay figurines of females and animals, which were apparently used in fertility and healing rites (Ceja Tenorio 1985). They likely practiced an animistic form of religion, whose adherents, as described by Joyce Marcus (1989), believed the world to be alive with spirits that dwelled within mountains, earthquakes, thunder, fire, wind, and so on. It was probably during these times that a symbolic visual correspondence between the spirit of a natural entity or place and a particular animal was established.

The appearance of the Olmec representational system around 1200 B.C. was a response to the growing requirements of public and private rituals. Reflecting the existing animistic beliefs, the new pictorial system codified the already familiar symbolic associations into the three familiar themes—the composite zoomorph, the composite anthropomorph, and the baby-face—with the composite anthropomorph as the living ceremonial link, or "mediator" in Beatriz de la Fuente's designation (1981: 93), between mankind and the natural forces surrounding it. This codification of beliefs into a coherently articulated representational system is one of the great intellectual achievements in history.

For the first two hundred or so years, the primary focus of the Olmec representational system was on the compos-

ite anthropomorph and the baby-face representations, both expressed in clay and, possibly, as monumental carvings used in public ritual. By 900 B.C., the introduction of portable carving suggests an intensification of public and private ritual practices, with an accompanying thematic shift. The pictorial emphasis is no longer on baby-face and reptilian zoomorph images. Clay vessels bearing the image of the latter had been discontinued, and shortly after 800 B.C., baby-face clay figures were no longer modeled. While still carved on both portable and monumental scales, these images were secondary to the composite anthropomorph, the preferred theme of this new religious era. The introduction of avian and serpentine motifs into the zoomorphic complex and the appearance of human images with other than baby-face characteristics by 600 B.C. reduced the pictorial role of the reptilian zoomorph to monumental altars and basal bands on stelae, and that of the anthropomorph to stylized motifs shown on ceremonial objects and richly attired individuals. These changes brought to a close the "classical" era of the Olmec representational system, a time when the central pictorial concerns were primarily religious and the anthropomorph the principal subject.

ACKNOWLEDGMENTS

I wish to express my sincerest appreciation to several friends and colleagues for their generous gift of time and knowledge in the preparation of this essay. In particular, I wish to thank Felipe Solís O., Joyce Marcus, Louise I. Paradis, Elizabeth P. Benson, Mary Yakush, and my angel, Claudia Pohorilenko. While their comments and editing greatly improved this effort, I assume total responsibility for any misrepresentations of their ideas.

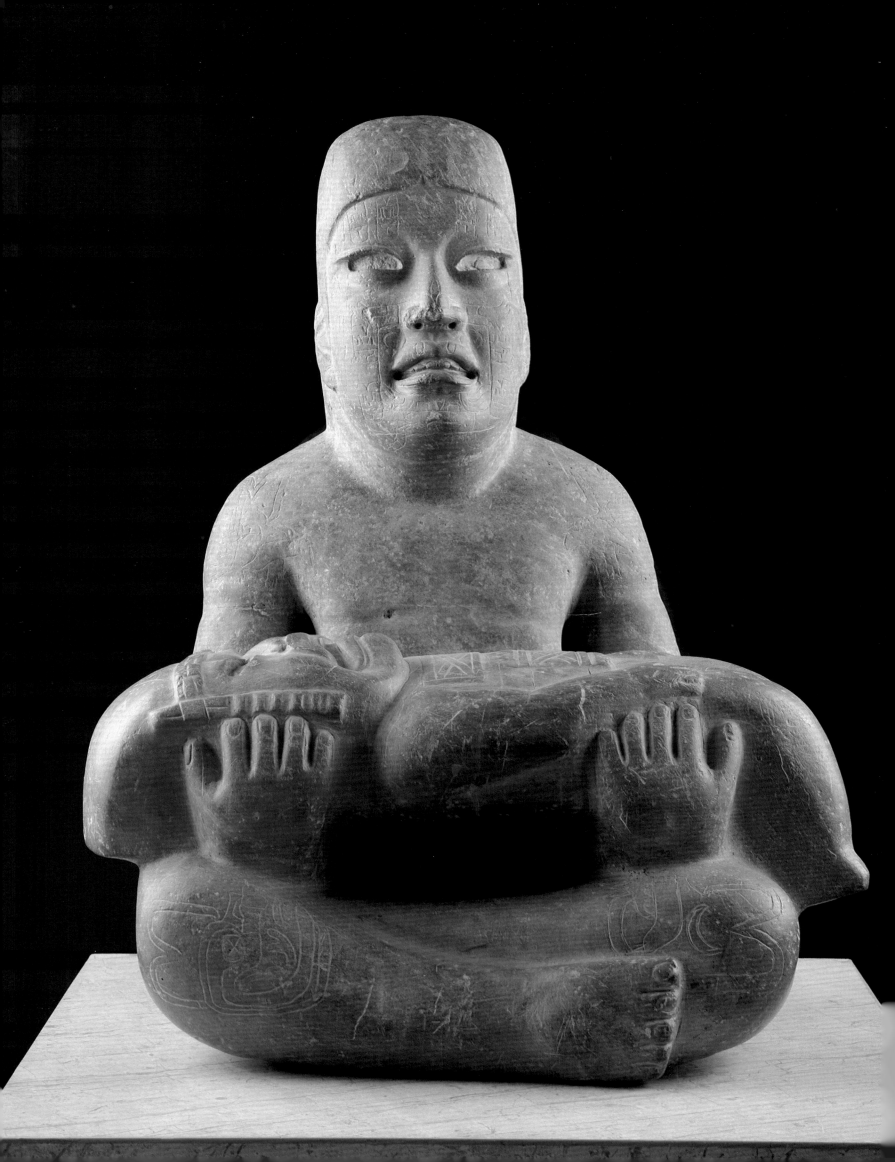

Collections of Olmec Objects Outside Mexico

ELIZABETH P. BENSON

During the Spanish Conquest of the New World in the sixteenth century, objects from the Americas were sent back to Spain as curiosities, as exotic gifts, as tokens of conquest, usually to the Crown, but not always. Some found their way into wonder cabinets, treasure rooms, or gem collections. Most sixteenth-century Europeans who saw artifacts from the New World were impressed by them. The accounts of conquistadors Hernán Cortés and Bernal Díaz del Castillo reveal their appreciation of the cities and of the ritual paraphernalia they saw first-hand (Cortés 1986; Díaz del Castillo 1956). In Europe, Pietro Martire d'Anghiera (Anghiera 1964–1965) and Albrecht Dürer saw objects from the New World and described them in glowing terms. Dürer, after seeing, in Brussels in 1520, the first Pre-Columbian traveling exhibition, wrote:

> I saw the things which have been brought to the King from the new land of Gold.… All the days of my life I have seen nothing that has rejoiced my heart so much as these things, for I saw amongst them wonderful works of art, and I marvelled at the subtle ingenuity of men in foreign lands (Fraser 1971: 25).

The objects sent back by Cortés and others were the work of Aztec (Mexica) or contemporary craftsmen. It is unlikely that many Olmec objects would have arrived in Spain. There might have been a few heirlooms, but most Olmec art was under ground. Many objects in Cortés' shipments were of gold, which the Olmec did not work. The emperor Charles V had much of the gold melted down, but his sons and other members of the Hapsburg family saved some curiosities, a few of which are now in the Museum für Völkerkunde, Vienna (Boone 1993: 317; Braun 1993: 22). A figurine in this exhibition (cat. 46) belongs to the Vienna museum, but it did not arrive there in the sixteenth century.

The Medici in Florence, who had connections with the Hapsburgs, were avid collectors, as were some members of other Italian noble families, notably Ulisse Aldrovandi, who began to form a museum in Bologna in 1549, with both natural history specimens and Pre-Columbian artifacts (Heikamp 1976; Coe 1991: 556; Laurencich Minelli 1991, 1992; Zanin 1991; Boone 1993: 317; Braun 1993: 22). Pre-Columbian objects exist today in various Italian ethnographic museums, but few, if any, come from Medici collections.

A piece that might be counted as the first Olmec—or Olmecoid—object known outside Mexico is a Late Formative greenstone bib-pendant, apparently recarved by an Aztec lapidary (Easby and Scott 1970: no. 307). It reached Europe and the collection of Albrecht V of Bavaria probably before 1511 and is now in the Schatzkammer der Residenz, Munich (fig. 1). It was made the centerpiece of an elaborate concoction comprising a niche, decorations, and draperies, fashioned from gold, silver gilt, gilt bronze, cabochon and faceted rubies, and rose-cut diamonds, with arms and hands enameled to match the green face.

The enthusiasm for the past of the Americas faded in the seventeenth century. Wonder cabinets were usually disbanded. Very few of the early arrived materials survived, but a more analytical attitude slowly began to develop. With the outbreak of the French Revolution, Pre-Columbian objects in the king's collections were transferred to the Bibliothèque Nationale, Paris (Braun 1993: 31; Williams 1993: 132). The Sloane Collection in London had a few Pre-Columbian pieces at this time, which eventually went to the British Museum.

The celt that Alexander von Humboldt took to the royal collections in Berlin from his American travels, c. 1803, might mark the beginning of serious foreign interest in Olmec art (fig. 2), although "Olmec" was still unknown, and there was a time gap before real collecting began. In the first half of the nineteenth century, isolated pieces came into European and American museums. Interest in the Pre-Columbian world intensified in mid-century with publication of the travels, 1839–1842, of John Lloyd Stephens and Frederick Catherwood (Stephens 1841, 1843). Stephens collected some Pre-Columbian pieces, which were destroyed in a fire (New York 1933: 29), but he and Catherwood had not gone into the Olmec "heartland"

Fig. 1. Early eighteenth-century niche figure, with Olmec bib pendant as the face.

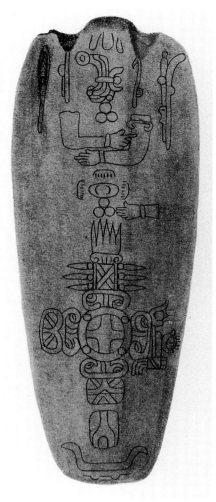

Fig. 2. The Humboldt Celt. Formerly in the Museum für Völkerkunde, Berlin (after Peñafiel 1890: pl. 119).

and had not, apparently, seen Olmec objects.

New ventures in archaeology and ethnology, and the collections that reflected those interests, soon began. In the 1860s and 1870s, permanent Pre-Columbian exhibits began to be installed in ethnographic museums. Harvard's Peabody Museum, endowed in the 1860s, was the first specifically anthropological museum in the United States (Braun 1993: 33) (cat. 93 comes from this collection). The Smithsonian Institution had been founded in 1846; its Bureau of American Ethnology began its work in 1879.

The National Museum of Ethnology (Rijksmuseum voor Volkenkunde), Leiden, founded in the eighteenth century, was the first strictly ethnographic museum. In 1865, the British Museum inherited the collection of the ethnologist Henry Christy, who had traveled in Mexico (Braun 1993: 31; see also Joyce 1912: fig. 7; Williams 1993: 132–133). The collection then was opened to the public in his house until it was moved to the museum in 1883. The Christy Collection, which included remarkable Aztec mosaics and a famous Olmec axe, was the foundation and core of the Pre-Columbian collection at the British Museum. Elizabeth Williams has noted that the "two greatest British collections of Pre-Columbian materials were built

by individuals," Christy and Alfred Maudslay (Williams 1993: 125). In the 1880s, Maudslay was one of the first archaeologists in the Maya area, and his photographs and commissioned drawings are still valued. He once owned a small Olmec jade carving, which he gave to the Cambridge University Museum of Archaeology and Ethnology in 1926 (Bushnell 1964). Pre-Columbian objects had begun to appear in other English institutions, in Liverpool and Oxford, for example (Williams 1993: 131). Displays were also mounted in London.

The Berlin Museum für Völkerkunde was established in 1873 (Braun 1992: 31). A "crying-baby" maskette that attracted archaeologist Matthew Stirling to the Olmec was in that museum by 1898. A number of other German museums were founded also in the late nineteenth century. The Rautenstrauch-Joest Museum für Völkerkunde, Cologne, has old collections; it has lent a dragon-head waterspout from a more recent collection, that of Peter Ludwig, to this exhibition (cat. 14).

The Musée d'Éthnographie du Trocadero (now the Musée de l'Homme) was founded in 1880. Napoleon III's intervention in Mexico, with the emperor Maximilian, had caused a certain flow of artifacts to France in the 1860s,

some from a scientific expedition, some as souvenirs (Williams 1993: 124–125). At least one Olmec object, a man holding a were-jaguar baby (cat. 48), is thought to have arrived in France in the 1860s and to have been in the Chasseloup Loubat Collection there; it was first illustrated in 1901 (Spinden 1947; Easby and Scott 1970: no. 41; Lothrop and Ekholm 1975: 307–312).

Institutional archaeology began in the last decade of the nineteenth century: the excavations of the Peabody Museum, Harvard University, at the Maya site of Copan, which produced a few Olmec-style objects, were among the early projects (Gordon 1898). The early archaeologists, while excavating as scientifically as the abilities of the era allowed—they were all pioneers—were also collecting for their institutions.

Toward the end of the century, archaeological and ethnographic collections were being formed in many places, not only from these sources but also from donations of travelers, businessmen, and amateurs. Although Olmec objects were still rare, collections of Pre-Columbian art sometimes included a few examples.

Interest in collecting precious stones in the late nineteenth century preserved some pieces. The Olmec axe in the American Museum of Natural History (cat. 110) was collected by George F. Kunz, a gem expert for Tiffany's,

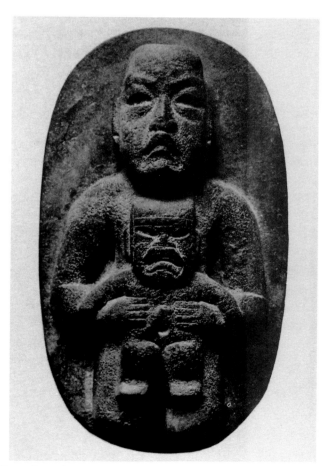

Fig. 3. Cast of cat. 48 in the form of a cameo. Once in the University of Pennsylvania Museum, Philadelphia (after Spinden 1947: 3).

who, in 1890, described the axe in his collection of gems and stones (Kunz 1889, 1890; see also Stirling 1968: 2). The extraordinary, gemlike Necaxa figurine (cat. 73) went to the American Museum of Natural History in 1932.

At the turn of the century, collections of sculpture casts were popular museum exhibits. Among smaller objects, Olmec jades were popular. A plaster cast of cat. 48, redesigned to resemble a cameo, was published in 1889 by Marshall Sommerville of The University Museum, Philadelphia (fig. 3; Spinden 1947; Fane 1993: 147–151). Casts were also made of a standing jade man (cat. 46), and of the Kunz Axe.

George G. Heye became interested in Indian artifacts in 1896, at the age of twenty-two (Dockstader 1973; see also Braun 1993: 42). After sponsoring archaeological expeditions in the American Southwest and West Indies, he inaugurated, in 1916, The Museum of the American Indian in New York as a center for the collection and study of Indian material. His Heye Foundation sponsored fieldwork and research, publishing, for example, Marshall Saville's study of Olmec axes (Saville 1929). In the 1920s, prominent archaeologists worked under the aegis of the foundation and the museum, which became a resource of some four million Indian objects.

The Middle American Research Institute at Tulane University, New Orleans, began about 1925, with the expedition of Frans Blom and Oliver La Farge, the beginning of archaeological work in the Olmec area (1926–1927). Cat. 65 has been lent by that institution.

A slow transition led Pre-Columbian and other non-European and non-Asian artifacts from natural history/ethnographic museums to art museums. In the lively awakening of "modern art" at the beginning of this century, artists began to take inspiration from exotic art, especially African art. Maurice Vlaminck, André Derain, Henri Matisse, and Pablo Picasso collected African objects (Fraser 1971; Newton and Boltin 1978). Henry Moore was specifically influenced by Olmec sculpture (Braun 1993: 101–131). Adventurous collectors also pioneered in acquiring these objects as art, rather than as curiosities or specimens. They, too, usually began with African art. Pre-Columbian art slowly became a part of the interest in "primitive" art, although it was generally considered less primitive. (Some museums have curators of "primitive and Pre-Columbian art.")

An exhibition of Pre-Columbian art was held at the Burlington Fine Arts Club, London, in 1920. From 1927 until 1940, the William Hayes Fogg Art Museum at Harvard University devoted a gallery to Maya art lent by the Peabody Museum (Cahill 1933: 21; Lothrop 1963: 92). In 1940, "An Exhibition of Pre-Columbian Art" at the Fogg Museum, arranged with the Peabody Museum, included objects from the Wadsworth Atheneum (cat. 60) and the Cranbrook Academy, as well as the American Museum of Natural History (cat. 73) and the Peabody Museum (cat.

93), and the collection of Robert Woods Bliss (cat. 44). In 1941, an exhibit of Pre-Columbian art was held at the Rhode Island School of Design, Providence. In 1942, "Ancient American Art" was shown at the Santa Barbara Museum of Art, The De Young Memorial Museum in San Francisco, and the Museum of Art, Portland, Oregon.

It is hard to separate the collecting of Olmec art from that of all Pre-Columbian art, although some collectors were especially attracted to Olmec objects. Stirling noted how many people had been drawn to Pre-Columbian art and archaeology by Olmec jades (Stirling 1968: 1). Robert Woods Bliss was one of these. The first Pre-Columbian object he acquired (cat. 44) was Olmec. He bought it in Paris in 1912; it might have been in France for some fifty years. Bliss acquired a few other Pre-Columbian objects in the following years and began to concentrate on this art in the 1940s. In 1947, his collection was placed on loan in the National Gallery of Art, when the director, David Finley, and the chief curator, John Walker, agreed "that it might be an interesting experiment" (Bliss, in Lothrop, Foshag, and Mahler 1957: 7). The collection remained on view in the National Gallery until 1962, when it was installed permanently at Dumbarton Oaks, which Robert and Mildred Bliss had given to Harvard University in 1940, along with their collection of Byzantine art. Olmec art had special appeal for Bliss, and a number of objects in this exhibition come from the Dumbarton Oaks collections (cats. 44, 52, 56, 58, 63b, 68, 70, 71, 82, 97, 106).

In Montreal, F. Cleveland Morgan began giving decorative arts to the Montreal Museum of Fine Arts in 1916. Among his later gifts were many Pre-Columbian objects, some of them Olmec (see cat. 37).

The Cleveland Museum of Art has long collected Pre-Columbian art, including Olmec. Mrs. Henry Norweb, the wife of an American diplomat in Latin America and elsewhere, began to give objects that she had acquired to the Cleveland Museum of Art in the 1930s (Turner 1991). This formed the basis of the museum's Pre-Columbian collection. A number of objects in this exhibition are lent by the Cleveland Museum (cats. 54, 59).

The Saint Louis Art Museum also started acquiring in the 1930s, as did Morton May, whose collection is now in that museum (cat. 30; Parsons 1980).

Nelson Rockefeller, whose mother had a collection of African art, began to collect Pre-Columbian art in 1933, in the course of a "memorable" three-month visit to Mexico, during which Diego Rivera and Miguel Covarrubias impressed upon him their interest in Pre-Columbian art and its influence on their work (Rockefeller 1978: 19–20; Braun 1993: 43). Through his mother's collecting, he had come to appreciate the place of "primitive art" in the long history of human creativity. As Rockefeller noted, "at that time only museums of natural history collected primitive art, and primarily for its ethnological interest rather than its aesthetic qualities." In the 1930s in New York, only the

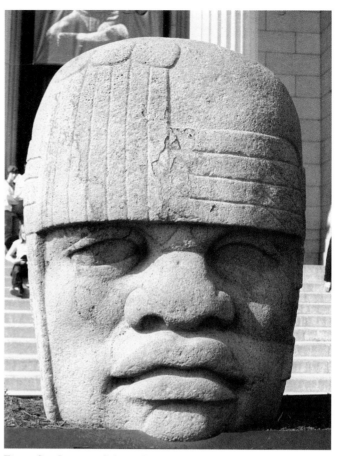

Fig. 4. San Lorenzo Colossal Head 4, at the Smithsonian Institution in 1978.

Rockefeller-supported Museum of Modern Art was interested in Pre-Columbian objects. In 1933, it mounted "American Sources of Modern Art," an exhibit of Pre-Columbian art from natural history/ethnographic museums and private collections, which was designed to show the influence of Pre-Columbian art on modern American artists. Rockefeller tried to persuade the Metropolitan Museum of Art to include Pre-Columbian art, but they refused, although there had been a show of Peruvian textiles at the museum in 1930 (Braun 1993: 43). Rockefeller also wanted to set up a joint Metropolitan Museum-American Museum of Natural History archaeological expedition. The American Museum was enthusiastic; the Metropolitan Museum was not (Rockefeller 1978: 20–21).

In 1940, President Roosevelt appointed Rockefeller, then president of the Museum of Modern Art board of directors, to be coordinator of the Office of Inter-American Affairs. At this time, Rockefeller worked with René d'Harnoncourt, of the Museum of Modern Art, who was also a close friend of Covarrubias, to produce "Twenty Centuries of Mexican Art" in 1940; this show included a very few Olmec pieces, one of which was cat. 96.

Rockefeller founded the Museum of Primitive Art, which opened in 1957 as an exhibition and repository space for his growing collection. In 1969, the Metropolitan Museum mounted a show of objects from the Museum of

Primitive Art. A 1970 exhibition at the Metropolitan Museum, "Before Cortes: Sculpture of Middle America," included a strong Olmec section, with objects from many lenders (Easby and Scott 1970). The Museum of Primitive Art collection was given to the Metropolitan Museum and permanently installed there in 1982. Rockefeller had finally won out. In 1990, the Metropolitan produced the enormous loan exhibition, "Mexico, Splendors of Thirty Centuries," which began with an impressive display of Olmec art. Cats. 53 and 116 are Rockefeller pieces lent from the Metropolitan Museum.

Alastair Bradley Martin began to collect many kinds of objects in 1947, the year that the Bliss collection went on exhibition at the National Gallery (Rubin 1975). Martin was especially attracted to Olmec art. The Mexican pieces in his collection were mainly Olmec (cats. 48, 87, 89, 102). These are now in museums in New York.

Ernest Erickson gave his collection to the American Museum of Natural History in the 1960s; cat. 88 comes from it (Couch 1988: 6). Constance Fearing McCormick owned important Olmec pieces; cat. 69, now in the Los Angeles County Museum of Art, belonged to her. Among collectors who acquired Olmec and other styles was Jay C. Leff, whose collection has now been dispersed. Cat. 67 once belonged to him. Mr. and Mrs. Peter G. Wray also had a notable collection of Pre-Columbian art, with some Olmec pieces (New York 1984). Other former collections represented in this exhibit are those of Jeanette Bello, John Hauberg, D. Daniel Michel, and William O'Boyle.

Pre-Columbian collecting flourished in the 1960s. Museums and private collectors were acquiring at that time; many objects that entered private collections then are now in public museums. The Dallas Museum of Art (cats. 55, 80, 119); Denver Art Museum (cat. 112); Los Angeles County Museum of Art (cat. 69); and The Art Museum, Princeton University (cats. 31, 32, 66) were building fine Pre-Columbian collections. Among other collections represented here are the Brooklyn Museum (cat. 64); Munson-Williams-Proctor Institute (cat. 15); Museum of Fine Arts, Boston (cat. 79); Snite Museum of Art, Notre Dame (cat. 43); and Tucson Museum of Art (cat. 100). The Sainsbury Collection at the University of East Anglia, Norwich (cat. 81), is an important relatively recent English collection.

In 1970, a treaty with Mexico and a UNESCO convention on illegally exported objects greatly slowed collecting by museums in this country. Some collecting continues, however, and collectors and art galleries elsewhere in the world have become involved in Pre-Columbian collecting. Interest by collectors and institutions in Australia and Japan, for example, has developed relatively recently.

Olmec art has been prominent in some general exhibitions. An exhibition of Mexican art, organized by Armand Hammer at the Smithsonian Institution in 1978 (Hammer and D'Andrea 1978), included three major Olmec sculptures (cats. 2, 9, 11; fig. 4). A 1992 exhibit of Pre-Columbian art of the Americas from Alaska to Argentina at the Musées Royaux d'Art et d'Histoire, Brussels, displayed an impressive array of Olmec art from many collections, mainly private (Brussels 1992). Exhibits of Formative period objects from Mesoamerica, including Olmec art, have been mounted. "The Jaguar's Children" at the Museum of Primitive Art in 1965, largely a ceramic show of objects from Central Mexico, was the first of these and probably the strongest (Coe 1965b). In 1963, The Houston Museum of Fine Arts mounted "The Olmec Tradition," with seventy objects, most of them Olmec. The sculpture focus of the show was San Lorenzo Colossal Head 2. Until recently, when The Art Museum, Princeton University, mounted a large exhibition, mostly of small and precious objects from private collections, there had been no exclusively Olmec exhibition. That show and this one complement each other elegantly and attest to the fact that Olmec art, which has long fascinated collectors, has at last come fully into its own as a great art style.

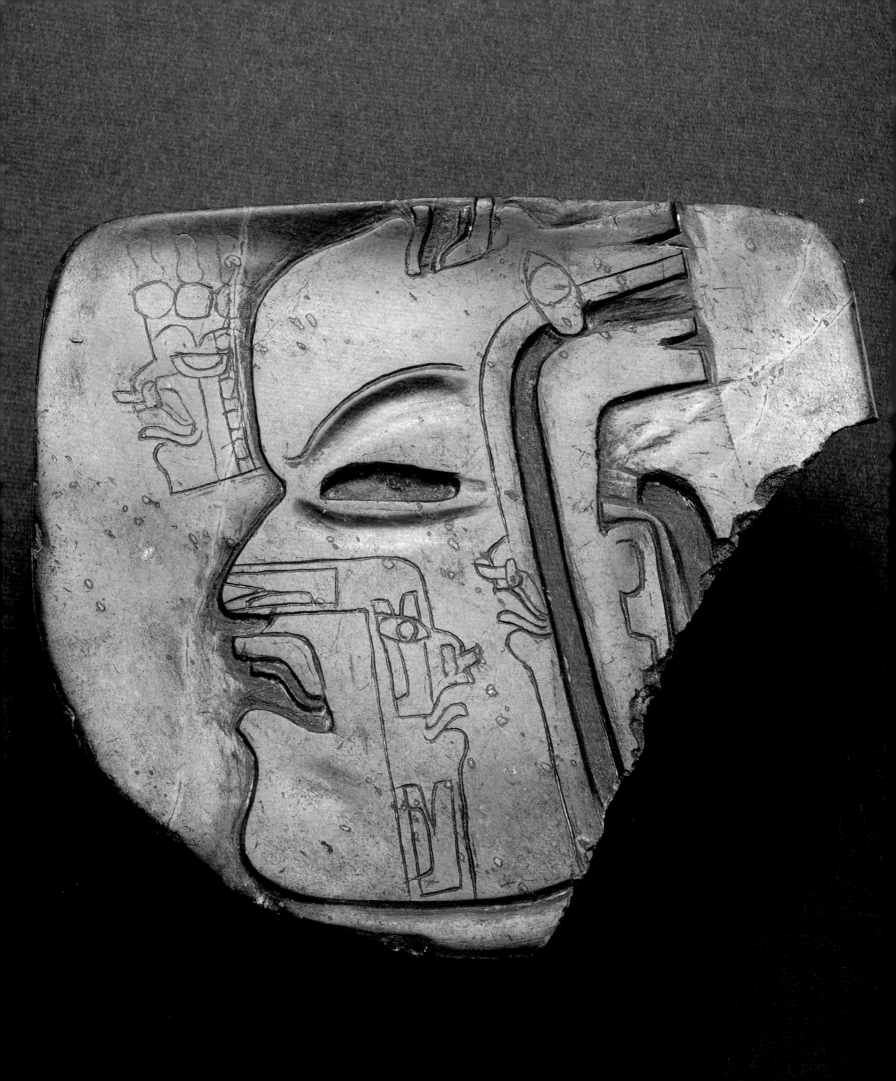

The Olmec Collections of the National Museum of Anthropology, Mexico City

MARCIA CASTRO-LEAL

The National Museum was founded in 1825 to preserve the archaeological remains of ancient cultures in Mexico. Over time, the museum's holdings were divided and used to form other museums. From 1909 until 1939, the anthropological and historical collections were kept together as the National Museum of Archaeology, History, and Ethnography. The historical collections were then transferred to the newly created National Museum of History, while the archaeological, ethnographic, and osteological artifacts were maintained within the museum that would become the National Museum of Anthropology.

Consequently, to discuss the Olmec collections, we must return to the nineteenth century, when sculptural pieces were arriving at the museum and the first mention of Olmec archaeological materials appears in the bibliography of the period, especially in the work of Francisco del Paso y Troncoso (1892). To commemorate the fourth centennial of the discovery of America, the Spanish government organized an international exhibition, at which Mexico presented a large and varied collection.

As director of the museum and a coordinator for the exhibition, Paso y Troncoso planned to present an historic vision of Mexico that included the pre-Hispanic cultures as well as the origin of the Mexican nation. The National Museum could send only part of its collection, however, and none of the bulky stone sculptures. It was decided that various expeditions would be undertaken, archaeological as well as ethnographic and photographic, to obtain more material. Archaeological collectors in Mexico City, as well as those from the interior of the Republic, lent pieces, to which were added the objects collected in field projects; together this group was sufficient to cover the commitment. Examples arrived from the Gulf Coast of Tabasco, such as gifts by Simon Sarlat and almost three hundred pieces from the Carbonell Collection, which included stone celts, "finely polished idols of diorite," and yokes with skulls collected at Santiago Tuxtla, San Andrés Tuxtla, and Hueyapan (Tres Zapotes), Veracruz, where a colossal head had been reported in 1869.

The colossal head of Hueyapan from the region of the Tuxtlas, Veracruz, was known from various articles (Melgar y Serrano 1869: 292–297; Melgar y Serrano 1871: 104–109). The head had provoked discussions over its significance and dating, as Alfredo Chavero noted in his 1884 book on the history of Mexico (1953: 63–64). Chavero associated the physical type of the head with the representation on a stone celt now known to be Olmec. A photograph of the Hueyapan sculpture, taken by Paso y Troncoso, was displayed at the 1892 Madrid exhibition. Years later, in 1897, Pedro Mimendi, owner of the land on which the colossal head had been found, wrote to cede it to the museum; the task of moving it, however, was so difficult that it had to be abandoned. An attempt in 1922 to carry it to Mexico City had been better prepared, and the cost of transportation from Hueyapan had already been calculated at 171 pesos; nevertheless, this second attempt also failed.

The "Ulmec" in 1892

The installation of the Madrid exhibition was supervised by Paso y Troncoso, who first classified the Mesoamerican materials, placing them in vitrines according to provenance or chronology within pre-Hispanic history. In a cabinet called "Prehistoric Civilization" he displayed objects from the "Ulmec and Michoacan nations." His catalogue explains when and why the term "ulmeca" was used for these archaeological pieces:

> The examples called ulmecas are recognizable by
> their various generic characteristics that favored this

grouping…. Examining this type one sees that the eyes are slanted down and inward, as in the type I have called *ulmeca*, it leads me to recognize that the Oriental posture for seating was used also for part of that ethnic group (Paso y Troncoso 1892).

Paso y Troncoso, who combined a solid background as an historian knowledgeable in the written sources of the sixteenth century with a great intuition for archaeological materials, mentioned that the objects he called "ulmecas" originated in a specific area that included the regions of Michoacan, the Gulf Coast, and Oaxaca. Unfortunately, this classification of archaeological objects as Olmec only survived in the museum during the presence and influence of Paso y Troncoso; later, his discovery remained unknown until the present.

During the first decade of the twentieth century, with the arrival of new investigators at the museum, different criteria were imposed on the classification of the collections. However, some of the ideas of Paso y Troncoso were picked up by other investigators, such as Eduard Seler. In a classification of the museum pieces, Seler assigned the Alvarado stela to the "Cuetlaxteca Civilization," a term that he used first in the 1892 exhibition catalogue to designate objects from southern Veracruz. This sculpture was referred to in the first catalogues as the "Totonac Obelisk." It had been donated in 1904 by Juan Esteva, who had discovered it on the southern shore of the Papaloapan River, transported it to the city of Alvarado, and from there sent it on to Mexico City.

THE JADE OBJECTS COLLECTION, 1927

In 1927, 553 jade and jadeite objects—small anthropomorphic figurines, pectorals, votive celts, collars, etc.—were deemed worthy of cataloguing and publishing. Ramón Mena, an investigator for the museum, had visited the Olmec region in 1916. On an archaeological map he registered such sites as Tortuguero, Tenosique, Ozancanac, Jonuta, La Reforma, Gracias a Díos, Comalcalco, Bellota, Centla, and Huimanguillo (La Venta), and reported some of their stone monuments (Mena 1927).

In the catalogue, he describes each object, its form, material, provenance, and culture, with a prologue that discusses jade and the technique used to work it in the pre-Hispanic era. However, the provenance and cultural designation for most of the objects was problematic. Frequently the provenance was unknown; sometimes it was known only that the object had come from a particular state or region, such as the "Mixteca" or the "Valley of Mexico." Only occasionally was an archaeological site, such as Monte Albán, Tula, Texcoco, or Escalerillas in Mexico City, known. Many objects had arrived at the museum without any type of information. Mena's criteria did not take into account the geographic provenance, even when he knew it. He considered most of these objects to be of the "Nahua" culture, even those that came from completely different places like Mexico City or the states of Morelos, Guerrero, Michoacan, Mexico, Oaxaca, Puebla, Hidalgo, Querétaro, and Yucatan, as well as specific sites like Texcoco, Teotihuacan, Tula, or regions like the Mixteca, the Balsas River, and Sierra Gorda.

Nevertheless, this work is valuable insofar as it attempted to order and classify the materials of the museum collections, work that had begun with the first catalogues of the nineteenth century. It also reveals the past criteria of some investigators of pre-Hispanic Mexico who used the term "Nahua culture" in such a broad and imprecise way, incorporating much of what was unknown in the region.

Some of the objects registered in Mena's publication are still in the museum today (see, for example, cat. 96).

COLLECTIONS ORIGINATING FROM OLMEC AREA EXCAVATIONS

Olmec objects also entered the museum from systematic excavations of the southern area of Veracruz and Tabasco, which had begun in the 1930s; the museum, as the central institution for all types of archaeological work in Mexico, received the greater part of this material for display in exhibition halls or conservation in storerooms.

Hueyapan, where the colossal head had been found, sparked the interest of archaeologists. Work was initiated in 1937, when Juan Valenzuela and Agustín García Vega, of the museum, and Karl Ruppert, of the Carnegie Institution, explored the Tuxtlas region and Lake Catemaco, Veracruz. From a visit to inspect Comalcalco and La Venta, Valenzuela reported mounds and some large sculptures, one of which was transported to the city of Villahermosa. Much later, in April of 1942, he made a second trip to La Venta in the company of Miguel Covarrubias to photograph and draw some sculptures and collect clay figurine heads. These materials had been donated by Engineer Ibarrola, who was responsible for the Petróleos Mexicanos work in the zone, and who had sent the Olmec sculpture originally from Arroyo Sonso to the museum in 1933.

Other institutions, such as the Smithsonian Institution of Washington, with whom the National Museum maintained a good relationship, also showed interest in working in this zone. In 1877 the National Museum of Mexico had lent some objects for exhibit at the American Museum of Natural History; later that institution donated archaeological objects that had been displayed in an exhibition in New Orleans. The contact was continued by visitors to Mexico. In 1884, for example, the Smithsonian Institution provided a letter of introduction to William H. Holmes, who arrived at the museum to see objects relating to his study of the ancient cities of Mexico, which was to be published by the Field Columbian Museum in 1897. Holmes, one of the investigators interested in Olmec art, published an article on the Tuxtla Statuette, from Veracruz.

In 1911 the Smithsonian Institution applied for the first permit to excavate in Mexico, but C.G. Abbott did not send the official petition to allow archaeological reconnaissance in Veracruz until 1938. Abbott already had a special interest in the "Archaic Horizon" and wanted to see if there existed "…some possible relationship with the mound constructions of the Valley of Mississippi" (Archive, National Institute of Anthropology and History, 1938), which was one of the scientific preoccupations of the period.

A permit was drawn up between the Smithsonian Institution, the National Geographic Society, and the Mexican government to do archaeological work in Hueyapan (Tres Zapotes), which began on the first of November, 1938, with a budget of 15,000 pesos. The expedition was directed by Matthew Stirling, accompanied by his wife, Clarence Weiant and his wife, and Alexander Westmore, assistant secretary of the Smithsonian Institution and member of the Research Committee of the National Geographic Society.

The project recovered various sculptures, including Stela C and the Stone Box. Initially, the dot and bar numbers on the stela sparked debate over its probable Maya origins. Many more sculptures were found at the site, as well as other clay objects, among them some 203 anthropomorphic figurines, 39 zoomorphic figurines, and stone yokes.

Tres Zapotes and La Venta, 1939–1940

Stirling solicited another permit to continue working at Tres Zapotes, but he also wanted to excavate at La Venta, so he initiated a short exploratory season there in 1940. The work team was almost the same as in the prior season, but with a new participant: Philip Drucker, from the University of California, who replaced Weiant.

Cerro de las Mesas, Veracruz, 1941

In 1941, Stirling excavated at the site of Cerro de las Mesas, near the towns of Cocuite and Ignacio de la Llave, an area far from the Gulf Coast Olmec heartland. He excavated thirty-six trenches, locating archaeological materials. In one trench he found an offering of jade objects richer than anything that had been detected previously. Not all the objects were of the Olmec style. Some were recognized as belonging to other eras, as had been the case at Tres Zapotes. Some of the pieces were associated with distinctive styles, such as the Zapotec, and believed to relate to a plaque showing a relief of a figure similar to the Danzantes of Monte Albán, Oaxaca.

La Venta, Tabasco, 1942–1943

Returning to La Venta in 1942, the team made test trenches and stratigraphic and exploratory pits. The last were carried out exclusively at Complex A, located to the north of the great mound. In the trenches of Mound A-2 they discovered a tomb with walls and roof of monolithic basalt columns, a unique feature to date. Two burials were found inside, each with a group of similar objects, including small jade pieces and figurines, obsidian disks, mirrors, tubular beads, and two jade forearms with hands (cat. 85). A stone sarcophagus was found behind the tomb, with an offering of thirty-seven celts arranged in rows.

Waldo R. Wedel coordinated the 1943 excavations in the structures, continuing the work in Complex A (operation A-3) and the Ceremonial Court (operation A-1). During this season two mosaics of stylized jaguar faces were found at a great depth (see González Lauck, "La Venta"). Work continued in the area north of Mound A-2 and Mound A-3. Tomb C, constructed of stone flagstones, was uncovered. Inside, the offering consisted of thirty-seven celts, three vessels, a jade bead approximately 7.5 centimeters long, earspools, two mandibles, many small jade beads (two in the shape of duck heads), a figurine with inlaid eyes of obsidian, a perforator, beads of rock crystal, an obsidian core, and sixty-four spherical beads (two of which represent a tortoise shell).

During this same season, a sculpture was also discovered: a monkey with its arms raised over its head (Monument 12, National Museum of Anthropology, no. 13-661).

The first of the La Venta materials arrived at the museum in 1943 and were exhibited to the public from June to September; the catalogue was written by Salvador Mateos and Alfonso Caso, the museum's director.

Río Chiquito, 1945–1946

After excavation work at Tres Zapotes, Cerro de las Mesas, and La Venta, Stirling became interested in work at Río Chiquito (Tenochtitlan) in Veracruz; large monuments had already been reported from the site and had attracted his attention. In 1946 he spent a season there and at Potrero Nuevo, during which he noted unimpressive mounds but abundant and beautiful sculptures, some of which had been removed from their original position by the local inhabitants. Many of the sculptures described in this season (Stirling 1955) would later be found again by Michael Coe in his works at the same site in 1965 and 1968; some of them would arrive at the museum in 1970. Among the sculptures from San Lorenzo (the three sites formed a single complex) were a headless feline sculpture (Monument 7, National Museum of Anthropology, no. 13-618); a colossal head with headdress of various bird heads, badly damaged (Monument 2, National Museum of Anthropology, no. 13-419); and a head with rectangular headdress (Monument 6, National Museum of Anthropology, no. 13-613). From Tenochtitlan came a sculpture representing two personages, both without heads and extremities, one on top of the other. Stirling argued that it represented the sexual act between a jaguar-human and a woman. Unfortunately, the sculpture was badly damaged, but the figures are clearly seen (Monument 1, National Museum of Anthropology, no. 13-619). At Potrero Nuevo a sculpture of a

decapitated serpent with a large, twisted body, was found (National Museum of Anthropology, no. 13-19).

La Venta, 1955

In August of 1954, another permit was solicited for work at La Venta by a team including Drucker, Robert Heizer of the University of California, as well as students Robert Squier of Berkeley and Pierre Agrinier, a representative of the National Institute of Anthropology and History archaeologist Eduardo Contreras.

Their goals were to establish the history of construction at La Venta, create an accurate site map, and investigate the activities of the pre-Hispanic occupants at the site. Work was to be done from January until the end of May.

The work began with the exploration of the second platform with basalt columns. Beneath this platform was a clay fill that extended for almost 2 meters, and under this had been placed a mosaic composed of 450 perfectly cut serpentine blocks. Below this offering were twenty-eight levels composed of serpentine blocks over a clay mortar. This entire structure, from the columns to the lowest strata, descended 11 meters. The offering, from the mosaic to the last serpentine block floor, represents one of the most exceptional characteristics of the Olmec culture at La Venta.

The season was very fruitful; about 2,700 jade pieces and fragments and various ceramic offerings, some post-Olmec, were found. Mound A-5 was excavated and four construction periods were uncovered; a sculpture (Drucker's Monument 23) was also recovered (National Museum of Anthropology, 13-600).

In the Ceremonial Court, pavements of polished serpentine blocks were found at 5 meters, the same depth of the mosaic found in 1943. The low platforms in this patio yielded offerings of jade and ceramic, many of which were given to the museum. In many cases, the National Museum of Anthropology had given archaeological materials to other national and state museums, or had established exchanges with foreign museums, and so on occasion did not preserve the complete collection. For example, in 1955, one of the stone mosaics with the stylized jaguar face was removed from La Venta and placed in the garden of the Museum at Moneda 13. However, during the organizing of the La Venta Museum Park in Villahermosa, the mosaic was returned to Tabasco by petition of Carlos Pellicer.

Offering 4, unique among Mesoamerican materials encountered to date, was discovered at little more than 2 meters below ground. It contained sixteen jade and serpentine figurines and six celts embedded in a floor and forming a scene (cat. 42).

The Covarrubias Collection

The Mexican artist Miguel Covarrubias dedicated himself to the study of pre-Hispanic Mexico, specifically Olmec art and the definition of its style. He collaborated with the museum, where he taught courses in museology and maintained a close relationship for forty years with the archaeologists there. He accompanied Hugo Moedano in his field excavations at Tlatilco in 1944. Throughout his life he collected archaeological works from various parts of the country; his knowledge of Mexican archaeology and his artistic sensibility resulted in a selection of pieces of exceptional quality, although most of it is unprovenanced. After his death in 1957 his collection was donated to the museum by his brothers, in compliance with his wishes. Eventually, Covarrubias' donation to the museum was converted into the purchase and construction of a new museum building in Chapultepec Park. In 1957–1958 the Miguel Covarrubias Hall was created to exhibit part of the collection. Works were presented according to artistic rather than archaeological merit, since no chronological or cultural order had been followed.

In 1964 the museum relocated to the building in Chapultepec Park. A new scientific conception of museology led to the creation of new exhibition halls as well as the redistribution of the works; much of the Covarrubias Collection, which contained materials from a variety of cultures, was assigned to different exhibition halls, integrating the materials to their specific cultures. The objects were located in vitrines in different rooms, but retained their number identifying them as part of the Covarrubias Collection. Some of the most beautiful pieces of the Covarrubias Collection were exhibited in the Gulf Coast Cultures Hall, among them the smiling jade face (cat. 83).

La Venta, Tabasco, 1958–1959

Román Piña Chan and archaeologist Roberto Gallegos, both researchers from the department of pre-Hispanic monuments at the National Institute of Anthropology and History, organized a salvage project at La Venta prior to the field installations of the oil company Petróleos Mexicanos. During this work they recovered materials from the leveled and partially destroyed mounds; in Complex A and B they obtained objects, not only from the fill of the destroyed structures, but also from the test pits done at surface level after the removal of the demolished constructions, recovering distinctive works from early to late eras. The majority of the material consisted of fragments of small figurines, which in number and characteristic formed an interesting group only for scientific value. Also found were six exceptional large figurines.

The report of this salvage project was not published, but Piña Chan used part of the material to classify the La Venta figurines (Piña Chan and Covarrubias 1964; Piña Chan 1982). The material has also been analyzed by the author, curator of the Gulf Coast collections, who has suggested a hypothesis for the mutilation of the heads and extremities of these figurines.

The Colossal Head of San Lorenzo, 1965

The chance finding of a colossal head at San Lorenzo inspired the museum to send Piña Chan and Luis Aveleyra to register and study it. They found it on the extreme western side of the site, half-buried in the slope near an arroyo, obviously displaced from its original position.

It was found in the same place in 1967 when Coe had his second season at San Lorenzo; he decided to clean it and incorporate it into the rest of the collection, and it arrived at the museum in 1970.

San Lorenzo, Veracruz, 1965–1968

Inspired by the work of Covarrubias, Coe decided to explore the Olmec area. He chose to work where Stirling had worked years before, at Río Chiquito and neighboring sites; in 1964 his project went into the Coatzacoalcos River drainage. In May of 1965 Yale University was issued a permit for four seasons of work and two years of study of the excavated objects. Coe received some of the unstudied Río Chiquito materials as well as Stirling's field notes from his wife, so that he could familiarize himself with the materials of this zone.

During the 1968 season, Froelich Rainey of the University of Pennsylvania arrived with a magnetometer, useful in locating monuments made of basalt, a material rich in iron and with a high magnetic density; a number of monuments were discovered with this tool, among them Monument 52, the humanized jaguar sculpture found with one of the drainage canals at the site.

Monument 21 was found in situ over an offering of serpentine celts; it consists of a rectangular block, one side of which depicts an animal, perhaps a walking dog; the other side has a deep rectangular hollowed space.

Monument 34 was found on 8 March 1967 on a floor of red gravel, covered with a limestone and bentonite fill from nearby gullies. The figure, a headless man on one knee, had well-defined circular sockets at the shoulders that would have supported movable arms. Figures with movable arms appear later in Mesoamerica, in figures called "puppets" from Teotihuacan.

San Lorenzo, 1969

The National Institute of Anthropology and History organized a field season at San Lorenzo with archaeologists Gallegos and Francisco Beverido from Veracruz. There they discovered Monument 58, a fish-jaguar figure in fine relief. The figure had an embossed jaguar lip and a body with crossed bands; these motifs occur on this same animal in other Olmec works.

THE STATE OF THE COLLECTIONS

The Olmec collections at the National Museum of Anthropology, created over more than one hundred years, are composed of 1,150 catalogued pieces. Objects are grouped according to type. Two of the largest groups are figurines in clay and greenstone, chiefly broken clay fragments (648), and celts (264), mostly of greenstone. The majority of the figurines have value strictly for archaeological study and analysis; in contrast, the celt group is well-preserved and the celts are almost always complete. The monumental sculpture group is significantly smaller, consisting of only twenty-seven objects, albeit the best-known ones.

The other groups include personal-ceremonial adornments: earspools (82); pendants (68); masks (20); collars (17); disks (14); mirrors (10); bracelets (2); and plaques (22), although this type of object does not have holes to suspend it. Other utilitarian-ceremonial objects include vessels (41), perforators (18), stamps (4), and mica (1).

Figurines

The collection includes whole figurines in clay (88) and greenstone (72); figurine heads of clay (230) and greenstone (17); body fragments, generally torsos in clay (147) and greenstone (3); extremities in clay (86) and greenstone (2); and figurines in clay (7) and greenstone (13).

Loose perforated beads form another category of objects. Some were found in the same offerings, although for most of them, the archaeological evidence does not allow us to assert that they are from the same object. They are of different sizes and forms, spherical being the most common shape, while there are also tubular forms as well as some in the shape of small vessels. The majority of these loose beads come from offerings at La Venta (970) or Cerro de las Mesas (397), or are without provenance (32).

Provenance

In the nineteenth century it was not customary to note clearly the place of origin of archaeological objects, especially when dealing with donations or museum purchases. The collections gathered by Paso y Troncoso for the 1892 exhibition did have the provenance correctly registered, but this was an exception.

During the twentieth century, the objects principally came from explorations in the Olmec area, although there were also purchases of specific collections, as well as donations. In these cases, the exact site was not always known.

Most of the Olmec collection comes from La Venta (535 items), the result of excavations in 1942, 1943, 1955, and 1958–1959. A season at Cerro de las Mesas also produced abundant materials of greenstone offerings (171 items), and two seasons at Tres Zapotes produced few materials (100 items). Only nineteen pieces are from San Lorenzo.

There are also some pieces of known provenance from a variety of sites (75 items), and a group of 250 items, primarily figurine fragments, with no registered provenance. Some are labeled only "Gulf Coast." These objects are archaeologically and stylistically Olmec, and for this reason were incorporated into the collection.

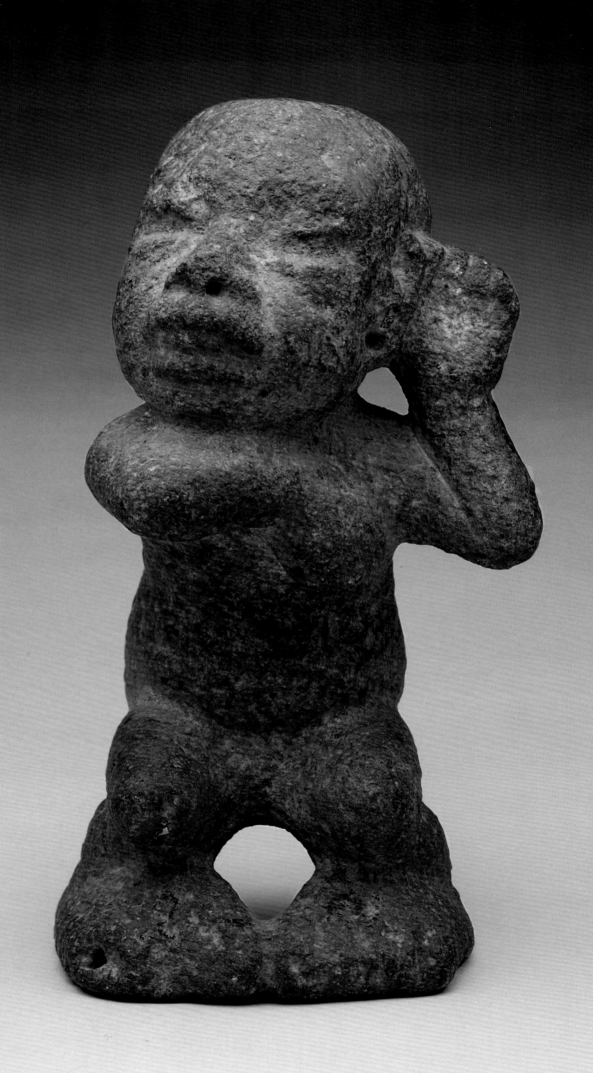

Olmec Collections in the Museums of Tabasco: A Century of Protecting a Millennial Civilization (1896–1996)

REBECCA GONZÁLEZ LAUCK AND FELIPE SOLÍS OLGUÍN[1]

INTRODUCTION AND ANTECEDENTS

In 1896, the inhabitants of San Juan Bautista, then the name of the capital of Tabasco, observed with astonishment the arrival of the first Olmec sculpture to the city. What is now called La Venta Monument 8, popularly known as "Juchiman," was installed at the most important cultural center, the Juárez Institute.[2] This movement of pre-Hispanic pieces was common during that time, as "antiquities" and "idols" were undergoing a particular appraisal process in Mexico during the *Porfiriato* era, when collector's fever ruled even at the old National Museum and its "Gallery of Monolithic Works" in Mexico City. Monument 8 was not recognized as being Olmec until more than fifty years later, when the La Venta culture or Olmec civilization was identified, although these artistic works were already becoming known. The colossal head from Tres Zapotes, Veracruz, for example, had been discovered almost four decades earlier.

A little later, in 1905, a letter to Leopoldo Batres, inspector and conservator of archaeological monuments, written by Justo Sierra, undersecretary to the secretary of preparatory and professional instruction, stated:

> ...the undersigned, with all due respect, petitions: that you concede permission to review the ancient idols that exist at the place called "La Venta," and...send them to our President of the Republic, in gratitude... (Sierra 1905).

This letter, in addition to demonstrating the official nature of the more or less systematic gathering of the cultural patrimony, inveighed against Tabasco as guardian of the rich and varied material from La Venta in favor of other places in the state of Tabasco, Mexico City, and beyond the borders.

This article briefly outlines the collections of Olmec cultural materials in the various museums of Tabasco. Invariably, the most important Olmec assets are from the La Venta archaeological zone, but other works, such as pieces from San Miguel Zapotal and Las Encrucijadas, both in the Cárdenas municipality, as well as those from the east in the Tenosique and Balancán municipalities, are also represented. La Venta Museum Park, the site museum of La Venta, and the "Carlos Pellicer Cámara" Regional Museum of Anthropology—including its antecedents, such as the Tabasco Museum (1947–1952) and the Archaeological Museum of Tabasco (1952–1980)—are inventoried here, along with the History Museum in Villahermosa, the site museum of Pomona in Tenosique, and the "José Gómez Panaco" Museum in the Balancán municipality.

During the second half of this century, the state of Tabasco has put tremendous effort into the creation of various museums, some of which have been true innovators in organization and exhibition. As an introduction to this theme, a synthesis of the archaeological investigations in the area follows; these excavations are directly linked to the expansion of Olmec holdings in the Tabasco museums.

ARCHAEOLOGICAL INVESTIGATIONS ON THE OLMEC IN TABASCO

The first mention of La Venta in the archaeological literature is by Frans Blom and Oliver La Farge (1926), who visited the site during their trip through southeastern Mexico and Guatemala. Matthew Stirling, a decade later, began to associate the isolated, portable objects in European and U.S. museums with those reported in the coastal plain of the Gulf of Mexico; he initiated the pioneering epoch of

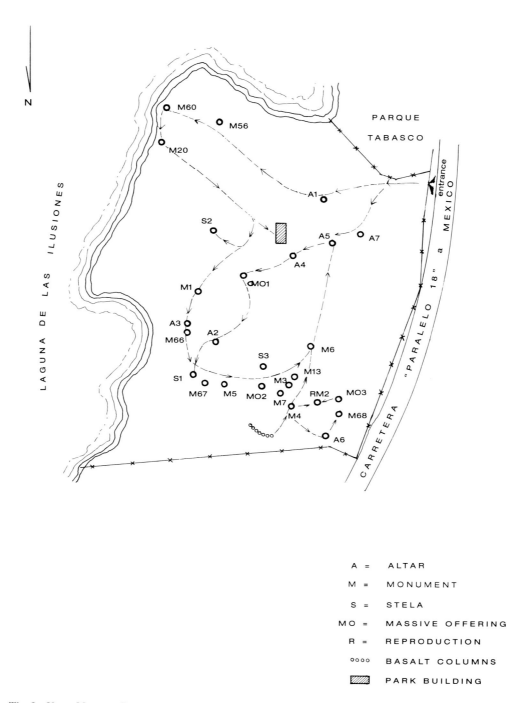

N

M60
M56
M20
A1

PARQUE
TABASCO

entrance
a MEXICO
"PARALELO 18"

LAGUNA DE LAS ILUSIONES

S2
A5 A7
A4
M1 MO1
A3
M66 A2
M6
S3 M13
S1 M3
M67 M5 MO2 M7 RM2 MO3
M4 M68
A6

CARRETERA

A = ALTAR
M = MONUMENT
S = STELA
MO = MASSIVE OFFERING
R = REPRODUCTION
oooo BASALT COLUMNS
PARK BUILDING

Fig. 1. The La Venta Museum Park, after a plan by J. M. Arrecillas in the 1970s.

Olmec archaeology. His excavations at La Venta and San Miguel were reported in academic publications, and the most spectacular findings were diffused through the popular magazine *National Geographic*, which provided an international following and lent an aura of romanticism to one of the last archaeological frontiers in Mesoamerica (Drucker 1947, 1952; Stirling 1939, 1940, 1941, 1943a, 1943b, 1957; Stirling and Stirling 1942).

In 1955, Philip Drucker continued investigations in the ceremonial area of La Venta (Drucker, Heizer, and Squier 1959). Already the site began to be drastically affected by petroleum exploitation in the region. As a result, sculp-

tures began to appear without archaeological record, and it was then that the Tabascan poet Carlos Pellicer, of the National Institute of Anthropology and History (INAH), with due authorization, began to negotiate the transfer of most of the La Venta sculptures to Villahermosa for better security (Marquina 1955). At the insistence of Pellicer (1958a, 1958b), INAH, worried by the attested and accelerated destruction at La Venta, began a series of salvage projects in 1959 (Piña Chan and Covarrubias 1964; Piña Chan 1982). The University of California at Berkeley conducted investigations at the site between 1967 and 1969 (Heizer, Drucker, and Graham 1968; Heizer, Graham, and

Napton 1968). In the 1970s, no investigations were done in the archaeological zone, but as a consequence of urban blight and petroleum activity, a series of sculptures nevertheless came to light (Torres 1972, 1975, 1977). In 1985, under the auspices of the state government of Tabasco and INAH, a project was initiated to protect, investigate, and restore the archaeological patrimony of La Venta. This culminated in the Declaratory Decree of the La Venta Archaeological Zone and the establishment of a site museum of La Venta (González Lauck 1988).

With the exception of three pieces that were exhibited in the Gulf Coast gallery of the National Museum of Anthropology, most of the La Venta sculptures were found in the La Venta Museum Park and the "Carlos Pellicer Cámara" Regional Museum of Anthropology, both in Villahermosa, because there was no infrastructure in the archaeological zone to protect the site until very recently. Much of the ceramic material recovered was also sent to the National Museum of Anthropology, with samples at the Smithsonian Institution in Washington, D.C., and in the Phoebe Hearst Museum of Anthropology at the University of California, Berkeley. In addition, most of the holdings of worked greenstone objects were found in exhibitions at the National Museum (anonymous 1955), while a small number have been indefinitely lent to the Smithsonian Institution; however, only two pieces were found at the Regional Museum of Anthropology. Since 1988, all cultural materials recovered at the site are protected in the site museum of La Venta or in their storehouse.

THE MUSEUM OF TABASCO (1947–1952) AND THE ARCHAEOLOGICAL MUSEUM OF TABASCO (1952–1980)[3]

It was not until 1947 that a museum in Tabasco would emerge, initiating formally the collection and presentation of archaeological and historic objects; previously, individual Tabasqueños, such as Francisco Chablé and Angel Enrique Gil, expressed interest in forming archaeological collections from various cultures. In his first year in office, then governor of the state of Tabasco Francisco J. Santamaría decreed the creation of a museum, with the goal of "acquiring and conserving all those objects, reliquaries and documents that, in some form, have a relationship to the history, archaeology, and art of Tabasco and the Republic of Mexico" (Hernández 1980: 6). This first Tabascan museum contained pre-Hispanic and historic objects, as well as pieces that depicted sport and artisan activities (Hernández 1980: 6).

Unfortunately, the information on this museum is minimal; presumably the exhibition focus was man's evolution in Tabasco. The Olmec and Maya pieces would have aided in understanding the pre-Hispanic antiquity of the state.

As for the Olmec material in this museum, La Venta Monuments 9, 10, and 11 were exhibited there.[4]

The work of Carlos Pellicer Cámara was highlighted in the last years of the Santamaría government; from 1950 to 1952, Pellicer systematically organized and united a number of pieces not only from the state of Tabasco, but also from other regions of the country, including the collections of Emilio Dupeyrón, Benito Sastré, Rosendo Taracena Padrón, Diego Rivera, Pellicer himself, and a collection ceded by INAH (Pellicer 1961: 8; Hernández 1980). The Archaeological Museum of Tabasco was inaugurated in 1952 in a building at one end of the Plaza de Armas, the principal plaza of the Tabascan capital. The Pellicer Museum displayed pre-Hispanic objects from cultures all over Mexico (Teotihuacan, Tarascan, Totonac, Zapotec, and Mixtec), with an emphasis on those that had left traces in Tabasco: the Maya and the Olmec. In its time, this museum was considered "one of the most valuable collections in the country" (Ramírez and Sánchez 1978: 27), as the archaeological collections also counted the mural of Dr. Atl and a reproduction of the Bonampak murals (Pellicer 1959: 8 and 34).

One of its principal exhibition halls, "The Great Gallery of La Venta Culture," was a spacious area, where Colossal Head 2, extracted from the site in 1952, was displayed. At the entrance to the gallery, the visitor passed at least seven Olmec sculptures positioned like sentinels: Monuments 5, 9, 11, and 70 from La Venta, and Monument 60 from Ixhuatlán, Veracruz, and two more which could not be identified. The holdings already contained the offering of more than one hundred votive celts and the elaborately carved "ceremonial knife" from the Ojoshal *ejido* in Cárdenas (Pellicer 1959: 9; Hernández, personal communication).

THE LA VENTA MUSEUM PARK (1958–PRESENT)

The earliest reference to the creation of what is now known as the La Venta Museum Park (originally called the La Venta Archaeological Park) is in the correspondence between Pellicer and the authorities of INAH and Petróleos Mexicanos early in 1955. There he argued about the lack of security for the La Venta Olmec sculptures in the archaeological zone—at that moment virtually unprotected. In his correspondence to the director of Petróleos Mexicanos, he writes of the move to Villahermosa of

> …twenty-some monuments of the great culture of La Venta…where I would create the La Venta Archaeological Park on the shores of a lake….The objects would be placed in their original positions with the same orientation, but at a lesser distance that would make the necessary walkway possible and easy to become familiar with them. And they would remain…in a similar landscape to that in

which they were erected more than twenty-five centuries ago (Pellicer 1955a).

Pellicer suggests to Architect Marquina, the director of INAH, that:

> we bring them to Villahermosa to a neighboring property in the city....although small, the 20 monuments, the formidable monoliths of La Venta, would be scattered within 90,000 square meters (Pellicer 1955b).

Pellicer's dream was realized with the inauguration of the La Venta Archaeological Park in 1958. We have not found photographs, nor a detailed description of this movement of sculpture, which for its time would have been an extraordinary task: the branch of the Pan-American highway between Coatzacoalcos and Villahermosa had scarcely been traced, and the rivers would have had to have been crossed on ferries (Hernández, personal communication). In Pellicer's correspondence with Eusebio Dávalos Hurtado, director of INAH, in July of 1957, he writes:

> …on the past 13th of June, after 11 in the morning I began the movement of the great altar of 38 tons…. at 3:30 in the afternoon of this same day I saw the departure of the enormous Mack [truck] slowly carrying the great monument… (Larrauri and Romero 1994: 15).

In August of the same year he writes to Ignacio Bernal:

> …that with one exception, all of the heavy pieces, better said the heaviest pieces of La Venta, I have already transferred to Villahermosa. In total, I have already brought 15 sculptures, *for now*, leaving 5 sculptures, the tomb, and numerous columns of dispersed basalt. Probably it will be during the next spring that I will totally end the undertaking I have invented…. You can be assured that two-thirds of the La Venta archaeological materials are already in Villahermosa… (Pellicer 1957).

In 1958 he continues the transfer; in a letter to Bernal he writes that he has been "…interrupted by the movement of a 25 ton piece from La Venta…" (Pellicer 1958a).

In the midst of his self-imposed task he writes a letter in 1957 to his colleague Alfonso Reyes, in which he describes his visualization of the Archaeological Park:

> …imagine a poem of seven hectares. With millenarian verses and bound in mystery. Naturally on the shores of a lake with some errors called crocodiles. With [King] Solomon's (sic) fortune, I will let loose there the same fourteen deer that will give rapid punctuation to such a magnificent text…. On the same property I am organizing a zoo with only Tabascan species…. With very little effort I will complete a botanical garden and in this manner the three kingdoms will be in me, because already all this business is part of my body… (del Villar 1995: 54).

The La Venta Archaeological Park was named by Pellicer. For the location, he selected an area that was then on the outskirts of Villahermosa and on the borders of La-guna Ilusiones, a small, lacustrine complex between the Grijalva River and one of its branches, known as the Carrizal River. Visitors left the city to arrive at a space with abundant vegetation, fenced with mesh to protect it from intruders and preserve the wildlife, especially deer, which gave the park a more natural ambience. The deer were accompanied by monkeys, various birds, as well as crocodiles and snakes in cages, in this antecedent of the modern eco-museum. Upon crossing the entrance, the visitor encountered what appeared to be a fragment of jungle. This La Venta Museum Park represented, in its moment in the history of Mexican museums, one of the greatest attractions in "cultural visits."

The first version of the La Venta Museum Park contained twenty-two sculptures and two mosaics from the massive offering (Pellicer 1959: 35–51) (fig. 1).[5] Although it was originally proposed that, in terms of orientation and grouping, the layout in the park would match the layout of the archaeological zone, this was not carried out. No documents have been found to explain the organization of the sculptures in the park, which does not follow the layout of La Venta either in theme or chronological order. Almost the only similarity between the park and the site is that the sculptures were exposed out of doors. They were either embedded in or seated over concrete bases (Pellicer 1959: 36). According to the historical photographs, it is apparent that already free restoration had been practiced on missing areas of some sculptures, like Monument 56, the right lateral figure on Altar 4, and some of the features of the personage on the right side in Stela 3. In the 1961 photographs of the sculptures from the La Venta Museum Park it is still not possible to detect the modifications, which used some type of material (concrete?) to cover the small, natural orifices of the stone. International conventions were not applied in these sculptural alterations, although today these conventions are respected in Mexico.

In terms of museum presentation, Pellicer, in accordance with the time, considered the Olmec to be the "mother culture," and presented his own interpretation of certain monuments: he calls Monument 56 a "monkey watching the sky," although it is an architectural tenon; Altar 5 is interpreted as "the monument to maternity"; the incisions from Monument 66 are interpreted as the "beginning of numeration," when in reality it is the lower part of a celt-shaped form (Porter 1989); Monument 79 is explained as a "sketch of sculpture?" when it is actually a natural formation of sandstone (Oscar Jiménez S., geological engineer, personal communication); and for Monument 7, which is the tomb with basalt columns, he suggests a "cage to conserve a living divine jaguar?" (Pellicer 1961: 39). Surprisingly, these interpretations and others were still maintained until very recently (anonymous 1992).

The park was subject to various renovations over time, while its sculptural holdings were growing, although 1977 was the last time that La Venta sculptures were incorpo-

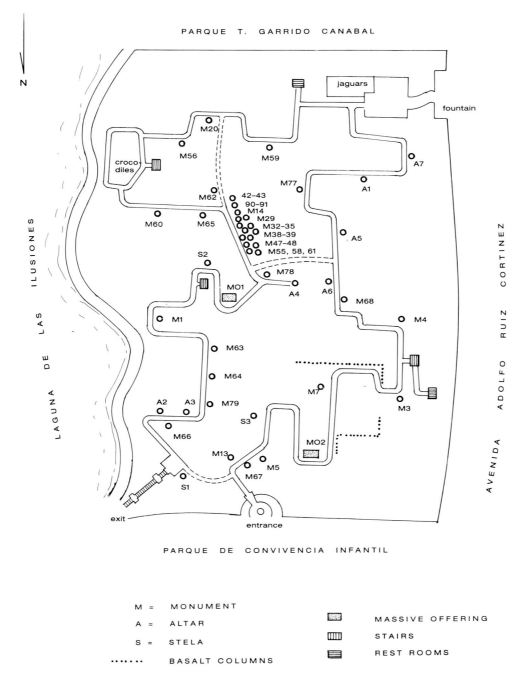

PARQUE T. GARRIDO CANABAL

Fig. 2. Plan of the La Venta Museum Park, 1995.

rated into the park (Pareyón 1977). In the 1970s an introductory gallery was added, which offered a presentation of Preclassic to Postclassic cultures from the width and length of the Mesoamerican world with materials on loan from the National Museum of Anthropology. Also in this presentation were large-scale photographs from the first La Venta archaeological investigations, a maquette of the architectural plan of La Venta in its 1968 version, a series of medium-sized sculptures (Monuments 43, 61, 78), and part of the water distribution system discovered in 1968 in the Stirling "Acropolis" (Monuments 45 and 46). In addition, the faunal assets were increased with a collection of beautiful jaguars.

Even though no document has been found that details the La Venta Museum Park holdings between 1961 and 1980, it is known that during this period sculptures were incorporated from the La Venta archaeological zone from both controlled and uncontrolled excavations (Clewlow and Corson 1968; de la Fuente 1973). Some of these were deposited initially at the park for later incorporation into the holdings of the "Carlos Pellicer Cámara" Regional Museum of Anthropology in 1980. Also, some sculptures that were adequately protected in the Archaeological Museum of Tabasco were later moved to the park in 1958.

In the 1970s, public outcry began over the "unconscionable destruction" of the archaeological heritage at the

park from exposure to the elements (de la Fuente 1973: 8). In 1981, the state government sent a proposal to INAH for a light and sound spectacle in the La Venta Museum Park (Jiménez Pons 1981). In response, the INAH Archaeology Council pronounced the following in the same year:

> …the original sculptures…continue to deteriorate, for which we solicit…the local authorities that control said Park…to outline the situation and to make them see the advantage of making duplicates, with the objective of putting the originals in a closed place and exhibiting copies in the Park, since, besides natural phenomenon, the destruction of said sculptures could be incremented by the illumination that has been placed on them by the Light and Sound Spectacle. It is important to remember that in November of 1977 a similar proposition was made in relation to these sculptures (García Cook 1981).

Beginning in 1985, as part of an enlarged cultural program, the state government prepared new archaeological and botanical guides for the La Venta Museum Park (Ochoa and Castro 1985; Capello and Alderete 1986). In these guides thirty-four sculptures and a stone replica of Monument 19 are enumerated. Most of these continued to be exhibited outdoors, with only four placed in the introductory gallery of the museum park. In addition, in coordination with INAH, a program of cleaning and conservation for those sculptures exposed to the elements was implemented for the first time in 1986 (García Vázquez 1985). Within this project, besides the elimination of microflora, microfauna, and chemical agents applied in the past, which had impregnated the pieces, new fiberglass bases were prepared for some of the monuments. Between 1987 and 1988, a series of fiberglass reproductions by indirect molding was made for some of the sculptures as part of the La Venta Archaeological Project.

In 1994, the state government of Tabasco carried out a remodeling project at the La Venta Museum Park. In terms of conservation measures, new bases were installed to prevent capillary suction and to highlight the pieces. At the same time, improvements in the walkway and the presentation at the park were introduced. Additionally, the park entrance was changed and a new museum, "The Olmec of La Venta," was constructed, which showed a partial version of the La Venta architectural plan with miniatures of some of the most important sculptures and findings (anonymous 1994; Cervantes 1995). It is alarming that on this occasion replicas by direct molding were made of some of the La Venta sculptures (Herrera 1994). Surprisingly, the greater part of these replicas are found exhibited within the museum, while the four original sculptures that were adequately protected within the introductory gallery were removed and are now exhibited out in the open.

Currently fifty sculptures are exhibited, in addition to the two mosaics from the massive offerings, and are exposed to the elements at the La Venta Museum Park (fig. 2). Their state of conservation, despite the recent improve-

ments with the installation of new bases, continues to be disquieting. In a survey of thirty-one sculptures, eighty percent have missing pieces, seventy percent present cracks, sixteen percent show flaking, while ninety-six percent show erosion, loss of constituent materials and decoration (García Vázquez 1993). Another recent study affirms the degradation of the surface stone of the sculptures, precisely the part on which the Olmec had carved (Martínez C. 1993: 5). Finally, while it has been more than twenty years, studies continue recommending that "Transfer of the monuments to a controlled, stable environment in a museum…would provide the most reliable means for assuring their indefinite survival" (Ginnel and Stulik 1994: 4).

"CARLOS PELLICER CÁMARA" REGIONAL MUSEUM OF ANTHROPOLOGY (1980 – PRESENT)

Over the years, the Archaeological Museum of Tabasco outgrew its space. So, a new building was constructed at the end of the Paseo de Malecón on the shores of the Grijalva River. Today it is part of a dynamic cultural zone in Villahermosa, which includes the Pino Suárez Public Library, the Esperanza Iris Theater, the Fine Arts Center, and a small commercial center with the Fondo de Cultura Económica bookstore. However, for the museum originally visualized as part of the Center of Olmec and Maya Cultural Investigation (CICOM), only the name has survived the cultural politics of the state.

The Regional Museum of Anthropology contains 1,858 square meters of exhibition space, which is divided into three floors (Hernández 1980: 6). The Olmec holdings are concentrated in the first two floors of the museum, while the rest of the space is dedicated to the exhibition of materials from the Maya culture and other pre-Hispanic civilizations. The welcome is given by one of the La Venta colossal heads (Monument 2). Behind it, the "Gallery of Monumental Art" is found, which includes Monuments 11, 28, 31, 44, 70, 72, 75 (lower fragment), and 76 from La Venta, as well as Monument 71 from San Miguel. Also included is a fragment of a seated figure, whose legs, loincloth, and lower torso are rendered in clear Olmec style, but without certain provenance (de la Fuente 1973: 259). Another Olmec-style sculpture with unknown provenance is of a seated human figure with an elaborate headdress carrying incised decorations, while at the back of the figure, the knots from the headdress are represented in low relief (González Moreno 1990).

Approximately half of the space on the second floor of the museum is dedicated to the Olmec. The sculptures include Monuments 9, 10, 21, 30, 40, 41, 57, 69, 73, and 74 of La Venta. There is also an Olmec-style sculpture of unknown provenance, worked in low relief on a cylindrical stone, depicting a contortionist. Most of the repre-

sentation is devoted to the face of the human figure with an elaborate headdress, while a lesser emphasis is placed on the crossed arms and soles of the feet. Also displayed in this part of the museum are ceramic vessels from Tlatilco, although some are of unknown provenance, but in a style that could have been from La Venta. Various *metates* are exhibited, part of the water distribution canal of volcanic stone that appeared on the Stirling "Acropolis," and various stone instruments. There is a series of polished votive celts, some with incisions, the majority of unknown provenance. Also exhibited is a group of celts from Panjole, Cárdenas, of supposed Olmec affiliation. In terms of jewelry, greenstone collars and earspools of unknown provenance are displayed.

The "Selected Works Gallery" is found in the mezzanine of the Regional Museum, where six small-format Olmec-style pieces are found. The first is located a step before the entrance to the Gallery; it is a worked greenstone representing a supernatural being with a feline body and a face that is a combination of human and fantastic features. In the entrance is a ceremonial celt with coarse incisions representing a human being. Two niches are found over the north wall. One holds the ceremonial knife from Ojochal and a La Venta piece, which is believed to have come from uncontrolled excavations, worked in a thin piece of cream-colored stone (probably sedimentary). It represents in low relief a predominantly human figure with fantastic features, carrying a rectangular object in its arms. The second niche houses two La Venta figurines (Drucker 1952: pl. 49 and 50).

The information that accompanies the Olmec objects in the Regional Museum of Anthropology is brief and concise. The exhibition labels are a combination of scientific information and popular beliefs (e.g., "the jaguar cult seems to have been the core around which the life of the village revolved") and focuses principally on the material remains of the Olmec elite of La Venta.

Site Museum of La Venta (1988–present)

The site museum of La Venta, established in 1988, is on the western side of the archaeological zone, over what had been an airstrip. In 1977, an antecedent of this museum, the "Museum of Olmec Culture," was established by the inhabitants of Villa La Venta in the lower floor of the Municipal Delegation building (anonymous 1977). By 1984 this museum barely existed, given that half of its space was used as a library, although its holdings included Monument 80 and the upper fragment of Monument 75, as well as other lesser pieces of clay and stone instruments. All of the pieces that were guarded here, except for the fakes, were moved to the Museum of the Site of La Venta in 1988.

The design of the site museum integrates the successful forms of "modern" architecture with the architectural tra-

ditions of the region, for example, the large thatched roofs. The museum has two principal exhibition spaces: half of the hexagonal entrance serves as an introductory gallery, where a maquette of the architectural plan of the ancient Olmec city is shown, and the main exhibition gallery occupies an additional area of 486 square meters. The museum exhibits established in 1988 are now in the process of improving a series of deficiencies, among them the incorporation of an excessive number of monumental sculpture replicas[6] from La Venta and other Olmec sites, exhibition labels that do not always coincide with the exhibited objects, a lack of coherent information and viewing order, and caricatured graphics.

Despite the acceptable holdings of stone sculptures in the storehouse in 1988, the actual exhibition presented only Monument 80 and two other fragments, as well as a group of ceramic vessels, figurines—the majority fragmented—lithic instruments, and a minute collection of Olmec greenstone jewelry. Since 1994, with the resources of INAH, work was initiated to make the museum more suitable by correcting and improving the exhibition displays and the presentation of information, in an attempt to equate the museum with the importance of the site. For this proposed improvement, an introductory gallery will offer a geographic and cultural framework of the Olmec civilization within the context of ancient Mexico during the first millennium before our era. The main space will be divided into five galleries. In the first space the visitor is welcomed by three sculptural monuments, used by the ancient Olmec to signal the southern access of the ancient city of La Venta. The second and third galleries will exhibit those objects of Olmec daily life, including pottery, lithic, and architectural traditions, as well as a brief review of the archaeological investigations at the site. The fourth and fifth galleries will display cultural vestiges of the Olmec elite, principally those that display ideology and the exhibition of power. Also contemplated is the incorporation of ten sculptures never before on view to the public and an exhibition of replicas of greenstone objects, generically known as jades, from the small ceremonial area that has brought such fame to La Venta. The site museum of La Venta has a cultural character that, continuing in the example of other archaeological sites, allows the visitor to acquire a basic knowledge of the site in a broad manner and with original elements. In this way, the museum will be converted into the best protector of future findings, which will not have to be moved to Villahermosa or Mexico City for protection, study, and diffusion (González Lauck 1995).

Other Olmec Works in Museums in Tabasco

In 1988, the state government of Tabasco recovered one of the most important constructions of historic and artistic

character in the city of Villahermosa and converted it into the Museum of the History of Tabasco. Curiously, although having no relationship to the rest of the displays, one of the most notable pieces of portable Olmec art found in recent times is located there. It is a pectoral of worked greenstone rescued by an archaeological salvage project in the La Encrucijada *ejido* in the Cárdenas municipality. This pectoral depicts in low relief a late Olmec-style face: an open, downturned mouth, almond-shaped eyes, wide nose, and a V-shaped cleft in the upper half of the face, and vestiges of red pigment in its incisions and grooves (Campos 1988: 48; Gómez and Courtés 1987).

In 1990 a small site museum was established at the Pomoná archaeological zone in the Tenosique municipality bordering Guatemala. Although most of the museum pertains to Late Classic Maya civilization, it does exhibit a late provincial Olmec-style sculpture. This limestone sculpture is worked in low relief showing a common theme in Olmec art: the contortionist. The predominant element is the contortionist's face, giving less emphasis to the rest of the body, of which one only notes the arms and soles of the feet. This piece was discovered in the Emiliano Zapata *ejido* in the Tenosique municipality (García Moll 1979). Also in the museum storehouse is a sculpture in the same style, found at El Mirador or BA-17 to the west of the Río San Pedro Mártir in the Balancán municipality. It appeared in 1974 as a result of infrastructure works in the locality. This limestone sculpture, called "Stela 6 of Balancán," is 2 meters high and worked in low relief (Hernández Ayala 1976). In theme and format it is considered a "celtiform stela," because it represents a being similar to those seen in Olmec votive celts. It is not well preserved, however. It has a central cleft head, almond-shaped eyes, and downturned mouth. The body of the figure is not clearly seen, but the left arm appears to be doubled at a right angle in front of the torso, and the figure is in a seated position.

In Balancán, another Tabascan municipality in the eastern end of the state, the Jose Gómez Panaco Museum was recently established; principally the stelae from a Maya site known as Reforma are exhibited. In the lower floor of this museum, a group of smooth petal-shaped celts is exhibited with no information on their origins. Also seen is a late provincial Olmec-style votive celt with a human figure representation, in which the face predominates; it was located within the city limits of Balancán (Ochoa 1977: 80).

Through this detailed review, we realize that fortunately for the Tabasqueños, the majority of their Olmec collections are guarded in one of their museums, such as the two great locations in the state capital and the site of La Venta. In this way the inheritors of the Olmec cultural heritage, those that inhabit the same territory that was once the important society of the Middle Formative period, have a fundamental mission to protect and disseminate the testimony of their indigenous ancestors.

APPENDIX 1

Olmec Works in the Principal Museums of Tabasco

La Venta Museum Park: Altars 1−5, 7; Stelae 1−4; Monuments 1, 3−5, 7, 13−14, 20, 29, 32−35, 38−39, 42−43, 45−48, 55−56, 58−68, 77−79, 90−91; two mosaics from the massive offering.

Regional Museum of Anthropology: Monuments 2, 9−11, 21, 28, 30−31, 40−41, 44, 57, 69−76; unnumbered monument with a contortionist; unnumbered monument with a seated human figure.

Site Museum of La Venta: Altar 8; Stela 5; Monuments 25−27, 52−54, 75, 80−86, 88−89.

ACKNOWLEDGMENTS

Mr. José Luis Ramírez of the Technical Archive of the National Coordination of Archaeology is acknowledged for his delight and satisfaction in sharing his documentary treasures on La Venta in the archive under his care, and we wish to thank him for his ever-present generosity and support. The staff of the Historic Archive of the National Museum of Anthropology is recognized and thanked for its professionalism in organization and efficiency. In addition, this article was enriched by oral information by Carlos Sebastián Hernández Villegas, Flora Salazar Ledesma, and Nazario Magaña Totosaus, to whom the authors express their profound gratitude.

NOTES

1. Tabasco Center, National Institute of Anthropology and History (INAH), and the National Museum of Anthropology, respectively.
2. Since then, this sculpture has formed the central part of the coat of arms for what is now the Autonomous Juárez University of Tabasco, and is actually the most important symbol of intellectual recognition for that organization (anonymous 1987; Torrucco 1987: 296).
3. The latter institution was also known as the State Museum.
4. These sculptures, known as the "San Vicente Group," were extracted from La Venta sometime in the past when Don Policarpo Valenzuela was the landholder of the locality; he also donated Monument 8 to the Juárez Institute. This monument was moved to his farm, San Vicente, near Comalcalco, which was destroyed during the Revolution (Stirling 1957: 226−228). It is not known when the sculptures were moved to Villahermosa, although in 1944 Stirling reported them still in the area of Comalcalco.
5. Based on Pellicer (1959) and a plan by J. M. Arrecillas, it was originally thought to include the holdings of the La Venta Museum Park, the sarcophagus (Monument 6), and a third mosaic from the massive offerings. However, this seems not to have been carried out. It is important to note that the first mosaic of the massive offerings was removed from La Venta in 1946 and exhibited in the National Museum in Calle de Moneda in Mexico City, until Pellicer solicited its return to Tabasco.
6. These fiberglass replicas were initially made with the idea of installing them in the archaeological zone to offer the public a sculptural architectural vision of the ancient city of La Venta. They were never intended to be installed as an exhibit in the site museum of La Venta.

CATALOGUE

Some three thousand years ago, the artists who created the stunning works of art that we call Olmec appeared among quite simple cultures and, with primitive tools, fashioned masterpieces that reflect an extraordinary moment in prehistory, when creativity, trade, and political and religious development came together in a surge of energy to create a new kind of civilization in the region archaeologists call Mesoamerica.

This florescence set the basic pattern for future development in Mesoamerica. It linked this large and geographically varied region, long before the great civilizations of the Maya, Teotihuacan, and the Aztec. What complex interactions were at work is not fully understood, but it is obvious that extraordinary talent and vigor developed the remarkable craftsmanship that impresses us today.

Multiton monuments carved from basalt in the form of colossal heads and figures in full-round or low relief; smaller figurative sculptures, often of greenstone; lapidary work of precious jade and other fine stones, finely cut and highly polished, as ornaments, masks, and figurines, ultimately placed in offerings or graves; handsome ceramics of many shapes: these are expressions of Olmec art.

Common subjects of Olmec art are fine portraits of important men, mythic characters with cleft heads and snarling faces, and men with downturned mouths and slanted eyes, who link these two groups. There are also small stone figures of dwarfs and of men who are taking on feline traits in shamanic transformation. There are ceramic figures of acrobats and babies, and of old women who sometimes nurse infants. Felines and monkeys are carved from stone, and ducks and fish modeled in clay. All of these objects may be decorated with incised or low-relief abstract motifs, which make up a symbolic language that might well have been a beginning of writing.

Art of the style called Olmec has been found in many places, although there is not general agreement on exactly what the Olmec phenomenon was. On the Gulf Coast of Mexico, Olmec art reflected the power of divine kings who built large ceremonial-administrative cities. The state of Guerrero seems to have produced a less personalized religious art in this style. The relief sculptures of Chalcatzingo, Morelos, showed figures in ritual and mythic scenes. In Oaxaca and Honduras, the art style may have defined social groups. Faraway outposts sometimes boasted monuments and handsome carvings on living rock, in addition to portable objects. Although the variations were many, the motifs and style of Olmec art were recognizable everywhere, and they conveyed power, whether religious or political or both.

This exhibition presents art from the remarkable site of La Venta, in the rich, lowlands of Tabasco, with its pyramid, its immense buried offerings, its sculpture monuments, its fine jades. There is also art from the slightly earlier site of San Lorenzo-Tenochtitlan, Veracruz, and from other Gulf Coast sites. Portable objects come from the Mexican states of Mexico, Puebla, Morelos, Guerrero, Oaxaca, Chiapas, and Yucatan, and from Guatemala, Honduras, and Costa Rica.

The art is centered on human beings and their beliefs about the cosmos and the ways they could keep it going, and survive and prosper in it themselves, spiritually and practically. The art focuses on human accomplishments in a world that was evolving rapidly—and that was even more complex than we usually imagine it to have been.

Elizabeth P. Benson and Beatriz de la Fuente

Note to the Reader:
The general Mesoamerican chronology in Olmec times is divided into three periods: Early Formative (c. 1500–900 B.C.); Middle Formative (c. 900–300 B.C.); and Late Formative (c. 300 B.C.–A.D. 300).

1. San Lorenzo Monument 61— Colossal Head 8

Early Formative Period
Andesite
220 x 165 x 160 (86⅝ x 64¹⁵⁄₁₆ x 63); 13 tons
San Lorenzo, Veracruz
Museo de Antropología de Xalapa, Universidad Veracruzana

Also known as Monument 61, Colossal Head 8 was uncovered and reported in 1970 by Brüggemann and Hers. It remained buried at San Lorenzo until 1986, when it was moved to the new Museum of Anthropology at Veracruz University in Xalapa.

To date, seventeen colossal heads are known. Ten come from San Lorenzo, Veracruz; four from La Venta, Tabasco; two from Tres Zapotes, Veracruz (known as Monument A or 1 and Monument Q or 2 from Tres Zapotes, also called Nestepe); and one from Rancho de Cobata in Cerro El Vigía, Veracruz.

The colossal heads represent faces and attributes of rulers; they are portraits. Young but mature individuals, their athletic physiognomy projects a sense of control. No two are alike; each exhibits powerful individuality in their features and facial expression. They are adorned with distinctive helmet headdresses and earspools, aspects that mark their individual character.

The San Lorenzo heads, including Monuments 1a, 1, 4, and 8, display faultless carving as well as a harmony of almost perfect proportions. The excellent state of preservation, the quality of the carving, and the absolute order of its proportions confers upon Colossal Head 8 a primacy of place among these monuments. B.F.

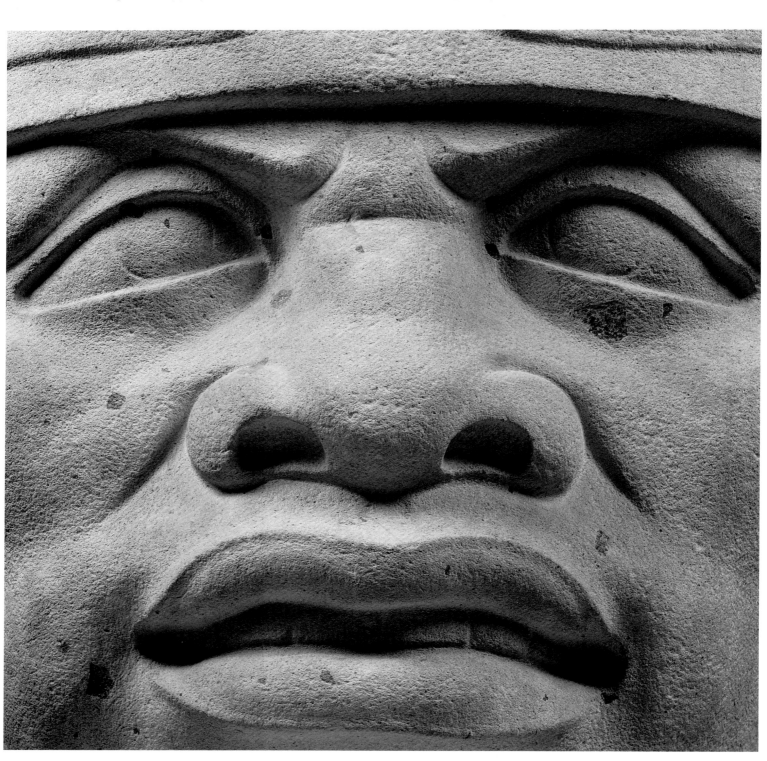

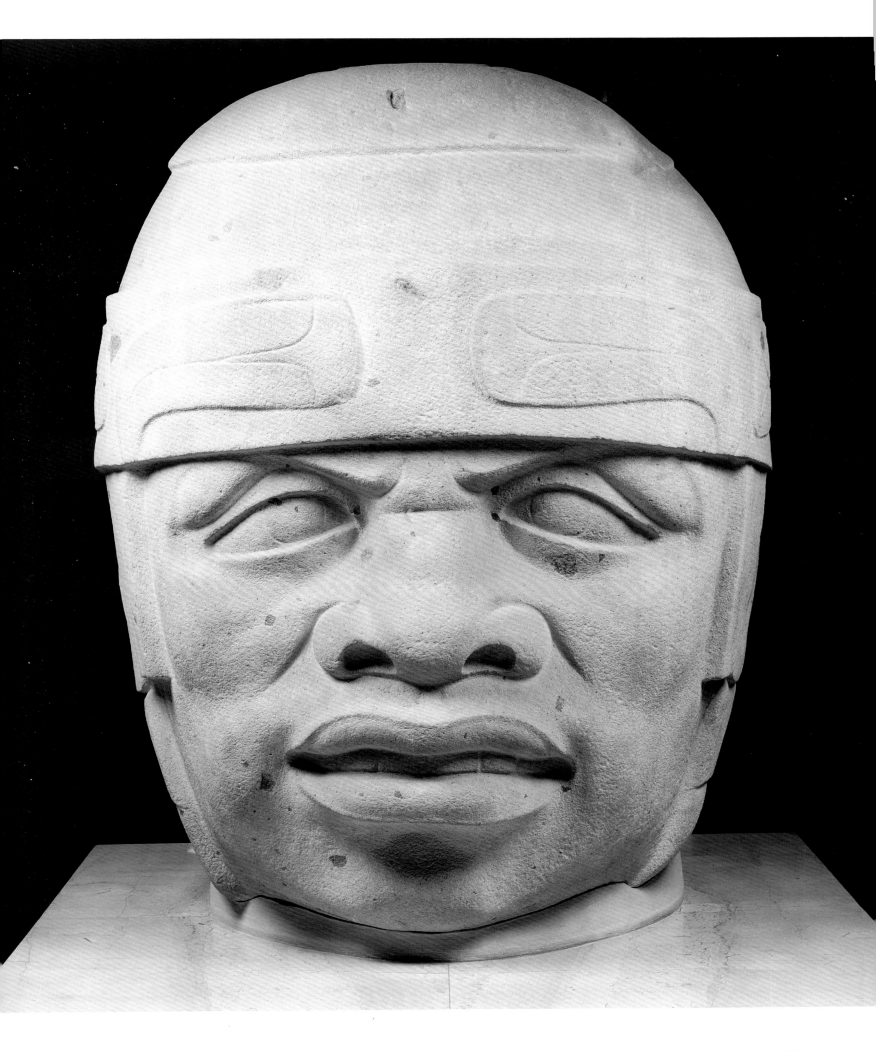

2. San Lorenzo Monument 4 – Colossal Head

Early Formative Period
Basalt
178 x 117 x 94 (70⅟₁₆ x 46⅟₁₆ x 37); 6 tons
San Lorenzo Tenochtitlan, Veracruz
Museo de Antropología de Xalapa, Universidad
Veracruzana

According to Beatriz de la Fuente, this sculpture is the most harmoniously proportioned of all colossal heads. Of the ten from San Lorenzo, this head is one of the smallest and best preserved.

Like the other colossal heads from the Olmec heartland, Monument 4 wears a helmet of a smooth, thick material, possibly leather. Helmets, with their multiple forms and decorative elements, are primarily symbols of rulership; they may also have been worn in the ballgame. A long history of portraiture of Olmec society rulers probably reflects the dynastic nature of the rulership, in which the individuals and the office were celebrated, commemorated, and legitimized.

The particular elements of rulers' helmets seem to be naming devices that identify each individual. On Monument 4, a tripartite tassel hangs down the front of the helmet; four parallel ropes are horizontally placed across it and two others serve as a strap on the right side of the head. The association of ropes and cords with rulership is often found in Olmec art. In the high tropical forest of the Gulf Coast, ropes and cords were essential to survival and, of course, were necessary for the transportation of large stones.

Only the right side of the head shows the ear and its ornament, a disk with a hanging curved element similar to greenstone adornments found in excavations. The left side of the head is totally covered by the helmet and is crossed by three knotted cords.

The face is highly individualized, even though it shares traits with other colossal heads. This is the experienced face of a mature male ruler, which clearly shows the effects of aging: the lines from nose to mouth, the sunken eyes, drooping eyelids, and flaccid cheeks and jowls. The wide nose and fleshy lips are sometimes cited as evidence for an African origin of the Olmec, but the epicanthic fold is its single most important racial feature. It harks back to the origin of Native American populations, 30,000 years ago when people crossed the Bering Strait and settled this continent. Crossed-eyes, a mark of beauty among the Olmec, were induced by training the eyes to focus on a bead on the tip of the nose.

The face of Monument 4 is not marred by mutilations as in other heads; however, the back shows twenty-six dimpled pits and three grooves, intentionally placed for unknown reasons. Ringing the flat back of the head is a rough, hammered surface that is related to the sculpting process. A.C.

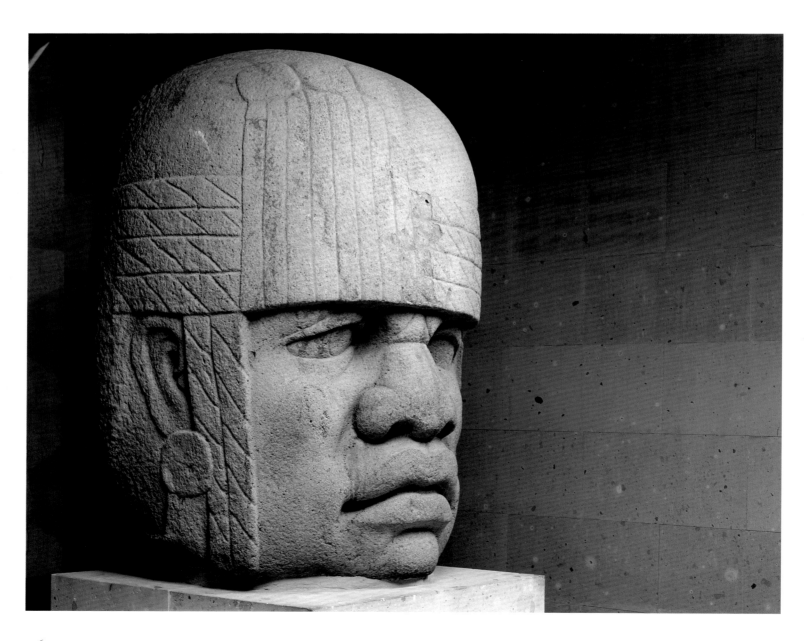

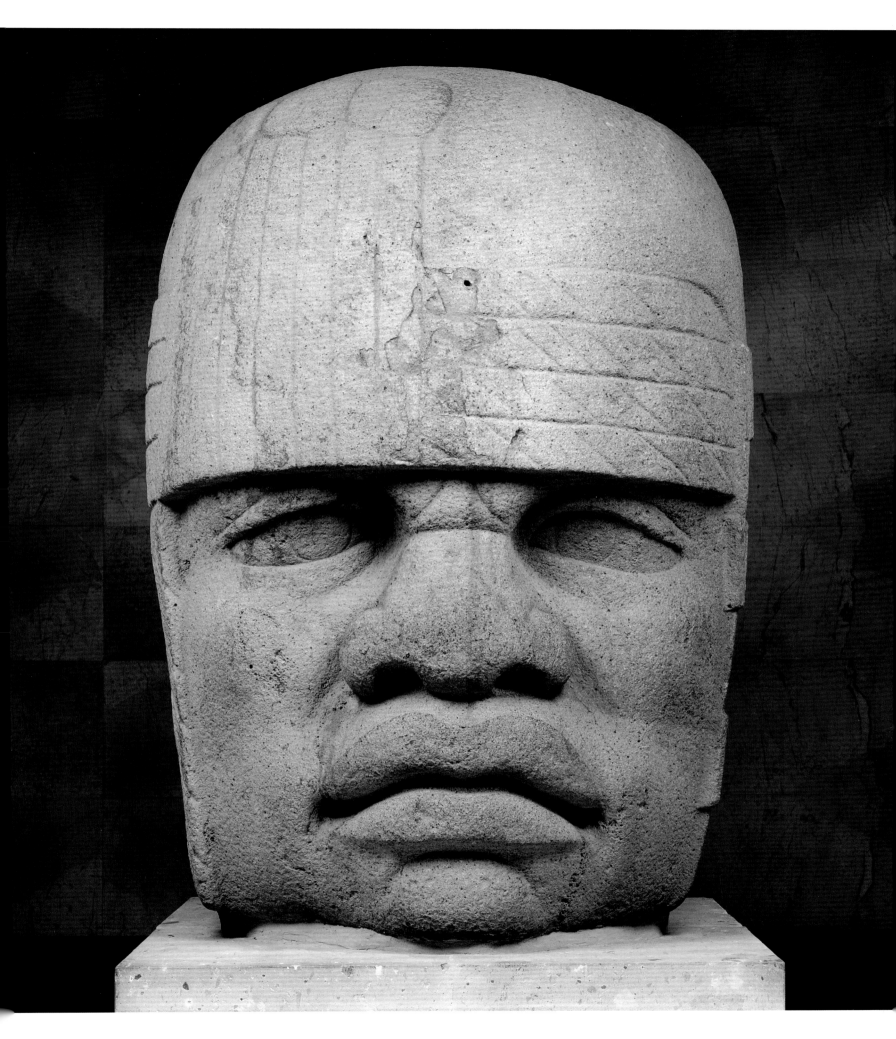

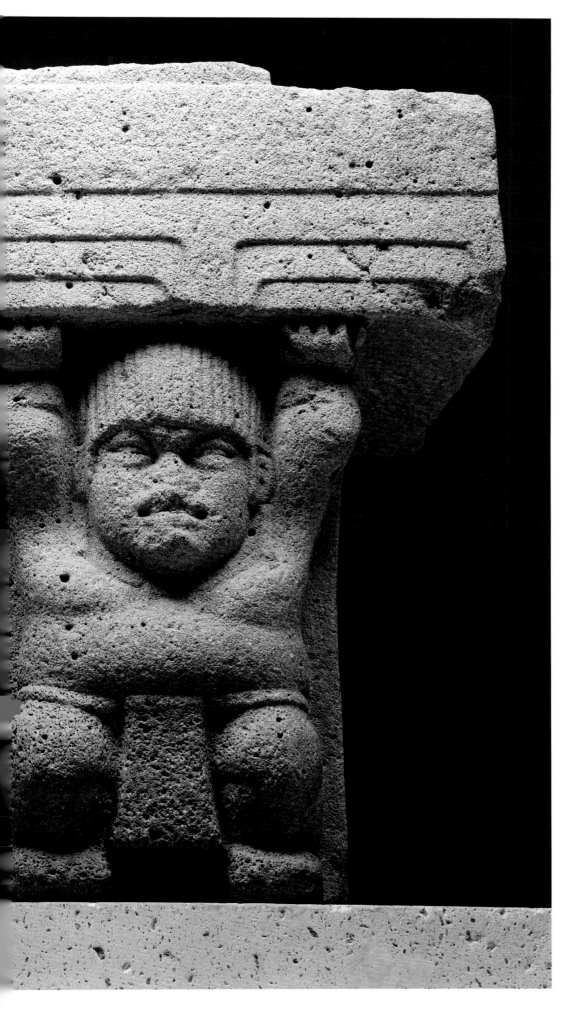

3. Potrero Nuevo Monument 2–4109–Throne with Atlantean Figures

Early Formative Period
Basalt
96 x 129 x 65 (37¹³/₁₆ x 50¹³/₁₆ x 25⁹/₁₆); 2 tons
Potrero Nuevo, Veracruz
Museo de Antropología de Xalapa, Universidad Veracruzana

Monuments such as this one were once termed "altars" because of their table-top form and similarity to modern examples, but David Grove was able to demonstrate convincingly that such "altars" really functioned as thrones, based on the evidence from an Olmec cave painting at Oxtotitlan in Guerrero.

This small throne was discovered by Matthew Stirling in 1946 in the communal lands of Potrero Nuevo. Based on recent research by the San Lorenzo Tenochtitlan Archaeological Project, it is now known that this area pertains to the second largest site in the San Lorenzo hinterland, Loma del Zapote. The presence at this site of a small throne—clearly a symbol of rulership—is not surprising, because Loma del Zapote exercised an important role in the regional settlement hierarchy controlled by San Lorenzo.

One of the finest Olmec thrones combining high and low relief, Monument 2 shows the typical raised surface, on the top of which is either a skin or a mat for the ruler to sit upon. The upper ledge is adorned with crescent-shaped elements that are a stylized symbol of the supernatural earth monster frequently associated with rulership. This motif was also adopted on Olmec ceramics at a later time and is known by archaeologists as the double-line-break motif.

Whereas many Olmec thrones show a seated person in a niche, this throne is supported by two Atlantean-style dwarfs. Subtle differences in the dwarfs' headgear, ear ornaments, necklaces, and loincloths indicate that they are distinct beings, although they could be considered twins. Also from Loma del Zapote come two nearly identical sculptures of twins on the Azuzul acropolis. The early manifestation of twins in Early Formative mythology is a notable Olmec theme in the San Lorenzo region. These chubby fellows are also similar to those portrayed on the highly mutilated Monument 18 from San Lorenzo.

A.C.

4. Standing Anthropomorphic Jaguar

Middle or Late Formative Period
Basalt
102.2 (40¼)
Tuxtla Chico, Chiapas
Museo Regional de Antropología e Historia, Tuxtla Gutiérrez, Chiapas

This standing figure has an anthropomorphic body and a feline's face and feet. These composite images are frequently called "transformation figures" on the theory that they depict a shamanistic transformation from human to jaguar (see cats. 68–71). This statue comes from Tuxtla Chico, on the Pacific Coast of Chiapas, very near the major Late Formative center of Izapa. Stone monuments have been found at several Middle Formative period sites in that area, and while those carvings reflect a Gulf Coast Olmec inspiration and technology, they were nevertheless executed within their own regional style, and thus exhibit some differences from their Olmec counterparts. In the case of this statue, the jaguar's large head-dress is very similar to that on many Gulf Coast monuments (see cats. 5, 10) and some small stone figures (cat. 52). However, those head-dresses all sweep to the rear and have the distinct V-shaped cleft that is common in many Olmec objects, while this one projects forward and lacks such a cleft. In addition, the jaguar's ankle decorations and the treatment of the rear of the carving are not found in Gulf Coast Olmec statuary. In fact, no equivalent transformation figures occur among the more than two hundred known Gulf Coast Olmec stone monuments, thus demonstrating that regional differences were thematic as well as stylistic.

D.G.

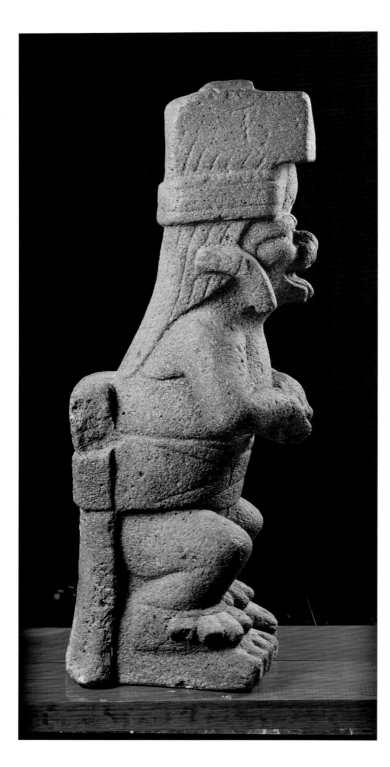

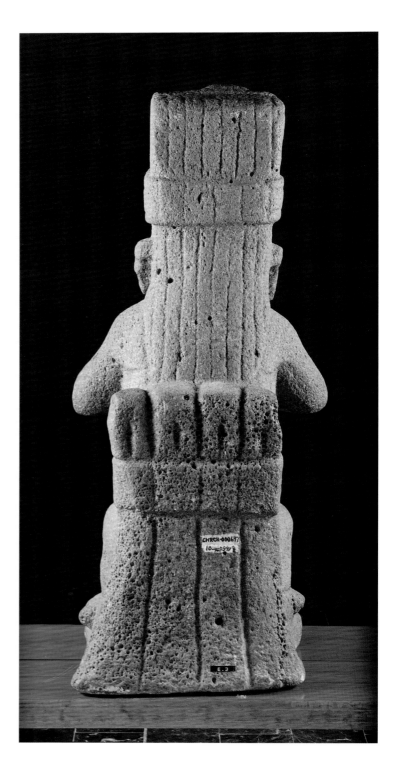

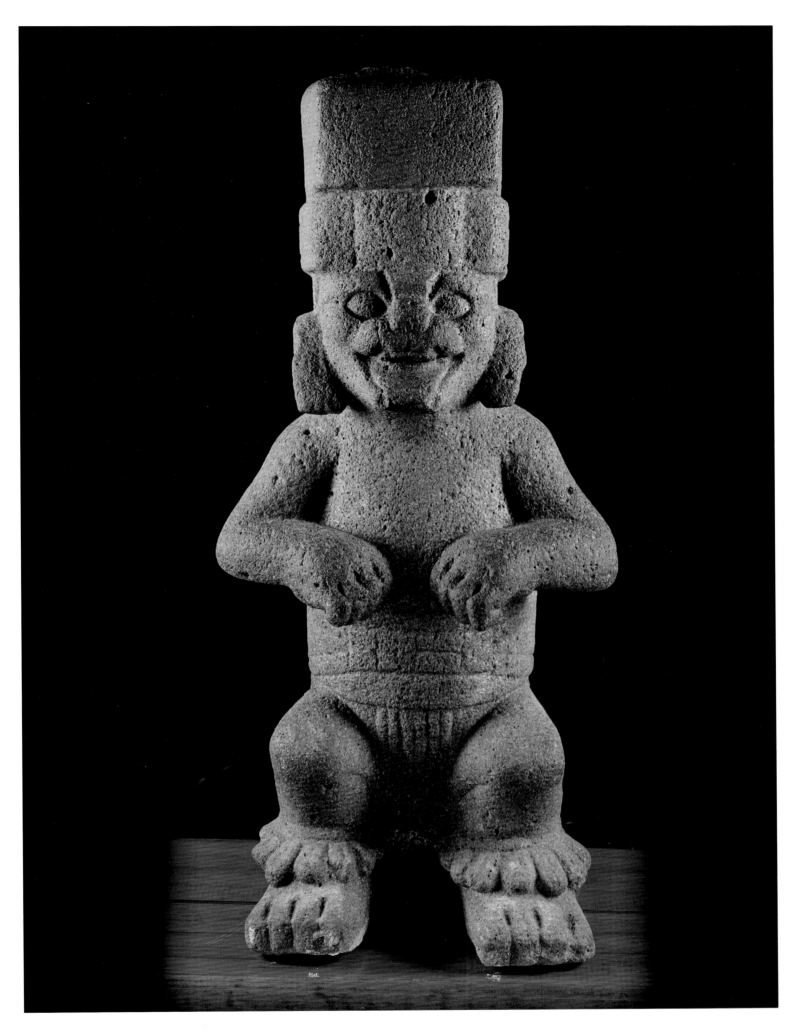

5. San Martín Pajapan Monument 1 — Crouching Figure with Headdress and Ceremonial Bar

Early Formative Period
Basalt
142 x 93 x 94 (55⅞ x 36⅝ x 37); 1.2 tons
San Martín Pajapan, Veracruz
Museo de Antropología de Xalapa, Universidad
Veracruzana

When this monument was found in a rocky
shelter at the top of the San Martín volcano,
Veracruz, part of the arms, the legs, and the bar
it carried between its hands had been broken.

Some of the fragments were returned to their
original place; others were reconstructed.
Although it was found well preserved, the face
was surprisingly damaged, probably by inten-
tion. It remained in the cave of the San Martín
volcano for centuries, receiving uninterrupted
offerings.

Its face, massive eyes, plump features, and
thick lips with downturned mouth indicate the
Olmec facial prototype; also notable is its thick
and rounded body. There is no attempt to
represent individuality. The role is indicated by
the bar the figure carries between its hands — a
convention in Mesoamerican art — and its head-
dress, a sign of authority. Distinction is mani-
fested in the sculptural treatment of the figure
and headdress. This plastic treatment is

resolved by organic forms, but it is restricted to
geometric designs. Thus, the face of the
"supernatural image" is circumscribed to a
cubelike head, accented by a combination of
features that would never occur in reality:
elliptical eyes slanted inward, flat nose, enor-
mous upper lip with eyeteeth, and the cleft
forehead. At the back is a spectacular head-
dress divided into four areas by the intersection
of two grooves, one vertical and the other
horizontal; it may record the four reference
points of the universe and indicate the cosmic
guardian character of the figure.

Elsewhere I have considered this sculpture
as part of an iconographic group similar to the
"lords under supernatural protection" (de la
Fuente 1977). B.F.

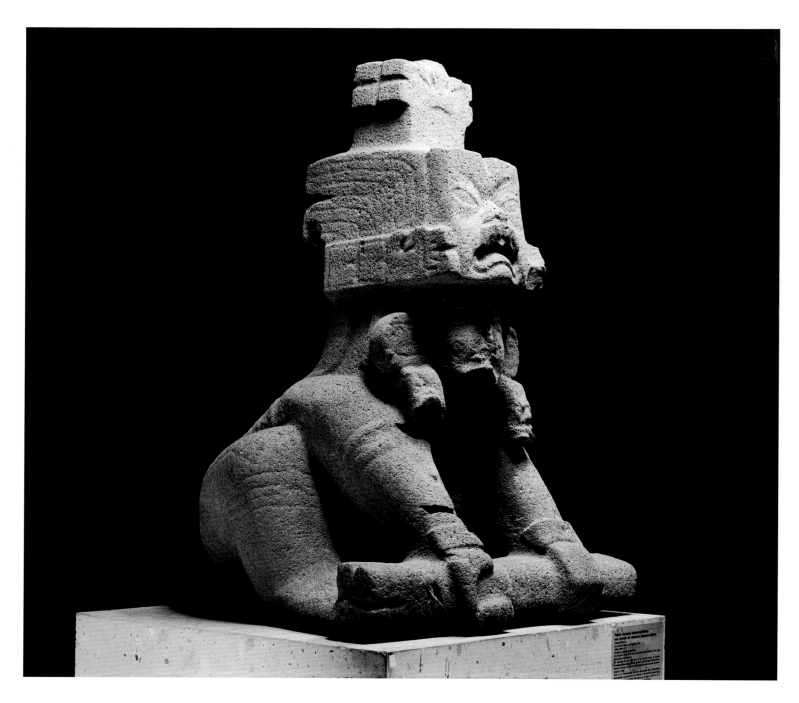

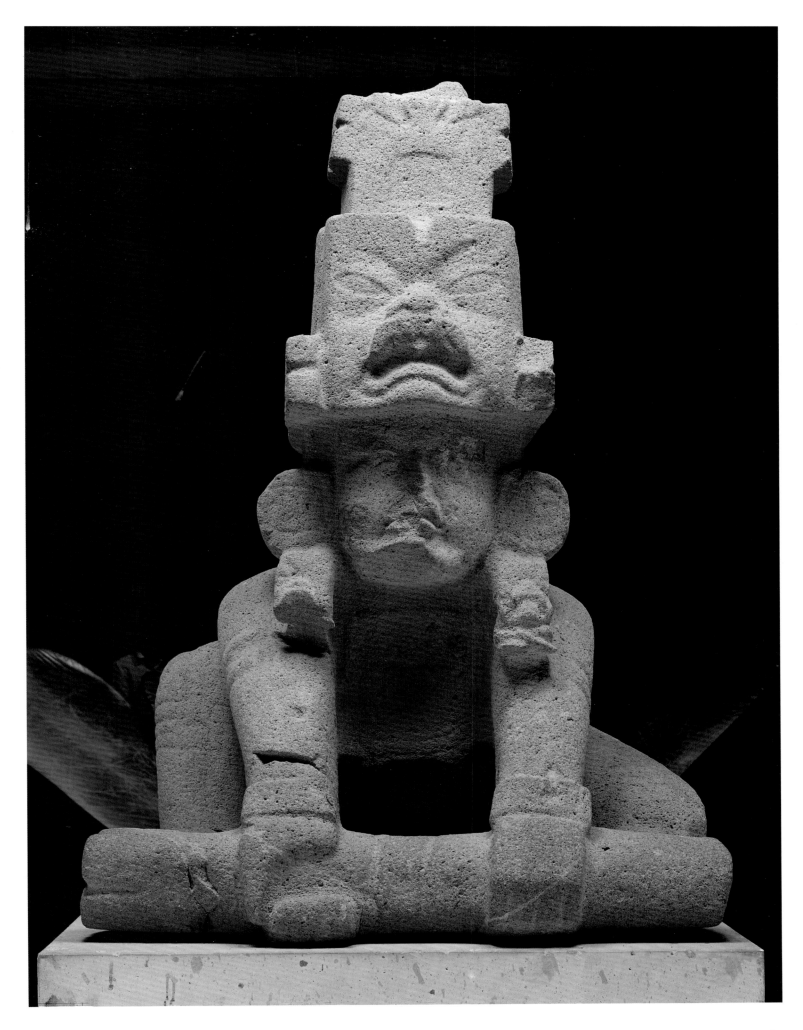

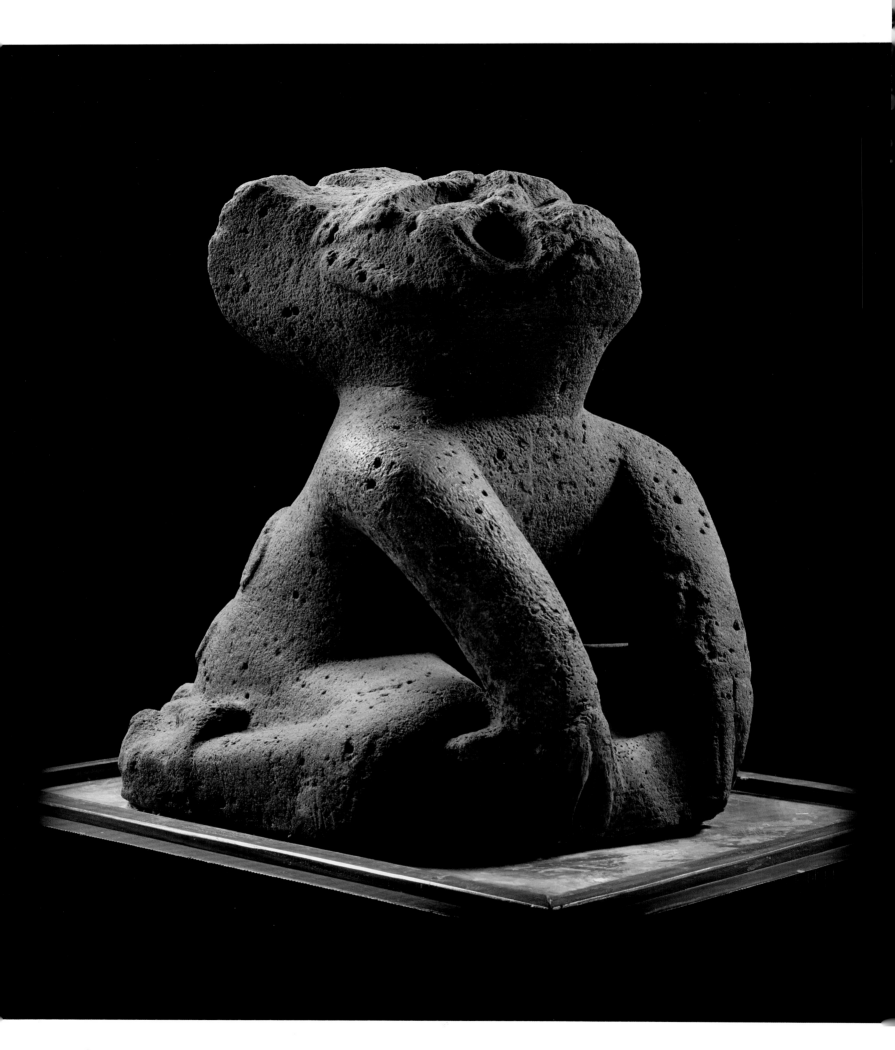

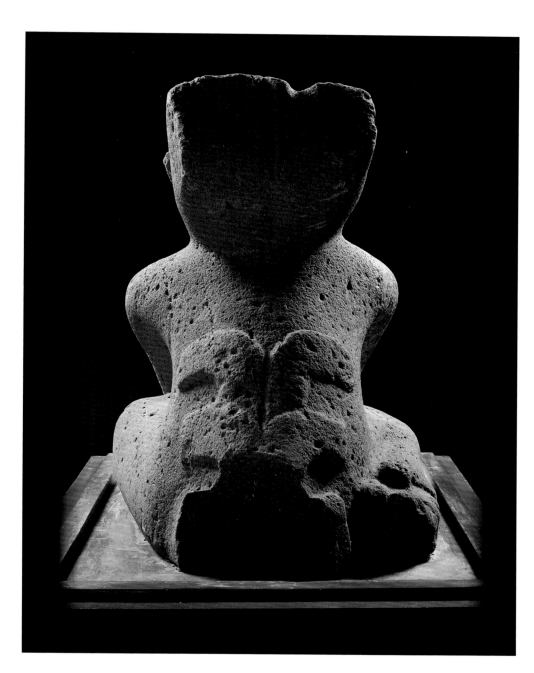

6. La Venta Monument 11 – Seated Were-Jaguar Figure with Upturned Head

Middle Formative Period
Basalt
91 x 67 x 85 (35¹³/₁₆ x 26³/₈ x 33⁷/₁₆)
La Venta, Tabasco
Museo Regional de Antropología Carlos Pellicer Cámara

This hybrid combines human and fantastic features with those of animals to create a supernatural character. The seated body leans forward, its rigid arms extended over the bent legs with their clawlike feet; all elements are reduced to essential forms. The head tilts far back in an almost straight angle, so that the face looks upward. The open mouth covers almost a third of the face, and a pair of fangs emerges from the thick lips. The nose is wide and flat; the ears are elongated and thin. Above the eyes, flame forms are depicted in place of eyebrows. The forehead merges with the headdress, giving the impression of an extended head with a V-shaped cleft terminating the center part. In the middle of the straight back is an element with four curved branches, which probably originated in the lower part of the figure, now destroyed. The right arm of the figure is completely restored. This monument shows an Olmec approach toward open forms in sculptural volumes.

R.G.L.

7. Cruz del Milagro Monument 1—Seated Figure with Crossed Legs

Early Formative Period
Basalt
130 x 90 x 100 (51³/₁₆ x 35⁷/₁₆ x 39³/₈): .7 tons
Cruz del Milagro, Sayula, Veracruz
Museo de Antropología de Xalapa, Universidad
Veracruzana

Popularly known as "The Prince," this cross-legged figure is notably well preserved. The monumental sculpture comes from Cruz del Milagro, Sayula, Veracruz, where it was found by residents and made known to archaeologist Medellín Zenil in 1961. That same year it was moved to the Museum of Xalapa, where it is found today.

Its general aspect and posture recall Monument 8 of La Venta and reconcile human proportions with the Olmec archetype: there is no attempt at individualization. It has a pyramidal structure with a squared base. Its volume, broken only by the space between the arms and the chest, weighs heavily over its base. Seen in profile, the body is a pyramid, the vertex of which is displaced forward by the cube-shaped head. It is the Olmec style—always geometric—to anchor sculpture.

The features are voluminous, but reduced to their essence; this is highlighted by the slightly different legs without feet. The figure wears a unique garment: a skirt, fitted at the waist with a crease at the thighs. Its headdress is formed from a skull divided in sections, with a band fastened by a large buckle in the lower half. Over the band is a hierarchical symbol, a vertical plaque in a trapezoid form.

Depersonalized and conventional figures such as this may represent priests or mediators, who through ritual travel between the terrestrial and supernatural worlds. B.F.

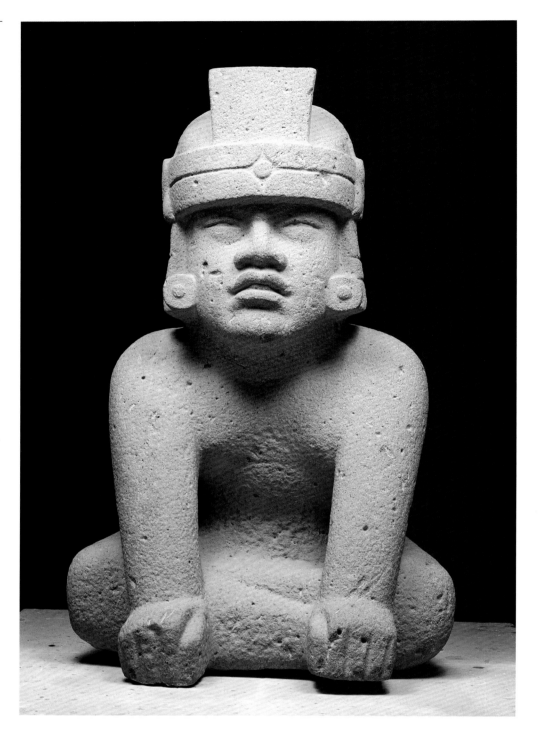

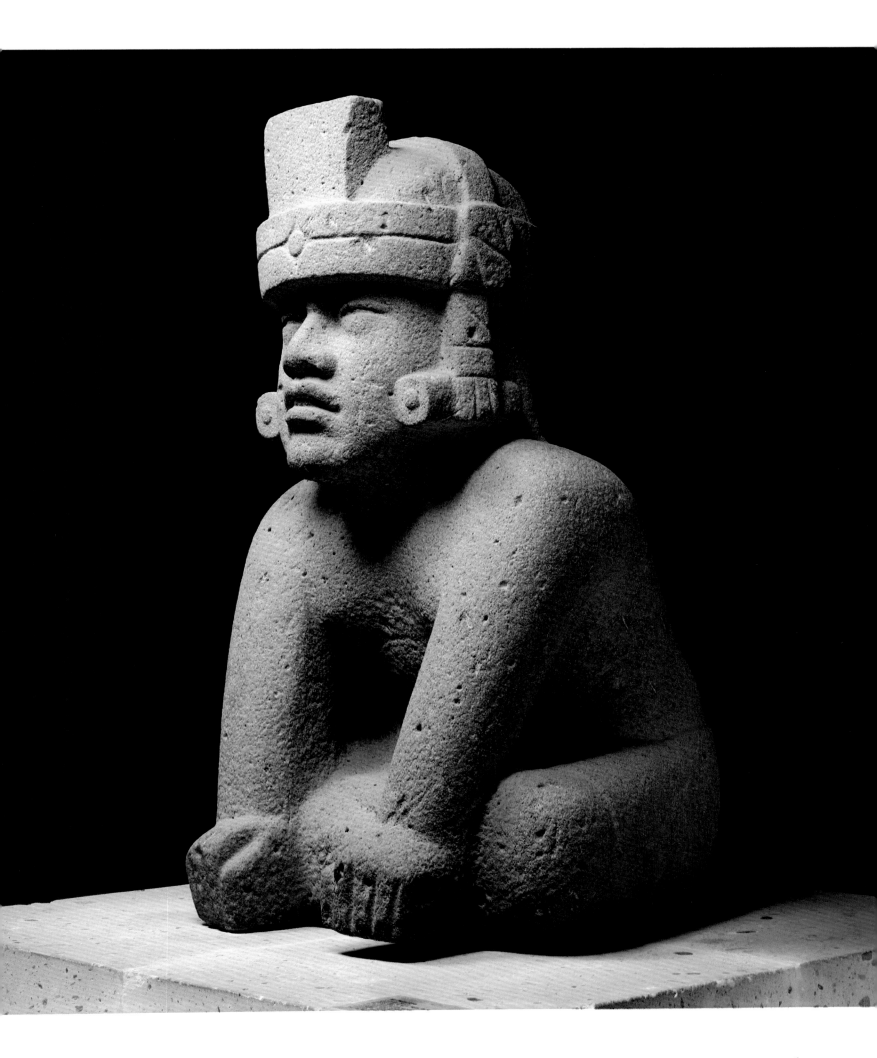

8. San Lorenzo Monument 10 — Seated Figure with "Knuckle-Dusters"

Early Formative Period
Basalt
119 x 86 x 49 (46⅞ x 33⅞ x 19⁵⁄₁₆): .9 ton
San Lorenzo, Veracruz
Museo de Antropología de Xalapa, Universidad
Veracruzana

In Olmec religious thought, the were-jaguar manifests transformation. The peculiar combination of human and feline traits illustrates a possible shamanistic transformation, such as that described by Peter Furst (1968). Monu-

ment 10 has a human body, but the face contains clear feline features. Matthew Stirling (1955) once proposed that the typical combination of feline and human traits was derived from an Olmec origin myth, in which the copulation of a feline and a human brought forth a were-jaguar.

In Monument 10, feline traits are clearly shown in the downturned mouth, which has a prominent, snarling upper lip framing the long bifurcated fangs and gums. The small, wide nose touches the upper lip. Eyes represented as horizontal slits with downturned ends are characteristic of the were-jaguar. The cleft head is bound by a thick band, and the stylized rectangular ears show three internal incisions. Seated in cross-legged fashion, the hefty human body wears a wide belt that is visible

across the back and on the lower chest. The sculpture shows little mutilation except for the legs and the back of the head.

Each human hand holds an object frequently called a "knuckle-duster" by Olmec scholars. No such objects have ever been found in Olmec sites, which suggests that they may have been made of wood or some other perishable material. The "knuckle-duster" form is similar to that of a D-shaped adze, a woodworking tool. The Olmec frequently made elaborate ceremonial objects that were similar or identical to utilitarian ones, such as the well-known jade and jadeite axes; perhaps "knuckle-dusters" are yet another example of this usage.

This piece was discovered in 1945 by Stirling in a deep ravine west of the basalt aqueduct and Monument 14. A.C.

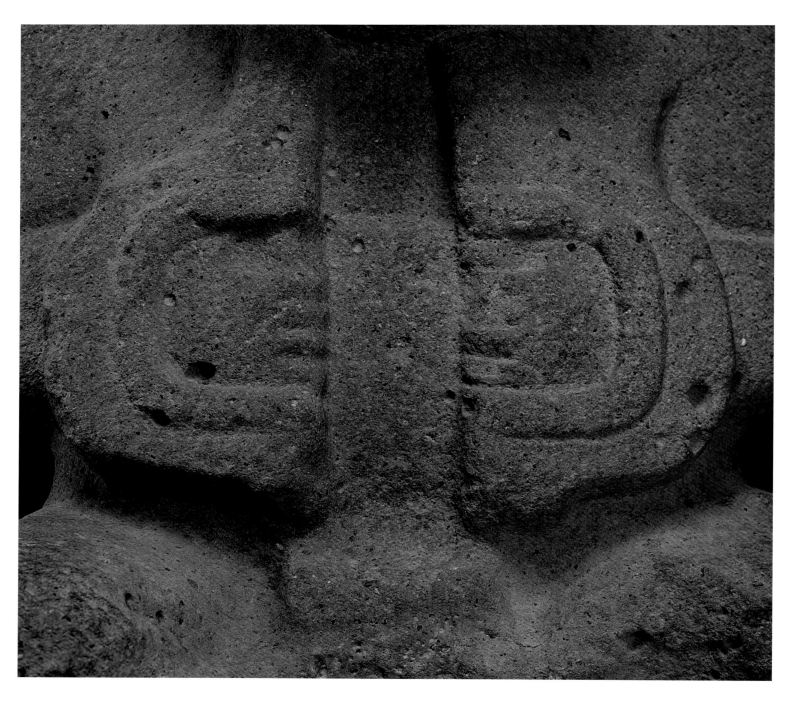

168

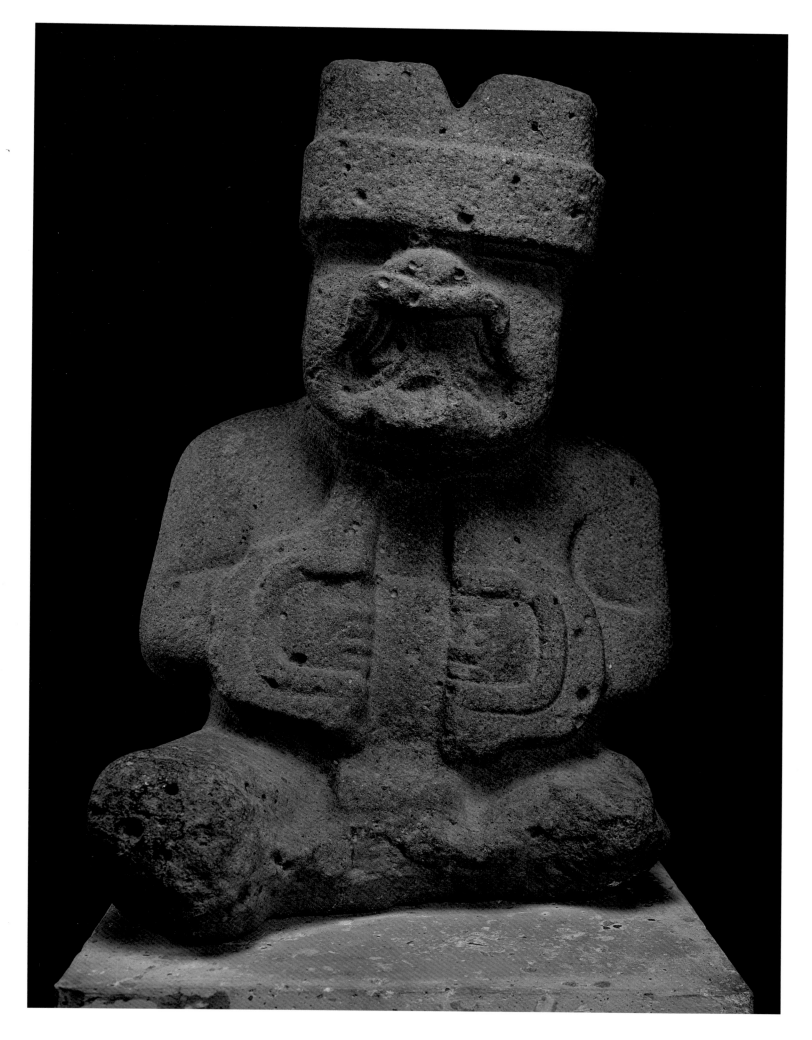

9. Las Limas Monument 1 – Seated Figure Holding Were-Jaguar Infant in Lap

Middle Formative Period
Greenstone
55 x 42 (21⁵⁄₈ x 16⁹⁄₁₆); 60 kg
Las Limas, Jesus Carranza, Veracruz
Museo de Antropología de Xalapa, Universidad
Veracruzana

This monument was discovered accidentally by two children in the village of Las Limas, Jesus Carranza, Veracruz, on 16 July 1965. It was moved to the Museum of Xalapa, where it was stolen; it later reappeared and was restored to the museum.

One of the most perfect monumental sculptures in its carving and iconographic message, it has been considered by some to be the Olmec "Rosetta Stone." Now known popularly as "The Lord of Las Limas,"[1] it was once venerated with candles and flowers "as if it were a Madonna" or a "lady." It portrays an anonymous priest, in an attitude of offering, presenting an inanimate being that confers upon him supernatural powers.

The "priest," "official," or "intermediator" is presented with schematic features; the body has Olmec proportions. His face, masked and well executed, exhibits numerous, fine incisions. Framing the central part of the head are some bands with the ends split in two and decorated with small masks of rectangular shape, a cleft head, and slanted eyes. Over each eye are two masks and a design that circumscribes the mouth and reaches the bridge of the nose. The sides of the mask are defined by symmetrical bands, in which symbols of the swallow's tail—emblem of a ruler—alternate with other small masks of a supernatural image.

On the shoulders and the knees are four incised heads with different aspects. All have cleft foreheads and profiles that show open mouths. However, each has individual traits; assuming a relationship to later Mexican (Aztec) deities, the heads have been interpreted as Xipe, god of spring, on the right shoulder; Xiuhcoatl, the fire-serpent, on the left shoulder; Quetzalcoatl, the plumed serpent, on the right knee; Mictlantecuhtli, god of death, on the left knee. The sculpture consists of two significant figures: a man who acquires supernatural powers through the infantile and fantastic figure that he carries in his arms.

B.F.

Notes
1. In the United States it is called "The Las Limas Figure." I have used the Mexican title here.

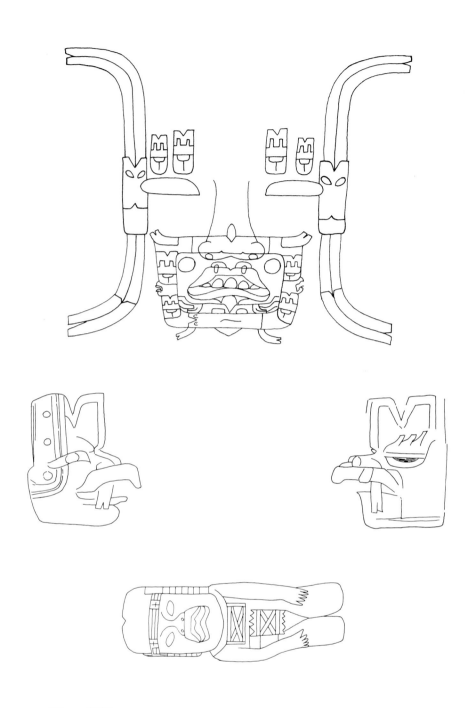

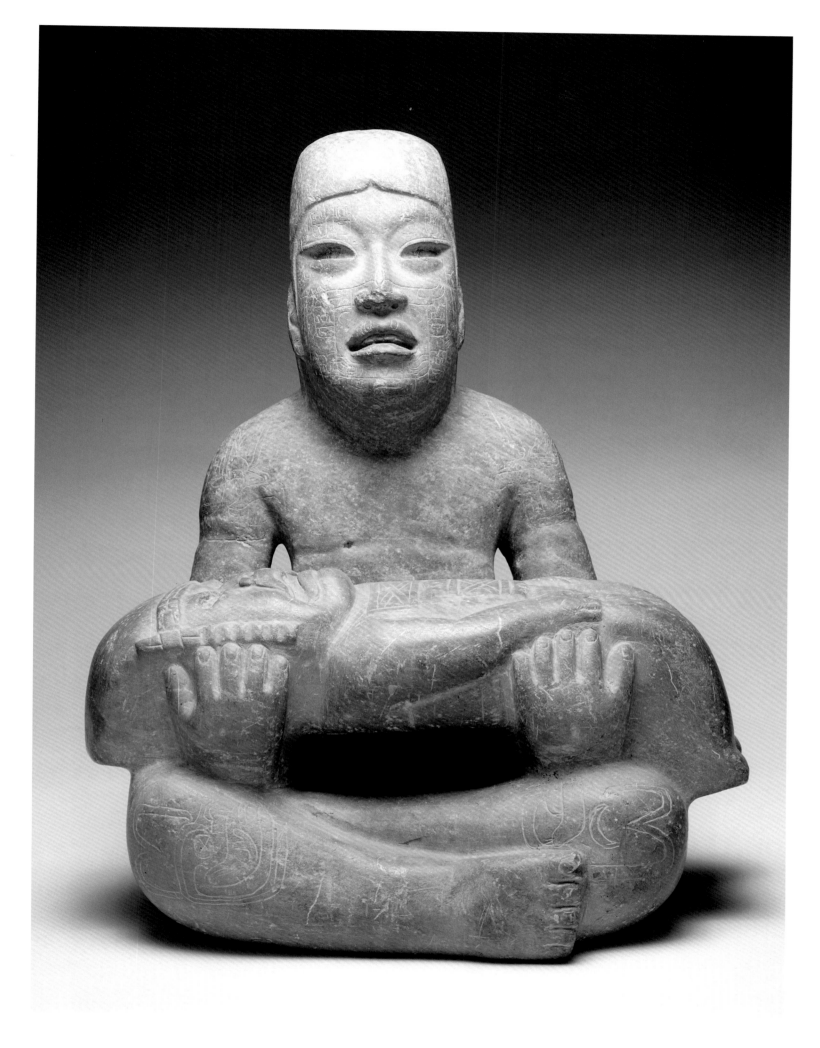

10. La Venta Monument 77 — Seated Figure Wearing Cape

Early Formative Period
Basalt
91 x 73 x 77 (35⁷/₈ x 28³/₄ x 30⁵/₁₆)
La Venta, Tabasco
Parque Museo de La Venta

La Venta Monument 77 is unique in the Olmec sculptural corpus. This work presents the static image of a plump individual in a seated position, the arms bent at the elbow and fists resting on the knees. Its rounded volumes convey a sense of gravity. Most of the face is recognizably human, but the mouth incorporates features of a supernatural being. The richness of the attire, unusual in this type of portrayal, includes a loincloth, sash, pectoral, bracelets, and anklets. The cape and headdress have details showing how it was carved as well as identifying symbols. R.G.L.

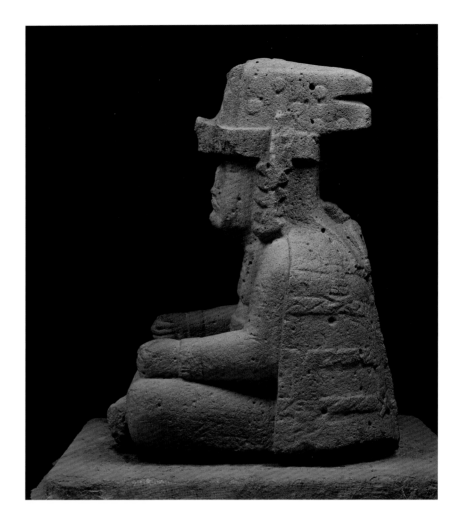

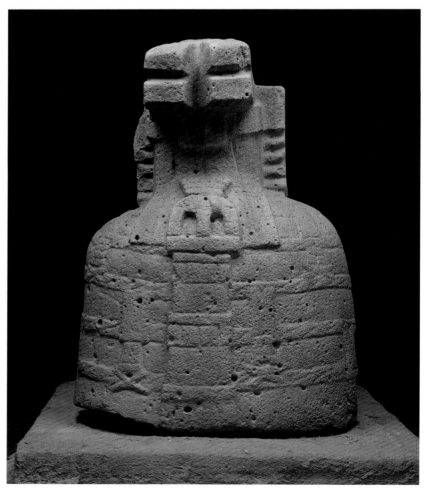

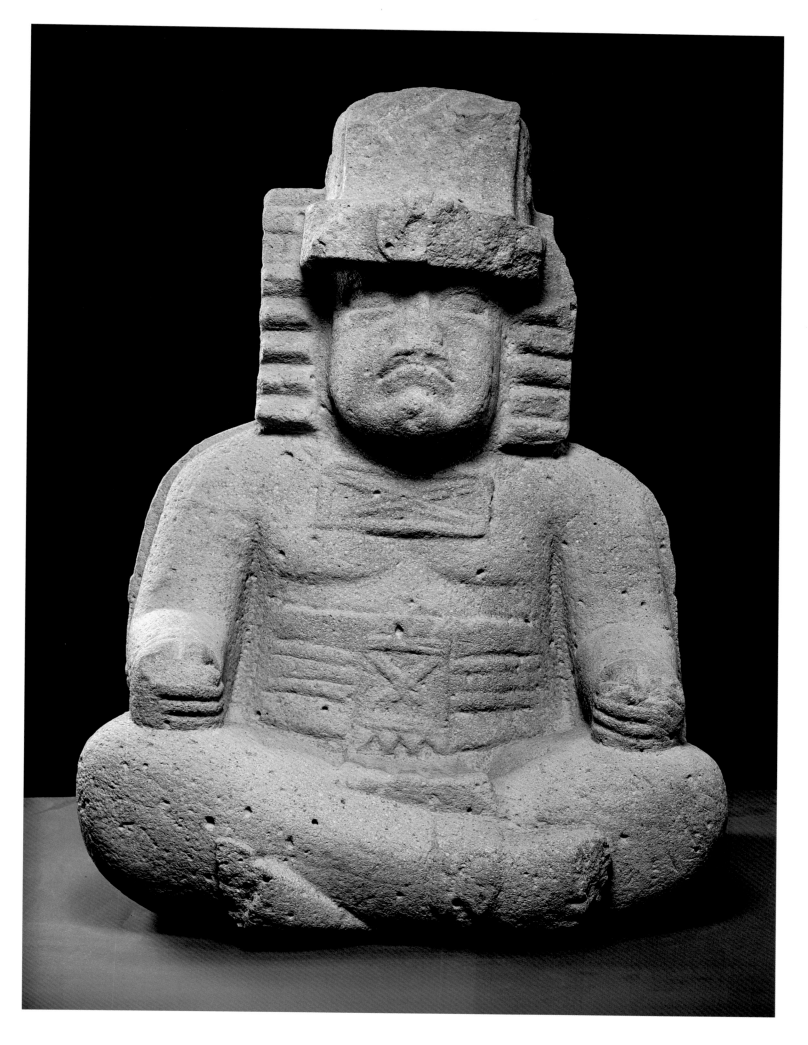

11. Antonio Plaza Monument 1—Seated Figure with Mustache and Beard

Late Formative Period
Basalt
66 x 40 x 30 (26 x 15¾ x 11¹³⁄₁₆)
Antonio Plaza, Veracruz
Museo Nacional de Antropología, Mexico City

This sculpture was given to the National Museum of Anthropology for the 1964 inauguration of its new building in Chapultepec Park. Gustavo Corona, who had found it on the shores of the Uxpanapa River in Veracruz, demanded much more than the authorities were willing to pay; they finally purchased the piece for 250,000 pesos. One of the most important Mesoamerican sculptures, its value lies not only in the type of personage represented, but also in its exceptional aesthetic qualities. The bending of the torso and extremities and the control of complex volumes are rare in pre-Hispanic sculpture.

The work is popularly known as "The Wrestler," but in spite of his robust aspect and the energy implied in his posture, it is not clear what the figure actually represents. The beard and mustache, similar to those seen on other Olmec personages, signal a connection to the political-religious hierarchy.

Although the sculpture shows Olmec traits, it is a late work representing the transition to a style that developed later on in southern Veracruz. M.C.-L.

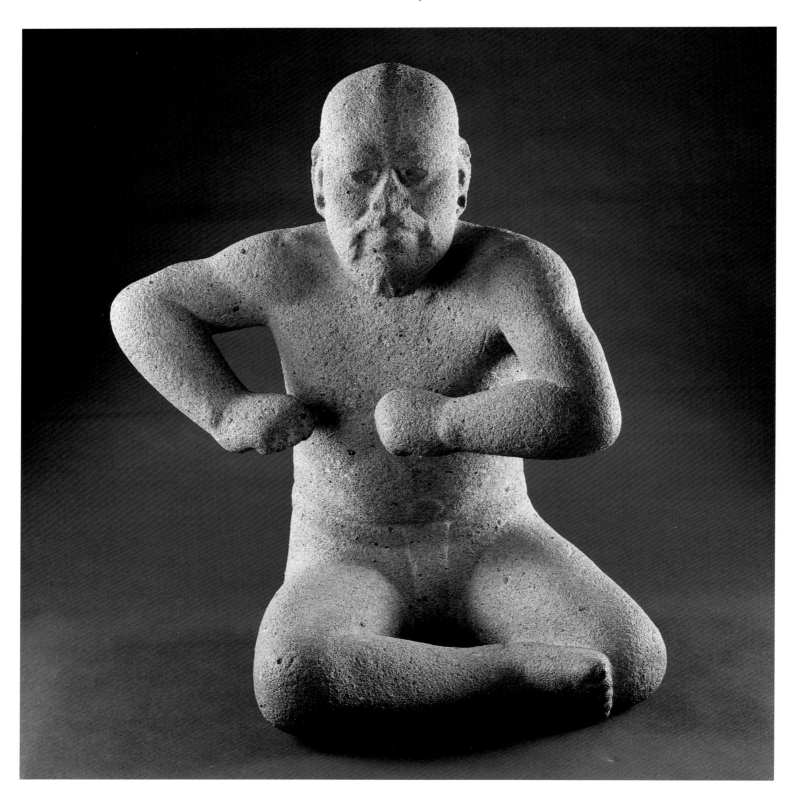

12. San Lorenzo Monument 52 – Seated Were-Jaguar

Middle Formative Period
Andesite
93 x 45 x 36 (36⅝ x 17¹¹⁄₁₆ x 14³⁄₁₆)
San Lorenzo, Veracruz
Museo Nacional de Antropología, Mexico City

This sculpture was found with a magnetometer during the 1968 Yale University excavations under the direction of Michael Coe. This instrument is useful for locating basalt monuments, a material rich in iron and with high magnetic intensity; the survey was conducted by Froelich Rainey of the University of Pennsylvania. The piece was buried and associated with one of the underground stone drains. It represents a seated jaguar, almost a meter high, with a groove in its back for water flow. Its position near the subterranean canal reaffirms its relation to the water cult. The jaguar represented the earth, and the serpent symbolized water.

The sculpture is a work that realizes the synthesis of jaguar and man, one of the principal Olmec themes. The head and posture of the creature combine both animal and human features. M.C.-L.

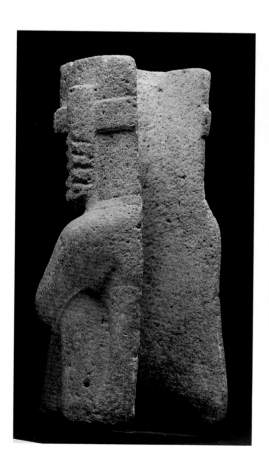

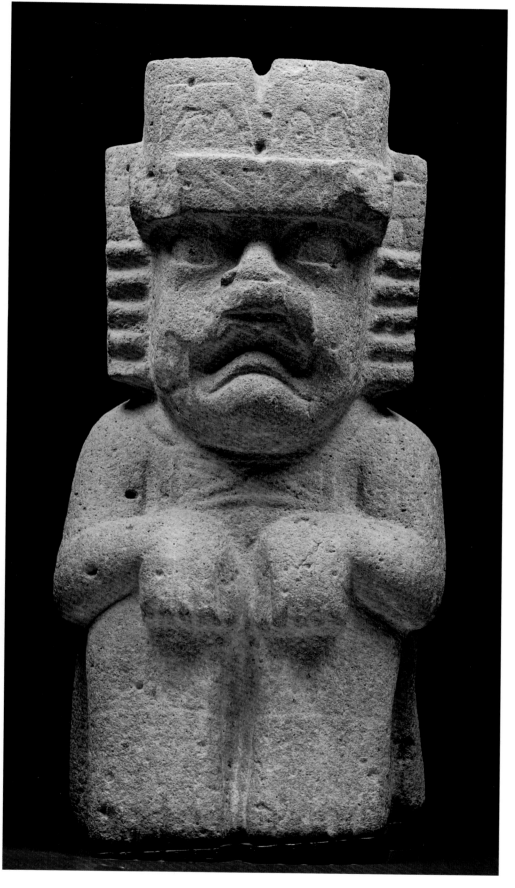

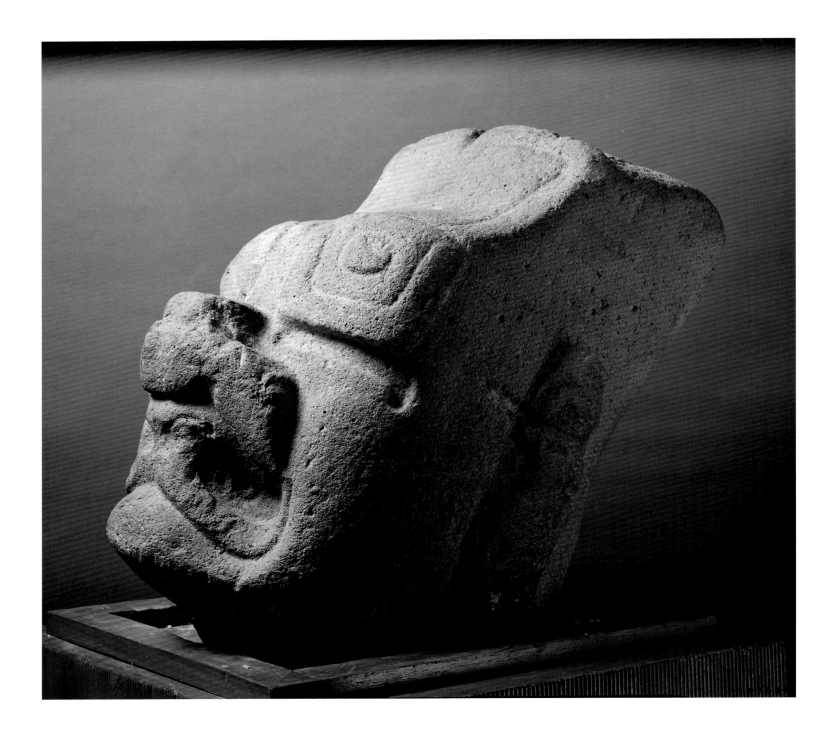

13. La Venta Monumental Head of a Were-Jaguar Creature

Middle Formative Period
Volcanic stone
63 x 46 x 48 (24¹³/₁₆ x 18¹/₈ x 18⁷/₈)
La Venta, Tabasco
Museo Regional de Antropología Carlos
Pellicer Cámara

This impressive fragment of Olmec sculpture depicts a human head overwhelmed with symbolic elements announcing its supernatural status. The flat nose of the figure is joined to a buccal plaque that covers and raises the upper lip, exposing gums that are toothless except for two fangs; the lower lip shows the open, down-turned mouth. The forehead is fluidly united by a soft curve toward the back to the head-dress, which has a V-shaped cleft in its upper border. Over the stylized eyes, in the form of an inverted L, are two cartouches, embossed and almost squared; within one is an X known as the St. Andrew's cross, and in the other a circle framed with a U. The combination of this pair of motifs is repeated in both small and large works from various Olmec sites.

R.G.L.

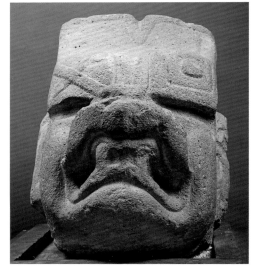

14. Dragon Head Waterspout

Early Formative Period
Basalt
24 x 69 x 26 (9⁷/₁₆ x 27³/₁₆ x 10¼)
San Lorenzo, Veracruz
Museum Ludwig, Cologne, permanent loan to the
Rautenstrauch-Joest Museum

The Olmec dragon is a creature with several aspects, the most important derived from the caiman who inhabits the rivers and estuaries of the Gulf Coast lowlands (Joralemon 1971, 1976). Combined with eagle, jaguar, and serpent attributes, the crocodilian beast represents the earth monster, lord of the middle realm of the cosmos. Portrayed throughout the Olmec world in both Early and Middle Formative times, the dragon was associated with earth, caves, fertility, and rulership. Many Olmec works of art, both monumental sculptures and small-scale objects, portray this image. In abbreviated form, earth monster iconography frequently decorates Olmec ceramic vessels.

This extraordinary spout representing the Olmec dragon is rumored to come from San Lorenzo. It portrays the rectangular head of the crocodilian god with a trough cut down its middle. The creature has elongated flame eyebrows and L-shaped eyes. At the blunt end of the snout are two enlarged round nostrils from which water once gushed. The jaws are outlined with a ridge, undulating in form at the top and straight on the bottom. From each side of the upper jaws protrude four large teeth curved backward at the ends and overlapping the lower jaw line. The bottom of the sculpture is flat.

This waterspout was probably part of the vast underground hydraulic system that Olmec engineers built to channel water from lagunas on top of the San Lorenzo plateau, through a network of covered stone conduits, to sculpted fountains below. A monumental figure representing the were-jaguar storm god (cat. 12) and a large fountain in the shape of a duck (Monument 9) were also part of the San Lorenzo waterworks.

There is a widespread Mesoamerican belief that rain originates deep within the earth in the underground abode of the storm gods. If this spout was in fact part of the San Lorenzo hydraulic system, it would have been a powerful visual statement of that religious concept.

P.D.J.

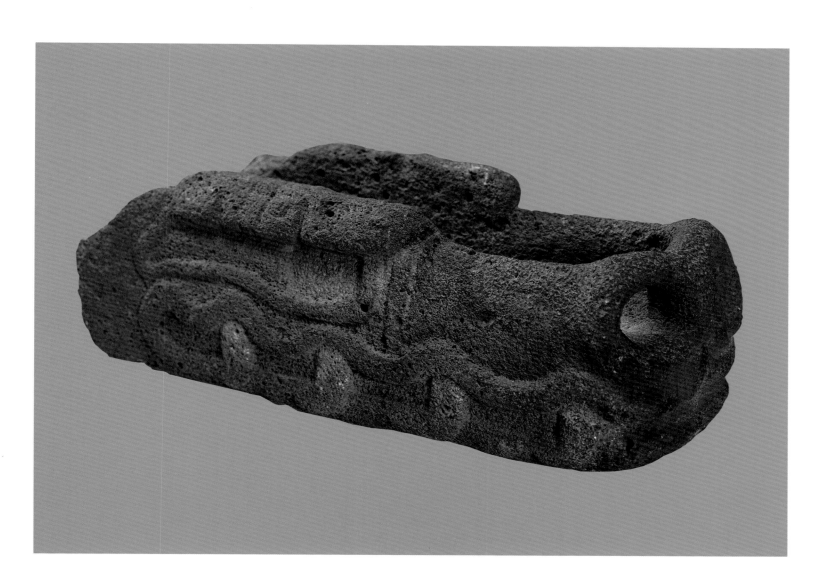

15. Relief Carving of an Earth Monster Face with Open Mouth

Middle Formative Period
Granodiorite
182.9 x 142 x 15.2 (72 x 56 x 6)
Chalcatzingo, Morelos
Munson-Williams-Proctor Institute, Museum of Art,
Utica, New York

The great supernatural face carved in bas-relief on this large stone slab is that of an "earth monster." It is created by two large oval eyes (with faint crossed-band motifs) that sit atop a multilayered cruciform mouth, from the corners of which sprout vegetation. The carving, Monument 9, is one of three quite similar "earth monster" faces that occur among the thirty-two carved stone monuments known at Chalcatzingo, in Central Mexico. However, it is unique there, and among all known Middle Formative monuments in Mesoamerica, for its mouth that is hollowed out from the entire stone. Such "earth monster" faces are perhaps better understood as "cave mouth" faces, for that is what they symbolize. This concept is best seen in Chalcatzingo's most famous carving, "El Rey" ("the king"; Monument 1), a cave mouth face executed on a rock high on the mountainside overlooking the site. That cave mouth image is rendered in "profile" by dividing the face vertically through its center and depicting only the left half. A personage ("El Rey") is shown seated within the cruciform mouth, from which large scroll motifs issue outward. In Mesoamerica, mountain caves have an important association with rain, water, and plant fertility. Rain clouds with falling mist and raindrops are carved above the cave mouth face of Monument 1, and together with the sprouting plant motifs common to all three of Chalcatzingo's cave mouth carvings, they demonstrate that such a concept was held by Middle Formative societies as well. Monument 13, a smaller broken carving also on the mountainside, depicts a supernatural cleft-head personage seated within the cave mouth face. Monument 9's large cave mouth face carries the cave symbolism a step further, because its hollow yawning mouth *is* the cave mouth. That cruciform opening may have served as an actual passageway for people and objects during certain rituals, for the bottom of the mouth appears worn as if from use. The carving was in fragments when it was found by a farmer digging to remove stones from his field prior to plowing. The field in that instance was the broad (2,000 square meters) upper surface of Chalcatzingo's largest construction, a massive 70-meter-long earthen platform mound. It is very likely that the great cave mouth face of Monument 9 had stood in a vertical position atop that mound, where it and associated ritual activities would have been readily visible to the peoples living in the ancient village that covered the fields beyond the mound. Results of archaeological research at Chalcatzingo indicate that the site's carvings date to 700–500 B.C., making them contemporaneous with most of those at the Olmec center of La Venta.

D.G.

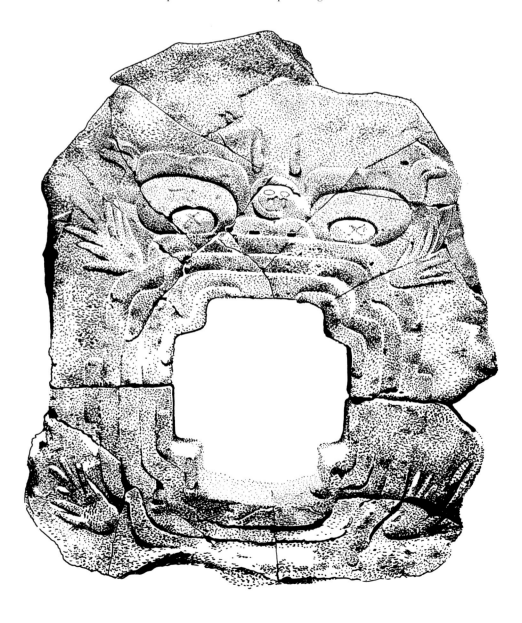

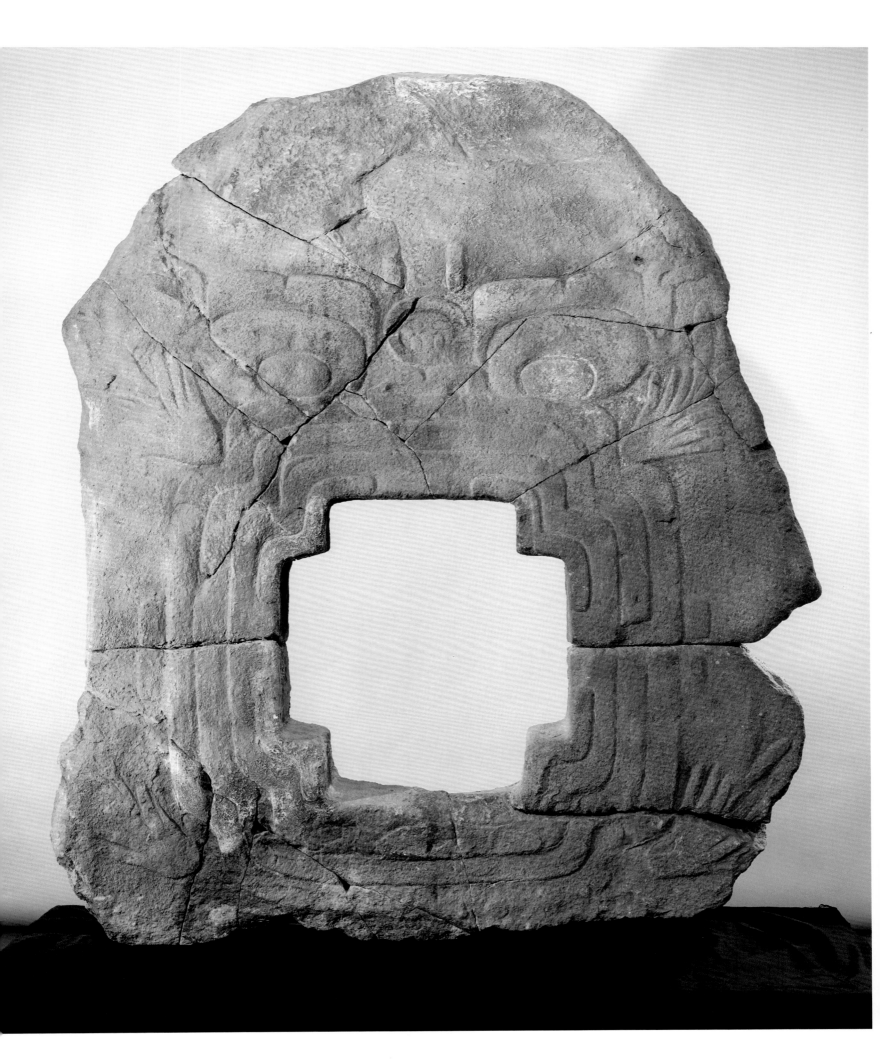

16. San Lorenzo Monument 58—Relief Carving of a Fish

Middle Formative Period
Andesite
72 x 132 x 28 (28³/₈ x 52 x 11)
San Lorenzo, Veracruz
Museo Nacional de Antropología, Mexico City

In 1969, under the auspices of the National Institute of Anthropology and History and the University Museum, University of Pennsylvania, a field season was carried out at San Lorenzo, which conducted magnetometric exploration to detect stone remains. The excavation was directed by archaeologists Francisco Beverido of the Veracruz Institute of Anthropology and Roberto Gallegos of the National Institute of Anthropology. The readings from the magnetometer were taken every 2 meters and produced six sculptural finds, designated as Monuments 53, 54, 55, 56, 57, and 58.

Monument 58, from test pit 11, is a thick, rectangular stone tablet with a relief carving of a fish. It is accompanied by exceptional elements, among them, a very accentuated upper lip—interpreted by some as that of a jaguar—as well as large eyeteeth and a thick nose that rests over the lip, which suggests a shark to some scholars. The fish representation is evident in its closed eye and the central part of its body, which has a bifurcated tail and two narrow crossed bands of equal length.

M.C.-L.

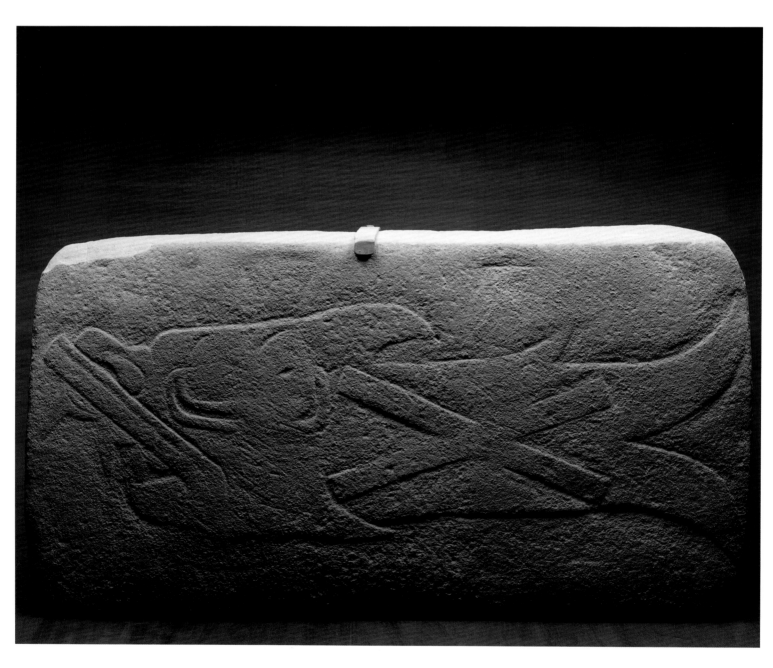

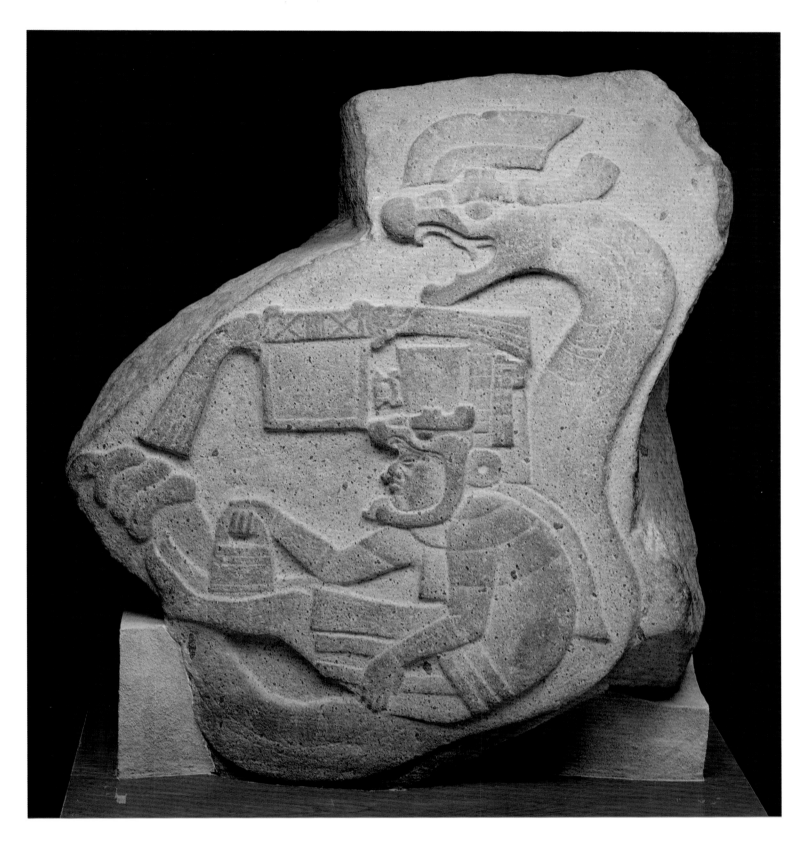

17. La Venta Monument 19 – Relief Carving with Serpent and Priest

Middle Formative Period
Basalt
95 x 76 x 50 (37³/₈ x 29¹⁵/₁₆ x 19¹¹/₁₆)
La Venta, Tabasco
Museo Nacional de Antropología, Mexico City

The artist skillfully uses the shape of the stone to create a sense of movement, in the body of the animal as well as in the human. The rattlesnake with the open jaws and crest of feathers is the dominant element of the piece; the human is encompassed by the animal.

The design that forms the serpent's open mouth is reproduced in the human's helmet; both the mouth and the helmet form a duality in which the human part is the less important.

The attire of the personage is that of other Olmec priest figures: a headdress, a small cape that covers half of the back, a belt that falls in bands to the knees, and a rigid bag.

Between the head of the personage and the mouth of the serpent is a rectangle, crested with a band of two crosses. The ends of the crosses are formed from flexible elements, possibly feathers or vegetable motifs that lend a divine character to the object. M.C.-L.

18. Seated Figure with Head Resting on Hand

Early Formative Period
White-slipped ceramic
13 (5⅛)
Las Bocas, Puebla
Fundación Amparo–Museo Amparo

Probably representing a fat male, this fired clay figure from Las Bocas, Puebla, offers an image of leisure and repose. The corpulent personage is cross-legged, his head resting on his left arm; body curves and volumes are depicted with an effortless realism. Remains of the ancient mirrorlike polish of the white-slipped surface add to the artist's intention of rendering a lively, familiar scene. But the iconographic message could be more complex. The personage with thick, half-opened lips, large nose, and nearly Mongolian eyes seems to be associated with supernatural forces.

C.N.

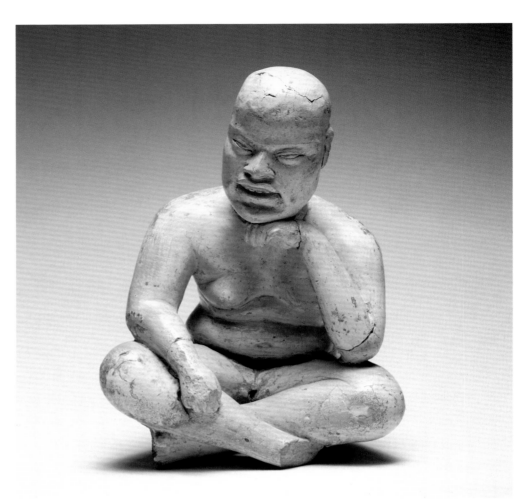

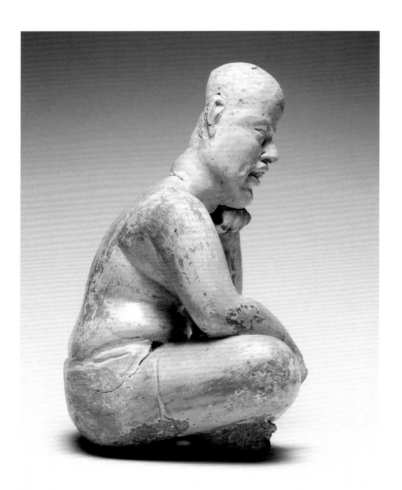

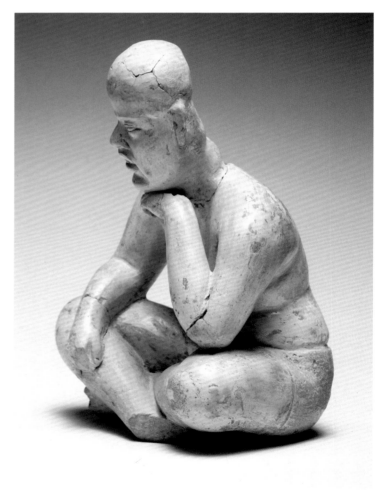

19. Seated Figure

Early Formative Period
Gray-slipped ceramic
16.5 (6½)
Tlapacoya, Mexico
Anonymous loan

Of exceptional plastic quality, this small clay sculpture of a robust, slightly fat, male personage, leisurely seated cross-legged as if to observe an event, conveys a somewhat ambiguous impression. On the one hand, the rendering of the well-balanced muscular torso, the expression of litheness, and the natural movement of the arms reveal the artist's acute sense of volume and his will to present a realistic image of a human body. On the other hand, the emphasis on the large, bald, intentionally deformed head, the expression of the face with its almond-shaped eyes, and thick half-open mouth with downturned corners provoke an odd visual effect characteristic of certain mythical, and not entirely human, Olmec creatures.

With the rise of regional capitals in the Basin of Mexico toward 1250 B.C., the development of specialized groups of artisans, showing a particular skill in their craft and qualified to manipulate a codified repertoire of esoteric symbols, is clearly attested at Tlapacoya. Figurines of the Pilli type include a high number of male representations. They are generally covered with a thick white slip, with an ivorylike polish, and often bear traces of cinnabar or red hematite powder, applied in areas such as incised earlobes. C.N.

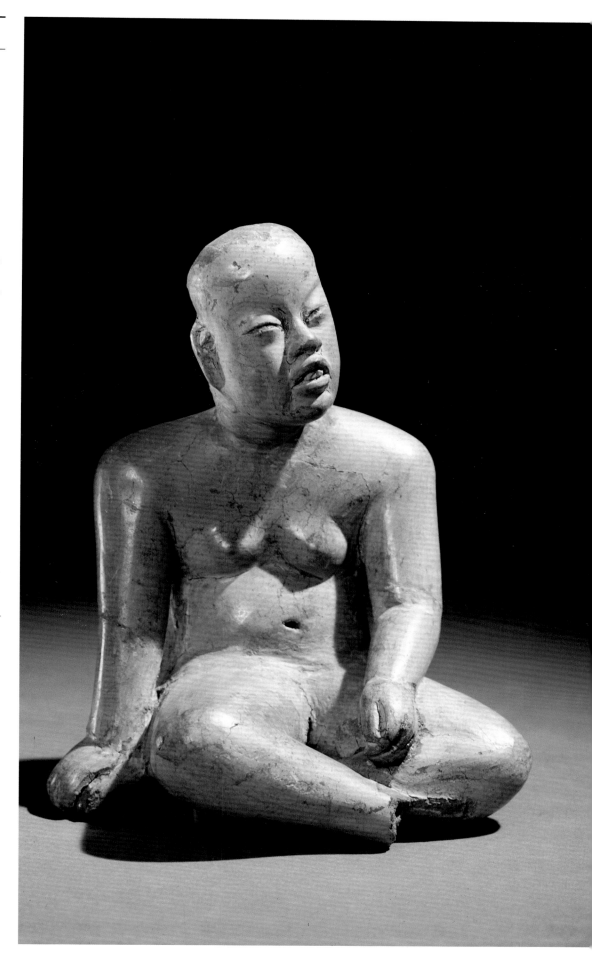

20. Hollow Seated Figure with Fat Cheeks and Splayed Legs

Early Formative Period
White-slipped ceramic
28.9 x 33.1 x 18.8 (11⅜ x 13¹/₁₆ x 7⅜)
Xochipala, Guerrero
Private Collection, currently on loan to
The Art Museum, Princeton University

Xochipala, Guerrero, where this hollow figure is said to have originated, still holds numerous unsolved chronological and cultural enigmas. Although archaeological excavations have led to a better understanding of Late Formative and Classic occupations at that site, Olmec horizon levels, well represented in private and public collections, remain poorly understood.

Excavations carried out in Teopantecuanitlan, another ancient site of Guerrero, and particularly in the Lomeríos residential unit of this site, offer now a chronological and cultural context to Olmec-period hollow baby-faced clay figurines found there. The peak occurrence is between 1000 and 800 B.C. Their plump, babylike face and body are always covered with a thick layer of highly polished white slip and, in some instances, partly covered with red cinnabar.

Like most of the hollow baby figurines from Guerrero, this Xochipala figure, with wide-open mouth, has crossed eyes, considered in later Mesoamerican cultures as a sign of beauty and elegance, and intentionally induced. The purpose of these baby representations, which are found in domestic areas as well as ceremonial zones, is not clear. They may be related to infant cults, well attested in the Mesoamerican belief system, or to lineage rituals. C.N.

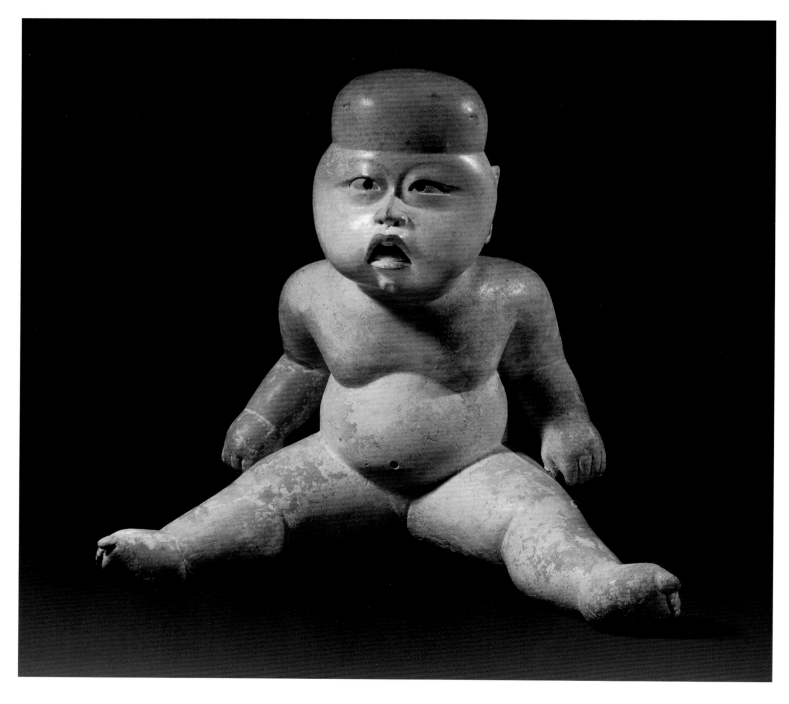

21. Hollow Seated Figure with Upraised Arm

Early Formative Period
Gray-slipped ceramic
41.5 x 31 (16⁵/₁₆ x 12³/₁₆)
Tlapacoya, Mexico
Museo Nacional de Antropología, Mexico City

A large number of anthropomorphic clay figurines were modeled during the Formative period; these figurines, primarily of females, were related to an earth-fertility cult.

This hollow, seated figurine, characterized by its large size and infantile aspect, was found by Paul Tolstoy in 1963 at Tlapacoya. Christine Niederberger (1987: 420) identifies it as the Pilli type, which most frequently occurred during the Ayotla phase (1200–1000 B.C.). As with all clay sculptures of the Formative period, sections of the body were made separately and later joined together (Pohorilenko 1990b: 85); this technique indicates the existence of considerable craft specialization. The piece, with only a gray-slipped surface, lacks a finished appearance. The features and details of the body were created by modeling and incision. A perforation marked the navel, which may have also served to ventilate the piece during the firing process or perhaps to unite fragments that were already broken, as did the various perforations in the right leg and base.

The head is bulbous, possibly the result of cranial deformation; this can be seen clearly on the shaved head. The eyebrows are defined by smooth arches over the almond-shaped eyes, which slant toward the center; the iris is indicated by modeling. The nose is small and pointed with flaring nostrils. The mouth is slightly opened with downturned corners, the upper lip touching the nose; the toothless upper gum is also visible. The ears are rectangular, and incised lines delineate their realistic features; the lobes are partially perforated. The chin is rounded, the neck short, and the torso large with an absence of genitals; the arms and legs are plump. The right arm is raised, with the thumb pointed toward the mouth. As with most of these figures, no clothing is depicted.

Traces of red paint are evident on the face and body. This pigment, found covering the majority of human burials of these early cultures, surely had important religious significance during the pre-Hispanic era. P.O.

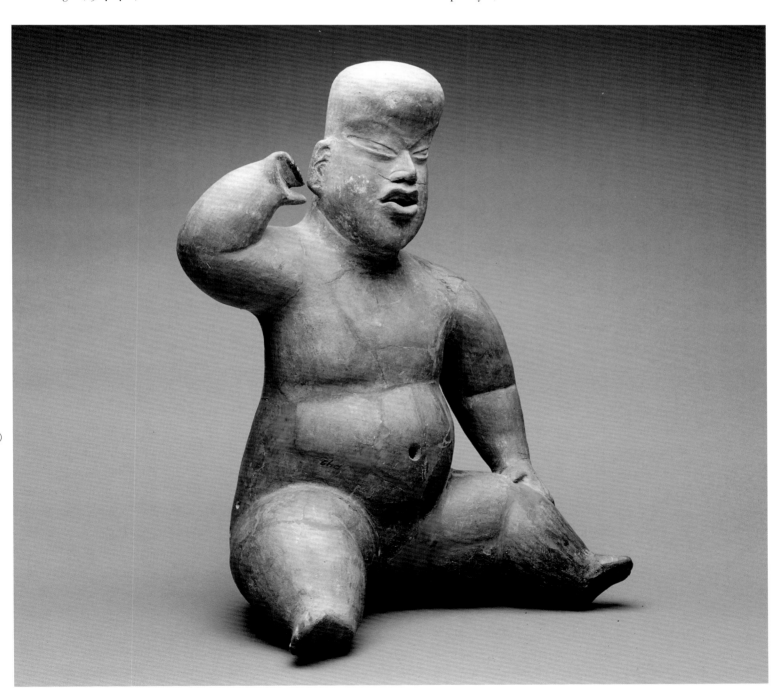

22. Hollow Seated Figure with Splayed Legs

Early Formative Period
White-slipped ceramic
36.6 (14⁷/₁₆)
Tlatilco, Mexico
Private Collection

The Olmec period represents a highpoint within the Pre-Columbian trajectory of large and small sculptural art related to the human figure. The sites of Tlatilco and Tlapacoya, in the Basin of Mexico, and Las Bocas, in Puebla, have yielded some of the finest examples of anthropomorphic clay figures in ancient Mesoamerica.

This hollow baby-faced figure from Tlatilco splendidly illustrates the skill of specialized craftsmen, their sense of volume, and their mastery of three-dimensional representations. The purity of lines and the striking soberness of plastic conception—in contrast with art forms of later periods—intensify the beauty of the graceful interplay of curves shown in this infant depiction.

Infants are a recurrent theme in Olmec art and belief systems. Olmec iconography indicates that they were often central to dynasty or lineage rituals. In most ancient societies, infants, before acquiring language ability, are considered to be able to communicate with the invisible world and favorable or harmful forces, as well as ancestors.

These baby-face figurines are often depicted with some nonhuman features or expressions, such as marked slant eyes or a snarling, feline mouth, with flaring upper lip and downturned lower corners. C.N.

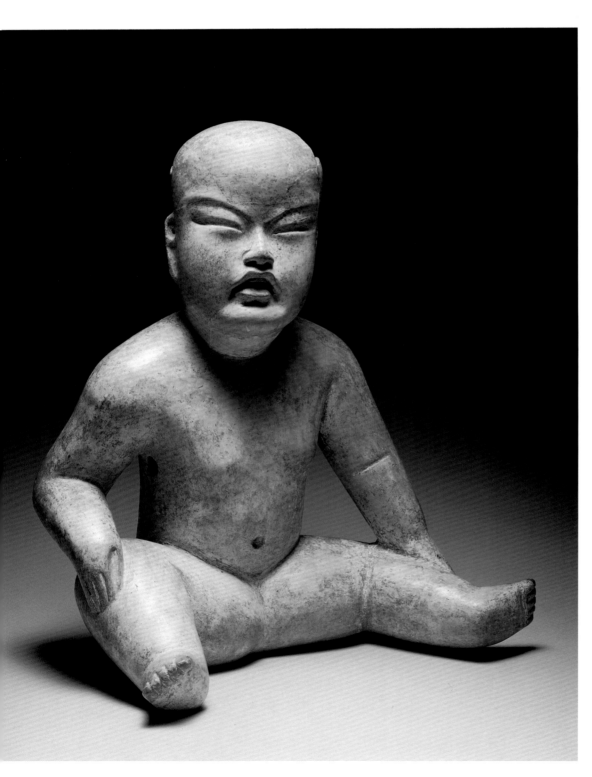

23. Personage of Atlihuayan

Early Formative Period
Cream-slipped ceramic
29.5 x 21.3 (11⁵/₈ x 8³/₈)
Atlihuayan, Morelos
Museo Nacional de Antropología, Mexico City

This vessel represents a seated personage wearing a cape made from a stylized jaguar skin. It was recovered by Román Piña Chan at Atlihuayan in Morelos (Piña Chan and López 1952). During the Formative period, Morelos had favorable environmental conditions that permitted settlement by various groups; such was the case of Atlihuayan, near the river Yautepec in the north of the state. It was an important site within the complex exchange network that the Olmec had established in the Central Highlands, because of its strategic location in a communication corridor between the states of Guerrero, the Valley of Mexico, Puebla, Oaxaca, and the Gulf Coast.

The presence of Olmec groups is evident in the high-quality ceramics and figurines, such as this beautiful sculpture that was shaped in clay, with incisions to delineate the face and body and decorative motifs. This masculine figure presents the typical characteristics of the baby-face Olmec: composite eyes with deep incision; wide nose and mouth with thick lips in the form of a trapezoid, the downturned mouth and upper lip touching the nose. The teeth and tongue are not shown. The face is rounded; the torso is inclined forward. The arms are bent, and the fingers are denoted by incision; the left hand and foot are broken, as is the right leg.

After constructing this piece in sections and joining them together, the artist then formed the whole skin of the monster zoomorph (Pohorilenko 1990b: 85). The head of the animal covers the head of the man like a helmet, and the skin falls like a cape over his back. The hook-shaped, upper gums of the animal cover the man's ears. The nose is small; the eyebrows are flames; the claws are humanized by five fingers; the upper claws rest on the shoulders while the lower claws fall over the legs. Crosses, made by incision, cover the skin, as do three hook motifs. A wide tail falls in folds.

The figure has orange paint, while the cape shows traces of white paint applied prior to firing. P.O.

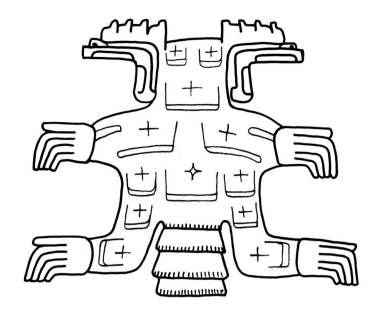

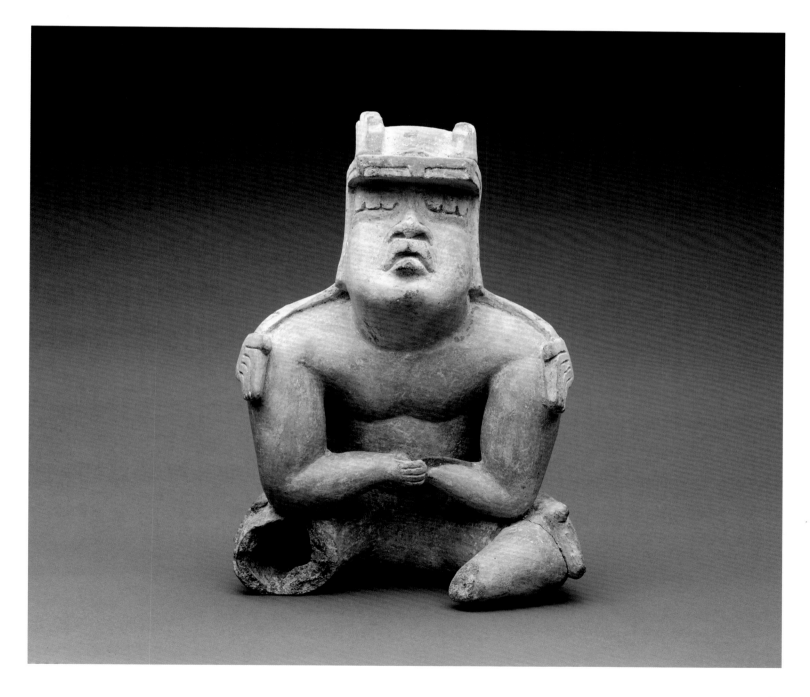

187

24. *Tecomate* in the Shape of a Kneeling Personage with Wrinkled Face

Early Formative Period
Serpentine
10 x 11 (3¹⁵⁄₁₆ x 4⁵⁄₁₆)
Laguna de los Cerros, Veracruz
Museo de Antropología de Xalapa, Universidad Veracruzana

A fascinating group of Olmec statues and effigy vessels represents an aged female with wrinkled face, drooping breasts, and skeletal ribs and vertebrae (Joralemon 1981). Always shown emaciated, the old woman is sometimes portrayed as pregnant, kneeling in a birthing position; occasionally she is depicted seated, cradling an infant in her lap. Although several interpretations of these sculptures are possible, it is most likely that the figures represent the old goddess, mother of human beings and gods alike. Among her several aspects, she is Mother Earth, provider of food and sustenance, and devourer of the dead. She was associated with sorcery, healing, and midwifery, as well as feminine arts such as weaving. Both womb and tomb, the old goddess is one of Mesoamerica's most ancient divinities, venerated by every culture from Olmec to Aztec times.

This remarkable serpentine representation of the aged goddess comes from Laguna de los Cerros in Veracruz. Modeled in three dimensions around the contours of a *tecomate*, the old personage rests in a kneeling position on thin legs, head turned upward and enormous belly resting on the thighs. The left hand supports the lower abdomen, while the right touches the head. The figure has skeletal ribs and backbone and sharply defined shoulder blades and pelvis. Toes and fingers are clearly indicated. The figure's face is a lively study of old age, almost to the point of caricature. Alert, elongated eyes with drilled pupils are set in a deeply wrinkled face with hollow cheeks. The prominent nose is hooked, the lips are pursed, and the chin juts out. The ear is naturalistically rendered. The crown of the head is shaved, and the neat coiffure has vertical engravings to suggest strands of hair. Two small suspension holes pierce the figure near the backbone and two large holes appear on the top and bottom of the belly. The round opening of the *tecomate* is cut through the figure's left side.

Although the Xalapa sculpture lacks breasts or other unambiguous sexual characteristics, its similarity to a figure on an effigy jar from Santa Cruz, Morelos, strongly suggests that the old personage is female. Other Olmec sculptures portray old men and women in various forms, but none has the humor and vitality of this marvelous effigy from Veracruz.

P.D.J.

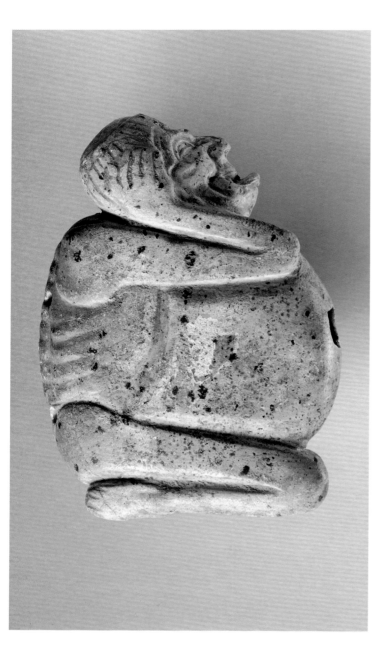

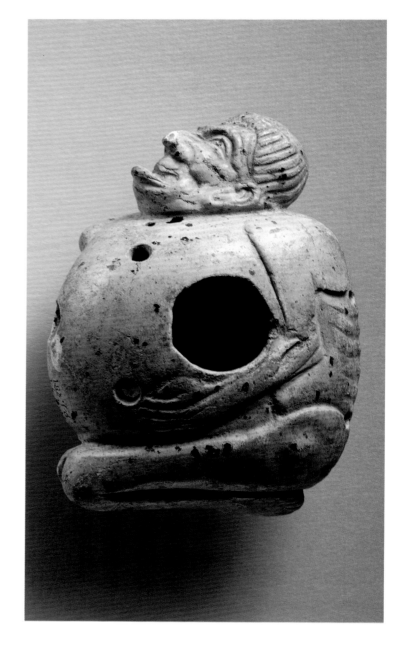

25. Acrobat Effigy Vessel

Early Formative Period
Whiteware ceramic
25 x 16 (9¹³/₁₆ x 6⁵/₁₆)
Tlatilco, Mexico
Museo Nacional de Antropología, Mexico City

Commonly known as the "Acrobat," this effigy vessel was recovered from the 1967 excavations at Tlatilco. It was part of an offering from Burial 154, that of a male adult who had tabular-erect cranial deformation and dental mutilation, which is described by Arturo Romano (1967: fig. 130). Other offerings in this burial included clay pieces that may have represented mushrooms or phalli (Ochoa Salas 1973), and some small *tezontle metates*[1] used to prepare hallucinogenic mushrooms that

were ingested or applied by shamans to attain altered states. The acrobatic position shown here would have had the same objective. Thus, the contents of this burial may indicate that the man was a shaman (Ochoa et al., in prep.).

The acrobats depicted in these large effigy vessels adopt a variety of poses. The Tlatilco "Acrobat" rests on its elbows with the chest high, the feet over the head; the hands, unseen, are under the chin. The spout was formed by an opening in the left knee. This position appears in other depictions from this period, and is common in the hollow, baby-face clay figurines (Pohorilenko 1990b: 134). In Tlatilco various examples were recovered, some smaller solid ones. They are also frequently found in private collections; the origins of these examples seem to be the Valley of Mexico or the Gulf Coast. In addition to clay, there are some made of jade, as well as the well-known relief of the contortionist from Las Choapas,

Veracruz, reported by archaeologist Medellín Zenil (1978: 14). It consists of a gray andesite disk, approximately 55 centimeters in diameter, on which is carved the equivalent of the "Acrobat."

The acrobat is skillfully modeled in fine white clay, and shows typical Olmec features: cranial deformation and dental mutilation. The nose is fine, the lips striped, and the earlobes have deep incisions that do not completely penetrate the ear. The individual wears a unique outfit, a *maxtlatl* (a type of loincloth), also indicated by incision.

P.O.

Notes

1. *Tezontle* refers to a type of volcanic stone common in the Mesa Central of Highland Mexico. *Metates* are flat or basin-shaped stones used to grind plants, particularly corn.

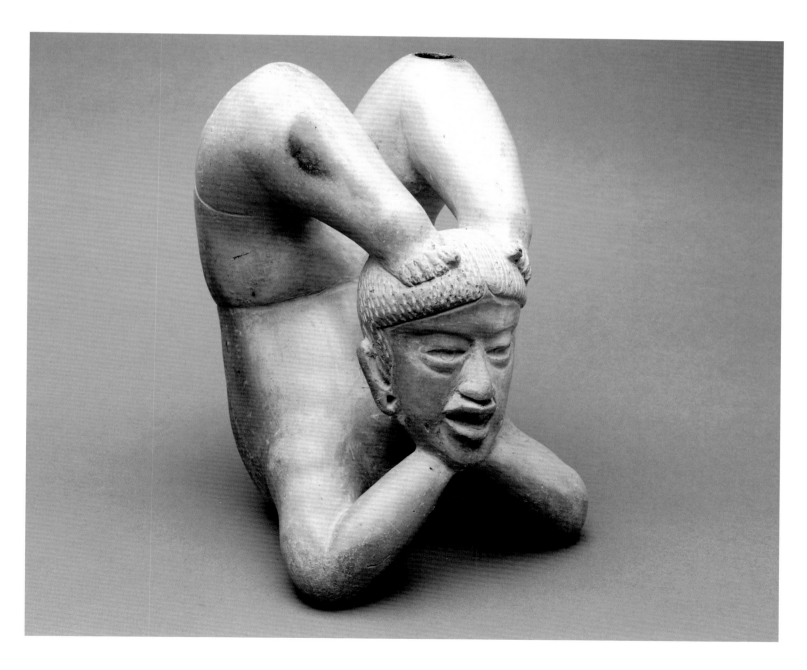

26. Fish Effigy Vessel

Early Formative Period
Blackware ceramic
12.8 x 11.5 (5 1/16 x 4 1/2)
Tlatilco, Mexico
Museo Nacional de Antropología, Mexico City

The agrarian communities developed a cult of the dead and were buried with belongings to accompany them on the road "to the other life." At Tlatilco, a site located in the western side of the Valley of Mexico, five hundred burials with rich offerings were excavated, among them magnificent objects in the Olmec style (Ochoa Castillo 1982). During the second season of excavations (1947–1949) directed by Román Piña Chan, he uncovered this vase as part of an offering from Burial 53.

Beautifully modeled in clay, this superb effigy vessel represents a fish with open mouth, which serves as the spout (Covarrubias 1957: XVII). The finish, achieved by fine polishing of the black slip, is extraordinary.

The eyes were probably made by a circular object that left a depression. The decoration on the stomach area, as well as the fins and mouth, is rough-textured.

The texture is produced by scraping prior to the final firing, revealing the natural color of the clay. The stomach zone is incised with a motif known as the *ilhuitl*, or opposed volutes, which harmonize with the straight lines; this symbolic motif is characteristic of fish effigy vessels. The fins also have incised lines. In this piece the naturalistic decoration conforms with the symbolism of Olmec iconography. As with many objects of a ceremonial nature, it has red pigment that was applied after firing.

Also found in the burial were other Valley of Mexico materials, such as bowls with incised "Tlatilco panel" decoration and vessels made of kaolin, a very fine-textured, white clay also used to make Olmec figurines and vessels.

P.O.

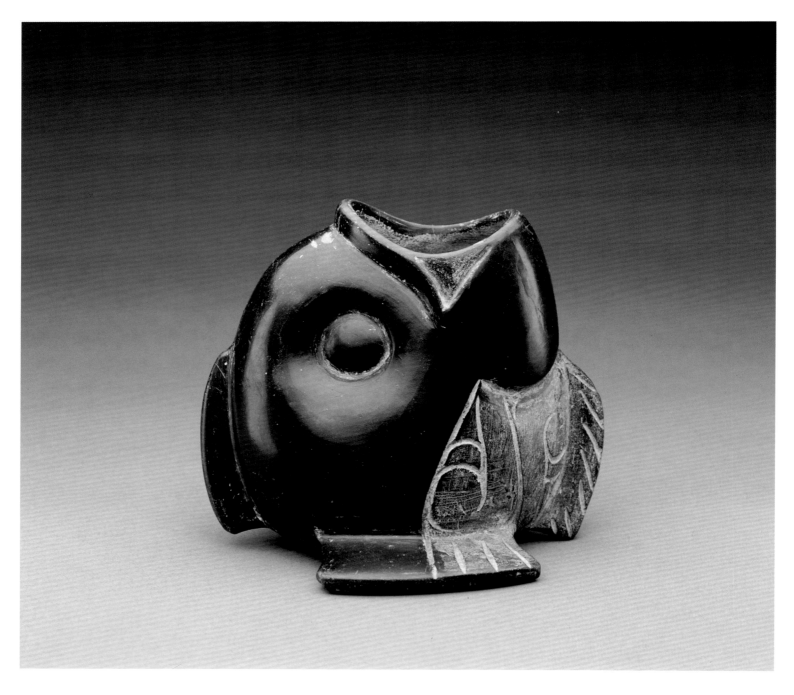

27. Duck Effigy with Resist Painting

Early Formative Period
Ceramic
11.8 x 3.3 x 15 (4⅝ x 1¼ x 5⅞)
Tlapacoya, Mexico
Collection Leof Vinot

Masterly modeled, full of charm and spontaneity, this duck effigy vessel demonstrates that the potters of the Basin of Mexico, in general, and of the site of Tlapacoya, in particular, did not limit their plastic repertoire to esoteric themes. In fact, they excelled in naturalistic rendering of life. This duck has an upturned, spoon-shaped bill that seems ready to quack. Two sharp, prolonged curves animate its wide-open eyes. The body is covered with a yellow-whitish slip, and an original technique of resist or negative painting imitates its plumage. The negative decor of circles and bands was probably obtained by applying buttons and strips of clay or perishable material before firing.

Aquatic birds were a familiar sight for the ancient inhabitants of the Basin of Mexico. This lacustrine region was characterized by a dense resident avifauna and was a major winter ground for many migratory species of geese and ducks, including shovelers, pintails, mallards, teals, and red-heads. Up to recent times, when its main lacustrine extensions were artificially drained, around 1900, the Basin of Mexico remained a highly desirable environment for resident and migratory birds. In 1862, the Mexican historian Orozco y Berra noted, in special reference to ducks and geese, that "these palmipeds arrive, in their season, in such prodigious number that they cover... considerable surfaces" of the lakes.

C.N.

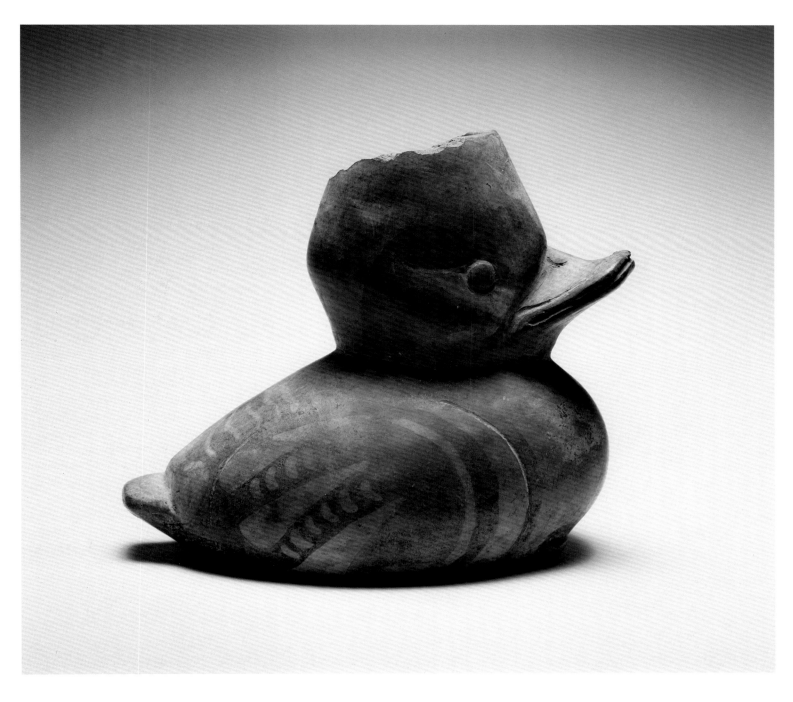

28. Duck Effigy Incense Burner

Early Formative Period
Blackware ceramic
23 x 19 x 13 (9¹/₁₆ x 7¹/₂ x 5¹/₈)
Las Bocas, Puebla
Private collection

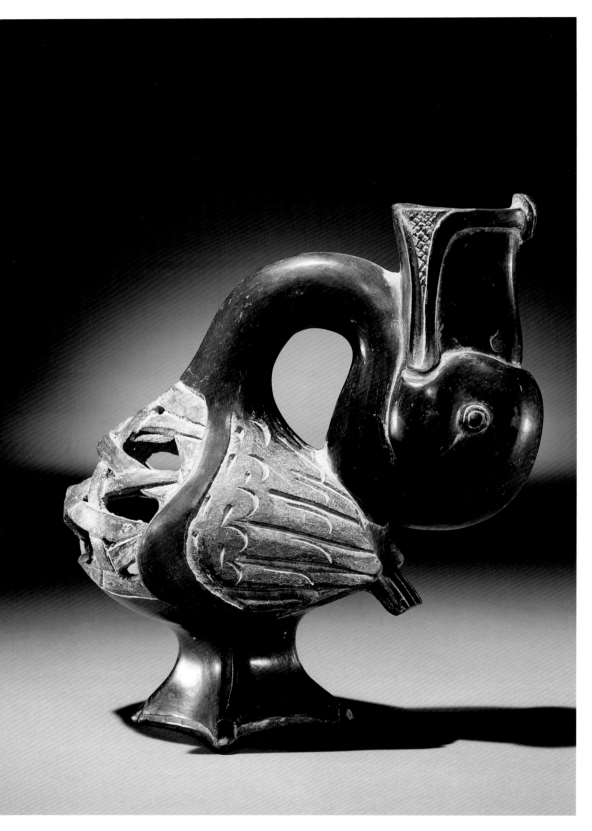

Olmec effigy ceramic vessels in various animal forms have been found in Early Formative burials at important sites in the Central Mexican Highlands. Usually modeled in white, gray, brown, or black ware, the best examples come from Tlatilco, Tlapacoya, Las Bocas, and Xochipala. Virtually no Olmec graves dating to this period have been documented from the Gulf Coast lowlands, so no comparisons between funerary offerings from the two regions can yet be made. These ceramic forms are always containers of some sort. They are never merely sculptures in the round.

Some effigies represent particular animals in naturalistic fashion. Others are embellished with carved or incised motifs that appear also on Early Formative Olmec ceramic figures, vessels, and cylinder seals, as well as on monumental sculpture from the Gulf Coast. Animals portrayed in ceramic effigies include a variety of birds—ducks, parrots, eagles, owls, and vultures—as well as jaguars, armadillos, opossums, serpents, toads, and several kinds of fish. A few examples depict supernatural beings with their iconographic attributes. These include dragons and bird monsters. There is even an effigy of a standing monkey man holding a blowgun, which must refer to an Olmec version of the Hero Twin story recorded in the Maya Popol Vuh (Easby and Scott 1970: fig. 21).

Most of these effigy ceramics are bottles or jars, but this extraordinary blackware duck is an incense burner. The bird stands on a pedestal support formed by its webbed feet. The chest is decorated with a roughened openwork design that allowed air into the cavity where coals and incense were placed. The tubular neck is thrown back in an exaggerated curve, and the head is set in a vertical position. Smoke from the incense would have flowed through the curved neck and emerged from the duck's open beak.

The bird has a rounded head and disk-shaped eyes with incised irises. The bill points upward with gouged nostrils at the top and a small protuberance at the tip. Cross-hatched panels fill the space between the two sections of the parted beak. The duck's chest is decorated with a roughened open-work pattern suggesting weaving or plaited bands. The large wings are also roughened and embellished with engraved lines and curves to indicate the bird's feathers. A short square tail with incised lines appears just below the duck's upturned head.

Olmec ceramicists typically contrasted the shiny burnished surfaces of the unadorned blackware with roughened and carved zones decorated with iconographic detail. Before burial, the incense burner was painted with red pigment to sanctify it, and traces of color remain. P.D.J.

29. Jaguar-Dragon Effigy Vessel

Early Formative Period
Whiteware ceramic
14 x 26.2 x 15.5 (5½ x 10⁵/₁₆ x 6⅛)
Tlapacoya, Mexico
Museo Nacional de Antropología, Mexico City

Modeled from a gray clay typical of Puebla and Oaxaca, this elaborate vessel has a well-polished slip of the same color. The manufacturing technique probably consisted of molding clay into the desired shape, as if creating a sculpture. It was later hollowed out for use as a container, and decorated with incision and carving.

Between 1963 and 1964 George Pepper donated the vessel to the National Museum of Anthropology, one of "Twelve magnificent vessels and figurines from the Preclassic period of the Valley of Mexico, some of which were in Olmec style." According to the information given, it came from Tlapacoya. A piece almost exactly identical to this, but of jade, is also known (Joralemon 1971: 36–37, obj. 94).

Fantastic animal representations are common in Olmec symbolism, and this effigy vessel is potentially the best example of abstraction in Olmec art. It combines the elements of the jaguar and the reptile, giving it the appearance of a dragon; it may have signified the union between the earth (the jaguar) and water (the reptile).

The stylized elements include modeled and elongated flame eyebrows. The eyes, represented by an inverted ⌐, are cut out like caverns, which would have signified subterranean water, associated with agricultural fertility. The nose is wide and bulbous; the upper lip is modeled. The gums are carved in the form of hooks, and two appliqués fall over the upper lip, as can be noted in other examples, such as the bowl with jaguar profiles (cat. 40). Four feet end in stylized claws, each with five toes; circular incisions along the body may symbolize animal spots. The spout of the vessel, completely broken off, was at the back.

P.O.

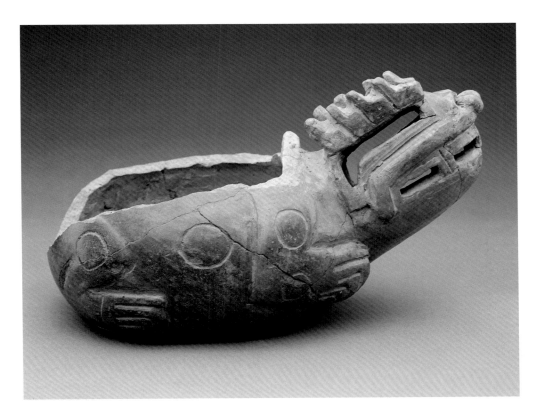

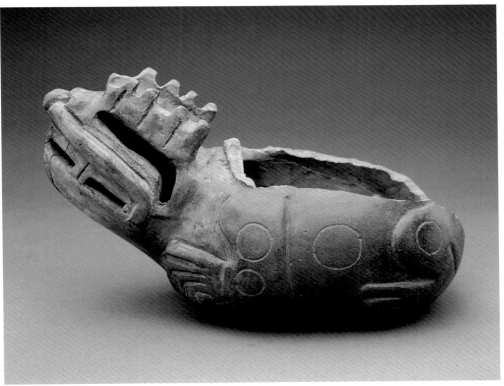

30. Calabash Effigy Vessel

Early Formative Period
Blackware ceramic
9.5 x 16.5 (3¾ x 6½)
Las Bocas, Puebla
The Saint Louis Art Museum, Gift of Morton D. May

Several species of cucurbits (pumpkins, squashes, and gourds) figure among the most ancient domesticated plants in Mesoamerica. The hard-shelled bulbous fruit of the calabash or gourd tree, once hollowed out and dried, had been used to make vessels and containers since preceramic times. With the first appearance of fired clay vessels, the multiform calabash fruit remained a favorite shape to imitate and stayed in vogue among potters throughout the pre-Hispanic sequence.

The site of Las Bocas, Puebla, has yielded one of the most beautiful assemblages of pottery vessels of the Olmec horizon. The remarkable balance and the symmetry of this well-burnished black-slipped bowl attest to the particular skill of the Las Bocas artisans.

C.N.

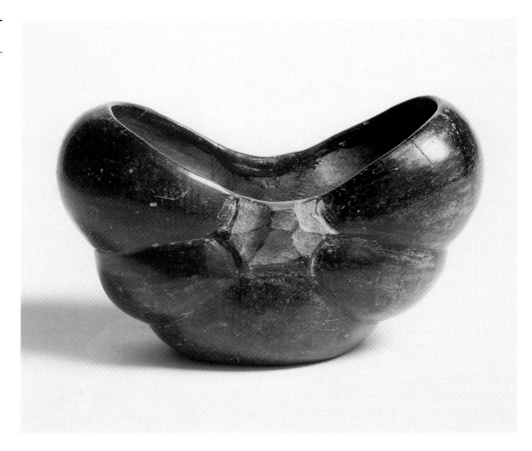

31. Plate with Fire Clouding

Early Formative Period
White-slipped ceramic
3.2 x 14.5 (1¼ x 5¹¹/₁₆)
Las Bocas, Puebla
Private collection, currently on loan to
The Art Museum, Princeton University

This white-slipped plate from Las Bocas, Puebla, with its flat base and its outflaring straight walls, constitutes one of the most diagnostic vessel shapes made in early Mesoamerica between 1200 and 800 B.C. Its decorative technique, however, is uncommon. The special patterning of the surface decoration has been obtained by firing the vessel with smudging material and by a differential firing of the slip.

C.N.

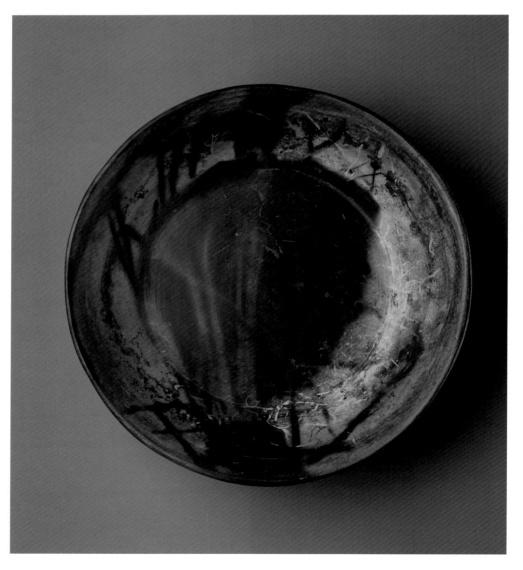

32. *Tecomate* with Fire Clouding

Early Formative Period
White-slipped ceramic
10.3 x 13.8 (4¹/₁₆ x 5⁷/₁₆)
Las Bocas, Puebla
The Art Museum, Princeton University, Gift of
Gillett G. Griffin in honor of Allen Rosenbaum

The site of Las Bocas, Puebla, was never the
subject of scientific excavations and research.
Its delicate solid figurines, masterly sculpted
hollow baby-face clay representations, and
exceptionally sophisticated pottery vessels,
often decorated with complex esoteric mes-
sages, have been largely taken out of their
context and have found their way into private
and public collections.

Las Bocas potters exercised ceramic art with
great skill. This fine neckless jar or *tecomate*,
modeled with thin walls into a regular and
harmonious form, is decorated with special
firing techniques. On the white-slipped sur-
face, a special patterning was obtained by
skillful control of the atmosphere at the hearth
and the application of perishable materials
during firing. C.N.

33. *Tecomate* with Painted Bird Monster Profiles

Early Formative Period
Whiteware ceramic with black paint
13 x 17.5 (5¹/₈ x 6⁷/₈)
Las Bocas, Puebla
The Metropolitan Museum of Art, Anonymous loan

Olmec ceramic vessels from the Central
Mexican highlands are often decorated with
carved or incised designs representing Olmec
supernatural beings. Some bowls from Tlapa-
coya and Las Bocas combine incised designs
with resist-painted decoration, but only a few
vessels are embellished with resist-painted
designs alone.

This beautifully shaped creamware *tecomate*
from Las Bocas has a boldly painted composi-
tion depicting four bird monster profile heads
descending from the rim. Each downturned
profile has the sky god's attributes: flame eye-
brows, trough-shaped eyes, and sharply

recurved beak with pointed tip. At the top of each beak is a rounded nostril hole. The mouth is open and the lower jaw is straight. Separating the bird monster profiles is an elongated pointed motif. The bird heads are the cream color of the vessel itself, which was covered with a resist material during firing; the background and the linear details of the design are painted black.

The bird monster is not often represented on Early Formative ceramics (Joralemon 1971, 1976). Olmec artists generally depicted either the bird monster's profile head or the god's distinctive footprint. The fourfold repetition of the deity's head in a band encircling the rim is unprecedented. This composition may relate to the ancient Mesoamerican veneration of the four cardinal directions. Gods often had four separate aspects, each associated with a direction. P.D.J.

34. *Tecomate* with Carved Jaguar-Dragon Profile

Early Formative Period
Cream-slipped ceramic with orange-slipped zone
12.5 (4¹⁵/₁₆)
Las Bocas, Puebla
Lent courtesy of The Cleveland Museum of Art

At the end of the second millennium B.C., regional centers—a new type of territorial organization—appear in various zones of Meso-america. These major sites—larger in size, density, and variety of function—exercised a political, economic, and religious control on surrounding territories. These centers were a locus for information storage, including the production, reception, and redistribution of graphic symbols and messages related to mythic and cosmological beliefs.

Highland regional capitals such as Tlapa-coya and Tlatilco, in the Basin of Mexico, and Las Bocas, in Puebla, have yielded one of the most sophisticated and varied repertoires of sacred symbols carved or incised on ceramic supports in ancient Mesoamerica.

This neckless jar or *tecomate* from Las Bocas, covered with cream and orange slips, is typical of the highly stylized and condensed esoteric messages related to the Olmec horizon belief system. In the dragonlike creature, several levels of increasing abstraction can be observed. Some designs offer a general rendering of this hybrid feline-saurian-avian creature

with crested head, flame eyebrows, bulbous nose, L-shaped upper jaw, toothless gums, and a paw-wing-shaped tail. This vessel presents a striking example of an abridged, abstract representation by the selection of significant graphic elements, such as flame eyebrows and L-shaped upper jaw. C.N.

35. Bowl with Engraved Hand-Paw-Wing Motif

Early Formative Period
Blackware ceramic
8.6 x 10.2 (3³/₈ x 4)
Tlatilco, Mexico
Jeanette Bello

Situated in the fertile alluvial plains west of the ancient Texcoco lake, in the Basin of Mexico,

Tlatilco was an important regional center between 1200 and 700 B.C. Now covered by the buildings and highways of Mexico City, the site has served since the 1930s as a source of clay for brick makers and was largely destroyed while hundreds of ancient burials were system-atically looted. Progress made in the under-standing of the ancient archaeological sequence of the Basin of Mexico permits the findings made in Tlatilco to be placed within a coherent chronological and cultural context.

This cylindrical, flat-bottomed bowl, covered with a highly polished black slip, is character-istic of the Ayotla phase (1200–1000 B.C.). The iconographic message transmitted by the design engraved on its wall offers an abstract evocation of a hybrid creature, represented by a combination of hand, paw, and wing elements. Tlatilco has produced a large number of splendid clay vessels that support sacred motifs. This demonstrates the pivotal role of this ancient capital in the elaboration and distribu-tion of esoteric symbols, the expression of a pan-Mesoamerican belief system.

C.N.

36. Bottle with Carved Jaguar-Dragon Paw-Wing Motif

Early Formative Period
Blackware ceramic
16.7 x 10 (6⁹/₁₆ x 3¹⁵/₁₆)
Tlatilco, Mexico
Museo Nacional de Antropología, Mexico City

The Formative period of Central Mexico was characterized by small villages that adapted to the environment; this adaptation is manifested in their artistic expression. With the arrival of Gulf Coast Olmec groups, naturalistic conceptions developed into a complex symbolism based on stylized elements. Certain decorative motifs of Olmec iconography were molded on some ceramic forms. Bottles, in particular, are abundant in a variety of styles in Central Mexico, in contrast to the Gulf Coast where they are less frequent; these flat-bottomed bottles have straight walls on both the body and neck.

This vessel has black slip with a high luster that contrasts with the decorative motifs, which have a flat appearance achieved by scraping the decorative area before the final firing. This excising technique, which produces a relief, may have been an antecedent to reliefs in Olmec carvings.

The thematic design is a zoomorphic monster (Pohorilenko 1990b: 86) seen in profile, with the flame eyebrow, rectangular eye, and hook-shaped nose and gums. The burnished body has a hook-shaped tail of a stylized jaguar. Fugitive red resist paint was applied to this decoration.

This piece forms part of the Covarrubias Collection donated to the National Museum of Anthropology. Miguel Covarrubias was a supporter of the first excavations at Tlatilco, and emphasized the importance of the "Olmec" component in vessels and figurines at the site. In accordance with other information provided by Luis Covarrubias, his brother, this bottle is believed to have come from Tlatilco and was published for the first time by Román Piña Chan (1958: lám. 25, 26). P.O.

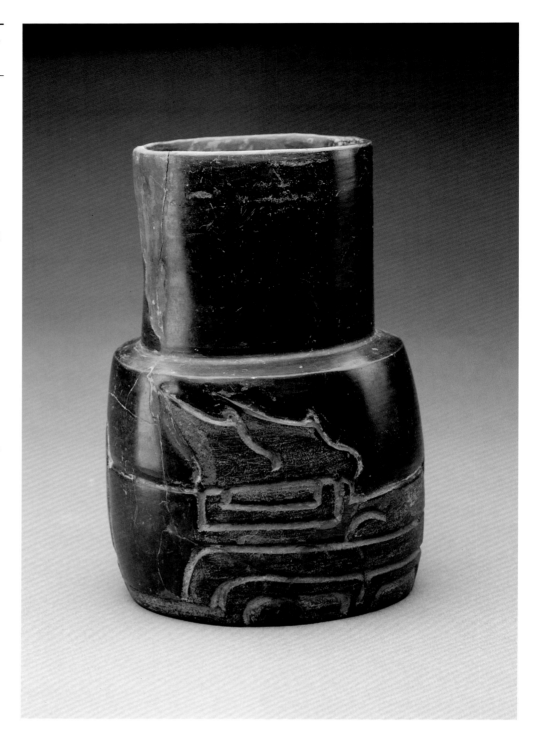

37. Bottle with Carved Fish Monster

Early Formative Period
Blackware
18.4 x 13.5 (7¼ x 5⁵⁄₁₆)
Las Bocas, Puebla, Mexico
The Montreal Museum of Fine Arts Collection,
Purchase, Horsley and Annie Townsend Bequest

Early Formative blackware vessels from Tlatilco, Las Bocas, and other Central Mexican sites are often decorated with boldly carved images of Olmec supernatural beings. Sometimes abbreviated, using the *pars pro toto* principle, these ceramics are important documents of Olmec religious belief.

This well-proportioned blackware bottle is probably from Las Bocas. It has a globular body and wide neck. The sharply carved design with roughened interior vividly contrasts with the vessel's shiny burnished surface. Decorating the bottle is a representation of the Olmec fish monster. Best known from San Lorenzo Monument 58 (cat. 16), the mythological creature has a large head and an elongated body ending in a bifid tail with short engraved lines around its edges. The rectangular eye has pointed elements extending front and back. A finlike extension appears above the eye with engraved lines giving it detail. The large upper jaw ends in a blunt snout. Below the elongated nose are two prominent teeth, the front triangular in shape and the rear with a commalike form. The lower jaw is absent altogether. At the center of the fish monster's body is a crossed-bands motif with three horizontal lines to its left.

The bottle's design is closely related to the fish monster carved on the San Lorenzo monument and incised on the right leg of the Young Lord from Guatemala (cat. 50). The iconographic similarities linking a Central Mexican ceramic vessel, a relief carving from an Olmec capital on the Gulf Coast, and a serpentine statue from the Pacific slope of Guatemala emphasize the common religious beliefs that bound the Olmec world. P.D.J.

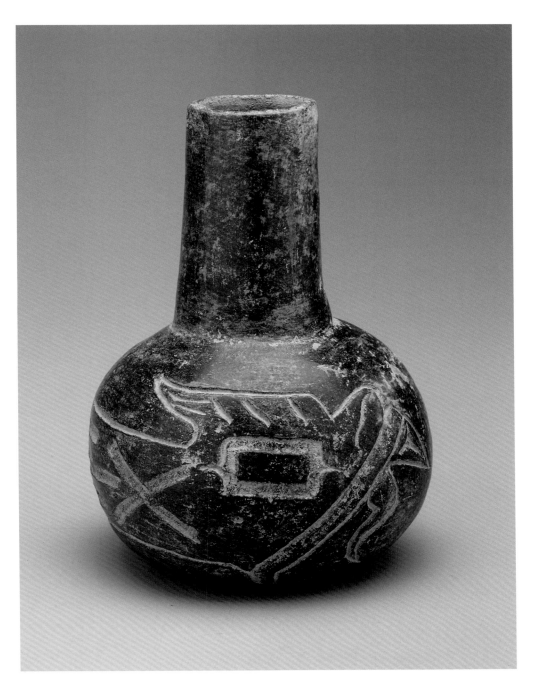

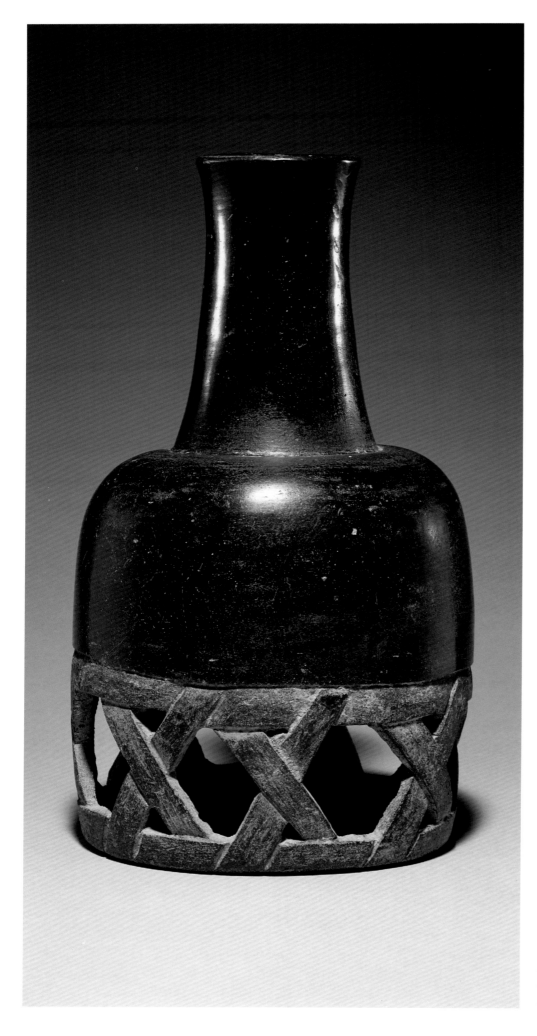

38. Bottle with Open-Work Base

Early Formative Period
Blackware ceramic
21.9 x 11.4 (8⅝ x 4½)
Las Bocas, Puebla
Private collection

This highly polished, black-slipped, fired clay vessel is an excellent example of the creativity of highland potters in such sites as Tlatilco, Tlapacoya, or Las Bocas during the Early and Middle Formative periods (1200–600 B.C.). A bottle-shaped vessel, perhaps from Las Bocas, it presents a decorative, open-work base made of two parallel rings linked by a series of crossed strips. The artisan may have found some amusement and aesthetic pleasure in imitating, in a clay version, the probably long-standing Mesoamerican technique of laying down round-bottomed pottery on a wickerwork annular base to keep it straight. The result is a harmonious balance between a globular, opaque volume and the play of light through basketry motifs.

C.N.

39. Vessel with Incised Frontal and Profile Jaguar-Dragons

Middle Formative Period
White-slipped ceramic
16 x 14.7 (6⁵/₁₆ x 5¹³/₁₆)
Valley of Mexico
Museo Nacional de Antropología, Mexico City

This white-clay vessel is decorated with thick and shallow excised lines, some of which form squares. On one side, the jaguar faces front with its open mouth, represented as a type of squared cross, occupying the greater part of the surface; the upper lip reaches to the eyes, which are topped by a rectangle with flame brows. On the sides of the face are two vertical columns, one of them composite, and the other uniting three circles. On the other side of the vessel the jaguar face appears in profile; there the mouth and cleft head are the most important features.

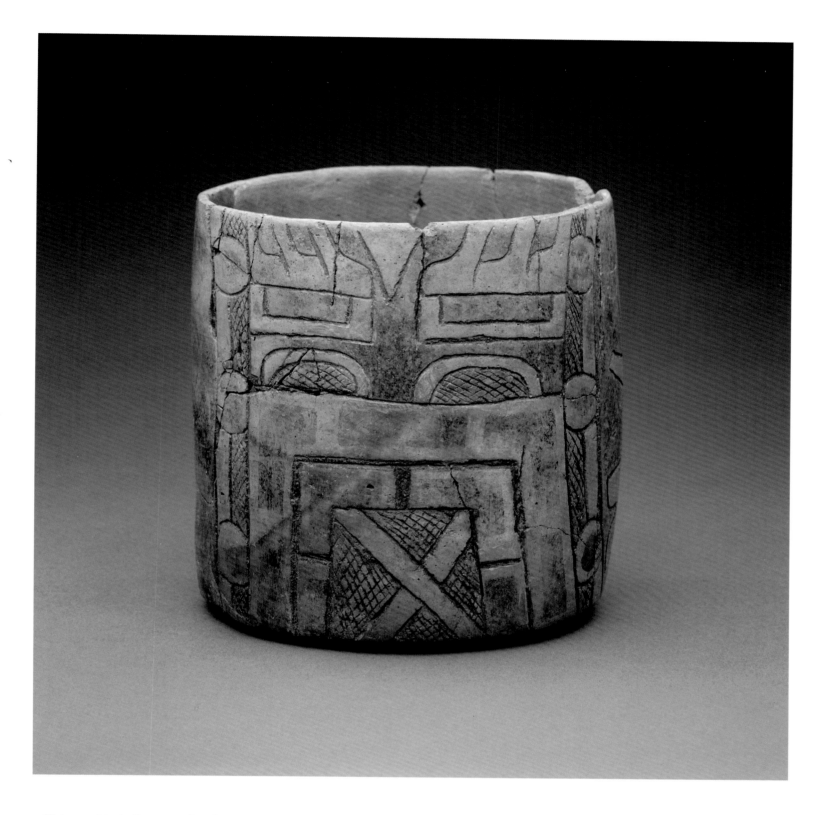

This vessel is similar to one found at Tecaxic, Calixtlahuaca, Mexico (Piña Chan 1993). Both have the same elements, which have been interpreted as follows: the jaguar face represents the earth; the cleft head is the earth open to bring forth plants; the square signifies the arid earth; the rectangle is a cornfield; the circles are the grains of corn.

This vessel was donated to the museum in 1964 by George Pepper, who said that it came from the Valley of Mexico but did not specify the exact site.　M.C.-L.

40. Bowl with Incised and Resist-Painted Profile

Early Formative Period
Ceramic
12 x 14.8 (4³/₄ x 5¹³/₁₆)
Tlapacoya, Mexico
Museo Nacional de Antropología, Mexico City

Around 1200 B.C., the life of highland groups was influenced by cultural elements from the Gulf Coast Olmec, who established themselves in the Valley of Mexico, principally at Tlatilco and Tlapacoya. An exchange network of goods and ideas existed during this period, and a greater complexity of religious concepts based on the forces of nature developed. Nature inspired the complex symbolism associated with beliefs of the Olmec, who venerated such animals as the jaguar and whose iconography was shaped in ceramics, figurines, and elaborate objects in other media.

This bowl, of gray clay with a finely burnished white slip, is covered with symbolic decoration of pure Olmec style. Its ceramic form, as well as the iconographic theme, was found by Christine Niederberger at Tlapacoya; the ceramic type is called Paloma Negativo and is associated with the Ayotla phase at approximately 1200–1000 B.C. (Niederberger 1987: 546–547). Other examples are found in collections from Morelos and Tlapacoya (Coe 1965b: 26). This piece is from the Covarrubias Collection; little is known of its provenance other than that it originated in Puebla (Piña Chan and Covarrubias 1964: lám. 31).

The bowl has straight walls and a flat base, with tones ranging from gray to brown. The coloring, incising, and the negative-resist zones were done prior to firing. The decorative theme consists of four composite anthropomorphic heads, the profiles facing left, commonly seen in cylindrical bowls (Pohorilenko 1990b: 816). The composite figures are primarily men with jaguar features, as noted by Beatriz de la Fuente (1972: 6).

Two of the heads have a V-shaped cleft, which terminates at the almond-shaped eye. The nose rests directly over the upper lip, which is rectangular. Under the lip is a line to indicate the upper gum (carved and painted dark gray); the lower lip is thin. A double line runs from the eye to a point below the ears, which are like vertical double bars. Between the ears and this double bar is an area of cross-hatching. The difference between these relatively similar figures and the other two is chiefly in the area above the head (although one of the figures is broken off). One figure has a horizontal V-shaped cleft and three lines that define the eye, the space of which is excised and painted, with no cross-hatching; the ear consists of a rectangular line.

The four figures show circular patterns achieved by the negative-resist technique. With its undeniable symbolic character and decorative techniques, this piece indicates a high degree of craft specialization.

P.O.

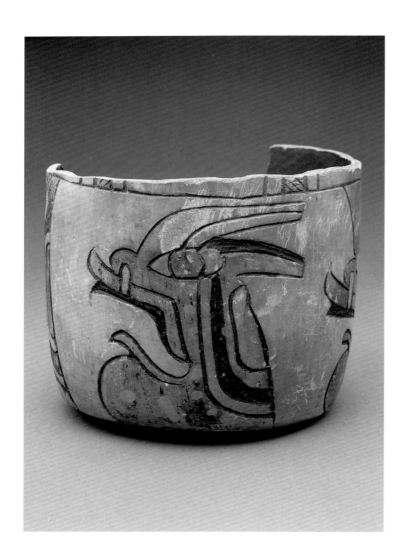

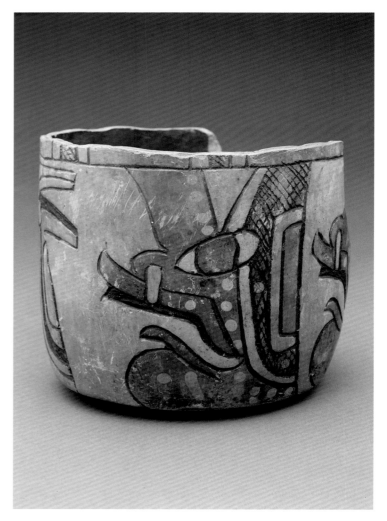

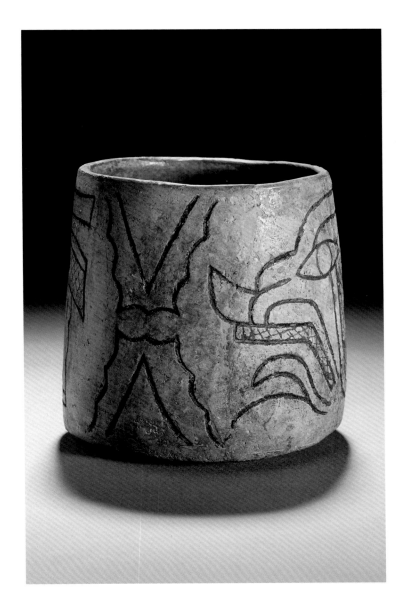

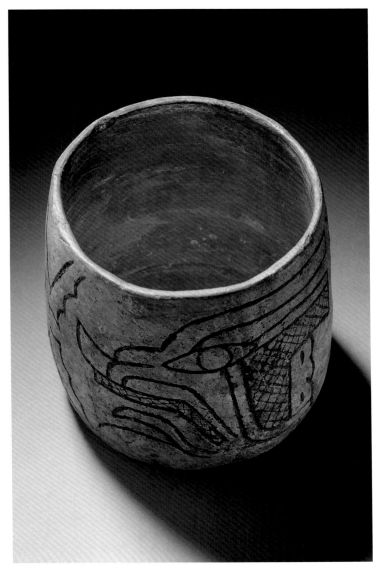

41. Bowl with Incised Were-Jaguar Profiles

Early Formative Period
Whiteware ceramic
11.4 x 10.8 (4½ x 4¼)
Morelos
Private collection

The Olmec tradition of incising jade and serpentine works of art with iconographic designs is well known. However, boldly engraved images are also common on Early Formative ceramic vessels from Olmec sites in the Basin of Mexico, Puebla, and Morelos. In particular, many examples, both whole and fragmentary, have been recovered from Tlapacoya.

This bowl is a fine example of Olmec incised pottery. Said to have been found in Morelos with a similar bowl now in the Raymond and Laura Wielgus Collection at the Indiana University Art Museum, it depicts a pair of iconographically identical profile heads of an Olmec supernatural separated by scalloped framing devices. Deeply engraved lines define each profile head with almond-shaped eye with round iris, pug human nose, and large open mouth with flared upper lip, toothless gum ridge decorated with cross-hatching, thin curved lower lip, and downturned corners. The deity has a low forehead that sweeps back in a straight line and ends in a deep cleft. Extending from the back of the head and transecting the eye is a plain band that crosses the cheek and turns back under the ear. The ear is depicted by a rectangular form with one straight edge and one scalloped border. Two short vertical incisions suggest the ear's contours. Cross-hatching decorates the rear portion of the head bordered by the band.

The supernatural being shown on this Morelos bowl appears on the Las Limas Figure's right shoulder (cat. 9) and on a plaque in the National Museum of Anthropology, Mexico City (cat. 90). This enigmatic creature has been called the banded-eye god. Never portrayed with a body, it is difficult to know who this deity is, what animal he is derived from, and what role he played in Olmec religion. Although many examples of his image are found on Early Formative ceramic vessels from Central Mexico, his image is less well represented in other regions or on other types of art work. His head is the main subject on many Central Mexican ceramics, but his form assumes a secondary role on Olmec stone sculptures. This suggests that the banded-eye god was especially important in highland religious belief and practice during the initial centuries of Olmec civilization.

P.D.J.

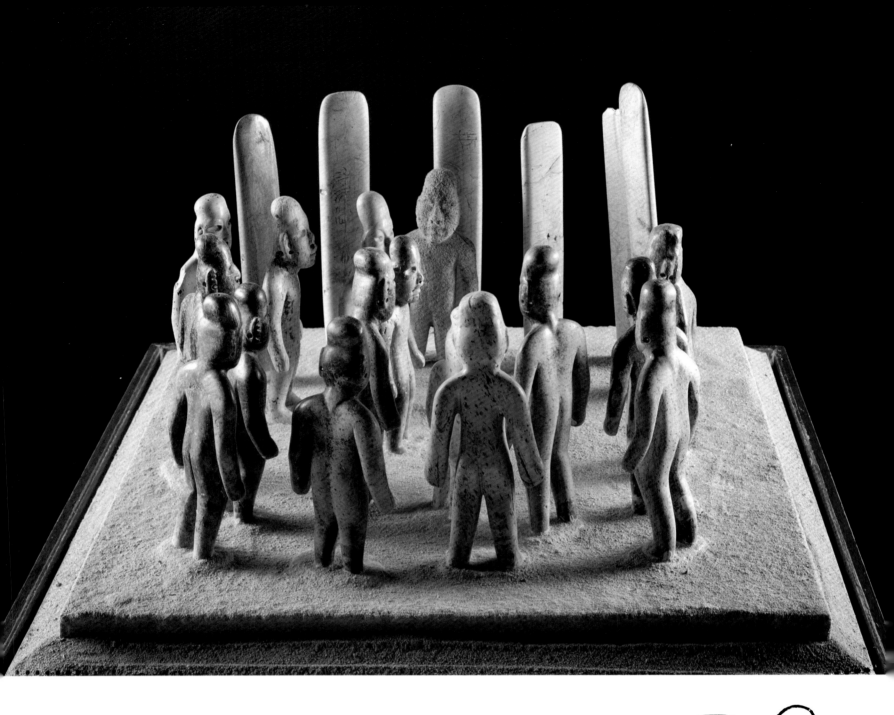

42. La Venta Offering 4 – Group of Standing Figures and Celts

Middle Formative Period
Jade and serpentine
Figurines: 20 to 15.3 x 7.5 to 6.1 x 3.7 to 2.7
(7⅞ to 6 x 3 to 2⅜ x 1½ to 1¹/₁₆)
Celts: 25.5 to 23.8 x 4 to 3.4 x 2.2 to 1
(10 to 9⅜ x 1⅝ to 1⅜ x ⅞ to ⅜)
La Venta, Tabasco
Museo Nacional de Antropología, Mexico City

The most impressive offering from early Meso-america was found at La Venta, Tabasco, during the 1955 season (Drucker, Heizer, and Squier 1959). Located in the Northeast Platform under a layer of white sand, Offering 4 consists of a group of related objects in what appears to be a ritual ceremony: sixteen figurines stand in a semicircle, in front of six standing celts that form a wall. One figurine, carved from a different material, is behind the others; his back is to the celts, and he faces the other figurines. This offering is a unique ceremonial representation from pre-Hispanic Mexico that has been preserved intact.

The figurines are of similar measurements, except for one that measures 15 centimeters. They have the same physical type, and they show cranial deformation, more exaggerated in some than in others, as is clearly seen from the unadorned shaved heads. Almost all the figurines wear loincloths, which are indicated by a fine incision. Gums, and in some cases mutilated teeth, are noted in the half-open mouths, as well as the remains of red powder (cinnabar).

The celts are also upright, possibly marking a ceremonial area. Two are totally smooth, while two others have a representation of the upper half of a prone personage; the remaining two have the geometric and symbolic designs seen on other Olmec objects: hand, footprint, canine teeth, eyes, and vegetable elements, among others. M.C.-L.

43. Standing Figure with Flexed Arms

Middle Formative Period
Serpentine
12.7 x 3.8 x 2.5 (5 x 1½ x 1)
Guerrero
The Snite Museum of Art

This standing figure of unclear origin, whether from Guerrero or from Veracruz, is a characteristic example of the small lapidary art produced in Mesoamerica during the Olmec horizon period. This anthropomorphic statuette clearly represents a male personage with a loincloth and a decorated belt. Arms are flexed and hands are closed as if to grasp a particular object. Fingers and toes are indicated by large incisions. The stone carver has focused on the head to transmit a specific codified message and to create a special visual impact. The head, therefore, appears somewhat out of proportion, representing nearly one-third the length of the figure. The personage, perhaps meant to depict a high-status individual, is represented with an intentional frontal-occipital skull deformation. His features, executed with strength and following certain symbolic and stylistic conventions, such as the feline mouth with downturned corners, are meant to evoke awe and to associate the personage with supernatural forces.

Made of serpentine, a metamorphic rock in which Guerrero is particularly rich, the object, highly polished, offers splendid visual and tactile properties. C.N.

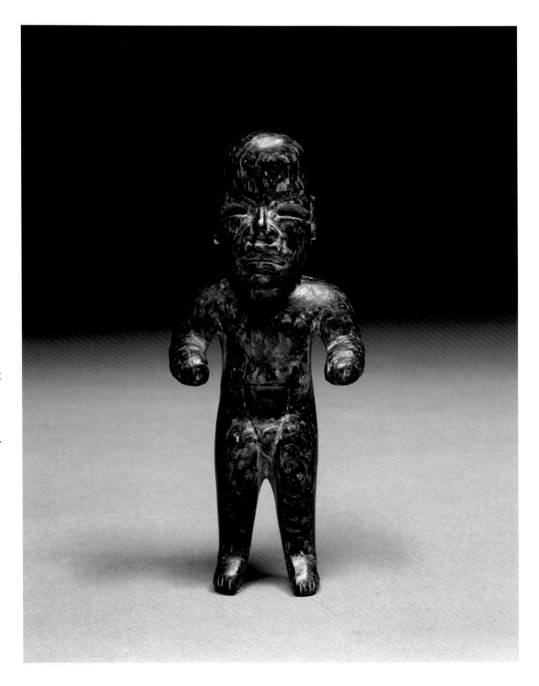

44. Standing Bearded Figure with Flexed Arms

Middle Formative Period
Diopside-jadeite
23.9 x 12 (9⁷/₁₆ x 4³/₄)
Unknown
Dumbarton Oaks Research Library and Collections,
Washington, D.C.

Purchased by Robert Woods Bliss in Paris in 1912, this figurine was probably the first Pre-Columbian object acquired as a work of art rather than as an archaeological object, curiosity, or interesting stone (R. W. Bliss, in Lothrop, Foshag, and Mahler 1957: 7; Benson 1981b: 95–98; Benson 1993: 15–16). At that time it was called "Aztec," for the Olmec style was little known and was not called by that name.

Standing figurines of this general type are common in Olmec lapidary work. Separated legs, an open, downturned mouth, nostrils and earlobes drilled for ornaments, and a deformed skull are usual traits. Elite males of most highly developed Pre-Columbian cultures had skulls deformed by some means of tying and flattening in infancy, when the skull was soft. This is noticeable on most Olmec figurines. The sex of Olmec figures is rarely indicated; this one wears a penis sheath, as do some others.

This figurine is more modeled and muscular than most examples. The arms are more bent than those of the La Venta figurines (cats. 42, 45). The raised, angular arms give a sense of movement absent in the straight-armed figures. The hands are drilled and probably once held a ritual object. Although beards are frequent in the Olmec oeuvre, it is unusual for a figure of this type. The beard may associate it with transformation figures, which are often bearded.

Its unconventional traits suggest that this piece may have come from outside the Gulf Coast region or that it was made somewhat later than other standing figures.

There are old mended breaks in both arms, feet, and the left leg; the original parts have been reattached. The breaks may have been accidental, or they may have been a deliberate "killing" of the object, as was done in some later cultures. Other Olmec figures have similar breaks (see cat. 48). E.P.B.

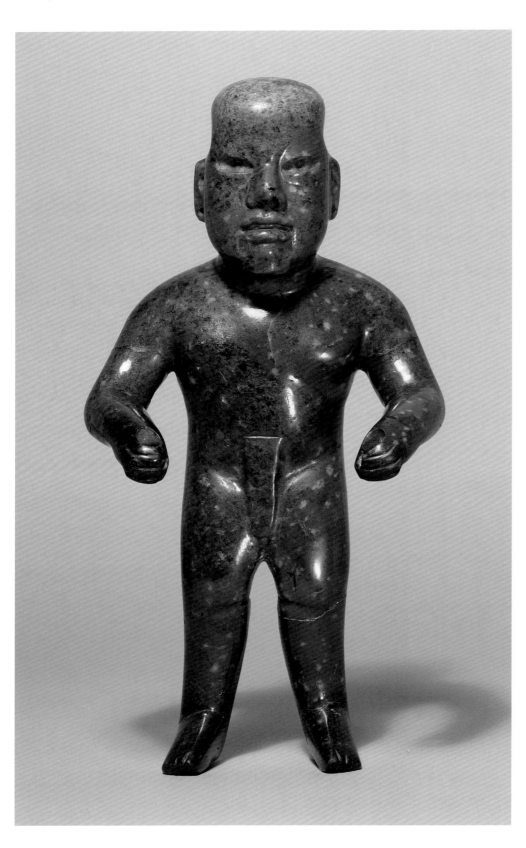

45. Standing Figurine

Middle Formative Period
Jade
10.8 x 3 (4¹/₄ x 1³/₁₆)
La Venta, Tabasco
Museo Nacional de Antropología, Mexico City

This figurine was found in one of the burials in the Tomb of the Monolithic Columns during the 1942 season. It was part of the offering to a youth, identified as such on the basis of a few remaining teeth. Each tomb mortuary cache had a figurine representing a seated personage and another of a standing individual, as well as other objects. In the case of Offering 2, there are two jade forearms with hands, a center-perforated disk with a notched edge, a broken perforator, a frog-shaped pendant, as well as fragments of an animal spine, an elongated

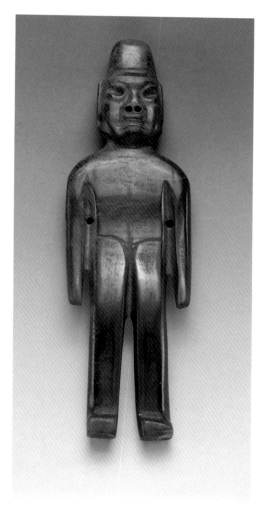

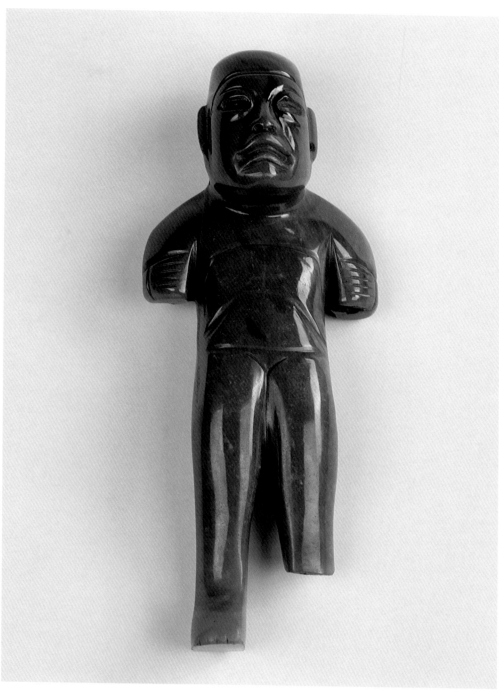

narrow jade object, various tubular beads, and
a shark tooth.

The cranial deformation, combined jaguar-
man features, and the unadorned, asexual
body are all characteristics that make this
figurine one of the best examples of this type
of burial figure. M.C.-L.

46. Standing Figure with Recarved Arms

Middle Formative Period
Jade
24.5 x 9.5 x 5.5 (9⅝ x 3¾ x 2³⁄₁₆)
Unknown
Museum für Völkerkunde, Vienna

A considerable number of standing baby-face
figurines are carved in jade, but no two are
identical. All of them, however, conform to the
same physical characteristics: a large and arti-
ficially deformed head, almond-shaped eyes
set in swollen tissue, a short and wide nose, a
mouth with full lips and downturned corners,
a rounded prominent chin, and heavy jowls.
The ears are nearly always placed low on the
head, with both the helix and lobes attached.
A short, wide neck connects this pear-shaped
head to a sizable torso with short and stocky
limbs. The legs are always shown slightly bent
at the knees; peculiar to the baby-face, this
stance is not found in any other Mesoamerican
representational system. Most adult baby-faces
are shown wearing a loincloth. When depicted
naked, the genitalia is not usually indicated.

This particular adult baby-face wears a
skull-hugging helmet, a wide abdominal band,
and a short loincloth. Perhaps broken in For-
mative times, the short arms, once extending
forward from the elbows, now have cupped
hands carved directly onto them. A.P.

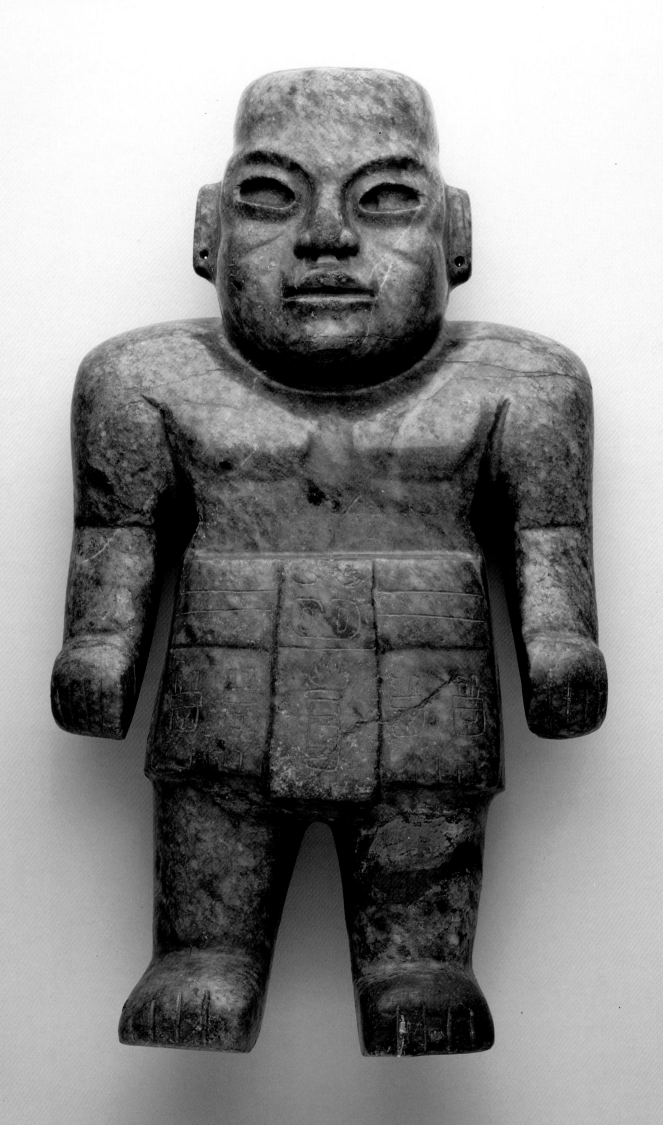

47. Large Standing Figure with Arms at Side, Wearing an Incised Loincloth

Middle Formative Period
Jade
52.5 x 29 (20^{11}/$_{16}$ x 11^{7}/$_{16}$)
Puebla
Museo del Estado de Puebla

An unusual figure, this object is exceptionally large, exceptionally heavyset, and exceptionally dressed. Although it has the build of a wrestler, its stance is characteristic of conventional Olmec standing figures, as are the face, the rectangular ears, and the head that shows that it had been bound in infancy.

Miguel Covarrubias drew this figure, showing the incising on the loincloth apron (see Piña Chan 1989: fig. 56). The motif on the apron, usually called a torch, here resembles a feathered bundle. It has been also interpreted as a bloodletter (Grove 1994) or a maize ear (Taube, in press). The motif placed above it, usually called a "knuckle-duster," has also been interpreted as a bloodletter, perhaps a cut gastropod shell (Joyce et al. 1991). These motifs are commonly paired and are surely regal symbols. At either side of the loincloth are two repetitions of a motif; these must refer to the four cardinal directions. The incising seems to be a concise cosmic diagram, with the loincloth's wearer as the royal center of the world, the world tree.

This piece is one of the early known Olmec objects. E.P.B.

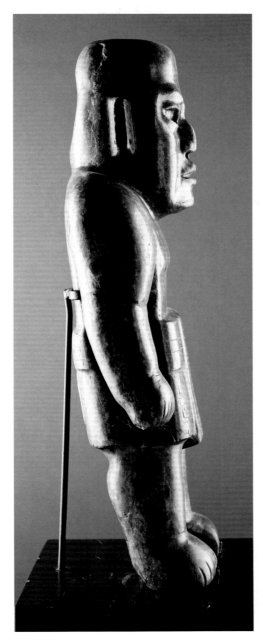
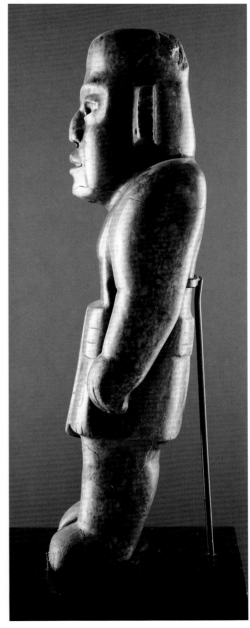

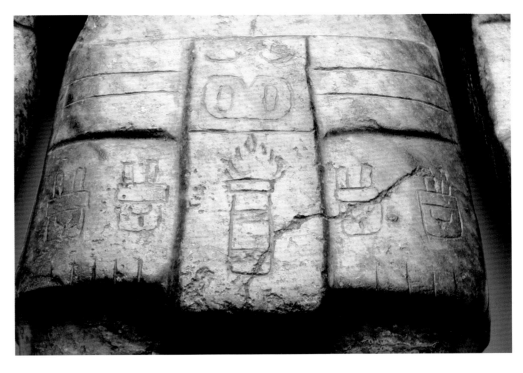

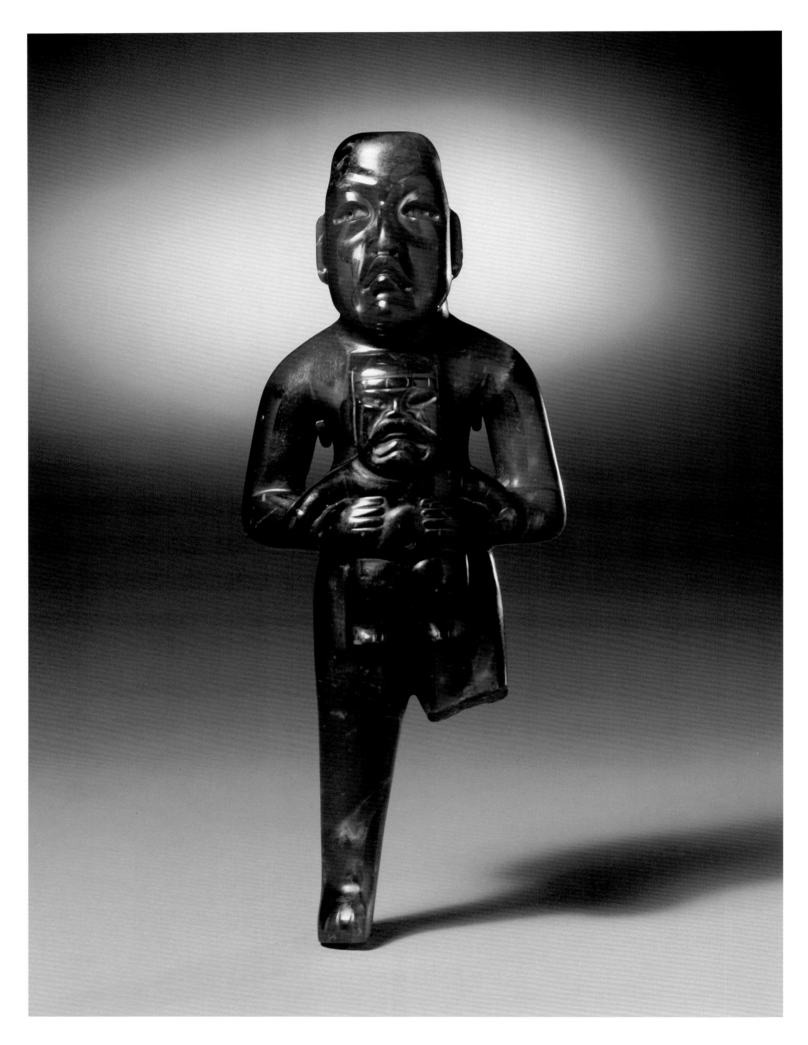

48. Standing Figure Carrying Were-Jaguar Baby

Middle Formative Period
Jade
21.9 x 8.9 x 3.2 (8⅝ x 3½ x 1¼)
Unknown
From the collection of Robin B. Martin, currently on loan to The Brooklyn Museum L47.6

This remarkable carving of an especially beautiful jade depicts a figure much like those in La Venta Offering 4, with the typical Olmec drooping-lipped face, flattened head, drilled ears, and unclothed body. This figure holds a "baby" with a cleft head, pleated ear ornaments, and a fangless Olmec mouth, which somewhat resembles the little figures on La Venta Altar 5 (de la Fuente 1984: opp. 286, pl. 50), the Las Limas Figure (cat. 9), or the faces on elaborately carved Olmec axes (Joralemon 1971: 71–76). These compositions may portray an elite figure holding an ancestral or deity image; they may represent the presentation of a child for sacrifice, the child having become a supernatural being through the sacralizing process of the ritual. There is archaeological evidence for Olmec child sacrifice. Maria Elena Bernal-García (1994), citing Kent Reilly, sees the baby-jaguar as the principal emblem of rulership, the divine ancestor, the progenitor and protector of the ruling Olmec lineage.

This object shows two varieties of jadeite found together in nature. The upper part, to the right shoulder and diagonally down to the left elbow, is of a lighter green; most of the main figure and the baby are carved from a rare, darker emerald-colored jade.

The proper left leg of the larger figure is missing. It may have been ritually broken.

This figurine was first illustrated in 1901 (Spinden 1947). It is said to have been taken to France in the 1860s (Lothrop and Ekholm 1975: 315). Some Pre-Columbian objects apparently did go to France with returning members of Emperor Maximilian's entourage. There was also a rumor that the figure had been sold as a "Khmer jade," which had belonged to a family descended from a minister of Napoleon III (Spinden 1947). A previous owner, the Marquis de Chasseloup Loubat, minister of the navy under Napoleon III, was in office at the time of the conquest of Indochina, and he served also during the French Mexican campaign.

E.P.B.

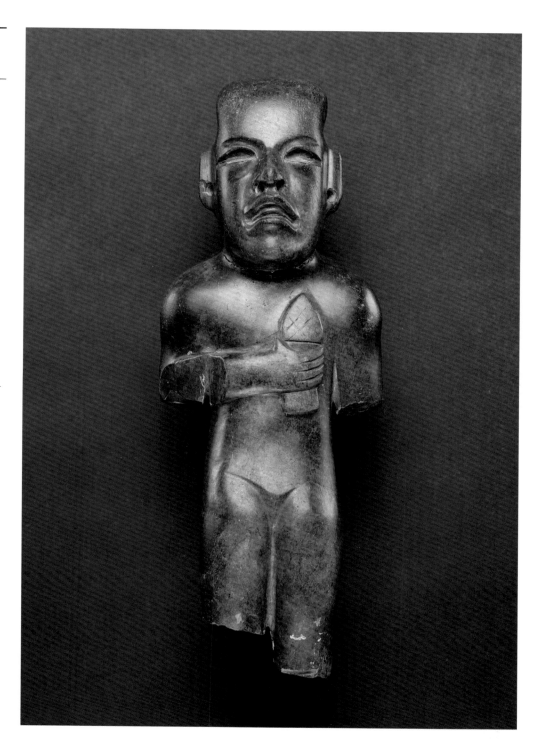

49. Standing Figure with Torch Motif

Middle Formative Period
Serpentine
18 x 6.5 x 4 (7¹⁄₁₆ x 2⁹⁄₁₆ x 1⁹⁄₁₆)
Paso de Ovejas, Veracruz
Museo Nacional de Antropología, Mexico City

Although this figure does not come from the Olmec Gulf Coast heartland, it exhibits all the characteristics of the Olmec figurine type: the shaved and deformed head; the human features with the jaguar mouth; and the absence of clothing and adornment on the asexual body. The right hand, bent at the chest, carries an element identified as a torch. The torch is found in other examples (cats. 54, 98) associated with the use of "knuckle-dusters"; possibly both objects were used in a religious ceremony. Because the other arm is broken, it is not known if it carried a "knuckle-duster."

M.C.-L.

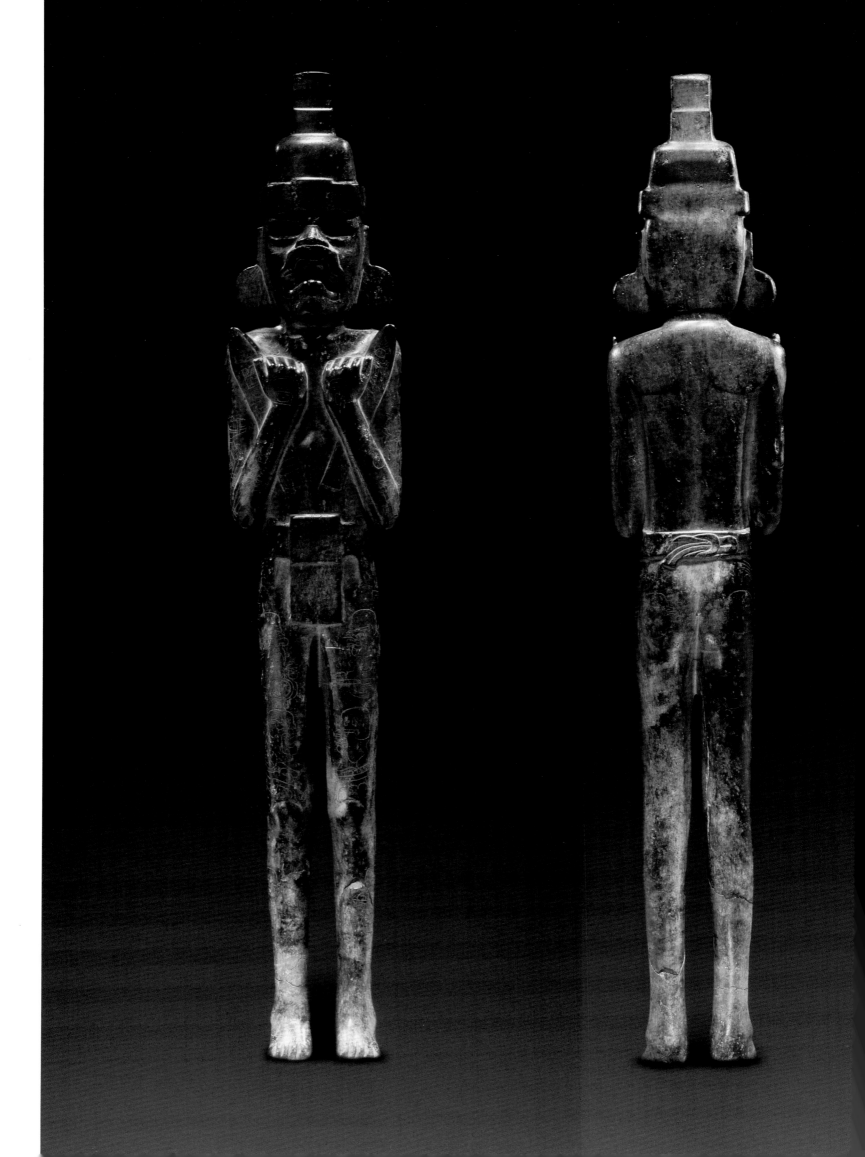

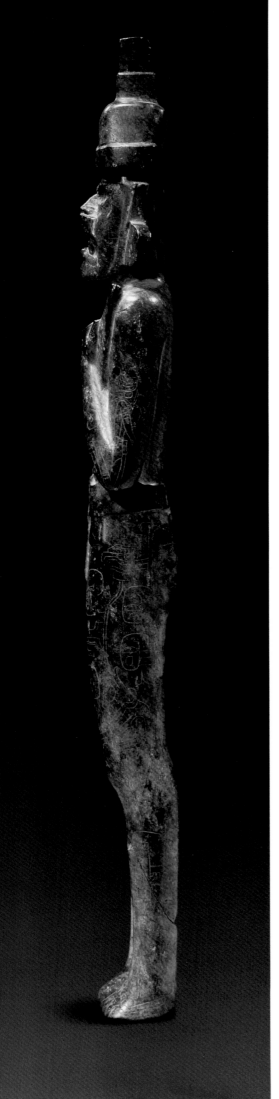

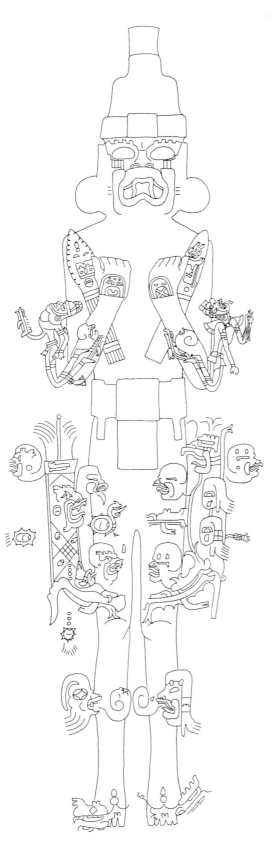

50. Young Lord (Tall Standing Figure Carrying a Scepter and Bloodletter)

Middle Formative Period
Serpentine
Pacific Coast of Guatemala
65.5 x 11 x 5.4 (25¹³⁄₁₆ x 4⁵⁄₁₆ x 2¹⁄₈)
Private collection, currently on loan to The Art Museum, Princeton University

Relatively few Olmec objects have been discovered in the hot fertile coastal plains that border the Pacific Ocean in Guatemala. The documented examples are mostly jade and serpentine sculptures closely related to Olmec art work from Mexico's Gulf Coast lowlands and Central Highlands. Rumored to have been found by villagers near Salinas la Blanca, not far from the Guatemalan border with Mexico, this Olmec figure depicts a standing Young Lord displaying symbols of rulership and decorated with complex iconographic design. The tall, lean proportions of the statue suggest it was carved from a slender slab of serpentine, and that the subject is a young man, perhaps an adolescent. The body, costume, mask, and symbols of authority are modeled, while secondary iconographic information is engraved in fine lines, now colored red.

The Young Lord stands in a formal, frontal pose with a rigid posture. The carefully modeled details of the clavicles, shoulder blades, rib cage, knees, and anklebones lend a subtle naturalism to the figure. The iconographic program is bilaterally symmetrical, and themes of dualistic opposition and confrontational pairing permeate the design. Four symbolic zones carry the iconography: the head, torso, thighs, and lower legs and feet.

The simple costume includes a headdress, ear ornaments, and loincloth. The figure wears a loaf-shaped helmet with a two-tiered sprouting element at top and a plain band with a central square ornament at the base. The elongated earflanges are decorated with large, unembellished spools. A waistband, tied in the back with a knot, encircles the figure's midsection. It has a large square element at the center and a rectangular apron attached. Flanking the loincloth are two rectangular projections, which probably represent pouches.

A mask representing the Olmec bird monster, god of sun and sky, covers the Young Lord's face. The deity is depicted with large eyes surmounted by flame eyebrows, a fleshy nose with flared nostrils, and a large open mouth with a prominent beak, upper fangs, and downturned corners. Short incised lines

213

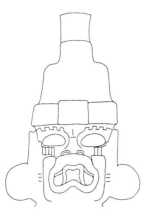

extend vertically from the eyes to the upper beak and horizontally from the mouth across the cheeks.

The Young Lord holds two Olmec symbols of authority against his chest. In his left hand is a scepter incised with a dragon profile. The supernatural creature has a flame eyebrow, and rounded eye with a defined iris and fringed border. The open mouth has a flared upper lip, partly obscured by the lord's hand, and a rounded chin. A cleft element rises from the back of the upper jaw. Below the dragon head a circle and a band indicate the binding that attached the scepter to its plain handle. The right hand of the figure holds a sacrificial knife. The leaf-shaped blade has serrated edges and, at the center, incised designs. At top is a raindrop motif, below which are two oval elements. At the center is a cleft rectangle with a double-merlon band and a lozenge-shaped element flanked by two circles. This may be an abbreviated version of the four-dots-and-bar motif. At the base of the blade is a circle containing a double-merlon symbol. The blade is attached to a handle formed by a bundle of stalks, bound with horizontal bands at top and bottom.

Additional designs are incised on the hands and arms of the Young Lord. The hand holding the scepter is decorated with a simplified, frontal face of a creature with a hoop-shaped head, small blank eyes, and a bracket-shaped mouth with a crossed-bands motif. The hand holding the knife has a similar design, but this creature has three circles across the forehead, eyes with flat bottoms and incised irises, and a mouth with an upturned bracket. These are the only frontal images in the composition. The heads contrast with each other. A bolder contrast divides the fluid, attenuated figures engraved on the Young Lord's forearms and biceps.

The left hand is embellished with a flying or floating human form with slender proportions. The arms are held away from the body, one flexed and grasping three pointed sticks, the

other straight. The legs are bent at the knees. It has an almond-shaped eye with defined iris and a mouth in the shape of the bird monster's beak. Circling the head is a two-part headband with paired celt-shaped corn motifs on the side and a round ball at the front. The band is held in place by a strap that extends across the top of the cranium. Behind the head is a large diamond motif, and in front is a cleft rectangle. The figure wears a cape with decorative border, a simple loincloth, and bands at the biceps, wrists, knees, and feet. Bands at the biceps

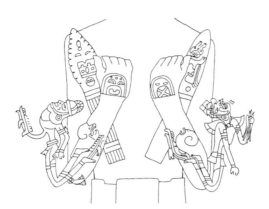

bind small celts close to the muscle. Emanating from the sole of the left foot is a were-jaguar profile head with a slit eye and scroll top, and a profile dragon head with oval eye, bulbous nose, elongated L-shaped jaw, and cleft upper fang. This engraved figure wears corn god headgear and holds a bundle of sticks reminiscent of the torch motif, associated with fertility. The fluid posture and maize deity iconography link this image with the floating figures incised on a number of jade and serpentine clamshell pendants from both the Pacific slope and the Gulf Coast lowlands (cat. 98).

On the right arm, a bound and sacrificed captive is depicted. Unique in Olmec art, this slender individual has a human face with almond eye, bony nose, and closed mouth. At the end of the chin is the suggestion of a beard. On the head is a helmet, held in place by a band and a chin strap; it has a fanlike device at the top. A circular ornament decorates the earlobe. The body is thin and elongated, and the arms are tied awkwardly behind the back. The legs are bent at the knees. Emerging from the exposed rib cage is a band terminating in a dragon head with flame eyebrow and round nose, L-shaped jaw, and curved upper fang. The figure wears a loincloth with tassel in front and bands on the wrists, thighs, knees, and ankles. A fan-shaped device with two tassels, similar to the helmet ornament, is attached to the right knee band. The feet are clearly defined and the toenails marked. From the sole of

the right foot comes a profile head of a supernatural with flame eyebrows, cleft upper fang, and elongated jaw. A simple were-jaguar profile with scroll head is attached to the monster's profile. Although this figure does not have the closed eye that usually signifies death in Mesoamerican symbolism, he has clearly been bound and disemboweled. The knife that must have been used in such human sacrifice is held in the arm just above the engraved figure.

The most complex iconographic design incised on the Young Lord's body appears on the thighs and upper legs. Wrapping around the limbs and buttocks are images of two downturned Olmec supernaturals, the dragon and fish monster, each with three profile heads and various symbolic elements in close proximity. The artist carefully positioned the design so that two pairs of profile heads confront each other on the front of the figure's thighs, the two zoomorphic deities appear vertically on the outer sides of the legs, and two profile heads face each other on the buttocks.

Engraved on the left leg is a downturned dragon with an enormous head and open jaws. The mythological beast has curvilinear flame

brows and an L-shaped eye and upper jaw. At the end of the snout is a flattened nose. Two cleft fangs and a scalloped line suggest the upper row of teeth. The short lower jaw is toothless and square at the end. The creature's elongated crocodilian body has a curved back and tightly flexed, powerful legs with paw-wing feet. Each haunch is marked with an eye motif and an oval element. The front leg wears a wrist band. Growing from the earth monster's underbody is a plant symbol. Embedded in the dragon's cleft hindquarters is the bird monster's profile head, looking toward the center of the body. The sky god's attributes include flame brows; L-shaped eye; flat nose; open mouth with prominent upper beak and downturned

tip; and groups of three lines, one extending from the eye to the upper beak and the other reaching from the mouth to the back of the head. The bird monster's head is remarkably similar to the avian deity mask worn by the Young Lord. Attached to the earth monster's body are three fleshy profile heads, each with low rounded top, pronounced folds of skin above the nose, and an L-shaped eye. The profile over the dragon's head has a pair of celt-shaped motifs, and the head attached to the bottom of the tail has those elements and a circle on the cheek. Joined to the rear is a third profile with an undecorated face. The final appendage to the dragon's body extends horizontally from the middle of the back and represents a supernatural's head with flame brows, L-shaped upper jaw, and curved top fang with cleft tip.

On the Young Lord's right leg, opposite the dragon, is a rendering of a downturned fish monster, god of the sea and lord of the realm of the dead. The creature has a large head, rectangular body, and bifurcated tail. The large rounded eye has an eyebrow plaque with cleft top and back. A curved form with single merlon occupies the center of the eye. The nose is large and flat. The blunt snout has a hammer-shaped tip; the lower jaw is scalloped and ends in a point. The undifferentiated upper tooth line ends in a bifurcated front fang. A second L-shaped upper tooth is shown with a cleft end. At the center of the fish monster's body is a crossed-bands symbol with cross-hatched center. The arms of the cross are decorated with oval motifs, with a curved form at one side. These may be disembodied eyes, similar to the death eyes of Classic Maya iconography. A row of four plain circles extends from the monster's jaw to the cross. Embedded in the base of the sea god's back and looking to the center of the figure's body is a profile head with an inverted crescent eye bisected by a hooklike element. Surmounting the eyes is an eyebrow element with double merlon at the top and a cleft projection at the rear. The head has a round nose and wide open mouth with flared upper lip, upper gumline with two short curved teeth, and downturned corner. The rectangular element framing the mouth has a cleft protrusion at the bottom corner. Just behind the head is a large oval design with a curved element at one side and a curved line at the center. This profile head with the hook bisecting the eye may represent the banded-eye god, an enigmatic deity whose image appears on the shoulder of the Las Limas Figure. At the base of the fish monster's body is a collarlike band decorated with a flame eyebrow and L-shaped eye. The bifid tail ends in curved, incised lines that suggest fins. An elongated

linear element with a circle at the end bisects the tail. Attached to the sea god's body are three profile heads with rounded contours. The examples above the fish monster's head and beneath the tail are closely related to the banded-eye god profile in the creature's hindquarters. Both secondary heads have a circle on the cheek; the one over the deity's head has a raindrop motif. The third profile above the tail is different from the rest. It has an almond-shaped eye, flat forehead, and pointed beard. The face has a rather sinister expression. Midway between the profile heads to the right of the fish monster is a strange zoomorph unique in Olmec art. It has an S-shaped body, trough eye with a pointed crest, and mouth with elongated pointed upper jaw and receding chin. Attached to the body is an oval element with a rounded form at one end and a curved line in the middle, perhaps to represent a *Spondylus* shell. The creature bears a striking resemblance to the oyster dragons depicted on the Late Classic Maya Tablet of the Slaves from Palenque. The scalloped shell motif appears twice more in close proximity to the fish monster. In one example, within the gaping jaws of the sea god, it has a fanlike element at one end, similar to the god's tail, and three circles at the other. The second example, to the left of the deity's midsection, is shown with a set of five short incised lines arranged in a row. The oyster dragon and shell motifs must have been symbols of the sea and the watery realm of the dead.

The fourth zone of iconographic design engraved on the Young Lord includes the lower leg and feet. Two profile heads carved on the middle of the shins face each other, and two heads of zoomorphic creatures decorate the feet at the base of the statue. On the figure's left shin is a head with were-jaguar features, including an almond-shaped eye with two celt-shaped corn symbols above, a rounded nose, and open mouth with downturned corners. The head is covered by a tight-fitting cap with a paw-wing motif, which dangles below the ear. A scroll emerges from the mouth, perhaps to indicate speech; in front of the nose is a lozenge-shaped motif. On the opposite shin is

a profile with rounded cranium and flat forehead with a fold of skin over the nose. The round eye is decorated with a star sign, perhaps to represent Venus. A double-scalloped motif appears behind the eye, and the low nose sits atop the prominent upper jaw. Inside the mouth is an upper gum ridge and single fang. The chin comes to a point, indicating a beard. Extending from the lower jaw are curved lines that suggest the fins on the fish monster's tail. From the mouth emerges a scroll element that forms an upward-looking profile head with rounded top, slit eye, bulbous nose, and crossed bands over the mouth. Encircling the feet and ankles are two supernatural profiles. On the left foot is a dragon head with flame brows, trough-shaped eye, bulbous nose, and elongated upper jaw. In front of the head is a raindrop motif, a cleft rectangle, and curved lines. On the right foot is a profile of a creature with elongated eye, pinched at the back with scalloped upper eyelid, above which is an eyebrow plaque of rounded form with cleft elements at the top and back, and a diamond symbol at the center. The creature's upper jaw is shown with bracket tooth marking and a single upper curved fang. A raindrop sign and cleft rectangle are in front of the profile.

The statue of the Young Lord is the richest and most complex Olmec iconographic image yet discovered. Many of its general themes and individual motifs link the sculpture to important Olmec works of art from other areas. Certain aspects of the figure are unique to this carving, perhaps reflecting symbolism associated with its original function or a vocabulary of motifs specific to the Pacific slope region. The iconography of the Young Lord is positioned on the figure from the neck down, where the human body is naturally divided into paired components. Generally, the symbolism contrasts left/right, earth/water, life/death. More specifically, its imagery stresses binary oppositions between scepter/ dagger, corn god/human sacrifice, bird monster/banded-eye god, dragon/fish monster. The left side of the sculpture links agricultural fertility, sun, earth and life; the right side concerns blood sacrifice, darkness, water, and death. The ancient Mesoamerican concept of the unity of opposites is also celebrated here. There can be no corn harvest without the nourishment of human sacrificial blood, no productive fields without the fertilizing powers of rain and water, and no cycle of existence without both life and death. The Young Lord seeks to balance these oppositions and mediate between the supernatural world and the human community.

However, the Olmec ruler did more than just claim the power to balance the opposing forces

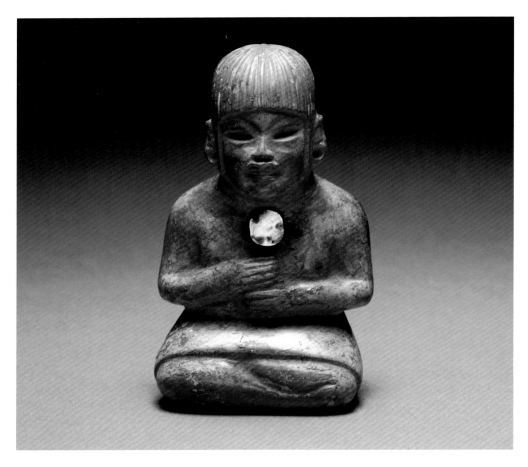

52. Seated Figure Wearing Elaborate Headdress and Cape

Middle Formative Period
Diopside
16.3 (6⁷/₁₆)
Río Pesquero, Veracruz
Dumbarton Oaks Research Library and Collections, Washington, D.C.

This figurine is an official portrait. A man is seated cross-legged with hands on knees, a common pose with important Olmec people. The face is slightly asymmetrical and very lifelike. It is particularly naturalistic and appealing in its setting of stylized carving and multiple complex symbols that must have stood for all the spiritual and political power of this man.

This small piece is comparable to monumental portrait sculpture—for example, San Martín Pajapan Monument 1 (cat. 5), La Venta Monument 77 (cat. 10), and what remains (the head) of La Venta Monument 44 (de la Fuente 1984: fig. 37). Most Olmec figurines are not carved to show clothing, but were probably dressed with actual miniature cloth garments for different occasions. This and some other small portrait representations are dressed as elaborately as comparable monumental figures.

The head, the most important part of the body, is, even without the headdress extension,

that together rule the cosmos. He claimed to be a god incarnate. Above all the oppositions depicted on the Young Lord's body is the image of the Olmec sun god. By wearing the avian divinity's mask, the Young Lord became the solar deity himself. Many ancient rulers have identified themselves with the sun. Crossing the sky during the day, the sun descends into the underworld at night and is born again at dawn. The solar transit has been a symbol of the cycle of birth, death, and rebirth for many ancient peoples. By embodying the sun god, the Young Lord claimed the power to join the Lord of Heaven on his eternal journey.

Although some researchers have offered interpretations of the Young Lord based on the premise that shamanism is a central factor in Olmec ideology (Princeton 1995: chap. 6), other scholars believe that the statue presents a particularly complex, but far from unique, statement of the iconography of Olmec rulership. From this perspective, the figure portrays a young man's accession to power. He wields scepter and dagger, the sacred symbols of authority. Blessed by the most important gods in Olmec religion, the young ruler occupies the fertile center of the universe, balancing the opposed powers of the cosmos, and resolving the dualistic forces that underlie all existence. Ruler and priest in one, the Young Lord assumes the burdens and authority of office.

P.D.J.

51. Seated Female Figurine with Polished Hematite Disk

Middle Formative Period
Jade and hematite
7.5 x 4.4 x 3.5 (2¹⁵/₁₆ x 1³/₄ x 1³/₈)
La Venta, Tabasco
Museo Nacional de Antropología, Mexico City

During the 1942 excavations at La Venta, a tomb was discovered with walls, roof, and floor of monolithic basalt columns (Stirling 1943b; Drucker 1952). Various celts and mortuary caches were found inside on a floor of stone fragments. The second burial had some bones and teeth, together with other objects, among them an exceptional figurine of a female—a rare representation. This figurine wears a mirror on her chest, similar to those seen on Olmec priests; this may indicate her role as an important woman in Olmec society.

Associated with this same offering were other pieces, some small: jade bracelets, a jade perforator, a disk with a central perforation, fragments of the spine of an aquatic animal, a shark tooth, and some tubular jade beads.

M.C.-L.

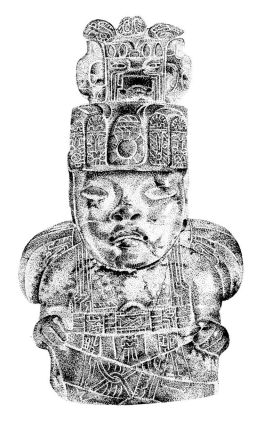

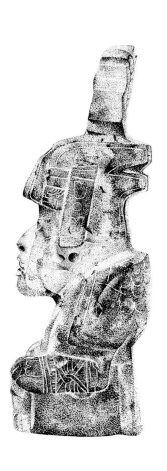

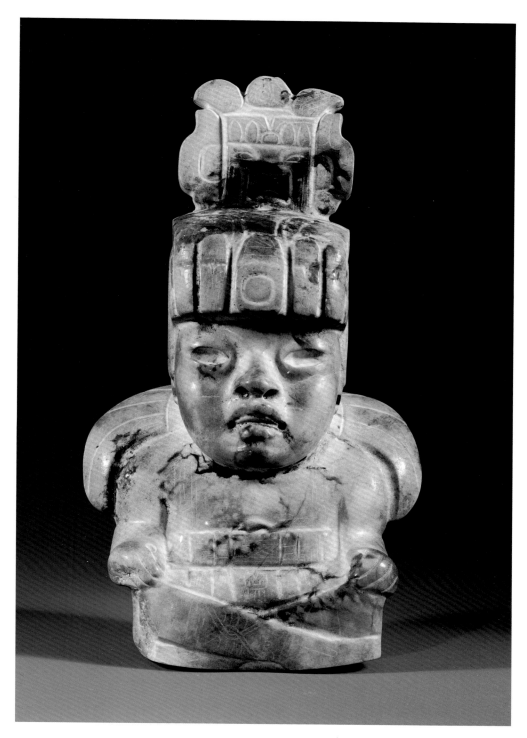

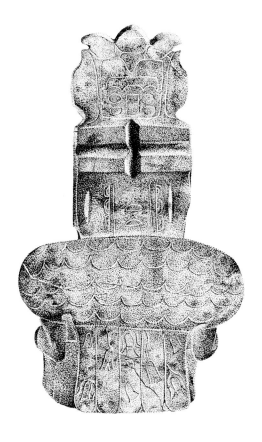

longer than the seated body. The body and costuming are merely surfaces for symbolic elements, and almost the entire surface of the piece is incised with various glyphlike designs (Benson 1971). Meanings of Olmec motifs are still under discussion, but no one who works with them doubts that they have specific meaning (see Joralemon 1971, 1976; Fields 1991; Reilly 1991). On this figure, motifs appear in fours: on the sides of the headdress, on the arms and legs. The four cardinal directions were of great importance to early peoples in the Americas, and they often serve as a basic iconographic framework. There are strong arguments for the face on the plaquelike head-

dress extension as being that of the maize god. The trefoil design depicts vegetation, perhaps specifically maize. The crossed-bands motif, a cosmic diagram, appears on the pectoral and the "belt."

Later, Maya rulers dressed as maize gods (Miller 1991), a custom that must have begun in Olmec times, if not earlier. Olmec rulers also obviously wore attributes of the most important staple food for ancient American civilizations. Karl Taube (in press) sees the cleft-celt shapes as representing maize ears.

This figure is said to have been found in a large cache of stone objects, mostly jade masks and celts (Benson 1971).　　　　E.P.B.

53. Figure Seated on a Throne with Infant on Lap

Middle Formative Period
Serpentine
11.4 x 5.7 (4½ x 2¼)
Tabasco
The Metropolitan Museum of Art, The Michael C. Rockefeller Memorial Collection, Bequest of Nelson A. Rockefeller, 1979

The presentation of the were-jaguar infant is an iconographic theme well documented in Olmec monumental sculpture on impressive thrones from San Lorenzo and La Venta. The Las Limas Figure (cat. 9) provides the most complete and undamaged representation of the concept.

This small serpentine carving depicts an Olmec male seated on a cloud throne holding an infant. The figure has an oversized head with Olmec features and well-defined coiffure with incised detail. At the sides of the head are large earflanges with drilled lobes. He sits upright on a throne with two legs and a rectangular top with scroll ends. The baby has Olmec facial characteristics and a rigid, sexless body with extended arms and legs. No ornaments or costume elements are indicated.

Figures seated on cloud thrones have been found at Tres Zapotes (Princeton 1995: fig.

139) and in the Guatemala highlands (Brussels 1992: pl. 164), although these are thought to date to the Late Formative period or even the Protoclassic era. The thrones resemble the thundercloud motifs pictured on Relief 1 from Chalcatzingo.

This infant has features and body proportions more like the hollow ceramic "babies" than the were-jaguar beings. The remarkable rigidity of this baby is reminiscent of the ceremonial bar held in the lap of the elaborately costumed figure in Chalcatzingo Relief 1. The cloud motifs on the thrones duplicate the rain symbolism that accompanies the presentation theme at La Venta and Chalcatzingo. Whether infant deity or human sacrifice, the presentation of the child is linked to rain and its fertilizing power. P.D.J.

54. Seated Figure Carrying Torch and "Knuckle-Duster" Motif

Middle Formative Period
Albitite
11 (4⁵⁄₁₆)
Unknown
The Cleveland Museum of Art, Purchase from the J. H. Wade Fund

Carved from pale green albitite, this marvelously fluid human figure sits on an oval pedestal and holds two ritual implements in his hands. The elongated head has a rounded top and a slightly constricted forehead, which suggests cranial deformation. The almond-shaped eyes are set far apart, and the nose and mouth are naturalistically modeled. Large rectangular earflanges with drilled lobes extend from the sides of the head. The figure sits in a casual posture with his left leg hanging over the pedestal and the right sharply flexed. In the left hand the figure grasps a ritual object scholars have termed a "knuckle-duster." Weapon or ceremonial implement, it is grasped at its center, with a curved section in the hand and a rectangular extension at the base. "Knuckle-dusters" usually have a vertical extension above the hand hold, but this is missing here. The figure's right hand grasps a bundle with a budlike top decorated with chevrons; this motif is usually called a torch. Although certain figures in Olmec art are shown with one or the other of these two motifs, they are often depicted as an iconographic pair. They are particularly common on flying figures incised on clamshell pendants who usually wear the corn god's headgear (cat. 98). The complex design on the Chalcatzingo vase depicts two richly detailed examples of these motifs, flanking a central bundle with sprouting top. Because many examples of the torch motif have budlike tops or sprouting

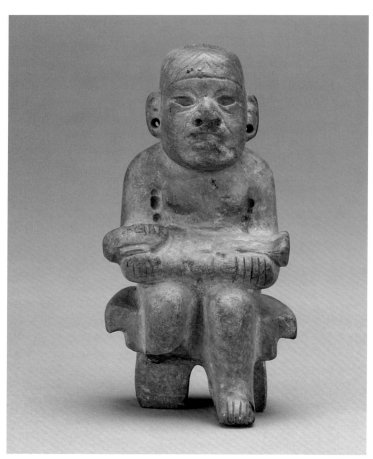

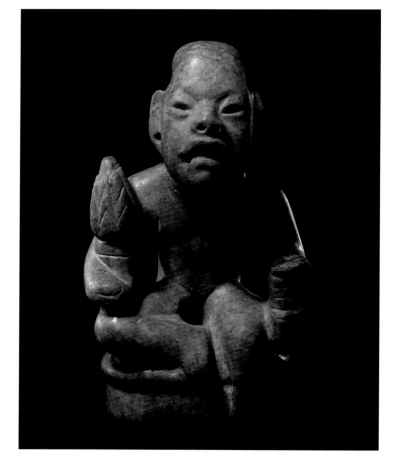

218

motifs, it is probably associated with corn and agricultural fertility. Likewise, "knuckle-dusters" are closely linked to maize symbolism. They flank the were-jaguar corn god head shown on the Dumbarton Oaks Río Pesquero figure (cat. 52) and appear on the related celts supposedly from Chiapas and Guerrero (cats. 118, 119). Both of these paired motifs are clearly part of the iconography of corn fertility, which is so prominently represented in Olmec art.

P.D.J.

55. Seated Figure with Upraised Knee and Incised Face

Middle Formative Period

Serpentine

18.4 x 13.7 x 7.8 (7¼ x 5⅜ x 3¹/₁₆)

Puebla

Dallas Museum of Art, Gift of Mrs. Eugene McDermott, The Roberta Coke Camp Fund, and The Art Museum League Fund

Discovered in the early 1950s near Tlaxaca, in the Mexican state of Puebla, this deep green serpentine statue is a masterpiece of Olmec craftsmanship. The figure is seated upright with one leg raised and tightly bent and the other lying close to the ground, flexed so that the sole of the left foot rests against the side of the other. The figure's left hand rests on his leg, while the right arm rests casually on top of the upraised knee. The oversized head has an elongated shape and a high domed top. The constrictive band, which encircles the head, is

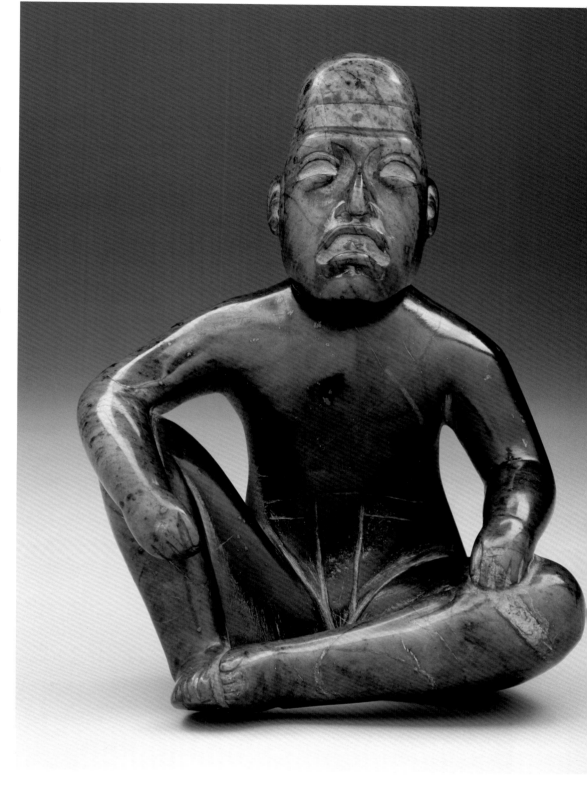

held in place at the back by crossed bands with a celt-shaped object at its center. Seen in profile, the figure shows obvious signs of cranial deformation. The face is broad with heavy cheeks and a protruding rounded chin. The deeply carved eyes curve down at the outer edges. Engraved lines mark the upper eyelids, and the lower eye sockets are swollen and puffy. The narrow nose has a curved profile and flared nostrils with drilled holes. The open trapezoidal mouth has a thin flared upper lip, protuberant lower lip, and downturned corners

with a row of clearly marked upper teeth. The small ears are naturalistically modeled with internal contours and drilled earlobes. The head rests directly on the torso, lending a monumental appearance to the statue. The chest is broad and minimally modeled. Around the middle is an engraved waistband with loincloth. The fingers and the arms are indicated with short grooves. The contours of the figure are round and smooth. The large openings that separate the legs and divide the arms give the figure a natural appearance. The modeling

suggests an aesthetic derived from the fluid volumes of ceramic figurines rather than the rigid forms of stone figures.

The rich green color of the serpentine is accentuated by the high polish of the surface. Although the sculpture was painted with red pigment before burial, the color remains only in the roughened creases and carved portions of the figure.

Decorating the right half of the face is an incised design. Above the eye is the cleft-headed frontal face of a were-jaguar, with almond-shaped eyes and a trapezoidal upper lip. A partially worn profile head appears on the left. Below the eye and extending across the cheek is a rectilinear double-scroll motif. With its distinctive iconography, the figure has been labeled the Lord of the Double Scroll.

This design appears on a group of jade and serpentine carvings, all of which have similar features. These sculptures include a fragmentary serpentine figurine, now in a private collection (Princeton 1995: fig. 22); a small serpentine mask from Guerrero, formerly in the Constance McCormick Fearing Collection (Covarrubias 1957: pl. x, lower right; fig. 35, lower right); a white mask pendant (cat. 92); a broken mask pendant with golden brown stain from Guerrero, now in a private collection; a small fragmentary maskette in the Metropolitan Museum of Art; and an incised jade spoon from Río Pesquero in the Guennol Collection (New York 1982: fig. 118). Although it is possible that the features represent a style of figure popular at a certain time or place, it is more likely that the double scroll is an iconographic symbol for a specific individual. P.D.J.

56. Reclining Figure with Hand on Head

Middle Formative Period
Serpentine
11.2 x 5 (4⁷/₁₆ x 1¹⁵/₁₆)
San Cristobal Tepatlaxco, Puebla
Dumbarton Oaks Research Library and Collections, Washington, D.C.

The large and carefully carved head of this figure has characteristic Olmec traits: an inverted-U mouth; puffy, slanting eyes; a long, flattened skull; and earlobes drilled for ornaments. The hands, one facing outward at the left ear and one across the chest in a pointing gesture, are also carefully carved. The body, with feet together, is flat, slack, and small. Buttocks and penis sheath are incised. This proportion of large head and slight body is typical of many Olmec pieces.

This figure has been described as reclining; it has also been called a man doing an *entre-chat* (see Benson 1981b: 98–99). It can be suspended easily in either a horizontal or a vertical position. The only drilling is through the earlobes.

Similar stone or clay figures come from a wide range of places away from the Gulf Coast: Guerrero, Central Mexico, Michoacan, and Honduras (Bernal 1969: pl. 74a–d; Easby and Scott 1970: nos. 8–11). The ceramic versions are clearly reclining; some represent women. The stone examples, although presumably male, show no genitalia. Acrobats, contortion-

ists, or dancers in related poses are also depicted in stone and clay (cat. 25). Such figures surely had ritual, shamanic meaning. Later Maya rulers are shown on monumental sculpture with a bent knee in what has been interpreted as a "dance of death" (Schele 1988).

This figure was broken across the shoulders in the past; its two sections were found several years apart. E.P.B.

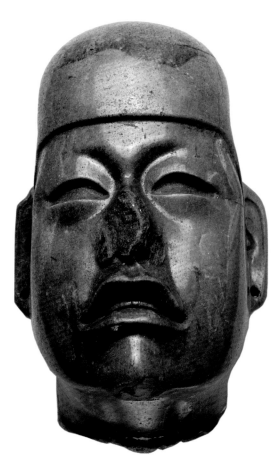

57. Elongated Head

Middle Formative Period
Jadeite
21.5 x 13 x 10 (8⁷/₁₆ x 5¹/₈ x 3¹⁵/₁₆)
Tenango del Valle, Mexico
Museo Nacional de Antropología, Mexico City

This piece became part of the museum collection in the mid-1950s. It is a beautiful example of Olmec-style sculpture as reflected in its facial characteristics and stone workmanship. The shaved head with a half-open, down-turned mouth, and almond-shaped eyes with slightly protruding eyelids, is typical of Olmec sculpture. M.C.-L.

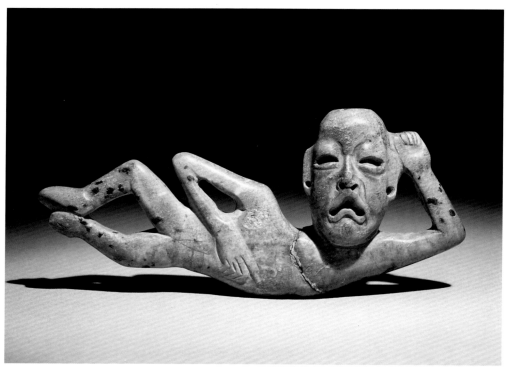

58. Bust with Long Hair

Middle Formative Period
Jadeite
6.6 x 3.8 (2⅝ x 1½)
Unknown
Dumbarton Oaks Research Library and Collections,
Washington, D.C.

59. Head Fragment with Incised Design

Middle Formative Period
Jadeite
7.3 x 6.2 x 4.9 (2⅞ x 2⁷⁄₁₆ x 1¹⁵⁄₁₆)
Unknown
The Cleveland Museum of Art. Purchase from the
J. H. Wade Fund

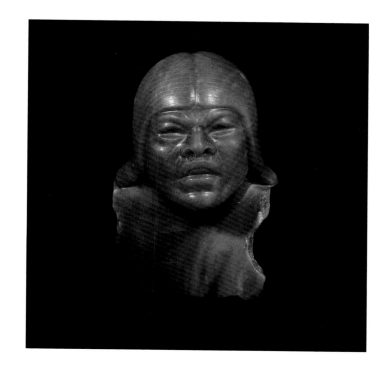

Cat. 58, a very small, superbly carved bust of
fine blue jade, broken from a figurine, is one of
the strongest Olmec portraits. When magnified,
it looks like a monumental sculpture. The face,
with frown lines, cheek wrinkles, and slightly
skewed nose and mouth, is that of someone
accustomed to both power and worry, depicted
perhaps at a time of intense ritual activity.
It is remarkable that a carving that would
require so much time and effort could have
such spontaneity.

This bust has been described as male and
as female (Benson 1981b: 99–100). The fea-
tures are strong, rather heavy and masculine,
but, because of the long, finely incised hair
with center part, some have described it as
female. The Las Limas Figure (cat. 9) and
another seated figure (cat. 53) raise a similar
question; they are probably masculine. A few
portrayals of old women with hair exist
(Joralemon 1981). Male transformation figures
may show hair (cat. 67), but standing stone
figurines (cat. 42) and ceramic "babies" (cats.
20–22) are usually hairless, or they wear caps.
Some ceramic figures have asymmetrical hair
styles. Monumental figures often wear head-
dresses or helmets (cats. 1, 2, 10, 17). There are
precedents for long hair, however, and the jade
bust probably depicts a male.

Figurines of jadeite or serpentine usually
stand or sit in stylized, symmetrical, frontal
poses. The proper left shoulder of cat. 58 is
slightly forward, indicating that the body was
in a somewhat twisted position. Other Olmec
figurines suggest possible interpretations of the
pose: some "transformation" figures (cats. 69,
70) and a seated figure (cat. 55). Monumental
sculptures such as the Wrestler (cat. 11),
Laguna de los Cerros Monuments 3 and 11

(de la Fuente 1984: pls. 57, 58), and a newly
discovered sculpture at Xochiltepec, near San
Lorenzo (Cyphers Guillén 1992b: figs. 2, 4),
have similar shoulder positions. These figures
exhibit a variety of poses and activities, but
they do not help with a specific explanation for
this figure.

Much less remains of the fragmented head
from the Cleveland Museum (cat. 59), but this
small piece is also very strong. It may have
come from a stylized standing figure like those
in cat. 42. The face is more conventional and
less of an individual portrait than that of cat.
58, yet it projects a remarkable intensity.

The open mouth, with clearly carved teeth,
has a slightly squared upper lip, reminiscent of
those on supernatural faces. Just forward of
each ear a profile face is faintly incised, and
each is slightly different. The incised profile
echoes the stone profile, and the ear of the
figure forms a "skull" for this incised face.
Miguel Covarrubias sketched this head and
the incised profiles. His drawings are in the
Cleveland Museum of Art (Hawley 1961: fig. 2);
slightly different, more recent drawings have
been made at the museum.

A number of Olmec faces have a supernat-
ural profile incised on the cheek, which may
indicate some special power residing in the
person portrayed. E.P.B.

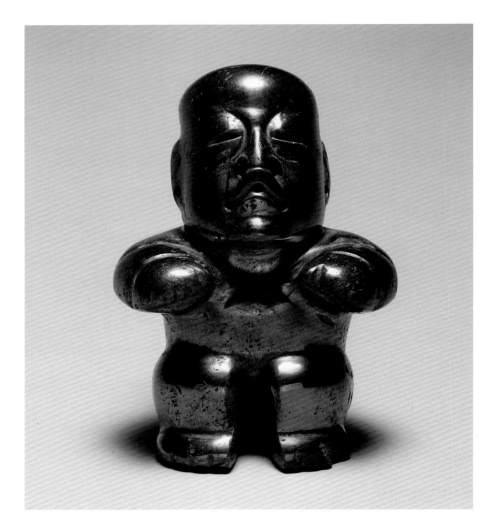

60. Seated Dwarf with Arms Extended

Middle Formative Period
Hematite
11.5 x 8 (4½ x 3⅛)
Unknown
Wadsworth Atheneum, Hartford, CT. The Henry D.
Miller Fund

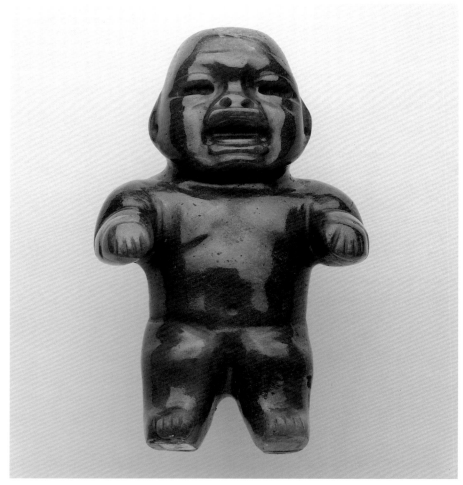

Hematite is an iron-ore mineral that can be
polished to a mirror shine. Olmec lapidaries
used it and other iron ores to make concave
mirrors and manufacture inlays for shell orna-
ments. This is the only sculpture yet discovered
that is carved from this exotic material. Illus-
trated in Pal Kelemen's pioneering study of
Pre-Columbian art (1943), this statue depicts
a seated human figure, probably a dwarf, with
massive head and powerful squat body. The
squarish head has soft, fleshy features. The
elongated eyes are deeply carved, the wide
nose has a flat tip with drilled nostrils, and the
triangular mouth has a flared upper lip and
downturned corners. Rectangular earflanges
with incised channels and drilled lobes jut from
the sides of the head. By joining the enormous

head directly to the broad, thick torso, the sculpture's stoutness is emphasized. The short stocky arms are outstretched and the powerful legs are spread apart and held close to the body. Hands and feet are rendered in simple rounded forms with incised lines indicating the fingers and toes. Although the statue's sex is not marked, it clearly has the stocky bulkiness of a male.

The hematite sculpture's proportions and posture resemble those of the finely carved jade dwarf excavated in the Cerro de las Mesas cache (cat. 61). Although the iron-ore piece is considerably more massive than the jade, both carvings probably represent the same Olmec being. It is likely that these figures portray the same stout dwarfs depicted on Potrero Nuevo Monument 2 (cat. 3). The paired atlanteans are earth-bearers who support the middle plane of the cosmos. They have the same oversized heads, stocky bodies, and powerful legs shown on the two smaller stone statues. P.D.J.

61. Standing Dwarf with Flexed Arms

Middle Formative Period
Jade
12.1 x 7.5 x 4.5 (4³/₄ x 2¹⁵/₁₆ x 1³/₄)
Cerro de las Mesas, Veracruz
Museo Nacional de Antropología, Mexico City

In the rich offering found during the 1941 season at Cerro de las Mesas was a beautiful small figurine of clear Olmec style, carved in jade of an extraordinary color. Some of the most interesting representations of pre-Hispanic religious figures were the child-dwarfs, who are seen kneeling and in the arms of priests in anthropomorphic sculptures on the La Venta altars and on the stone altar of Potrero Nuevo, Veracruz (cat. 3).

The plump body with the small extremities emphasizes a massive torso. The head is carved with great skill and simplicity, and is, as in many Olmec works, the center of this piece. The head shows typical Olmec cranial deformation. The wide-open mouth is highlighted by its raised upper lip, as if it were emitting a loud cry. The eyes are like holes, and the nose is marked by deep cavities. The unadorned body is naked, without genitalia.

The significance of small beings for the Olmec is lost, except in the *cosmovisión* of some modern indigenous groups of the Veracruz isthmus who call them *chaneques*, beings who live in the underworld and are identified with the jaguar. M.C.-L.

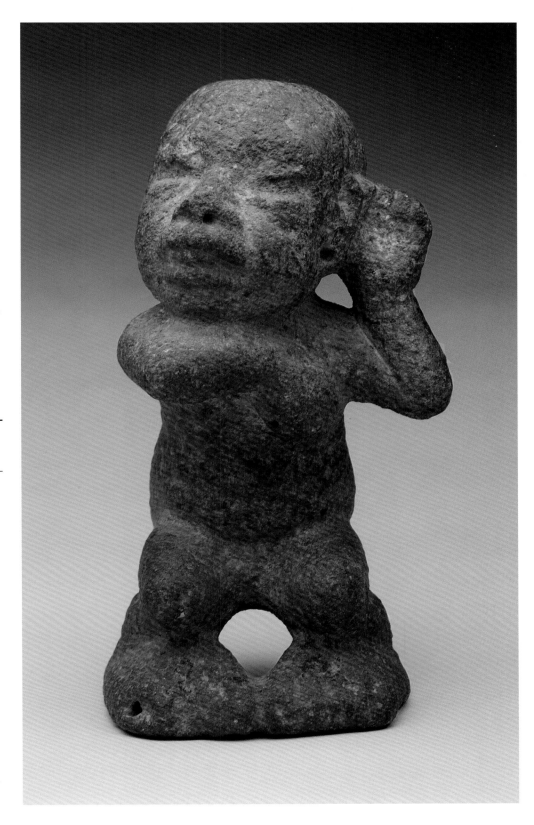

62. Standing Dwarf with Hand to Ear

Middle Formative Period
Stone
18 x 10 x 11 (7¹/₁₆ x 3¹⁵/₁₆ x 4⁵/₁₆)
Gulf Coast
Museo Nacional de Antropología, Mexico City

Images of people with physical deformities, such as hunchbacks and dwarfs, have been excavated at some Olmec sites, including La Venta. While this example does not have precise provenance, it possesses the characteristics of Olmec objects of this class. The face presents all of the Olmec physical features clouded by an expression of infirmity; his hand placed at the ear seems to indicate an aural deficiency. M.C.-L.

223

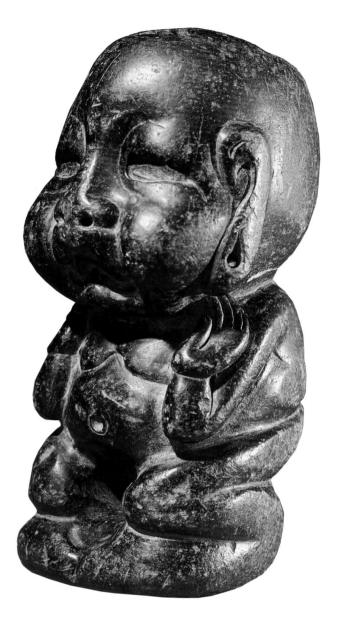

63a

Olmec-style figurines depicting dwarfs have been found in many places (see cats. 60, 62, 64). Cat. 63a is somewhat larger than most. The septum and the lobes of its figure-eight-shaped ears were drilled for ornaments. The head appears to be bald. Puffy cheeks crowd the large eyes, and the receding jaw pulls the nose and mouth down: the mouth has the typical Olmec squared-off extension. The left hand, palm out, is raised to the chin; the left arm is broken. A large, hollow drill was used to perforate the space between the legs. The top of the head was hollowed out probably at some later time. It has been suggested that this was done to convert it to the kind of incense burner used in Early Classic times in the department of El Quiché (Easby and Scott 1970: no. 36). If this is so, the figurine would have appeared in highland Guatemala a considerable length of time ago, if one assumes that it had been made elsewhere.

Cat. 63b is a small figure of highly polished talc. It has a large torso and spindly legs, with fringe around the ankles. The hands are together at the chest. The odd-shaped ears are drilled.

La Venta Monument 5 represents a dwarf with a similar face holding a box, likely for offerings (de la Fuente 1984: fig. 36). Potrero Nuevo Monument 2 (cat. 3) shows two dwarfs in Atlantean pose, holding up a probable sky band. People with physical deformities had special significance for most Pre-Columbian groups. Such people were thought to have unusual, supernatural abilities. On the monuments, they are given important tasks.

David Joralemon (1976) associates agnatic dwarfs with his God III, the Olmec bird monster, who is associated with the heavens, maize, and agricultural fertility. Some of the Olmec dwarfs are incised with maize designs (Joralemon 1976: 52, fig. 20f). E.P.B.

63a. Crouching Dwarf

Middle Formative Period
Blackstone
24.8 (9¾)
El Quiché, Guatemala
National Museum of the American Indian,
Smithsonian Institution

63b. Crouching Dwarf

Middle Formative Period
Talc
9.3 x 3.9 (3¹¹/₁₆ x 1⁹/₁₆)
Unknown
Dumbarton Oaks Research Library and Collections,
Washington, D.C.

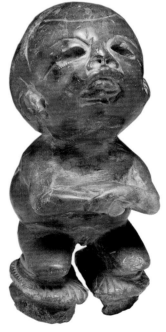

63b

64. Stooped Dwarf

Middle Formative Period
Basalt
19.1 x 10.2 x 11.4 (7½ x 4 x 4½)
Unknown
The Brooklyn Museum, Dick S. Ramsay Fund 75.89

Miguel Covarrubias (1946: 81, pl. 12) wrote of Olmec dwarf figurines from various parts of southern Mexico, carved from different kinds of stone. These figures usually have puffy cheeks and severely receding jaws. The noses tend to be flattened, the eyes squinty or drooping, the mouth pulled in toward the neck.

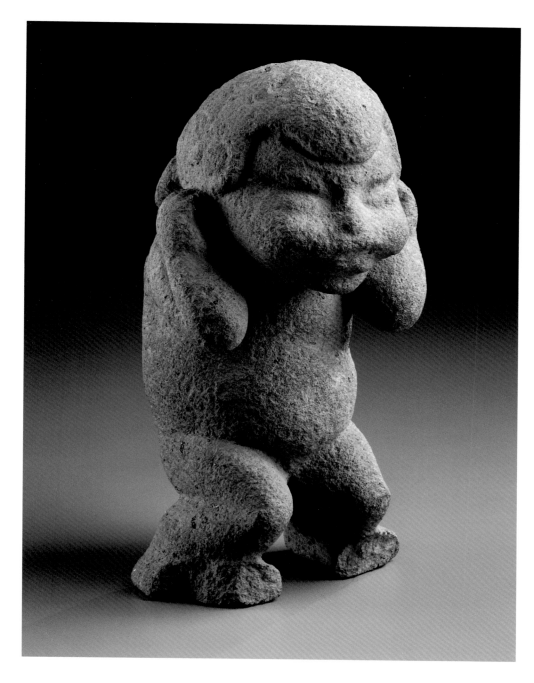

plants or stalks bound with a tie with glyphic meaning. The ties are similar to those seen on Maya bloodletters (see Joralemon 1974; Joyce et al. 1991: 144–145; Reilly 1991: 156). The association between blood sacrifice and agriculture is strong. Dwarfs were depicted on later Maya monuments along with rulers (Miller 1985). This dwarf is carrying a motif of royal insignia. The raised hands may be ready to steady the burden he carries. E.P.B.

65. Kneeling Muscular Figure with Beard

Middle Formative Period
Jade
8.9 (3½)
La Lima, Ulua Valley, Honduras
Middle American Research Institute, Tulane University, New Orleans, Louisiana

This figurine is smaller than most kneeling figurines (see cats. 66, 67) and different in other respects as well. The face is broader and less Oriental-looking than most, the nose and mouth larger. The body is heavy and muscular; the fists that rest on the thighs are large. The carving was probably made away from a major center of Olmec art. The pose is characteristic, however, and the figurine is carved with skill to express liveliness and potential energy: the figure seems about to rise.

The earlobes are drilled, and there is a drilling in each hand. The carving of the skull indicates artificial flattening.

This figure may belong to the group of the

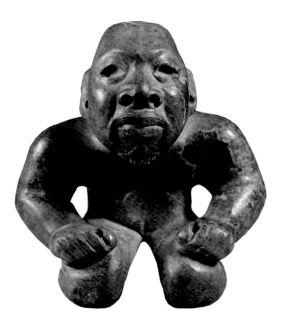

Some dwarf figures may be hunchbacked. Some figures are club-footed; some feet make a sort of platform, others are large or "fringed" around the ankles. The heads often have a distinctive, wiglike hairline. Hand positions vary; hands are usually at the ears or the chest (see cat. 62). The knees are bent, and the figures are frequently knock-kneed or pigeon-toed. There must have been ritual pantomime meaning in gestures and postures recorded in stone.

Covarrubias might well have associated these figures with the *chaneques* he described as tricksters who belong to modern folklore on the Veracruz coast. *Chaneques* are very old dwarfs with baby faces. They were the masters, or owners, of game animals and fish; they lived in caves or behind waterfalls, where they hid the best maize and other treasures. They could

be dangerous to man, but, if treated properly, might produce rain (Covarrubias 1946: 98–99). In 1993, when a carving of bright-green jadeite, depicting a left footprint, was found at the newly discovered Olmec site of El Manatí, the local people said that the foot was evidence of the presence of *chaneques* (Stuart 1993: 92).

Cat. 64 is of rough reddish basalt. The feet are broken off. Circles incised on either side of the head may be part of a tumpline, for the figure bears on its back an object comprising verticals crossed by horizontal bands. The same motif makes up the body of a maize god scepter (cat. 104; see also Joralemon 1971: fig. 183); a similar configuration appears on the scepter held in the right arm of a figure found in Guatemala (cat. 50). The motif seems to represent a ritually wrapped bundle of maize

transformation figures, which are sometimes kneeling and often bearded, unlike most other figures. A correlation between beards and jaguar transformation may relate to the jaguar's hair or whiskers, but it may also relate to sprouting maize. It is not known on what occasion the transformation ritual took place. Amerindians have less facial hair than many other groups, and hair has special significance. Maya sculpture shows bearded portraits of rulers, and Maya ritual chiefs may still grow beards for special occasions.

E.P.B.

66. Kneeling Bearded Figure with Incised Design on Forehead

Middle Formative Period
Gray stone
17.5 x 15.5 x 9 (6⅞ x 6⅛ x 3⁹/₁₆)
Veracruz
The Art Museum, Princeton University, Gift of Mrs. Gerard B. Lambert by exchange

67. Large Kneeling Figure with Beard

Middle Formative Period
Serpentine
29.3 (11⁹/₁₆)
Puebla
Anonymous loan

A lifelike, subtly carved portrait, with a sense of potential movement, cat. 66 shows a man kneeling with legs apart, leaning slightly forward with his elbows somewhat bent and his hands resting on his knees (Reilly 1989). His toes are shown at the rear, under his body. The strongly modeled face is clearly that of a man of power. The eyes were probably originally inlaid; the ears are drilled. The chin is damaged; there may have been a small beard. Hair is incised in two feathery tiers.

The figure is unclothed; as is often true in Olmec art, no attempt was made to depict genitalia. Remains of a coating of red pigment are concentrated on the face, lighter on the body; color is absent where a loincloth or kilt of perishable material was once placed. The putting on, taking off, and changing of clothing—on people and on sculpture—may well have been a part of ritual.

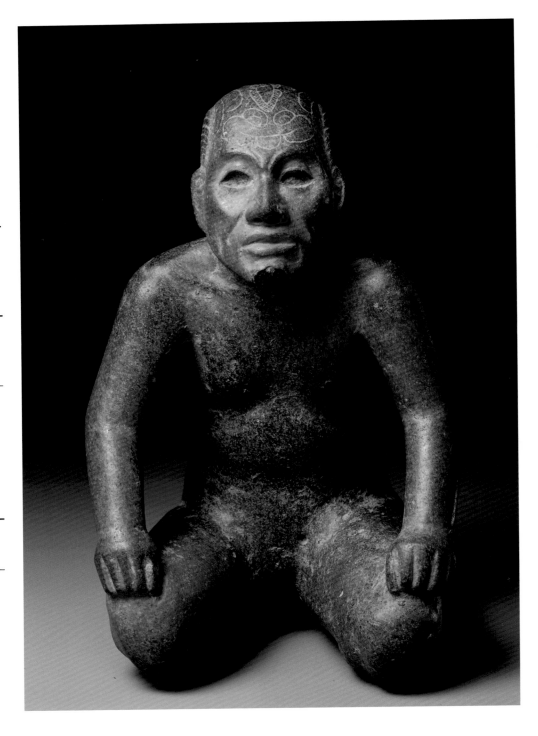

The smooth, bald dome of the head of cat. 66 has been incised with a stylized toad design, probably *Bufo marinus*, the giant, or marine, toad. This widely distributed, large toad is highly toxic; from the venom in its parathyroid glands a psychoactive drug can be made. Considerable quantities of *Bufo marinus* remains were found in the excavations by Michael Coe and Richard Diehl at San Lorenzo (Wing 1980).

This figure does not show evidence of transformation, but it takes a pose typical of jaguar-transformation figures (cats. 68, 69), and it may well be a depiction from the beginning of the process, with the toad incising as evidence of the means by which the transformation will be achieved.

Cat. 67 takes the same pose. There is no overt evidence of transformation here, but this figure may belong to that group. It is certainly engaged in a ritual moment, perhaps a moment of preparation.

Cat. 67 is unusually large. The figure sits calmly, looking upward. The eyes may have been inlaid. Flowing hair and beard are finely incised. The beard looks as if it might have been a false one attached under the jaw of the model. Some Maya sculptures show an apparently false beard. Indians have little facial hair; hence, the false beards. Both hands of this figure, which rest on the knees, may have been intentionally damaged. There is also damage at the top of the head and elsewhere on the body.

E.P.B.

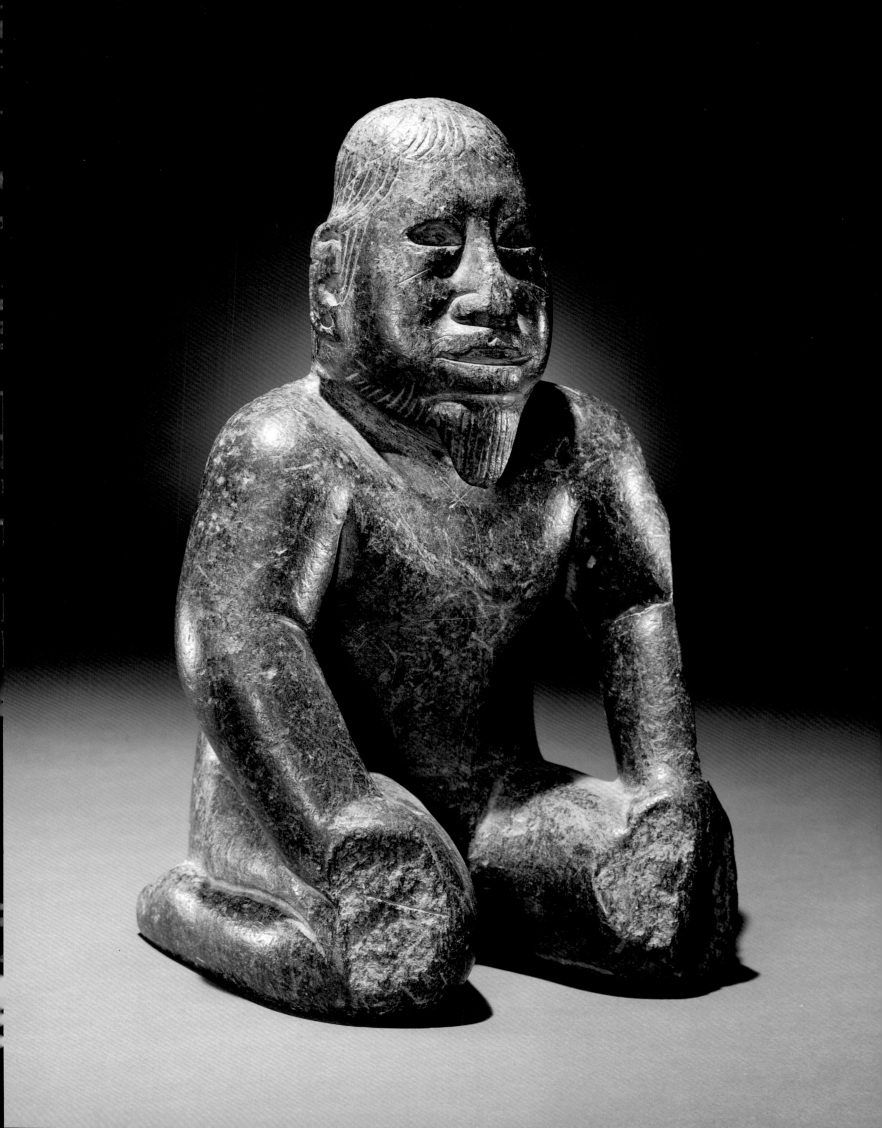

68. Kneeling Transformation Figure with Jaguar Features

Middle Formative Period
Serpentine
19 x 9.7 x 10.6 (7¹/₂ x 3¹³/₁₆ x 4³/₁₆)
Puebla
Dumbarton Oaks Research Library and Collections,
Washington, D.C.

69. Kneeling Transformation Figure with Jaguar Features

Middle Formative Period
Serpentine
11.4 x 7.9 (4¹/₂ x 3¹/₈)
Guerrero
Los Angeles County Museum of Art, Gift of
Constance McCormick Fearing

70. Standing Muscular Transformation Figure

Middle Formative Period
Serpentine
18.8 x 10.5 (7³/₈ x 4¹/₈)
Veracruz
Dumbarton Oaks Research Library and Collections,
Washington, D.C.

71. Standing Jaguar Transformation Figure

Middle Formative Period
Serpentine
8 x 4.5 (3¹/₈ x 1³/₄)
Veracruz
Dumbarton Oaks Research Library and Collections,
Washington, D.C.

Ethnographic literature from the tropical
Americas is rife with references to shamanic
transformation, especially into a jaguar, and
usually with the ritual use of a psychotropic
drug. This concept must be deeply rooted in
the prehistory of the Americas. Kent Reilly
(1989) has suggested that these figures, and
other similar ones, can be arranged in the
sequence of the process of transformation from
man to jaguar.

The powerful, shining-eyed, mostly noctur-
nal jaguar has long inspired awe. As a predator,
it has the qualities hunters and warriors most
want to emulate. As a silent presence in the
forest, it is a metaphor for mystery and the
supernatural. Jaguars were symbols of power,

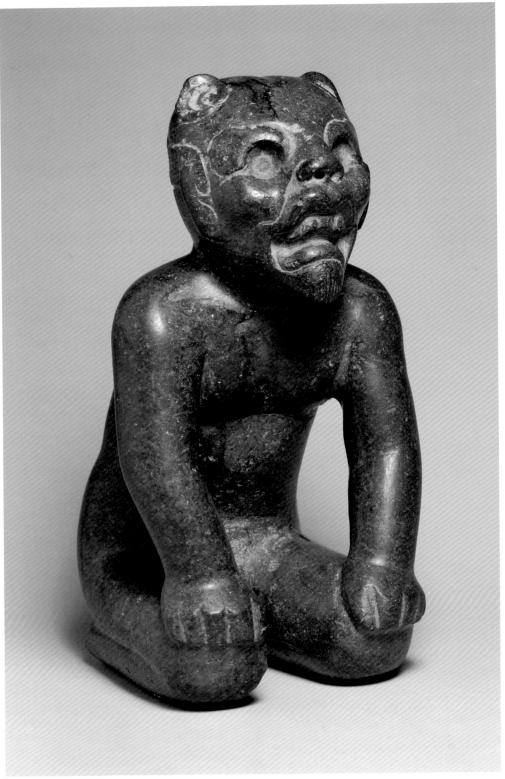

68

at the top of the list of shamanic animals
(Covarrubias 1946: 77–79; Saunders 1989).

Cat. 68 is a kneeling figure with a human
body. The fists rest downward on the knees.
The profile is essentially human, and there
seems to be a small beard, but the features
have been somewhat felinized, with heavy
folds around the eyes and some flattening of
the nose. The open mouth lacks feline canines
but has a thick, squarish upper lip. There
are jaguar ears near the top of the head and
human ears below. Human hair behind the

human ears seems to have been peeled back
to reveal the jaguar ears and face (see Furst
1968; Reilly 1989: 13). The finely incised hair
suggests an inverted cleft in the back (Easby
and Scott 1970: 43). The drilled eyes were
probably inlaid. This figure is said to have
come from Petlalcingo, Puebla, in 1928, to
the collection of Ferdinand Ries, Frankfurt,
Germany.

The figure of cat. 69, as it rises, holds the
fists on the knees and the head slightly up.
The head shows the jaguar-revealing hairline.

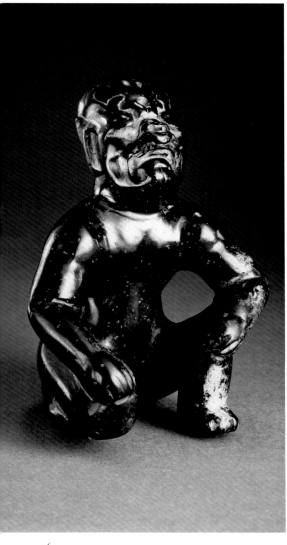

69

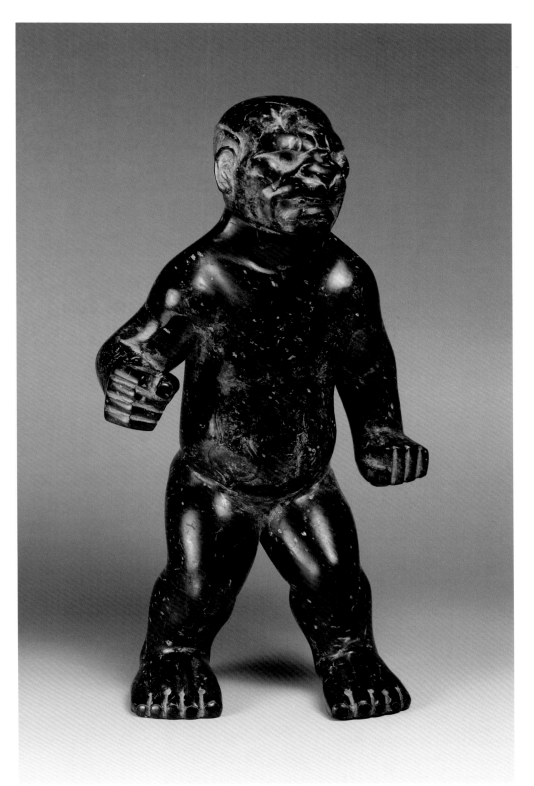

70

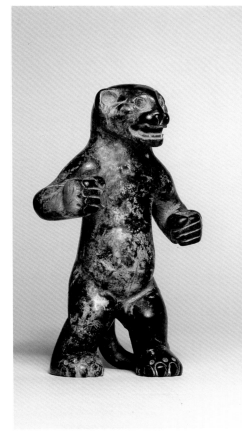

71

The ears are human. A flame-brow motif extends from above the eyes to the back of the head. This motif, said to represent the crest of the harpy eagle (Drucker 1952: 194), here seems to be a kind of flame between the human skin and the jaguar beneath. This may relate to a chemical reaction to the transformation drug, a flamelike feeling as a stage in the process. Many important Pre-Columbian motifs have multiple meanings, and this motif may evoke both fire and the harpy eagle. It appears especially flamelike as it emerges from the cinnabar-red eye. These figurines all have traces of red pigment, which was strewn on high-status burials and offerings throughout Mesoamerica, and apparently sometimes applied directly to objects.

The eyes of cat. 69 are drilled and were probably inlaid; a vestige of yellowish substance remains in the right eye. A drilling in the center of the brow may also have had inlay; this would have been an unusual treatment. There is a vertical cleft in the chin and an incipient cleft in the top of the head. This

figure was in the collection of Constance Fearing McCormick.

Cats. 70 and 71 stand like boxers with one foot forward and arms at the ready. Both fists of cat. 71 are drilled through, and there is pyrite inlay in both eyes. Only the right fist of cat. 70 is drilled through, and pyrite inlay remains in the left eye only. Reportedly found together, these figurines were probably made in the same workshop. The carving of cat. 70 shows veins standing out on the body. Like the previous two examples, cat. 70 has thick human hair above the bare jaguar skull. The face is partially felinized. Cat. 71 has the only fully feline face and the only tail, but its hands and its stance are human.

Representations of naturalistic jaguars are relatively rare in Olmec art, although a few have been found in or near San Lorenzo (Cyphers Guillén and Botas 1994). A newly discovered sculpture at that site is a headless transformation figure (Cyphers Guillén 1994c: fig. 4). The body is almost in a four-legged feline posture, and it appears to be holding a ritual object in its forepaws.

E.P.B.

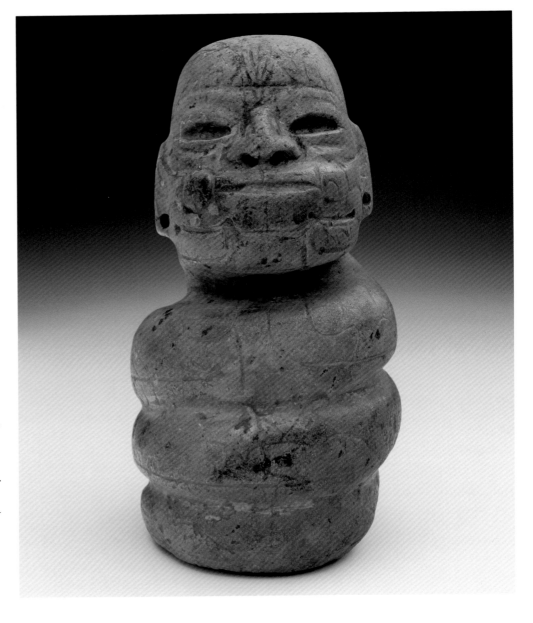

72. Coiled Serpent Figurine

Middle Formative Period

Serpentine

12 (4¾)

Coatepeque, Quezaltenango, Guatemala

Museo Nacional de Arqueología y Etnología, Guatemala

This unusual piece combines two important images of Olmec art, the human and the serpent, and does so in an ingenious manner, as a visual pun. In Middle Formative Olmec art, many human figures are depicted in a seated position, and, at first glance, the human rendered here was fashioned to create the basic proportions of such a figure, with folded arms, a bulging stomach, and crossed legs. However, closer inspection shows those to be also the three coils of the serpent's body. The morphological merging of human and serpent forms in this small figurine is particularly interesting, because this is one of the rare representations in Olmec art of a coiled serpent. The person's head and features, with oval eyes and the face framed by bangs or helmetlike headgear, are similar to those of other small figures in this exhibition, including the famed seated figure found at Las Limas, Veracruz, in 1965 (cat. 9).

The serpent's head is a buccal mask that covers the lower face of the person, and its long bifurcated tongue extends downward onto the first coil. The serpent's mouth and eye replicate the features of the serpent face engraved on the right leg of the Las Limas Figure. In Olmec art the serpent is an icon frequently associated with rulership. The blackstone scepter from Cárdenas, Tabasco (cat. 104), for example, is a serpent head and body, with a "corn god" mask on its tail. Serpent and serpentlike masks, both buccal and full-faced, occur in Olmec art found primarily outside of the Gulf Coast, including a painting at Oxtotitlan Cave, Guerrero (Painting 7), and bas-relief stone carvings at Chalcatzingo, Morelos (Monument 2), and Xoc, Chiapas (Benson, "History," fig. 5). The small, featherlike element extending backward from the eye area, not uncommon in other Middle Formative serpent images, is one trait behind a controversial theory that such figures represent "feathered serpents." Because of the small number of serpent images in Olmec art, that theory cannot be reasonably tested at this time. The curvilinear engraving on the coiled body

of this serpent does not suggest feathers.

Regional differences in small Olmec greenstone objects such as this indicate that while some may have been produced at Gulf Coast Olmec centers, others were apparently created on the Pacific Coast of Chiapas-Guatemala, in Guerrero, and possibly elsewhere. Coatepeque, where the figurine was found, is on the Pacific slopes of Guatemala, near two other important Middle Formative period sites that have yielded Olmec-style objects: La Blanca (see cat. 50) and Abaj Takalik, the latter famed for its carved monuments. D.G.

73. Seated Were-Jaguar with Crest and Pleated Ear Decorations

Middle Formative Period
Jade
8.6 (3⅜)
Necaxa, Puebla
American Museum of Natural History

This intricately carved piece was found in 1909, when it washed out of a mound in the course of dam construction. The dwarflike or babyish body has a characteristic were-jaguar face with snarling mouth. It lacks fangs but has teeth, which are often absent in dwarf and baby-face depictions. The deformed and cleft head tilts back slightly. There is a caplike headdress or hair, with a crest element (like a flame-brow motif) running from the brow toward the back. A horizontally pleated strap falls from a headband in front of each ear. A profile, similar to the figure's face, is incised on both cheeks. An incised band falls from the headband to the eye and continues past the eye of the incised profile. Ties are incised at the neck and the wrists. The figure has human arms; hands and feet are delineated on the base. A crossed-bands motif appears at the waist. Descending from the waist on either side are two pairs of streamers, which might be ribbons, feathers, or maize shucks. They have a slight cleft and resemble the "fangs" of faces thought to derive from toads swallowing their skin (cat. 110). There is a ∪ motif on the back. The figure sits cross-legged, the right foot tucked under (Easby and Scott 1970: 42).

Although the posture is human, this figure does not seem to relate directly to the series of human figures that are turning into jaguars (cats. 68–71); pose and accoutrements differ. This may reflect a difference in provenance, or

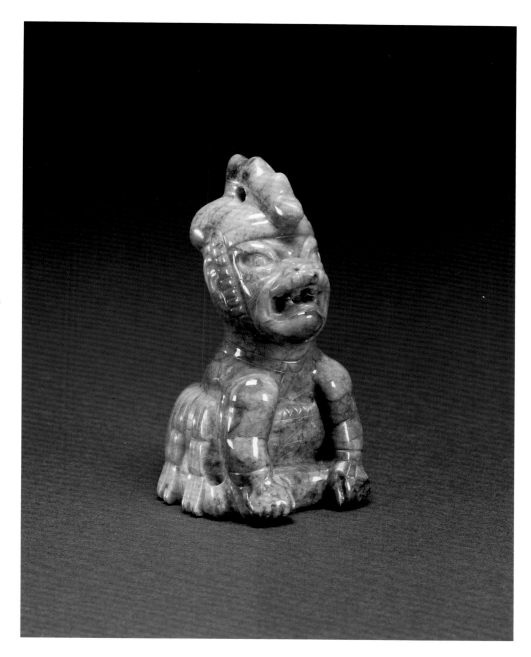

it may mean that the figure belongs to a different iconographic complex.

The piece does not resemble a pendant, but there is a perforation in the crest and also in the rump and through each knee. Gordon Ekholm (1970: 41) suggested that it might have been mounted on a staff.

E.P.B.

74. Stooped Figure with Bag on Back

Middle Formative Period
Jade
9.2 x 3.8 (3⅝ x 1½)
Guerrero
The Metropolitan Museum of Art, Anonymous loan

Olmec lapidaries valued jade above all other materials. Harder than steel and difficult to obtain, it was polished to a mirror finish to reveal its color and translucency. Olmec artists show a strong preference for jades with a uniform blue-green hue. This color was later associated with the center of the cosmos.

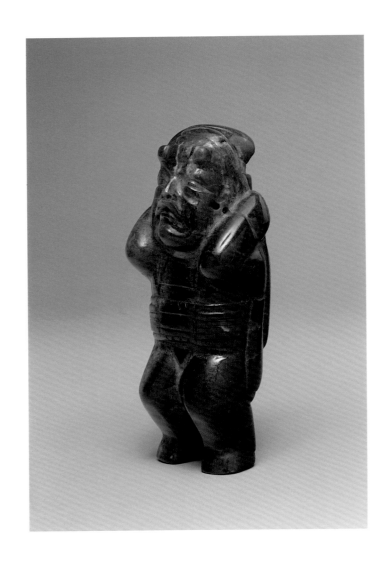

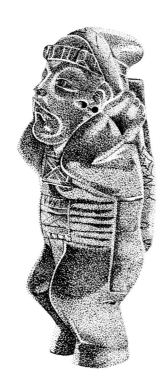

This well-carved Olmec figure was made from a particularly fine piece of blue-green jade. Probably quarried from a jade source in the Río Motagua in Guatemala, the sculpture was supposedly found in Guerrero, where many of the most beautiful Olmec jades have been discovered. The carving depicts an Olmec supernatural being in slightly stooped posture carrying a bag. The figure has a cleft head and the soft fleshy features of a were-jaguar. The almond eyes have incised irises, and the nose has an arched bridge and drilled nostrils. The elegantly carved mouth has a classic Olmec shape with bowed upper lip and downturned corners. Ears are rendered with some naturalism; each lobe is pierced with a biconical drilling. The bent arms are raised and held close to the body. The hands grasp a tumpline that supports a flat bag slung across the back. The tumpline is decorated with chevrons, and star motifs mark the intersection of tumpline and bag. The bag is marked with rows of oval motifs, probably indicating the fabric texture. Inside the sack is a large rectangular motif with cleft top and scalloped design at the base, which represents an ear of corn. The statue's legs are bent at the knees. Although the hands are well defined, the feet are simply rendered.

The figure wears the costume elements and ornaments of the Olmec storm god. The supernatural were-jaguar infant held in the lap of the Las Limas Figure portrays this important deity in his complete iconographic form (cat. 9). The Guerrero figure has the divinity's distinctive headband decorated with a pair of well-spaced bosses. The rectangular pectoral with crossed bands and the loincloth with a rectangular central ornament with a crossed-bands symbol and framed top and bottom with serrated bands are also typical attributes of the storm god.

The were-jaguar rain god carrying an ear of maize on his back rendered in jade of the utmost preciousness emphasizes the critical role that rain played in the agricultural cycle and the importance of the corn harvest to Olmec civilization. The image of a storm god with maize on his back appears again at Teotihuacan in Central Mexico nearly a thousand years later. A mural in the great Classic period metropolis portrays a standing Tlaloc, the Central Mexican storm deity, holding a stalk of corn in one hand and carrying a sack full of corn ears across his back.

P.D.J.

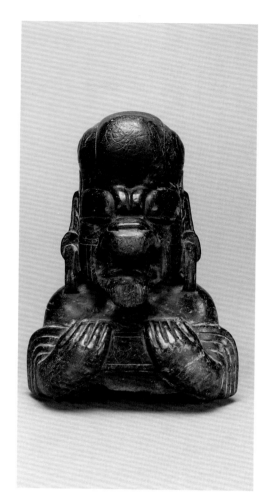

75. Bearded Figure Fragment with Ceremonial Bar or Bundle

Middle Formative Period

Serpentine

13.3 (5¼)

Veracruz

From the collection of Dana B. Martin

This remarkable figure holds symmetrically across its chest a ceremonial bar or bundle, much as later Maya rulers held a ceremonial bar. On two Olmec celts from Río Pesquero, a bar is held in a similar manner (Joralemon 1976: figs. 8 e–f, 11). The attached feathers are probably the tail coverts of the quetzal. A similar bundle, with crossed bands in the center, is depicted on La Venta Monument 19 (cat. 17).

The hands are human and graceful. The head is strange. It is topped with a rolled-scroll headdress or hair; a series of four tiers of hair is incised down the back (Lothrop and Ekholm 1975: 325–330). A design of two attached perpendicular bands is incised on the cheeks. There are frown lines between eyes that are

either covered with flaps or swollen and closed. Swollen lids and narrowed eyes are common Olmec traits, but these are unusually emphasized here. A protruding upper lip overhangs fangs. The ear ornaments, a disk with a strap looped through it, are unusual for the Olmec, but a similar form is seen on later Maya figures in sacrificial rites. Two parallel lines around the shoulders may indicate a garment.

The hands and the ceremonially held object indicate that this is a human being, but the head is supernatural. This may be a transformation figure somewhat different from those depicted in the jaguar sequence. The beard suggests that it may belong to this group. The hair incising is similar to that on cat. 68; however, instead of stripping down to the jaguar beneath, the head (possibly a mask) seems to be superimposed.

A previous owner of this figure was a dealer of land titles for an oil company, who, while negotiating with a family for land in Veracruz, noticed the son using the piece as a punch for riveting (A. B. Martin, in Rubin 1975: xviii–xxv). It had been found in a nearby stream. The son gave it to the oil man, who mounted it on the radiator cap of his Packard and rescued it when the car was later wrecked.

E.P.B.

76. Human Mask with Incised Design

Middle Formative Period

Jade

17 x 16 x 9 (6¹¹⁄₁₆ x 6⁵⁄₁₆ x 3⁹⁄₁₆)

Río Pesquero, Veracruz

Private collection

This remarkable mask captures the vitality and spirit of a human face far more successfully than most Olmec stone carvings. Probably representing a young man, the jade sculpture has a broad full face with shortened forehead and rounded chin. The irises of the large piercing eyes are cut through, and the eyelids are carefully rendered. The brow ridges are softly modeled and the nose has a curved profile and flared nostrils with drilled holes. The open mouth is carved with full lips and a row of upper teeth. Earflanges are set high on the head with curved channels and incised

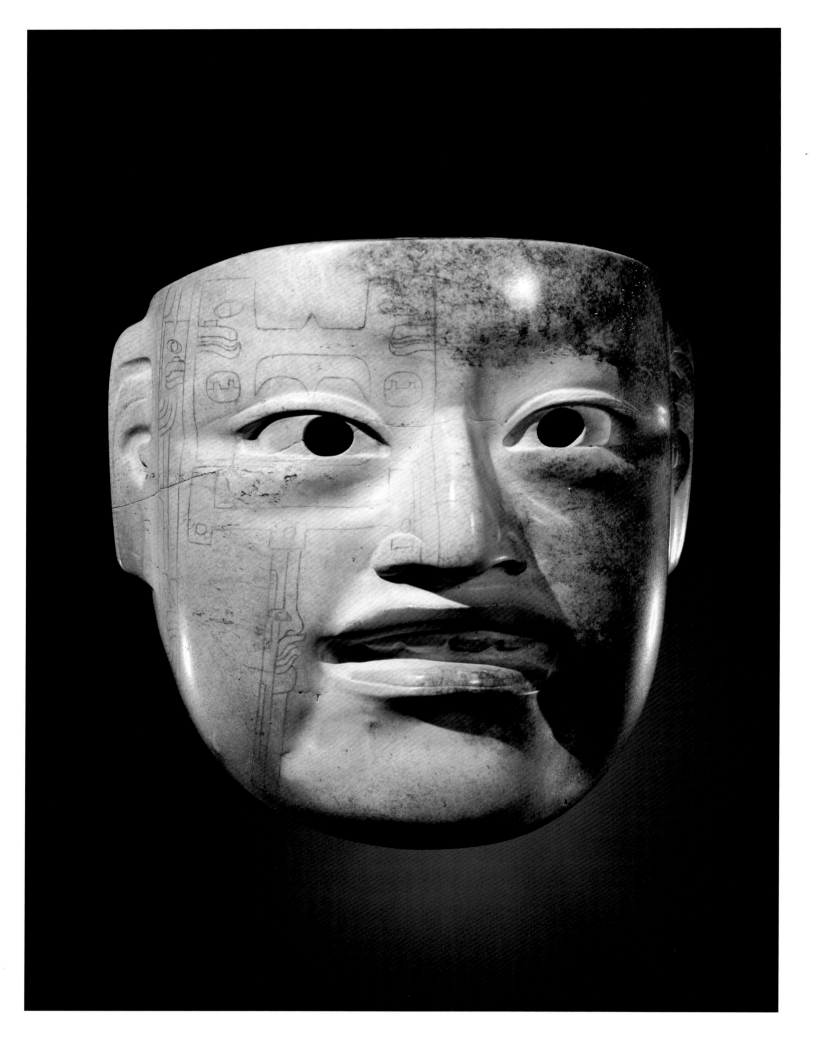

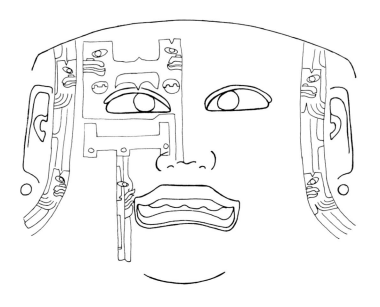

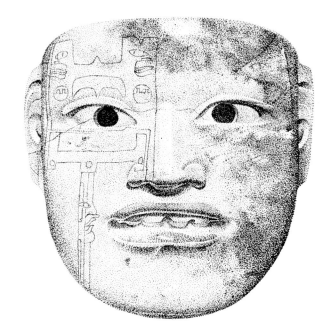

lines indicating the interior contours. The back of the mask is fully excavated and the front is polished to a mirror shine. The whitish coloration was probably the result of ceremonial burning. The mask has an expression of intense optimism conveyed by the piercing glance of the eyes and the smiling mouth.

A complex asymmetrical design is incised on the surface of the sculpture. The right eye is framed in a rectilinear design. A pair of lines extends from the tip of the nose to the corner of the eye, and then continues on to define a square motif with a pair of were-jaguar profiles staring in opposite directions at the top. The head of one creature has a cleft, while the other is flat on top. A downturned trident motif framed by disks with double-merlon signs appears just above the eye. Decorating the cheek is a rectangular element with a bracket-shaped top and a trident base with three dots. Descending from this motif is a band decorated with a were-jaguar profile, a line bisecting its almond-shaped eye. Flanking this asymmetrical iconographic compound are two bands extending from the top of the mask to its cheeks just in front of each ear. Symbolically identical, each band contains a pair of cleft-headed were-jaguar faces joined to paw-wing designs and linked by linear and bracket-shaped motifs. The fourfold repetition of the same profile heads may relate to the veneration of the four directions, an ancient Mesoamerican religious practice.

The incision was made with a sharp stone tool, either when the mask was carved or at a later date. Such incised decoration may represent tattooing or scarification that marked an individual's face, or it may refer to face painting that could have varied according to the ceremonial context. This design, unique in Olmec art, may represent the personal sign or name of a particular personage. P.D.J.

77. Human Mask with Incised Design

Middle Formative Period
Jade
16 x 15.2 (6 5/16 x 6)
Río Pesquero, Veracruz
Museo de Antropología de Xalapa, Universidad Veracruzana

In 1969 an important hoard of Olmec jade and serpentine sculptures was recovered from the muddy waters of the Río Pesquero near Las Choapas, in Veracruz. Initially discovered on the river bottom by local fishermen, the find included dozens of extraordinary life-size masks of humans and divinities; finely carved figurines; ritual implements and personal adornments; and several thousand axe blades (Medellín Zenil 1971). Although little is known of the architectural context of the Río Pesquero sculptures, it seems likely that the river had cut a course through an important Olmec site exposing elite graves filled with jade funerary offerings and caches of celts buried in dedicatory groupings. Los Soldados Monument 2, which depicts a seated figure with rain god attributes, was recovered not far from where the jades were found. Careful excavation of this area may reveal further information about the site.

Variation in style, workmanship, and aesthetic quality suggests that the Río Pesquero carvings were produced over a span of several centuries. There are intriguing relationships between the Río Pesquero hoard and Olmec stone works scientifically excavated at nearby La Venta. Like the La Venta artifacts, the Río Pesquero sculptures were probably carved during the Middle Formative period, when La Venta reached the pinnacle of its power and influence and when jade and serpentine art enjoyed its greatest popularity.

The jade and serpentine were probably procured from Central Mexico, the Río Motagua valley in Guatemala, and Costa Rica. Making fine sculptures from hard materials with tools of stone, bone, wood, shell, and cord required great skill and months of laborious effort. Only Olmec rulers and high dignitaries could have commissioned such works of art.

Carved in light green jade and polished to a brilliant shine, this realistic mask from Río Pesquero portrays a smiling young individual with a decoration incised across the lower part of the face. The mask's forehead has a boldly curved outline. The eyes are long and very deeply carved with elongated holes cut through the upper edges of the eye sockets. A narrow ridge borders the top of the eyes and swollen bags are shown below. Both nose and mouth

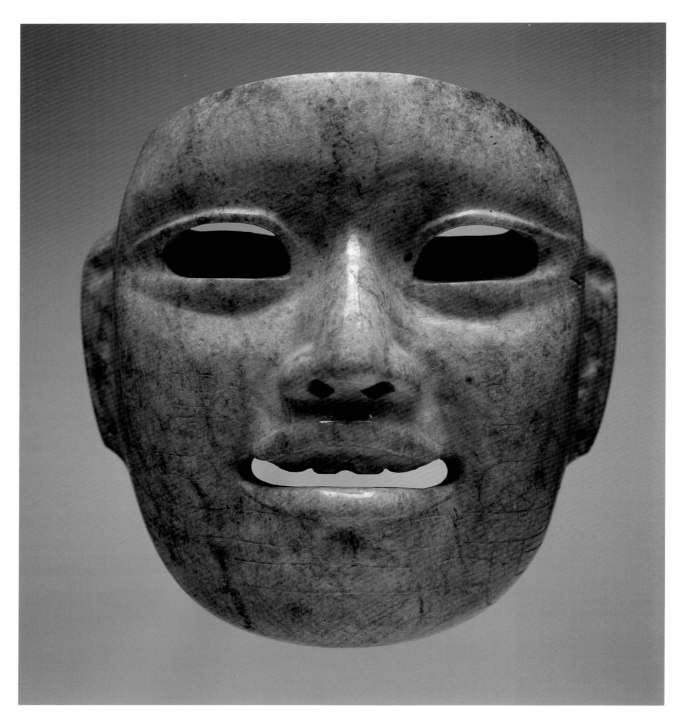

are naturalistically modeled. The lips are open in a smiling expression, and the upper teeth are clearly delineated. The cheekbones are prominently modeled and deep creases flank the mouth. Earflanges have shallow contours and drilled lobes. The back of the mask is fully hollowed out, and the eyes, nose, and mouth are cut through.

Incised across the lower face is a bold frontal image of the head of the Olmec dragon. This mythological creature has oval eyes, pinched at the outer edges, and rounded irises decorated with a crossed-bands motif. The broad mouth extends horizontally across the chin to rise in a gentle curve at either end. A pair of L-shaped fangs with cleft ends hangs from the creature's upper jaw. Directly above the dragon's eyes are pairs of abbreviated heads represented

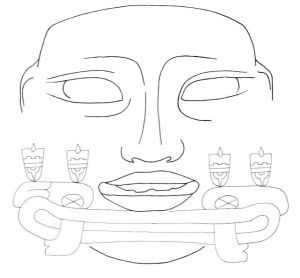

by rectangular motifs with cleft tops, double-merlon designs, and abstract eye motifs. Sprouting from the top of each head cleft is a pointed corn sprout.

The dragon represents the Olmec earth monster, a hybrid creature based on the caiman with eagle, jaguar, serpent, and toad attributes. The god is the earth itself and has strong associations with agricultural fertility. The placement of this deity's head on the Río Pesquero mask suggests the close link between the dragon and the ruler. The positioning of the design near the mouth of the mask may have been intended to show that the ruler spoke with the authority of the earth monster.

P.D.J.

78. Human Mask

Middle Formative Period
Jade
13 x 12.7 (5⅛ x 5)
Río Pesquero, Veracruz
Museo de Antropología de Xalapa, Universidad Veracruzana

Olmec stone masks are among the most beautiful face panels carved in ancient America. Some represent human beings, so realistically rendered that they must be portraits. Others depict bird monsters or were-jaguar divinities. Although a few Olmec masks have been found in Guatemala and Honduras, most come from the state of Guerrero in the Central Mexican Highlands or from Veracruz and Tabasco in the Gulf Coast lowlands. The great hoard of masks dredged from the Río Pesquero, Veracruz, along with stone figures, ornaments, and celts, is the most extraordinary group of Olmec portable stone sculptures yet found.

The dating of Olmec stone mask production is a matter of speculation. No Olmec face panels have yet been recovered from controlled excavations at Olmec sites, but a clue about their age may come from the jade. There is little archaeological evidence that jade was worked in any quantity by Olmec artisans before 900 B.C., so it is likely that masks carved in exotic hard stones were produced during the Middle Formative period.

Like Maya and Teotihuacan face panels, Olmec masks probably had a funerary function. Some show signs of burning, so the Olmec elite may have practiced cremation as well as regular burial. Olmec face panels generally have holes drilled in the top and sides, to allow them to be tied to the head or to be fastened to some other support. Masks may have been kept long after the death of the

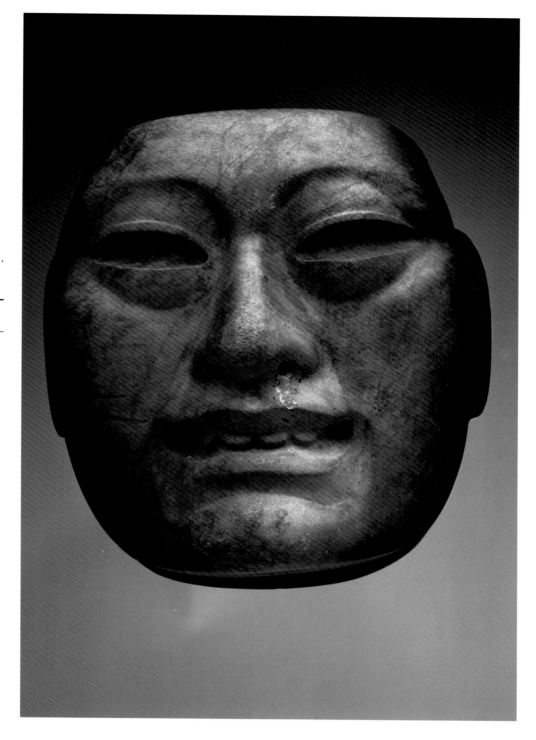

original owner and used in lineage ceremonies to honor ancestors. Some became heirlooms and were treasured for many generations.

The smallest of the jade masks recovered from the Río Pesquero is this sculpture with enigmatic expression in the Museo de Antropología, Xalapa. The surface of the mask has a brown beige color. The face has a low forehead, broad midsection with pronounced cheekbones, and full rounded chin. The eyebrow ridges are sharply modeled and the elongated, deeply carved eyes are set in puffy sockets. An engraved line curves across the top of each eye and defines the eyelids. The large nose is broad and fleshy with pierced septum.

The mouth is wide with sensuous lips, which are parted to reveal the upper row of teeth. Its expression suggests the beginning of a smile. The rounded earflanges have lightly incised designs and drilled earlobes, which once may have contained ornaments made from perishable materials.

It is generally true that most Olmec human images have dour expressions, but a number of stone sculptures have smiling countenances. The most impressive example of this type of face is depicted on Monument 2 from La Venta, a colossal head with a wide grin. Other masks and jade figures have the same expression.

P.D.J.

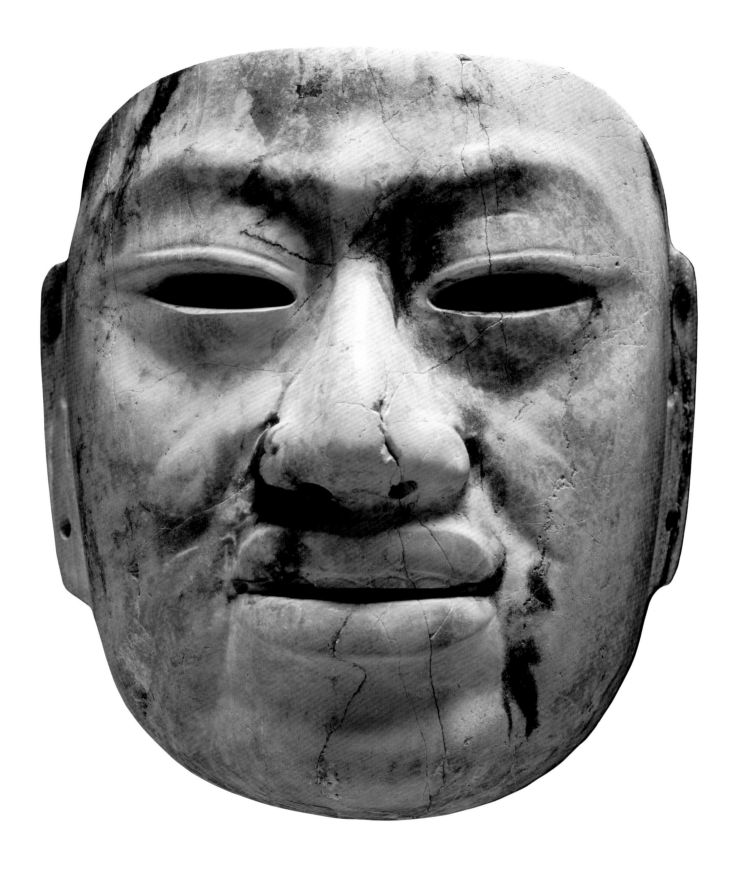

79. Human Mask

Middle Formative Period
Jade
21.6 (8½)
Río Pesquero, Veracruz
Museum of Fine Arts, Boston, Gift of Landon T. Clay

No Olmec mask has yet been scientifically excavated from its original context, nor are there any known representations of Olmec figures wearing masks with human features. It is thus difficult to determine how these works of art functioned in Olmec life. It is likely that most were used in funerary rituals, either placed over the face of the deceased lord

before burial or interred with his ashes after cremation. In either case, these sculptures portrayed the features of the dead lord in the most precious and immutable material known to Olmec artists. Masks may have been worn during the lifetime of the owner in dynastic and religious ceremonies. They were either placed over the face or attached to the head-

dress. Such masks may have been preserved and venerated after the lord's death. They might have been affixed to funerary statues carved in wood, clay, or stone, or worn by individuals in rites to commemorate the ancestors.

Olmec masks with human features fall into two broad categories. Some have individualized faces with softly modeled features. These carvings are clearly portraits of Olmec dignitaries. Another group of sculptures has classic Olmec features with standardized expressions and less individuality. These images generally have emblematic Olmec mouths, trapezoidal in shape with thin lips and carefully delineated teeth. Such masks seem to represent a generalized archetype rather than portraits of particular personages. These two categories may reflect differences in mask-making workshops or distinctions in regional style and date of manufacture. They may also indicate variation in the physical types of the Olmec rulers represented in the carvings.

The Boston Museum mask is a particularly large jade sculpture with realistic features. The face has strongly modeled eyebrow ridges and narrow elongated eyes with engraved lines marking the upper eyelids. The nose is large and fleshy, and the nostrils are drilled. The small mouth has fleshy lips, which are parted to reveal an upper row of incised teeth. Elongated rectangular flanges with curved interiors and drilling at the bottom represent the ears. The back is deeply excavated and the eyes, nostrils, and mouth are cut through. The sculpture has a strong portrait quality, suggesting a person of mature years with a broad face, jowls, cheeks, and a slightly sneering expression. The mask has been broken into a number of pieces. The whitish coloration of the stone was probably caused by ritual burning.

P.D.J.

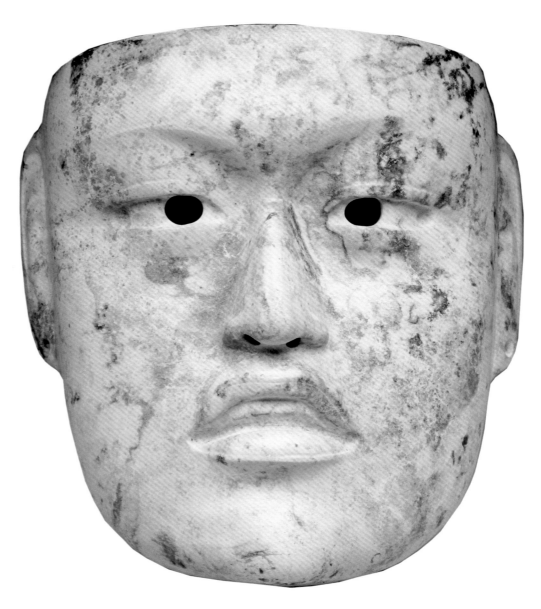

80. Human Mask

Middle Formative Period
Jade
18.1 x 16.7 x 10.2 (7⅛ x 6⁹⁄₁₆ x 4)
Río Pesquero, Veracruz
Dallas Museum of Art, Gift of Mr. and Mrs. Eugene McDermott, the McDermott Foundation, and Mr. and Mrs. Algur H. Meadows and the Meadows Foundation, Incorporated

Olmec masks with human features are among the most beautiful sculptures of jade and serpentine produced by Olmec lapidaries. The tradition of stone masks appears to be a Middle Formative phenomenon, although Early Formative clay masks from Guerrero in Central Mexico indicate the antiquity of the concept. Most Olmec stone masks that portray human beings come from the Río Pesquero find; similar masks have been found in the Mexican states of Chiapas, Guerrero, and Puebla, and in Guatemala and Honduras. Olmec artists carved masks from the same blue and green jade and serpentine that they favored for their small-scale sculptures. The wide varieties of surface colorations that Olmec masks exhibit were produced by exposure to heat in cremation fires and ritual burning, or by weathering caused by soil acids and groundwater. Olmec life-size stone masks usually have three suspension holes, one at the top of the carving and two more beneath the ears. Almost all have some combination of cut-through eyes, nostrils, and mouth.

Modeled in jade that now has white and gray coloration, this large Río Pesquero mask has an intense expression created by its small pierced pupils. The eyebrow ridges are sharply delineated, and the deeply carved eyes droop at the outer corners. An engraved line defines the upper eyelids, and the lower lids are soft and puffy. The aquiline nose has drilled nostrils. The mouth has thin lips, the upper one trapezoidal in shape and the lower one rounded and protuberant with downturned corners. Upper teeth are carefully defined. The face itself is broad and rather square, with a pronounced roundness to the chin. Earflanges have shallow curved contours and drilled lobes.

Like four other Río Pesquero jade masks (Brussels 1992: pls. 75, 90, 91), this carving has an emblematic Olmec mouth. The artist may have been more interested in showing the Olmecness of the subject rather than the realistic features of a specific individual. These masks may represent the standardized images of a particular mask-making workshop. Alternatively, it is possible that all four carvings were intended to represent the same individual or members of an elite lineage, as they bear an undeniable family resemblance.

P.D.J.

81. Human Mask with Incised Design

Middle Formative Period
Jade
16.5 (6½)
Río Pesquero, Veracruz
Robert and Lisa Sainsbury Collection,
University of East Anglia, Norwich

This mask realistically portrays a young individual, with a round, full face. The large eyes are almond-shaped, the nose is full, and the mouth is well proportioned. The lips are parted as if to speak or smile. Four upper teeth and the upper gumline are clearly shown. Shallow depressions in each cheek indicate dimples, and an incised beard decorates the chin. The earflanges have modeled channels and drilled lobes. The mask is carved in green jade and the surface is well polished. By cutting the walls thin and by fully excavating and finishing the back, the artist made the mask light and wearable. There is a single suspension hole at the top of the piece and two more just below the ears. Irises, nostrils, and mouth are cut entirely through. Extending from the top of the forehead to the chin and from ear to ear is a complex incised design, rich in iconographic references.

The iconographic information is divided into three subjects: the frontal were-jaguar image at the center of the forehead, the U-shaped bracket with dragon attributes around the mouth, and the bands with profile heads and abstract symbols along the sides of the mask.

The were-jaguar head is probably the Olmec rain god, a creature who combines characteristics of a human infant and a jaguar. This deity is often shown held in the arms of an Olmec ruler, either stretched across the lap, as on the Las Limas Figure (cat. 9), or held vertically against the torso, as on the standing jade figure in the Brooklyn Museum (cat. 48).

The bracket framing the mouth of the mask symbolizes the wide open maw of the Olmec dragon. The dragon is associated with the earth and agricultural fertility, and he is also the patron and legitimator of Olmec rulers. Seen from the front the creature's mouth is generally depicted as an inverted U. The framing device around the mouth is such a form. The dragon's eyes with flame brows and the beast's tooth markings further specify the motif. The dragon's body is the earth itself, so its mouth is equated with caves whose openings are entrances into the underworld. Olmec rulers, often carrying ceremonial bundles or figures of the rain god, are sometimes shown emerging from the dragon's mouth. In other

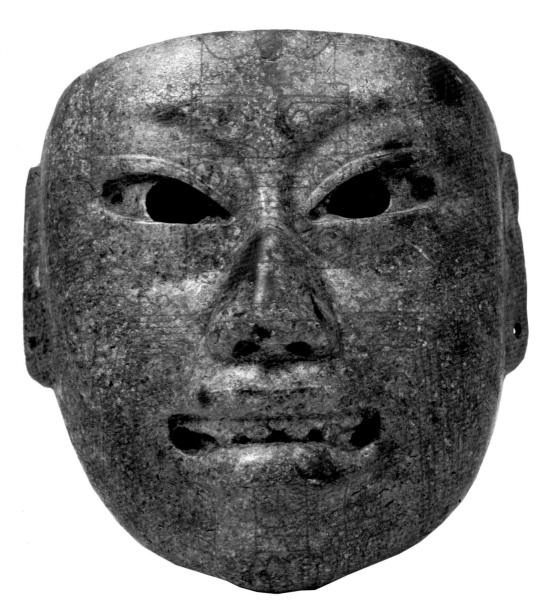

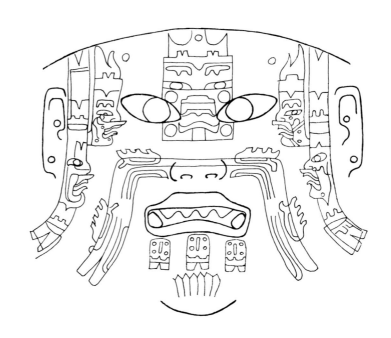

cases, rulers are portrayed seated on dragon thrones. The link between the Olmec dragon and Olmec kingship is clear. Thus, when the dragon's mouth is superimposed over the human mouth of this mask, it suggests that the human speaks with the power and authority of the dragon, that the voice of the god and the ruler are one.

The four profile deity heads on the bands along the sides of the mask probably have directional significance. Mesoamerican religion puts great importance on the four cardinal directions. Each had its own tree, bird, color, and group of deities associated with it. Individual gods often had four aspects, each linked to one of the cardinal points. One of the gods on the mask, the lower left image, is the banded-eye god, a character who appears frequently in Olmec art but whose nature is obscure (cat. 41). The profile at the lower right with the sprout motif at the center of the head is probably the corn god. As mentioned above, the two upper profiles are variants of the rain god head on the forehead.

The mask is a portrait of a ruler. The incised symbols are associated with an iconographic theme repeated often in Olmec art. The subject concerns the emergence of the ruler from the underworld through the cave mouth of the dragon and the presentation of the rain god or a ceremonial bundle. The ritual takes place at the symbolic center of the world with the gods of the four directions indicating the universal importance of the act. The ceremony may have been an accession ritual or a rite commemorating the return of the rains from the underground caverns where, according to ancient Mexican belief, they originate. What is clear is that this ceremony was of such importance in Olmec culture that it was recorded on enormous stone monuments, life-sized statuary, polished jade celts, and portrait masks.

P.D.J.

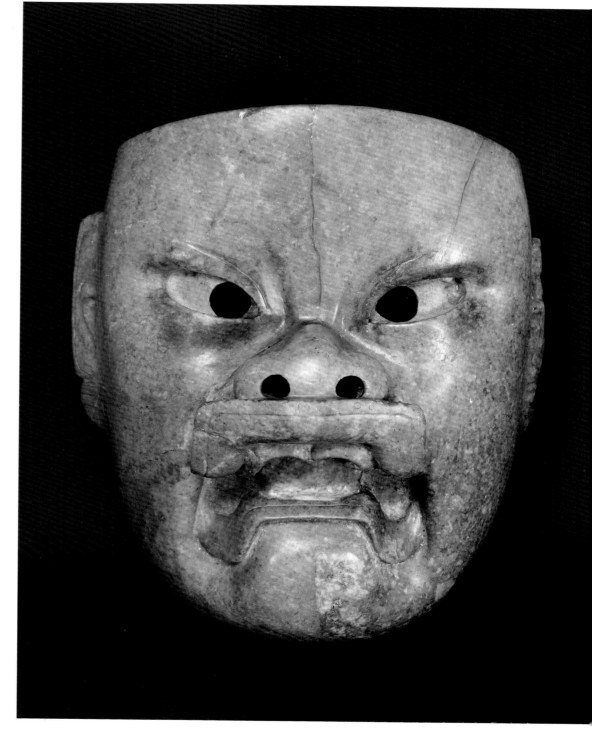

82. Were-Jaguar Mask

Middle Formative Period
Jadeite
20.8 x 17.8 (8³/₁₆ x 7)
Unknown
Dumbarton Oaks Research Library and Collections, Washington, D.C.

This large mask can be worn: there are holes for nostrils and eye pupils, and for attachment. The brownish color around the eyes may have been caused by something buried with the mask. Although it looks to be the result of iron-pyrite inlay, these do not appear to have been inlaid eyes. The eyes are crossed, as are the eyes of some other Olmec figures. In later Maya times, crossed eyes denoted distinction and beauty; they were induced by focusing on a bead placed on the nose. The mouth here lacks the fangs of many such faces, and its shape exaggerates the usual squared-off Olmec mouth form. The upper lip extension, projecting far out, is squared at the corners, as is typical of Olmec mouths. There is an incised line parallel to the edge. The double-curved upper lip or gum ridge is deeply carved. The lower lip is downturned in a sharp ∪ with a straight line across the center; a shallow tongue presses against the center. There is some incising on the ears.

This type of face is most commonly found in lower relief on axes or celts (cat. 110). Such a mask would have effected the transformation of the wearer into a supernatural being, although it is not immediately obvious which one this might be; it does not fit neatly into the categories established by David Joralemon (1971, 1976). The crossed eyes, for example, are anomalous.

This mask is rumored to have reached Italy in the 1530s, to have been published at some later date by a Hungarian professor as a Tang

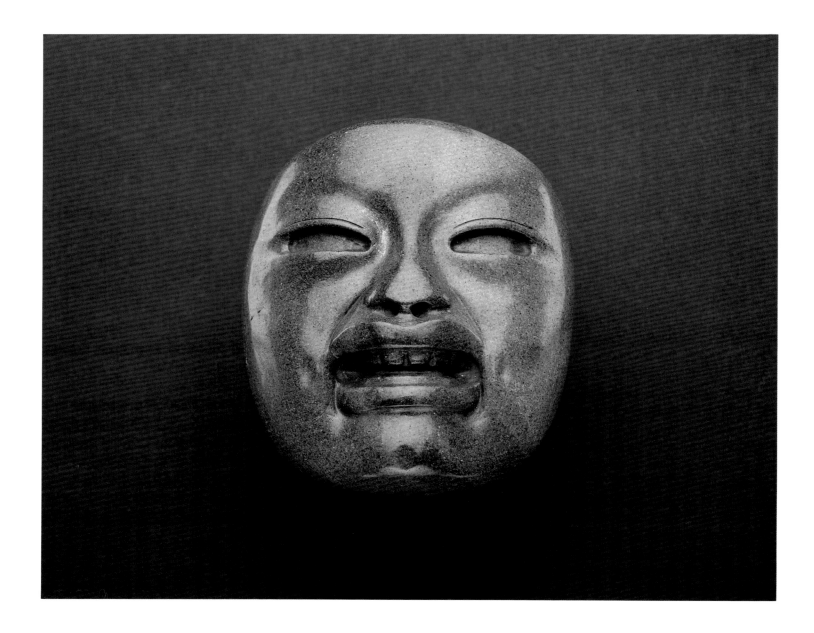

mask, and to have been sold as a Chinese piece and returned to the seller because it was not (Benson 1981b: 102–103).

One original piece of the brow is missing and has been replaced; another broken piece has been put back. The mask has been cut down in the back from the top; it may once have extended about an inch behind the ears.

<div style="text-align: right">E.P.B.</div>

83. Maskette with Smiling Expression

Middle Formative Period
Jade
10.8 x 9.3 x 4 (4¼ x 3⅝ x 1⅝)
Unknown
Museo Nacional de Antropología, Mexico City

This maskette entered the museum in 1957 as part of the Covarrubias Collection. It is of unknown provenance, although probably from the Gulf Coast, given that this representation of the smile was an exclusive feature of this zone during the pre-Hispanic era. It is considered an antecedent of the famous "smiling" clay figurines, which had great ritual importance and characterize the archaeology of the Veracruz area after the Olmec.

The face has the characteristic features of many Olmec works. The half-open mouth shows the gums, as in a jaguar face, or the teeth, as in anthropomorphic representations like some of the colossal heads; in this piece, however, the smile is explicit.

<div style="text-align: right">M.C.-L.</div>

84. Paired Hummingbirds

Late Formative Period
Jade
9.5 (3¾)
Xochipala, Guerrero
Lent courtesy of The Cleveland Museum of Art

Avian motifs, whether in full-scale versions or abbreviated form, were always an important component of the Olmec representational system. As whistles, birds were frequently depicted throughout Mesoamerica. As early as 1200 B.C., ducks were fashioned as clay effigy vessels and beaks of raptorial birds were depicted on clay pottery (see cats. 27, 28, 33). Avian imagery appears in the form of bird tails, single feathers, duck bills, raptorial avian beaks, talons, and full-body costumes (see cats. 23, 87). There are carvings of humans wearing duck bills. The long beak, the most distin-

guishing characteristic of the hummingbird, became this bird's *pars pro toto* symbol. It was usually depicted on awl-like perforators, in which the handle would correspond to the bird's head, and the pick would represent its beak (cat. 106).

Perforators are believed to have been used as bloodletters in shamanic rituals, in which the shed blood would be the magical substance that allowed access to the avian world, the celestial realm. In some societies, head plumes were symbolically used in transformation ceremonies, as ritual performances of shamanic flight.

After 700 B.C., avian and serpent zoomorph combinations surpassed reptilian images in popularity. Feathers, talons, and beaks were often used and prominently displayed as parts of headdresses, articulated into composite tadpole or "spoon" representations (see cat. 100), and, in combination with serrated brows, incised as secondary motifs on jade figurines that probably depicted shamans (see cat. 52). These hummingbirds do not appear to be either perforators or carved in a "classical" Olmec style. Their unusual eyes and geometric quality suggest a localized regional effort.

A.P.

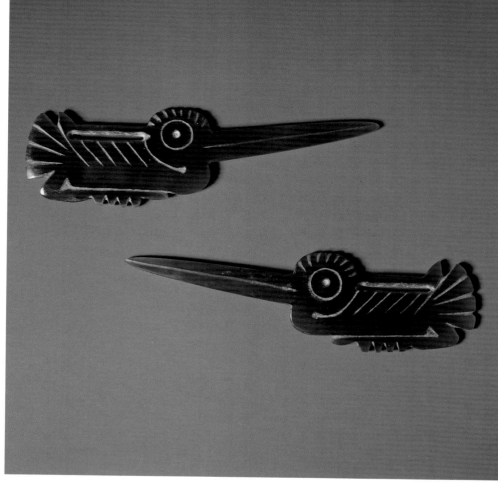

85. Two Matching Hands and Forearms

Middle Formative Period
Jade
6 x 4 (2⅜ x 1⅝)
La Venta, Tabasco
Museo Nacional de Antropología, Mexico City

This pair of forearms and hands was found during the 1942 season in the Burial 2 Offering from the Tomb of the Monolithic Columns at La Venta (Drucker 1952). Included in this offering was a female figurine (cat. 51). Independent of the beautiful jade from which these pieces are carved, they are especially important because the representation of hands is rare in Mesoamerica. This theme seems to begin with the Olmec, and other examples exist from San Lorenzo, Veracruz, and La Venta, Tabasco. In this case, it is significant that the pieces were associated with a female figurine, particularly as six hundred years later, hands embellished certain Veracruz Huaxtecan gods associated with the earth-fertility cult.

M.C.-L.

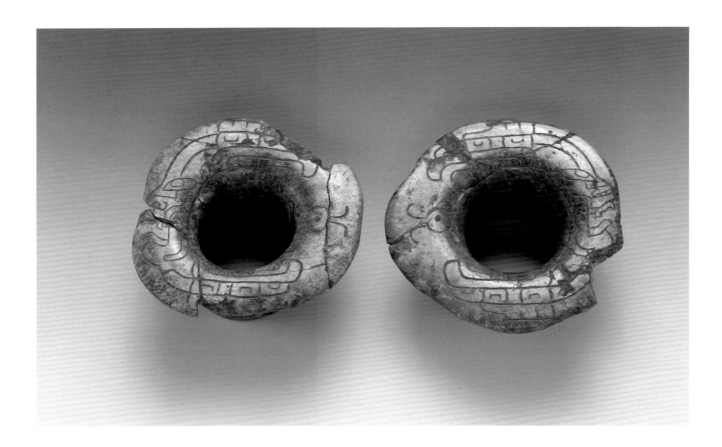

86. Paired Incised Earspools

Middle Formative Period
Jade
6 x 2.7 (2³⁄₈ x 1¹⁄₁₆)
La Venta, Tabasco
Museo Nacional de Antropología, Mexico City

Tomb C was discovered during the 1947 excavations at La Venta by a team from the Smithsonian Institution of Washington, The National Geographic Society, and the University of California. Within Mound A-3, at 2 meters deep, was a tomb measuring 5.2 meters in length and 1.8 meters in width, constructed with rectangular flagstones for the floor, walls, and roof. Underneath the flagstones was a floor covered with a thick layer of red powder (cinnabar). A few centimeters below that, thirty-seven celts in pairs were spread over the floor. In the center was an offering of various objects of greenstone, clay, obsidian, and rock crystal.

This pair of earspools was part of the central offering. They were placed about 15 centimeters from each other, suggesting that a body had been located between them, although nothing of it was preserved. The jade earspools were decorated with fine incisions of a design found in other Olmec works: a thick band decorated with three elements arranged symmetrically, two on the edge, and one in the center of the earspool body. Two serpent heads,

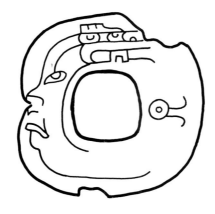

adorned with flame eyebrows, are at the end of each band; in the center is a small jaguar face with jaws open to show its fangs.

M.C.-L.

87. Celt Pendant

Late Formative Period
Jade
20 x 4.1 x 1.3 (7⁷⁄₈ x 1⁵⁄₈ x ¹⁄₂)
Costa Rica
Anonymous loan to The Brooklyn Museum TL1990.24

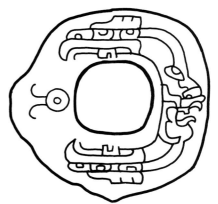

Once a large celt incised in the Olmec style (see cats. 115, 116), this quarter-celt pendant is a reworked heirloom from Costa Rica. In an attempt to make it resemble local avian god pendants, Late Formative Costa Ricans recarved this quarter-celt by means of low relief and incision, creating an image of a horned bird with folded wings. The protruding human legs, incised in a style unrelated to this bird, suggest that, perhaps sometime later, this image was made to represent a human figure wearing a bird costume, recalling the Late Formative Tuxtla statuette. It also resembles the avian perforator reported to have come

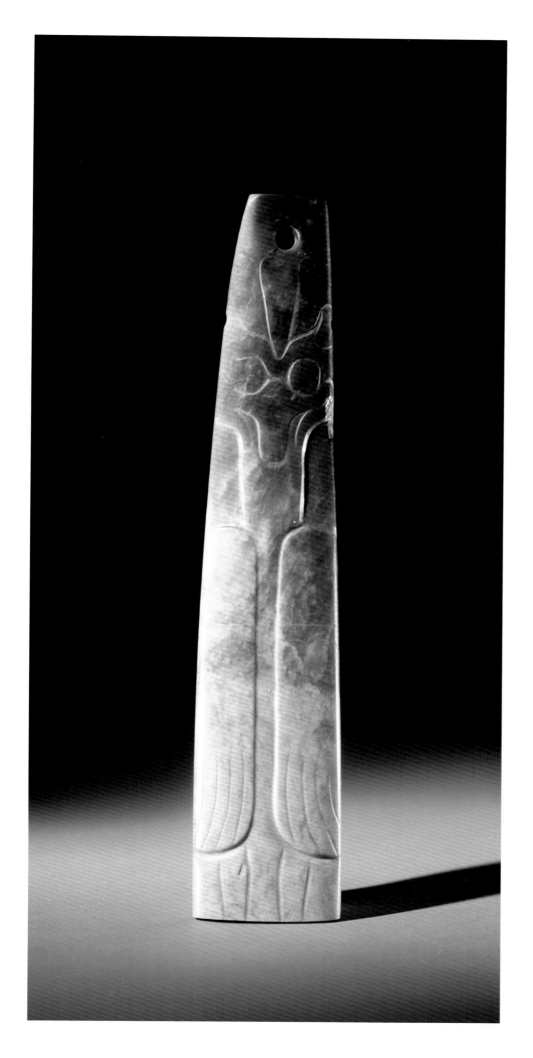

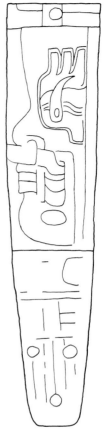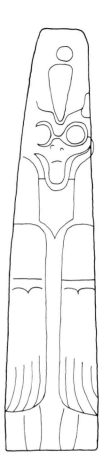

from Veracruz, on the Gulf Coast (see cat. 105).

Several reworked quarter-celt pendants have been discovered in Costa Rica. What makes this particular piece fascinating are the visible remnants of a composite anthropomorph, or were-jaguar, head in profile on the other side of the piece. Beautifully engraved in a seamless line, it shows an unusual eye rendition and the figure-eight motif supporting an everted upper lip, presumably attached to the septum. A similar lip-holding device is shown on other defining images of the composite anthropomorph (see cats. 12, 40, 73, 114).

Profile head versions of the anthropomorph are typical on these large celts (see cat. 115). Composite anthropomorphs were, in fact, depictions of baby-face individuals who, for ritualistic purposes, were attired with the attributes of the reptilian zoomorph. Like many heirloom pieces in the Olmec style found in Costa Rica, this celt was probably brought in from the Pacific Coast of Chiapas or Guatemala. A.P.

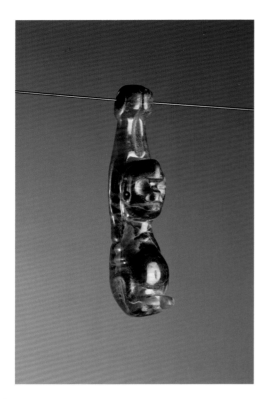

88. Monkey Pendant

Middle Formative Period
Jade
6.2 (2⁷/₁₆)
Guerrero
American Museum of Natural History

This pendant has a large drilling for suspension through the hands, and fine perforations in the ears, nose, and left foot (Easby and Scott 1970: 47). The rib cage is emphasized above a distended belly. The carving is naturalistic, except for the ear drilling for ornaments (Couch 1988: 7). Also, a crest from the brow to the back of the head has been added or exaggerated; this motif appears on other Olmec heads and, later in Veracruz, on Early Classic heads carved in an axelike form.

The monkey is not a common Olmec motif, but a very similar jade pendant was found at Chalcatzingo (Grove 1984: fig. 28), and La Venta Monument 12 (de la Fuente 1973: 70–72, pl. 24) depicts a somewhat more humanized, life-size monkey, which also shows the hands above the head and the scrolled tail against the back.

The symbolism of the monkey in Olmec mythology is not known, but monkeys appear often in New World origin myths: failed creations of human beings are turned into monkeys; people who disobeyed a god at a time of disaster become monkeys; or the brothers of culture-hero tricksters can be so transformed. This carving represents a member of the

Cebidae, probably the black-handed spider monkey (*Ateles geoffroyi*), which is particularly dexterous in trees; it is well-known in later Maya literature and art, where monkeys are artists and scribes, musicians and dancers.

E.P.B.

89. Standing Figure with Wings

Middle Formative Period
Jade
6.7 x 4.8 x 1.6 (2⁵/₈ x 1⁷/₈ x ⁵/₈)
Guanacaste Province, Costa Rica
Anonymous loan to The Brooklyn Museum
TL1990.23.4

This flat, broochlike jade artifact shows a baby-face individual with an everted upper lip and a pair of scalloped wings on its back. It also sports a skirtlike hipcover showing the schematic head version of the reptilian zoomorph, bearing, at its center, a cleft rectangle. A symbol of the anthropomorph, or were-jaguar, the motif usually shows foliage sprouting from its cleft.

The figure has a part of its left leg broken off; feet are shown pointing in opposite directions, and arms are placed against the chest with the cupped hands pointing downward. Such a placement is a two-dimensional solution for a type of arm position typical of figures carved in the round. In tridimensional carvings, some standing figurines have forearms that project forward from the elbows or shoulders and the cupped hands with palms that face downward, not unlike the rigid poses assumed by carved baby-face and composite anthropomorph images (see cat. 43). The everted upper lip and other zoomorphic attributes signify that this baby-face is being depicted as a composite anthropomorph (see cats. 12, 73).

The figure has suspension holes on its batlike wings. This fact and the knowledge that it was found in Costa Rica indicate that it is an heirloom piece, and was probably used by others in addition to the original makers. The high elevation of the figure's cranium, its massive rounded shoulders, the presence of batlike wings, and feet pointing in opposite directions suggest that this piece did not originate with the Gulf Coast Olmec, but, most likely, was traded or brought to Costa Rica from the Pacific Coast of Chiapas or Guatemala in Late Formative times.

A.P.

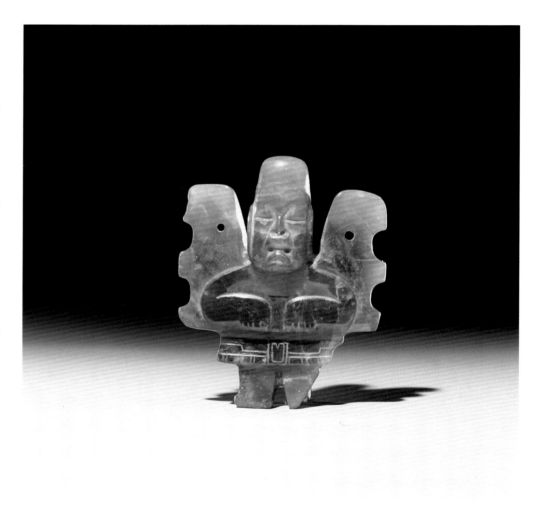

90. Rectangular Plaque with Carved Human Profile

Middle Formative Period
Greenstone
16.3 x 15.4 (6⁷/₁₆ x 6¹/₁₆)
Unknown
Museo Nacional de Antropología, Mexico City

This plaque arrived at the museum before 1943 without an exact provenance. A low relief Olmec face in profile appears on a thin sheet of highly polished greenstone. It is decorated with four stylized were-jaguar profiles: three with fine incisions; the fourth, larger and in relief, bordering the upper part of the face. Each profile is placed in a specific orientation and shows a varying degree of complexity. The mouth is the principal and consistent element of each small profile. Each of the five profiles is divided by a vertical band. The mouth of the large profile has vegetal elements.

The religious ideas that are reflected in this piece are no doubt a result of a broader process of symbolic abstraction. The combination of the diverse jaguar profiles expresses the multiplicity of spirits found in the human head, which the Olmec converted into one of their principal cult elements. M.C.-L.

91. Human Mask Pendant with Incised Design

Middle Formative Period
Jade
15 x 10 x 7 (5⅞ x 3¹⁵/₁₆ x 2¾)
Honduras
Private collection

During the Middle Formative period, Olmec artists made mask pendants of jade and serpentine, as well as stone masks large enough to be worn. The smaller sculptures were drilled for suspension and probably worn around the neck or used as ornaments in headdresses. Masks in this dimension were often carved from particularly fine jade and worked with exquisite care.

Seen from the front, this Olmec blue-green jade mask appears to be a complete human head with the softly modeled features of the were-jaguar. The carving has an elongated rectangular shape with a broad curved top, full face with finely rendered characteristics, and a gently rounded chin and jaw line. The sculpture has arched brow ridges and almond-shaped eyes with incised eyelids above and swollen bags below. The nose is well proportioned with a pronounced curve to the bridge. The mouth has the typical Olmec shape with narrow lips, parted to reveal the upper teeth, and downturned corners. The ears are rectangular flanges with interior contours and drilled lobes. The hairline is marked by a gentle curve extending across the forehead and part way down the sides of the head. At the center of the swept-back head is a V-shaped cleft carved in low relief. A pair of suspension holes is drilled in the top of the mask and additional holes appear below the earflanges. The sculpture is

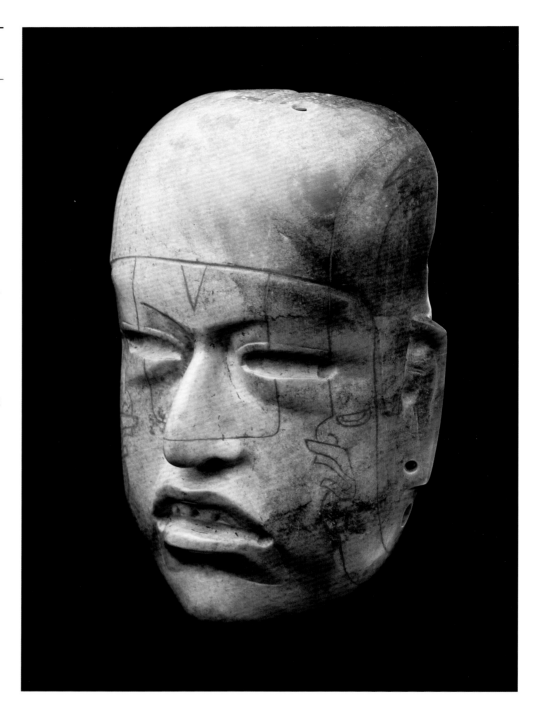

deeply hollowed out in the back, minimizing its weight and reducing its walls to thin, translucent sections. Neither eyes, nostrils, nor mouth is cut through.

Incised across the head is a bold Olmec symbolic design. An unembellished rectangular motif with V-shaped cleft at the top is positioned at the center of the face, extending vertically across the eyes and horizontally across the hairline and the tip of the nose. Arching along each side of the head in front of the ear is an elongated band containing the profile head of a were-jaguar creature.

This incised composition is similar to the symbolic motifs engraved on an Olmec serpentine mask reportedly found at San Felipe, Tabasco, not far from La Venta (Sisson 1970: Princeton 1995: fig. 153). In this example the cleft rectangle contains a Quincunx design. The blue jade mask's iconography is also reminiscent of a much more complex design incised on a Río Pesquero mask now in the Sainsbury Centre at the University of East Anglia (cat. 81). All three pieces illustrate the same iconographic formula: a cleft rectangular motif positioned between the eyes and flanked by a pair of were-jaguar profile heads extending from the top of the head to the jaw line. This iconographic composition may be associated with a particular ceremony, an accession rite, for example, or a religious ritual; it may designate a particular Olmec site or sacred place; or it may refer to a specific lineage or clan.

This mask pendant was reportedly discovered in Honduras in a cache with two Olmec life-sized stone masks, one an oxidized serpentine sculpture (Brussels 1992: pl. 76) and the other a pale green jade carving with deeply furrowed brows (Princeton 1995: fig. 190). It is likely that the masks were trade pieces or heirlooms. They have little in common stylistically and may well have been made in different Olmec workshops at different times. The incised blue jade mask pendant does have a remarkable similarity to an Olmec blue jade were-jaguar mask supposedly excavated in Ahuelican, Guerrero, and now in the Detroit Institute of Arts. P.D.J.

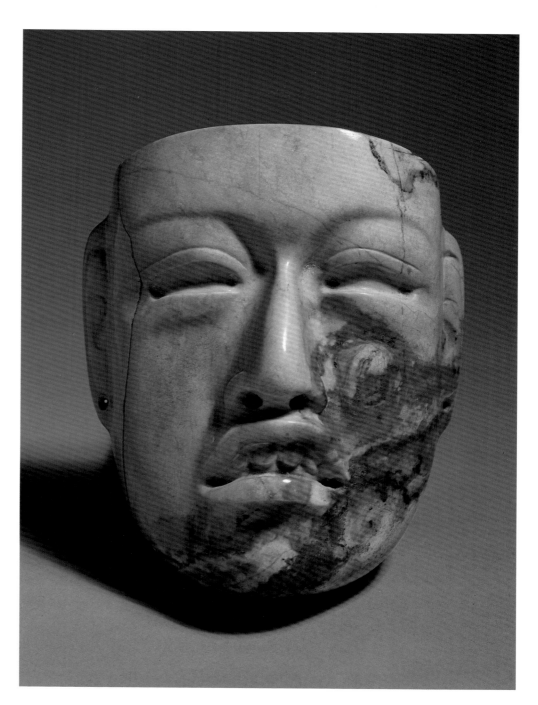

92. Human Mask Pendant with Incised Design

Middle Formative Period
Jade
13 x 10 x 4.5 (5⅛ x 3¹⁵⁄₁₆ x 1¾)
Unknown
Lent courtesy of The Cleveland Museum of Art

Although this beautiful Olmec mask pendant was originally sold as a Japanese piece, there is no information about where it was found. The sculpture shows evidence of long use and ancient reworking. Most likely carved from a fine piece of blue-green jade, the mask's white surface coloration was probably produced by heat from cremation fires or ritual burning. The golden brown staining and reddish brown encrustation were caused by the oxidation of iron-ore ornaments originally buried with the piece. The left side is missing and there are worn areas on the back. The fractures were smoothed and partially repolished in the distant past.

The Olmec face has softly modeled, fleshy features and an expression reflecting experi-

ence, self-confidence, and power. The proportions are like those of Olmec life-sized masks. It only extends to the middle of the forehead. There are boldly arched brow ridges and elongated eyes that turn down at the outer corner. A curved incision suggests the upper eyelids; the flesh under the eyes is soft and puffy. The long, elegantly carved nose has a rounded tip. The nostrils are deeply drilled and the septum is perforated. The open mouth has a classic Olmec shape with narrow lips and clearly marked upper teeth. The upper lip is flared, the lower lip is thrust forward, and the corners of the mouth are downturned. The ear is a long rectangular flange with curved grooves indicating the interior contours. The earlobe is perforated. Like other Olmec masks of this size, there are no cuts or drillings for the eyes, nostrils, or mouth. A pair of conical suspension holes is centered in the top of the carving, and a biconical drill hole is located beneath the ear. The mask has a mirror polish on the front and a shiny surface on the back.

Incised on the left half of the mask is an unusual iconographic compound. Above the left eye is the frontal face of a were-jaguar with a deeply cleft head, almond-shaped eyes, and simple mouth with downturned corners. Bands showing were-jaguar profile heads with cleft tops extend along each side of the head and cut through the almond eyes. On the left cheek is an incised double-scroll motif with square corners.

The double-scroll motif is not common in Olmec art except in this particular iconographic compound. It appears as the dragon's

extended tongue on Chalcatzingo Monuments 1-A-5 and 1-A-6 and as a palm decoration on the hand-paw-wing motifs carved on a stone *yugito* from Guerrero and various Olmec blackware ceramic vessels from Central Mexico. It is probably a symbol of the Olmec earth monster or the earth itself.

The combination of were-jaguar head and double-scroll motif appears on a half dozen finely worked Olmec stone sculptures of human beings carved during the Middle Formative period. Although some versions of the motif are more elaborate than others, there is a remarkable consistency in iconographic expression. The incised design on the white mask is similar to the symbolic statements carved on an Olmec seated serpentine figure from Puebla in the Dallas Museum of Art (cat. 55), and on other objects.

The jade mask pendant and the other figures and ornaments bearing the double-scroll compound have similar features and a striking physical resemblance. Although without incised design, the jade head fragment from Tenango del Valle (cat. 57) also belongs to this group. These carvings likely represent idealized portraits of the same Olmec ruler. The double-scroll compound may be his personal name or title, or perhaps his clan or lineage symbol. The strong correlation between a particular portrait image and a cluster of iconographic symbols raises the intriguing possibility that the white mask and related Olmec sculptures depict one of the earliest historical individuals yet identified in Mesoamerican art.　　　　P.D.J.

93. Mask with Incised Design

Middle Formative Period, with Late Formative Incisions
Greenstone
20 x 13 (7⅞ x 5⅛)
Oaxaca, Mexico
Peabody Museum of Archaeology and Ethnology,
Harvard University

Unlike masks with a clear baby-face visage, this type has a narrower and more elongated nose, as well as a facial outline that lacks the characteristic baby-face jowls. However, it shares with some baby-face images ears with attached lobes and helix, and a mouth that appears to be slightly trapezoidal. Pierced earlobes and buccal pits are other features it shares with baby-face images carved in stone. Two additional pits were placed over the upper front teeth. Suspension holes were drilled into the temple area just above the barlike ears. Neither the eyes nor the mouth were cut out, so it may have been used in a funerary context.

When it was first carved, this mask probably had no incised designs. Its flowery incisions exhibit a Late Formative style, which suggests that the mask had been an heirloom. The designs incised on its forehead may depict a stylized version of the corn motif surrounded by leaves. A more explicit version of this motif is depicted on the forehead of composite anthropomorphs, or were-jaguars, incised on celts. Similar motifs occur on the helmet of a winged figurine found in Costa Rica and on a *yuguito*. A reworked split piece, originally a mask in the collection of the Brooklyn Museum, shows this corn motif placed above the headdress band and cut in half. The U-element incised on the mask's nose is the throat symbol for the composite zoomorph as it appears on Oxtotitlan Mural I. The remaining incisions are difficult to unravel. A number of similarly beautiful masks bear incised motifs in a purer Olmec style (see cats. 77, 91).

A.P.

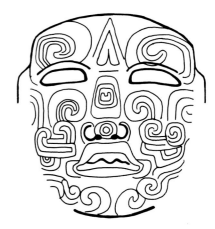

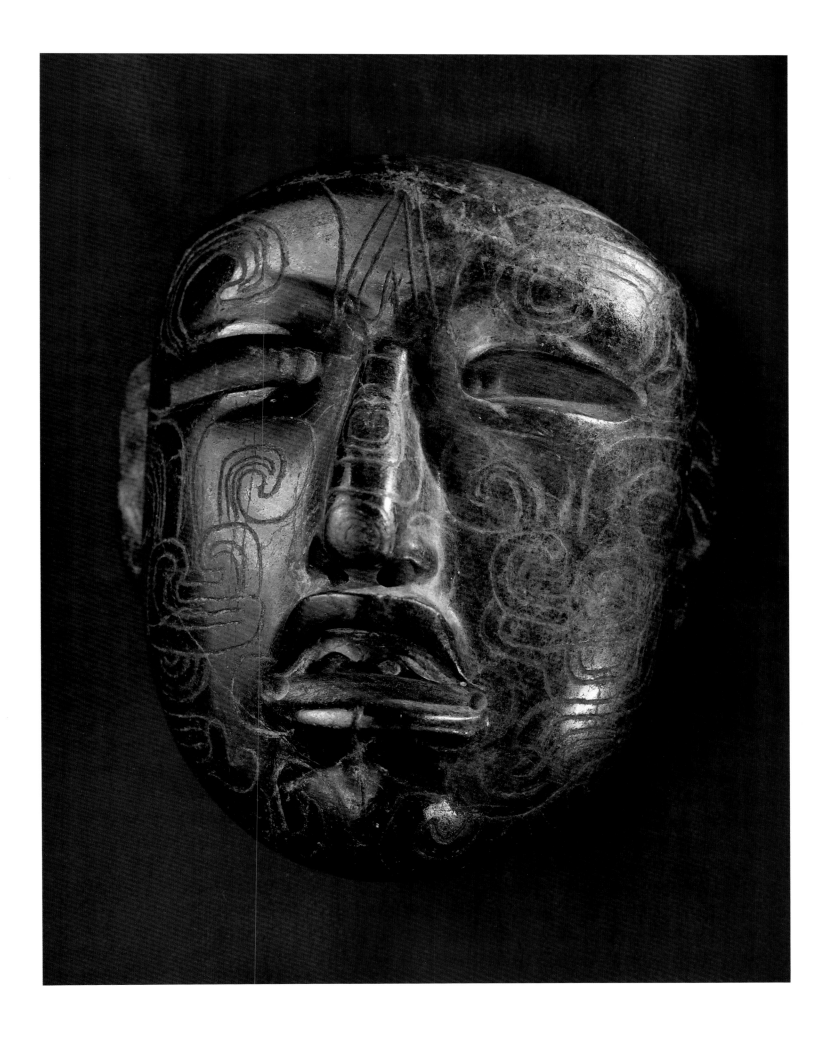

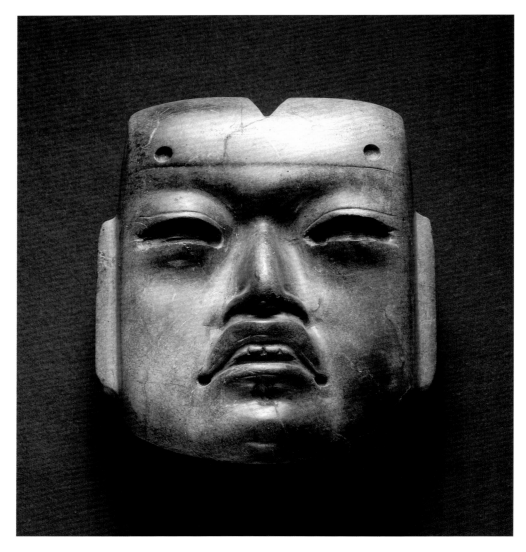

composite anthropomorph, or were-jaguar, inside a cave. With its nose resting on an everted upper lip, the anthropomorph wears a helmet whose band contains three elliptical excisions flanked by inclined bands. From the top of the helmet to below the chin run two parallel bands. Incised above the base of these bands are two cleft-rectangle motifs, which appear on either side of the mouth where buccal bands usually show profile heads of the composite anthropomorph (see cat. 90). The maskettes at the base of the cave band also double as ear ornaments for the anthropomorph. Similar ear ornaments are worn by baby-faces depicted as gigantic stone monuments, such as La Venta Monument 44.

The cave entrance is presented as a band with three composite anthropomorphic cleft "masks." Together with the earringlike

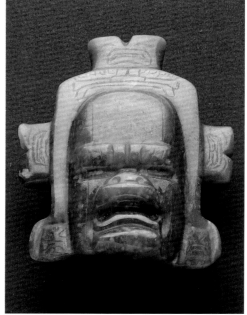

94. Deity Mask

Middle Formative Period
Jade
10.2 x 8.6 x 3.1 (4 x 3⅜ x 1¼)
Templo Mayor
Museo del Templo Mayor

under Aztec control. It is not the first time that an Olmec piece has been found in a late context, but this example is noteworthy for the quality of the piece as well as for the manner in which it was treated at the principal Aztec temple. E.M.M.

This Olmec mask from the Middle Formative period was found in Offering 20 from the lower part of the Great Temple of the Aztecs, a context dating to 1470 A.D. Other objects in the offering included a Teotihuacan mask, works from Mezcala, shell, fragments of sawfish, turtles, knives, and representations of gods such as Tlaloc and Xiuhtecutli.

This mask has typical Olmec features—for example, the V-shaped cleft and the eyes and mouth. The stone came from the region of Puebla, Oaxaca, and Guerrero.

It is possible that the mask was found in an ancient Olmec offering from that region and sent as tribute or gift to Tenochtitlan. There it was placed to honor Huitzilopochtli and Tlaloc, as the region where it originated was

95. Pendant with Were-Jaguar Head Framed with Cleft Elements

Middle Formative Period
Jade
6.7 x 55 (2⅝ x 21⅝)
Cozumel, Yucatan
Museo Regional de Antropología, Mérida

Suitable to be mounted on a headdress or attached at chest level, this carving, probably an heirloom found in Yucatan, depicts a theme common in Middle Formative Olmec art—the

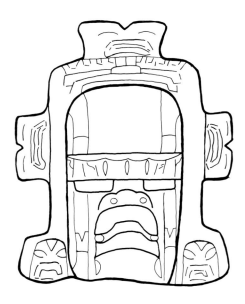

"masks" at the base of the cave band, the two laterally projecting "masks" are pictorially equivalent to the vegetation motifs shown on cave entrances depicted on some monumental altars. On the top center portion of the cave band is an incised frontal "mask" of a reptilian zoomorph with serrated brows, L-shaped eyes, a nose resting upon an inverted U-shaped mouth, and bracketlike teeth. This image is surmounted by a fifth projecting cleft rectangle containing yet another composite anthropomorph mask, creating an abbreviated version of the composite anthropomorph sitting atop the primary composite zoomorph (see cats. 115, 118, 119). This scene depicts the anthropomorph as the symbol of mankind inside the sacred mountain. Similar compositions also occur on incised celts and squarish pendants.

A.P.

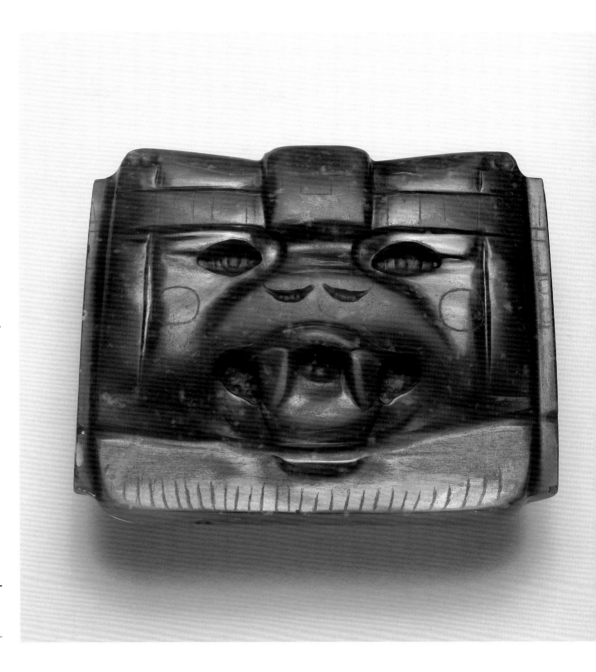

96. Pectoral of Rectangular Form with Were-Jaguar Face

Middle Formative Period
Jade
10 x 13 x 2.5 ($3^{15}/_{16}$ x $5^{1}/_{8}$ x 1)
The Mixtec region, Oaxaca
Museo Nacional de Antropología, Mexico City

This piece is the first object in the 1927 catalogue of the Jade Objects Collection of the National Museum of Anthropology: it was acquired in 1910, and probably originated in the Mixtec region. When Alfonso Caso was an archaeology student at the museum in 1929, he sent two photographs, one of which showed this piece, to Marshall Saville for his article on Mexican votive celts.

A magnificent example of pre-Hispanic workmanship, this pectoral bears traces in the eye sockets of the small borers used to hollow out the stone. Despite its identification as a jaguar, the face seems to have, more correctly, the features of a bat, as seen in the nose and small pointed fangs.

M.C.-L.

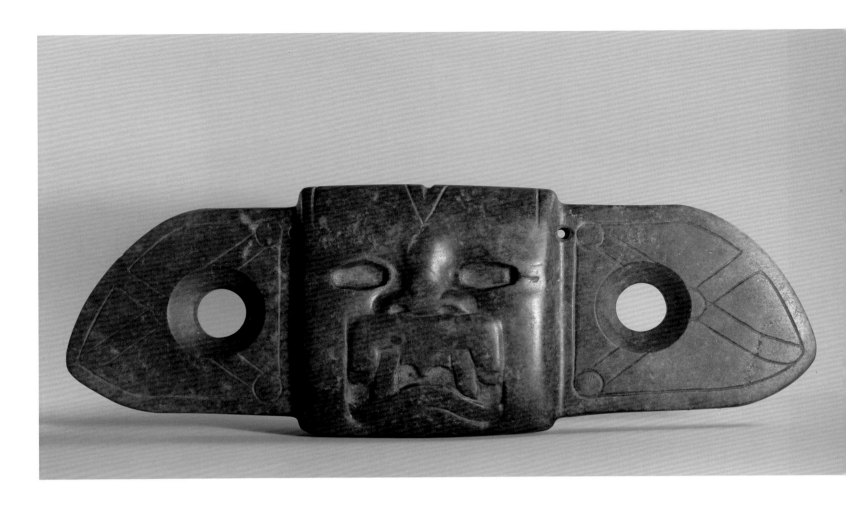

97. Winged Pendant with Were-Jaguar Face at Center and Proto-Maya Design on Back

Middle Formative Period with Protoclassic Inscription
Quartzite
9 x 26.5 (3⁹⁄₁₆ x 10⁷⁄₁₆)
Northern Yucatan
Dumbarton Oaks Research Library and Collections,
Washington, D.C.

This is probably a late Olmec piece. It is an excellent example of an Olmec object treasured and reused by later people.

A square Olmec were-jaguar face, with an almost-square fanged mouth and a cleft brow, is carved in the center of the obverse of the pendant. Incised on the wing at either side is the ubiquitous crossed-bands motif. Small holes, presumably for suspension, were drilled at either side of the brow, probably at the time of manufacture. The large funnel-shaped holes in the wings were likely drilled later.

On the reverse, the seated figure of a ruler has been incised, facing an Izapan or proto-Maya inscription. These would have been added in the post-Olmec period, around the

beginning of our era. There may not have been a great difference in time between the original manufacture and the additions.

Winged pendants of this general form were found all around the Caribbean basin in various cultures over a long period of time. This one is larger than most. It is said to have belonged to an American missionary in Mérida, Yucatan, who acquired it in a village near there (Coe 1966). Olmec carvings of jade and other greenstones sometimes found their way into the Maya area (Andrews 1986), although most of them were probably not carved there.
 E.P.B.

98. Clamshell Celt Pendant with Incised Prone Figure with Torch and "Knuckle-Duster"

Middle Formative Period
Jade
22.5 x 7.2 x 2 (8⁷⁄₈ x 2⁷⁄₈ x ¹³⁄₁₆)
Gulf Coast
Museo Nacional de Antropología, Mexico City

The four perforations along the longest edge indicate the use and placement of this piece. The figure, delineated with fine incisions on the interior surface of the pectoral, permits corroboration of its correct position. The prone personage has one arm in front and the other bent at the chest; this type of personage is identified as a "swimmer." The figure, dressed in a skirt-belt arrangement that covers part of the chest to the thighs, is adorned with knee bands, bracelets, and earspools; he has a human face with a jaguar mouth.

The headdress combines various elements similar to those of cat. 115, repeating the upper half of the cleft head with accompanying vegetable elements. These personages probably participated in a ceremony related to the jaguar and to plant cultivation. The headdresses combine diverse elements related to the cult of the earth and/or corn, such as the "knuckle-duster" and torch.
 M.C.-L.

254

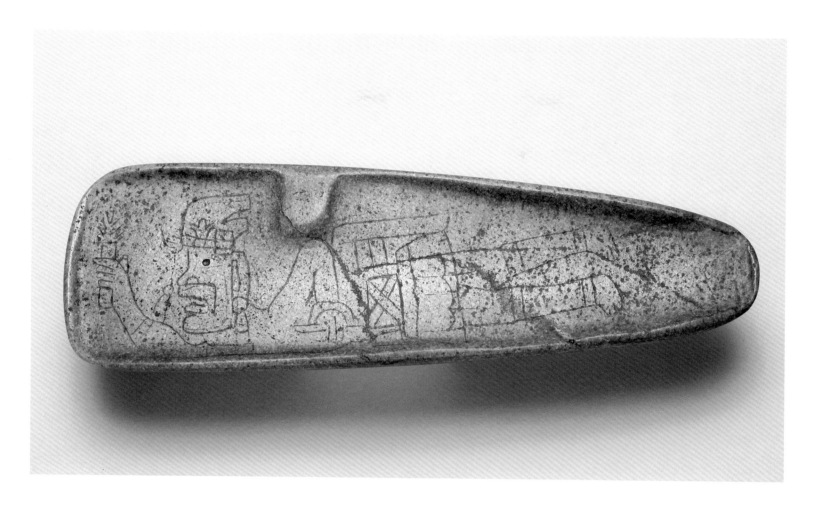

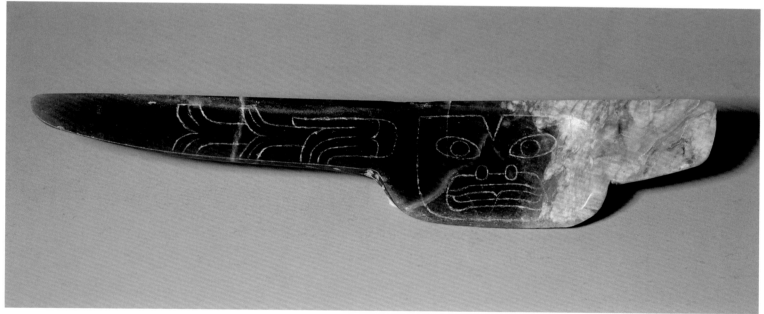

99. Spoon Pendant with Incised Frontal Face

Middle Formative Period
Jade
3.7 x 18.5 (1⁷/₁₆ x 7⁵/₁₆)
Guerrero
Lent courtesy of The Cleveland Museum of Art

Guerrero has yielded an interesting number of so-called Olmec spoons, made out of jade. The semiprecious stone was worked into an elongated object, with a wide subangular area—support for the main image—asymmetrically disposed between a long, narrow, tail-like appendage and a shorter counterpart.

The costumes, ornaments, and ceremonial paraphernalia of large anthropomorphic stone sculptures have shown that these spoon-like objects were, in fact, used by high-status personages as insignia and worn as pectoral ornaments.

The delicately engraved design presents a frontal view of the ubiquitous Olmec horizon hybrid with cleft head, almond-shaped eyes, and large mouth with toothless upper gum. A lateral design with curvilinear motifs, also incised, seems related to fire-serpent and paw-wing symbols.

C.N.

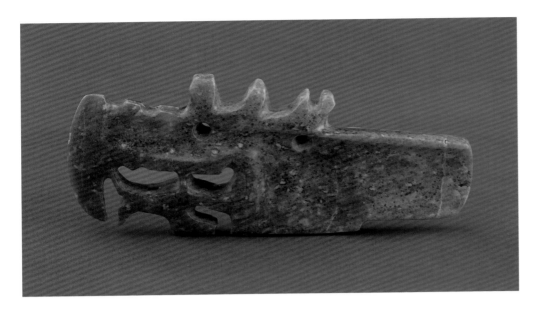

100. Spoon in the Shape of a Bird Monster Profile Head

Middle Formative Period
Jade
4.4 x 10.8 x .6 (1¾ x 4¼ x ¼)
Costa Rica
The Tucson Museum of Art, Gift of Frederick R. Pleasants, 68.11

Although most Olmec spoons are simple, undecorated pendants, some are elaborately carved in the shape of the profile head of the bird monster or embellished with incised designs in the dish. The bird monster type is the most common of the decorated spoons. Eight have been documented in the literature. Generally carved in translucent blue-green jade and polished to a high finish, these ritual objects often come from Guerrero and Costa Rica.

Cut from a halved celt, this Costa Rican spoon depicts the Olmec bird monster, god of the sun and sky. Based on the harpy eagle, a powerful tropical-forest raptor, the mythological creature has clearly defined flame eyebrows, a trough-shaped eye, and the bird monster's distinctive recurved beak. Within the open-work mouth is an L-shaped upper fang. A pair of biconical suspension holes appears at the center of the pendant. A narrow ridge extends along the top and bottom of the undecorated section of the spoon, framing concave spaces that may have held powders or fluids.

The exotic material, fine workmanship, and specialized iconography of the spoons indicate their important role in ancient ceremonial life. An epi-Olmec relief carving from San Antonio Suchitepequez on the Pacific Coast of Guate-

mala depicts a strange image of a central masked figure wearing a plain spoon pendant around his neck and a downturned bird monster profile head on the loincloth, joined to a contortionist whose body completely encircles the scene (Parsons 1986: fig. 3).

The function of Olmec spoons is uncertain. They may have been used to hold hallucinogenic snuff taken to induce the trance states central to transformation rituals or other shamanistic ceremonies. The bird monster iconography would be appropriate for objects used in religious practices involving ecstatic flight to distant realms of the cosmos. Alternatively, spoons may have been receptacles for blood drawn in self-sacrifice rites performed by the elite to honor their ancestors, propitiate the gods, or guarantee the fertility of the earth. A beautifully shaped jade spoon recently on loan to the Metropolitan Museum of Art has a handle in the form of a bloodletter point. The merger of spoon and bloodletter in a single piece may indicate that both types of artifacts played a role in blood sacrifice. Bird monster images commonly decorate fine jade ornaments and costume elements worn by rulers and buried in their graves.

P.D.J.

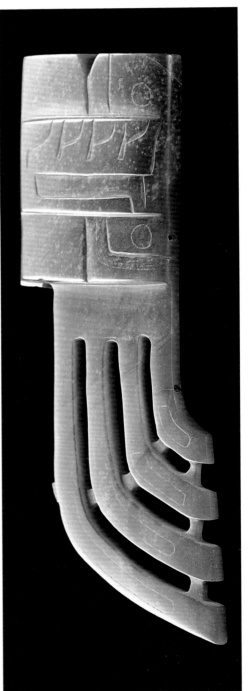

101. Pendant with Paw-Wing Motif

Middle Formative Period
Jade
16.5 x 5.8 (6½ x 2⁵⁄₁₆)
Costa Rica
Museo del Jade Fidel Tristan, Instituto Nacional de Seguros, San José, Costa Rica

This unusual carving of a human hand with splayed fingers, also known as the paw-wing motif, is, in fact, a *pars pro toto* symbol of a baby-face individual. Apparently, its thumb was broken off in Pre-Columbian times and where it had once been attached, it was never smoothed away. A pair of similarly shaped hands, also carved out of jade, were included in a rich burial offering unearthed at La Venta, on the Gulf Coast (see cat. 85).

Although this is a baby-face *pars pro toto*, similarly splayed hands are usually shown as part of reptilian zoomorph compositions, a theme that relates to caves and mountains. As such, they are shown as paws on reptilian zoomorph images carved in greenstone, modeled in clay as effigy vessels (see cat. 29), attached to a zoomorph's pelt worn by a baby-face (see cat. 23), or carved on such monumental sculptures as altars. On this particular piece a serrated brow, a *pars pro toto* for the reptilian zoomorph, is shown incised on its forearm or bracelet. Its provenance is given as Costa Rica, so this splayed hand pendant in the Olmec style must be regarded as an heirloom brought in from Mesoamerica. A.P.

102. Canoe in the Shape of a Hand

Middle Formative Period
Jade
20.5 x 6.7 x 3.2 (8¹/₁₆ x 2⁵/₈ x 1¹/₄)
Unknown
Anonymous loan to The Brooklyn Museum L60.5

This remarkable flat-bottom canoe, carved out of jade in the shape of an open hand, belongs to a special class of artifacts in Olmec art. Like celts, votive axes, perforators, needles, and miniature *manos* and *metates*, they are "precious" copies, in jadeite and other types of greenstone, of tools and objects used in daily activity. Highly polished and showing traces of red pigment between the finger grooves, this hand-shaped canoe is realistically rendered, down to the carefully incised fingernails.

Flat-bottom canoes were often depicted in Olmec art, both in stone and clay. Four small jade canoes were included in a burial offering at La Venta. Another remarkable jade canoe,

depicting beautifully incised head versions of the composite anthropomorph, or were-jaguar, was recovered as part of the Cerro de las Mesas treasure (see cat. 103). All known jade canoes have a number of perforations that would allow them to be hung from or attached to some surface. They were probably used in propitiatory rituals related to water travel, perhaps involving such activities as transportation, trading, or both. The use of a hand as a metaphor for canoe is particularly sensitive. Flat-bottom canoes are still used in the shallow rivers of the Mexican Gulf Coast.

A.P.

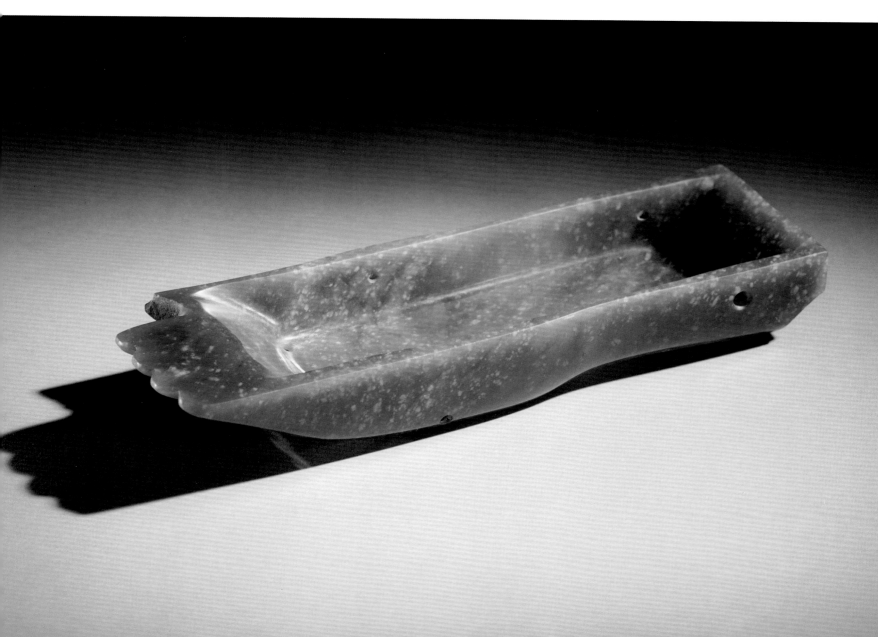

103. Pectoral in the Shape of a Canoe

Middle Formative Period
Jade
20.4 x 5.7 x 2.5 (8¹/₁₆ x 2¹/₄ x 1)
Cerro de las Mesas, Veracruz
Museo Nacional de Antropología, Mexico City

During the 1941 season at Cerro de las Mesas, a trench was excavated at the base of the great mound, and one of the richest jade offerings in Mesoamerica was discovered. Hundreds of distinctive objects were uncovered in a variety of materials including jade, jadeite, calcite, serpentine, chloromelanite, basalt, and metadiorite. Some are in a style very different from that of the Olmec.

Among the most interesting objects was a pectoral with four perforations on its longest side. The form was a narrow canoe with a fine incised jaguar face on each end, with a half-open mouth, almond-shaped eyes, and a triangular cleft forehead.

The environment where the Olmec lived was crossed by numerous rivers and streams; no doubt water transport was of great social, as well as economic, importance.

M.C.-L.

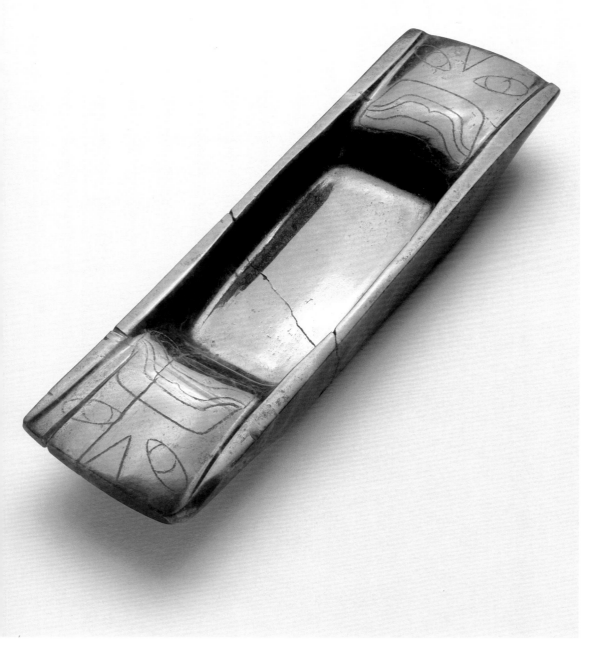

104. Scepter

Middle Formative Period
Blackstone
25 x 4.7 x 2.2 (9¹³/₁₆ x 1⁷/₈ x ⁷/₈)
Ojoshal *ejido*, Cárdenas, Tabasco
Museo Regional de Antropología Carlos Pellicer Cámara

This portable sculpture is a rectangular and pointed object that could have functioned as a scepter (Navarrete 1974: 16). Carved on it in low relief is a composite being with both viper and human features. The face is human with almond-shaped eyes and a wide, flat nose. Supernatural elements are indicated by the V-shaped cleft, the buccal plaque that covers the upper lip while exposing the toothless gums, and the open mouth with downturned lower lip. The torso is represented by three horizontal bars that seem to be fastened, from which the face of a viper in profile emerges at the lower tip. From the head of the human figure emerges a conical element, decorated with two pairs of incised lines, which could represent the headdress of the figure or the distal end of a serpent.

This scepter formed part of the composite offering of "more than 100 celts" found a little more than 15 kilometers north of La Venta in the 1950s, and is the only complete example of its type known to date.

R.G.L.

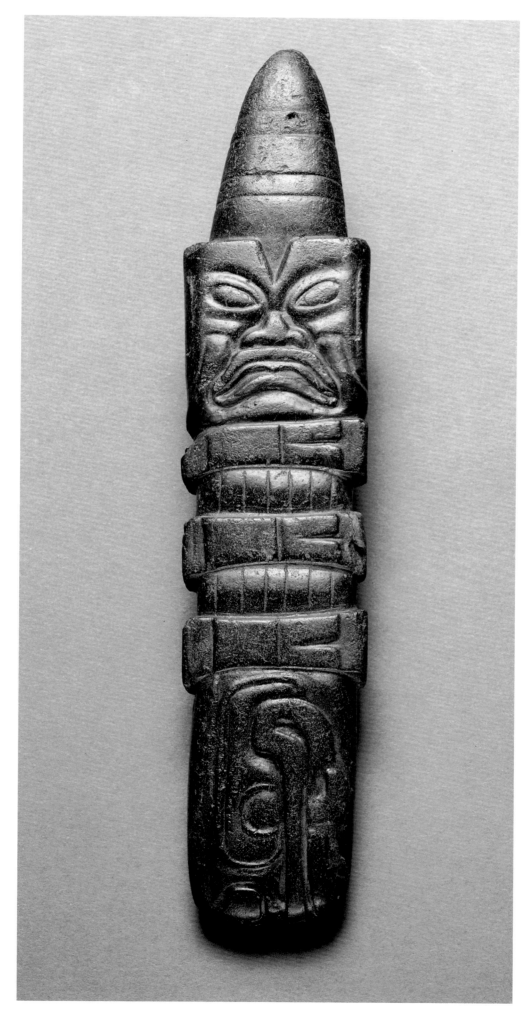

105. Perforator with Bird Monster Handle

Middle Formative Period
Jade
15.6 (6⅛)
Veracruz
Lent courtesy of The Cleveland Museum of Art

The offering of human blood drawn in self-sacrifice by men and women is a religious rite well documented in ancient Mesoamerica. Blood was obtained from the ears, tongue, and penis. Self-sacrifice was sometimes viewed as a penitential ritual, but more often practiced as an elite obligation to maintain the vitality of the cosmos and fertility of the earth. Various implements were used to draw the blood. Some were natural objects, such as stingray

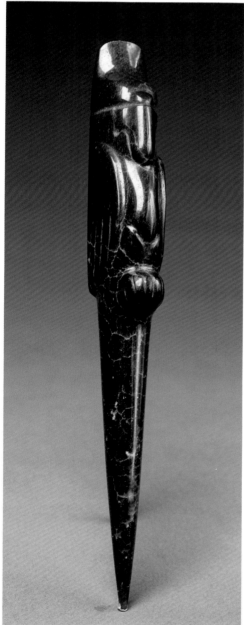

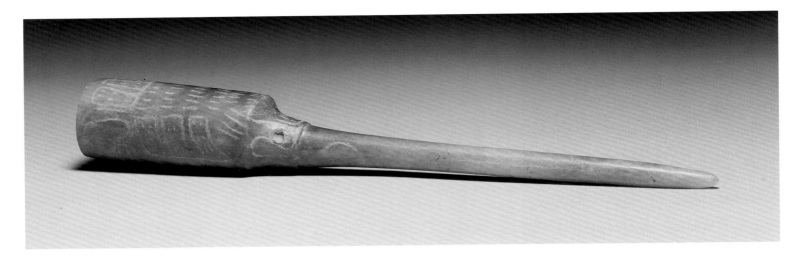

spines, sharks' teeth, and cactus points. Others were artifacts carved from bone or jade and serpentine.

Olmec bloodletters take a variety of forms. Basically shaped like icepicks, perforators usually have plain, tubular handles, although some are carved in the shape of supernatural beings or incised with symbols associated with different deities. One common type of bloodletter is an effigy hummingbird, the beak of which served as the point (cat. 106). The tips of the ritual implements are always sharp. A number of jade examples were reworked in ancient times. Handles and points were sometimes broken off and drilled with holes for suspension.

Many of the Middle Formative graves excavated at La Venta include jade bloodletters in their funerary offering. Two bloodletters were excavated from the bundle burials in Tomb A, one a jade effigy stingray spine with serrated edges and the other a simple tubular handle with broken point. In Tomb C, a plain perforator handle with missing tip was found resting over the groin of the deceased and surrounded by jade beads and effigy turtle shells that once composed a belt. This bloodletter handle is not perforated, so it may have been carried in a pouch attached to the belt or added to the burial just prior to interment. A bloodletter in perfect condition was recovered from the burial in the sandstone coffer.

Bloodletters are occasionally depicted in Olmec representations of rulers wearing elaborate ritual costume, paired with a scepter or held alone. Bloodletters clearly represent significant elements of the ruler's paraphernalia and may signify his role as priest.

Supposedly found with an Olmec blue-green jade standing figure in a grave in Veracruz (Princeton 1995: fig. 19), this perforator has a handle in the shape of a bird monster in repose. The creature has a prominent central plume rising over his head and a large raptorial beak. The wings are held close to the powerful body; incised lines indicate feathers. The bird monster's talons are shown at the base of the body. The perforator tapers to a sharp point and the surface of the implement is polished to a mirror finish. Incised on the back is a sprouting motif with a pointed vegetal element flanked by two curved leaves. This is attached to a bundlelike form that ends in a rectangle with two squares.

The Olmec bird monster iconography is closely associated with agricultural fertility (Joralemon 1971, 1976). The sprouting elements on the back of the bloodletter reinforce the link between the bird monster, corn, and sacrificial blood. P.D.J.

106. Perforator in the Shape of a Hummingbird

Middle Formative Period

Jadeite

17.2 x 2.6 (6¾ x 1)

Southern Veracruz

Dumbarton Oaks Research Library and Collections, Washington, D.C.

The piercing end of this implement resembles the long beak of a hummingbird, and the handle has been incised with fine feathering and drilled with two bird eyes. Traces of red pigment remain in the carving. Most of the approximately 325 species of hummingbird have a long, tapering beak. The birds are not common in Olmec art, but they were surely present in quantity in the Olmec environment.

In 1957, Samuel Lothrop suggested that this "stiletto" was used for blood sacrifice (Lothrop, Foshag, and Mahler 1957: 6). Since then, much has been written on Olmec and Maya bloodletting (Joralemon 1974; Schele and Miller 1986; Benson 1988; Joyce et al. 1991; Reilly 1991). Olmec bloodletters of jadeite, obsidian, flint, bone, stingray spine, and shark tooth have been found in excavations at La Venta and other sites. One La Venta find was described as a jade "ice-pick" perforator (Drucker 1952: 23–26; Drucker, Heizer, and Squier 1959: 272). A ruler's bloodletting nourished the gods of nature who, in turn, nourished the population; bloodletting was also a means of communicating with the sacred ancestors.

Eduard Seler (1923: 56, 576–580, fig. 398) noted the association of hummingbirds with sacrifice in the Maya codices, and he illustrated, from Chichen Itza, a huge bejeweled hummingbird with the point of its beak at the penis of a small human figure in a flower. Others have also remarked on the sacrificial implications of hummingbirds in Mesoamerica (see Benson 1989: 4). E.P.B.

107. Perforator

Middle Formative Period

Jade

8.6 x 3 (3⅜ x 1³⁄₁₆)

La Venta, Tabasco

Museo Nacional de Antropología, Mexico City

This perforator is part of the Burial 2 Offering of the Tomb of the Monolithic Columns at La Venta (see also cats. 45, 51, 85). The handle and point seem to have been polished later. Jade perforators were believed to have been used to extract drops of blood as a ritual offering. M.C.-L.

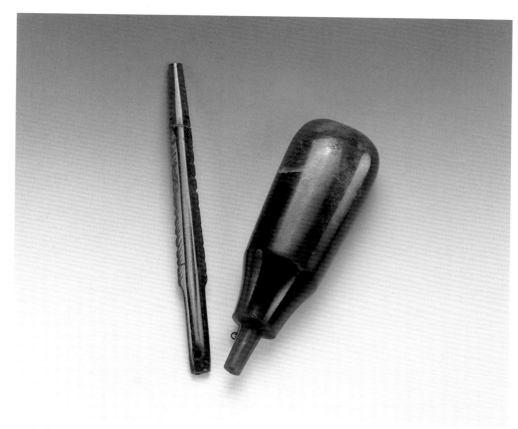

109. *Yugito* with Were-Jaguar Face and Trident Motifs

Middle Formative Period
Blackstone
12.5 x 12 x 14 (4^{15}/$_{16}$ x 4^{3}/$_4$ x 5^1/$_2$)
Tlacotepec, Guerrero
Museo Nacional de Antropología, Mexico City

This type of horseshoe-shaped small sculpture is uncommon in Mesoamerica; the earliest is associated with the Olmec culture, as in this piece. The stone, beautifully polished on the exterior, bears on one end an Olmec face, which has jaguar features and wears earspools, divided into two distinctly marked halves. Above the face are two rectangular elements delineated by incision.

This piece formed part of the Covarrubias Collection that entered the National Museum of Anthropology in 1957.

M.C.-L.

108. Jade Object Representing a Stingray Tail

Middle Formative Period
Jade
10 x 9 (3^{15}/$_{16}$ x 3^9/$_{16}$)
La Venta, Tabasco
Museo Nacional de Antropología, Mexico City

This object formed part of burial bundle 2, uncovered during the 1942 excavations of the Tomb of Mound A-2 at La Venta. Other pieces from this offering include a small, seated female figurine who wears a mirror on her chest (cat. 51), another standing jade figurine (cat. 45), two small reproductions of arms and hands (cat. 85), a jade perforator, various jade beads, and a shark tooth, among other items.

One element of Olmec culture is the appreciation of objects related to aquatic animals, the symbolism of which is not yet understood. The stingray and the shark, for example, were sometimes reproduced in stone; sometimes their body parts were placed as offerings. That these remains are associated with a female figurine is significant; they may be a complex set of ritual elements that associated the sea with a female deity.

This object was intended to be worn as a necklace, as is apparent by the suspension hole in its widest end.　　　M.C.-L.

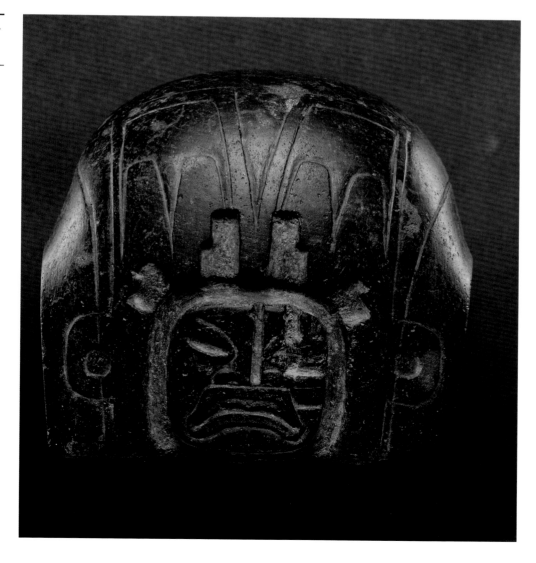

110. Votive Axe

Middle Formative Period
Jade
30 x 15.2 (11¹³⁄₁₆ x 6)
Southern Veracruz or Tabasco
American Museum of Natural History

Votive axes have been known for more than a hundred years. This axe was described in 1890 (Kunz 1890). The head is larger than the body and carved with great detail in considerable depth; the legs, arms, hands, and belt are cursorily incised in very low relief on a relatively small body that narrows into a blade shape. David Joralemon names this as a depiction of his God I, the Olmec dragon, an earth, fire, water, and agricultural fertility deity (Joralemon 1976: 37–58). In a land of volcano eruptions, earthquakes, and hurricanes, these were related aspects of nature.

Several large and a number of small, greenstone Olmec objects have the head of a deity or supernatural and a body with the shape of an axe. Finely made blade-shaped objects appear in many Pre-Columbian cultures. These axes and smaller Olmec versions may be prototypes for the later, smaller "axe gods" of the Nicoya peninsula, Costa Rica (Easby 1968: 89–93).

Cat. 110, known as the Kunz Axe, has incising on the face and ears. One hand is placed above the other, and it looks as if the figure were holding a knife. The flattened

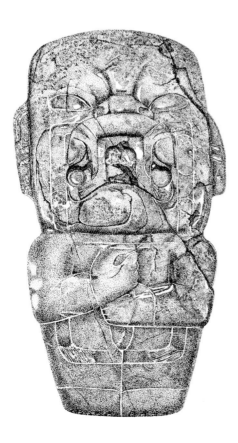

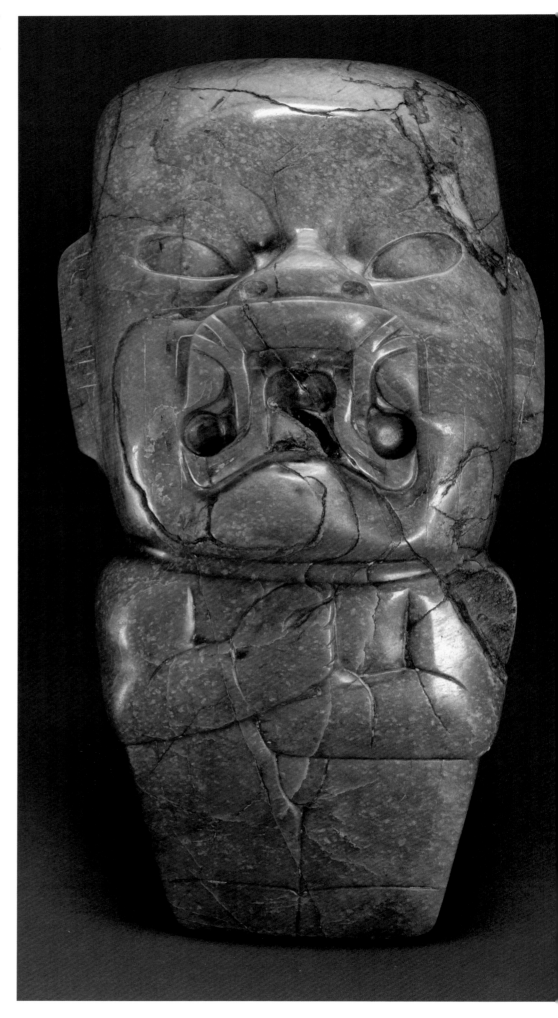

snout and squarish, flaring upper lip are typical
of the style. The mouth is large and has been
called fanged when the piece is described as a
"were-jaguar." It has also been argued that this
kind of Olmec mouth depicts a toad swallowing
the skin it is shedding, forming a motif that
resembles two bifurcated tongues (Furst 1981;
Kennedy 1983). This trait of the toad is a
notable symbol of regeneration. If this is a true
interpretation, it is not a were-jaguar but a
toad-man. A toad is incised on cat. 66, prob-
ably a reference to transformation by means of
ingesting a drug made from a *Bufo* venom.
Olmec toad iconography may be quite complex.

The Kunz Axe is one of the largest jade
objects ever found in Mesoamerica; it weighs
15½ pounds (Ekholm 1970: 36). It was once
larger, but some of the back was cut away,
probably to make other objects, something that
occurred quite frequently with jade.

E.P.B.

111. Votive Axe with a Were-Jaguar Creature with Flame Eyebrows

Middle Formative Period
Jade
22 x 10 x 1.3 (8¹¹/₁₆ x 3¹⁵/₁₆ x ½)
The Mixtec region, Oaxaca
Museo Nacional de Antropología, Mexico City

Olmec jade workmanship produced a master-
piece in this celt representing a humanized
jaguar. The features are typically Olmec: the
face with combined animal and human fea-
tures; the downturned open mouth; the raised
upper lip; the flat nose; and the almond-
shaped eyes with flame brows. In the lower
half, the human element is emphasized by the
hands supporting the front of the body. The
jaguar head symbolizes the earth, with a cut
in its center for the emerging plants, an image
found in other Olmec works.

This piece was probably part of the Doren-
berg Collection, which became part of the
museum in 1927.

M.C.-L.

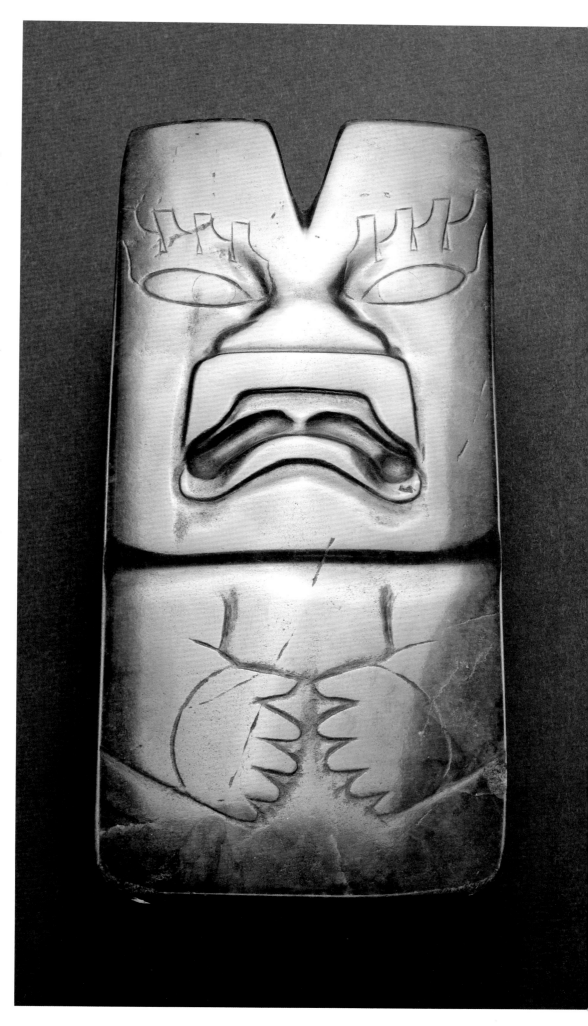

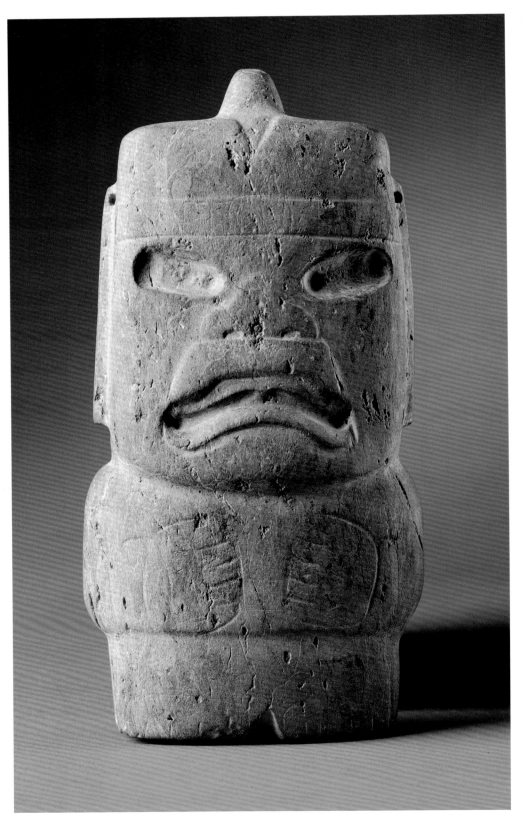

lip, toothless gums, and downdrawn corners. A pointed maize sprout emerges from the head cleft. He wears a simple headband with long striated ear coverings attached. The ear ornaments are drilled at top and bottom. The square head sits directly on the short broad torso. Engraved arms with large hands rest symmetrically across the chest. The lower body is short with a small cleft indicating the division between the legs. Simple engraved lines suggest a loincloth.

Often depicted on jade and serpentine celts, the corn god rarely appears on votive axes. The maize motif takes a variety of forms in Olmec iconography. It can be depicted as a pointed triangular-shaped sprout, sometimes with flanking leaves, an ear of maize sheathed in leaves, or an entire plant. The Olmec corn deity is closely associated with the were-jaguar rain god, occasionally wearing that creature's pleated ear decoration, as on this axe.

P.D.J.

113. Celt

Middle Formative Period
Diopside-jadeite
28.3 x 9 (11⅛ x 3⅝)
Rancho Potrerillos, El Mangal, Veracruz
Dumbarton Oaks Research Library and Collections, Washington, D.C.

This highly polished celt, fashioned with care in a precious material, seems to be a ritual reproduction of a basic utilitarian tool. It is too heavy to be used with any ease, and it is not shaped for easy hafting. Celt forms, often incorporated into elaborate ritual objects (cats. 111, 114–118), probably referred both to the clearing of land for planting, using functional axes, and to the ritual beheading that was part of sacrifices to gods of nature who might protect or destroy crops (Bernal 1969: 79–80; Covarrubias 1957: 71). In later times, jade axes were thought to be lightning bolts identified with the god known to the Aztec as Tezcatlipoca (Saville 1929; Stirling, in Coe 1972: 13).

E.P.B.

112. Votive Axe of Were-Jaguar with Corn Sprout

Middle Formative Period
Stone
21.6 x 10.2 (8½ x 4)
Veracruz, Mexico
Denver Art Museum Collection

Olmec artists carved two varieties of stone votive axes. One type has a massive blade with thick head dramatically tapering to a straight bit. Others are thin plaques with rectangular outline and a straight, flat profile.

This is an anthropomorphic plaque axe depicting the Olmec corn god. The creature has a boldly carved were-jaguar face with large, slanted eyes, broad flat nose with drilled nostrils, and a trapezoidal mouth with flared upper

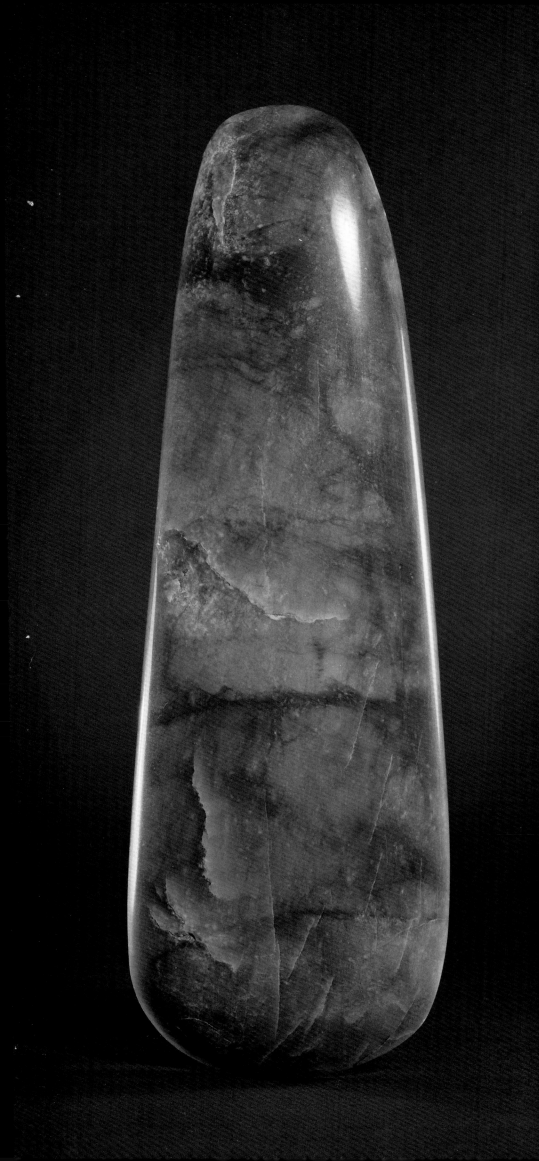

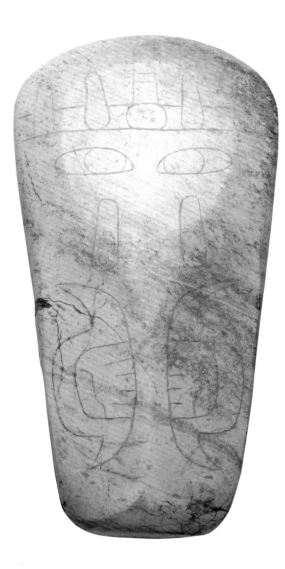

114. Incised Celt

Middle Formative Period
Jade
14 x 7.5 x 2.7 (5½ x 2¹⁵/₁₆ x 1¹/₁₆)
La Venta, Tabasco
Museo Nacional de Antropología, Mexico City

During the 1942 season at La Venta, Complex
A was excavated just north of the Great
Pyramid. Within the Mound A-2 complex, the
Tomb of the Monolithic Columns was un-
earthed, and a stone sarcophagus was discov-
ered just a short distance south. A test pit was
dug to determine the extent of the mound, and
at a depth of 3.85 meters, within a layer of very
compact olive green-brown clay 7 to 10 cen-
timeters thick, an offering of thirty-seven celts
in well-defined rows was found. Three were
finely incised with different designs.

Of the three celts, one has a more complex
theme than the others. It presents in a stylized
and symbolic way a personage of which only
relevant parts were emphasized (i.e., the face,

265

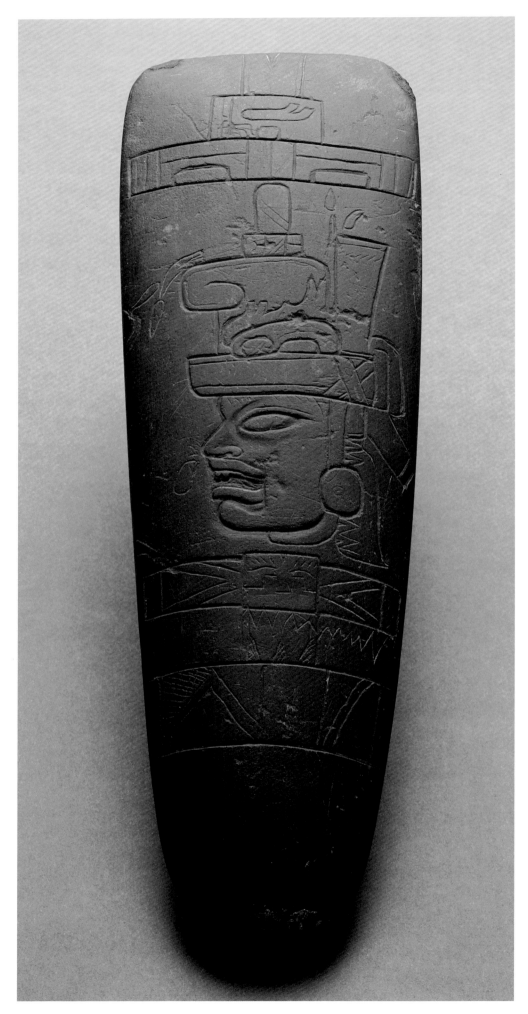

eyes, head, and hands). The eyes are unequiv-
ocally the same as those in other figures that
represent the jaguar; in the lower half appear
two enlarged areas that may relate to water.
The head is completed by a band with five
oval objects from which emerge vegetal ele-
ments; the body is suggested by the hands that
carry two curved objects known as "knuckle-
dusters."

M.C.-L.

115. Celt with Carved Human Profile Head Wearing Complex Headdress

Middle Formative Period
Black slate
31 x 9.5 x 3.5 (12³/₁₆ x 3³/₄ x 1³/₈)
Simojovel, Chiapas
Museo Nacional de Antropología, Mexico City

Found in a cave in Simojovel, Chiapas, this celt
was sent to the National Museum of Anthro-
pology by its discoverer through the interces-
sion of Matthew Stirling when he was visiting
the area.

Very few celts carry such a complex design.
It is formed by three groups of elements
arranged along the vertical axis. In the center
is a human head in profile, framed by two
geometric groups of symbolic motifs; each
group is composed of rectangles, squares,
broken lines, and triangles. The head is topped
by a complex headdress fastened by a chin-
strap. The headdress is formed from eight
distinct motifs, including vegetable elements.

M.C.-L.

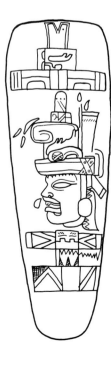

116. Celt with Incised Human Profile and Hand Motif

Middle Formative Period
Jade
36.5 x 7.9 (14⅜ x 3⅛)
Tabasco
The Metropolitan Museum of Art, The Michael C. Rockefeller Memorial Collection, Gift of Nelson A. Rockefeller, 1963

This elongated jade axe blade, supposedly found in the state of Tabasco, is engraved with a bold design. At the top of the celt is a profile head who shows attributes of the Olmec dragon and wears headgear with sprouting vegetation. The L-shaped eye has a scalloped top representing flame eyebrows. The mouth has a flared upper lip and downturned corners to reveal a prominent gumline and L-shaped upper fang. Framing the mouth is a bracket motif, decorated with four disks with circular centers. In the middle of the head is a deep V-shaped cleft, from which emerges a banded maize motif with three elements representing sprouting ears of corn. Across the forehead is a band with a feathered ornament and an iconographic compound of an upturned dotted bracket motif framed in a cleft element, with a crossed-band symbol at the side. Feather ornaments embellish the back of the headdress. The ear is decorated with a round spool with feather tassels. Below the profile is an unusual Olmec emblem consisting of an ear, an almond-shaped eye with round iris, and a hand with blunt fingers and a carefully rendered thumbnail. The hand is emblazoned

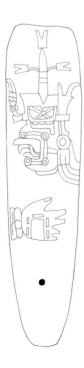

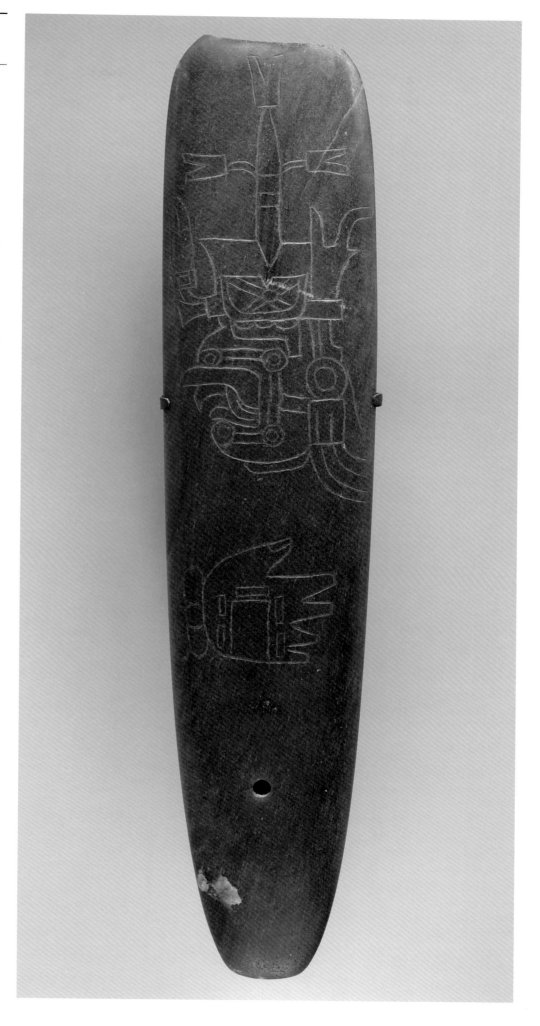

with a downturned bracket motif framed by rectangular elements that represent the dragon's open mouth. Near the rounded butt of the axe blade is a hole for suspension from a belt or waistband.

Like many celts, this example is decorated with images of corn and agricultural fertility. Maize was the most important food stuff for Olmec civilization; celts may represent ears of corn. Precious blue-green jade was a perfect symbol for the valued green maize color. Although this figure has attributes of the dragon, the earth monster from whose body all crops grew, the cruciform corn sprout emerging from the head is a diagnostic trait of the maize god. The profile may represent the were-jaguar deity himself, or it may depict a ruler wearing the divinity's distinctive costume. The other emblem is an enigmatic compound that appears in more simplified form on other Olmec works of art. The complex design incised on the Humboldt Celt includes an almond-shaped eye with round iris framed by three comblike elements and resting on three circles. A disembodied hand and forearm appear directly to the right. Although the meaning of this motif is obscure, it may refer to an Olmec belief about how the world is perceived through sound, sight, and touch.

<div align="right">P.D.J.</div>

117. Celt with Incised Profile Head and Ceremonial Bundle

Middle Formative Period
Jade
24.8 (9¾)
Río Pesquero, Veracruz
Lent courtesy of The Cleveland Museum of Art

Of the thousands of stone celts recovered from Río Pesquero, only a handful have incised designs. These celts, however, bear some of the richest and most detailed iconographic compositions in Olmec art. This petaled example is carved from jade of an emerald color with areas of gray, blue, and green with white inclusions. Delicately incised along the piece is a design that includes a profile head with a cruciform corn motif above a horizontal ceremonial bundle supported by disembodied hands. The profile is flanked by two pairs of identical rectangular cleft elements, each with a lineal sprout emerging from the top of the head. The symbolism of the composition indicates that the figure carrying the bundle is at the center

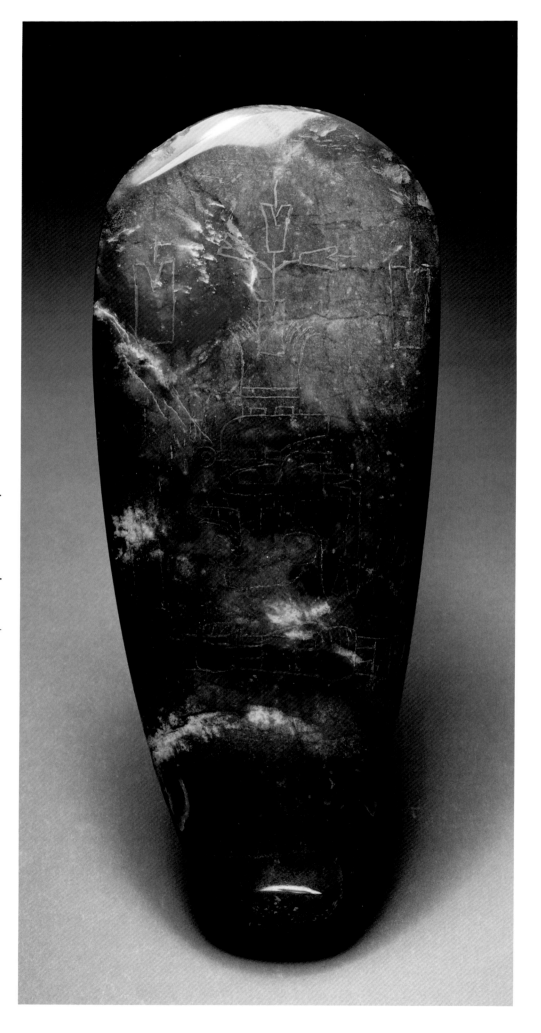

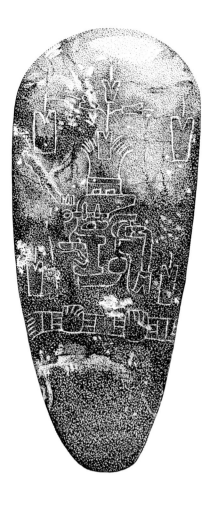

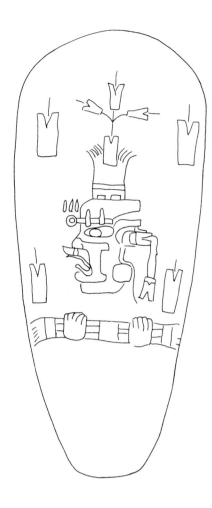

118. Celt with Carved Elaborately Dressed Ruler Holding Bloodletter

Middle Formative Period
Jade
20 (7⅞)
Chiapas?
Museo de Antropología de Xalapa, Universidad Veracruzana

119. Incised Celt: Masked Figure

Middle Formative Period
Jadeite
27.9 x 7.9 x 3.8 (11 x 3⅛ x 1½)
Guerrero?
Dallas Museum of Art, Dallas Art Association Purchase

of the cosmos, surrounded by the four cardinal directions. Facing left, the profile has a deeply cleft head, almond-shaped eye with round iris, fleshy nose, and classic Olmec mouth with thick lips, toothless gums, and downturned corner. Framing the mouth is a rectangular motif with rounded protuberant corners. The figure wears a corn god headband with a circular ornament at the center and three vegetation symbols above a pair of celt-shaped elements at the side. Rising from the upper part of the head is an elaborate corn symbol. At its base is a fringed rectangular element with a horizontal band framing a double-merlon motif; at the top is a cleft rectangle, from which emerges a cruciform corn motif. The profile head has an oblong ear ornament, and, at the back of the head, a decoration of two cleft rectangles with scalloped bases linked by a band. The ceremonial bundle comprises three horizontal bands bound at the center and sides. Each end of the bundle droops downward and is decorated with small incised lines.

A related design is found on another Río Pesquero celt in the Museo de Antropología, Xalapa (Joralemon 1976: fig. 8f). It is unusual to find two iconographic compositions from the same site that are so closely related.

Although the presentation of the baby or were-jaguar infant is a well-known theme in Olmec sculpture, the offering of a bundle or

ceremonial bar is less common. The fullest expression of the theme is depicted in Relief 1 from Chalcatzingo. The presentation of the bundle is linked to the images of corn plants and symbols of agricultural fertility. Other representations of the Olmec elite bearing bloodletters and scepters are embellished with images of sprouting maize, suggesting that Olmec artists celebrated their rulers as corn kings who played critical roles in maintaining the fertility of the earth and guaranteeing the abundance of agricultural harvests.

P.D.J.

Thousands of polished jade and serpentine celts have been found throughout the Olmec world. Although most are undecorated axe blades, some are incised with iconographic images that provide a wealth of information about the Olmec world view.

In the Museo de Antropología in Xalapa, Veracruz, is a beautiful Olmec carved jade celt in the shape of a thin axe blade, which flares slightly toward the top (cat. 118). Both ends are curved and there is a single suspension hole drilled through the base. The blade was cut from a fine piece of translucent blue-green jade and polished to a mirror finish. The stone was probably quarried in the Río Motagua valley in Guatemala and traded into the Gulf Coast lowlands of Mexico. The carving has been broken in half at the middle and reglued. Red pigment has been added to the design in modern times to highlight the relief and the incised detail.

On the front of the celt is a low relief carving of a standing Olmec lord wearing an elaborate costume and holding a bloodletter in his left hand. The upright posture of the figure and the towering headdress emphasize the vertical axis of the composition. Important elements of the sculpture are rendered in low relief and details are indicated with finely incised lines. The torso and cape are pictured frontally; the rest of the image is presented in profile. The design is centered just above the midline of the celt, occupying the full width of the axe blade only at the dignitary's shoulders. Although the composition is richly detailed, there is ample empty space surrounding the figure to balance its dense imagery. By positioning the elaborately attired lord against a plain background,

269

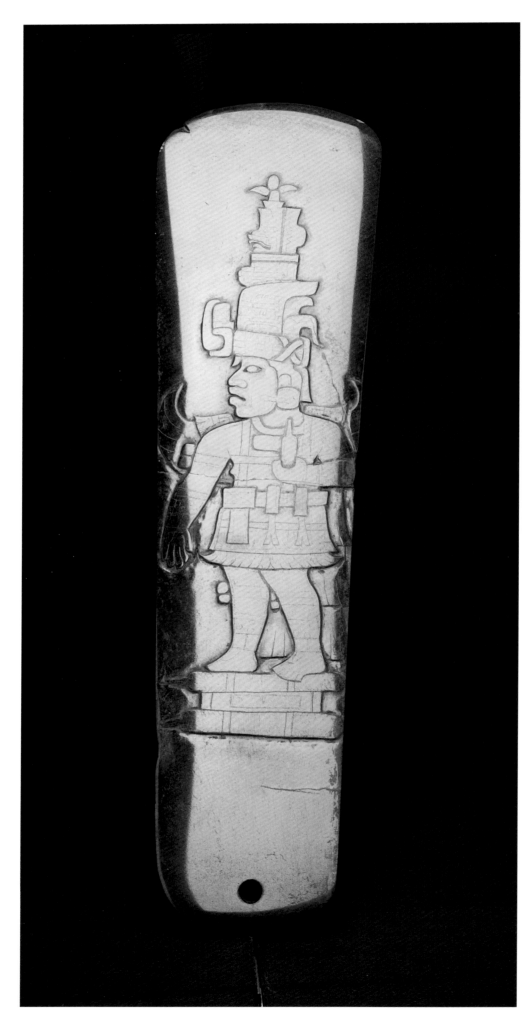

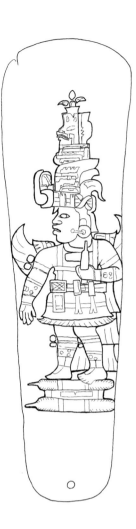

the Olmec artist created an image of striking power and monumentality.

The costume depicted on the Xalapa jade is one of the most elaborate in Olmec art. The figure functions as a mannequin for the display of Olmec symbolic finery; his human attributes are subordinate to the costume elements. The regalia consists of a tall headdress, a feathered cape, and a cloth skirt with elaborate waistband. Additional paraphernalia includes an earplug assemblage, a necklace with oblong pendant, and various bands and cuffs on arms and legs.

At the top of the headdress is the profile head of the maize god. Emerging from the cleft in the top of the head is a sprouting corn motif. The design includes a square base with slightly flared top, a vertical corn sprout with rounded tip, and three leaf elements in a cruciform pattern. A pair of celt-shaped motifs appears on the god's forehead, and an L-shaped design brackets the mouth. To the right of the deity's profile head is a "knuckle-duster" with lobed profile and serrated finger holds.

The corn god rests on the profile head of the Olmec dragon, which forms the second component of the headgear. The earth monster has a rounded snout and a squared back. Incised lines depict the flame brow, L-shaped eye with trilobed eyelid, small round nose, and elon-

gated L-shaped upper jaw with cleft fang.

The third section of the headdress is a helmetlike element representing the upper section of the were-jaguar profile head. It has a vertical forehead, swept-back top, and cleft at the back. An incised line extends from the bottom of the cleft to the headband at the base of the headdress. At the top of the forehead is the profile head of the bird monster with flame eyebrows, L-shaped eye, bulbous nose, and elongated beak with curved tip and upper fang with cleft end. A second incised design depicts a flame brow on top of a rounded bracket motif that may represent an eye. To the left of the eyebrow is a small round nose.

The final component of the headdress is a wide, striated headband. At the front is a bracket with a scroll-like element that emerges from its center and rises vertically to end in a curved tip. A representation of sprouting corn is framed by the bracket and scroll. The motif includes a celt-shaped corn symbol with a diagonal band and a cleft square element that resembles the cleft head of Olmec supernaturals. To the right of the bracket and scroll is a pair of rectangular forms with cleft tops. At the end of the headband is a large crossed-bands symbol, above which is a wide curved design that tapers to a point. Descending from the back of the headband are flaps and pieces of cloth.

The Olmec lord holds a ritual bloodletter in his left hand. The perforator has an elongated tubular handle and a short point with blunt tip. It bears a striking similarity to a jade perforator with broken point found in the tomb in Mound A-2 at La Venta (cat. 107).

The dignitary also wears a feathered cape, the upper part of which covers the shoulders and extends to the small of the back. A three-tiered train descends from the winged cape to the ankles in overlapping layers. Incised lines indicate the feathers that make up the garment. The cape is held in position by a pair of suspenders that extend vertically across the bare chest and attach to the waistband. A plain horizontal strap crosses the upper chest and binds the suspenders together. Two bell-shaped flower motifs with bands around the middle appear on top of the shoulders, apparently attached to the suspender straps.

Around the middle is a knee-length skirt with an undecorated band extending across its midline and a fringed border. At the top of the skirt is a decorated waistband with a square element emblazoned with the crossed-bands motif at one side. A rectangular panel with plain border hangs from the square. Also attached to the waistband is a pair of rectangular motifs, each with an inverted Y-shaped element suspended from the bottom.

The figure wears several types of jewelry and personal ornaments. The earplug assemblage consists of a disk or spool with a tubular bead and a round bead attached. The necklace is a plain band with an oblong pendant, which probably represents a concave iron-ore mirror. Plain bands with pairs of round beads appear at the biceps and knees. Wide cuffs with spotted designs encircle the forearms and calves, and simple bands with flaps decorate the wrists and ankles.

The richly attired dignitary depicted on this jade celt reveals much about Olmec concepts of rulership. The ritual offering of human blood was one of the primary responsibilities of Olmec rulers. Acting as an intermediary between the supernatural realm and the human community, the lord performed this sacrificial act to sustain the energies of the cosmos. The bloodletter held in the left hand symbolizes the centrality of blood sacrifice in Olmec belief. The association of the ruler and the bird monster is strongly emphasized in the costume. The sun god's profile head incised on the headdress and the winged cape made from bird feathers are marks of the close link between the Olmec lord and the avian master of the celestial realm. Finally, the ruler's pivotal role in assuring agricultural fertility and a bountiful harvest is reinforced by the repetition of maize god images and sprouting corn motifs on the headdress. Corn was the staff of life for Olmec civilization and the ruler played a key role in guaranteeing the blessings of a fruitful harvest. These concepts about rulership must have had ancient roots, for Early Formative Pilli ceramic figurines from Tlapacoya and Tlatilco exhibit some of the same iconographic associations shown on the Xalapa celt (Bradley and Joralemon 1993). However, they were not fully formalized until Middle Formative times. That these ideas were widely shared throughout the Olmec world is suggested by other works of art that are iconographically related to the Xalapa celt.

An incised jade celt in the Dallas Museum of Art is decorated with a design remarkably similar to the carving on the Xalapa jade axe (cat. 119). Rumored to have been found in Guerrero, the Dallas celt is boldly incised with a striding Olmec figure with muscular body and elaborate costume. The dignitary is shown with frontal torso and profile body. His right arm is extended near the side of the body, while the left arm is tightly flexed. Both legs are somewhat bent to suggest a striding movement. He wears a towering headdress, a bird monster mask, and an ankle-length cape. A long, clublike scepter is cradled in the left arm. The headdress includes a maize god profile head at the top with a corn sprout emerging

from the cleft. The profile rests on an abstract Olmec dragon head symbolized by a flame brow. At the center of the headdress is the profile head of the banded-eye god, who wears a disk above his nose from which curls a scroll-like element. At the base of the headdress is a wide headband decorated with a pair of rectangular forms with cleft tops. At the back of the headdress is a vertical panel of cloth with a plain border at the top and a disembodied hand grasping a "knuckle-duster." The ruler also wears a bird monster mask, which has a Kan cross in the eye and an L-shaped upper jaw with pointed fang. An ankle-length winged cape, complete with fringed border and long train, covers the back of the figure. He wears hip protectors and a loincloth, which has a square panel decorated with a cross motif. His jewelry includes an earspool, necklace, and arm and leg bands.

The iconographic similarities between the Xalapa celt and the Dallas axe are striking. Although the style and workmanship of the two sculptures are quite different, the parallels in the structure and detail of the two designs argue for a shared ideology and iconography of rulership.

The most significant difference between the two carved celts is the alternation of bloodletter and scepter. Other evidence suggests that the pairing of bloodletter/sacrificial knife and scepter/club is necessary to fully define the meaning of Olmec rulership. The bloodletter/ sacrificial knife may represent the ruler's position as religious leader and priestly intermediary who offers human blood to fertilize the earth and sustain the gods. The scepter/club may have symbolized the king's role as political leader and warrior who protects his people and goes to battle to obtain captives for human sacrifice. A statue of a Young Lord from the Pacific slope of Guatemala depicts a youth wearing a bird monster mask and holding a sacrificial knife and a scepter against his chest (cat. 50). A second Olmec sculpture that depicts the pairing of bloodletter and scepter is the rock carving of a standing lord discovered at Xoc in Chiapas (Ekholm-Miller 1973).

Other Olmec works of art depict variations of the same ceremonial regalia. Some include a bird monster mask and a scepter/club instead of the bloodletter/sacrificial knife. Monumental versions are shown on Stela 2 from La Venta, the San Miguel Amuco stela, and the stela in Tuxtla Gutiérrez. Smaller scale representations are engraved on the Simojovel celt (cat. 115) and an incised ax in the Metropolitan Museum of Art (cat. 116).

The Olmec sculpture most useful in understanding the costumes portrayed on the two celts is the jade statue from Río Pesquero at

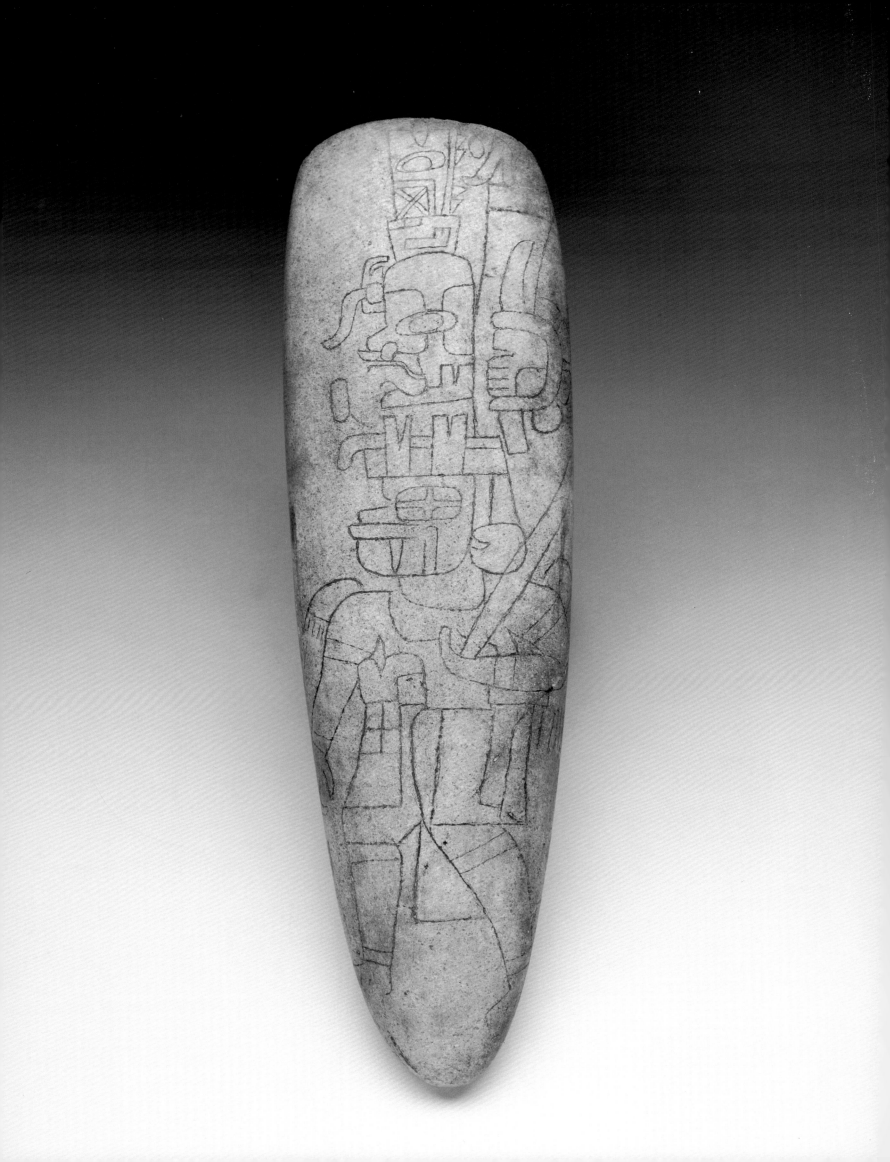

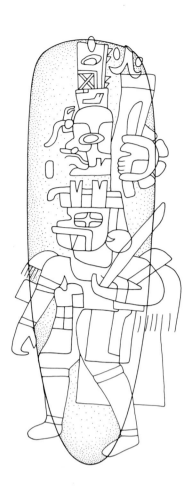

Dumbarton Oaks (cat. 52). Iconographic elements that are compressed and abbreviated on the axe blades are shown with more detail and clarity on the three-dimensional jade figure.

Both Olmec jade axe blades bear a general resemblance to the Leiden Plaque, an important Early Classic Maya incised jade celt depicting a standing ruler elaborately attired and holding ceremonial emblems. The Leiden jade commemorates a Maya ruler's accession to the throne. It is likely that the Olmec celts also record a lord's assumption of the responsibilities of rulership. P.D.J.

Bibliography

Abascal y Macías 1987
Abascal y Macías, Rafael. "Miguel Covarrubias: Antropologo." In *Miguel Covarrubias: Homenaje*, 144–190. Mexico, 1987.

Agrinier 1975
Agrinier, Pierre. *Mound 1A, Chiapa de Corzo, Chiapas, Mexico*. Papers of the New World Archaeological Foundation 37. Provo, 1975.

Agrinier 1984
Agrinier, Pierre. *The Early Olmec Horizon at Mirador, Chiapas, Mexico*. Papers of the New World Archaeological Foundation 48. Provo, 1984.

Agrinier 1989
Agrinier, Pierre. "Mirador Plumajillo, Chiapas y sus relaciones con cuatro sitios del Horizonte Olmeca en Veracruz, Chiapas y la Costa de Guatemala." *Arqueología*, época 2, 2 (1989), 19–36.

Anderson 1978
Anderson, Dana. "Monuments." In *The Prehistory of Chalchuapa, El Salvador* 1, 155–180. Edited by R. J. Sharer. Philadelphia, 1978.

Andrews 1986
Andrews, E. Wyllys, V. "Olmec Jades from Chacsinkin, Yucatan, and Maya Ceramics from La Venta, Tabasco." Middle American Research Institute Publication 57: 11–49. New Orleans, 1986.

Andrews 1987
Andrews, E. Wyllys, V. "A Cache of Early Jades from Chacsinkin, Yucatan." *Mexicon* 9 (August 1987), 78–85.

Anghiera 1964–1965
Anghiera, Pietro Martire d' [Pedro Martir de Angleria]. *Décadas del Nuevo Mundo*. Mexico, 1964–1965.

Angulo 1987
Angulo V., Jorge. "The Chalcatzingo Reliefs: An Iconographic Analysis." In *Ancient Chalcatzingo*, 132–158. Edited by D. C. Grove. Austin, 1987.

Angulo 1994
Angulo, Jorge. "Observaciones sobre su pensamiento cosmogónico y la organización sociopolítica." In *Los olmecas en Mesoamérica*, 223–237. Edited by J. E. Clark. Mexico, 1994.

Anonymous 1955
"Tesoros de jade traídos de La Venta, Tabasco." Archivo Histórico del INAH. Mexico, 1955.

Anonymous 1977
"Museo de la Cultura Olmeca." *Expediente C/311.41 (Z62-4)/1, Año 1980. Documentación sobre las exploraciones e investigaciones de la zona arqueológica de La Venta, Tab.* INAH. Mexico.

Anonymous 1987
Presea Juchiman de Plata X Aniversario. Villahermosa, 1987.

Anonymous 1992
Tabasco. Parque Museo de La Venta. Villahermosa, 1992.

Anonymous 1994
Los olmecas de La Venta. Guía arqueológica del Parque Museo de La Venta. Villahermosa, 1994.

Armillas 1949
Armillas, Pedro. "Notas sobre sistemas de cultivo en Mesoamérica: cultivos de riego y humedad en la cuenca del río Balsas." *Anales del Instituto Nacional de Antropología e Historia* 3 (1949), 85–113.

Armillas 1971
Armillas, Pedro. "Gardens on Swamps." *Science* 174 (1971), 653–661.

Balser 1959
Balser, Carlos. "Los 'baby-faces' olmecas de Costa Rica." *Actas del XXXII Congreso Internacional de Americanistas* 2, 280–285. San Jose, 1959.

Barba Pingarrón 1988
Barba Pingarrón, Luis Alberto. "Trabajos de prospección realizados en el sitio arqueológico de La Venta, Tabasco." *Arqueología*, época 1, 4 (1988), 167–218.

Barlow 1949
Barlow, Robert H. "The Extent of the Empire of the Colhua Mexica." In *Ibero-Americana* 28. Berkeley, 1949.

Beltrán 1965
Beltrán, Alberto. "Reportaje gráfico del hallazgo de Las Limas." *Boletín del INAH* 21 (1965), 9–16.

Benson 1968
Benson, Elizabeth P., ed. *Dumbarton Oaks Conference on the Olmec*. Washington, D.C., 1968.

Benson 1971
Benson, Elizabeth P. *An Olmec Figure at Dumbarton Oaks*. Studies in Pre-Columbian Art and Archaeology 8. Washington, D.C., 1971.

Benson 1981a
Benson, Elizabeth P., ed. *The Olmec and Their Neighbors: Essays in Memory of Matthew W. Stirling*. Washington, D.C., 1981.

Benson 1981b
Benson, Elizabeth P. "Some Olmec Objects in the Robert Woods Bliss Collection at Dumbarton Oaks." In *The Olmec and Their Neighbors*, 95–108. Edited by E. P. Benson. Washington, D.C., 1981.

Benson 1988
Benson, Elizabeth P. "A Knife in the Water: The Stingray in Mesoamerican Ritual Life." *Journal of Latin American Lore* 14, 2 (1988), 173–191.

Benson 1989
Benson, Elizabeth P. "In Love and War: Hummingbird Lore." In *"In Love and War: Hummingbird Lore" and Other Selected Papers from LAILA/ALILA's 1988 Symposium*, 3–8. Edited by M. H. Press. Culver City, 1989.

Benson 1993
Benson, Elizabeth P. "The Robert Woods Bliss Collection of Pre-Columbian Art: A Memoir." In *Collecting the Pre-Columbian Past*, 15–34. Edited by E. H. Boone. Washington, D.C., 1993.

Berger, Graham, and Heizer 1967
Berger, Rainer, J. A. Graham, and R. F. Heizer. "A Reconsideration of the Age of the La Venta Site." *Contributions of the University of California Archaeological Research Facility* 3: 1–24. Berkeley, 1967.

Bernal 1968
Bernal, Ignacio. *El mundo olmeca*. Mexico, 1968.

Bernal 1969
Bernal, Ignacio. *The Olmec World*. Translated by D. Heyden and F. Horcasitas. Berkeley, 1969.

Bernal-García 1994
Bernal-García, Maria Elena. "*Tzatza*: Olmec Mountains and the Ruler's Ritual Speech." In *Seventh Palenque Round Table 1989*, 113–124. Edited by M. G. Robertson and V. M. Fields. San Francisco, 1994.

Beverido 1970
Beverido, Francisco. "San Lorenzo Tenoch-titlán y la civilización olmeca." Master's thesis, Facultad de Antropología, Universidad Veracruzana-Xalapa, 1970.

Beyer 1927
Beyer, Herman. Review of Blom and La Farge, *Tribes and Temples. El Mexico Antiguo* 2 (1927), 305–313.

Blom and La Farge 1926
Blom, Frans, and Oliver La Farge. *Tribes and Temples* 1. Middle American Research Institute Publication 1. New Orleans, 1926.

Boggs 1950
Boggs, Stanley H. *"Olmec" Pictographs in the Las Victorias Group, Chalchuapa Archae-ological Zone.* Carnegie Institution of Washington Notes on Middle American Archaeology and Ethnology 99. Washington, D.C., 1950.

Boggs 1971
Boggs, Stanley H. "An Olmec Mask-Pendant from Ahuachapan, El Salvador." *Archaeology* 21, 4 (1971), 356–358.

Boone 1993
Boone, Elizabeth Hill. "Collecting the Pre-Columbian Past: Historical Trends and the Process of Reception and Use." In *Collecting the Pre-Columbian Past*, 315–350. Edited by E. H. Boone. Washington, D.C., 1993.

Borah and Cook 1963
Borah, Woodrow, and Sherborne Cook. *The Aboriginal Population of Central Mexico on the Eve of the Spanish Conquest.* Ibero-Americana 45. Berkeley, 1963.

Bove 1977
Bove, Frederick. "Laguna de los Cerros, an Olmec Central Place." *Journal of New World Archaeology* 2 (1977), 1–56.

Bradley and Joralemon 1993
Bradley, Douglas, and Peter David Joralemon. *The Lords of Life: The Iconography of Power and Fertility in Preclassic Mesoamerica.* Notre Dame, Ind., 1993.

Braun 1993
Braun, Barbara. *Pre-Columbian Art and the Post-Columbian World.* New York, 1993.

Breiner and Coe 1972
Breiner, Sheldon, and Michael D. Coe. "Magnetic Exploration of the Olmec Civilization." *American Scientist* 60, 5 (1972), 566–575.

Brüggeman and Hers 1970
Brüggeman, Jürgen, and Marie-Areti Hers. "Exploraciones Arqueológicas en San Lorenzo Tenochtitlán." *Boletín del INAH* 39 (1970), 18–23.

Brussels 1992
Tresors du Nouveau Monde. Brussels, 1992.

Bushnell 1964
Bushnell, Geoffrey H. S. "An Olmec Jade Formerly Belonging to Alfred Maudslay." In

XXXV Congreso Internacional de Americanistas, Actas y Memorias, México, 1962 1 (1964), 541–542.

Byrne and Horn 1989
Byrne, Roger, and Sally Horn. "Prehistoric Agriculture and Forest Clearance in the Sierra de los Tuxtlas, Veracruz, Mexico." *Palynology* 13 (1989), 181–193.

Cahill 1933
Cahill, Holger. "American Sources of Modern Art." In *American Sources of Modern Art* [exh. cat., Museum of Modern Art] (New York, 1933), 5–21.

Cambridge 1941
An Exhibition of Pre-Columbian Art [exh. cat., William Hayes Fogg Museum] (Cambridge, Mass., 1941).

Campbell and Kaufman 1976
Campbell, Lyle, and Terrence S. Kaufman. "A Linguistic Look at the Olmec." *American Antiquity* 41 (1976), 80–89.

Campos 1988
Campos, Julieta. *Bajo el Signo de IX Bolon.* Villahermosa, 1988.

Capello and Chávez 1986
Capello García, Silvia, and Angel Alderete Chávez. *Guía Botánica del Parque-Museo de La Venta.* Villahermosa, 1986.

Carlson 1981
Carlson, John B. "Olmec Concave Iron-Ore Mirrors: The Aesthetics of a Lithic Technology and the Lord of the Mirror." In *The Olmec and Their Neighbors.* Edited by E. P. Benson. Washington, D.C., 1981.

Carmona Macias 1989
Carmona Macias, Martha, ed. *El Preclásico o Formativo: Avances y Perspectivas: Seminario de Arqueología "Dr. Román Piña Chan."* Mexico, 1989.

Caso 1965
Caso, Alfonso. "Existío un imperio olmeca?" *Memoria del Colegio Nacional* 5, 3 (1965), 11–60.

Ceja Tenorio 1985
Ceja Tenorio, Jorge Fausto. *Paso de la Amada, An Early Preclassic Site in the Soconusco, Chiapas, Mexico.* Papers of the New World Archaeological Foundation 49. Provo, 1985.

Cervantes 1995
Cervantes, Maria Antonieta. "Renovación del Parque Museo de La Venta." *México en el Tiempo* 6 (1995), 35–39.

Chavero 1888
Chavero, Alfredo. "Historia Antigua y de la Conquista." In *México a través de los siglos* 1. Edited by V. R. Palacio. Barcelona, 1888.

Chavero 1953
Chavero, Alfredo. *México a través de los Siglos.* Mexico, 1953.

Ciruzzi 1983
Ciruzzi, Sara. "Gli antichi oggetti americani nelle collezioni del Museo Nazionale de Antropología e Etnologia dei Firenze." In *Archivo per l'Antropología e la Etnologia* 113 (1983), 151–165.

Clark 1991
Clark, John E. "The Beginnings of Meso-america: *Apologia* for the Soconusco Early Formative. In *The Formation of Complex Society in Southeastern Mesoamerica*, 13–26. Edited by W. R. Fowler, Jr. Boca Raton, 1991.

Clark 1994
Clark, John E., ed. *Los olmecas en Mesoamerica.* Mexico, 1994.

Clark and Blake 1989
Clark, John E., and Michael Blake. "El origin de la civilización en Mesoamerica: los olmecas y Mokaya del Soconusco de Chiapas, Mexico." In *El Preclásico o Formativo: Avances y Perspectivas: Seminario de Arqueología "Dr. Román Piña Chan,"* 385–403. Edited by M. Carmona Macias. Mexico, 1989.

Clewlow 1974
Clewlow, Carl William, Jr. *A Stylistic and Chronological Study of Olmec Monumental Sculpture. Contributions of the University of California Archaeological Research Facility* 19. Berkeley, 1974.

Clewlow and Corson 1968
Clewlow, C. William, and C. R. Corson. "New Stone Monuments from La Venta, 1968." *1968 Excavations at La Venta*, App. 2, 171–203.

Clewlow et al. 1967
Clewlow, Carl William, Jr., R. A. Cowan, J. F. O'Connell, and C. Benemann. *Colossal Heads of the Olmec Culture. Contributions of the University of California Archaeological Research Facility* 4. Berkeley, 1967.

Cobean et al. 1971
Cobean, Robert H., Michael D. Coe, Edward A. Perry Jr., Karl K. Turekian, and Dinkar P. Kharkar. "Obsidian Trade at San Lorenzo Tenochtitlán, Mexico." *Science* 174 (1971), 666–671.

Cobean et al. 1991
Cobean, Robert H., James R. Vogt, Michael D. Glascock, and Terrance Stocker. "High-Precision Trace-Element Characterization of Major Mesoamerican Obsidian Sources and Further Analyses of Artifacts from San Lorenzo Tenochtitlán, Mexico." *Latin American Antiquity* 2, 1 (1991), 69–91.

Coe 1965a
Coe, Michael D. "Archaeological Synthesis of Southern Veracruz and Tabasco." In *Handbook of Middle American Indians* 3: 679–715. Austin, 1965.

Coe 1965b
Coe, Michael D. *The Jaguar's Children* [exh. cat., Museum of Primitive Art] (New York, 1965).

Coe 1965c
Coe, Michael D. "The Olmec Style and Its Distribution." In *Handbook of Middle American Indians* 3: 739–775. Austin, 1965.

Coe 1966
Coe, Michael D. *An Early Stone Pectoral from Southeastern Mexico.* Studies in Pre-Columbian Art and Archaeology 1. Washington, D.C., 1966.

Coe 1967
Coe, Michael D. "An Olmec Serpentine Figurine at Dumbarton Oaks." *American Antiquity* 32, 1 (1967), 111–113.

Coe 1968
Coe, Michael D. *America's First Civilization: Discovering the Olmec.* New York, 1968.

Coe 1972
Coe, Michael D. "Olmec Jaguars and Olmec Kings." In *The Cult of the Feline*, 1–12. Edited by E. P. Benson. Washington, D.C. 1972.

Coe 1973
Coe, Michael D. "The Iconology of Olmec Art." In *The Iconography of Middle American Sculpture*, 1–12. New York, 1973.

Coe 1981
Coe, Michael D. "Gift of the River: Ecology of the San Lorenzo Olmec." In *The Olmec and Their Neighbors*, 15–20. Edited by E. P. Benson. Washington, D.C., 1981.

Coe 1989
Coe, Michael D. "The Olmec Heartland: Evolution of Ideology." In *Regional Perspectives on the Olmec*, 68–82. Edited by R. J. Sharer and D. C. Grove. Cambridge and New York, 1989.

Coe 1991
Coe, Michael D. "Turquoise Mosaic Mask." In *Circa 1492.* Edited by J. A. Levenson [exh. cat., National Gallery of Art] (Washington, D.C., 1992), 556.

Coe 1993
Coe, Michael D. "From *Huaquero* to Connoisseur: The Early Market in Pre-Columbian Art." In *Collecting the Pre-Columbian Past*, 271–290. Edited by E. H. Boone. Washington, D.C., 1993.

Coe and Diehl 1980
Coe, Michael D., and Richard A. Diehl. *In the Land of the Olmec.* 2 vols. Austin and London, 1980.

Coe and Fernández 1980
Coe, Michael D., and Louis A. Fernández. "Appendix 2. Petrographic Analysis of Rock Samples from San Lorenzo." In *In the Land of the Olmec*, 397–404. Edited by M. D. Coe and R. A. Diehl. 2 vols. Austin and London, 1980.

Coe and Stuckenwrath 1964
Coe, William, and Robert Stuckenwrath Jr. "A Review of La Venta, Tabasco and Its Relevance to the Olmec Problem." *Kroeber Anthropological Society Papers* 31 (1964), 1–43. Berkeley.

Cortés 1986
Cortés, Hernan. *Letters from Mexico.* Translated and edited by A. Pagden, introduction by J. H. Elliott. New Haven and London, 1986.

Couch 1988
Couch, N. C. Christopher. *Pre-Columbian Art from the Ernest Erickson Collection* [exh. cat., American Museum of Natural History] (New York, 1988).

Covarrubias 1942
Covarrubias, Miguel. "Origen y Desarrollo del Estilo Artistico 'Olmeca.'" In *Mayas y Olmecas*, 46–49. Mexico, 1942.

Covarrubias 1943
Covarrubias, Miguel. "Tlatilco: Archaic Mexican Art and Culture." *Dyn* 4–5 (1943), 40–46.

Covarrubias 1946
Covarrubias, Miguel. *Mexico South: The Isthmus of Tehuantepec.* New York, 1946.

Covarrubias 1950
Covarrubias, Miguel. "Tlatilco: el arte y la cultura preclásica del Valle de México. *Cuadernos Americanos* 51 (1950), 149–162.

Covarrubias 1957
Covarrubias, Miguel. *Indian Art of Mexico and Central America.* New York, 1957.

Cyphers Guillén 1992a
Cyphers Guillén, Ann. *Chalcatzingo, Morelos: Estudio de cerámica y sociedad.* Mexico, 1992.

Cyphers Guillén 1992b
Cyphers Guillén, Ann. "Escenas escultóricos olmecas." *Antropológicas*, nueva época 6 (April 1992), 47–52.

Cyphers Guillén 1992c
Cyphers Guillén, Ann. "Women, Rituals, and Social Dynamics at Chalcatzingo." *Latin American Antiquity* 4 (1992), 209–224.

Cyphers Guillén 1994a
Cyphers Guillén, Ann. "La nueva cabeza colosal de San Lorenzo." *Antropológicas* 11 (July 1994), 55–72.

Cyphers Guillén 1994b
Cyphers Guillén, Ann. "San Lorenzo Tenochtitlan." In *Los olmecas en Mesoamérica*, 43–67. Edited by J. E. Clark. Mexico, 1994.

Cyphers Guillén 1994c
Cyphers Guillén, Ann. "Three New Olmec Sculptures from Southern Veracruz." *Mexicon* 16 (1994), 30–32.

Cyphers 1995
Cyphers, Ann. *Descifrando los Misterios de la Cultura Olmeca: Una exposición museográfica de los resultados del Proyecto Arqueológico San Lorenzo Tenochtitlán 1990–1994* [exh. cat., Instituto de Investigaciones Antropológicas, Universidad Nacional Autónoma de México] (Mexico, 1995).

Cyphers, in press
Cyphers, Ann. "Los Felinos de San Lorenzo." In *Población, Subsistencia y Medio Ambiente en San Lorenzo Tenochtitlán*, in press.

Cyphers Guillén and Botas 1994
Cyphers Guillén, Ann, and Fernando Botas. "An Olmec Feline Sculpture from El Azuzul, Southern Veracruz." *Proceedings of the American Philosophical Society* 138 (1994), 273–283.

Davis 1978
Davis, Whitney. "So-called Jaguar-Human Copulation Scenes in Olmec Art." *American Antiquity* 43, 3 (1978), 453–456.

de la Fuente 1972
de la Fuente, Beatriz. "La escultura monumental." *Artes de México* 154 (1972).

de la Fuente 1973
de la Fuente, Beatriz. *Escultura monumental olmeca.* Mexico, 1973.

de la Fuente 1975
de la Fuente, Beatriz. *Las cabezas colosales olmecas.* Mexico, 1975.

de la Fuente 1976
de la Fuente, Beatriz. "Sobre una Escultura Recientemente Encontrada en La Venta, Tabasco." *Anales del Instituto de Investigaciones Estéticas* 45 (1976), 31–43.

de la Fuente 1977
de la Fuente, Beatriz. "Pequena Obra Maestra de la Escultura Olmeca." *Anales del Instituto de Investigaciones Estéticas* 47 (1977), 5–10.

de la Fuente 1981
de la Fuente, Beatriz. "Toward a Conception of Monumental Olmec Art." In *The Olmec and Their Neighbors: Essays in Memory of Matthew Stirling.* Edited by E. P. Benson. Washington, D.C., 1981.

de la Fuente 1983
de la Fuente, Beatriz. "Figura Humana Olmeca de Jade." *Anales del Instituto de Investigaciones Estéticas* 52 (1983), 7–19.

de la Fuente 1984
de la Fuente, Beatriz. *Los hombres de piedra: Escultura olmeca.* Mexico, 1984. First edition, 1977.

de la Fuente 1987
de la Fuente, Beatriz. "Tres cabezas colosales olmecas procedentes de San Lorenzo Tenochtitlán, en el nuevo Museo de Antropología de Xalapa." *Anales del Instituto de Investigaciones Estéticas* 58 (1987), 13–28.

de la Fuente 1992a
de la Fuente, Beatriz. *Cabezas colosales olmecas.* Mexico, 1992.

de la Fuente, 1992b
de la Fuente, Beatriz. "Order and Nature in Olmec Art." *The Ancient Americas: Art from Sacred Landscapes.* Edited by R. F. Townsend [exh. cat., The Art Institute of Chicago] (Chicago, 1992), 120–133.

del Villar 1995
del Villar K., Mónica. "Imagen de una obra: Carlos Pellicer y el Parque-Museo de La Venta." *Arqueología Mexicana* 2, 12 (1995), 52–57.

Demarest 1989
Demarest, Arthur A. "The Olmec and the Rise of Civilization in Eastern Mesoamerica." In *Regional Perspectives on the Olmec*, 303–311. Edited by R. J. Sharer and D. C. Grove. Cambridge, 1989.

de Morales 1987
de Morales, Marcia Merry. "Chalcatzingo Burials as Indicators of Social Ranking." In *Ancient Chalcatzingo*, 95–113. Edited by D. C. Grove. Austin, 1987.

Díaz del Castillo 1956
Díaz del Castillo, Bernal. *The Discovery and Conquest of Mexico.* Translated by A. P. Maudslay. New York, 1956.

Di Castro, in press
Di Castro, Anna. "Los bloques de ilmenita de San Lorenzo." In *Población, Subsistencia y Medio Ambiente en San Lorenzo Tenochtitlán*, in press.

Diehl 1981
Diehl, Richard A. "Olmec Architecture: A Comparison of San Lorenzo and La Venta." In *The Olmec and Their Neighbors*, 69–81. Edited by E. P. Benson. Washington, D.C., 1981.

Diehl 1989
Diehl, Richard A. "Olmec Archaeology: What We Know and What We Wish We Knew." In *Regional Perspectives on the Olmec*, 17–32. Edited by R. J. Sharer and D. C. Grove. Cambridge and New York, 1989.

Diehl 1990
Diehl, Richard A. "The Olmec at La Venta." In *Mexico: Splendors of Thirty Centuries* [exh. cat., Metropolitan Museum of Art] (New York, 1990), 51–54.

Dockstader 1973
Dockstader, Frederick J. "Introduction." In *Masterworks from the Museum of the American Indian* [exh. cat., Metropolitan Museum of Art] (New York, 1973).

Drucker 1943
Drucker, Philip. *Ceramic Sequences at Tres Zapotes, Veracruz, Mexico.* Bureau of American Ethnology Bulletin 140. Washington, D.C., 1943.

Drucker 1947
Drucker, Philip. *Some Implications of the Ceramic Complex of La Venta.* Smithsonian Miscellaneous Collections 107, 8. Washington, D.C., 1947.

Drucker 1952
Drucker, Philip. *La Venta, Tabasco: A Study of Olmec Ceramics and Art.* Bureau of American Ethnology Bulletin 153. Washington, D.C., 1952.

Drucker 1955
Drucker, Philip. *The Cerro de las Mesas Offering of Jade and Other Materials.* Bureau of American Ethnology Bulletin 157, Anthropological Papers 44. Washington, D.C., 1955.

Drucker and Contreras 1953
Drucker, Philip, and Eduardo Contreras. "Site Patterns in the Eastern Part of Olmec Territory." *Journal of the Washington Academy of Sciences* 43 (1932), 389–396.

Drucker and Heizer 1956
Drucker, Philip, and Robert F. Heizer. "Gifts for the Jaguar God." *National Geographic* 110 (1956), 366–375.

Drucker, Heizer, and Squier 1957
Drucker, Philip, Robert F. Heizer, and Robert Squier. "Radiocarbon Dates from La Venta, Tabasco." *Science* 126, 3263 (1957), 72–73.

Drucker, Heizer, and Squier 1959
Drucker, Philip, Robert F. Heizer, and Robert Squier. *Excavations at La Venta, Tabasco, 1955.* Bureau of American Ethnology Bulletin 170. Washington, D.C., 1959.

Easby 1967
Easby, Elizabeth Kennedy. *Ancient Art of Latin America: From the Collection of Jay C. Leff* [exh. cat., The Brooklyn Museum] (New York, 1967).

Easby 1968
Easby, Elizabeth Kennedy. *Pre-Columbian Jade from Costa Rica.* New York, 1968.

Easby and Scott 1970
Easby, Elizabeth Kennedy, and John F. Scott. *Before Cortés: Sculpture of Middle America* [exh. cat., Metropolitan Museum of Art] (New York, 1970).

Edmonson 1971
Edmonson, Munro S., ed. *The Book of Counsel: The Popol Vuh of the Quiché Maya of Guatemala.* Middle American Research Institute Publication 35. New Orleans, 1971.

Eisen 1888
Eisen, Gustav. "On Some Ancient Sculptures from the Pacific Slope of Guatemala." *Memoirs of the California Academy of Sciences* 2 (1888), 9–20.

Ekholm 1970
Ekholm, Gordon F. *Ancient Mexico and Central America.* New York, 1970.

Ekholm-Miller 1969
Ekholm-Miller, Susanna. *Mound 30a and the Early Preclassic Ceramic Sequence of Izapa, Chiapas, Mexico.* Papers of the New World Archaeological Foundation 25. Provo, 1969.

Ekholm-Miller 1973
Ekholm-Miller, Susanna. *The Olmec Rock Carving at Xoc, Chiapas, Mexico.* Papers of the New World Archaeological Foundation 32. Provo, 1973.

Fane 1993
Fane, Diana. "Reproducing the Pre-Columbian Past." In *Collecting the Pre-Columbian Past*, 141–176. Edited by E. H. Boone. Washington, D.C., 1993.

Fash 1987
Fash, Jr., William L. "The Altar and Associated Features." In *Ancient Chalcatzingo*, 82–94. Edited by D. C. Grove. Austin, 1987.

Fash 1991
Fash, William L. *Scribes, Warriors, and Kings.* London and New York, 1991.

Fields 1991
Fields, Virginia M. "The Iconographic Heritage of the Maya Jester God." In *Sixth Palenque Round Table, 1986*, 167–174. Edited by M. G. Robertson and V. M. Fields. Norman, Okla., and London, 1991.

Flannery 1968
Flannery, Kent V. "The Olmec and the Valley of Oaxaca: A Model for Inter-regional Interaction in Formative Times." In *Dumbarton Oaks Conference on the Olmec*, 79–110. Edited by E. P. Benson. Washington, D.C., 1968.

Flannery 1976
Flannery, Kent V., ed. *The Early Mesoamerican Village.* New York, 1976.

Flannery 1982
Flannery, Kent V. "Review of *In the Land of the Olmec.*" *American Anthropologist* 84 (1982), 442–447.

Flannery and Marcus 1976a
Flannery, Kent V., and Joyce Marcus. "Evolution of the Public Building in Formative Oaxaca." In *Cultural Change and Continuity: Essays in Honor of James Bennett Griffin*, 205–221. Edited by Charles E. Cleland. San Diego, 1976.

Flannery and Marcus 1976b
Flannery, Kent V., and Joyce Marcus. "Formative Oaxaca and the Zapotec Cosmos." *American Scientist* 64 (1976), 374–383.

Flannery and Marcus 1983
Flannery, Kent V., and Joyce Marcus, eds. *The Cloud People: Divergent Evolution of the Zapotec and Mixtec Civilizations.* New York, 1983.

Flannery and Marcus 1994
Flannery, Kent V., and Joyce Marcus. *Early Formative Pottery of the Valley of Oaxaca, Mexico.* Memoirs of the Museum of Anthropology 10. University of Michigan, Ann Arbor, 1994.

Flannery, Marcus, and Kowalewski 1981
Flannery, Kent V., Joyce Marcus, and Stephen A. Kowalewski. "The Preceramic and Formative of the Valley of Oaxaca." In *Supplement to the Handbook of Middle American Indians 1, Archaeology*, 48–93. Austin, 1981.

Fraser 1971
Fraser, Douglas. "The Discovery of Primitive Art." *Anthropology and Art: Readings in Cross-Cultural Aesthetics*, 20–36. Edited by C. M. Otten. Austin and London, 1971.

Furst 1968
Furst, Peter T. "The Olmec Were-Jaguar Motif in the Light of Ethnographic Reality." In *Dumbarton Oaks Conference on the Olmec, October 18th and 19th, 1967*, 143–178. Edited by E. P. Benson. Washington, D.C., 1968.

Furst 1981
Furst, Peter T. "Jaguar Baby or Toad Mother." In *The Olmec and Their Neighbors: Essays in Memory of Matthew W. Stirling*, 149–162. Edited by E. P. Benson. Washington, D.C., 1981.

Garber et al. 1993
Garber, James F., David C. Grove, Kenneth G. Hirth, and John W. Hoopes. "Jade Use in Portions of Mexico and Central America." In *Pre-Columbian Jade*, 211–231. Edited by F. W. Lange. Salt Lake City, 1993.

Garber et al. 1995
Garber, James F., F. Kent Reilly, C. J. Hartman, and Tonia Wildman. "Formative Period Architecture at Blackman Eddy in the Belize Valley Archaeological Project: Results of the 1995 Field Season." Report submitted to the Department of Archaeology, Belmopan, Belize.

García Cook 1981
García Cook, Angel. "La Venta, Tab., zona arqueológica de…Exploraciones y conservaciones de la 1944." *Expediente B/311.32 (Z62-4)/1.* INAH. Mexico.

García Moll 1979
García Moll, Roberto. "Un relieve olmeca en Tenosique, Tabasco." *Estudios de Cultura Maya* 12 (1979), 53.

García Moll et al. 1989
García Moll, Roberto, Daniel Juárez, Carmen Pijoan Aguade, Ma. Elena Salas Cuesta, and Marcela Salas. "San Luis Tlatilco, Mexico, Temporada IV." In *El Preclásico o Formativo: Avances y Perspectivas: Seminario de Arqueología "Dr. Román Piña Chan,"* 237–248. Edited by M. Carmona Macias. Mexico, 1989.

García Moll et al. 1991
García Moll, Roberto, et al. *San Luis Tlatilco, México. Catálogo de entierros, Temporada IV.* Serie Antropología Física/Arqueología, INAH. Mexico, 1991.

García Vázquez 1985
García Vázquez, Joaquín. "Anteproyecto de restauración y conservación que se exhibe en el Museo-Parque La Venta de la Ciudad de Villahermosa, Tab." Manuscript on file, Centro INAH Tabasco, Villahermosa.

García Vázquez 1993
García Vázquez, Joaquín. "Proyecto de conservación de los monolítos olmecas del Parque Museo de La Venta en la ciudad de Villahermosa, Tabasco. Segunda etapa de conservación." Manuscript on file, Centro INAH Tabasco, Villahermosa.

Gay 1967
Gay, Carlo T. E. "Oldest Paintings of the New World." *Natural History* 76, 4 (1967), 28–35.

Gay 1973
Gay, Carlo T. E. "Olmec Hieroglyphic Writing." *Archaeology* 26 (1973), 278–288.

Gay 1972a
Gay, Carlo T. E. *Chalcatzingo.* Portland, Ore., 1972.

Gay 1972b
Gay, Carlo T. E. *Xochipala: The Beginnings of Olmec Art* [exh. cat., The Art Museum, Princeton University] (Princeton, 1972).

Gillespie 1994
Gillespie, Susan D. "Llano del Jícaro: An Olmec Monument Workshop." *Ancient Mesoamerica* 5 (1994), 231–242.

Ginell and Stulik 1994
Ginell, William S., and Dusan Stulik. "Report on Condition of Olmec Monuments in La Venta Park Villahermosa, Mexico." Marina del Rey, 1994.

Gómez Rueda 1989
Gómez Rueda, Hernando. "Nuevas Exploraciones en la región olmeca: una aproximación a los patrones de asentamiento." In *El Preclásico o Formativo: Avances y Perspectivas: Seminario de Arqueología "Dr. Román Piña Chan,"* 91–100. Edited by M. Carmona Macias. Mexico, 1989.

Gómez and Courtés 1987
Gómez Rueda, Hernando, and Valèrie Courtés. "Un pectoral olmeca de La Encrucijada, Tabasco. Observaciones sobre piezas olmecas."

González de la Vara 1994
González de la Vara, Fernán. "El valle de Toluca hasta la caída de Teotihuacán (1200 A.C.–750 D.C.)." Thesis, INAH, Mexico, 1994.

González Lauck 1988
González Lauck, Rebecca. "Proyecto Arqueológico La Venta." *Arqueología* 4 (1988), 121–165.

González Lauck 1989
González Lauck, Rebecca. "Recientes Investigaciones en La Venta, Tabasco." In *El Preclásico o Formativo: Avances y Perspectivas: Seminario de Arqueología "Dr. Román Piña Chan,"* 81–89. Edited by M. Carmona Macias. Mexico, 1989.

González Lauck 1995
González Lauck, Rebecca. "Adecuación Museográfica del Museo de Sitio de la zona arqueológica de La Venta, Huimanguillo, Tabasco, México." INAH. Mexico.

González Moreno 1990
González Moreno, Angeles. "Una escultura olmeca de procedencia desconocida en el Museo Regional de Villahermosa." In *Tierra y Agua. La antropología de Tabasco.* Villahermosa, 1990.

González and Jiménez 1991
González Lauck, Rebecca, and Oscar Jiménez Salas. "Un acercamiento al medio ambiente del área de La Venta, Tabasco y el uso de sus recursos por la población durante el auge olmeca." Presented at the conference "Ancient Maya Agriculture and Biological Research Management," University of California at Riverside, 1991.

Gordon 1898
Gordon, George Byron. "Caverns of Copan, Honduras: Report on Explorations by the Museum, 1896–1897." *Memoirs of the Peabody Museum of American Archaeology and Ethnology* 1: 137–148. Cambridge, Mass., 1898.

Graham 1977
Graham, John A. "Discoveries at Abaj Takalik, Guatemala." *Archaeology* 30 (1977), 196–197.

Graham 1979
Graham, John A. "Maya, Olmecs, and Izapans at Abaj Takalik." *Actes du XLII Congrès International des Américanistes* 8 (1979), 179–188. Paris.

Graham 1982
Graham, John A. "Antecedents of Olmec Sculpture at Abaj Takalik." In *Pre-Columbian Art History*, 7–22. Edited by A. Cordy-Collins. Palo Alto, 1982.

Graham 1989
Graham, John A. "Olmec Diffusion: A Sculptural View from Pacific Guatemala." In *Regional Perspectives on the Olmec*, 227–246. Edited by R. J. Sharer and D. C. Grove. Cambridge and New York, 1989.

Graham, Heizer, and Shook 1978
Graham, John A., Robert F. Heizer, and Edwin M. Shook. "Abaj Takalik 1976: Exploratory Investigations." *Contributions of the University of California Archaeological Research Facility* 36: 85–114. Berkeley, 1978.

Graham 1993
Graham, Mark Miller. "Displacing the Center: Constructing Prehistory in Central America." In *Reinterpreting Prehistory of Central America*, 1–38. Edited by M. M. Graham. Niwot, Colo., 1993.

Gregory 1975
Gregory, David. "San Gervasio." In *A Study of Changing Pre-Columbian Commercial Systems.* Edited by J. A. Sabloff and W. Rathje. Peabody Museum Monographs 3. 1975.

Green and Lowe 1967
Green, Dee F., and Gareth W. Lowe. *Altamira and Padre Piedra: Early Preclassic Sites in Chiapas.* Papers of the New World Archaeological Foundation 20. Provo, 1967.

Griffin 1981
Griffin, Gillett G. "Olmec Forms and Materials Found in Central Guerrero." In *The Olmec and Their Neighbors.* Edited by E. P. Benson. Washington, D.C., 1981.

Griffin 1993
Griffin, Gillett G. "Formative Guerrero and Its Jade." In *Pre-Columbian Jade*, 203–210. Edited by F. W. Lange. Salt Lake City, 1993.

Grove 1969
Grove, David C. "Olmec Cave Paintings: Discovery from Guerrero, Mexico." *Science* (April 1969), 421–423.

Grove 1970a
Grove, David C. *The Olmec Paintings of Oxtotitlan Cave, Guerrero, Mexico.* Studies in Pre-Columbian Art and Archaeology 6. Washington, D.C., 1970.

Grove 1970b
Grove, David C. "The San Pablo Pantheon Mound: A Middle Preclassic Site in Morelos, Mexico." *American Antiquity* 35 (1970), 62–73.

Grove 1972
Grove, David C. "Olmec Felines in Highland Central Mexico." In *The Cult of the Feline*, 153–164. Edited by E. P. Benson. Washington, D.C., 1972.

Grove 1973
Grove, David C. "Olmec Altars and Myths." *Archaeology* 26 (1973), 128–135.

Grove 1974
Grove, David C. *San Pablo Nexpa, and the Early Formative Archaeology of Morelos, Mexico.* Vanderbilt University Publications in Anthropology 12. Nashville, 1974.

Grove 1981a
Grove, David C. "The Formative Period and the Evolution of Complex Culture." In *Handbook of Middle American Indians*, 373–391. Austin, 1981.

Grove 1981b
Grove, David C. "Olmec Monuments: Mutilation as a Clue to Meaning." In *The Olmec and Their Neighbors*, 45–68. Edited by E. P. Benson. Washington, D.C., 1981.

Grove 1984
Grove, David C. *Chalcatzingo: Excavations on the Olmec Frontier.* London and New York, 1984.

Grove 1987a
Grove, David C., ed. *Ancient Chalcatzingo.* Austin, 1987.

Grove 1987b
Grove, David C. "'Torches,' 'Knuckledusters,' and the Legitimization of Formative Period Rulership." *Mexicon* 9 (June 1987), 60–65.

Grove 1989a
Grove, David C. "Chalcatzingo and Its Olmec Connection." In *Regional Perspectives on the Olmec*, 122–147. Edited by R. J. Sharer and D. C. Grove. Cambridge and New York, 1989.

Grove 1989b
Grove, David C. "Olmec: What's in a Name?" In *Regional Perspectives on the Olmec*, 8–14. Edited by R. J. Sharer and D. C. Grove. Cambridge and New York, 1989.

Grove 1992
Grove, David C. "The Olmec Legacy." *National Geographic Research and Exploration* 8, 2 (1992), 148–165.

Grove 1993
Grove, David C. "'Olmec' Horizons in Formative Period Mesoamerica: Diffusion or Social Evolution?" In *Latin American Horizons*, 83–111. Edited by D. S. Rice. Washington, D.C., 1993.

Grove 1994
"La Isla, Veracruz, 1991: A Preliminary Report, with Comments on the Olmec Uplands." *Ancient Mesoamerica* 5 (1994), 223–230.

Grove and Angulo 1987
Grove, David C., and Jorge Angulo V. "A Catalog and Description of Chalcatzingo's Monuments." In *Ancient Chalcatzingo.* Edited by D. C. Grove. Austin, 1987.

Grove and Cyphers Guillén 1987
Grove, David C., and Ann Cyphers Guillén. "The Excavations." In *Ancient Chalcatzingo*, 29–36. Edited by D. C. Grove. Austin, 1987.

Grove and Gillespie 1984
Grove, David C., and Susan D. Gillespie. "Chalcatzingo's Portrait Figurines and the Cult of the Ruler." *Archaeology* 37 (1984), 27–33.

Grove and Gillespie 1992a
Grove, David C., and Susan D. Gillespie. "Ideology and Evolution at the Pre-State Level: Formative Period Mesoamerica." In *Ideology and Pre-Columbian Civilizations*, 15–36. Edited by A. Demarest and G. Conrad. Santa Fe, 1992.

Grove and Gillespie 1992b
Grove, David C., and Susan D. Gillespie. *Informe Final del Proyecto La Isla-Llano del Jícaro, Veracruz, 1991.* Mexico, 1992.

Grove and Paradis 1971
Grove, David C., and Louise I. Paradis. "An Olmec Stela from San Miguel Amuco, Guerrero." *American Antiquity* 36 (1971), 95–102.

Grove et al. 1993
Grove, David C., Susan D. Gillespie, Ponciano Ortiz C., and Michael Hayton. "Five Olmec Monuments from the Laguna de los Cerros Hinterland." *Mexicon* 15 (1993), 91–95.

Guzmán 1934
Guzmán, Eulalia. "Los relieves de las rocas del Cerro de la Cantera, Jonacatepec, Mor. Mexico." *Museo Nacional de Arqueología, Historia y Etnografía, Anales*, época 5, 1 (1934), 237–251.

Hammer and D'Andrea 1978
Hammer, Olga, and Jeanne D'Andrea, eds. *Treasures of Mexico from the Mexican National Museums / Tesoros de Mexico de los Museos Nacionales Mexicanos* [exh. cat., The Armand Hammer Foundation] (Los Angeles, 1978).

Hammond 1988
Hammond, Norman. "Cultura hermana: Reappraising the Olmec." *Quarterly Review of Archaeology* 9, 4 (1988), 1–4.

Hatch 1971
Hatch, Marion Poponoe. "An Hypothesis on Olmec Astronomy, with Special Reference to the La Venta Site." *Contributions of the University of California Archaeological Research Facility* 13: 1–64. Berkeley, 1971.

Hawley 1961
Hawley, Henry H. "An Olmec Jade Head." *The Bulletin of the Cleveland Museum of Art* (October 1961), 212–215.

Healy 1974
Healy, Paul F. "The Cayumel Caves: Preclassic Sites in Northeast Honduras." *American Antiquity* 39 (1974), 335–337.

Healy 1992
Healy, Paul F. "Ancient Honduras: Power, Wealth, and Rank in Early Chiefdoms." In *Wealth and Hierarchy in the Intermediate Area*, 85–108. Edited by F. W. Lange. Washington, D.C., 1992.

Heikamp 1976
Heikamp, Detlef. "American Objects in the Italian Collections of the Renaissance and Baroque: A Survey." In *First Images of America*, 1: 455–482. Edited by F. Chiappelli. Berkeley, Los Angeles, London, 1976.

Heizer 1968
Heizer, Robert F. "New Observations on La Venta." In *Dumbarton Oaks Conference on the Olmec*, 9–36. Edited by E. P. Benson. Washington, D.C., 1968.

Heizer 1971
Heizer, Robert F. "Commentary on: 'The Olmec Region—Oaxaca.'" *Contributions of the University of California Archaeological Research Facility* 11: 51–69. Berkeley, 1971.

Heizer, Drucker, and Graham 1968
Heizer, Robert F., Philip Drucker, and John A. Graham. "Investigations at La Venta, 1967." *Contributions of the University of California Archaeological Research Facility* 5: 1–39. Berkeley, 1968.

Heizer, Graham, and Clewlow 1971
Heizer, Robert F., John A. Graham, and C. W. Clewlow, Jr., eds. *Observations on the Emergence of Civilization in Mesoamerica.* Contributions of the University of California Archaeological Research Facility 11. Berkeley, 1971.

Heizer, Graham, and Napton 1968
Heizer, Robert F., John A. Graham, and Lewis K. Napton. "The 1968 Investigations at La Venta." *Contributions of the University of California Archaeological Research Facility* 5: 127–154. Berkeley, 1968.

Henderson 1979
Henderson, John S. *Atopula, Guerrero, and Olmec Horizons in Mesoamerica.* Yale Publications in Anthropology 77. New Haven, 1979.

Hernández 1980
Hernández Villegas, Carlos Sebastián. "Genesis y Configuración del Museo." In *CICOM*, 9–25. Villahermosa, 1980.

Herrera 1994
Herrera, Manuel. "Cabeza olmeca tendrá una réplica fiel y exacta." In *El Suresta de Tabasco.* Villahermosa, 1994.

Herrera 1978
Herrera Castaneda, Sergio R. "Neotectonismo y sedimentación del área Villa Azueta, San Juan Evangelista, Edo. de Veracruz." Thesis, Facultad de Ingeniería, Universidad Nacional Autónoma de México, 1978.

Hester, Heizer, and Jack 1971
Hester, Thomas R., Robert F. Heizer, and Robert N. Jack. "Technology and Geologic Sources of Obsidian Artifacts from Cerro de las Mesas, Veracruz, Mexico, with Observations on Olmec Trade." *Contributions of the University of California Archaeological Research Facility* 13: 133–141. Berkeley, 1971.

Hester, Jack, and Heizer 1971
Hester, Thomas R., Robert N. Jack, and Robert F. Heizer. "The Obsidian of Tres Zapotes, Veracruz, Mexico." *Contributions of the University of California Archaeological Research Facility* 13: 65–131. Berkeley, 1971.

Holmes 1907
Holmes, William H. "Masterpieces of Aboriginal American Art: IV Sculpture in the Round." *Art and Archaeology* 3, 2 (1916), 71–85.

Houston 1963
The Olmec Tradition [exh. cat., The Museum of Fine Arts] (Houston, 1963).

Humboldt 1810
Humboldt, Alexander von. *Vues des Cordillières et Monuments des Peuples Indigènes de l'Amérique.* 2 vols. Paris, 1810.

Jiménez Moreno 1942, 1976
Jiménez Moreno, Wigberto. "El enigma de los olmecas." *Reimpresos* 2. Reprint edition, Mexico, 1976.

Jiménez Pons 1981
Jiménez Pons, Rogelio. "Propuesta para espectáculo de Luz y Sonido del Parque Museo de La Venta." INAH. Mexico.

Jiménez Salas 1990a
Jiménez Salas, Oscar. "Geomorfología de la región de La Venta, Tabasco: un sistema fluvio-lagunar costero del Cuaternario." *Arqueología*, época 2, 3 (1990), 5–16.

Jiménez Salas 1990b
Jiménez Salas, Oscar. "Geología Cuaternaria y Geomorfología Aplicadas al Proyecto Arqueológico La Venta, en los estados de Tabasco, Veracruz y Chiapas." Manuscript on file, Informe de Investigación No. 1 del Laboratorio de Geología. INAH, Mexico.

Joesink-Mandeville and Meluzin 1976
Joesink-Mandeville, L. R. V., and Sylvia Meluzin. "Olmec-Maya Relationships: Olmec Influence in Yucatan." In *Origins of Religious Art and Iconography in Preclassic Mesoamerica*, 87–105. Edited by H. B. Nicholson. Los Angeles, 1976.

Joralemon 1971
Joralemon, Peter David. *A Study of Olmec Iconography.* Studies in Pre-Columbian Art and Archaeology 7. Washington, D.C., 1971.

Joralemon 1974
Joralemon, Peter David. "Ritual Blood-Sacrifice among the Ancient Maya, 1." In *Primera Mesa Redonda de Palenque*, 2: 59–76. Edited by M. G. Robertson. Pebble Beach, Calif., 1974.

Joralemon 1976
Joralemon, Peter David. "The Olmec Dragon: A Study in Pre-Columbian Iconography." In *Origins of Religious Art and Iconography in Preclassic Mesoamerica*, 27–71. Edited by H. B. Nicholson. Los Angeles, 1976.

Joralemon 1981
Joralemon, Peter David. "The Old Woman and the Child: Themes in the Iconography of Preclassic Mesoamerica." In *The Olmec and Their Neighbors: Essays in Memory of Matthew W. Stirling.* Edited by E. P. Benson. Washington, D.C., 1981.

Joyce et al. 1991
Joyce, Rosemary A., Richard Edging, Karl Lorenz, and Susan D. Gillespie. "Olmec Bloodletting: An Iconographic Study." In *Sixth Palenque Round Table, 1986*, 143–150. Edited by M. G. Robertson and V. M. Fields. Norman, Okla., and London, 1991.

Joyce 1912
Joyce, Thomas A. *A Short Guide to the American Antiquities in the British Museum.* London, 1912.

Kelemen 1943
Kelemen, Pal. *Medieval American Art: Masterpieces of the New World Before Columbus.* New York, 1943.

Kelley 1966
Kelley, David H. "A Cylinder Seal from Tlatilco." *American Antiquity* 31, 5 (1966), 744–746.

Kennedy 1983
Kennedy, Alison Bailey. "*Ecce Bufo*: The Toad in Nature and in Olmec Iconography." *Current Anthropology* 23 (1983), 273–290.

Kidder 1942
Kidder, Alfred V. "Archaeological Specimens from Yucatan and Guatemala." *Carnegie Institution of Washington Notes on Middle American Archaeology and Ethnology* 9. Washington, D.C., 1942.

Kirchhoff 1943
Kirchhoff, Paul. "Mesoamerica." *Acta Americana* 1 (1943), 92–107.

Kunz 1889
Kunz, George F. "Sur une hâche votive gigantesque au jadeite, de l'Oaxaca e sur un pectoral en jadeite du Guatemala." In *Dixième Session Congrès International d'Anthropologie et d'Archéologie Préhistorique*, 517–523. Paris, 1889.

Kunz 1890
Kunz, George F. *Gems and Precious Stones of North America.* New York, 1890.

Lane n.d.
Lane Rodríguez, Marci. "Identificación de macrorestos de San Lorenzo Tenochtitlán, Informe al Proyecto Arqueológico San Lorenzo Tenochtitlán." Mexico, n.d.

Lange 1993
Lange, Frederick W. "The Conceptual Structure in Lower Central American Studies: A Central American View." In *Reinterpreting Prehistory of Central America*, 277–324. Edited by M. M. Graham. Niwot, Colo., 1993.

Lange, Bishop, and van Zelst 1981
Lange, Frederick W., Ronald L. Bishop, and Lambertus van Zelst. "Perspectives on Costa Rican Jade: Compositional Analyses and Cultural Implications." In *Between Continents/Between Seas: Precolumbian Art of Costa Rica.* Edited by E. P. Benson. New York, 1981.

Larrauri and Romero 1994
Larrauri, Iker, and Héctor Manuel Romero. *El retorno del mundo olmeca*. Mexico, 1994.

Lathrap 1971
Lathrap, Donald. "Complex Iconographic Features Shared by Olmec and Chavin and Some Speculation on Their Possible Significance." In *Primer Simposio de Correlaciones Antropológicas Andino-Mesoamericano, 1982*. Edited G. Marcos and P. Norton. Guayaquil, Ecuador, 1971.

Laurencich Minelli 1991
Laurencich Minelli, Laura. "Atlatl." In *Circa 1492*. Edited by J. A. Levenson [exh. cat., National Gallery of Art] (Washington, D.C., 1991), 561–562.

Laurencich Minelli 1992
Laurencich Minelli, Laura, ed. *Bologna e il Mondo Nuovo*. Bologna, 1992.

Lee 1989
Lee, Thomas A., Jr. "Chiapas and the Olmec." In *Regional Perspectives on the Olmec*, 198–226. Edited by R. J. Sharer and D. C. Grove. Cambridge and New York, 1989.

Lesure, in press
Lesure, Richard G. "Early Formative Platforms at Paso de la Amada, Chiapas, México." *Latin American Antiquity*, in press.

Litvak King 1971
Litvak King, Jaime. "Cihuatlán and Tepecuacuilco. Provincias tributarias de México en el Siglo xvi." Thesis, Universidad Nacional Autónoma de México, 1971.

London 1920
Catalogue of an Exhibition of Objects of Indigenous American Art [exh. cat., Burlington Fine Arts Club] (London, 1920).

Lothrop 1963
Lothrop, Samuel K. "Robert Woods Bliss, 1875–1962." *American Antiquity* 29 (1963), 92–93.

Lothrop and Ekholm 1975
Lothrop, Samuel K., and Gordon F. Ekholm. "Pre-Columbian Objects." In *The Guennol Collection*, 1: 291–354. Edited by I. E. Rubin. New York, 1975.

Lothrop, Foshag, and Mahler 1957
Lothrop, Samuel K., William F. Foshag, and Joy Mahler. *Pre-Columbian Art: Robert Woods Bliss Collection*. New York, 1957.

Love 1991
Love, Michael W. "Style and Social Complexity in Formative Mesoamerica." In *The Formation of Complex Society in Southeastern Mesoamerica*, 47–76. Edited by William R. Fowler. Boca Raton, 1991.

Lowe 1959
Lowe, Gareth W. *Archaeological Exploration of the Upper Grijalva River, Chiapas, Mexico*. Papers of the New World Archaeological Foundation 2. Provo, 1959.

Lowe 1975
Lowe, Gareth W. *The Early Preclassic Barra Phase of Altamira, Chiapas*. Papers of the New World Archaeological Foundation 18. Provo, 1975.

Lowe 1981
Lowe, Gareth W. "Olmec Horizons Defined in Mound 20, San Isidro, Chiapas." In *The Olmec and Their Neighbors*. Edited by E. P. Benson. Washington, D.C., 1981.

Lowe 1989a
Lowe, Gareth W. "Algunas aclaraciones sobre la presencia olmeca y maya en el preclásico de Chiapas." In *El Preclásico o Formativo: Avances y Perspectivas: Seminario de Arqueología "Dr. Román Piña Chan,"* 363–383. Edited by M. Carmona Macias. Mexico, 1989.

Lowe 1989b
Lowe, Gareth W. "The Heartland Olmec: Evolution of Material Culture." In *Regional Perspectives on the Olmec*, 33–67. Edited by R. J. Sharer and D. C. Grove. Cambridge and New York, 1989.

Lowe 1994
Lowe, Gareth W. "Comunidades de Chiapas relacionadas con los olmecas." In *Los olmecas en Mesoamérica*, 113–127. Edited by John E. Clark. Mexico, 1994.

Lowe and Agrinier 1960
Lowe, Gareth W., and Pierre Agrinier. *Mound 1, Chiapa de Corzo, Chiapas, Mexico*. Papers of the New World Archaeological Foundation 8. Provo, 1960.

Lunagómez 1995
Lunagómez, Roberto. "Patrón de asentamiento en el hinterland interior de San Lorenzo Tenochtitlán, Veracruz." Thesis, Facultad de Antropología, Universidad Veracruzana-Xalapa, 1995.

Marcus 1976
Marcus, Joyce. "The Size of the Early Mesoamerican Village." In *The Early Mesoamerican Village*, 79–90. Edited by K. V. Flannery. New York, 1976.

Marcus 1989
Marcus, Joyce. "Zapotec Chiefdoms and the Nature of Formative Religions." In *Regional Perspectives on the Olmec*, 148–197. Edited by R. J. Sharer and D. C. Grove. Cambridge and New York, 1989.

Marcus 1992
Marcus, Joyce. *Mesoamerican Writing Systems*. Princeton, N.J., 1992.

Marquina 1955
Marquina, Ignacio. "Carta del Arq. Ignacio Marquina. . . al Ing. Antonio Bermúdez." *Archivo Histórico del Instituto Nacional de Antropología e Historia* 59. 11. INAH. Mexico.

Martínez 1993
Martínez C., Gustavo. "Informe del estado de conservación de los monolítos olmecas que se exhiben en el Museo Parque de la ciudad de Villahermosa, Tabasco." INAH. Mexico.

Martínez, Ramírez-Arraiga, and Cyphers 1994
Martínez, Enrique, Elia Ramírez-Arraiga, and Ann Cyphers. "Determinación de Paleoambiente en Asentamientos Olmecas en San Lorenzo Tenochtitlán, en el Sur de Veracruz (Preclásico Inferior)." Paper presented at the VII Coloquio Internacional de Paleobotánica y Palinología, 1994.

Martínez Donjuán 1982, 1984
Martínez Donjuán, Guadelupe. "Teopantecuanitlan, Guerrero: Un sitio olmeca." *Revista Mexicana de Estudios Antropológicos* 28 (1982 [1984]), 123–132.

Martínez Donjuán 1985
Martínez Donjuán, Guadelupe. "El Sitio Olmec de Teopantecuanitlan en Guerrero." *Anales de Antropología* 22 (1985), 215–226.

Martínez Donjuán 1986
Martínez Donjuán, Guadelupe. "Teopantecuanitlan." In *Primer Coloquio de Arqueología y Etnohistoria del Estado Guerrero*, 53–80. Mexico, 1986.

Martínez Donjuán 1994
Martínez Donjuán, Guadalupe. "Los olmecas en el estado de Guerrero." In *Los olmecas en Mesoamérica*, 143–163. Edited by J. E. Clark. Mexico, 1994.

Matos 1989
Matos, Eduardo. "El Uso de Materiales Olmecas en Ofrendas Postclasicas en Mesoamerica." In *El Preclásico o Formativo: Avances y Perspectivas*, 481–484. Edited by M. Carmona Macias. Mexico, 1989.

McClung and Serra 1993
McClung, E., and M. C. Serra. "La revolución agrícola y las primeras poblaciones urbanas." In *El poblamiento de México. Una visión histórico-demográfica*, 138–163. Mexico, 1993.

McDonald 1977
McDonald, Andrew J. "Two Middle Preclassic Engraved Monuments at Tzutzuculi on the Chiapas Coast of Mexico." *American Antiquity* 42 (1977), 560–565.

McDonald 1983
McDonald, Andrew J. *Tzutzuculi: A Middle Preclassic Site on the Pacific Coast of Chiapas, Mexico*. Papers of the New World Archaeological Foundation 47. Provo, 1983.

McNear 1982
McNear, Everett. *High Culture in the Americas Before 1500*. Chicago, 1982.

Medellín Zenil 1960
Medellín Zenil, Alfonso. "Monolítos inéditos olmecas." *La palabra y el hombre* 16 (1960), 75–97.

Medellín Zenil 1965
Medellín Zenil, Alfonso. "La Escultura de Las Limas." *Boletín del INAH* 21 (1965), 5–8.

Medellín Zenil 1971
Medellín Zenil, Alfonso. *Monolítos olmecas y otros en el Museo de la Universidad de Veracruz.* Corpus Antiquitatum Americanensium, Mexico 5. Mexico, 1971.

Medellín Zenil 1978
Medellín Zenil, Alfonso. "El contorsionista de Las Choapas, Veracruz." *Boletín del INAH*, época 3, 22 (1978).

Medellín Zenil and Torres Guzmán 1968
Medellín Zenil, Alfonso, and Manuel Torres Guzmán, "El dios jaguar de San Martín." *Boletín del INAH* 33 (1968), 9–26.

Melgar y Serrano 1869
Melgar y Serrano, José María. "Antigüedades Mexicanas." *Sociedad Mexicana de Geografía y Estadística Boletín*, época 2, 1 (1869), 292–297.

Melgar y Serrano 1871
Melgar y Serrano, José María. "Estudios sobre las antigüedades y el origen de la cabeza colosal de tipo etiópico que existe en Hueyapan del cantón de los Tuxtlas." *Sociedad Mexicana de Geografía y Estadística Boletín*, época 2, 3 (1871), 104–109.

Mena 1927
Mena, Ramón. *Catálogo de la Colección de Objetos de Jade.* Mexico, 1927.

Mercado Arreguín 1994
Mercado Arreguín, Lourdes Ligia. "Notas de campo de las excavaciones al costado sur del edificio C-1." Manuscript on file, Archivio del Proyecto Arqueológico La Venta, Centro INAH Tabasco, Villahermosa.

Metcalf and Flannery 1967
Metcalf, George, and Kent Flannery. "An Olmec 'Were-Jaguar' from the Yucatan Peninsula." *American Antiquity* 32, 1 (1967), 109–111.

Mexico 1987
Miguel Covarrubias: Homenje. Mexico, 1987.

Mexico 1990
Arqueología 3 (1990).

Milbrath 1979
Milbrath, Susan. *A Study of Olmec Sculptural Chronology.* Studies in Pre-Columbian Art and Archaeology 23. Washington, D.C., 1979.

Miller 1985
Miller, Virginia E. "The Dwarf Motif in Classic Maya Art." In *Fourth Palenque Round Table, 1980*, 141–153. Edited by M. G. Robertson and E. P. Benson. San Francisco, 1985.

Miller 1992
Miller, Mary Ellen. "The Image of People and Nature in Classic Maya Art and Architecture." In *The Ancient Americas.* Edited by R. F.

Townsend [exh. cat., Art Institute of Chicago] (Chicago, 1992), 158–169.

Montreal 1977
Guide. Montreal Museum of Fine Arts. Montreal, 1977.

Morrison and Benavente 1970
Morrison, Frank, and José Benavente. "Magnetometer Evidence of a Structure within the La Venta Pyramid." *Science* 167 (1970), 1488–1490.

Morrison, Clewlow, and Heizer 1970
Morrison, Frank, C. W. Clewlow, Jr., and Robert F. Heizer. "Magnetometer Survey of the La Venta Pyramid." *Contributions of the University of California Archaeological Research Facility* 8: 1–20. Berkeley, 1970.

Muse and Stocker 1974
Muse, Michael, and T. Stocker. "The Cult of The Cross: Interpretation in Olmec Iconography." *The Journal of the Steward Anthropological Society* 5 (1974), 67–98.

Navarrete 1959
Navarrete, Carlos. *A Brief Reconnaissance in the Region of Tonala, Chiapas, Mexico.* Papers of the New World Archaeological Foundation 4. Provo, 1959.

Navarrete 1960
Navarrete, Carlos. *Archaeological Explorations in the Region of Frailesca, Chiapas, Mexico.* Papers of the New World Archaeological Foundation 7. Provo, 1960.

Navarrete 1971
Navarrete, Carlos. "Algunas piezas olmecas de Chiapas y Guatemala." *Anales de Antropología* 8 (1971), 69–82.

Navarrete 1974
Navarrete, Carlos. *The Olmec Rock Carvings at Pijijiapan, Chiapas, Mexico and Other Pieces from Chiapas and Guatemala.* Papers of the New World Archaeological Foundation 35. Provo, 1974.

Newton and Boltin 1978
Newton, Douglas, and Lee Boltin. *Masterpieces of Primitive Art: The Nelson A. Rockefeller Collection.* New York, 1978.

New York 1933
American Sources of Modern Art [exh. cat., Museum of Modern Art] (New York, 1933).

New York 1940
Twenty Centuries of Mexican Art/Veinte Siglos de Arte Mexicano [exh. cat., Museum of Modern Art and Instituto Nacional de Antropología e Historia] (New York, 1940).

New York 1982
The Guennol Collection. Vol. 2 [exh. cat., The Metropolitan Museum of Art] (New York, 1982).

New York 1984
Masterpieces of Pre-Columbian Art from the Collection of Mr. and Mrs. Peter G. Wray [exh. cat., Andre Emmerich Gallery and Perls Gallery] (New York, 1984).

Nichols 1982
Nichols, Deborah. "A Middle Formative Irrigation System near Santa Clara Coatitlan in the Basin of Mexico." *American Antiquity* 47, 1 (1982), 133–144.

Nicholson 1976
Nicholson, H. B., ed. *Origins of Religious Art and Iconography in Preclassic Mesoamerica.* Los Angeles, 1976.

Niederberger 1969
Niederberger, Christine Betton. "Paleoecología humana y playas lacustres postpleistocénicas en Tlapacoya." *Boletín del INAH* 37, (1969), 19–24.

Niederberger 1975
Niederberger, Christine. "Excavaciones en Zohapilco-Tlapacoya, Mexico." In *Actas del XLI Congreso Internacional de Americanistas* 1: 403–411. Mexico, 1975.

Niederberger 1976
Niederberger, Christine. *Zohapilco: cinco milenios de ocupación humana en un sitio lacustre de la Cuenca de México.* Colección Científica, Arqueología, Departamento de Prehistoria, INAH 30. Mexico, 1976.

Niederberger 1979
Niederberger, Christine. "Early Sedentary Economy in the Basin of Mexico." *Science* 203 (1979), 131–142.

Niederberger 1986
Niederberger, Christine. "Excavaciónes de un área de habitación doméstica en la capital 'olmeca' de Tlalcozotitlán." In *Primer Coloquio Arqueología y Etnohistoria del Estado de Guerrero*, 81–103. Mexico, 1986.

Niederberger 1987
Niederberger, Christine. "Paléopaysages et archéologie pré-urbaine du Bassin de México (Méxique)." In *Études Mésoamericaines* 11. Mexico, 1987.

Niederberger 1995
Niederberger, Christine. "Nacar y 'jade': Guerrero y las redes de intercambios interregionales en la Mesoamérica antigua (1000–600 B.C.)." Paper presented at the International Conference on Culture and Society in Guerrero, Museo Nacional de Antropología, June 1995.

Ochoa Salas 1973
Ochoa Salas, Lorenzo. "El culto fálico y la fertilidad en Tlatilco, México." *Anales de Antropología* 10 (1973).

Ochoa 1976
Ochoa Salas, Lorenzo. "Un Hacha 'Olmeca' de Etzatlan-San Marcos, Jalisco." *Anales de Antropología* 13 (1976), 47–54.

Ochoa 1977
Ochoa, Lorenzo. "Los olmecas y el Valle del Usumacinta." *Anales de Antropología* 14 (1977), 75–90.

Ochoa Castillo 1982
Ochoa Castillo, Patricia. *Secuencia Cronológica-Cultural de Tlatilco, México. IV Temporada.* Mexico, 1982.

Ochoa and Castro 1985
Ochoa, Lorenzo, and Marcia Castro-Leal. *Guía Arqueológica del Parque-Museo de La Venta.* Villahermosa, 1985.

Ochoa et al., in prep.
Ochoa Castillo, Patricia, Michael Schultz, Josefina Mansilla, and Juan Martin Rojas. "Evidencias bioarqueológicas sobre prácticas durante el periodo aldeano (1400–800 A.C.) en la Cuenca de México," in preparation.

Orrego Corzo 1990
Orrego Corzo, Miguel, ed. *Investigaciones arqueológicas en Abaj Takalik, El Asintal, Retalhuleu, Año 1988, Reporte no. 1.* Guatemala, 1990.

Ortiz and Cyphers, in press
Ortiz, Mario Arturo, and Ann Cyphers. "La geomorfología y las evidencias arqueológicas en la región de San Lorenzo Tenochtitlán, Veracruz." In *Población, Subsistencia y Medio Ambiente en San Lorenzo Tenochtitlán,* in press.

Ortiz Ceballos and Rodríguez 1989
Ortiz Ceballos, Ponciano, and María del Carmen Rodríguez. "Proyecto Manatí 1989." *Arqueología* 1 (1989), 23–52.

Paradis 1974
Paradis, Louise. "The Tierra Caliente of Guerrero, Mexico; An Archaeological and Ecological Study." Manuscript on file, Yale University, New Haven.

Paradis 1978
Paradis, Louise Iseut. "Early Dates for Olmec-Related Artifacts in Guerrero." *Journal of Field Archeology* 5 (1978), 110–116.

Paradis 1981
Paradis, Louise Iseut. "Guerrero and the Olmec." In *The Olmec and Their Neighbors.* Edited by E. P. Benson. Washington, D.C., 1981, 195–208.

Pareyón 1977
Pareyón Moreno, Eduardo. "Carta con fecha de 4 de febrero de 1977 del Arqlgo. Eduardo Pareyón Moreno...a Don Fermín Torres Alor." *Expediente B/311.32 (Z62-4)/1, Año 1944. Zona arqueológica de La Venta, exploraciones y conservaciones.* INAH. Mexico.

Parsons 1980
Parsons, Lee A. *Pre-Columbian Art: The Morton D. May and the Saint Louis Art Museum Collections.* New York, 1980.

Parsons 1986
Parsons, Lee A. *The Origins of Maya Art.* Studies in Pre-Columbian Art and Archaeology 28. Washington, D.C.

Parsons, Carlson, and Joralemon 1988
Parsons, Lee A., John B. Carlson, and Peter David Joralemon. *The Face of Ancient America: The Wally and Brenda Zollman Collection of Precolumbian Art* [exh. cat., Indianapolis Museum of Art] (Indianapolis, 1988).

Paso y Troncoso 1892
Paso y Troncoso, Francisco. *Catálogo de la Sección de México, Exposición Histórico-Americana de Madrid.* 2 Vols. Madrid, 1892.

Pellicer 1955a
Pellicer Cámara, Carlos. "Carta de Carlos Pellicer a Antonio J. Bermúdez." *Archivo Histórico del Instituto Nacional de Antropología e Historia* 59, 11. INAH. Mexico.

Pellicer 1955b
Pellicer Cámara, Carlos. "Carta de Carlos Pellicer a Ignacio Marquina." *Archivo Histórico del Instituto Nacional de Antropología e Historia* 59, 11. INAH. Mexico.

Pellicer 1957
Pellicer Cámara, Carlos. "Carta de Carlos Pellicer a Ignacio Bernal." *Expediente B/3.032 (M62-1)/1. Museo Regional de Villahermosa…. Archivo Técnico de la Coordinación Nacional de Arqueología.* INAH. Mexico.

Pellicer 1958a
Pellicer Cámara, Carlos. "Carta de Carlos Pellicer a Ignacio Bernal…de 13 de abril." *Expediente B/311.32 (Z62-4)/1, Año 1944. Zona arqueológica de La Venta, exploraciones y conservaciones.* INAH. Mexico.

Pellicer 1958b
Pellicer Cámara, Carlos. "Carta de Carlos Pellicer a Ignacio Bernal…de 27 de mayo." *Expediente B/311.32 (Z62-4)/1, Año 1944. Zona arqueológica de La Venta, exploraciones y conservaciones.* INAH. Mexico.

Pellicer 1959
Pellicer Cámara, Carlos. *Museos de Tabasco.* Mexico, 1959.

Pellicer 1961
Pellicer Cámara, Carlos. *Museos de Tabasco. Guía Oficial.* Mexico, 1961.

Peñafiel 1890
Peñafiel, Antonio. *Monumentos del Arte Mexicano Antiguo* 1. Mexico, 1890.

Piña Chan 1955a
Piña Chan, Román. *Chalcatzingo, Morelos.* INAH Informe 4. Mexico, 1955.

Piña Chan 1955b
Piña Chan, Román. *Las culturas preclásicas de la Cuenca de Mexico.* Mexico, 1955.

Piña Chan 1958
Piña Chan, Román. *Tlatilco.* 2 vols. INAH Investigaciones 1. Mexico, 1958.

Piña Chan 1971
Piña Chan, Román. "Preclassic or Formative Pottery and Minor Art of the Valley of Mexico." In *Handbook of Middle American Indians* 10: 157–178. Edited by G. Ekholm and I. Bernal. Austin, 1971.

Piña Chan 1982
Piña Chan, Román. *Los olmecas antiguos.* Mexico, 1982.

Piña Chan 1989
Piña Chan, Román. *The Olmec: Mother Culture of Mesoamerica.* New York, 1989.

Piña Chán 1993
Piña Chán, Román. *El Lenguaje de las Piedras.* Mexico, 1993.

Piña Chan and Covarrubias 1964
Piña Chan, Román, and Luis Covarrubias. *El Pueblo del Jaguar.* Mexico, 1964.

Piña Chan and López 1952
Piña Chan, Román, and Valentin López. "Excavaciones en Atlihuayán, Mor." *Tlatoani* 1, 1 (1952).

Pires-Ferreira 1976a
Pires-Ferreira, Jane W. "Obsidian Exchange in Formative Mesoamerica." In *The Mesoamerican Village,* 292–306. Edited by K. V. Flannery. New York, 1976.

Pires-Ferreira 1976b
Pires-Ferreira, Jane W. "Shell and Iron-Ore Mirror Exchange in Formative Mesoamerica, with Comments on Other Commodities." In *The Mesoamerican Village,* 306–311. Edited by K. V. Flannery. New York, 1976.

Pohorilenko 1972
Pohorilenko, Anatole. "La Pequeña Escultura: El Hombre y su Experiencia Artistico-Religiosa." In *El Arte Olmeca,* 35–62. Edited by B. de la Fuente. Artes de Mexico 154. Mexico, 1972.

Pohorilenko 1975
Pohorilenko, Anatole. "Paleopathology and the Olmec Style." Paper presented at Eliot House, Harvard University, 27 October 1975.

Pohorilenko 1981
Pohorilenko, Anatole. "The Olmec Style and Costa Rican Archaeology." In *The Olmec and Their Neighbors,* 309–327. Edited by E. P. Benson. Washington, D.C., 1981.

Pohorilenko 1984
Pohorilenko, Anatole. "A Propósito del Hacha Votiva Olmeca de la Casa de la Cultura de Juchitan, Oaxaca, Mexico." In *Los Olmecas,* 135–145. Edited by C. Navarrete. Revista Mexicana de Estudios Antropológicos 28. Mexico, 1984.

Pohorilenko 1990a
Pohorilenko, Anatole. "La Estructura del Sistema Representational Olmeca." *Arqueología* 3 (1990), 85–90.

Pohorilenko 1990b
Pohorilenko, Anatole. "The Structure and Periodization of the Olmec Representational System." Ph.D. diss., Tulane University, 1990.

Porter 1953
Porter, Muriel Noe. *Tlatilco and the Pre-Classic Cultures of the New World.* Viking Fund Publications in Anthropology 18. New York, 1953.

Porter 1967
Porter, Muriel. "Tlapacoya Pottery in the Museum Collection." Indian Notes and Monographs, Miscellaneous Series 56. New York, 1967.

Porter 1989
Porter, James B. "Olmec Colossal Heads as Recarved Thrones: 'Mutilation,' Revolution and Recarving." *Res: Anthropology and Aesthetics* 17–18 (1989), 23–29.

Porter 1990
Porter, James B. "Las cabezas colosales olmecas como altares reesculpidos: 'mutilación,' revolución e reesculpido." *Arqueología* 3 (1990), 91–97.

Porter, in press
Porter, James B. "Celtiform Stelae: A New Olmec Sculpture Type and Its Implications for Epigraphers." *Arqueología*, in press.

Porter Weaver 1993
Porter Weaver, Muriel. *The Aztecs, Maya, and Their Predecessors.* Third edition. San Diego and New York, 1993.

Princeton 1995
The Olmec World: Ritual and Rulership [exh. cat., The Art Museum, Princeton University] (Princeton, 1995).

Prindiville and Grove 1987
Prindiville, Mary, and David C. Grove. "The Settlement and Its Architecture." In *Ancient Chalcatzingo.* Edited by D. C. Grove. Austin, 1987.

Proskouriakoff 1968
Proskouriakoff, Tatiana. "Olmec and Maya: Problems of Their Stylistic Relation." In *Dumbarton Oaks Conference on the Olmec.* Edited by E. P. Benson. Washington, D.C., 1968.

Proskouriakoff 1971
Proskouriakoff, Tatiana. "Early Architecture and Sculpture in Mesoamerica." *Contributions of the University of California Archaeological Research Facility* 11: 141–156. Berkeley, 1971.

Proskouriakoff 1974
Proskouriakoff, Tatiana. *Jades from the Cenote of Sacrifice, Chichen Itza, Yucatan.* Memoirs of the Peabody Museum of Archaeology and Ethnology 10, 1. Cambridge, Mass., 1974.

Pyne 1976
Pyne, Nanette M. "The Fire-Serpent and Were-Jaguar in Formative Oaxaca: A Contingency Table Analysis." In *The Mesoamerican Village,*

272–282. Edited by K. V. Flannery. New York, 1976.

Quirarte 1973
Quirarte, Jacinto. *El Estillo Artistico de Izapa.* Mexico, 1973.

Quirarte 1981
Quirarte, Jacinto. "Tricephallic Units in Olmec, Izapan-Style, and Maya Art." In *The Olmec and Their Neighbors.* Edited by E. P. Benson. Washington, D.C., 1981.

Raab, Boxt, and Bradford 1995
Raab, L. Mark, Matthew A. Boxt, and Katherine Bradford. "Informe sobre las exploraciones arqueológicas en Bari 2 durante la temporada 1994." Manuscript on file, Archivo del Proyecto Arqueológico La Venta, Centro INAH Tabasco. Villahermosa.

Ramírez and Sánchez 1978
Rasgado Ramírez, Laura Elena, and Guadalupe Sánchez Azcona. *Una visita al pasado de Tabasco.* Villahermosa, 1978.

Rathje, Sabloff, and Gregory 1973
Rathje, William L., Jeremy A. Sabloff, and David A. Gregory. "El descubrimiento de un jade olmeca en la Isla de Cozumel, Quintana Roo, Mexico." *Estudios de Cultura Maya* 9 (1973), 85–91.

Reilly 1989
Reilly, F. Kent, III. "The Shaman in Transformation Pose: A Study of the Theme of Rulership in Olmec Art." *Record of The Art Museum Princeton University* 48, 2 (1989), 4–21.

Reilly 1991
Reilly, Kent, III. "Olmec Iconographic Influences on the Symbols of Maya Rulership." In *Sixth Palenque Round Table, 1986,* 151–166. Edited by M. G. Robertson and V. M. Fields. Norman, Okla., and London, 1991.

Reilly 1994a
Reilly, Kent, III. "Cosmología, soberanismo y espacio ritual en la Mesoamérica del Formativo." In *Los olmecas en Mesoamérica,* 239–259. Edited by J. E. Clark. Mexico, 1994.

Reilly 1994b
Reilly, Kent, III. "Enclosed Ritual Spaces and the Watery Underworld in Formative Period Architecture: New Observations on the Function of La Venta Complex A." In *Seventh Palenque Round Table, 125–135.* Edited by M. G. Robertson and V. M. Fields. San Francisco, 1994.

Reyna Robles 1971
Reyna Robles, Rosa. "Las figurillas pre-clásicas." Thesis, INAH, Mexico, 1971.

Reyna Robles and Martínez Donjuán 1989
Reyna Robles, Rosa, and Guadalupe Martínez Donjuán. "Hallazgos funerarios de 1a Época Olmeca en Chilpancingo, Guerrero." *Arqueología* 1 (1989), 13–22.

Rockefeller 1978
Rockefeller, Nelson A. "Introduction." In *Masterpieces of Primitive Art: The Nelson A. Rockefeller Collection.* Edited by D. Newton and L. Boltin. New York, 1978.

Romano 1967
Romano, Arturo. "Tlatilco." *Boletín del INAH* 30 (1967), 38–42.

Romano 1972a
Romano, Arturo. "Deformación craniana en Tlatilco." In *Religión en Mesoamerica, XII Mesa Redonda,* 415–419. Edited by J. Litvak K. and N. Castillo. Mexico, 1972.

Romano 1972b
Romano, Arturo. "Sistema de enterramientos en Tlatilco." In *Religión en Mesoamerica, XII Mesa Redonda,* 365–368. Edited by J. Litvak K. and N. Castillo. Mexico, 1972.

Rubin 1975
Rubin, Ida Ely, ed. *The Guennol Collection.* Vol. 1 [exh. cat., The Metropolitan Museum of Art] (New York, 1975).

Rubín de la Borbolla 1987
Rubín de la Borbolla, Daniel F. "Miguel Covarrubias: Insigne." In *Miguel Covarrubias: Homenaje,* 129–143. Mexico, 1987.

Rust 1987
Rust, William F. "A Settlement Survey of La Venta, Tabasco, Mexico. Preliminary Report of the 1986 Field Season." Manuscript on file, Archivo Técnico de la Coordinación Nacional de Arqueología, INAH. Mexico.

Rust 1988
Rust, William F. "Informe preliminar de la temporada de campo de 1987." Manuscript on file, Archivo Técnico de la Coordinación Nacional de Arqueología, INAH. Mexico.

Rust 1989
Rust, William F. "Environmental Change, Subsistence and Domestication at La Venta." Paper presented at the 88th Annual Meeting of the American Anthropological Association, 1989.

Rust 1992
Rust, William F., 1992. "New Ceremonial and Settlement Evidence at La Venta, and Its Relation to Preclassic Maya Cultures." In *New Theories on the Ancient Maya,* 123–130. Edited by E. D. Danien and R. J. Sharer. University Museum Monograph 77, University Museum Symposium Series 3. Philadelphia, 1992.

Rust and Leyden 1994
Rust, William F., and Barbara Leyden. "Evidence of Maize Use at Early and Middle Preclassic La Venta Olmec Sites." In *Corn and Culture in the Prehistoric New World.* Edited by S. Johannessen and C. A. Hastorf. Boulder, Colo., 1994.

Rust and Sharer 1988
Rust, William F., and Robert J. Sharer. "Olmec Settlement Data from La Venta, Tabasco, Mexico." *Science* 242 (1988), 102–104.

San José 1980
Jade Precolombino de Costa Rica. San José, 1980.

Santa Barbara 1942
Ancient American Art [exh. cat., Santa Barbara Museum of Art] (Santa Barbara, 1942).

Santley 1992
Santley, Robert. "A Consideration of the Olmec Phenomenon in the Tuxtlas: Early Formative Settlement Pattern, Land Use, and Refuse Disposal at Matacapan, Veracruz, Mexico." In *Gardens of Prehistory, The Archaeology of Settlement Agriculture in Greater Meso-america*, 150–183. Edited by T. W. Killion. Tuscaloosa, 1992.

Saunders 1989
Saunders, Nicholas J. *People of the Jaguar: The Living Spirit of Ancient America.* London, 1989.

Saville 1900
Saville, Marshall H. "A Votive Adze of Jadeite from Mexico." *Monumental Records* 1 (1900), 138–140.

Saville 1929
Saville, Marshall H. "Votive Axes from Ancient Mexico, parts 1 and 2." *Indian Notes* 6 (1929), 266–299, 335–342.

Schele 1988
Schele, Linda. "The Xibalba Shuffle." In *Maya Iconography*, 294–317. Edited by E. P. Benson and G. G. Griffin. Princeton, 1988.

Schele and Freidel 1990
Schele, Linda, and David Freidel. *A Forest of Kings. The Untold Story of the Ancient Maya.* New York, 1990.

Schele and Miller 1986
Schele, Linda, and Mary Ellen Miller. *Blood of Kings* [exh. cat., Kimbell Art Museum] (Fort Worth, 1986).

Schieber de Lavarreda 1994
Schieber de Lavarreda, Christa. "A Middle Preclassic Clay Ball Court at Abaj Takalik, Guatemala." *Mexicon* 16 (1994), 77–84.

Schmidt 1990
Schmidt Schoenberg, Paul. *Arqueología de Xochipala, Guerrero.* Mexico, 1990.

Seler 1923
Seler, Eduard. "Die Tierbilder in den mexikanischer und den Maya-Handschriften." In *Gesammelte Abhandlungen zur amerikanis-chen Sprach- und Altertumskunde*, 4. Berlin, 1923 (Graz, 1961).

Seler-Sachs 1922
Seler-Sachs, Caecilie. "Altertümer des Kanton Tuxtla im Staate Veracruz." In *Festschrift Eduard Seler*, 543–556. Edited by W. Lehmann. Stuttgart, 1922.

Serra 1986
Serra Puche, Mari Carmen. "Unidades habita-cionales en el Formativo en la Cuenca de México." In *Unidades habitacionales meso-americanas y sus áreas de actividad*, 161–192. Mexico, 1986.

Serra 1988
Serra Puche, Mari Carmen. *Los recursos lacus-tres de la Cuenca de México durante el forma-tivo.* Colección general de Estudios de Posgrado 3. Mexico, 1988.

Serra 1993
Serra Puche, Mari Carmen. *Vida Cotidiana. Un día, un año, un milenio. Periodo formativo de la Cuenca de México (1000 A.C.–100 D.C.).* Mexico, 1993.

Serra, in press
Serra Puche, Mari Carmen, ed. *Temamatla: un centro del Formativo en el sur de la Cuenca de México*, in press.

Sharer 1978
Sharer, Robert J., ed. *The Prehistory of Chalchuapa, El Salvador.* Philadelphia, 1978.

Sharer 1982
Sharer, Robert J. "In the Land of Olmec Archaeology." *Journal of Field Archaeology* 9 (1982), 253–267.

Sharer and Grove 1989
Sharer, Robert J., and David C. Grove, eds. *Regional Perspectives on the Olmec.* Cambridge and New York, 1989.

Shook 1956
Shook, Edwin M. "An Olmec Sculpture from Guatemala." *Archaeology* 9 (1956), 260–262.

Shook 1971
Shook, Edwin M. "Inventory of Some Pre-Classic Traits in the Highlands and Pacific Guatemala and Adjacent Areas." In *Obser-vations on the Emergence of Civilization in Mesoamerica*, 70–77. Edited by R. F. Heizer, J. A. Graham, and C. W. Clewlow, Jr. *Contribu-tions of the University of California Archae-ological Research Facility* 11. Berkeley, 1971.

Shook and Hatch 1978
Shook, Edwin M., and Marion P. Hatch. "Ruins of El Balsamo, Department of Escuintla, Guatemala." *Journal of New World Archaeology* 3, 1 (1978), 1–38.

Shook and Heizer 1976
Shook, Edwin M., and Robert F. Heizer. "An Olmec Sculpture from the South Coast of Guatemala." *Journal of New World Archaeology* 1, 3 (1976), 1–8.

Sierra 1905
Sierra, Justo. "Carta dirigida a Leopoldo Batres…." *Expediente B/311.32 (Z62-4)/1, Año 1944. Zona arqueológica de La Venta, explo-raciones y conservacions.* INAH. Mexico.

Sisson 1970
Sisson, Edward B. "Mascara olmeca de San Felipe." *Boletín del INAH* 40 (1970), 45–48.

Sommerville 1889
Sommerville, Maxwell. *Engraved Gems: Their History and Place in Art.* Philadelphia, 1889.

Soto 1993
Soto, Zulay. "Jades in the Jade Museum, Instituto Nacional de Seguros, San Jose, Costa Rica." In *Precolumbian Jade*, 68–72. Edited by F. W. Lange. Salt Lake City, 1993.

Spinden 1947
Spinden, Herbert. "An Olmec Jewel." *Brooklyn Museum Bulletin* 9 (1947), 1–14.

Squier 1964
Squier, Robert J. *A Reappraisal of Olmec Chronology.* Ann Arbor, Mich., 1964.

Stark and Voorhies 1978
Stark, B., and B. Voorhies. *Prehistoric Coastal Adaptation.* New York and San Francisco, 1978.

Stephens 1841
Stephens, John Lloyd. *Incidents of Travel in Central America, Chiapas, and Yucatan.* New York, 1841.

Stephens 1843
Stephens, John Lloyd. *Incidents of Travel in Yucatan.* New York, 1843.

Stirling 1939
Stirling, Matthew W. "Discovering the New World's Oldest Dated Work of Man." *National Geographic* 76 (1939), 183–218.

Stirling 1940
Stirling, Matthew W. "Great Stone Faces of the Mexican Jungle." *National Geographic* 78 (1940), 309–334.

Stirling 1941
Stirling, Matthew W. "Expedition Unearths Buried Masterpieces of Carved Jade." *National Geographic* 80 (1941), 277–302.

Stirling 1943a
Stirling, Matthew W. "La Venta's Green Stone Tigers." *National Geographic* 84 (1943), 321–332.

Stirling 1943b
Stirling, Matthew W. *Stone Monuments of Southern Mexico.* Bureau of American Ethnol-ogy Bulletin 138. Washington, D.C., 1943.

Stirling 1947
Stirling, Matthew W. "On the Trail of La Venta Man." *National Geographic* 91 (1947), 137–172.

Stirling 1955
Stirling, Matthew W. "Stone Monuments of the Río Chiquito." Bureau of American Ethnology Bulletin 157. Washington, D.C., 1955, 1–23.

Stirling 1957
Stirling, Matthew W. *An Archaeological Reconnaissance in Southeastern Mexico.* Bureau of American Ethnology Bulletin 164. Washington, D.C., 1957.

Stirling 1961
Stirling, Matthew W. "The Olmec, Artists in Jade." In *Essays in Pre-Columbian Art and Archeology*, 43–59. Cambridge, Mass., 1961.

Stirling 1965
Stirling, Matthew W. "Monumental Sculpture of Southern Veracruz and Tabasco." In *Handbook of Middle American Indians* 3: 716–738. Austin, 1965.

Stirling 1968
Stirling, Matthew W. "Early History of the Olmec Problem." In *Dumbarton Oaks Conference on the Olmec*, 1–8. Edited by E. P. Benson. Washington, D.C., 1968.

Stirling and Stirling 1942
Stirling, Matthew W., and Marion Stirling. "Finding Jewels of Jade in the Mexican Swamp." *National Geographic* 82 (1942), 635–661.

Stuart 1993
Stuart, George. "New Light on the Olmec." *National Geographic* 184 (1993), 88–115.

Symonds 1995
Symonds, Stacey. "Settlement Distribution and the Development of Cultural Complexity in the Lower Coatzacoalcos Drainage, Veracruz, Mexico: An Archaeological Survey at San Lorenzo Tenochtitlán." Ph.D. diss., Vanderbilt University, Nashville, 1995.

Taube, in press
Taube, Karl. "Symbolism of Maize in Mesoamerican and Southwestern Thought," in press.

Thomson 1987
Thomson, Charlotte W. "Chalcatzingo Jade and Fine Stone Objects." In *Ancient Chalcatzingo*. Edited by D. C. Grove. Austin, 1987.

Tolstoy 1978
Tolstoy, Paul. "Western Mesoamerica before A.D. 900." In *Chronologies in New World Archaeology*, 241–284. Edited by R. E. Taylor and C. W. Meighan. New York, 1978.

Tolstoy 1989a
Tolstoy, Paul. "Coapexco and Tlatilco: Sites with Olmec Materials in the Basin of Mexico." In *Regional Perspectives on the Olmec*, 85–121. Edited by R. J. Sharer and D. C. Grove. Cambridge and London, 1989.

Tolstoy 1989b
Tolstoy, Paul. "Western Mesoamerica and the Olmec." In *Regional Perspectives on the Olmec*, 275–302. Edited by R. J. Sharer and D. C. Grove. Cambridge and London, 1989.

Tolstoy and Fish 1973
Tolstoy, Paul, and Susan K. Fish. "Surface Evidence for Community Size at Coapexco, Mexico." *Journal of Field Archaeology* 2 (1973), 97–104.

Tolstoy and Paradis 1970
Tolstoy, Paul, and Louise I. Paradis. "Early and Middle Preclassic Culture in the Basin of Mexico." *Science* 167 (1970), 344–351.

Tolstoy and Paradis 1971
Tolstoy, Paul, and Louise I. Paradis. "Early and Middle Preclassic Culture in the Basin of Mexico." In *Observations on the Emergence of Civilization in Mesoamerica*, 169–195. Edited by R. F. Heizer, J. A. Graham, and C. W. Clewlow, Jr. Contributions of the University of California Archaeological Research Facility 11. Berkeley, 1971.

Tolstoy et al. 1977
Tolstoy, Paul, Suzanne K. Fish, Martin W. Boksenbaum, Kathryn Blair Vaughn, and C. Earle Smith, Jr. "Early Sedentary Communities of the Basin of Mexico: A Summary of Recent Investigations." *Journal of Field Archaeology* 4 (1977), 92–106.

Torres 1972, 1975, 1977
Torres Alor, Fermin. "Carta de Fermin Torres Alor...." *Expediente B/311.32 (Z62-4)/1, Año 1994. Zona arqueológica de La Venta, exploraciones y conservaciones.* INAH. Mexico.

Torrucco 1987
Torrucco Saravia, Geney. *Villahermosa Nuestra Ciudad.* Vol. 1. Villahermosa, 1987.

Turner 1991
Turner, Evan H., ed. *Object Lessons: Cleveland Creates an Art Museum.* Cleveland, 1991.

Tuxtla Gutiérrez 1942
Mayas y Olmecas: Segunda Mesa Redonda sobre Problems Antropológicas de México y Central America. Tuxtla Gutiérrez, 1942.

Vaillant 1930
Vaillant, George C. *Excavations at Zacatenco.* Anthropological Papers of the American Museum of Natural History 32, 1. New York, 1930.

Vaillant 1931
Vaillant, George C. *Excavations at Ticoman.* Anthropological Papers of the American Museum of Natural History 32, 2. New York, 1931.

Vaillant 1932
Vallant, George C. "A Pre-Columbian Jade." *Natural History* 32 (1932), 512–520, 556–558.

Vaillant 1935a
Vaillant, George C. *Early Cultures of the Valley of Mexico.* Anthropological Papers of the American Museum of Natural History 35, 3. New York, 1935.

Vaillant 1935b
Vaillant, George C. *Excavations at El Arbolillo.* Anthropological Papers of the American Museum of Natural History 35, 2. New York, 1935.

Vaillant and Vaillant 1934
Vaillant, Susannah B., and George C. Vaillant. *Excavations at Gualupita.* Anthropological Papers of the American Museum of Natural History 35, 1. New York, 1934.

Villela 1989
Villela, Samuel F. "Nuevo testimonio rupestre olmeca en el oriente de Guerrero." *Arqueología*, época 2, 2 (1989), 37–48.

Washington 1947
Indigenous Art of the Americas [exh. cat., National Gallery of Art] (Washington, D.C., 1947).

Washington 1963
Handbook of the Robert Woods Bliss Collection. Washington, D.C., 1963.

Wedel 1952
Wedel, Waldo. "Structural Investigations in 1943." In *La Venta, Tabasco. A Study of Olmec Ceramics and Art.* Bureau of American Ethnology Bulletin 153: 34–79. Washington, D.C., 1952.

Weitlaner 1946
Weitlaner, Robert. "Situación lingüística del Estado de Guerrero." In *El Occidente de México*, 129–133. Mexico, 1946.

West, Psuty, and Thom 1969
West, Robert C., Norbert P. Psuty, and Bruce G. Thom. *The Tabasco Lowlands of Southeastern Mexico.* Technical Report 70, Coastal Studies Institute. Louisiana State University, Baton Rouge, 1969.

Westheim 1963
Westheim, Paul. *Arte Antiguo de México.* Mexico, 1963.

Wicke 1971
Wicke, Charles R. *Olmec: An Early Art Style of Precolumbian Mexico.* Tucson, 1971.

Willey 1978
Willey, Gordon R. *Excavations at Seibal, Department of Peten, Guatemala.* Memoirs of the Peabody Museum of Archaeology and Ethnology 14, 1. Cambridge, Mass., 1978.

Williams 1993
Williams, Elizabeth A. "Collecting and Exhibiting Precolumbiana in France and England, 1870–1930." In *Collecting the Pre-Columbian Past*, 123–140. Edited by E. H. Boone. Washington, D.C., 1993.

Williams and Heizer 1965
Williams, Howell, and Robert F. Heizer. "Sources of Rocks used in Olmec Monuments." *Contributions of the University of California Archaeological Research Facility* 1: 1–39. Berkeley, 1965.

Wing 1980
Wing, Elizabeth S. "Faunal Remains from San Lorenzo." In *In the Land of the Olmec*, 1: 375–386. Edited by M. D. Coe and R. A. Diehl. Austin and London, 1980.

Winter 1972
Winter, Marcus. *Tierras largas: A Formative Community in the Valley of Oaxaca*. Tucson, 1972.

Zanin 1991
Zanin, Daniela. "Necklace with Central Idol." In *Circa 1492*. Edited by J. A. Levenson [exh. cat., National Gallery of Art] (Washington, D.C.), 580.

Zurita, in press
Zurita, Judith. "Los fitolitos: Indicaciones sobre dieta y vivienda en San Lorenzo Tenochtitlán." In *Población, Subsistencia y Medio Ambiente en San Lorenzo Tenochtitlán*, in press.

Picture Credits

Photographic materials have kindly been supplied by lenders or owners of works of art except as noted.

Catalogue Photography
C. Chesek: cat. 75. Justin Kerr: cats. 19, 28, 48, 67, 76, 87, 89, 102. The Marlow Group, Inc.: cat. 41. Adrián Mendieta Pérez: cats. 8, 77-78. John Bigelow Taylor: cats. 50, 88. Bruce M. White: cat. 31. Michel Zabé: 1-7, 9-13, 16-18, 21, 23-26, 29, 36, 39-40, 42, 45, 47, 49, 51, 57, 61-62, 83, 85-86, 90, 94-96, 98, 103-104, 107-109, 111, 114-115, 119.

Additional Illustrations
American Museum of Natural History, New York: p. 129 fig. 10. A. Apostolides: p. 115 fig. 11. Elizabeth P. Benson: p. 43 fig. 1; p. 44 fig. 2; p. 45 fig. 3; p. 136 fig. 4. Fernando Botas: p. 62 fig. 1; p. 63 fig. 2; p. 69 fig. 5. The Brooklyn Museum: p. 125 fig. 5. From Covarrubias 1957, figs. 21, 9, 35, 34: pp. 187, 198, 250, 265. Ann Cyphers: p. 65 fig. 3; p. 68 fig. 4; p. 69 fig. 6. José de Los Reyes Medina: p. 86 fig. 3. Denver Art Museum: p. 122 fig. 1. Richard Diehl: p. 20 fig. 4. From Philip Drucker, "La Venta Tabasco: A Study of Olmec Ceramics and Art," in Bureau of American Ethnology Bulletin 153 (Washington, D.C., 1952), fig. 46b: p. 244. From Drucker, Heizer, and Squier 1959, fig. 40: p. 204. Dumbarton Oaks Research Library and Collections: p. 130 fig. 11. Barbara Wascher Fash: p. 114 fig. 9. Susan Gillespie: p. 111 fig. 4. Rebecca González

Lauck: p. 74 fig. 1; p. 75 fig. 2; p. 149 fig. 2. John Graham: p. 77 fig. 3. David Grove: p. 107 fig. 1; p. 108 fig. 2; p. 110 fig. 3; p. 112 figs. 5-6; p. 113 figs. 7-8; p. 114 fig. 10. Instituto Nacional de Antropología e Historia: p. 89 fig. 7; p. 146 fig. 1. Justin Kerr: p. 25 fig. 8. © Peter David Joralemon: pp. 170, 178, 197, 199, 201, 216, 217, 219, 230, 232, 235, 236, 240, 245, 248, 249, 253, 262, 267, 269, 270, 273. Victor Lagarde: p. 86 fig. 2; p. 88 fig. 6; p. 89 fig. 8. Museo Tuxteco, Veracruz: p. 123 fig. 2. Museum für Völkerkunde, Berlin: p. 130 fig. 12. National Geographic Society: p. 18 fig. 3; p. 79 fig. 4. National Museum of Anthropology, Mexico City: p. 127 fig. 9. From Navarrete 1974, fig. 16: p. 258. Christine Niederberger: p. 84 map 1; p. 85 fig. 1; p. 87 fig. 4; p. 88 fig. 5; p. 90 fig. 9; p. 91 figs. 10-11; p. 92 fig. 12; p. 96 fig. 1; p. 98 figs. 2-3; p. 100 figs. 4-5; p. 101 fig. 6. ©1995 by The Trustees of Princeton University. *The Olmec World: Ritual and Rulership* [exh. cat. The Art Museum, Princeton University] (Princeton, 1996), pp. 2, 10, 280 fig. 2: basis for maps on pp. 14, 15, cat. 50 pp. 213, 214, 215. From Rathje, Sabloff, and Gregory 1973, 91: p. 252. Schatzkammer der Residenz, Munich: p. 134 fig. 1. Edwin M. Shook: p. 23 fig. 7. Margaret Young-Sánchez: p. 221.

Illustrations on p. 74 fig. 1; p. 84 fig. 1; p. 124 fig. 4; p. 219; p. 221; p. 244; and p. 270 were redrawn for publication by Patricia Condit.